THE WRIGHTSMAN PICTURES

THE

WRIGHTSMAN PICTURES

Edited by Everett Fahy

with a preface by Pierre Rosenberg

and contributions by Elizabeth E. Barker, Everett Fahy,

George R. Goldner, Alain Gruber, Colta Ives, Asher Ethan Miller,

Sabine Rewald, Perrin V. Stein, and Gary Tinterow

THE METROPOLITAN MUSEUM OF ART, NEW YORK

YALE UNIVERSITY PRESS, NEW HAVEN AND LONDON

Published by The Metropolitan Museum of Art, New York

John P. O'Neill, Editor in Chief
Gwen Roginsky, Associate General Manager of Publications
Margaret Rennolds Chace, Managing Editor
Cynthia Clark, Editor
Bruce Campbell, Designer
Gwen Roginsky, Jill Pratzon, and Sally VanDevanter, Production
Robert Weisberg, Assistant Managing Editor
Jayne Kuchna, Bibliographer

Translations from the French by Lory Frankel, M. E. D. Laing, and Rebecca Tilles

Typeset in Dante and Snell Roundhand
Printed on 150 gsm Consort Royal
Separations by Professional Graphics, Inc., Rockville, Illinois
Printed and bound by Arnoldo Mondadori Editore S.p.A., Verona, Italy

Jacket illustration: Jean-Étienne Liotard, *Woman in Turkish Dress, Seated on a Sofa* (cat. 60)
Frontispiece: Jean Marc Nattier, *Marie Thérèse Geoffrin (1715–1791), Marquise de La Ferté–Imbault* (cat. 50)

Cataloguing–in–publication data is available from the Library of Congress.

ISBN: 1–58839–144–2 (The Metropolitan Museum of Art)
ISBN: 0–300–10719–6 (Yale University Press)

Contents

Director's Foreword

On the publication of this remarkable collection of pictures, which includes a large number of paintings and drawings in Mrs. Wrightsman's personal collection as well as works already given to or purchased for The Metropolitan Museum of Art, the personal tribute that I would have wanted to pen, as it turns out, follows under the signature of my friend and colleague Pierre Rosenberg. There he expresses, in a piece of felicitous writing, much of what I would have been delighted to say about Mrs. Wrightsman. To be preempted so elegantly, in this instance, is a pleasure.

Since the early 1970s, when the Metropolitan Museum published the first comprehensive catalogue of the Wrightsman collection, the passion and discernment that Jayne Wrightsman has brought to her collecting has not diminished. Indeed, in the history of this museum, very few benefactors have combined such grace and complete devotion to both art and the institution. Mrs. Wrightsman's keenness of eye accounts for the fact that a Wrightsman credit line on any object (from the great Guercino *Samson Captured by the Philistines* to a small, exquisite Ingres portrait drawing—or a Frederick the Great *tabatière* from the earlier catalogue) contributes a true imprimatur of the highest quality and interest.

I am conscious in writing this brief note that we are not talking of a final chapter. The ensuing years, we fervently trust, will continue to see the expansion of this catalogue, as Mrs. Wrightsman adds further jewels to her own collection as well as to that of the Metropolitan Museum.

Philippe de Montebello
Director
The Metropolitan Museum of Art

Acknowledgments

The creation of this catalogue, from research to printing, required the assistance of many hands. In addition to the scholars named in discussions of specific Wrightsman works, the following people have contributed significantly to this publication: Katharine Baetjer, Joseph Baillio, Denise Bastien, Charles Beddington, Esther Bell, Mark Brady, Virginia Budny, Bruce Campbell, Edmund Capon, Andrew Caputo, Margaret Chace, Keith Christiansen, Cynthia Clark, James Draper, Lory Frankel, Nicole Garnier, Stephen Geiger, Christine Giviskos, Mary Gladue, Taube Greenspan, Zeina Hakim, Jo Hedley, Mary-Elizabeth Hellyer, Rena Hoisington, Katherine Holmgren, Jan Howard, Danielle Kisluk-Grosheide, Edouard Kopp, Jayne Kuchna, Alastair Laing, M. E. D. Laing, Risha Lee, Constance McPhee, Emmanuel Moatti, Kate Niedermeyer, John O'Neill, Anna Ottani Cavina, Anne Poulet, Jill Pratzon, Aileen Ribeiro, Robert-Jan te Rijdt, Gwen Roginsky, Marianne Roland Michel, Pierre Rosenberg, Francis Russell, Marie-Catherine Sahut, Xavier Salmon, Alan Salz, Guilhem Scherf, Adelaide Sharry, Marjorie Shelley, Penelope M. Smith, Holly Snyder, Gerd Spitzer, Mary Springson de Jesus, Guy Stair Sainty, Gerald G. Stiebel, Russell Stockman, Patricia Tang, Eugene Victor Thaw, Dominique Thiébaut, Wendy Thompson, Rebecca Tilles, Angus Trumble, David Tunick, Sally VanDevanter, Robert Weisberg, and Gretchen Wold.

Contributors to the Catalogue

EEB Elizabeth E. Barker, Director, Picker Art Gallery, Colgate University

EF Everett Fahy, John Pope-Hennessy Chairman, Department of European Paintings, The Metropolitan Museum of Art

GRG George R. Goldner, Drue Heinz Chairman, Department of Drawings and Prints, The Metropolitan Museum of Art

AG Alain Gruber, independent scholar

CI Colta Ives, Curator, Department of Drawings and Prints, The Metropolitan Museum of Art

AEM Asher Ethan Miller, Research Associate, Department of Nineteenth-Century, Modern, and Contemporary Art, The Metropolitan Museum of Art

SR Sabine Rewald, Curator, Department of Nineteenth-Century, Modern, and Contemporary Art, The Metropolitan Museum of Art

PS Perrin V. Stein, Curator, Department of Drawings and Prints, The Metropolitan Museum of Art

GT Gary Tinterow, Engelhard Curator in Charge, Department of Nineteenth-Century, Modern, and Contemporary Art, The Metropolitan Museum of Art

Preface

*B*efore surveying the Wrightsman collection, I could not fail to say a few words about Jayne Wrightsman herself. To do so consists of picking out memories, in great disarray, of my encounters in New York, Paris, and London, cities that harbor the world's greatest museums and that are Jayne's ports as well as the points of departure for this indefatigable traveler, who would not be caught missing the latest exhibition in Munich, the reorganization of Prague's museums, or the restoration of some monument in Saint Petersburg. In New York: while I was a resident at the Institute for Advanced Studies in Princeton for several months in 1977, I was regularly invited by Jayne and Charles Wrightsman to premieres of the Metropolitan Opera. "Cravate noire," to use an English idiom, or "Black tie," as the French say, required. On the return trip, changing clothes unobtrusively called for some acrobatics in the almost empty Greyhound bus that took me from New York to Princeton late at night. The contrast between the dismal bus terminal and the glittering lobby of the Metropolitan Opera has always remained one of my strongest images of New York. More recently, again in New York, I put the finishing touches on a catalogue raisonné of Watteau's drawings (of which Jayne Wrightsman owns a magnificent sheet in *trois crayons*, or three chalks, *Study of a Woman's Head and Hands*, hands of which Watteau is the most tender and delicate poet). Somehow, the conversation turned to a drawing in the Cleveland Museum of Art that had long troubled me. I had seen it many years ago and had not been convinced of its attribution. The issue could not be decided by looking at a photograph. No matter; with her perfect mastery of arrangements, Jayne had four of us—herself, Everett Fahy, my wife, and I—go out to see it the next day. On examining it, I found the work disappointing; even today, although alone in my doubts, I am still not persuaded by its attribution, and I have never budged on that position. Besides Jayne Wrightsman's swiftness and efficiency—the trip there and back in a single day, carried by private airplane—there is a lesson to be drawn: Jayne Wrightsman wants to learn, to know, and to understand. What were the reasons for my hesitancy; how could a direct examination of the drawing enable me to accept or reject the attribution; what were the objective criteria (the paper, its watermark, the nuances of the chalk color, and

so on) and subjective criteria (hard to define; in general called the "eye") of my decision?

Once more in New York, the memory of an evening, Fifth Avenue. I had just shown in Paris, in the exhibition *From David to Delacroix* at the Grand Palais, the admirable portrait of Lavoisier and his wife by David, then owned by the Rockefeller Institute for Medical Research. Before borrowing it for the exhibition, I went to see the masterpiece at the institute. I can still hear the piercing cries of the swallows that echoed in that immense unair-conditioned reading room of the library, embellished by David's imposing canvas. The painting was for sale, and the Louvre was interested. So was the Metropolitan Museum, and the proposal of a shared purchase arose. The two institutions would take turns exhibiting the painting. The French got stuck on a problem that today appears trifling: How could a French national museum acquire and share a work with an American private museum? More than official opposition on the part of France and the United States, the insurmountable obstacle seemed to be resolving the legal issues between a state institution, the Louvre, and a private institution, the Metropolitan. That night, Charles Wrightsman—I remember it with perfect clarity—broke the impasse. He bought the splendid painting outright and gave it to the Metropolitan Museum. And that was that. Today it numbers among the museum's masterpieces.

I also retain numerous memories of Jayne Wrightsman in Paris. From the exploration of new restaurants, some of which would become famous, to the visit of little-noted "cutting-edge" exhibitions, from secret Parisian sites (I promised Jayne a comprehensive visit to the Val-de-Grâce and the private apartments of Anne of Austria; this remains to be organized) to some recently renovated museum on the outskirts of Paris, or a visit to Saint-Denis or Beauvais (to see the Bussy exhibition)—nothing that relates to the cultural life of France in its most overarching sense leaves Jayne Wrightsman indifferent (I do not mention, from total incompetence on my part, our great couturiers). I still remember a walk on the roof of the Louvre's Pavillon de Flore (now, unfortunately, inaccessible) that gave us a view on a splendid and moving Paris, the miracle of a city that owes as much to the ingenuity of humans as to the accidents of history, a city to which Jayne

Wrightsman brings a measureless love (and which we always wish to separate, alas, from all the crimes still committed there).

Others would know better how to evoke the London, the England, that is Jayne Wrightsman's second country: not only the England of castles and lords, but also that of an art of living, now on the verge of extinction—a remarkable tolerance and civility, as well as the most eccentric personalities, free from all constraints, of connoisseurs and antiquarians, a breed, unfortunately, also on the path to extinction, along with the platypus and the giant panda. Finally, Jayne Wrightsman is a "European," deeply attached to our old continent—something, unhappily, no longer fashionable, and worth emphasizing.

Were I forced to venture a definition, I would choose without hesitation the word *curiosity*—an all-devouring, endless, and boundless curiosity that Jayne Wrightsman has for art. She has read everything, seen everything. Jayne Wrightsman is always on the alert, listening and attentive. She loves to give pleasure. She never shows off her knowledge, but nothing escapes her. Her network, or rather, her circle of friends, from Everett Fahy to Neil MacGregor, Philippe de Montebello to Jacob Rothschild and Annette de La Renta, to name some of the closest ones—and friendship is essential for Jayne (my apologies for mentioning here only a few names from a very long list)—is exemplary. Admirable Jayne Wrightsman, whose way of going about things, discreet, generous, and always controlled, in her approach to the arts—the Fine Arts, as they used to be called—has not perhaps been sufficiently stressed. Among the great women patrons of previous centuries, to whom could she be compared? What figures from Renaissance Florence, Enlightenment Paris, Victorian England, twentieth-century America does she call to mind? I will not undertake an exercise that, in any case, would require me to award a position that is not at my disposal. A course carried out with reserve and efficacy, with perseverance and resolve, in the service of a museum—but let's not anticipate.

Now let us open the catalogue and attempt to conjure up the superb collection of Charles and Jayne Wrightsman (I will speak only of the paintings and drawings, but the reader should not overlook the breadth of the collection, its sculpture, furniture, and decorative arts).

And right away a question arises: How can a collection made over a long period of time reflect the tastes and personality of those (Charles, we recall, died in 1986) who created it? Isn't a collection more the result of chance than of a determination to stay on one path? Don't the exigencies of the moment and the market put pressure on the desire for coherence and homogeneity? Isn't it hard to resist an exceptional work whose like will not be offered again, even if it doesn't follow the thread of one's choices and tastes? Who can claim that he has never let himself be led astray from the right road that he has firmly designated and has sworn never to deviate from? Those who leaf—even quickly—through this catalogue (for which warm congratulations are due to the nine authors, who have produced over one hundred twenty entries of a perfect erudition) will be struck by the coherence of the material. This may be surprising: coherence, when the earliest purchases date back to the 1950s? When the Wrightsman collection embraces works from all the European countries, including Spain (El Greco) and Germany (Caspar David Friedrich, the rare Wilhelm von Kobell)? When the earliest works date to the beginning of the sixteenth century (Gerard David) and the most recent from the final years of the nineteenth (*Nature morte aux violettes* by Trouillebert is dated 1898)? When it contains as many drawings as paintings? When the greatest names in painting (Vermeer, Rubens) coexist with those of lesser-known (Goffredo Wals, Michiel Sweerts) or unknown artists (Gilles Allou, François Vernay)?

To begin with, several observations in no particular order: on the one hand, there are no Italian, French, or Flemish "primitives"; on the other, no (or very few) "impressionists" in the broad sense of the term (a lovely Pissarro offered to the Metropolitan Museum in 1973, Éva Gonzalès, a wonderful oil sketch by Seurat). Few English paintings, despite Jayne Wrightsman's complete love for England, an Anglophilia without boundaries. Then there are lacunae in the French eighteenth century, so close to Jayne's heart, that one could think of as involuntary (Fragonard and, above all, Chardin, which saddens me).

This type of observation could be multiplied if, by contrast, a unified view did not prevail over the apparent diversity. Let us look at the example of Ingres, Chassériau, and Delacroix. I am among those who think, not without a touch of impudence, that it is difficult, if not impossible, to love both Ingres and Delacroix: Ingres, the painter who in the nineteenth century symbolized regressive academicism but who became, in one of those frequent changes of taste, one of the main inspirations of the greatest artists of the twentieth century, for Matisse as well as for Picasso; and Delacroix, the painter who was considered in his own time avant-garde and who is today placed among the last disciples of Veronese and Rubens. In short, the fervent Poussinist and the complete Rubenist, the supreme master of line and the tenacious defender of color. Jayne Wrightsman proves me wrong. She owns a wonderful suite of drawings by Ingres, showing only portraits,

the finest ensemble of sheets by the artist in private hands today. It portrays French soldiers, English tourists passing through Rome, the master's students, and, especially, the artist's much beloved first wife, Madeleine Chapelle, drawn in 1814.

Moving to Delacroix: no drawings, but two paintings, and to bridge the gap between these two fierce enemies, Chassériau represented equally by drawings (three portraits) and paintings. Thus, setting aside categories and going beyond the somewhat artificial classifications of art history, Jayne, with an infallible sense of discrimination, knows how to bring together in her collection those who at first glance seem incompatible and irreconcilable. And here we add, while lingering in the turbulent first decades of the nineteenth century, a very beautiful painting by Géricault (but nothing by Corot).

From thence to Italy: of course, "baroque" Italy—Rome, Bologna, and Naples—is far from absent (Mola, Domenichino, Guercino, Reni, Franceschini, Giordano—all purchased for the museum). But Venice gloriously surpasses all in triumph: Venice of the sixteenth century, with the notably unique and exceptional *Venus and Cupid* by Lorenzo Lotto, offered to the Metropolitan Museum in 1986, among the most audacious and fascinating works by the artist and one of the museum's jewels; and, especially, Venice of the eighteenth century, from Bellotto to Canaletto, from Guardi to Tiepolo father and son (seventeen paintings, not one drawing).

I write these lines a short hop from the Campo Sant'Angelo (the painting by Canaletto in the Wrightsman collection describes it; although greatly changed, far as it is from Saint Mark's Square and all its tourists, the *campo* has retained something of the Venice typical of the eighteenth century), with the Grand Canal under my windows and the Ca' Foscari and the Ca' Rezzonico in view, as well as the Palazzo Grassi (will it see again those wonderful exhibitions that made it famous in these last years?). I find this important facet of the Wrightsman collection particularly meaningful, since Pirna (Bellotto), Warwick Castle (Canaletto), and Madrid's Royal Palace or Würzburg (Tiepolo) are there to remind us of Venice's European dimension in the eighteenth century. If I had to take one painting among so many Venetian masterpieces, I would choose a landscape of "terra ferma" (the Venetian mainland), the miraculous view of the Villa Loredan by Francesco Guardi.

The eighteenth century is the preeminent century in the Wrightsman collection. We have just spoken of the Venetian eighteenth century, but there is also the French eighteenth century. I would be remiss not to mention the French seventeenth century, which is especially dear to me (Georges de La Tour, Poussin, Le

Sueur, Stoskopff, and most recently, the delicate *Annunciation*—in a perfect state of conservation—by Philippe de Champaigne, one of the latest purchases made by the Metropolitan Museum through the Wrightsman Fund; this work originally came from Anne of Austria's private chapel, since destroyed, in the Palais Royal—the same Anne of Austria mentioned earlier in connection with the Val-de-Grâce). I must also say a word about the impressive Neoclassical ensemble dominated by David's *Lavoisier*. At the same time, it would be unbecoming of me to omit Gros (who made the portrait of Gérard seen here), as well as Gérard and Prud'hon, reunited on the walls of the Metropolitan Museum through the good offices of Talleyrand. In addition, there is the painting whose loss is still mourned by the curators of the Louvre's Department of Paintings, *The Public at the Louvre Salon Viewing "Le Sacre,"* Boilly's supreme achievement, his homage to David and the latter's depiction of the coronation of Napoleon and Josephine, one of the unequivocal masterpieces of French painting. And I should not neglect the minor masters of the nineteenth century, most of whom tasted glory before falling into oblivion and whom Jayne Wrightsman had the impulse to take in hand and revive. I'll list them alphabetically, so as to avoid the appearance of favorites: Duez, Gérôme, Alfred Stevens (but wasn't he actually Belgian?), James Tissot (English?), Winterhalter (German), as well as Duval le Camus, Pingret, Horace Vernet, and the exquisite *Louis-Vincent-Léon Pallière in His Room at the Villa Medici, Rome*, whose window looks out over two beautiful cypresses, painted by the undeservedly obscure Jean Alaux.

At last, among the works of the French eighteenth century: drawings by Watteau, Boucher; some wonderful works by Saint-Aubin (the first-rate *Allegory of Louis XV* by Gabriel de Saint-Aubin, beautifully treated here by Perrin Stein), Hubert Robert, Élisabeth Vigée Le Brun, as well as Carmontelle and Cochin; pastels by Liotard (not forgetting that he was Swiss and that his model for pastel was English) and Perronneau; perfectly chosen portraits by Largillierre, Nattier, Madame Vigée Le Brun, and Vestier; Carle Vanloo's sketch for *The Hunt Breakfast* in the Louvre; and, especially, the two delicious pieces by Jean François de Troy—*The Declaration of Love* and *The Garter*—undoubtedly the artist's two most perfect paintings, which every visitor to Jayne Wrightsman's New York apartment could not help but carry away in memory (in spite of the formidable competition offered by truffles and foie gras).

These paintings, these drawings, for the most part, were not included in the last catalogue of the Wrightsman collection, whose volume on paintings and drawings was written under the

direction of Everett Fahy and Francis Watson (and so intelligently prefaced by the late John Walker) and published in 1973. We see here the importance and breadth of the enrichments, an increase in quality as well as quantity, all the more impressive given the fact that in general the number of masterpieces remaining in private hands has dropped dramatically, whereas the competition to gain possession of them has greatly increased (and the prices along with it). And while the collection has been enlarged, it has also developed in perfect continuity, following the same thread it began with some fifty years ago.

By now it is clear that Jayne's selections answered to a particular conception of eighteenth-century French art—to *her* conception. How shall it be defined? We note that religious paintings (although well represented for the seventeenth century), history paintings, and still lifes are almost all absent. Instead, she has selected portraits, favoring famous sitters who in one capacity or another (explorer, scholar, artist, woman of the world) played a role in France's history. Likewise, provenances. But Jayne has a special affinity for genre paintings that afford insight into Parisian life of the eighteenth century, of the middle class along with that of the court: the clothes people wore, their work, their pleasures. While granting priority to perfection of execution and the beauty of the piece, she never overlooks the subject. If the painting or drawing she keeps has information to offer, it will always give delight.

The fashion in art history today, in the wake of the pioneering work of two friends of mine who left this world too soon, Francis Haskell and Antoine Schnapper, is the study of masters and painters, patrons and patronage, collections and collectors. But who gives sufficient attention to their *taste*? It is clear that there is a Rothschild taste. There is also a Wrightsman taste.

We conclude with an evident truth, with the thread that underlies the decisions of Charles and Jayne Wrightsman over a half century and constitutes the complete aspiration of their beings, the direction they pursued with a tenacity and determination all the more trustworthy for being accompanied by the desire for discretion (the discretion with which she wears her ribbon of the Legion of Honor): to serve the Metropolitan Museum, to make of it a museum without peer in the United States and beyond its borders. To serve it in a way that will serve as an example for new generations of patrons of the arts. To serve the museum without being self-serving, to protect it when the need makes itself felt, to criticize it when the need makes itself felt, to surrender to each his share of responsibility, his share of authority. To attend to it lovingly, faithfully, and with faith in its development, in the service of the greatest number of people. For every museum director in the world, no more desirable partners could exist. A former director of the Louvre can bear witness to this and own up to it. Lucky Metropolitan!

Pierre Rosenberg
de l'Académie française

THE WRIGHTSMAN PICTURES

GERARD DAVID

(ca. 1455–d. 1523)

Born at Oudewater in southern Holland, Gerard David spent most of his life working in Bruges. Although the date of his birth is unrecorded, he is generally assumed to have belonged to the same generation as the Dutch painter Geertgen tot Sint Jans (active ca. 1475–95). Nothing is known about David's early training, but, for stylistic reasons, it seems probable that, like Geertgen, he was a pupil of the Haarlem painter Albert van Ouwater (active ca. 1450). The physical types in David's earliest works—the triptych of Jan de Sedano, in the Louvre, and an Adoration of the Shepherds, in the Metropolitan Museum—recall those of Geertgen, and the landscapes are filled with closely observed naturalistic detail in the Dutch manner.

The earliest reference to David dates from 1484, when he became a member of the painters' guild at Bruges. After settling there, he quickly refashioned his style on the example of Hans Memling (active by 1465– d. 1494). Following Memling's death, David became the leading painter in Bruges, receiving the city's most important civic and religious commissions, such as the large Cambyses diptych of 1498 for the Judgment Room of the Town Hall (Groeningenmuseum, Bruges). By 1500 he had evolved a more personal style incorporating large statuesque figures that rarely show strong emotions or physical movement but rather convey a feeling of calm and quiet reverie. His palette, particularly in the later works, tends toward a subdued bluish monochrome. In 1506 he painted an imposing polyptych for the church of San Girolamo della Cervara, near Genoa, parts of which are now divided between the Galleria di Palazzo Bianco, Genoa, and the Metropolitan Museum.

During the fifteenth century, Bruges attracted the talents of Jan van Eyck (active by 1422–d. 1441), Petrus Christus (active by 1444– d. 1475/76), Rogier van der Weyden (1399/1400–1464), and Hugo van der Goes (active by 1467–d. 1482), as well as Memling. By the time Gerard David arrived, the city was in economic decline, and the greatest era of Netherlandish painting was coming to an end. David's students Ambrosius Benson (active by 1519–d. 1550) and Adriaen Isenbrandt (active by 1500–d. 1551) abandoned Bruges for the richer opportunities of Antwerp, which soon replaced Bruges as the cultural center of the Netherlands. EF

ABBREVIATIONS

Ainsworth 1998. Maryan W. Ainsworth. *Gerard David: Purity of Vision in an Age of Transition.* New York, 1998.

Fahy 1973. Everett Fahy, in *The Wrightsman Collection*, vol. 5, Everett Fahy and Francis Watson, *Paintings, Drawings, Sculpture.* New York, 1973.

New York 1998–99. Maryan W. Ainsworth and Keith Christiansen, eds. *From Van Eyck to Bruegel: Early Netherlandish Paintings in The Metropolitan Museum of Art.* Exh. cat., The Metropolitan Museum of Art, New York. New York, 1998.

New York 2004. Helen C. Evans, ed. *Byzantium: Faith and Power (1261–1557).* Exh. cat., The Metropolitan Museum of Art, New York. New York, 2004.

1. *The Virgin and Child with Four Angels*

Oil on wood, 24⅞ × 15⅜ in. (63.2 × 39.1 cm); painted surface, 4⅝ × 14½ in. (62.5 × 37 cm)

Inscribed on cloth: IHESVS [RE]DEMPT[OR] (Jesus Redeemer). Along the right and left sides and the bottom are narrow margins of unpainted wood, which originally were covered by an engaged frame that no longer exists. Four vertical cracks in the panel have been reinforced on the back with canvas strips. There are negligible local losses in the paint surface along the cracks; otherwise the painting is remarkably well preserved.

The Metropolitan Museum of Art, New York, Gift of Mr. and Mrs. Charles Wrightsman, 1977 (1977.1.1)

PROVENANCE

Private collection, Madrid (until about 1940; sold to Linares); [Abelardo Linares S.A., Madrid, about 1940–62; sold to Wrightsman]; Mr. and Mrs. Charles Wrightsman, New York (1962–77; cat., 1973, no. 7); their gift in 1977 to the Metropolitan Museum.

EXHIBITED

Metropolitan Museum, New York, September 22, 1998–January 3, 1999, "From Van Eyck to Bruegel: Early Netherlandish Paintings in The Metropolitan Museum of Art," no. 81; Metropolitan Museum, New York, March 23–July 4, 2004, "Byzantium: Faith and Power (1261–1557)," no. 355.

LITERATURE

Johann Conrad Ebbinge-Wübben, in *The Thyssen-Bornemisza Collection*, ed. Rudolf J. Heinemann (Lugano, 1969), pp. 206–7; Everett Fahy, "A Madonna by Gerard David," *Apollo* 90 (September 1969), pp. 190–95; Fahy 1973, pp. 53–61 no. 7; John Oliver Hand, in John Oliver Hand et al., *The Age of Bruegel: Netherlandish Drawings in the Sixteenth Century*, exh. cat., National Gallery of

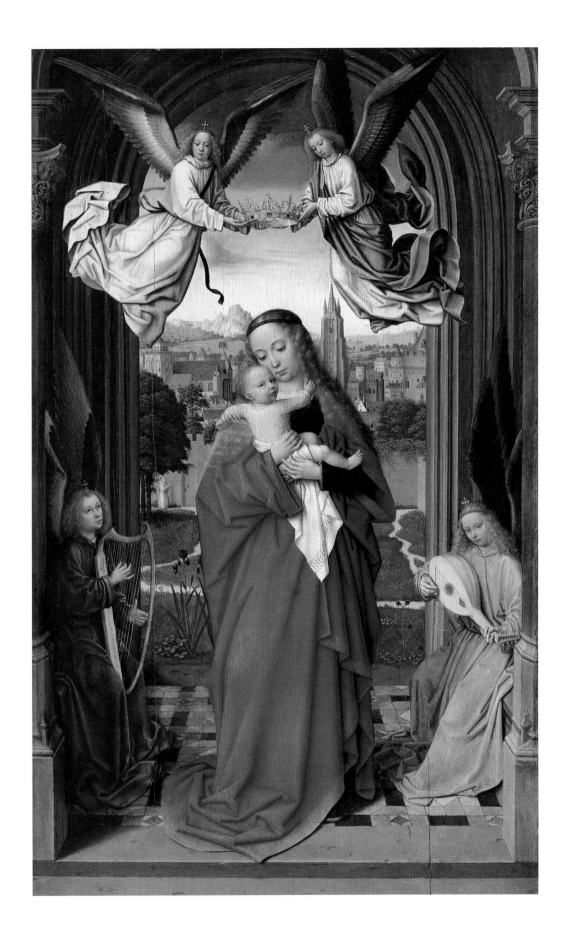

Art, Washington, D.C., and Pierpont Morgan Library, New York (Cambridge, 1986), p. 131 n. 8; Hans J. van Miegroet, *Gérard David* (Antwerp, 1989), pp. 246, 251, 254, 265 n. 65, 304 no. 38; Maryan W. Ainsworth, in New York 1998–99, pp. 20, 29, 31, 261–72, 309, 317, 320.

DRAWING
BERLIN, Kupferstichkabinett, Staatliche Museen zu Berlin (KdZ 579). Pen and brown ink over black chalk on paper, $7\frac{3}{4} \times 5\frac{1}{8}$ in. (19.7 × 13 cm) (fig. 2).

RELATED WORKS
GERMANY, private collection (Christie's, New York, January 11, 1995, lot 43). Oil on wood, $9 \times 6\frac{7}{8}$ in. (22.8 × 17.4 cm). By Adriaen Isenbrandt.
LONDON, Sotheby's, December 14, 1977, lot 155A. Oil on wood, $28\frac{1}{2} \times 18\frac{1}{4}$ in. (72.5 × 46.5 cm). A late sixteenth-century copy.
MADRID, Museo Thyssen-Bornemisza (1930.62). Oil on wood, $24\frac{3}{8} \times 12\frac{1}{4}$ in. (62 × 31 cm). By the Master of the André Virgin (fig. 3).[1]
NEW YORK, Newhouse Galleries (in 1975). Oil on wood, $12\frac{1}{2} \times 8\frac{3}{4}$ in. (31.8 × 22.2 cm). By Adriaen Isenbrandt (fig. 4).

Like many early Netherlandish paintings, this picture is filled with realistic details, most of them now presumed originally to have had symbolic meaning. Here they are connected with the Seven Sorrows of the Virgin: the iris on the left is thought to illustrate the prophecy of Simeon in the Gospel of Luke (2:35) because its leaves resemble "the sword that shall pierce through" the Virgin's heart; the columbine on the right is associated with the Virgin's sorrows because its name (*ancolie*, in French) and its purple color are identified with melancholy; the strawberry plant on the left is linked with the five wounds endured by Christ on the cross because of its five-petaled blossoms, and so forth. The courtyard in the middle ground may allude to the *hortus conclusus* (enclosed garden) in the Song of Solomon (4:12). Even the architectural setting is said to be symbolic: the arched portal can be interpreted as the *Porta Coeli* (Gate of Heaven).

In designing the picture, Gerard David made use of motifs in paintings by earlier artists. The standing Virgin, for example, is derived from Jan van Eyck's *Virgin and Child at the Fountain* of 1439 (fig. 1). The angels holding a crown above the Virgin recall those in Memling's altarpiece of the two Saint Johns (Sint-Janshospitaal, Bruges) and Van Eyck's *Virgin and Child with Chancellor Rolin* (Musée du Louvre). The music-making angels are derived from a *Madonna in an Apse* by Robert Campin (ca. 1378–1444), now lost but known from contemporary copies.[2]

To prepare for the painting, David made a drawing that survives in the Kupferstichkabinett, Berlin (fig. 2).[3] A copy of Van Eyck's *Virgin and Child at the Fountain*, it focuses on the figures and

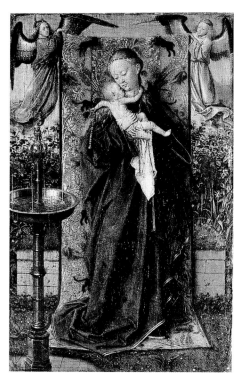

Fig. 1. Jan van Eyck, *The Virgin and Child at the Fountain*. Oil on wood, $7\frac{1}{2} \times 4\frac{3}{4}$ in. (19 × 12.2 cm). Koninklijke Museum voor Schone Kunsten, Antwerp

the fall of the drapery, and its use in the preparation of the painting might account for the comparatively small amount of cross-hatching in the underdrawing.[4] Examination of the painting with X-radiography and infrared reflectography has revealed that the underlayers of paint closely follow the Van Eyck, with the Virgin's hair pulled back and the Christ Child's face in profile.[5] Only as David finished the painting did he modify the Virgin's head more in keeping with his characteristic physiognomies, adding flowing hair over the Virgin's shoulders and turning the Child's face to the viewer. The greatest change occurred in the setting: in place of the shallow garden of Van Eyck, David has set the holy figures before the city of Bruges. Contemporary viewers would have recognized the prominent churches of Sint-Jakobs (Saint James) on the left and Onze-Lieve-Vrouw (Our Lady) on the right, as it appeared before lightning damaged the tower in 1519.[6]

The diminutive Carthusian monk reading a book as he takes his exercise in the courtyard may throw some light on the identity of the patron who commissioned the picture. As the only Carthusian monastery of the period in or near Bruges was the

4

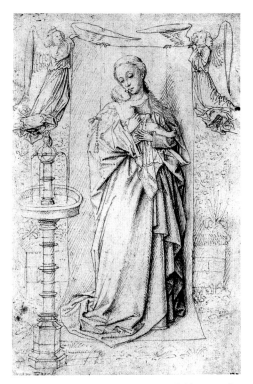

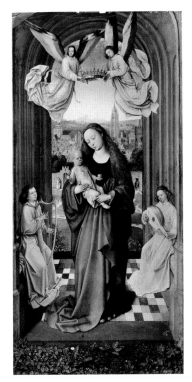

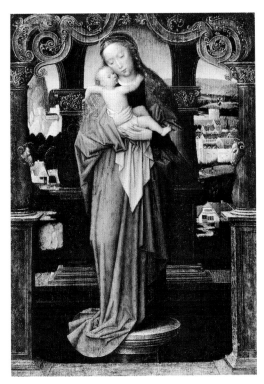

Fig. 2. Gerard David, *The Virgin and Child*. Pen and brown ink over black chalk on paper, 7¾ × 5⅛ in. (19.7 × 13 cm). Kupferstichkabinett, Staatliche Museen, Berlin (KdZ 579)

Fig. 3. Master of the André Virgin, *The Virgin and Child with Four Angels*. Oil on wood, 24⅜ × 12¼ in. (62 × 31 cm). Museo Thyssen-Bornemisza, Madrid

Fig. 4. Adriaen Isenbrandt, *The Virgin and Child*. Oil on wood, 12½ × 8¾ in. (31.8 × 22.3 cm). Art market, New York (in 1975)

charterhouse of Genadedal, just outside the city walls of Bruges, it is possible that the painting was made for someone connected with it. If so, it would join the distinguished company of the *Virgin and Child with Saints Barbara and Elizabeth and Jan Vos* from the workshop of Jan van Eyck in the Frick Collection, New York, and the *Portrait of a Carthusian* by Petrus Christus in the Metropolitan Museum, both of which come from Genadedal.

The curious posture of Van Eyck's Christ Child, with one arm around the Virgin's neck and the other twisted over her shoulder, may repeat the design of an icon venerated in Bruges, possibly at the charterhouse of Genadedal, making it one of the earliest examples of Byzantine influence on Netherlandish painting.[7]

The picture probably dates from about 1510–15, as the *changeant* hues of the angels' robes anticipate the palette of later sixteenth-century Flemish painting.

EF

NOTES

1. Teresa M. Abatemarco, Colin Eisler, and Sophie R. Hagar, in *Early Netherlandish Painting: The Thyssen-Bornemisza Collection*, ed. Colin Eisler (London, 1989), pp. 146–51; José Manuel Pita Andrade and María del Mar Borobia Guerrero, *Old Masters: Thyssen-Bornemisza Museum* (Barcelona, 1992), pp. 137, 690.
2. Martin Davies, *The National Gallery, London*, Les Primitifs Flamands (Antwerp, 1953), pls. CXXXVI–CXLI.
3. New York 2004, no. 354.
4. Maryan W. Ainsworth, "Gerard David's Working Methods: Some Preliminary Observations," in *Le dessin sous-jacent dans la peinture—colloque V, 29–30 septembre–1ᵉʳ octobre 1983: Dessin sous-jacent et autres techniques graphiques*, ed. Roger van Schoute and Dominique Hollanders-Favart (Louvain-la-Neuve, 1985), pp. 54–57, 58 n. 3.
5. For the underdrawing revealed by infrared reflectography, see Ainsworth 1998, p. 31, fig. 250.
6. Fahy 1973, p. 60, reported that A. Janssens de Bisthoven identified the church on the left as Saint-Donatien; it was convincingly identified as Sint-Jakobs by Didier Martens, "Identification de deux 'portraits' d'église dans la peinture brugeoise de la fin du Moyen Âge," *Jaarboek van het Koninklijk Museum voor Schone Kunsten Antwerpen*, 1995, pp. 39–45. An almost identical view of the church of Our Lady appears in Gerard David's *Augustinian Friar (?)* in the National Gallery, London; see Lorne Campbell, *The Fifteenth Century Netherlandish Schools*, National Gallery Catalogues (London, 1998), p. 120.
7. First suggested by Maryan W. Ainsworth, in New York 1998–99, pp. 28, 306, and elaborated upon in New York 2004, pp. 590, 591–93.

LORENZO LOTTO

(ca. 1480–1556)

Information about Lorenzo Lotto is unusually rich, in comparison to what is available for other major artists of the sixteenth century: he left contracts, letters, and an account book (Libro di spese) that he kept from 1540 to 1556, not to speak of his helpful habit of signing and dating his paintings. He was almost certainly born in Venice, unlike his contemporaries, Titian (ca. 1490–1576) and Giorgione (1477 or 1478–1510), who were born and raised on the terraferma (the mainland territory of the Republic of Venice). Lotto probably was trained in Venice by Giovanni Bellini (ca. 1435–1516); he is first recorded in 1503 in Treviso, a city on the principal road between Venice and southern Germany. The stiff, wrinkled drapery and the introspective pathos of the figures in the altarpieces he produced there reflect his admiration for Albrecht Dürer (1471–1528) and other northern artists.

Lotto left Treviso in 1506 for a commission at Recanati, a town in the Marches, along the Adriatic coast. In 1509 he received payment for work in the Vatican, which recently has been identified with the execution of certain frescoes in the Stanze based on cartoons designed by Raphael (1483–1520). He returned to the Marches but in 1513 signed a contract in Bergamo to paint the grandiose Martinego Colleoni altarpiece (completed in 1516; now in San Bartolomeo, Bergamo), inspired by Raphael and Donato Bramante (1444–1514). Between 1521 and 1523 Lotto finished four more altarpieces in Bergamo (all still in situ), and between 1524 and 1525 he frescoed the entire interior of the oratory of the Villa Suardi near Trescore outside Bergamo with frescoes of the lives of Saint Barbara and Saint Brigid of Ireland. While working on the frescoes, he began to make designs for sixty-eight intarsia panels for the choir screen and choir stalls of the church of Santa Maria Maggiore, Bergamo, which he completed in Venice in 1531 and in which he gave free rein to his lifelong fondness for emblems and symbols.

In December 1525 Lotto returned to Venice, where he remained until 1532, shipping five altarpieces to churches in the Marches and one to a church near Bergamo, and painting at least ten portraits in which he showed a special talent for revealing the sitter's state of mind. During the last twenty-four years of his life, Lotto moved frequently: Treviso (1532), Jesi (1535), Ancona (1538), Marcerata (1539). The altarpieces he produced during the late 1530s in the Marches, such as the Lamentation for the church at Monte San Giusto, show his deep religious faith. In the 1540s Lotto gradually abandoned the brilliant color and vivid details of his earlier work in Bergamo and Venice and adopted a more somber mode. Almost to the end of his life, however, Lotto continued to paint with smooth brushwork. Only in the artist's last works, produced during his final two years as an oblate in the Santa Casa at Loreto, does his brush tremble, caused by failing health rather than a deliberate attempt to imitate the rough and sketchy technique of his successful contemporaries in Venice.

EF

ABBREVIATIONS

Berenson 1956. Bernard Berenson. *Lorenzo Lotto*. London, 1956.

Christiansen 1986. Keith Christiansen. "Lorenzo Lotto and the Tradition of Epithalamic Paintings." *Apollo* 124 (September 1986), pp. 166–73.

Cortesi Bosco 1980. Francesca Cortesi Bosco. *Gli affreschi dell'Oratorio Suardi: Lorenzo Lotto nella crisi della Riforma*. Bergamo, 1980.

Humfrey 1997. Peter Humfrey. *Lorenzo Lotto*. New Haven, 1997.

Reinach 1905–23. Salomon Reinach. *Répertoire de peintures du Moyen Âge et de la Renaissance (1280–1580)*. 6 vols. Paris, 1905–23.

2. *Venus and Cupid*

Oil on canvas, 36⅜ × 43⅞ in. (92.4 × 111.4 cm)

Signed at lower right, on the tree trunk: Laurent°.Loto.

The painting was cleaned in 1985 by John Brealey. He removed various additions including drapery that had been added over Venus's thigh (for its appearance before restoration, see Berenson 1956, pl. 258).

The Metropolitan Museum of Art, New York, Purchase, Mrs. Charles Wrightsman Gift, in honor of Marietta Tree, 1986 (1986.138)

PROVENANCE

Granet (or Grasset?) collection, Paris (1912); private collection, Switzerland (until 1986); [Adrian Ward-Jackson, New York, 1986; sold to the Metropolitan Museum]; purchased in 1986 by the Metropolitan Museum through a gift from Mrs. Charles Wrightsman in honor of Marietta Tree.

EXHIBITED

Grand Palais, Paris, March 9–June 14, 1993, "Le siècle de Titien: L'âge d'or de la peinture à Venise," no. 154.

LITERATURE

Reinach 1905–23, vol. 4 (1918), p. 652 no. 1; Anna Banti and Antonio Boschetto, *Lorenzo Lotto* (Florence, 1953), p. 113; Berenson 1956, p. 83; Cortesi Bosco 1980, p. 145 n. 69; Christiansen 1986, pp. 166–73; Sylvie Béguin, in *Le siècle de Titien:*

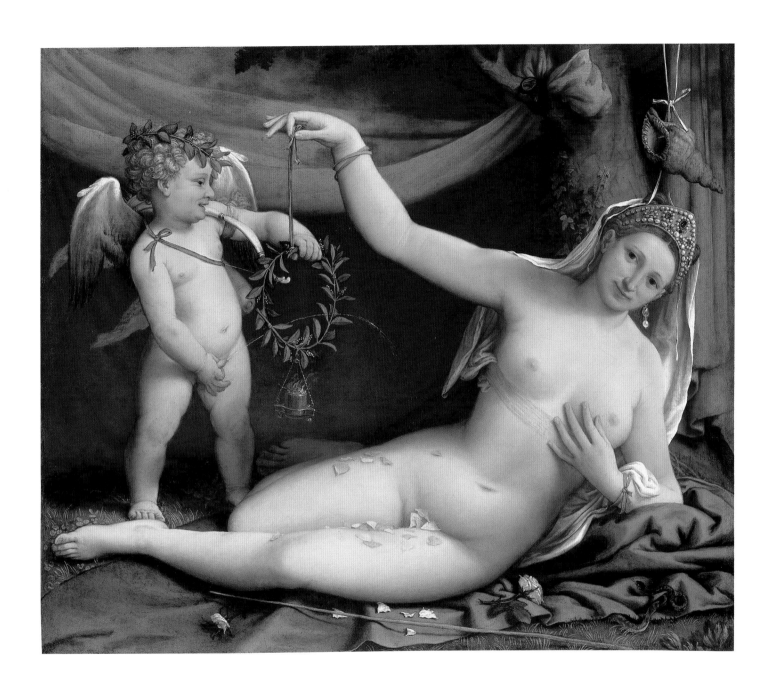

L'âge d'or de la peinture à Venise, exh. cat., Grand Palais, Paris (Paris, 1993), pp. 546–47; David Rosand, "'So-And-So Reclining on Her Couch,'" in *Titian 500,* ed. Joseph Manca, Studies in the History of Art (National Gallery of Art, Washington, D.C.) 45 (Washington, D.C., 1993), pp. 109, 116 n. 10; Humfrey 1997, pp. 139–40, 174 n. 34, 177 n. 1; Wendy Stedman Sheard, in David Brown et al., *Lorenzo Lotto: Rediscovered Master of the Renaissance,* exh. cat., National Gallery of Art, Washington, D.C., Accademia Carrara di Belle Arti, Bergamo, and Galeries Nationales du Grand Palais, Paris (Washington, D.C., 1997), p. 47.

Because most of Lotto's work remains in provincial places, he was forgotten for almost three centuries. Local historians occasionally published documents concerning him, but the real discovery of the artist began in 1895, when the young Bernard Berenson (1865–1959) published his influential book *Lorenzo Lotto: An Essay in Constructive Art Criticism,* which introduced the public to Lotto's intriguing personality. In the greatly expanded third edition of the book, Berenson published an old photograph of the Wrightsman *Venus and Cupid,* which had been known previously only from a line engraving (fig. 1).[1] Berenson stated that the picture belonged to the Louvre, "Grasset Bequest, not exhibited." The Louvre, however, has no record of it, and scholars could only speculate about its appearance, so it was an exciting event when the picture resurfaced in a private Swiss collection in 1984 and was brought to the Metropolitan Museum for cleaning. Some time in the past it had been repainted: Venus's face was transformed to make the goddess's features more conventional, the rose petals scattered on her body were hidden, and a veil had been added over Venus's lap. Cleaning removed these additions and revealed Lotto's signature on the tree trunk behind Venus's head.

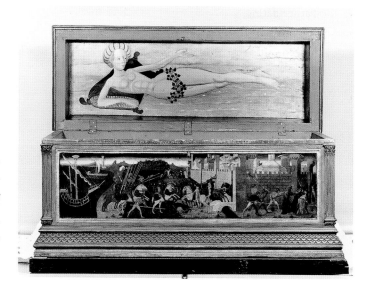

Fig. 2. Apollonio di Giovanni and Marco del Buono, marriage chest showing the inside of the lid with reclining female nude. Tempera on wood, inside of lid, 20 3/4 × 67 in. (52.8 × 170.5 cm). Yale University Art Gallery, New Haven, Connecticut

Shortly after the painting was given to the Metropolitan Museum, Keith Christiansen published it in a masterly essay in which he proposed that it is a wedding picture based on the ancient literary genre of marriage poems, or epithalamia. In these poems Cupid urges Venus to make marriages fruitful. All the objects in the painting allude to marriage: the wreath of myrtle held by Venus, the incense burner, crown and bridal veil, rose petals, rod, and snake. Even the motif of Cupid peeing on Venus's lap is an augury for good health and fortune. Christiansen also observed that the painting may be a portrait, given the "highly individual features" of Venus, which differ markedly, for example, from the idealized types of Titian's grand mythologies.

The horizontal format of the composition goes back to Quattrocento paintings of reclining female nudes on the inner faces of the lids of cassoni, trousseau chests made for newly married couples in the fifteenth century (fig. 2). In the sixteenth century these horizontal images migrated to the walls of the newlyweds' bedchambers, and easel paintings on canvas, such as Titian's *Venus of Urbino* (Uffizi, Florence) or Palma Vecchio's *Venus and Cupid* (Fitzwilliam Museum, Cambridge), became the fashion.

Usually dated in the 1520s, the painting is assigned either to the artist's last years in Bergamo or to immediately after his return to Venice in 1525. The bright enameled colors of the draperies argue

Fig. 1. Line engraving in Reinach 1905–23, vol. 4 (Paris, 1918). Plate, 2 7/8 × 3 1/2 in. (7.3 × 8.9 cm)

for the earlier dating, as does the presence of another urinating putto in Lotto's Bergamask work. In the frescoes in the Suardi oratory, a putto on the ceiling, seen from below like the putti on the ceiling of Mantegna's Camera degli Sposi in Mantua, pees on the heads of the onlookers.[2] For those who claim that recumbent females were a quintessentially Venetian theme, one can point to several examples of similar paintings by Lombard artists. Bergamo, then a Venetian dependency, is only thirty miles from Milan, and Lotto could have seen in Milan the work of Leonardo's follower Bernardino Luini (ca. 1480–1532). Pictures by Luini of life-size recumbent Venuses with portrait-like features belong to the National Gallery of Art, Washington, D.C., and a private collection, Milan (fig. 3).[3] To the west of Bergamo lies the town of Brescia, where the Veneto-Lombard painter Moretto (ca. 1498–1554) painted a Venus and Cupid (fig. 4) in an interior that belongs to the same tradition.[4] In December 1528, about the time Moretto painted his *Venus,* Lotto wrote to ask him to collaborate on his intarsia designs.[5]

More recently the Wrightsman painting has been identified by Peter Humfrey as the *Venus* that Lotto gave to his nephew, Mario d'Armano. It is mentioned in Lotto's account book in September 1540 and May 1541. But the style of the *Venus and Cupid* is quite unlike that of the Saint Antoninus altarpiece in the church of Santi Giovanni e Paolo, Venice, which Lotto painted between 1540 and 1542. The gift to d'Armano probably was the *Toilet of Venus* in a private Milanese collection.[6] EF

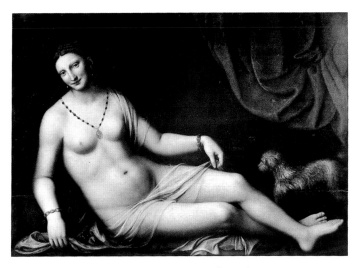

Fig. 3. Bernardino Luini, *Venus*. Oil on wood, 40⅛ × 58¼ in. (102 × 148 cm). Collection of Count Paolo Gerli di Villa Gaeta, Milan

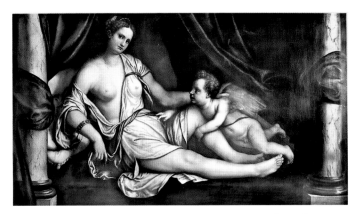

Fig. 4. Moretto da Brescia, *Venus and Cupid*. Oil on canvas, 46⅞ × 83½ in. (119 × 212 cm). Private collection, Italy

Notes

1. Berenson 1956, pl. 258; Reinach 1905–23, vol. 4 (1918), p. 652 no. 1.
2. Cortesi Bosco 1980, p. 145 n. 69.
3. Ibid.
4. In 1939 it belonged to the Tempini family, Brescia; sold at Finarte, Milan, May 31, 2000.
5. Pier Virgilio Begni Redona, *Alessandro Bonvicino, il Moretto da Brescia* (Brescia, 1988), pp. 593–94, under entries for December 8, 1528, and January 26, 1529.
6. For the *Toilet of Venus,* see Pietro Zampetti, "Un capolavoro del Lotto ritrovato," *Arte veneta,* no. 11 (1957), pp. 75–82.

PARIS BORDON

(1500–1571)

Paris Bordon worked in the shadow of Titian (ca. 1490–1576) and Tintoretto (1518–1594) yet maintained a style of painting all his own. A secondary figure, he nonetheless contributed much to the art of his time. He is best known for his elaborate mythological compositions that introduced into Venice a variation of Mannerism inspired by the School of Fontainebleau.

The son of a saddler, Bordon was baptized on July 5, 1500, at Treviso, some sixteen miles north of Venice. At the age of eight he moved to Venice with his mother, who was Venetian by birth. Throughout his long, peripatetic career he maintained his residence in Venice while preserving ties with Treviso, occasionally filling a commission for one of his compatriots and frequently signing his paintings Paris bordonus tarvisinus.

Although he signed over fifty paintings, only a handful of them are dated, and the chronology of his oeuvre is difficult to follow. The primary source of information about Bordon is Giorgio Vasari (1511–1574), who visited Bordon in 1566 when he was living in quiet retirement. According to Vasari, Bordon first studied for a few years with Titian but, finding the latter to have little interest in teaching, set himself to studying the works of Giorgione (1477 or 1478–1510). In Bordon's earliest datable paintings, such as an altarpiece from Crema, now in the Galleria dell'Accademia Tadini, Lovere, and the Giorgionesque Lovers in the Pinacoteca di Brera, Milan, he shows a proclivity to make movement a key element in his compositions: his figures appear to rotate with self-conscious grace, as though performing a slow, stylized dance. The Fisherman Presenting the Ring to the Doge, commissioned in 1534 for the Scuola di San Marco in Venice (Gallerie dell'Accademia, Venice), shows his fascination with theatrical architectural settings. Like Lorenzo Lotto (see p. 6) and Giovanni Antonio Pordenone (ca. 1484–1539), Bordon often accepted commissions outside the city of Venice. His excursions took him as far as Fontainebleau, where, according to Vasari, he worked in 1538 for Francis I (r. 1515–47). It is more likely, however, that he visited France during the brief reign of Francis II (1559–60), when he could have become acquainted with the painter Antoine Caron (ca. 1515–1593), with whose paintings some of Bordon's late works have much in common. Vasari also says that Bordon decorated the Fugger residence at Augsburg; a portrait in the Louvre of the Augsburg merchant Hieronymus Kraffter is dated 1540. By April 1543 Bordon was back in

Venice, and in October 1548 he appraised three portraits for Lotto.[1] Among his late works are a grand altarpiece for Santa Maria presso San Celso in Milan, of about 1548; a series of altarpieces for the Dominican convent of San Paolo at Treviso, documented 1557/58; and an altarpiece of Saint Lawrence of 1562 in the Duomo, Treviso.

Through his travels Bordon was exposed to Mannerist paintings in a way that most Venetian painters were not. The personal idiom he evolved, combining artificially posed figures and fantastic architectural settings inspired by Sebastiano Serlio (1475–1554), was a precedent for the style developed slightly later by Tintoretto and El Greco (see p. 22).

EF

ABBREVIATIONS

Canova 1964. Giordana Mariani Canova. Paris Bordon. Venice, 1964.
Fahy 1973. Everett Fahy, in The Wrightsman Collection, vol. 5, Everett Fahy and Francis Watson, Paintings, Drawings, Sculpture. New York, 1973.
Fossaluzza and Manzato 1987. Giorgio Fossaluzza and Eugenio Manzato, eds. Paris Bordon e il suo tempo. Proceedings of an international colloquium, Treviso, October 28–30, 1985. Treviso, 1987.

NOTE

1. Giorgio Fossaluzza, "Codice diplomatico bordoniano," in Paris Bordon, exh. cat., Palazzo dei Trecento, Treviso (Milan, 1984), p. 133 no. 36.

3. Portrait of a Man in Armor with Two Pages

Oil on canvas, 46 × 62 in. (116.8 × 157.5 cm)
Inscribed at lower center, on the ribbon: OPVS / PARIDIS BO / RDON.
Cleaned in 1967 by Hubert von Sonnenburg.
The Metropolitan Museum of Art, New York, Gift of Mr. and Mrs. Charles Wrightsman, 1973 (1973.311.1)

PROVENANCE
?Bernardo Trincavalla, Venice (1648); Paolo del Sera, Venice (until 1654; sold to Cardinal Leopoldo); Cardinal Leopoldo de' Medici, Florence (1654–d. 1675); Medici family, Florence; art market, Palazzo Guadagni, Florence (in 1861); Philip Reginald Cocks, fifth Baron Somers, Eastnor Castle, Herefordshire (by 1866–d. 1899); Arthur Cocks, sixth Baron Somers (1899–before 1932); Henry Lascelles, sixth Earl of Harewood, Harewood House,

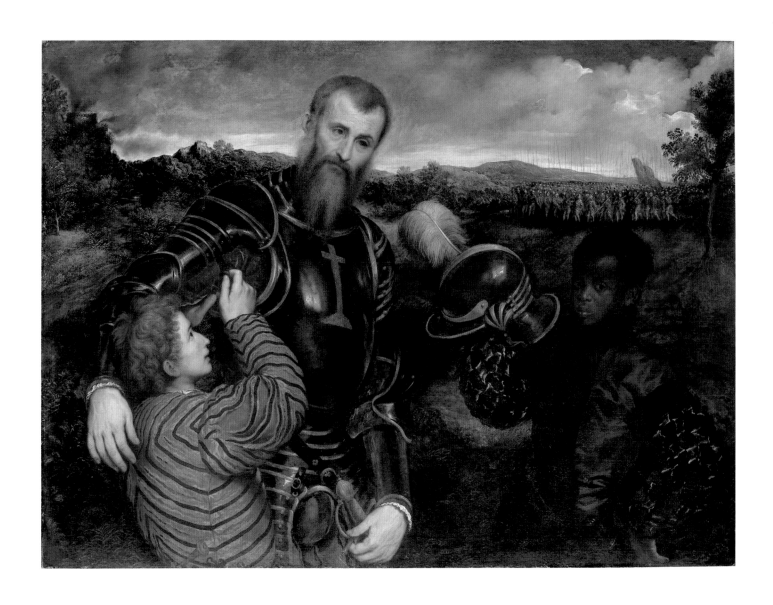

near Leeds, Yorkshire (by 1932–d. 1947; cat., 1936, no. 9); his son, George Lascelles, seventh Earl of Harewood (1947–65; sale, Christie's, London, July 2, 1965, lot 76, for 16,000 guineas, to Colnaghi for Wrightsman); Mr. and Mrs. Charles Wrightsman, New York (1965–73; cat., 1973, no. 1); their gift in 1973 to the Metropolitan Museum.

EXHIBITED
British Institution, London, 1866, "Pictures by Italian, Spanish, Flemish, Dutch, French, and English Masters," no. 32 (lent by Earl Somers); Royal Academy of Arts, London, 1873, "Exhibition of the Works of Old Masters," no. 227; Wildenstein, New York, 1967, "The Italian Heritage," no. 24 (lent by Mr. and Mrs. Wrightsman); Metropolitan Museum, New York, 1965–73.

LITERATURE
Marco Boschini, *La carta del navegar pitoresco. Dialogo tra un senator venetian deletante, e un professor de pitura* (Venice, 1660), pp. 366–67; Tancred Borenius, *Catalogue of the Pictures and Drawings at Harewood House and Elsewhere in the Collection of the Earl of Harewood* (Oxford, 1936), pp. 7–8 no. 9; Rodolfo Pallucchini, *La giovinezza del Tintoretto* (Milan, 1950), pp. 26–27; Canova 1964, p. 79; Fahy 1973, pp. 15–24 no. 1; Giordana Mariani Canova, "Paris Bordon: Problematiche cronologiche," in Fossaluzza and Manzato 1987, p. 156, fig. 46; Paola Rossi, "Paris Bordon e Jacopo Tintoretto," in Fossaluzza and Manzato 1987, p. 31.

In this three-quarter-length portrait, a military officer stands before an open landscape while a page in a doublet of golden rust and black stripes fastens armor on his right arm and a blackamoor in a glossy black doublet holds up an open helmet. All three carry weapons: the officer rests his left hand on a rapier, and the pages wear daggers at their waists. In the landscape, infantrymen march along the horizon on the right, carrying dozens of pikes and an unfurled banner of salmon and black stripes. Gray smoke streams from the fortified tower on the left.

The picture may be the portrait by Paris Bordon that belonged to Bernardo Trincavalla, an art collector who was granted Venetian citizenship in 1629. Trincavalla's painting was described by Carlo Ridolfi in 1648 as a "knight whose page fastens his armor."[1] Ridolfi does not mention the blackamoor, but then neither do several modern writers who have described the picture. A blackamoor does figure in a military portrait by Bordon that belonged somewhat later to Paolo del Sera, a Florentine painter who resided in Venice from 1640 until his death in 1672. His picture gallery contained a portrait of a general armed by two pages, one of them a "moor who proffers his helmet," which Marco Boschini described in 1660 in a long poem in Venetian dialect.[2] According to Boschini, del Sera's collection was acquired en bloc by Cardinal Leopoldo de' Medici (1617–1675) in Florence.[3] How the present painting subsequently made its way to England, where it was recorded in the nineteenth century, remains a mystery.

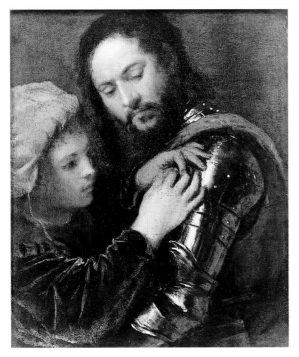

Fig. 1. Copy after Titian, *A Man in Armor with a Page*. Oil on wood, 8¼ × 7⅛ in. (21 × 18.4 cm). Collection of George Howard, Castle Howard, Yorkshire

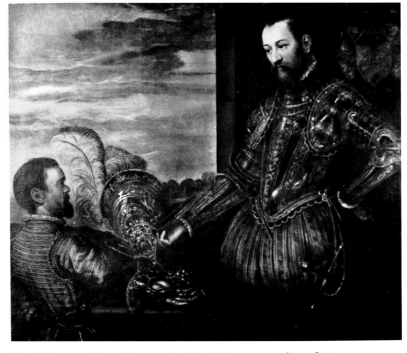

Fig. 2. Tintoretto, *Scipione Clusone with a Page*. Oil on canvas, 45¼ × 59⅞ in. (114.9 × 152.1 cm). Galleria Nazionale di Palazzo Spinola, Genoa

Bordon's depiction belongs to the genre of military portraiture that was popular in Europe from the time of the Roman Empire until the nineteenth century. From ninth-century portraits of Charlemagne to Sir Thomas Lawrence's likeness of George IV, in the Pinacoteca Vaticana, great rulers were often represented as military heroes. The full-length standing portrait of Philip II, now in the Prado, which Titian painted in 1551, is one of the most magnificent;[4] it was later adapted by Rubens (see p. 113), Van Dyck (see p. 123), and many other artists (see, for instance, the portrait by Largillierre, cat. 47). A less formal format, showing the sitter preparing for battle, was also developed in Venice during the sixteenth century, and it is with this type that the present portrait is most closely associated. In such examples, an officer looks over his shoulder as a page adjusts his suit of armor; the format seems to have originated with an early sixteenth-century prototype known only from numerous replicas (fig. 1). One of the replicas of this composition, formerly in the Orléans collection, was catalogued in the eighteenth century as a portrait of Gaston de Foix by Giorgione; yet the true prototype may well have been an early work by Titian, as Roberto Longhi and others have suggested.[5] The action of the page and the gaze of the officer endow this portrait type with an informality and psychological intimacy that rarely appear in conventional military portrayals.

Enlarging the format of the Giorgionesque composition and making it more complex, Bordon has added the landscape and introduced the second page holding the helmet. A suggestion that the portrait depicts Carlo da Rho (d. 1553) must be abandoned, as da Rho did not have a military career.[6] The style of the portrait, however, is typical of the work Bordon undertook in 1549–50, when he resided in da Rho's palace in Milan. The horizontal format, with three-quarter-length figures standing before undulating hills, is also seen in Bordon's *Holy Family with Saint Catherine* in the Brera, which dates from about 1550. Tintoretto's portrait of Scipione Clusone (fig. 2), dated 1561, seems to have been inspired by the present painting.[7]

EF

Notes

1. "Cavaliere à cui un paghetto allacia l'armatura." Carlo Ridolfi, *Le maraviglie dell'arte; ovvero, Le vite degli illustri pittori veneti e dello stato*, ed. Detlev von Hadeln (Berlin, 1914), vol. 1, p. 234.
2. Marco Boschini, *La carta del navegar pitoresco. Dialogo fra un senator venetian deletante, e un professor de pitura* (Venice, 1660), pp. 366–67.
3. Ibid., p. 361, marginal note. On relations between del Sera and Cardinal Leopoldo, see Michelangelo Muraro, "Studiosi, collezionisti e opere d'arte veneta dalle lettere al Cardinale Leopoldo de' Medici," *Saggi e memorie di storia dell'arte* 4 (1965), pp. 72–74, 79–81.
4. Miguel Falomir, *Tiziano*, exh. cat., Museo Nacional del Prado, Madrid (Madrid, 2003), pp. 218–19.
5. Roberto Longhi, *Viatico per cinque secoli di pittura veneziana* (Florence, 1946), p. 64.
6. Fahy 1973, p. 23.
7. Paola Rossi, "Nota in margine alla mostra 'L'opera ritrovata,'" *Arte veneta* 38 (1984), p. 256, fig. 2.

BATTISTA FRANCO

(ca. 1510–1561)

Nicknamed Semolei, Battista Franco was a Venetian painter and printmaker who worked in Rome, Florence, Urbino, and, during the last decade of his life, Venice (throughout his life he signed his works "Baptista Veneziano"). At the age of twenty, he reputedly settled in Rome; in 1535 he joined the Accademia di San Luca, the painters' guild in that city. Giorgio Vasari, his friend and contemporary, describes how Battista made endless drawings after everything he could see by Michelangelo.

Battista's first recorded paintings were part of the temporary decorations for the triumphal entry of the Emperor Charles V into Rome in 1536. During the following year, as chief court painter to Duke Cosimo I de' Medici, he painted the Allegory of the Battle of Montemurlo *(Galleria Palatina, Florence), with figures derived from Michelangelo's presentation drawing of the* Rape of Ganymede. *Back in Rome, Battista executed one of the strangest paintings of the sixteenth century, the* Arrest of the Baptist *in the oratory of San Giovanni Decollato, Rome. From 1545 to 1551 he resided in Urbino, where he frescoed the vault of the choir of the cathedral, supplied numerous designs for majolica, and trained the young Federico Barocci (ca. 1535–1612). One of Battista Franco's best paintings is the* Way to Calvary *(Uffizi, Florence); dated 1552, it probably was painted in Venice, though he is not documented there until 1554. His work flowered during his last years in altarpieces and frescoes that brought central Italian Mannerism to his native city.* EF

ABBREVIATIONS

Bellosi 2002. Luciano Bellosi. "Per Battista Franco." *Prospettiva*, nos. 106–7 (April–July 2002), pp. 175–82.

Freedberg 1961. Sydney J. Freedberg. *Painting of the High Renaissance in Rome and Florence.* 2 vols. Cambridge, Massachusetts, 1961.

Frommel 1968. Christoph Luitpold Frommel. *Baldassare Peruzzi als Maler und Zeichner.* Beiheft zum römischen Jahrbuch für Kunstgeschichte, vol. 11. Vienna and Munich, 1968.

4. *Portrait of an Olivetan Monk*

Oil on canvas, 38 1/4 × 28 5/8 in. (97.2 × 72.7 cm)
Inscribed on the packet: B[ologna(?)]; on the letter: C . . . [illegible]; on the bookmark: [illegible].
The Metropolitan Museum of Art, New York, Gift of Mrs. Charles Wrightsman, 1986 (1986.339.1)

PROVENANCE
Private collection, England; [Aldo Briganti, Rome, in 1942]; [Morandotti, Rome, until 1950; sold to Segal]; Mrs. C. Segal, São Paolo (1950–82; sale, Sotheby Parke Bernet, London, April 21, 1982, lot 79, as Peruzzi, for £42,000, to Wrightsman); Mr. and Mrs. Charles Wrightsman, New York (1982–his d. 1986); Mrs. Wrightsman's gift in 1986 to the Metropolitan Museum.

LITERATURE
Frommel 1968, p. 80 no. 41; Carlo Volpe and Mauro Lucco, *L'opera completa di Sebastiano del Piombo* (Milan, 1980), p. 139 no. 222; Bellosi 2002, pp. 178–79, 182 nn. 30–36.

This is a lifesize portrait of an ecclesiastic seated before a blank brown background at a narrow table covered with a green cloth on which are spread a stack of paper, a packet of letters, a book, and writing utensils: a pot of ink, two quills, a knife for making erasures, a seal, and a cylinder of red sealing wax. The youthful sitter has dark tonsured hair, and he wears white and beige garments: a beige skull cap, a beige scapular, a white alb, and, appearing at his wrists, the sleeves of a beige undergarment. The format of the portrait recalls that of Raphael's *Tommaso Inghirami* of about 1510 (Galleria Palatina, Florence).

The attribution of the portrait is controversial. During the Second World War, when the painting turned up on the art market in Rome, Rodolfo Pallucchini identified it as a work by Sebastiano del Piombo (ca. 1485–1547), the Venetian protégé of Michelangelo, and dated it about 1515. Pallucchini's attribution was accepted by Luitpold Dussler, the author of the first monograph on Sebastiano, and by Johannes Wilde, the great Michelangelo scholar, but it was rejected in 1946 by Roberto Longhi, who proposed instead that it might be by an anonymous painter active on the Venetian mainland, perhaps the author of the pair of ecclesiastical portraits formerly in the collection of Mrs. J. Horace

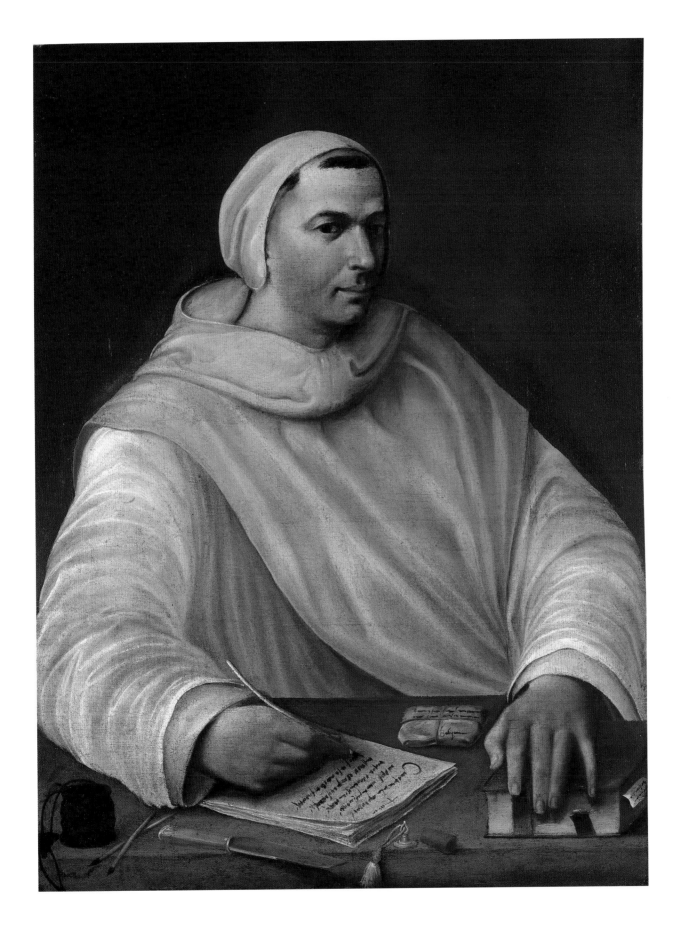

Harding, New York.[1] Fifteen years later Philip Pouncey, a formidable connoisseur and, coincidentally, owner of an impressive painting by the Sienese architect and painter Baldassare Peruzzi (1481–1536), suggested that the portrait was by Peruzzi.[2] Pouncey's attribution was accepted by Sydney Freedberg, calling the former attribution to Sebastiano del Piombo "not incomprehensible,"[3] and by Christoph Luitpold Frommel, the author of the basic book on Peruzzi, who dated it about 1514–15 on the basis of its supposed affinity with Peruzzi's *Adoration* of 1514 in the church of San Rocco, Rome.[4] It would be Peruzzi's only independent portrait (there are donor portraits in two of his surviving frescoes, but they are not comparable to the Wrightsman painting). With the exception of Pallucchini, none of these authorities had seen the painting in the original: it was in a private collection in Brazil from 1950 until 1982, when it came up at auction in London and was purchased by Mrs. Wrightsman on the advice of the staff of the Metropolitan Museum. Although it has been exhibited at the Museum as a work by, or attributed to, Peruzzi, visiting scholars occasionally voiced doubts about the attribution. The only one to discuss it in print was Luciano Bellosi, who examined the portrait in person in 1987. Bellosi argued that the soft, rounded folds of the sitter's habit lack the chiseled appearance of Peruzzi's crisply folded drapery and that the overall design of the portrait does not reflect Peruzzi's classical bearing. The glimmer of light, especially on the sleeves, and the bulging form of the cowl of the monk's scapular, with its contorted folds, are hallmarks of Battista Franco's personal style.

Going hand in hand with the attribution have been various attempts to identify the sitter. Pallucchini suggested in passing that he might be Battista Mantovano, a Carmelite scholar. However, as Frommel observed, the white habit is that of the Olivetans, a strict branch of the Benedictine order. Frommel advanced the theory that the sitter is Barnaba Cevennini, the abbot general of the Olivetans in 1513–14, 1518–19, and 1524–25; Cevennini also served as the prior of San Michele in Bosco, Bologna, in 1522. To support his argument, Frommel read the word beginning with a *B* on the packet as Bologna, a city where Peruzzi worked. Keith Christiansen observed that Peruzzi designed the entrance portal of San Michele

in Bosco in 1522, during Cevennini's priorship, and the portrait could have been commissioned at that time, though he preferred to date the portrait to 1513–14, when Cevennini was at Monte Oliveto Maggiore, near Siena, or to 1515, when he was in Bologna.[5] Frommel interpreted the large *C* at the top of the long inscription as the initial of Cevennini's name, although it would be odd to start a sentence with a cognomen. However, Bellosi eliminated Cevennini as a possibility by pointing out that the sitter bears no resemblance to the portrait of Cevennini by Innocenzo da Imola (ca. 1490–ca. 1545) in a fresco in the sacristy of San Michele in Bosco, which Cevennini commissioned on December 22, 1522.[6] Moreover, Cevennini's balding pate and chubby features were also depicted by Bagnacavallo (ca. 1484–ca. 1542) in an altarpiece in the Pinacoteca Nazionale, Bologna.[7] Bellosi suggested the sitter may be Antonio Bentivoglio (d. 1567), who as a young man served as the abbot general of the Olivetans from 1538 to 1540.

EF

NOTES

1. Roberto Longhi, *Viatico per cinque secoli di pittura veneziana* (Florence, 1946), pp. 65–66. The Harding portraits are now believed to be early works by Moretto da Brescia (Mauro Lucco, in Carlo Volpe and Mauro Lucco, *L'opera completa di Sebastiano del Piombo* [Milan, 1980], nos. 199, 200); one is in the Detroit Institute of Arts, Detroit, Michigan; the other belonged to Walter P. Chrysler Jr., New York (sold, Sotheby's, New York, June 1, 1989, lot 17).

2. Pouncey's attribution was reported by Freedberg 1961, vol. 1, p. 408, and later was affirmed in Philip Pouncey and J. A. Gere, *Italian Drawings in the Department of Prints and Drawings in the British Museum: Raphael and His Circle* (London, 1962), vol. 1, p. 135.

3. Pallucchini's attribution was reported by Luitpold Dussler, *Sebastiano del Piombo* (Basel, 1942), p. 143 no. 59. Rodolfo Pallucchini repeated it in his monograph *Sebastian Viniziano (Fra Sebastiano del Piombo)* (Milan, 1944), pp. 40, 160; it went unquestioned in Johannes Wilde's review of Pallucchini's monograph, in *Burlington Magazine* 88 (October 1946), p. 259.

4. Frommel 1968, pp. 80–81 no. 41.

5. Keith Christiansen, in The Metropolitan Museum of Art, *Recent Acquisitions: A Selection, 1986–1987* (New York, 1987), pp. 34–35.

6. Vera Fortunati Pietrantonio, *Pittura bolognese del '500* (Bologna, 1986), vol. 1, p. 60, ill. p. 75.

7. Carla Bernardini, in *Il Cinquecento a Bologna. Disegni dal Louvre e dipinti a confronto,* ed. Marzia Faietti, with Dominique Cordellier, exh. cat., Pinacoteca Nazionale, Bologna (Milan, 2002), p. 120.

FRANÇOIS CLOUET

(ca. 1515–1572)

François Clouet, son of the leading portraitist of Renaissance France, Jean Clouet (ca. 1485–1540), inherited his father's positions as Valet of the Bed Chamber and First Painter to the King—and his father's nickname, Janet. His workshop produced paintings and finished portrait drawings; miniatures; designs for enamels and coins; and elaborate decorations for weddings, funerals, and festivals.

Born at Tours, Clouet is first documented in royal account books in 1541, when his name replaced that of his deceased father. François continued the elder Clouet's manner of painting, and, in fact, the famous portrait in the Louvre of Francis I (r. 1515–47) is thought to have been based on a design by Jean Clouet but executed by François. Like his father, François Clouet also made numerous drawings of the royal family and members of the court, usually shoulder-length likenesses with the faces turned three-quarters toward the viewer. Finished products, not preparatory studies for painted images, they are almost always executed in red and black chalk, quite similar to Jean Clouet's drawings in their rhythmic, parallel hatching though drier in execution. There are some eight hundred drawings by the Clouets and their school in the Bibliothèque Nationale de France, Paris, and about three hundred more in the Musée Condé, Chantilly.

François Clouet was primarily a court painter, in contrast to his contemporary Corneille de Lyon (ca. 1510–1575), the transplanted Dutch painter, whose portrait heads, painted with minute precision on small panels, appealed to a wealthy, middle-class clientele. At the death of Francis I, François Clouet took a wax cast of the king's face and hands to prepare an effigy, and he made paintings and banners for the funeral ceremonies. After performing the same tasks in 1559 for the obsequies of Henry II, Clouet's name disappeared from the royal account books until 1572. During this period he resided in Paris and may have been employed by some of the courtiers. To 1562 belongs Clouet's marvelous portrait of his neighbor and friend, the apothecary Pierre Quthe (Musée du Louvre); it shows his familiarity with Florentine portraiture, particularly with the Mannerist style of Francesco Salviati (1510–1563), whose portrait of Pietro Aretino (untraced) was one of Francis I's prize possessions.

The large painting Diana and the Nymphs Bathing of about 1558–59, in the Musée des Beaux-Arts, Rouen, is one of Clouet's rare surviving mythological compositions. He died on September 22, 1572, a month after the Massacre of Saint Bartholomew's Day. Although Clouet never married, he recognized three illegitimate daughters in his will.

EF

Abbreviations

Adler 1929. Irene Adler. "Die Clouet: Versuch einer Stilkritik." *Jahrbuch der Kunsthistorischen Sammlungen in Wien*, n.s., 3 (1929), pp. 201–46.

Denord 1866. Octave Denord. *Les thermes et le château d'Uriage*. Extract from *Le Dauphiné*. Grenoble, 1866.

Jollet 1997. Étienne Jollet. *Jean & François Clouet*. Trans. Deke Dusinberre. Paris, 1997.

Paris 1970. Jean Adhémar, ed. *Les Clouet & la cour des rois de France: De François I*er* à Henri IV*. Exh. cat., Bibliothèque Nationale de France, Paris. Paris, 1970.

Reynolds 1999. Graham Reynolds. *The Sixteenth- and Seventeenth-Century Miniatures in the Collection of Her Majesty the Queen*. London, 1999.

5. *Charles IX, King of France*

Oil on canvas, 78⅜ × 42¼ in. (199.1 × 107.3 cm)
The painting was restored in 1976 by Mario Modestini.

Provenance
Château de Chemault, near Orléans (until its demolition in 1853); M. le comte de Saint-Ferriol, Château d'Uriage, near Grenoble (by 1866–until 1960s); comte de Divonne; [Rosenberg & Stiebel, Inc., New York, by 1985; sold to Wrightsman]; Mr. and Mrs. Charles Wrightsman, New York (1985–his d. 1986); Mrs. Wrightsman (from 1986).

Exhibited
Thos. Agnew & Sons, London, June 14–22, 1977, "Master Paintings: Recent Acquisitions," no. 1.

Literature
Denord 1866, p. 38; *Master Paintings: Recent Acquisitions*, exh. cat., Thos. Agnew & Sons, London (London, 1977), pp. 3–4 no. 1; "Old Masters," *Connoisseur* 195 (July 1977), p. 231.

This lifesize image of the penultimate king of the house of Valois, which ruled France from 1328 to 1558, shows the twenty-two-year-

old monarch standing in a darkened interior with a bright rose-pink curtain hanging on the right. His right hand rests on the back of an armchair covered in crimson velvet; in his left he holds a pair of gloves. He is dressed in white leather *scarpine* (slipper-like shoes), white silk hose, and a white doublet with gold metallic-thread embroidery. His sleeveless jerkin, worn over the doublet, has vertical slashing and a narrow peascod belly; his trunk hose, with a small matching codpiece, is a very short variation on breeches. Draped over his shoulders is a black silk Spanish cape with gold metallic embroidery trim and gilded brocade lining. The hilt of a rapier, suspended from a belt hanging from his waist, appears under his arm, and a high lace ruff frames his face. His Spanish toque of black felted wool sports a white aigrette, worn on the right in the French style, and a band of three strands of pearls and jewels en suite with the two triple-stranded chains on his chest, from which hangs the badge of the Order of Saint Michael (the oldest French royal order, founded by Louis XI in 1469).

The second of the four sons of Henry II (1519–1559) and Catherine de' Medici (1519–1589), Charles IX (1550–1574)—called the duc d'Orléans until 1560—became king of France at the age of ten upon the death of his brother Francis II. An intelligent man, Charles was educated by the Humanist Jacques Amyot, who inspired in him a love of literature; he was a patron of the Pléiade, the group of seven poets who promoted the writing of French as opposed to Latin. His mother, however, exercised a disastrous influence over him. Concerned with preserving the power of the monarchy in the religious conflicts of the time, she persuaded her short-lived son to approve the Massacre of Saint Bartholomew's Day, August 23–24, 1572, in which thousands of Huguenots throughout France died.

The protocol of court portraiture dictated the painting's format: lifesize, full length, in a shallow spatial setting with a low viewpoint and a curtain to one side. This oft-repeated formula was invented by Lucas Cranach the Elder (1472–1553), and—especially in official Habsburg portraits by Jakob Seisenegger (1505–1567), Antonio Moro (1517/21–1576/77), Titian (ca. 1490–1576), and Alonso Sánchez Coello (1531/32–1588)—it became an international standard for images of majesty. François Clouet adopted the format for his rather stiff likeness of Henry II (r. 1547–59) in the Galleria Palatina, Florence;[1] painted probably in about 1547, it shows Charles IX's father standing in white hose and slippers before pink silk curtains parted to either side of him. The Wrightsman portrait is an elegant variation of the format, with a

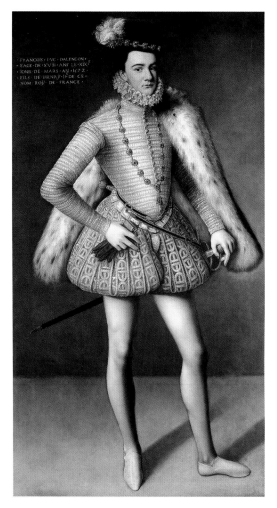

Fig. 1. French School, 16th century, *Prince Hercule François, duc d'Alençon*. Oil on canvas, 74¼ × 40¼ in. (188.6 × 102.2 cm). National Gallery of Art, Washington, D.C.

more graceful, nonchalant pose. In 1572, the probable date of the Wrightsman portrait, a painter from Clouet's circle followed the tradition in a portrait of Charles IX's youngest brother, Hercule François, duc d'Alençon (1554–1584; fig. 1).[2]

Clouet made portrait drawings of Charles IX throughout his life (the earliest is dated June 1552), and three of them served as prototypes for paintings, two of which are known in several versions. The earliest of these three is a drawing in the Bibliothèque Nationale de France, inscribed with the date 1561.[3] It served as the model for a bust-length painting, also dated 1561, in the Kunsthistorisches Museum, Vienna, that depicts a surprisingly mature eleven-year-old, wearing a fur-lined jacket, the year after

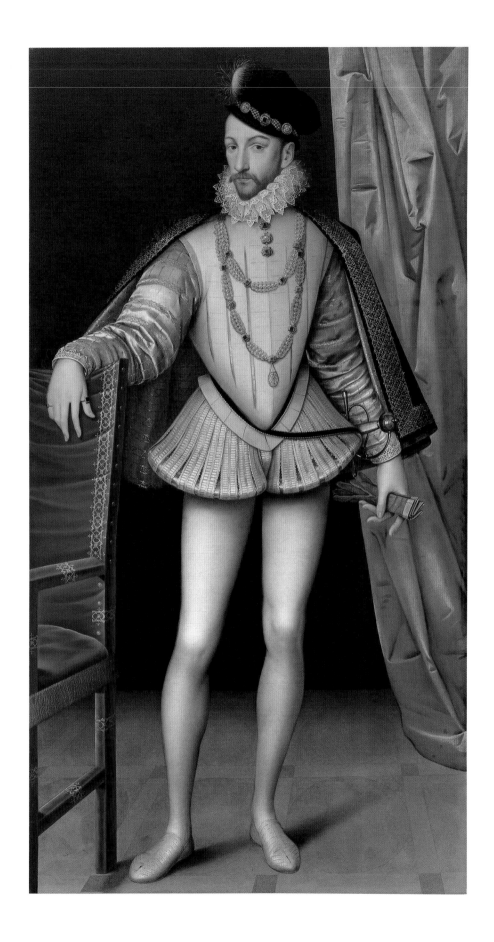

Fig. 2. Style of François Clouet, *Charles IX (1550–1574), King of France*. Oil on wood, 12⅜ × 9 in. (31.4 × 22.9 cm). The Metropolitan Museum of Art, New York, The Friedsam Collection, Bequest of Michael Friedsam, 1931 (32.100.124)

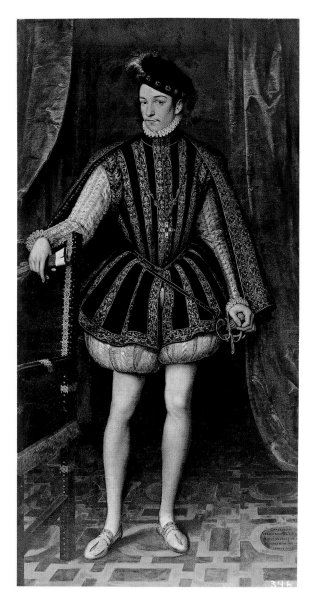

Fig. 3. François Clouet, *Charles IX (1550–1574), King of France*. Oil on canvas, 87⅜ × 45¼ in. (222 × 115 cm). Kunsthistorisches Museum, Vienna

he became king, of which there is a good replica in the Metropolitan Museum (fig. 2). A drawing in the State Hermitage Museum, Saint Petersburg, was used for the more famous portrait of Charles IX in Vienna (fig. 3), which shows the king standing between green curtains in a pose similar to that of the Wrightsman portrait. The date at the base of the Vienna full-length portrait has been tampered with; in the latest catalogue of the Kunsthistorisches Museum,[4] it is read as 1563, but it must originally have been 1566, the same as the date on the Hermitage drawing.[5] The facial features and costume in the drawing and the full-length portrait are identical, and it should be noted that there is no moustache, only a faint suggestion of hair above the sixteen-year-old king's upper lip. The Hermitage drawing also served as the prototype for the fine bust-length version formerly in the collection of Peter Jay Sharp, New York.[6] One of Clouet's late drawings was the prototype for the Wrightsman portrait; although there are no inscriptions on it, the sheet usually is dated about the time of the king's marriage to Elizabeth of Austria in 1570.[7] Charles's features have matured, his face is thinner, and he has a moustache and a short beard. He wears a puffed-up cap with a feather, a tall ruff collar, one chain of pearls (not two, as in the Wrightsman portrait) on his chest, and an earring. This drawing also served as the prototype for miniatures in the Royal Collection, London; the Galleria degli Uffizi, Florence; and the Schatzkammer, Vienna (fig. 4). The

latter is enclosed in a locket with a miniature of Catherine de' Medici, probably the locket that she commissioned in 1571.[8]

According to an old tradition, the Wrightsman portrait comes from the Château de Chemault, near Orléans. Octave Denord, the only authority for this provenance, states that the portrait hung between two windows in the king's room in the château; it is possible that the painting is connected with a payment made to Clouet's heirs in 1573.[9] The king supposedly bought the château for his mistress Marie Touchet, the daughter of an apothecary who lived at Orléans. She is sometimes identified as the sitter in François Clouet's famous painting of a *Lady in Her Bath* (National Gallery of Art, Washington, D.C.), usually dated about 1571; the nude woman's features have a remarkable resemblance to those of Marie Touchet in Clouet's drawing of her in the Bibliothèque Nationale.[10] Charles IX and Marie Touchet began their relationship before 1570, the year of the king's marriage to Elizabeth of Austria; in 1573 Marie bore him a child, Charles, later duc d'Angoulême.

EF

NOTES

1. See Marco Chiarini, in *La Galleria Palatina e gli Appartamenti Reali di Palazzo Pitti. Catalogo dei dipinti,* ed. Marco Chiarini and Serena Padovani, vol. 2, *Catalogo* (Florence, 2003), p. 130.

2. Colin Eisler, *Paintings from the Samuel H. Kress Collection: European Schools, excluding Italian* (Oxford, 1977), pp. 257–58; Elizabeth Goldring, "The Earl of Leicester and Portraits of the Duc d'Alençon," *Burlington Magazine* 146 (February 2004), pp. 108–11.

3. Jean Adhémar, "Les portraits dessinés du XVe siècle au Cabinet des Estampes," *Gazette des beaux-arts,* 6th ser., 82 (September 1973), p. 168 no. 347. The drawing was also the prototype for several miniatures by Clouet or his workshop; see Reynolds 1999, pp. 61–62.

4. *Die Gemäldegalerie des Kunsthistorisches Museums in Wien: Verzeichnis der Gemälde* (Vienna, 1991), p. 44.

5. T. D. Kamenskaya and I. N. Novoselskaya, *French Drawings of the Fifteenth and Sixteenth Centuries in the Hermitage* (in Russian) (Leningrad, 1969), no. 30. Like many Clouet drawings, it is inscribed in the upper-right corner with the date and name of the sitter, in this case, *1566* [and below it, *1569*] *le roi charles ix.* The year 1566 must be correct; see Louis Dimier, *Histoire de la peinture de portrait en France au XVIe siècle,* vol. 1 (Paris and Brussels, 1924), pl. 31.

6. It now belongs to the Bemberg Foundation, Toulouse. See Philippe Cros, *Peintures anciennes: De Cranach à Tiepolo,* Fondation Bemberg (Paris, 2000), p. 85.

7. For the drawing, see Paris 1970, no. 90. The marriage took place by proxy on October 22, 1570, and was celebrated in person in November of that year. Cecil Gould, "The Early History of Leonardo's *Vierge aux Rochers* in the Louvre," *Gazette des beaux-arts,* 6th ser., 124 (December 1994), p. 220, suggested that the two paintings of Charles IX in Vienna came there on the occasion of the wedding.

8. Yvonne Hackenbroch, "Catherine de' Medici and Her Court Jeweller François Dujardin," *Connoisseur* 163 (September 1966), pp. 28–33, especially p. 31, fig. 8a. Hackenbroch argued that it was a gift from Catherine to Emmanuel Philibert, duke of Savoy, Catherine's brother-in-law. For the miniature in the Royal Collection, see Reynolds 1999, p. 62. The miniature in the Uffizi is reproduced by Jollet 1997, p. 220.

9. Denord 1866, p. 38. Archives Nationales, Paris, Royal Accounts, records a payment to Clouet (d. 1572) in 1573 for "un grand tableau de plusieurs toises de notre roi."

10. Adler 1929, pp. 214, 230, 232–34, 246 no. 13. The drawing is reproduced in Paris 1970, no. 98.

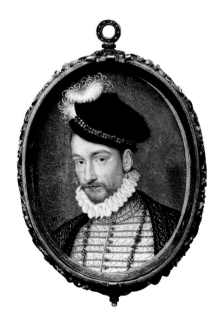

Fig. 4. François Clouet, *Charles IX (1550–1574), King of France.* Parchment, 2 × 1 ½ in. (5.1 × 3.8 cm). Schatzkammer, Vienna

EL GRECO

(Domenikos Theotokopoulos, 1541–1614)

The greatest painter in Spain during the last quarter of the sixteenth and the first years of the seventeenth century, El Greco was born at Candia (modern Iráklion), a seaport on the north shore of Crete, then part of the Venetian republic. The last record of his presence there is dated 1566. An avid collector of Greek and Latin books, he befriended learned Humanists in Italy and Spain.

El Greco studied painting in Venice under Titian (ca. 1490–1576) for an unspecified length of time. During the decade of the 1560s, Titian painted several masterpieces that marked the beginning of his late style, notably the Annunciation *and the* Transfiguration, *in the church of San Salvatore, Venice, and the* Martyrdom of Saint Lawrence, *now in the monastery of San Lorenzo del Escorial, near Madrid. The explosive handling of paint and the impassioned emotional force of these pictures made a profound impression on the young artist from Crete.*

El Greco left Venice for Rome shortly before November 1570, when Giulio Clovio (1498–1578), the manuscript illuminator, recommended him to his patron, Cardinal Alessandro Farnese. El Greco appears to have been granted lodgings in the Palazzo Farnese, and several of his early works, among them Christ Healing the Blind *(Galleria Nazionale, Parma), once belonged to the Farnese collections. In Rome El Greco was also befriended by Fulvio Orsini, librarian to Cardinal Farnese. The inventories of Orsini's possessions show that he owned at least seven paintings by El Greco, including the portrait of Giulio Clovio now in the Museo Nazionale di Capodimonte, Naples.*

Sometime before the spring of 1577, El Greco moved to Spain. He may have left Italy, where he never received commissions for altarpieces or other large paintings, because of the promise of important work in the city of Toledo or for the Escorial. Philip II commissioned El Greco's large altarpiece of the Allegory of the Holy League *for the Escorial; unfortunately, it did not win the king's favor.*

Ultimately, El Greco settled in Toledo and remained there for the rest of his life. His three altarpieces for the church of Santo Domingo el Antiguo and his Espolio, *in the cathedral, all completed by 1579, were received favorably. Their success marked the first appearance of El Greco as a truly major artist. He developed quickly, and the high point of his career was reached with the* Burial of the Conde de Orgaz *(1586) in Santo Tomé, Toledo. With its intensely expressive, elongated figures placed in an unrealistic setting, it is an outstanding example of El Greco's highly personal idiom. The stylized character of the artist's work recalls the contemporary painting of the Italian Mannerists, but the highly charged, mystical force of his paintings is the product of his own reaction to the Counter-Reformation and the religious beliefs of his time.*

Throughout his career, El Greco often painted more than one version of his compositions. As his popularity grew, the number of these versions increased so much that it is not unusual to find as many as ten or twelve of a single composition. His assistants were so skillful that it is sometimes difficult to determine which versions the master painted himself. To the end of his life he always signed his paintings with his Greek name, Domenikos Theotokopoulos, using Greek characters.

EF

ABBREVIATIONS

Fahy 1973. Everett Fahy, in *The Wrightsman Collection*, vol. 5, Everett Fahy and Francis Watson, *Paintings, Drawings, Sculpture.* New York, 1973.

New York, London 2003–2004. David Davies et al. *El Greco.* Exh. cat., The Metropolitan Museum of Art, New York, and National Gallery, London; 2003–2004. London, 2003.

Vechnyak 1991. Irina Barskova Vechnyak. "El Greco's Miracle of Christ Healing the Blind: Chronology Reconsidered." *Metropolitan Museum Journal* 26 (1991), pp. 177–82.

Wethey 1962. Harold E. Wethey. *El Greco and His School.* 2 vols. Princeton, New Jersey, 1962.

Xydis 1963. A. G. Xydis. "New Light on the Sources and Compositional Methods of El Greco" (in Greek). *Krētika chronika* 17 (1963), pp. 27–36.

6. *Christ Healing the Blind*

Oil on canvas, 47 × 57 ½ in. (119.4 × 146.1 cm)
Cleaned and relined in 1958 by Gertrude Blumel. Treated again two years later by Mario Modestini.
The Metropolitan Museum of Art, New York, Gift of Mr. and Mrs. Charles Wrightsman, 1978 (1978.416)

PROVENANCE
[Martin Colnaghi (Guardi Gallery), London, from 1876]; William Rennie, London (by 1877–88; his estate sale, Christie's, London, April 23, 1888, lot 88, as Tintoretto, for 17 guineas, to "Eyles"); Horace James Smith-Bosanquet (in or shortly after 1888–d. 1907); his son, George Richard Smith-Bosanquet

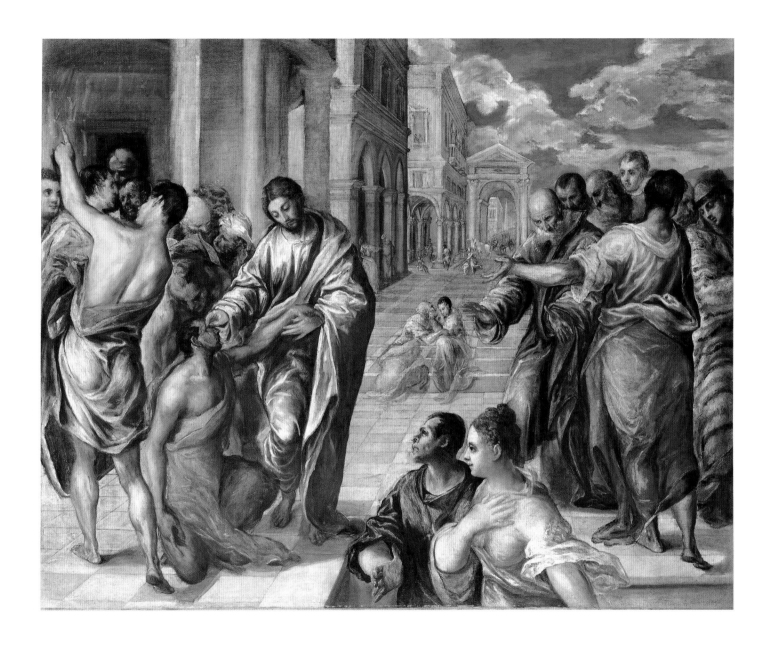

(1907–d. 1939); his son, George Andrew James Smith-Bosanquet, Hengrave, Bury St. Edmunds, Suffolk (1939–58); sale, Christie's, London, May 9, 1958, lot 14, as Veronese, for £37,800, to Agnew); [Agnew, London, 1958–60; sold to Wrightsman]; Mr. and Mrs. Charles Wrightsman, New York (1960–78, cat., 1973, no. 11); their gift in 1978 to the Metropolitan Museum.

EXHIBITED
Metropolitan Museum, New York, June–September 1960, June–August 1961, May–October 1967, December 1972–April 1973; Metropolitan Museum, New York, October 7, 2003–January 11, 2004, and National Gallery, London, February 11–May 23, 2004, "El Greco," no. 4 (shown in New York only).

LITERATURE
Alfred Frankfurter, "El Greco: An Autobiography in Paint," *Art News* 59, no. 4 (summer 1960), pp. 36–37, 73–74; Wethey 1962, vol. 1, p. 38, and vol. 2, pp. 42–44 no. 63, 175; Roberto Longhi, "Una monografia su El Greco e due suoi inediti," *Paragone,* no. 159 (March 1963), p. 53; Xydis 1963, pp. 27–36; A. G. Xydis, "El Greco's 'Healing of the Blind': Sources and Stylistic Connections," *Gazette des beaux-arts,* 6th ser., 64 (November 1964), pp. 301, 303, 305 n. 2; Fahy 1973, pp. 94–104 no. 11; Katharine Baetjer, "El Greco," *Metropolitan Museum of Art Bulletin* 39, no. 1 (summer 1981), pp. 12–23, 28–29, 48; Jonathan Brown, in *El Greco of Toledo,* exh. cat., Toledo Museum of Art and other museums (Toledo, 1982), pp. 88, 90; Vechnyak 1991, pp. 177–82; Jutta Held, "El Greco: 'Die Blindenheilung,'" in *El Greco in Italy and Italian Art,* ed. Nicos Hadjinicolaou, Proceedings of the International Symposium, Rethymno, Crete, September 22–24, 1995 (Rethymno, 1999), pp. 125–37; Keith Christiansen, in New York, London 2003–2004, pp. 81, 82–83 no. 4, 84.

RELATED COMPOSITIONS
DRESDEN, Gemäldegalerie Alte Meister, Staatliche Kunstsammlungen Dresden (280). El Greco, *Christ Healing the Blind* (fig. 1). Oil on wood, 26 × 33⅛ in. (66 × 84 cm).
PARMA, Galleria Nazionale (201). El Greco, *Christ Healing the Blind* (fig. 2). Oil on wood, 19⅝ × 24 in. (50 × 61 cm).

COPIES
CÓRDOBA, Lourdes Peso Cortes (ex-collection José Eduardo del Valle, Madrid). Oil on canvas, 45⅝ × 56⅝ in. (116.2 × 144.1 cm).[1]
MADRID, Estanislao Herrán Rucabado (in 1958). Oil on canvas, 48⅜ × 58⅝ in. (123 × 149 cm).[2]

The miracle of Christ Healing the Blind takes place in a grand architectural setting: a line of gray arcaded buildings runs diagonally from the left side of the picture toward the horizon near the center of the composition. In the foreground are two large groups of figures: on the left are eleven people, including Christ, whose right hand touches the eyes of a blind man kneeling before him, and a partially clad youth who faces away from the spectator with his arm raised; on the right are seven standing figures, of whom the one closest to the edge of the pavement, near the foreground, faces away from the spectator and gesticulates like the youth seen from behind on the left. In an opening in the pavement in the fore-

ground, a dark-skinned man and woman stand and stare with amazement at the miracle. In the background several figures run before a carriage drawn by a pair of white horses.

This subject, typical of El Greco's Italian period, is described in the Gospels of Mark (8:22–25), John (9:1–11), and Matthew (9:27–31). The three accounts differ slightly. According to Mark, Christ healed a single blind man at Bethesda by spitting on his eyes and placing his hands on him. John recounts how Christ gave sight to a blind man by anointing his eyes with clay and sending him to bathe in the pool of Siloam. Matthew speaks of two blind men, and it is his version of the story that El Greco followed when he designed this painting.

Some observers have maintained that the picture illustrates the healing of one blind man, as related in the Gospels of Mark and John, depicted three times: kneeling before Christ; standing at the left and pointing upward in wonder at the light that he sees for the first time; and seated in the middle ground, where his eyes are examined by one of the Jews who "did not believe that he had been blind and had received sight." The man and woman in the foreground would be the blind man's parents, who were called and questioned about their son. The notion of composing a picture with different events of the narrative happening simultaneously was not uncommon during the Renaissance, and it was particularly characteristic of the Byzantine school of painting, with which El Greco was familiar from childhood. However, the three figures in the painting that are supposed to be the blind man are so dissimilar that it is unlikely the painter intended them to be the same person. Not only is their clothing of different colors, but the kneeling man has a much darker complexion than either the youth seen from behind or the figure seated on the step in the middle ground.

If El Greco used Matthew as his source, he may also have included other incidents that are described only in his Gospel. Matthew's account of the miracle of the blind men is immediately preceded by an account of Christ raising from the dead the daughter of Jairus, and it is followed by the story of Christ healing a dumb man "possessed with a devil." It is inferred by A. G. Xydis that El Greco also incorporated these miracles in the Wrightsman painting and that the mysterious figure with downcast eyes on the far right is the daughter of Jairus.[3] The shroudlike costume of this figure lends color to this hypothesis. By the same token, the emotion-filled man with the woman in the immediate foreground might be the mute whom Christ cured. But there is no

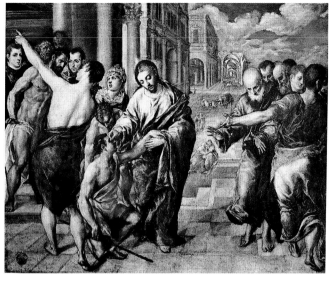

Fig. 1. El Greco, *Christ Healing the Blind*. Oil on wood, 26 × 33⅛ in. (66 × 84 cm). Gemäldegalerie Alte Meister, Staatliche Kunstsammlungen, Dresden

Fig. 2. El Greco, *Christ Healing the Blind*. Oil on wood, 19⅝ × 24 in. (50 × 61 cm). Galleria Nazionale, Parma

convincing internal evidence for identifying any of the figures, except Christ and the blind men.

Of the three accounts of the miracle, Matthew's is the most dramatic and the one most likely to have appealed to the imagination of the young painter. The only calm element in his painting is the figure of Christ, whose gentle gesture of healing contrasts with the turbulent crowd behind him, the gesticulating Pharisees, the little figures running in the distance, and even the agitated clouds in the sky. All of this is emphasized by the play of bright colors—intense blue, green, and red violet—and the free, almost impetuous quality of the brushwork.

Although the painting of the draperies recalls the free handling of El Greco's reputed master, Titian, the dramatic perspective of the space behind the figures is reminiscent of Tintoretto (1518–1594), particularly of such works as his *Christ and the Adulteress* (ca. 1546–47; Galleria Nazionale d'Arte Antica, Palazzo Barberini, Rome). The young El Greco must have felt an innate sympathy with Tintoretto's treatment of supernatural lighting effects and of wild, rushing movement. The Venetian elements in this picture were recognized in the past, for the painting was catalogued in 1888 as a Tintoretto, and only recently as a Veronese.

According to Wethey, Christ Healing the Blind was a subject inspired by the Counter-Reformation.[4] El Greco's contemporaries would have read the picture as an allegory of the Church of Rome

as an embodiment of true faith and religion. Similarly, El Greco's paintings of the Purification of the Temple were symbolic of the reform of the Church during the mid-sixteenth century. These subjects had rarely been depicted in art before the Counter-Reformation. The sudden rise in popularity of these themes is manifested by the numerous occasions on which El Greco and his followers painted them.

In addition to the Wrightsman picture, there are two other paintings by El Greco of Christ Healing the Blind: one, in the Gemäldegalerie, Dresden (fig. 1), is painted on a wooden panel about half the size of the Wrightsman canvas; the other, in the Galleria Nazionale, Parma (fig. 2), is also on canvas, about the same size as the Dresden panel. In all three pictures the main elements are the same, but in the two smaller versions the two half-length figures in the foreground of the Wrightsman picture are missing. The Dresden picture also lacks the blind man who raises his arm and turns his back to the spectator, and in place of the half-length figures in the foreground there is a dog sniffing a sack and a gourd. There are changes in emphasis, as well: the architectural background in the Dresden painting has a less pronounced sense of recession in depth, and the pair of figures sitting in the middle ground are much larger than their counterparts in the Wrightsman painting. The Parma version more closely resembles the Wrightsman painting. Its architectural background

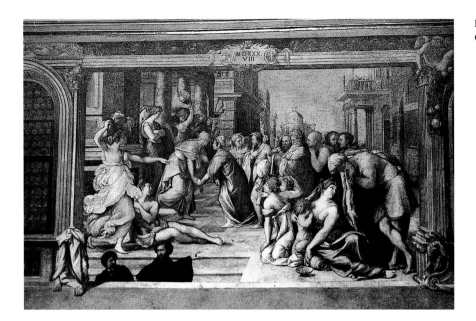

Fig. 3. Francesco Salviati, *The Visitation*. Fresco, San Giovanni Decollato, Rome

is more like that of the Wrightsman painting, and it includes the second blind man.

Together, all three variants form a remarkable record of El Greco's development as an artist. Although some writers have dated them over a span of as many as ten or twelve years, the three of them may well have been painted within two years, from shortly before the artist's departure from Venice to shortly after his arrival in Rome, 1568–70.

Irina Barskova Vechnyak has argued that, because it is "the most Venetian of the three versions," the Wrightsman canvas was painted after the Dresden and before the Parma picture.[5] The color and brushwork of the Dresden version have a strong Venetian cast; accordingly, it is usually dated before El Greco left Venice. The version in Parma was certainly done after he arrived in Rome in 1570. It once belonged to the Farnese family, and some details seem to have been inspired by Roman monuments: the ruins in the background, for example, resemble the Baths of Diocletian, and the nude with a black beard is reminiscent of the Farnese Hercules.

While the Wrightsman canvas may have been painted shortly after El Greco reached Spain in 1577, it is still the product of his experiences in Italy. Fundamentally, it is closely connected with the version at Parma and, like it, owes some of its style to con-temporary Roman art: the man and woman in the foreground, for instance, recall the spectators standing in the recessed area in the immediate foreground of a fresco by Francesco Salviati in the oratory of San Giovanni Decollato, Rome (fig. 3).

Two old copies of the Wrightsman picture by anonymous Spanish artists suggest that the picture was in Spain before it was taken to England in the nineteenth century. El Greco may actually have brought it with him from Italy and worked on it after his arrival in Spain. In fact, he never completed it; the largest building and the back row of heads on the left are only blocked in (and it is unsigned, unlike the other two versions). Nevertheless, the painting did not remain in El Greco's studio; it is not listed in the inventory of his possessions drawn up after his death by his son, Jorge Manuel. EF

Notes

1. José Camón Aznar, *Dominico Greco* (Madrid, 1950), vol. 1, p. 237, fig. 137; Wethey 1962, vol. 2, p. 175.
2. Halldor Soehner, "Greco in Spanien," *Münchner Jahrbuch der bildenden Kunst* 9–10 (1958–59), p. 227 no. 241, fig. 51; Wethey 1962, vol. 2, p. 175.
3. Xydis 1963, pp. 27–36.
4. Wethey 1962, vol. 2, p. 41.
5. Vechnyak 1991, p. 177.

GUERCINO

(Giovanni Francesco Barbieri, 1591–1666)

Although he began with fluidly painted compositions filled with glowing colors and strong contrasts of light and dark, Guercino gradually evolved a subdued, undramatic style in keeping with the official taste of the period. Born at Cento, a village situated halfway between Bologna and Ferrara, he was trained by Benedetto Gennari the elder (1563–1658). His youthful style, however, owes most to Ludovico Carracci (1555–1619) and Scarsellino (1551–1620). Guercino's first important work, the Madonna in Glory with Four Saints for an altar in Sant'Agostino, Cento (1616; Musée d'Art Ancien, Brussels), displays a precocious understanding of contemporary Bolognese and Ferrarese painting.

In 1617 Guercino was called to Bologna by Archbishop Alessandro Ludovisi (1555–1623), who later, as the Jesuit-trained Pope Gregory XV (r. 1621–23), was to play an important role in the artist's career. At Bologna the young Guercino painted several altarpieces that rank with the greatest masterpieces of seventeenth-century painting, including Saint William Receiving the Monastic Habit (Pinacoteca Nazionale, Bologna) and Saint Francis in Ecstasy (Musée du Louvre). Painted in 1620, they both show a distinctive, unexpectedly mature style for a nineteen-year-old painter. When Ludovisi was elected pope in 1621, Guercino was summoned to Rome, and among the works he painted there is the large fresco Aurora (1621) on the ceiling of the Casino Ludovisi, part of the newly acquired villa of the pope's twenty-five-year-old nephew Ludovico Ludovisi. The fresco's bold foreshortening and illusionistic setting mark the climax of Guercino's early development and an important stage in the evolution of the Baroque style.

Between 1621 and 1623 Guercino worked on a colossal painting of the Burial and Reception into Heaven of Saint Petronilla for one of the altars in Saint Peter's (Pinacoteca Capitolina, Rome). For some critics this was the turning point in Guercino's career. Its clearly organized composition, made up of compact forms seen in an evenly distributed light, shows a new classical approach, probably prompted by Giovanni Battista Agucchi (1570–1632), an art theorist who championed the classical style of the Carracci and Domenichino (see p. 38).

Following Pope Gregory's death in 1623, Guercino returned to Cento, where he worked for the next twenty years. Content in the provincial setting of his native town, he declined invitations to work in London for King Charles I and in Paris for Marie de' Medici, Queen Mother of France. In 1629 Velázquez (1599–1660) paid him a visit at Cento. Shortly after Guido Reni's death in 1642, Guercino transferred his studio to Bologna, where he took on religious commissions of the kind that Reni (see p. 45) had monopolized, and his style became increasingly reminiscent of Reni's late manner. Nevertheless, in 1660, when Don Antonio Ruffo of Messina commissioned him to produce a companion piece to Ruffo's painting by Rembrandt (1606–1669) of Aristotle with a Bust of Homer (1653), now in the Metropolitan Museum, Guercino agreed to paint it in his "vibrant early manner" (mia prima maniera gagliarda) so that it would harmonize with the rich chiaroscuro of Rembrandt's work. EF

ABBREVIATIONS

Fahy 1973. Everett Fahy, in *The Wrightsman Collection*, vol. 5, Everett Fahy and Francis Watson, *Paintings, Drawings, Sculpture*. New York, 1973.

Malvasia 1678. Carlo Cesare Malvasia. *Felsina pittrice. Vite de' pittori bolognesi, alla maesta christianissima di Luigi XIII.* 2 vols. Bologna, 1678.

Salerno 1988. Luigi Salerno. *I dipinti del Guercino*. Rome, 1988.

Stone 1991. David M. Stone. *Guercino. Catalogo completo dei dipinti.* Florence, 1991.

7. *Samson Captured by the Philistines*

Oil on canvas, 75¼ × 93¼ in. (191.1 × 236.9 cm)
Restored in 1979–80 by John Brealey at the Metropolitan Museum. An old relining, similar to that on the *Saint Sebastian Succored* in the Pinacoteca Nazionale, Bologna, was replaced.[1]
The Metropolitan Museum of Art, New York, Gift of Mr. and Mrs. Charles Wrightsman, 1984 (1984.459.2)

PROVENANCE
Jacopo Serra, Cardinal Legate of Ferrara (commissioned 1619–d. 1623); Serra family, probably Ferrara and later Naples (1623–probably about 1920); Mr. and Mrs. Alfred Bey Sursock [she was born Maria Teresa Serra], Beirut (after their marriage in 1920; acquired in Naples, probably on the advice of Mrs. Sursock's brother, Giovanni Battista Serra); their daughter, Yvonne Lady Cochrane, Beirut (by 1969–79; sold through Leggatt Brothers, London, to Wrightsman); Mr. and Mrs. Charles Wrightsman, New York (1979–84); their gift in 1984 to the Metropolitan Museum.

EXHIBITED
Pinacoteca Nazionale, Bologna, September 10–November 10, 1986, National Gallery of Art, Washington, D.C., December 19–February 16, 1987, and

Metropolitan Museum, New York, March 26–May 24, 1987, "The Age of Correggio and the Carracci: Emilian Painting of the Sixteenth and Seventeenth Centuries," no. 163.

LITERATURE
Malvasia 1678, vol. 2, p. 364; Denis Mahon, "Guercino and Cardinal Serra: A Newly Discovered Masterpiece," *Apollo* 114 (September 1981), pp. 170–75; Keith Christiansen, in The Metropolitan Museum of Art, *Notable Acquisitions, 1984–1985* (New York, 1985), pp. 21–22; Salerno 1988, pp. 38, 41, 136–37 no. 58; Stone 1991, pp. 75–76 no. 54.

DRAWINGS
FLORENCE, Gabinetto Desegni e Stampe degli Uffizi (1510F). Guercino, *Samson Captured by the Philistines* (fig. 4). Pen and wash on paper, 10 1/8 × 9 in. (25.8 × 22.7 cm).[2]
HAARLEM, Teylers Museum. Guercino, *Samson Captured by the Philistines* (fig. 5). Pen and wash on paper, 9 1/4 × 16 1/8 in. (23.6 × 41.1 cm).[3]
PARIS, Institut Néerlandais, Fondation Custodia, Fritz Lugt Collection. Guercino, *Back of a Man, Seated, Stripped to the Waist* (fig. 6). Red chalk, heightened with white on beige paper, 13 1/4 × 10 5/8 in. (33.5 × 27 cm).[4]

RELATED WORKS
BOLOGNA, Pinacoteca Nazionale (6483). Guercino, *Saint Sebastian Succored* (fig. 1). Oil on canvas, 70 1/2 × 88 5/8 in. (179 × 225 cm).
LONDON, Sir Denis Mahon. Guercino, *Elijah Fed by Ravens*. Oil on canvas, 76 3/4 × 61 5/8 in. (195 × 156.5 cm).
LONDON, Sir Denis Mahon. Guercino, *Jacob Blessing the Sons Joseph*. Oil on canvas, 66 1/2 × 83 1/4 in. (169 × 211.5 cm).
PARIS, Musée du Louvre (77). Guercino, *The Raising of Lazarus*. Oil on canvas, 79 1/8 × 91 3/4 in. (201 × 233 cm).
VIENNA, Kunsthistorisches Museum (253). Guercino, *The Return of the Prodigal Son*. Oil on canvas, 42 1/8 × 56 1/2 in. (107 × 143.5 cm).

COPIES
ANGOULÊME, Musée des Beaux-Arts. Oil on canvas, 71 1/4 × 93 1/4 in. (181 × 237 cm).[5]
COLOGNE, Lempertz, sale, October 28, 1924, lot 162. Oil on canvas, 80 1/4 × 98 3/8 in. (204 × 250 cm).

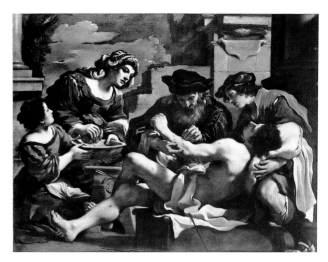

Fig. 1. Guercino, *Saint Sebastian Succored*. Oil on canvas, 70 1/2 × 88 5/8 in. (179 × 225 cm). Pinacoteca Nazionale, Bologna

(1471–ca. 1529), for example, followed the biblical text literally, showing Samson asleep on Delilah's knees with a servant cutting his hair (fig. 2). By contrast, Guercino conjured up a compressed group of figures with vehement facial expressions, filling the picture surface with an interlocking pattern of violent gestures. Adding to the drama, light falls across the composition, breaking it up into patches of light and dark, typical of Guercino's early naturalistic chiaroscuro style before he worked in Rome. Years later, when Guercino returned to the subject in a compositional sketch (fig. 3) for a painting of 1646, he chose the moment when Samson quietly points to his unruly mane.[6]

With massive, lifesize figures, Guercino's painting illustrates one of the climactic events of the Old Testament story of Samson and Delilah—the moment when "the Philistines took him, and put out his eyes" (Judges 16:21). In the foreground a voluptuous Delilah pushes Samson's elbow to release the white cloth caught on her knee, while he struggles in vain against four men who attack him and a fifth who holds up a pair of scissors with one hand and displays a white comb with the other; a young woman rushes to the right, looking back on the frenzied scene.

Samson had fallen in love with Delilah, whom the Philistines bribed with eleven hundred pieces of silver to discover the source of his superhuman strength. Earlier artists had depicted the episode as a serene scene: the Veronese painter Francesco Morone

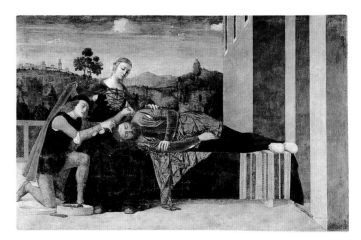

Fig. 2. Francesco Morone, *Samson and Delilah*. Oil on wood, 30 1/8 × 47 7/8 in. (76.4 × 121.7 cm). Pinacoteca Poldi Pezzoli, Milan

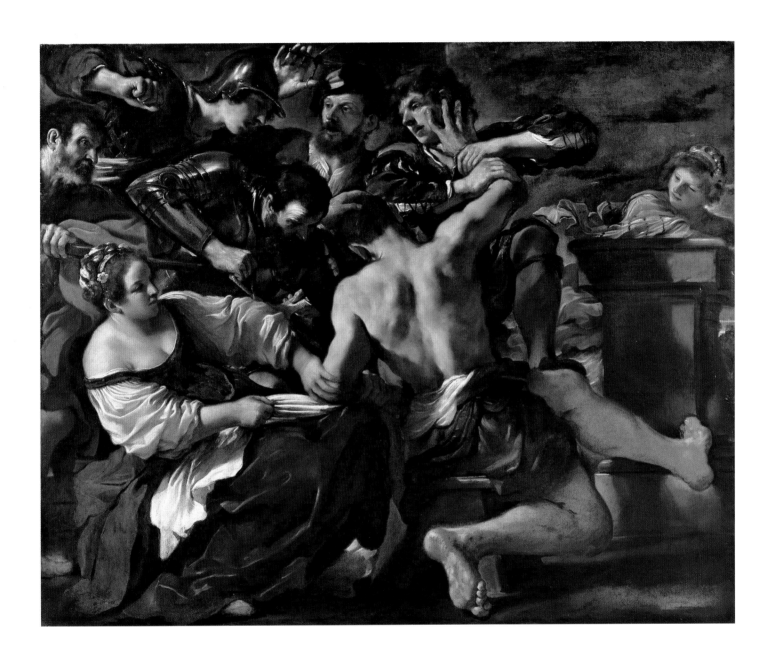

Fig. 3. Guercino, *Samson and Delilah*. Pen and brown ink on paper, 7⅞ ×
9⅝ in. (20.1 × 24.3 cm). Philadelphia Museum of Art

In an exhaustive essay on the painting, Denis Mahon identified
it as one that the young Guercino painted for Cardinal Jacopo
Serra (1570–1623), the legate, or papal governor, of the former
duchy of Ferrara, which had passed to the papacy in 1598 (and
which included Guercino's hometown of Cento). Serra, who had
been in charge of the papal treasury, had an eye for spotting young
talent. In Rome in 1606 he had pledged 300 scudi toward the cost
of a painting for the high altar of the Chiesa Nuova with the stip-
ulation that he would withdraw his offer if Rubens (see p. 113),
then at the beginning of his career, did not receive the commission.[7]

Serra arrived in Ferrara in 1615 and remained there until his
death eight years later. An enthusiastic patron of Guercino, he
commissioned at least five large paintings by him. According to
Guercino's first biographer, Carlo Cesare Malvasia, Serra sum-
moned Guercino in 1619 to Ferrara, "where he painted many pic-
tures," which pleased Serra so much that he paid Guercino more
than the agreed-upon prices.[8] Malvasia specified the subjects of
three of them: "a wounded Saint Sebastian being succored, with
various figures; a Samson with Delilah, who cuts his hair; and a
prodigal son received by his father."[9] Serra's pictures (see Related
Works, above) do not form a uniform group; they differ in size,
format, and the scale of the figures. The following year Guercino
was recalled to Ferrara to make further pictures for Serra and his

nephew, Giovan Paolo Serra, including *Elijah Fed by Ravens* and
Jacob Blessing the Sons of Joseph. After those two works were com-
pleted, Serra knighted the painter, making him a *cavalliero* on
December 8, 1620.

Roberto Longhi has suggested that Guercino's *Raising of Lazarus*
in the Louvre was a pendant to the Wrightsman canvas, though
Malvasia did not mention a painting of this subject.[10] To judge from
its style, the Louvre *Lazarus* certainly looks as if it was painted at
the same time as Serra's pictures. It is almost the same size as the
Wrightsman *Samson,* and its composition, with seated figures in the
foreground, is similar to that of the Wrightsman painting, but there
is no obvious thematic connection between them.

Three preparatory drawings for the Wrightsman canvas are
known: two pen-and-ink sketches in which the artist explores the
composition and a red chalk study for Samson's back (figs. 4–6).

EF

NOTES

1. Denis Mahon, "Guercino and Cardinal Serra: A Newly Discovered
 Masterpiece," *Apollo* 114 (September 1981), p. 175 n. 29.
2. Nicholas Turner, "A Drawing for Guercino's 'Samson Taken by the
 Philistines,'" *Burlington Magazine* 131 (January 1989), p. 29.
3. Denis Mahon, *Il Guercino (Giovanni Francesco Barbieri, 1591–1666). Catalogo
 critico dei disegni,* exh. cat., Palazzo dell'Archiginnasio, Bologna (Bologna,
 1968), p. 65.
4. Carel van Tuyll van Serooskerken, *Guercino (1591–1666): Drawings from
 Dutch Collections,* exh. cat., Teylers Museum, Haarlem (The Hague, 1990),
 p. 40 no. 4, credits Aiden Weston-Lewis with connecting a red chalk study
 in the Lugt collection, Paris, previously attributed to Annibale Carracci,
 with the figure of Samson in the Wrightsman picture.
5. Émile Biais, *Catalogue du Musée d'Angoulême: Peintures, sculptures, estampes*
 (Angoulême, 1884), no. 4.
6. Ann Percy and Mimi Cazort, *Italian Master Drawings at the Philadelphia
 Museum of Art,* exh. cat., Philadelphia Museum of Art (Philadelphia, 2004),
 no. 11. The drawing is a study for the painting in the collection of Edward
 Goodstein, Los Angeles (Salerno 1988, no. 228).
7. Michael Jaffé, *Rubens and Italy* (Oxford, 1977), pp. 86–89.
8. The document for the knighthood was published by Giampietro Zanotti
 in a footnote to his edition of Malvasia's *Felsina pittrice* (Bologna, 1841),
 vol. 2, pp. 284–85 no. 25.
9. "Fù chiamato à Ferrara dall'Eminentiss. Card. Serra Legato, dove fece
 molti quadri, e furono: Un S. Sebastiano ferito, quando vien curato, con
 diverse figure. Un Sansone con Dalida, che gli taglia i capelli. Un Figliuol
 ricevuto dal Padre." Malvasia 1678, vol. 2, p. 364.
10. Roberto Longhi, "The Climax of Caravaggio's Influence on Guercino,"
 Art in America 14 (June 1926), p. 140.

Fig. 4. Guercino, *Samson Captured by the Philistines*. Pen and wash on paper, 10 ⅛ × 9 in. (25.8 × 22.7 cm). Gabinetto Desegni e Stampe degli Uffizi, Florence

Fig. 5. Guercino, *Samson Captured by the Philistines*. Pen and brown ink, brown wash, 9 ¼ × 16 ⅛ in. (23.6 × 41.1 cm). Teylers Museum, Haarlem

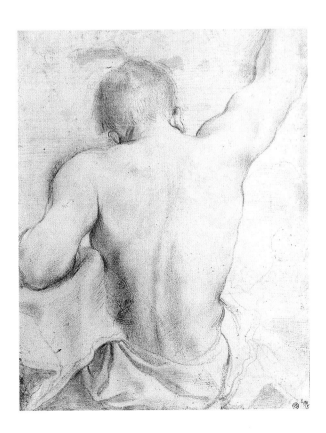

Fig. 6. Guercino, *Back of a Man, Seated, Stripped to the Waist*. Red chalk, heightened with white on beige paper, 13 ¼ × 10 ⅝ in. (33.5 × 27 cm). Institut Néerlandais, Fondation Custodia, Fritz Lugt Collection, Paris

8. The Vocation of Saint Aloysius (Luigi) Gonzaga

Oil on canvas, 140 × 106 in. (355.6 × 269.2 cm)
The Metropolitan Museum of Art, New York, Gift of Mr. and Mrs.
Charles Wrightsman, 1973 (1973.311.3)

PROVENANCE
Church of Santa Maria del Castello, Guastalla (by 1651–1805; valued at 500 scudi; expropriated in 1805 by Moreau, the French general administrator for Guastalla) Mérédic-Louis-Elie Moreau de Saint Méry, Parma (1805–6); the painter Gaetano Callani, Parma (1806; transferred to Junot); Jean Andache Junot, duc d'Abrantes, Paris (1806–d. 1813; his sale, Christie's, London, May 4, 1818, lot 58, for 190 guineas, to Woodburn); [Woodburn, from 1818]; [Sanquirico, Milan, until 1821; sold to Grant for 300 "luigi" and 3 horses with their saddles (equivalent to 400 louis d'or)]; John Grant III, Kilgraston, Scotland (1821–d. 1873); his son, Charles Thomas Constantine Grant, Kilgraston, Scotland (1873–d. 1891; sale, T. Chapman & Son, Edinburgh, April 15, 1882, lot 87, bought in for £100); his son, John Patrick Nisbet Hamilton Grant, Biel Dunbar, Scotland (1891–d. 1950); his cousin, Basil Charles Barrington Brooke (1950–57; sold through Agnew, London, to Wrightsman; Mr. and Mrs. Charles Wrightsman, New York (1957–73; cat., 1973, no. 13); their gift in 1973 to the Metropolitan Museum.

EXHIBITED
British Institution, London, 1857, "Pictures by Italian, Spanish, Flemish, Dutch, French, and English Masters," no. 4; Royal Academy of Arts, London, 1873, "Works of Art of the Old Masters," no. 225; Metropolitan Museum, New York, 1957–73; Pinacoteca Nazionale, Bologna, September 10–November 10, 1986, National Gallery of Art, Washington, D.C., December 19– February 16, 1987, and Metropolitan Museum, New York, March 26–May 24, 1987, "The Age of Correggio and the Carracci: Emilian Painting of the Sixteenth and Seventeenth Centuries" (shown in New York only; not in catalogue).

LITERATURE
Malvasia 1678, vol. 2, p. 378; Fahy 1973, pp. 117–25 no. 13; Nerio Artioli and Elio Monducci, *Dipinti "reggiani" del Bonone e del Guercino (pittura et documenti)*, exh. cat., Basilica della Beata Vergine della Ghiara, Reggio Emilia (Reggio Emilia, 1982), pp. 113–14 no. 23; Salerno 1988, p. 276; Stone 1991, p. 272 no. 263.

VERSION
PALERMO, collection of the Prince of Massa.[1]

On March 29, 1650, Guercino noted in his *libro dei conti* (account book) an advance payment for a painting of the "Blessed Luigi Gonzaga with a glory of angels above," commissioned by a certain Signor Quaranta Sampieri on behalf of the duke of Guastalla for an unspecified church in Guastalla, a town in Reggio Emilia. The following year Guercino received two further payments for the altarpiece from the duke himself.[2] The duke, Don Ferrante III Gonzaga (d. 1670), a member of the cadet branch of Luigi Gonzaga's family, may have ordered the painting to promote the

canonization of his relative. In 1621 Pope Gregory XV, the young Guercino's most important patron, beatified Luigi Gonzaga, yet it took over a century before Benedict XIII canonized him as San Luigi, or, as he is called in English, Saint Aloysius.

Luigi Gonzaga (1568–1591) was the eldest son of Ferdinando Gonzaga, marquis of Castiglione, kinsman to the duke of Mantua. Born in the castle of Castiglione near Brescia, as a young boy he showed concern for the poor and extraordinary piety, and, despite his family's opposition, he resolved to enter the Church. In 1585 he ceded his marquisate to his younger brother and entered his novitiate at the Jesuit church of Sant'Andrea in Rome, giving up a position of wealth and power to join one of the strictest arms of the Counter-Reformation. However, he served only six years, dying in an epidemic at the age of twenty-three. His pious and chaste character, often used as a model for Italian children, is also the source of the caustic Italian dismissal of a too pure young man as a "regular San Luigi."

Guercino's painting does not illustrate a specific event in the saint's life; instead, it telescopes different moments into a single image of the saint's dedication. According to Luigi's biographers, for example, his vocation became apparent when he was seven years old, considerably earlier than in the painting, and he relinquished his marquisate when he was seventeen, several months before he would have adopted the Jesuit habit he wears in the painting.

The altarpiece depicts in allegorical terms Luigi's abdication of a temporal vocation for a spiritual one. His family's coronet lies on the floor behind him, while a putto brings him a flowered wreath symbolizing his heavenly reward. The branch of lilies at his feet alludes to chastity, his most famous virtue. This iconography was firmly established shortly after the saint's death. The coronet, flowered wreath, and lilies appear in a pair of engravings (figs. 1, 2) made in about 1607 by Jerome Wierix (ca. 1553–1619) and Anton Wierix (ca. 1552–1624). It is quite possible that Guercino referred to these or similar prints when he designed the altarpiece a half century later.[3]

A good example of Guercino's late style, the Wrightsman picture has an air of dignity and monumentality; the broad shaft of light is steady and even, undramatically illuminating the folds of the saint's surplice, the head and upper body of the angel, and the bodies of the putti. The cool, harmonious colors and the even

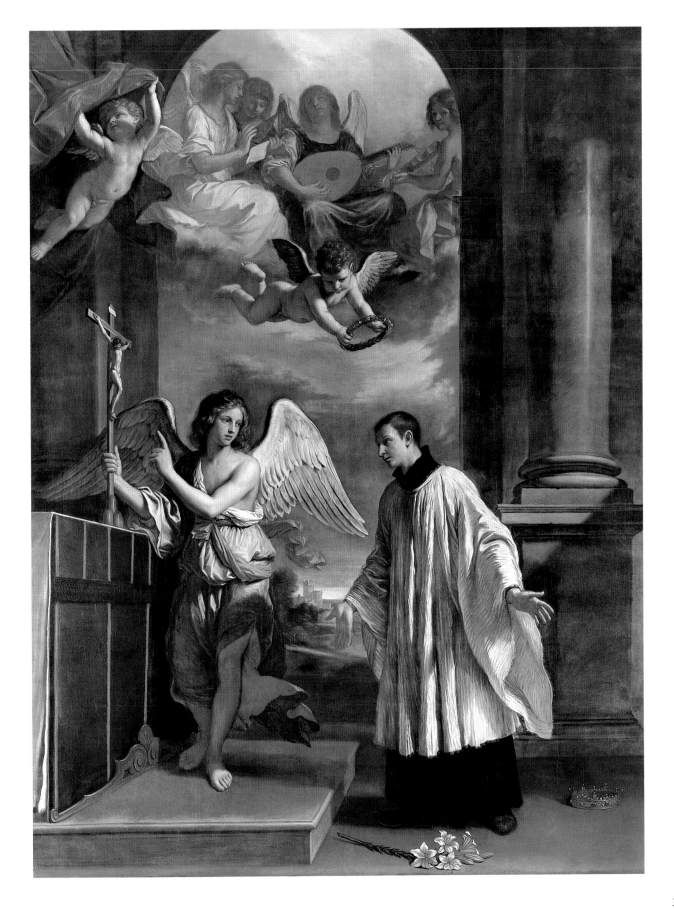

IL B. LVIGI GONZAGA MARCHESE
DI CASTIGL. DELLA COMP.ᴬ DI GIESV.

Hieronymus Wierx fecit et excud. Cum Gratia et Priuilegio. Buſchere.

Vnde flores caſti odoris, Quanuis terris habitabat,
Chriſtus, cum beatis choris Mente tamen euolabat
Cingunt Aloyſium? Campum ad Elyſium.

Anton. Wierx fecit et excud.

Fig. 1 (at left). Jerome Wierix, *The Vocation of San Luigi Gonzaga*. Engraving, 4¼ × 2⅝ in. (10.7 × 6.8 cm). The Metropolitan Museum of Art, New York, Elisha Whittelsey Fund (51.501.6197)

Fig. 2 (at right). Anton Wierix, *The Vocation of San Luigi Gonzaga*. Engraving, 4⅜ × 2¾ in. (11 × 6.9 cm). The Metropolitan Museum of Art, New York, Elisha Whittelsey Fund (51.501.6389)

handling of the paint help to communicate the calm, thoughtful, and detached feeling of the altarpiece.

Within a short period of fifteen years, this enormous painting was shipped back and forth across Europe: from Parma to Paris in 1806, to London in 1818, back to Milan, and to Kilgraston, Perthshire, in 1821. A young Scotsman, John Grant III of Kilgraston (1798–1873), had Samuel Woodburn (1786–1853), the famous collector and art dealer, bid on the altarpiece in the Junot sale at Christie's in London on May 4, 1818 (see Provenance, above). But Grant's father, angry at his son for having bought the painting for 190 guineas, by far the highest price paid for any of Junot's pictures, disclaimed the purchase sometime before his death (July 26, 1818), as his son was not yet of age. Woodburn subsequently disposed of the picture, and it next turned up with Carlo Sanquirico, a dealer in Milan. Once John Grant came of age, he tracked the picture down; according to a manuscript contract, dated Milan, August 24, 1921 (on deposit, Metropolitan Museum, Department of European Paintings), Sanquirico asked more for the picture than Grant could afford, although he did finally consent to accept as part payment three of Grant's horses with their saddles and harnesses. The picture was then shipped to Grant's house in

Perthshire, and it remained in his family until the Wrightsmans acquired it in 1957.[4]

A lifesize red chalk drawing of the head of a youthful saint in the Royal Collection at Windsor Castle (Berkshire), previously thought to be a study for the present painting, was convincingly identified as a finished study for Guercino's altarpiece in the church of the seminary at Finale nell'Emilia.[5] EF

NOTES

1. According to Iacopo Alessandro Calvi, *Notizie della vita, e delle opere del cavaliere Gioan Francesco Barberi, detto il Guercino da Cento, celebre pittore* (Bologna, 1808), p. 155. Guercino received 375 scudi for it in 1662, whereas he was paid 1,973 scudi in 1650 for the Wrightsman altarpiece.

2. Barbara Ghelfi, ed., *Il libro dei conti del Guercino, 1629–1666* (Bologna, 1997), pp. 146, 152. On March 29, 1650, the artist received an advance of 473 scudi; on April 24, 1651, a further payment of 1,000 scudi; and on April 27, 1651, a final payment of 500 scudi.

3. Luigi Bosio, "La 'Vocazione di San Luigi Gonzaga' della collezione Wrightsman," *Civiltà mantovana* 10 (1976), pp. 170–81, relates the iconography to a specifically Mantovan tradition, discounting the Wierix engravings as a possible source for Guercino's imagery.

4. Charles Thomas Constantine Grant, *San Luigi di Gonzaga and Guercino* (Bruges, 1882), pp. 3–7, 8.

5. It was recognized by Carol Plazzotta, in Nicholas Turner and Carol Plazzotta, *Drawings by Guercino from British Collections,* exh. cat., British Museum, London (London, 1991), no. 50.

34

GOFFREDO WALS

(ca. 1595 / 1600–ca. 1638)

*Born in Cologne, as a young man Goffredo Wals settled in Naples,
where he started his career coloring engravings by other artists. He
moved to Rome, and from 1616 to 1619 he worked in the studio of
Agostino Tassi (ca. 1580–1644), the landscape painter who specialized
in frescoes and small oil paintings—and who is perhaps best known
today as the man who allegedly raped Artemisia Gentileschi. In Rome
Wals was influenced by the naturalistic works of landscape painters
from northern Europe who had preceded him, notably Paul Bril (1554–
1626), who traveled to Rome in the 1570s and specialized in small land-
scapes of traveling pilgrims and peasants among ancient ruins; Jan
Breughel the Elder (1568–1625), who worked in Rome, Naples, and
Milan in the 1590s, producing small-scale landscapes, often on copper,
in exquisite detail; and Adam Elsheimer (1578–1610), the great, short-
lived German painter, who was active mainly in Rome. Returning to
Naples, Wals set up his own studio, where he instructed Claude
Lorrain (1600–1682) for an unspecified length of time between 1620 and
1622. Moving to Genoa in 1630, he joined the celebrated painter
Bernardo Strozzi (1581–1644) shortly before Strozzi left Genoa for
Venice. From Genoa Wals moved on to neighboring Savona, where he
spent a year before returning to Naples. He is reported to have died in
an earthquake in Calabria.* EF

ABBREVIATIONS

Repp-Eckert 1985. Anke Repp[-Eckert]. *Goffredo Wals: Zur Landschaftsmalerei
zwischen Adam Elsheimer und Claude Lorrain.* Cologne, 1985.

Repp-Eckert 1991. Anke Repp-Eckert. "Nachträge zum Werk von Goffredo
Wals." *Wallraf-Richartz-Jahrbuch* 52 (1991), pp. 321–30.

Roethlisberger 1979. Marcel Roethlisberger. "Additional Works by Goffredo
Wals and Claude Lorrain." *Burlington Magazine* 121 (January 1979),
pp. 20–28.

9. *A Roman Landscape with Figures*

Oil on copper, diameter 16 in. (40.6 cm)
The Metropolitan Museum of Art, New York, Wrightsman Fund,
1997 (1997.157)

PROVENANCE
Private collection, Newbury, Berkshire (until 1997; sale, Dreweatt Neate,
Newbury, March 5, 1997, lot 178, as Flemish School, 18th century, for £55,000,
to Hall & Knight; [Hall & Knight, London and New York, 1997; sold to the
Metropolitan]; purchased in 1997 by the Metropolitan Museum through the
Wrightsman Fund.

LITERATURE
Walter Liedtke, in "Recent Acquisitions: A Selection, 1997–1998," *Metropolitan
Museum of Art Bulletin* 56, no. 2 (fall 1998), p. 28; Marco Chiarini, "Il paesaggio
a Roma, Firenze e Napoli nel primo Seicento," in *Micco Spadaro: Napoli ai
tempi di Masaniello,* exh. cat., Certosa di San Martino, Naples (Naples, 2002),
pp. 30–31.

VERSION
AMSTERDAM, De Boer Gallery (before 1979). Oil on copper, diameter 16 in.
(40.5 cm).

Goffredo Wals enjoyed a certain amount of fame in his lifetime,
but later, if remembered at all, he was known as the teacher of
Claude Lorrain. Wals's name crops up in old inventories of col-
lectors who appreciated his small cabinet pictures, filled with all-
enveloping light and harmonious geometric structure, in the
tradition of Adam Elsheimer. Gaspar Roomer (1590–1674), the
Flemish merchant in Naples, shipowner, and art collector (in 1640
he owned Rubens's marvelous *Feast of Herod,* now in the National
Gallery of Scotland, Edinburgh), possessed sixty oil paintings and
fourteen gouaches by Wals.[1] The Deutz family, which owned
paintings by Sweerts (cat. 36), also had several.[2] It was only in the
late 1960s that the artist's reputation was revived by Marcel
Roethlisberger, the doyen of Claude studies, who began to isolate
Wals's rare works on the basis of an etching bearing the artist's ini-
tials and a few paintings inscribed on the backs with his name or
initials by later hands. Now some thirty works are attributed to
the artist. All of them are small—the Wrightsman roundel is one
of the largest—and many of them are painted on copper, a sup-
port first used by painters in printmaking centers; the smooth sur-

face appealed to artists with a delicate touch. Wals favored a circular format for his paintings and drawings. All of them are modest landscapes, a few with religious subjects in landscape settings, such as the Rest on the Flight into Egypt; none depict specific views or known buildings.

With no dated works to serve as guideposts for Wals's chronology, the dating of his work can only be approximate. Those most dependent on his mentors undoubtedly are early; works such as the Wrightsman picture, with its confident application of perspective creating a strong recession toward the center, are more mature, and probably were executed in the 1620s.

The success of the composition is suggested by the existence of an autograph replica, which was sold by the De Boer Gallery, Amsterdam, sometime before 1979.[3] Painted on a copper roundel the same size as the Wrightsman picture, it is virtually identical, except for the omission of the apostle-like figure standing in the foreground, clad in a brown robe over a green tunic. Another instance of Wals replicating an admired composition can be seen in the equally fine versions of the *Country Road by a House,* which the Fitzwilliam Museum, Cambridge, acquired in 1979, and the Kimbell Art Museum, Fort Worth, purchased in 1991.[4]

EF

NOTES

1. Giuseppe Ceci, "Un mercante mecenate del secolo XVII: Gaspare Roomer," *Napoli nobilissima,* n.s., 1, nos. 9–12 (1920), p. 163.
2. Jonathan Bikker, "The Deutz Brothers, Italian Paintings and Michiel Sweerts: New Information from Elisabeth Coymans's *Journael,*" *Simiolus* 26 (1998), especially pp. 292–302. Roethlisberger 1979, p. 20 n. 3, lists some works by Wals that appeared in the inventories of notable collectors such as Cardinal Mazarin, Cardinal Massimi, and Pierre Crozat.
3. Roethlisberger 1979, pp. 20–21; Repp-Eckert 1985, no. 9; Repp-Eckert 1991, pp. 326, 330 n. 28.
4. Marcel G. Roethlisberger, "From Goffredo Wals to Claude Lorrain: Recent Discoveries," *Apollo* 135 (April 1992), pp. 209–10.

DOMENICHINO

(Domenico Zampieri, 1581–1641)

Born at Bologna, Domenichino, like his slightly older compatriot Guido Reni (see p. 45), began his training with the Flemish painter Denis Calvaert (1540–1619). He moved on to the more progressive studio of Ludovico Carracci (1555–1619) and in 1602 went to Rome, where he joined the group of young Bolognese artists at work in the Palazzo Farnese with Ludovico's brother Annibale (1560–1609). Domenichino's earliest documented work, a small Vision of Saint Jerome, *mentioned in an inventory of 1603 and now in the National Gallery, London, is deeply influenced by Annibale's style. His earliest identifiable frescoes are three scenes from Ovid, painted on the garden loggia of the Palazzo Farnese. Their tender feeling and the prominence of their poetic landscape backgrounds reveal the artist's individuality. As Annibale's favorite assistant, Domenichino was entrusted with some of the frescoes on the walls beneath Annibale's masterpiece, the ceiling of the Farnese Gallery.*

In about 1608 Domenichino began the decoration of the abbey church of Grottaferrata for Cardinal Odoardo Farnese. The work was interrupted, however, by a project in association with Guido Reni to fresco the oratory of Sant'Andrea attached to the church of San Gregorio Magno, Rome. Reni's influence on Domenichino can be felt in the more graceful and fluid compositions with which he eventually completed the Grottaferrata frescoes in 1610.

After Annibale's death and Reni's return to Bologna, Domenichino became the leading exponent of the classical style in Roman painting. His position was championed by Giovanni Battista Agucchi (1570–1632), a Bolognese art theorist who upheld the principles of classicism as opposed to the naturalism of Caravaggio (1571/72–1610) and his followers. Domenichino's major works of this period were the Last Communion of Saint Jerome, *a justly famous altarpiece completed in 1614 and now in the Pinacoteca Vaticana, and the frescoes of the life of Saint Cecilia in San Luigi dei Francesi, Rome. Drawing upon Raphael's great narrative cycles and the antique, they had a lasting influence on painters in the classical tradition, particularly Poussin (see p. 136).*

In 1616 Domenichino designed the decoration of a garden pavilion of the Villa Aldobrandini at Frascati. This cycle of frescoes, most of which is now detached and in the National Gallery, London, was once regarded as the artist's early work; now, in light of its actual date of 1616–18, its uneven quality is attributed to workshop assistants. Domenichino's most influential oil, Diana with Nymphs at Play, *in the Borghese Gallery, Rome, was executed in about 1617.*

Returning in mid-1617 to his native city, then dominated by Reni, Domenichino executed two large altarpieces. In 1621 he went back to Rome as the architect to the new pope, the Bolognese Gregory XV (r. 1621–23). The following years were occupied by the important frescoes in the choir and on the pendentives of the dome of Sant'Andrea della Valle, completed in 1628. Challenged by the rivalry of Giovanni Lanfranco (1582–1647), who filled the dome of this church with a daringly illusionistic fresco of the Assumption of the Virgin, Domenichino divided the apse into irregularly shaped compartments, which he treated as separate pictures, avoiding an overall Baroque effect.

In 1628 the Accademia di San Luca, the artists' professional association, elected Domenichino its president, and in 1631 he accepted a commission to decorate the chapel of San Gennaro in Naples Cathedral. The jealousy of local painters caused him to flee to Rome in 1634, but he returned the following year and worked on the chapel until his death five years later. EF

ABBREVIATIONS

Fahy 1973. Everett Fahy, in *The Wrightsman Collection*, vol. 5, Everett Fahy and Francis Watson, *Paintings, Drawings, Sculpture*. New York, 1973.

Levey 1971. Michael Levey. *The Seventeenth and Eighteenth Century Italian Schools*. National Gallery Catalogues. London, 1971.

Spear 1982. Richard E. Spear. *Domenichino*. New Haven and London, 1982.

10. *Landscape with Moses and the Burning Bush*

Oil on copper, 17¾ × 13⅜ in. (45.1 × 34 cm)
Cleaned in 1970 by Hubert von Sonnenburg.
The Metropolitan Museum of Art, New York, Gift of Mr. and Mrs. Charles Wrightsman, 1976 (1976.155.2)

PROVENANCE

?Lorenzo Onofrio Colonna, Palazzo Colonna, Rome (d. 1689); Colonna family, Palazzo Colonna, Rome (by 1693–at least 1787; inv., 1714, no. 462; cat., 1783, no. 558); Arthur Harrington Champernowne (until d. 1819; his estate sale, Christie's, London, June 30, 1820, lot 84, to Emerson); Hon. Sir William Waldegrave, first Baron Radstock, London (until d. 1825; his estate sale, Christie's, London, May 12–13, 1826, lot 59, for £270, to Baring); Alexander Baring, first Baron Ashburton, London (1826–d. 1848); the Barons Ashburton (1848–1938); Alexander Francis St. Vincent Baring, sixth Baron Ashburton,

Itchen Stoke House, Alresford, Hampshire (1938–70; sale, Christie's, London, June 26, 1970, lot 73, for £35,700, to Agnew for Wrightsman); Mr. and Mrs. Charles Wrightsman, New York (1970–76; cat., 1973, no. 9); their gift in 1976 to the Metropolitan Museum.

EXHIBITED
British Institution, London, 1828, "Italian, Spanish, Flemish and Dutch Masters," no. 23; Pinacoteca Nazionale, Bologna, September 10–November 10, 1986, National Gallery of Art, Washington, D.C., December 19–February 16, 1987, Metropolitan Museum, New York, March 26–May 24, 1987, "The Age of Correggio and the Carracci" (shown in New York only; not in catalogue).

LITERATURE
Pietro Rossini, *Il mercurio errante delle grandezze di Roma, tanto antiche, che moderne* (Rome, 1693), book I, p. 48; Friedrich Wilhelm Basilius von Ramdohr, *Ueber Mahlerei und Bildhauerarbeit in Rom für Liebhaber des Schönen in der Kunst* (Leipzig, 1787), vol. 2, p. 109; Gustave Friedrich Waagen, *Treasures of Art in Great Britain* (London, 1854), vol. 2, pp. 98, 101; Evelina Borea, *Domenichino* (Milan, 1965), p. 173 under nos. 54a, 54b; Levey 1971, p. 92; Fahy 1973, pp. 73–81 no. 9; Spear 1982, p. 174 no. 39, and pp. 172–74 under nos. 37–38, 186 under no. 44, 189 under no. 49, 319; Clovis Whitfield, "Les paysages du Dominiquin et de Viola," *Monuments et mémoires* (Fondation Eugène Piot) 69 (1988), p. 98; *Domenichino, 1581–1641*, ed. Richard E. Spear, exh. cat., Palazzo Venezia, Rome (Milan, 1996), p. 408 under no. 19.

RELATED WORK
LONDON, National Gallery (48). Domenichino, *Landscape with Tobias Laying Hold of the Fish* (fig. 1). Oil on copper, 17 3/4 × 13 3/8 in. (45.1 × 33.9 cm).

COPIES/VERSIONS
LONDON, Earl of Waldegrave (sale, Prestage's, London, November 16–19, 1763, lot 21). Oil on canvas, 19 × 15 in. (48.3 × 38.1 cm).
LONDON, Christie's, April 16, 1970, lot 60.
MUNICH, Prince of Leuchtenberg (in 1845); Felix Ziethen (sale, Hugo Helbing, Munich, September 22, 1934, lot 98). Oil on canvas, 25 5/8 × 31 1/8 in. (65 × 79 cm).
PARIS, Cardinal Jules Mazarin (d. 1661).[1] Oil on canvas.
ROTTERDAM, Museum Boijmans Van Beuningen (1189). Oil on canvas, 17 1/8 × 13 1/8 in. (43.5 × 34.5 cm). A later copy.[2]
SHUGBOROUGH HALL, Staffordshire, Earl of Lichfield. Oil on canvas, 18 3/8 × 14 in. (47.6 × 35.5 cm).

The subject of this picture is one of three miracles—the burning bush, the serpent rod, and the leprous hand—that God showed Moses to confirm his divine mission to lead the people of Israel out of Egypt. As Moses was tending the sheep of his father-in-law, Jethro, "the angel of the Lord appeared unto him in a flame of fire out of the midst of a bush: and he looked, and, behold, the bush burned with fire, and the bush was not consumed." Moses stared at the bush, and God called out to him, "Draw not nigh hither: put off thy shoes from thy feet, for the place whereon thou standest is holy ground." Then, "Moses hid his face; for he was afraid to look upon God" (Exodus 3:2–6).

Domenichino has depicted the first part of this story, the instant Moses sees the bush and falls on one knee in a dramatic attitude of surprise and reverence. The Old Testament hero is portrayed as a robust shepherd, his face filled with awe. Behind Moses the flock grazes unperturbed, and the idyllic landscape contains no suggestion of the extraordinary event taking place in the foreground. If anything, the serenity of the setting makes the miracle seem all the more supernatural.

When the picture was first recorded, it was the pendant to another landscape by Domenichino, *Tobias Laying Hold of the Fish* (fig. 1), now in the National Gallery, London.[3] They are related to each other in having been painted on sheets of copper of the same size, in the uniform scale of the figures in relation to the backgrounds, and in the almost identical handling of paint. Furthermore, Tobias's red tunic is the very shade as Moses' cape. There does not, however, appear to be an obvious iconographic link between the two pictures, aside from the general one of miraculous themes.

Fig. 1. Domenichino, *Landscape with Tobias Laying Hold of the Fish*. Oil on copper, 17 3/4 × 13 3/8 in. (45.1 × 33.9 cm). National Gallery, London

Fig. 2. Domenichino, *Landscape with Apollo and Daphne*. Pen and brown ink on paper, 10⅛ × 7⅝ in. (25.6 × 19.4 cm). Royal Library, Windsor

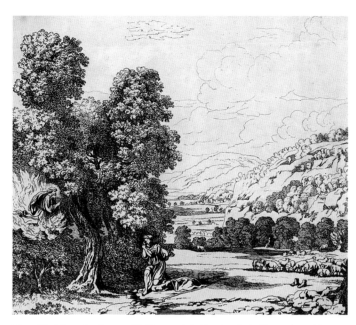

Fig. 3. H. Adam, *Landscape with Moses and the Burning Bush*. Engraving, 5¾ × 6½ in. (14.5 × 16.5 cm). From J. N. Muxel, *Gemälde Sammlung in München seiner Königl. Hoheit des Dom Augusto Herzogs von Leuchtenberg und Santa Cruz Fürsten von Eichstädt* (Munich [ca. 1835])

Nevertheless, they seem to have been conceived as a pair. Perhaps their subjects appealed to the artist because they afforded the opportunity to paint sweeping landscapes.

In two other paintings Domenichino illustrated different events from Moses' life, but neither of them is directly related to the Wrightsman picture. Both are landscapes: one is *Moses Delivering the Daughters of Raguel at the Well*, the other is the *Finding of Moses*—a picture that may be by a follower rather than by the artist himself.[4]

None of Domenichino's small landscapes can be dated with certainty, though comparisons can be made with the backgrounds of his documented works. His earliest landscapes appear to be pictures—such as the *Rest on the Flight into Egypt* in the Musée Mandet, Riom, and *Peasants Crossing a Ford* in the Galleria Doria Pamphilj, Rome—that are densely constructed in the manner of Annibale Carracci and filled with glimpses of genre scenes taken from everyday life. Domenichino's later landscapes are the grand pastoral canvases of the *Labors of Hercules* and *Erminia Appearing*

to the Shepherds, now in the Louvre. The latter, incidentally, has a fold of sheep not unlike the one in the Wrightsman picture.

The landscapes *Moses and the Burning Bush* and *Tobias Laying Hold of the Fish* would appear to be paintings of the artist's early maturity. The closest analogy in his documented work to the compositions of the Wrightsman painting can be seen in the artist's drawing for one of the frescoes at the Villa Aldobrandini, Frascati, showing Apollo pursuing Daphne (fig. 2). The figures occupy the foreground, and a pair of tall trees tower over the vista of the valley in the background with a lofty hill on the right. Since the Frascati frescoes were designed in 1616,[5] the Wrightsman and London landscapes probably date from about the same time.[6]

Both pictures are prime examples of Domenichino's contribution to the development of landscape painting. Although relatively small, they convey a sense of vast spaciousness. At the beginning of the seventeenth century, Domenichino's master Annibale Carracci had invented a new type of painting, the so-called heroic landscape, which consisted of carefully constructed

41

panoramas dominated by relatively large figures. In Domenichino's work, the figures are smaller in scale, and nature becomes the dominant subject of the picture: they are the direct antecedents of the celebrated landscapes of Claude Lorrain (1600–1682).

EF

NOTES

1. Gabriel-Jules Cosnac, *Les richesses du Palais Mazarin,* 2nd ed. (Paris, 1885), p. 295 no. 946. Number 947 was a copy of the London *Tobias Laying Hold of the Fish* (fig. 1).
2. See Willemien de Bruin, in *Italian Paintings from the Seventeenth and Eighteenth Centuries in Dutch Public Collections,* ed. Bernard Aikema et al. (Florence, 1997), p. 64 no. 58.
3. Luigi Salerno, *Pittori di paesaggio del Seicento a Roma* (Rome, 1980), vol. 3, p. 1127 no. 462.
4. For the first, see J. Byam Shaw, *Paintings by Old Masters at Christ Church, Oxford* (London, 1967), p. 106–7; for the second, see Evelina Borea, *Domenichino* (Milan, 1965), p. 179 no. 72.
5. Levey 1971, p. 101.
6. Spear 1982, pp. 173–74, places them about 1610–12 and summarizes the opinions of earlier writers.

11. *The Martyrdom of Saint Cecilia*

Charcoal with white chalk heightening on fourteen sheets of blue laid paper, two of the sheets cut from elsewhere on the original cartoon and reset at the left and right margins to make up the oval; irregular oval, 67¾ × 59½ in. (172.2 × 151 cm)
Annotated with the letter *F* at the upper left on the verso and bearing a fragmentary seal (Albani?) near the lower-left margin on the verso.[1] The second strainer has an inscription in pen and ink: Mano del . . . Signore Francesco 31 Ottobre 1766.
The Metropolitan Museum of Art, New York, Wrightsman Fund, 1998 (1998.211)

PROVENANCE
Albani Collection, Rome(?); Chigi Collection, Arricia (as of 1705–6);[2] private collection, Europe; purchased by the Metropolitan Museum in 1998 through the Wrightsman fund.

DRAWINGS/RELATED WORKS
There are a number of preparatory drawings for this scene, all listed in Spear 1982, p. 182. The two cartoon fragments of the lateral parts of the scene are in the Louvre (figs. 1, 2). A large copy of the saint and the maidservant holding her from behind is also in the Louvre (9113), attributed to Michel Corneille. This was probably made for LeBrun in place of the central cartoon, which was disposed of before he had a chance to acquire it, and may well copy the fresco itself rather than the cartoon.

The fresco cycle painted by Domenichino in the Polet Chapel of San Luigi dei Francesi in Rome is among the principal monuments of Baroque classicism and had a lasting impact on younger artists, notably Poussin (see p. 136). Commissioned by Pierre Polet of Noyon in a contract dated February 16, 1612, the frescoes were completed by September 11, 1615, when the artist received the final payment for his work.[3]

The two main scenes in the chapel are *Saint Cecilia Distributing Alms to the Poor* and *The Martyrdom of Saint Cecilia* (fig. 3) on the north wall opposite. Saint Cecilia is shown in the caldarium of her house. The Roman prefect Almachius ordered her execution, but she miraculously survived being boiled in water and three efforts at decapitation. She lingered for three days, during which her followers collected her blood and she gave her possessions to the poor. In addition, she offered to Pope Urban the Christians she had converted and asked him to consecrate her house as a Christian church. The scene depicted by Domenichino contains several of these events as if they occurred simultaneously. The Wrightsman cartoon was made in preparation for the lower central section of the scene of the saint's martyrdom, the critical moment in the narrative.

The composition represents one of the most Raphaelesque moments of Domenichino's career, clearly reflecting a profound comprehension of the classicism of Raphael's frescoes in the Vatican Stanze. The architectural balance of the composition and the precision with which each form and gesture is articulated make this work among the high points of Baroque classicism. Equally, the broad and economical draftsmanship, with firm outlines and broad shading, owe much to Raphael's own manner of drawing cartoons.

What is perhaps most unexpected is the large number of pentimenti in the cartoon, including changes in important details such as the position of the saint's head and right arm.[4] The cartoon was pricked but not pounced, as there is no trace of charcoal dust on its verso, indicating that it was probably transferred onto a further, final substitute cartoon that was used in preparing the fresco. It is noteworthy in this respect that special attention was given to the preparatory drawings and cartoons for this project in the original contract, which stipulated that these were to be retained by the priest Don Mass. Bruni.

The Wrightsman cartoon was cut with care and intelligence so as to retain all of the figures and gestures that are vital to the narrative of the scene. At the left and right pieces were added to make up an oval shape. These were taken from other parts of this or

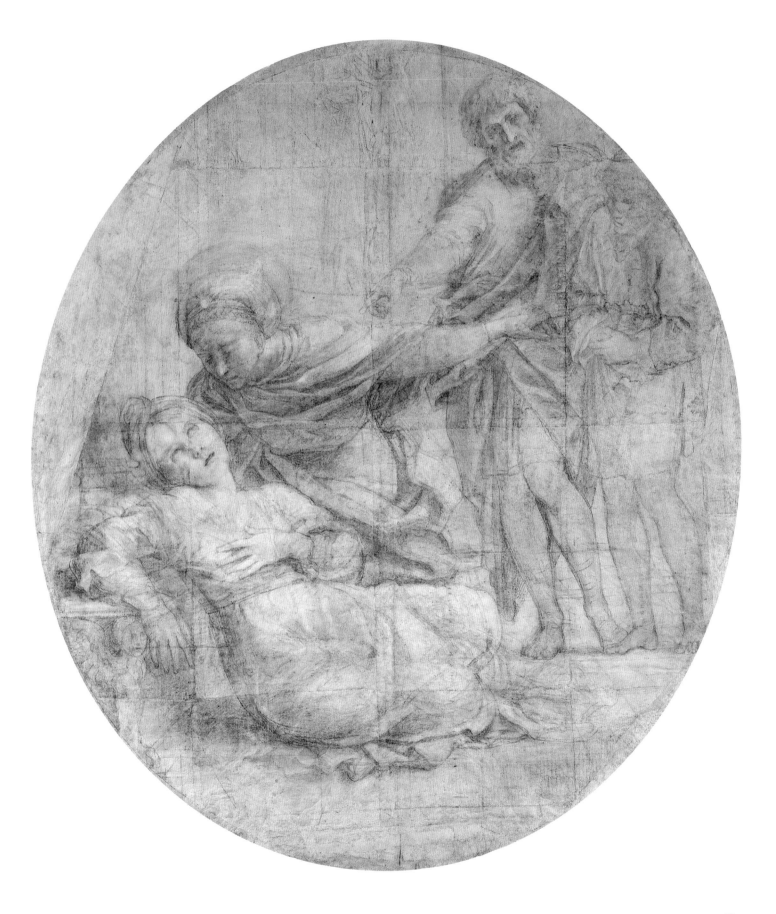

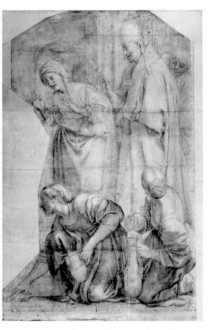

Fig. 1. Domenichino, *The Martyrdom of Saint Cecilia*. Cartoon fragment. Musée du Louvre, Paris (9081)

Wrightsman cartoon (cat. 11)

Fig. 2. Domenichino, *The Martyrdom of Saint Cecilia*. Cartoon fragment. Musée du Louvre, Paris (9080)

Fig. 3. Domenichino, *The Martyrdom of Saint Cecilia*, 1612–15. Fresco, San Luigi dei Francesi, Rome

another cartoon, very possibly from the section above the Museum's portion, which mainly consists of architecture. By 1705–6, at the latest, the cartoon was framed.[5] All of this indicates strongly that whoever acquired it was fully cognizant of its importance. It is interesting to note that by the time Charles LeBrun acquired the lateral pieces of the cartoon—presumably during his stay in Rome from 1642 to 1646—the central section was already unavailable, and he had to be satisfied by a partial copy.

GRG

NOTES

1. The seal was identified by S. Prosperi Valenti Rodinò during a visit to the Metropolitan Museum in 2004.
2. According to Spear 1982, p. 184 n. 61, the cartoon was not at Ariccia in 1977, and the marchese Chigi did not know when it had left the collection. It is often wrongly asserted that this cartoon was in the collection of Domenichino's heir Raspantino, an error that was corrected in Spear 1982, p. 183 n. 35.
3. See ibid., pp. 58–60, 178–84, for the best review and analysis of the frescoes and related drawings.
4. I am grateful to my colleague Marjorie Shelley, Head of Paper Conservation at the Metropolitan Museum, for her invaluable observations about the cartoon. She and her staff were responsible for its masterful restoration.
5. It is mentioned as framed in the Chigi inventory, as transcribed by Spear 1982, p. 184 n. 61.

GUIDO RENI

(1575–1642)

The most successful Italian painter of the seventeenth century, Guido Reni was born at Bologna, where he spent most of his life. At the age of nine he was apprenticed for ten years to Denis Calvaert (1540–1619), a painter from Antwerp who operated an influential workshop in which Domenichino (see p. 38) and Francesco Albani (1578–1660) were also trained. In about 1594 Reni joined the Accademia degli Incamminati, a school of painting run by Annibale Carracci (1560–1609) and his brothers. Reni's first public work, the Coronation of the Virgin with Four Saints, *a large altarpiece now in the Pinacoteca Nazionale, Bologna, seems to have been painted about this time. While it reflects his training, combining the ethereal linear grace of Calvaert's Mannerism with the bold naturalism of Annibale's style, it also testifies to Reni's interest in Raphael's Saint Cecilia altarpiece at Bologna, which made a lasting impression on him.*

Though never happy far from Bologna, Reni made several trips to Rome. During the first, about 1600, he studied classical antiquity and the works of the High Renaissance masters and came under the influence of Caravaggio (1571–1610). The latter's tenebrism left its mark on such masterpieces as Reni's Crucifixion of Saint Peter, *in the Pinacoteca Vaticana, Rome, painted in about 1603–4. Reni was in Rome again between 1609 and 1612. It was during this period that he painted the fresco* Saint Andrew Led to His Martyrdom, *which Cardinal Scipione Borghese commissioned for the oratory of Saint Andrew attached to the church of San Gregorio Magno in Rome. Another trip brought him back during the years 1613–14, when he completed the fresco of* Aurora *in the casino of the Palazzo Rospigliosi Pallavicini. An incontestable masterpiece of Reni's personal blend of refined coloring and linear elegance, this work set the seal on Reni's fame.*

Despite his success in Rome, Reni returned to Bologna and remained there for the rest of his life. Isolated from the high Baroque paintings of younger artists in Rome, such as Pietro da Cortona (1596–1669), Andrea Sacchi (1599–1661), and Poussin (see p. 136), his style became more refined and individual. This can be seen in the delicate colors, soft modeling, and gentle emotional character of the Assumption of the Virgin, *painted at Bologna in 1617 for the church of Sant'Ambrogio at Genoa. An even clearer example is the distinctive palette of pale silvery hues Reni used for the* Palione della Peste *(1631) (Pinacoteca Nazionale, Bologna). His mature compositions took on an almost iconic quality, and his brushwork became more and more spontaneous. In his final works the handling is so delicate, so light and free, that the paint resembles diaphanous veils of muted color. It is largely on the basis of these late works that Reni is acclaimed today as one of the great seventeenth-century painters.*

EF

ABBREVIATION

Fahy 1973. Everett Fahy, in *The Wrightsman Collection*, vol. 5, Everett Fahy and Francis Watson, *Paintings, Drawings, Sculpture*. New York, 1973.

12. *Charity*

Oil on canvas, 54 × 41 ¾ in. (137.2 × 106 cm)

The painting was cleaned and the canvas relined sometime between 1964 and 1967. There are numerous, but not major, pentimenti throughout the composition, the most conspicuous one appearing in the veil above Charity's forehead. The picture has a rather pronounced pattern of craquelure, which was already clearly visible before 1880, when the earliest known photograph of the painting was made (the negative is in the possession of the Sammlung Fürst von Liechtenstein, Vaduz).

The Metropolitan Museum of Art, New York, Gift of Mr. and Mrs. Charles Wrightsman, 1974 (1974.348).

PROVENANCE
Joseph Wenzel, prince of Liechtenstein (by 1767–d. 1772; cat., 1767, no. 498, as Guido Reni); princes of Liechtenstein, Vienna (1772–1858; cat., 1780, no. 581, as Guido Reni); Johann II, prince of Liechtenstein, Vienna (1858–82; cat., 1873, no. 62; sale, Hôtel Drouot, Paris, May 16, 1882, lot 21, as Guido Reni, for Fr 820); private collection, Paris (until about 1933; as by or attributed to Simon Vouet; sold to Reder); Mr. and Mrs. Jacob Reder, Brussels, later New York (about 1933–64; as attributed to Simon Vouet; sold to French & Co.); [French & Co., New York, 1964; as attributed to Simon Vouet; sold to Wildenstein]; [Wildenstein, New York, 1964–68; as Guido Reni; sold to Wrightsman]; Mr. and Mrs. Charles Wrightsman, New York (1968–74; cat., 1973, no. 19); their gift in 1974 to the Metropolitan Museum.

EXHIBITED
Metropolitan Museum, New York, December 1968–May 1970.

LITERATURE
Vincenzio Fanti, *Descrizzione completa di tutto ciò che ritrovasi nella galleria di pittura e scultura di Sua Altezza Giuseppe Wenceslao del S.R.I. principe regnante della casa di Lichteinstein [sic]* (Vienna, 1767), p. 98 no. 498; Gustav Parthey,

Deutscher Bildersaal: Verzeichniss der in Deutschland vorhandenen Oelbilder verstorbener Maler aller Schulen, vol. 2 (Berlin, 1864), p. 350; D. Stephen Pepper, "A Rediscovered Painting by Guido Reni," *Apollo* 90 (September 1969), pp. 208–13; Fahy 1973, pp. 170–80 no. 19.

RELATED WORK
An engraving of *Charity* (fig. 5) by Benoit Farjat (1646–1720) is inscribed "Guido Reni dip . . . Gio. Bat. Calandrucci dis.," but no other record of this composition survives.

COPIES
DUNCOMBE PARK (Yorkshire), Feversham collection (sale, Henry Spencer & Sons, Nottingham, April 7, 1959, lot 95).
MILAN, private collection (in 1961). Oil on canvas, 50⅜ × 41⅜ in. (128 × 105 cm).
POTSDAM, Bildergalerie, 1971 catalogue, no. 10. Oil on canvas, 55½ × 42⅞ in. (141 × 109 cm).
ROME, F. Echave (in 1972).
ROME, Palazzo Barberini (from the Bolognetti collection, Bologna). Mentioned by Carlo Cesare Malvasia, *Felsina pittrice. Vite de' pittori bolognesi, alla maesta christianissima di Luigi XIII* (Bologna, 1678), vol. 2, p. 90. Its composition, however, is unknown.
TOURS, Musée des Beaux-Arts (794-1-31). From the Château de Chanteloup.

Charity, represented by a young woman with three children, is shown as a three-quarter-length lifesize figure sitting on two rough-hewn blocks of gray masonry. To early Christian theologians, Charity denoted two forms of love—*amor dei,* the love of God, and *amor proximi,* the love of one's neighbors. In the art of the Middle Ages, these two meanings were exemplified by a female figure carrying two attributes symbolizing heavenly and earthly charity: respectively, a flame or flaming heart, and a basket or cornucopia filled with fruit. Artists gradually dispensed with the traditional flames and cornucopias and replaced them with a young woman suckling several infants. An example of this new iconography for Charity appears in the predella in the Vatican (fig. 1) that Raphael painted in about 1506–7 for the Baglioni *Deposition.* While it still shows the traditional attributes, they are held by two flanking putti; the Virtue herself is personified by a young woman with five children in her arms. Reni's *Charity,* represented with three nude children and no identifying attributes, belongs to this tradition.

In Bologna, Reni's compatriots tended to present Charity as a half- or three-quarter-length figure looking either to the right or to the left (as she does in the present painting). This Bolognese format can be seen in a fresco by Ludovico Carracci (1555–1619) in the Museo di San Domenico, Bologna, and in an engraving of 1626 by Guercino (see p. 27). It is also the format of the only other allegory of Charity by Reni, an upright oval composition in the Galleria Palatina, Florence (fig. 2).

Painted early in Reni's career, the Florence *Charity* has traditionally been connected with a document of 1607, although it may date somewhat later.[1] Like the *Crucifixion of Saint Peter,* which Reni painted in 1604, it reflects the influence of Caravaggio. The colors

Fig. 1. Raphael, *Allegory of Charity.* Oil on wood, 6¼ × 9½ in. (16 × 24 cm). Pinacoteca Vaticana, Rome

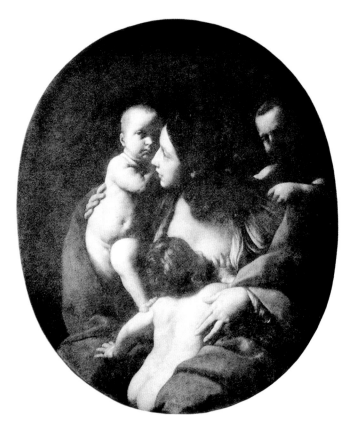

Fig. 2. Guido Reni, *Charity*. Oil on canvas, 45 1/4 × 35 3/8 in. (115 × 90 cm). Galleria Palatina, Florence

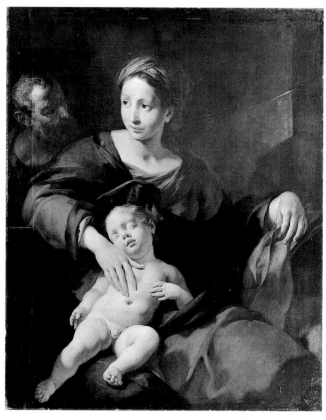

Fig. 3. Carlo Cignani, *The Holy Family*. Oil on canvas, 54 3/8 × 43 1/4 in. (138 × 110 cm). Statens Museums for Kunst, Copenhagen

are subdued, and the strong contrasts of light and shadow, so typical of Caravaggio's style, play an important part in the picture. By the time of the Wrightsman *Charity,* Reni preferred a palette of high-keyed colors with faint shadows rendered in breathtakingly light tonalities.

Despite the changes in Reni's style, the two versions have much in common: the women in both pictures are so similar as to even be taken for sisters, and the placement of the hand on the middle child in each painting is analogous. Yet fundamentally the pictures are different. Whereas the earlier painting is firmly modeled, with the figures tightly pulled together in an intricate pattern of curving shapes, the Wrightsman painting has the breadth and relaxed amplitude of Reni's mature masterpieces—the figures are more expansive and painterly, their proportions more robust, and there is a far greater sense of the interval of space between them.

In the absence of documentary evidence, the Wrightsman picture must be dated by comparing it to other works by Reni. While it is much more broadly painted than any of his securely dated

works of the 1620s, the Wrightsman *Charity* is not yet characterized by that complete freedom of handling that first appears in the *Palione della Peste*, on which Reni was working in 1631; the light tonality, delicate brushwork, and soft contours of that work herald the development of Reni's late style. In the Wrightsman painting the folds of drapery still have some sharp outlines, and most of the brightly lit forms are highly finished. The picture, consequently, should be dated to about 1630, immediately before the *Palione*.

On more than one occasion during the late 1620s, Guido Reni portrayed sleeping children similar to the one in the foreground of this work. Among them are his lost painting of the Madonna adoring the sleeping Christ Child, known in over a dozen replicas,[2] and the fresco of a sleeping putto, which Reni made for Cardinal Francesco Barberini in January 1629. The occurrence of these motifs in Reni's paintings of the late 1620s tends to corroborate the dating suggested by the style of the painting.

The picture also recalls—in its liberal display of smoky rose hues, masterly brushwork, and deft handling of paint—Reni's

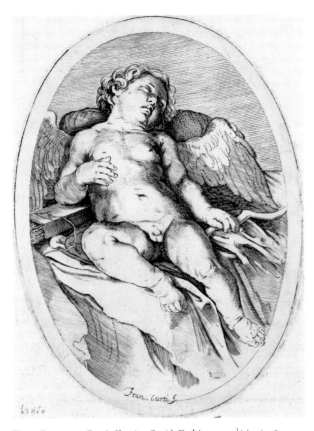

Fig. 4. Francesco Curti, *Sleeping Cupid*. Etching, 7 × 5⅛ in. (17.8 × 13 cm). The Metropolitan Museum of Art, New York, Harris Brisbane Dick Fund, 1917 (17.3.1862)

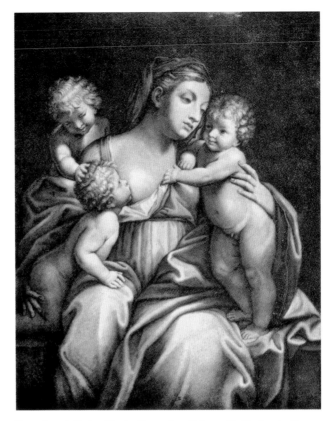

Fig. 5. Benoit Farjat, *Charity*. Engraving. Calcografia Nazionale, Rome

portrait of Cardinal Bernardino Spada (Galleria Spada, Rome), painted during the period Spada spent at Bologna as papal legate between 1629 and 1632. Spada took a keen interest in Reni's work and no doubt was an admirer of the *Charity* when it was first unveiled. In 1629, when Marie de' Medici invited Reni to paint a continuation of Rubens's cycle in the Luxembourg Palace, Paris, it was Cardinal Spada who declined the invitation on Reni's behalf. He wrote the queen that Reni was unable to leave his native city because of "the obligation to fulfill many commissions and entreaties from princes and other important people."[3] The queen's request gives some indication of the esteem in which Reni was held. One of the princes alluded to in the letter may have been Karl Eusebius von Liechtenstein, who traveled in Italy in about 1630.[4] His trip coincides not only with Spada's letter but also with the probable date of the Wrightsman painting.

Charity, in particular, seems to have been much admired by Reni's contemporaries. Other artists, who thought nothing of plagiarizing his work, lifted the motif of the sleeping child and incor-

porated it in their own compositions. The dozing Christ Child, for example, in a *Holy Family* (fig. 3) attributed to Carlo Cignani (1628–1719), is clearly a copy of Reni's figure. Similarly, the *Sleeping Cupid* (fig. 4), by the Bolognese engraver Francesco Curti (1603–1670), is no more than a reverse image of Reni's figure, embellished with wings, a bow, and a quiver of arrows.

EF

NOTES

1. D. Stephen Pepper, "Caravaggio and Guido Reni: Contrasts in Attitudes," *Art Quarterly* 34 (autumn 1971), p. 342 n. 34.
2. Robert Enggass, "Variations on a Theme by Guido Reni," *Art Quarterly* 25 (summer 1962), pp. 113–21.
3. Quoted in Jules Guiffrey, "Lettre du cardinal Spada à Marie de Médicis au sujet de la galerie du Luxembourg (1629)," *Nouvelles archives de l'art français,* 1876, pp. 252–54: "l'impegno di molti quadri, de quali hà ricevuto commissioni et gaggi da diversi Principi e personaggi."
4. Victor Fleischer, *Fürst Karl Eusebius von Liechtenstein als Bauherr und Kunstsammler (1611–1684)* (Vienna, 1910), p. 14.

PIER FRANCESCO MOLA

(1612–1666)

The son of an architect, Pier Francesco Mola was born at Coldrerio, near Como in the Swiss canton of Ticino, and moved to Rome by the age of four. His earliest known works are several sketches, dated 1631, in an album of his father's architectural drawings, now in the Metropolitan Museum. Initially trained in Rome by Cavaliere d'Arpino (1568–1640), he appears to have spent much time between 1634 and 1647 in northern Italy, which had a lasting influence on his style: he is documented in Lucca in 1637, in Venice in 1644, and he worked in Bologna for two years as a salaried assistant in the studio of Francesco Albani (1578–1660), probably in 1635–37. By early 1647 Mola had returned to Rome, where he remained for the rest of his life, enjoying considerable success with the splendid Oriental Warrior of 1650 (Musée du Louvre), his only signed and dated work, and the fresco Joseph and His Brethren for the gallery of Pope Alexander VII in the Quirinale, executed in 1656/57. From 1658 he was the official painter for Prince Camillo Pamphilj's household, and in 1662 he was elected president of the Accademia di San Luca, where he was succeeded two years later by Carlo Maratta (1625–1713). His work was admired by Queen Christina of Sweden, who paid him a generous salary, and in his last years Louis XIV invited him to France, but illness prevented him from going. Mola possessed genuine poetic talent that pursued a consistent course from early pastoral compositions, among them Mercury and Argus (Allen Memorial Art Museum, Oberlin, Ohio), to his late painting of the blind Homer (Galleria Corsini, Rome). His oeuvre falls within the neo-Venetian trend of artists such as Poussin (see p. 136), Pietro da Cortona (1596–1669), and Andrea Sacchi (1599–1661), who rejected Caravaggio's stark realism in favor of a more painterly, Arcadian style. EF

ABBREVIATIONS

Cocke 1972. Richard Cocke. Pier Francesco Mola. Oxford, 1972.

Genty 1979. Jean Genty. Pier Francesco Mola. Pittore. Lugano, 1979.

Lugano, Rome 1989–90. Pier Francesco Mola, 1612–1666. Exh. cat., Museo Cantonale d'Arte, Lugano, and Musei Capitolini; Rome, 1989–90. Milan, 1989.

13. *The Rest on the Flight into Egypt*

Oil on copper, 9 × 11 in. (22.9 × 27.9 cm)
The Metropolitan Museum of Art, New York, Wrightsman Fund, 1993 (1993.20)

PROVENANCE
Monsieur Duval, Geneva (his sale, Phillips, London, May 12–13, 1846, lot 69, for £350); Henry Petty-FitzMaurice, third Marquess of Lansdowne, Bowood, Calne, Wiltshire (by 1854–d. 1863); Marquesses of Lansdowne, Bowood (from 1863; cat., 1897, no. 141); Charles Maurice Petty-FitzMaurice, Earl of Shelbourne, Bowood (until 1992; sold to Agnew); [Agnew, London, 1992–93; sold to the Metropolitan Museum]; purchased in 1993 by the Metropolitan Museum through the Wrightsman Fund.

EXHIBITED
Royal Academy of Arts, London, 1884, "Works by the Old Masters . . . Winter Exhibition," no. 259; Burlington Fine Arts Club, London, 1925, "Italian Art of the Seventeenth Century," no. 3; Thos. Agnew and Sons, Ltd., London, December 8, 1954–January 29, 1955, "Loan Exhibition of the Lansdowne Collection," no. 49; Thos. Agnew and Sons, Ltd., London, November 6–December 7, 1973, "England and the Seicento," no. 39; Thos. Agnew and Sons, Ltd., London, June 9–July 24, 1992, "Agnew's 175th Anniversary," no. 7.

LITERATURE
Gustav Friedrich Waagen, *Treasures of Art in Great Britain* (London, 1854), vol. 3, p. 158; Stella Rudolph, "Contributo per Pier Francesco Mola," *Arte illustrata*, nos. 15–16 (March–April 1969), p. 17; Cocke 1972, pp. 17, 44 no. 3, 67 under no. R.27, 71 under no. R.49.

RELATED WORKS
BERLIN, ex-collection Hauffmann.
DUSSELDORF, Kunstmuseum.
LONDON, National Gallery (160). Oil on canvas, 12 × 18 in. (30.5 × 46 cm).
MILAN, private collection. Oil on canvas, 14 1/2 × 19 in. (36.8 × 48.3 cm).
ROME, Andrea Busiri Vici.
ROME, Palazzo Doria Pamphilj. Oil on canvas, 113 3/4 × 78 3/8 in. (289 × 199 cm).
SAINT PETERSBURG, State Hermitage Museum (1530). Oil on canvas, 28 7/8 × 38 3/4 in. (73.5 × 98.5 cm).

The story of the Rest on the Flight into Egypt first appeared in art during the late fourteenth century and became one of the most popular themes in the post-medieval period as an elaboration of the biblical account of how Joseph saved the infant Jesus from Herod's massacre of the innocents at Bethlehem (Matthew 2:13–15). Following the apocryphal gospel of the Pseudo Matthew,

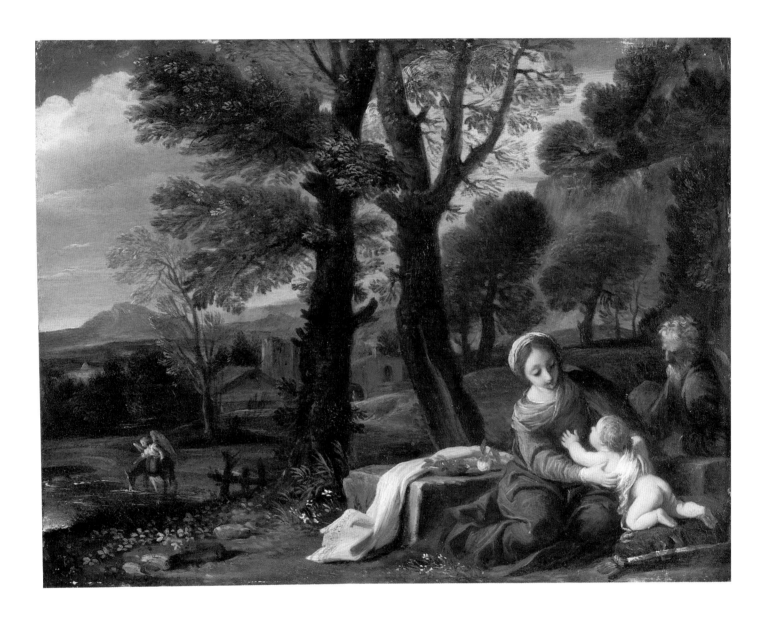

artists depicted the Holy Family stopping for a meal after they had reached safety in Egypt, often sitting under a palm tree, with angels offering them fruit. Mola imbues the subject with a charming informality—the Christ Child, nearly nude, climbs into Mary's lap, and an angel waters the donkey at a pool on the left (the pose of the Christ Child reappears in reverse in Mola's early painting the *Assumption of the Magdalen* in the Galleria Pallavicini, Rome).[1]

Mola also emphasizes the open landscape; in fact, he was one of the principal Italian artists to establish landscape as a separate genre.

Reflecting Mola's training with Albani, who reinterpreted the Rest on the Flight into Egypt many times throughout his long career, the composition of the Wrightsman painting owes most to the versions Albani executed in the mid- to late 1630s, notably one

Fig. 1 (at left). Pier Francesco Mola, etching of Francesco Albani's painting of the *Rest on the Flight into Egypt*. Plate, 18 ¼ × 12 ⅜ in. (46.5 × 31.3 cm). The Metropolitan Museum of Art, New York, Harris Brisbane Fund, 1947 (47.100.887)

Fig. 2 (at right). Pier Francesco Mola, *View of Brusata*. Pen and brown ink and brown wash on paper, 11 ⅛ × 8 ¼ in. (28.4 × 21.1 cm). British Museum, London (1898.1216.1)

in the Musée National du Château, Fontainebleau, which he sold in May 1637,[2] and a small variant of it in the collection of the Earl of Yarborough at Brocklesby Park, Lincolnshire, of which Mola made an etching (fig. 1) of exactly the same size and dedicated to a Bolognese patron, thus dating it from about 1635 to 1637. Albani's compositions particularly inspired the pose of Joseph, the motif of the angel watering the donkey, and even to a certain extent the posture of the Christ Child in the Wrightsman picture, one of at least five versions of the subject that Mola painted. Among these are a depiction that includes a statue of a sphinx, acquired by Catherine the Great (State Hermitage Museum, Saint Petersburg), and a large canvas in the Galleria Doria Pamphilj, Rome, closely based on the etching Mola executed at least a decade earlier. Most of the variants show small figures set in extensive landscapes and have three cherub heads hovering above the Madonna.

The painting is generally regarded as a work Mola executed before establishing himself in Rome in 1647. A more precise dating is suggested by Mola's sketch in the British Museum for a fresco of 1641/42 in the church of the Madonna del Carmelo in the artist's native town of Coldrerio, his first documented public commission. On the verso of the sketch is a freely executed wash drawing of the landscape seen from Mola's family's house (fig. 2).

As Mola has indicated in inscriptions on the drawing, it shows an old apple tree silhouetted before the valley of Brusata.[3] Either this drawing or a memory of the scene inspired the chain of mountains on the horizon seen across an extensive valley in the Wrightsman painting, as well as the trunk of an old tree slanting toward the landscape and echoing the diagonal movement of the clambering Christ Child.

A comment should be made about the size of the painting. It is a cabinet picture, a small painting intended for sophisticated clients, to be enjoyed in private. Works of this sort were collected by young Englishmen on the Grand Tour, and many of the best remain to this day in England, where they have always been prized. Thomas Gainsborough (1727–1788) famously lamented that he never could paint as well as Mola. EF

NOTES

1. Cocke 1972 (p. 44 under no. 3, and pp. 71–72 no. R.49) attributed the Pallavicini painting to G. B. Bancuore, or Bancore. See also Federico Zeri, *La Galleria Pallavicini in Roma. Catalogo dei dipinti* (Florence, 1959), p. 182, pl. 311.
2. Stéphane Loire, *L'Albane, 1578–1660*, exh. cat., Musée du Louvre, Paris (Paris, 2000), p. 80.
3. British Museum, London (1898.1216.1). See Genty 1979, pp. 25–28, and Lugano, Rome 1989–90, pp. 202–4.

LUCA GIORDANO

(1632–1705)

Nicknamed *"Luca fa presto"* (quick Luke) because of the speed with which he worked, Luca Giordano produced a prodigious number of easel paintings and frescoes in Naples, his native city, as well as in Florence and Madrid. At the beginning of his career, his style was most indebted to Jusepe de Ribera (1591–1652), the great Spanish painter who worked in Naples and who may have been his master. The year Ribera died, Giordano traveled to Rome and Venice, fell under the spell of Raphael (1483–1520) and Titian (ca. 1490–1576), and was deeply impressed by the Baroque style of Pietro da Cortona (1596–1669). The results of these influences can be seen in his altarpiece Saint Nicholas of Bari Saving the Cupbearer (signed and dated 1655; church of Santa Brigida, Naples). Although this work still reflects Ribera's influence, it shows Giordano's genius in its daring synthesis of Venetian Renaissance painting and Roman Baroque art. To the late 1670s belong the artist's great fresco cycles in the abbey of Montecassino (destroyed 1944) and in the churches of Santa Brigida and San Gregorio Armeno in Naples.

In early 1682 Giordano painted the cupola of the Corsini chapel in the church of Santa Maria del Carmine in Florence. In 1684 he painted Christ Driving the Money-Changers from the Temple, *an enormous fresco covering the entire entrance wall of the church of the Gerolamini, Naples. He returned to Florence to decorate the gallery of the Palazzo Medici-Riccardi in 1685/86.*

At the invitation of Charles II of Spain, Giordano moved to Madrid in 1692 and, as the official court painter, executed a dazzling series of frescoes in the Escorial; the monastery of San Jeronimo, Guadalupe; the Palace of the Buen Retiro, Madrid; and Toledo Cathedral. His works of this period are comparable to the late paintings of Velázquez (1599–1660) in their ability to convey a pictorial vision through loosely painted forms that appear to dissolve in light and color.

In 1702 Giordano returned to Naples and, during the three remaining years of his life, completed six magnificent altarpieces in the church of the Gerolamini in addition to the frescoes in the charterhouse of San Martino. He is remembered today as an artist of extraordinary talent and facility who profoundly changed the character of Neapolitan painting during the second half of the seventeenth century, replacing the dark tenebrism of Caravaggio and his followers with brilliantly colored, luminous compositions painted in a grandiloquent manner that paved the way for the Rococo painters of the next century.

EF

ABBREVIATIONS

Fahy 1973. Everett Fahy, in *The Wrightsman Collection*, vol. 5, Everett Fahy and Francis Watson, *Paintings, Drawings, Sculpture*. New York, 1973.

Ferrari and Scavizzi 1992. Oreste Ferrari and Giuseppe Scavizzi. *Luca Giordano. L'opera completa*. 2 vols. Rev. ed. [Naples], 1992. (1st ed., 3 vols., [Naples], 1966).

Michel 1991. Christian Michel, ed. *Le voyage d'Italie de Charles-Nicolas Cochin, 1758*. Rome, 1991.

Milkovich 1964. Michael Milkovich. *Luca Giordano in America: Paintings, Drawings, Prints*. Exh. cat., Brooks Memorial Art Gallery (Memphis Brooks Museum of Art), Memphis, Tennessee. Memphis, 1964.

14. *The Annunciation*

Oil on canvas, 93 1/8 × 66 7/8 in. (236.5 × 169.9 cm)
Signed and dated on the base of the prie-dieu: L. Jordanus F. 1672 (fig. 1).
The Metropolitan Museum of Art, New York, Gift of Mr. and Mrs. Wrightsman, 1973 (1973.311.2)

PROVENANCE
?Church of San Daniele, Venice, 1672–1804; ?parish church, Gropello, near Pavia (in 1814); [Heim, Paris, until 1958; sold to Wrightsman]; Mr. and Mrs. Charles Wrightsman, New York (1958–73; cat., 1973, no. 10); their gift in 1973 to the Metropolitan Museum.

EXHIBITED
Metropolitan Museum, New York, 1959–73; Brooks Memorial Art Gallery (Memphis Brooks Museum of Art), Memphis, Tennessee, April 1964, "Luca Giordano in America: Paintings, Drawings, Prints," no. 7; Metropolitan Museum, New York, November 1970–June 1971, "Masterpieces of Fifty Centuries" (listed in the exhibition's catalogue on p. 332).

LITERATURE
Milkovich 1964, pp. 9, 33 no. 7; Fahy 1973, pp. 83–92 no. 10; Michel 1991, p. 324 n. 4; Ferrari and Scavizzi 1992, vol. 1, pp. 56, 241 under the year 1672, 284 under no. A204, 285 no. A214, and vol. 2, p. 573.

RELATED WORKS
Giordano painted over a dozen *Annunciations*, ranging from copies after Tintoretto (1518–1594) and Titian to highly original devotional pictures and frescoes. The one closest in time of execution to the Wrightsman *Annunciation* is the altarpiece in the church of San Nicolò da Tolentino, Venice, which Giordano painted shortly after 1667, the same date as his altarpiece of the *Assumption of the Virgin* in the church of the Salute, Venice.

Ever since this altarpiece was first exhibited at the Metropolitan Museum (in 1959), seventeenth-century-painting specialists have found it difficult to place in Luca Giordano's oeuvre. That it is by him there can be no doubt: the signature and the date, 1672, are authentic. But the diaphanous handling of paint sets it apart from the artist's documented works of the period, which are still in his tight early style. It is quite unlike other works that Giordano painted in 1672—the altarpiece at Crispano, on the road between Naples and Caserta, and the altarpiece and fresco in an oratory in Naples.[1] The anomalous character of the *Annunciation,* however, may be due to its probable provenance from a church in Venice. Throughout his career, the facile Giordano painted imitations of earlier artists, such as Lucas van Leyden (ca. 1489–1533), Dürer (1471–1528), and Raphael. Perhaps knowing the present painting was destined for Venice, Giordano deliberately cast it in a style recalling Titian.

As Christian Michel first observed, the Wrightsman *Annunciation* may have been the "laudable work" by Giordano in the church of San Daniele in Venice that Marco Boschini mentioned in his guidebook, *Le ricche minere della pittura veneziana,* published in 1674, two years after the date of the Wrightsman picture.[2] Charles Nicolas Cochin the Younger (see p. 192), usually an admirer of Giordano, saw it there in the summer of 1751, on the same trip through Italy on which he admired Tiepolo's *Meeting of Antony and Cleopatra* (cat. 25); however, he complained that the altarpiece was an exaggerated imitation of the Venetian School, with the colors lacking in nuance and the brushwork slovenly.[3] Following the Napoleonic suppression of convents in Italy, the painting was moved from Venice to Milan and, in 1814, deposited in a church at Gropello, near Pavia.[4]

According to Giordano's early biographers, the artist spent six months in Venice in 1665–66, during which the work of the great

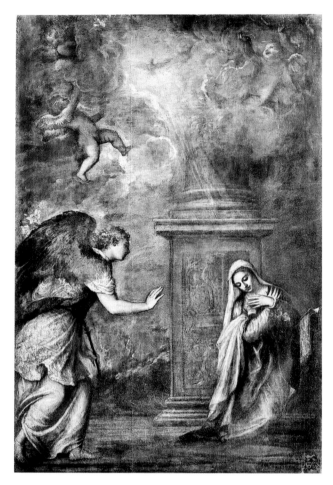

Fig. 2. Titian, *The Annunciation.* Oil on canvas, 107 7/8 × 74 5/8 in. (274 × 189.5 cm). San Domenico Maggiore, Naples

sixteenth-century Venetians made a deep impression upon him. Although Giordano had made a brief visit to Venice in the early 1650s, the later, extended visit inspired him to lighten his palette and to work in an increasingly free manner. It also led to the prestigious commission for three altarpieces in the church of the Salute in Venice, one of which is signed and dated 1667. Even before he traveled north, however, Giordano would have been familiar with a major Venetian work, Titian's *Annunciation* (fig. 2) in the church of San Domenico Maggiore, Naples (painted in about 1555–56 and installed shortly thereafter). When Giordano was about thirty years old, he paid the Venetian master the compliment of making a full-size copy of the altarpiece (church of San Ginés, Madrid) that is so accurate that some writers believed it to be by Titian and the original to be by Giordano. Another *Annunciation* by Titian, a lost painting sent to Spain in 1537, also inspired Giordano. Long before he moved to Madrid, Giordano

Fig. 1. Detail of signature and date

54

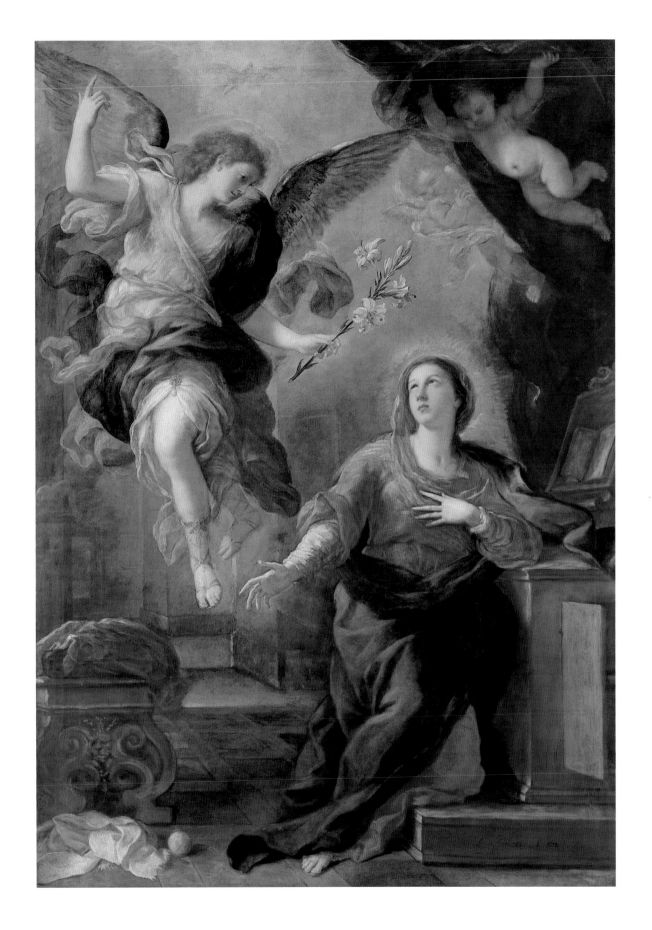

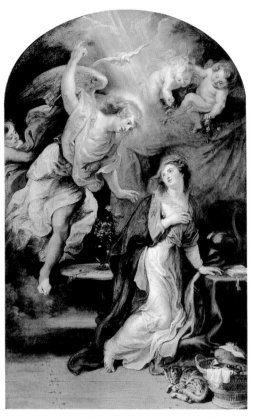

Fig. 3. Giovanni Jacopo Caraglio, engraving after a lost *Annunciation* by Titian. Plate, 17⅞ × 13½ in. (45.5 × 34.3 cm). The Metropolitan Museum of Art, New York, The Elisha Whittelsey Collection, The Elisha Whittelsey Fund, 1949 (49.97.219)

Fig. 4. Peter Paul Rubens, *The Annunciation*. Oil on canvas, 122 × 73⅞ in. (310 × 187.6 cm). Rubenshuis, Antwerp

would have known its composition from the engraving (fig. 3) by Giovanni Jacopo Caraglio (ca. 1505–1565). As in the Wrightsman altarpiece, the engraving shows the archangel raising his right hand with the index finger extended, his draperies billowing about him.

Giordano was also deeply influenced by Rubens (see p. 113). In Naples, as a young man, Giordano would have known Rubens's magnificent *Feast of Herod* (National Gallery of Scotland, Edinburgh), which then belonged to Giordano's patron Gaspar de Roomer (d. 1674). The impact of its luscious handling of paint, rich coloring, and fluid composition can be seen in the filmy transitions of glowing color in the Wrightsman *Annunciation*. Furthermore, the design of the altarpiece may well be derived from Rubens; it is surprisingly like that of an *Annunciation* by Rubens now in the Rubenshuis (fig. 4). The similarity of the twisting poses of the archangels and the postures of the two Virgins is striking. When and where Rubens painted his *Annunciation* is

unknown: it was first recorded in 1642—two years after the artist's death—in an inventory of the extensive collection in Madrid that Don Diego Mexiá, marquis of Leganés, had formed in Europe.[5] Given the similarities between the two paintings, Giordano must have seen Rubens's *Annunciation* either in Naples or on his travels in Italy.[6]

Along with Titian and Rubens, the great Roman painter and architect Pietro da Cortona contributed significantly to Giordano's cultural background. Cortona's frescoes in Rome and Florence, especially, were crucial to Giordano's development, as was Cortona's altarpiece the *Ecstasy of Saint Alexis* in the church of San Filippo Neri (ca. 1638) in Giordano's native city. (Coincidentally, Cortona painted *Daniel in the Lions' Den* [Gallerie dell'Accademia, Venice] for the high altar of San Daniele, the church in Venice for which Giordano probably executed the Wrightsman *Annunciation*.) Cortona's huge altarpiece of the *Annunciation* (fig. 5) in the church of San Francesco, Cortona, is sometimes cited as a source for the

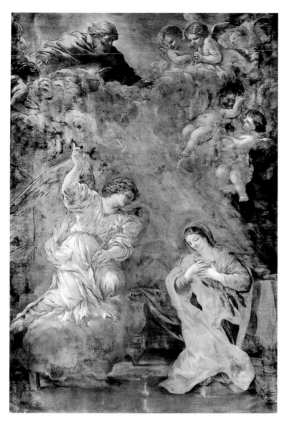

Fig. 5. Pietro da Cortona, *The Annunciation*. Oil on canvas,
157 1/2 × 110 1/4 in. (400 × 280 cm). San Francesco, Cortona

foible, & n'est qu'une imitation outrée de l'Ecole Vénitienne: les couleurs
sont entieres, & le pinceau en est trop négligé."

4. Inventario Napoleonico, Pinacoteca di Brera, Milan, no. 129 (not 142, as
Ferrari and Scavizzi 1992, vol. 1, pp. 227 n. 23, 405, write; Ferrari and
Scavizzi also mistranscribe the dimensions). According to Emanuela
Daffra, who kindly checked the inventory for the author, the dimensions
recorded are 109 1/2 × 50 3/4 in. (278 × 129 cm). Even making allowances for
the frame, they do not correspond with those of the Wrightsman paint-
ing, which is approximately fifteen inches shorter and fifteen inches wider.
As these records are notoriously unreliable, however, the identification of
the Wrightsman *Annunciation* with the altarpiece from the church of San
Daniele cannot be excluded.

5. Michael Jaffé, *Rubens. Catalogo completo,* trans. Germano Mulazzani
(Milan, 1989), no. 919; Alexander Vergara, *Rubens and His Spanish Patrons*
(Cambridge, 1999), p. 171.

6. John Smith, *A Catalogue Raisonné of the Works of the Most Eminent Dutch,
Flemish and French Painters,* vol. 2 (London, 1830), pp. 266–67 no. 901, states
that it was painted in Spain for the marquis of Leganés, but there is no
evidence for this provenance.

7. Cortona's *Annunciation* was cited as a source for the Wrightsman
Annunciation by Milkovich, when he published the painting for the first
time; Ferrari and Scavizzi 1992, vol. 1, p. 285, in their catalogue entry,
report his observation without comment.

8. Milkovich 1964, pp. 9, 33 no. 7.

Wrightsman altarpiece, and it is just possible that Giordano saw it
being painted in Rome, in the late 1660s, or, less likely, on one of
his trips through Tuscany.[7]

The suggestion that a drawing in the Museo di San Martino,
Naples, is a preparatory study for the altarpiece is unconvincing.[8]

EF

NOTES

1. The works of 1672 are the *Madonna of the Rosary* in the church of San
Gregorio Magno at Crispano, which is signed and dated, and the fresco of
the *Immaculate Conception* and the altarpiece of the *Circumcision*, both in the
oratory of the Monte dei Poveri in Naples, for which Giordano received
payments in October 1672 and April 1673. See Ferrari and Scavizzi 1992,
vol. 1, pp. 56, 241 under the year 1672, 285 no. A213, 287 no. A221a,b, and
vol. 2, figs. 286, 292, 293.

2. Marco Boschini, *Le ricche minere della pittura veneziana* (Venice, 1674),
Castello, p. 9. Michel 1991, p. 324 n. 4.

3. Charles Nicolas Cochin, *Voyage d'Italie; ou, Recueil de notes sur les ouvrages
de peinture & sculpture, qu'on voit dans les principales villes d'Italie* (Paris,
1758), vol. 3, p. 42 (reprinted in Michel 1991, p. 324): "Ce tableau est très-

CANALETTO

(Giovanni Antonio Canal, 1697–1768)

Canaletto was the most famous of all Venetian view painters. His father, Bernardo, was a painter of theatrical scenery, and it was in his father's studio that Canaletto received his training in quadratura, *or strict architectural perspective.*

In 1719 Canaletto traveled to Rome, where he came under the influence of Dutch artists who specialized in painting townscapes. In 1720, back in Venice, he is listed in the Venetian Fraglia, *or painters' guild. By 1726 he was employed by Owen McSwiney (ca. 1684–1754), an Irish ex-impresario living in Italy, to collaborate with other artists on a group of large allegorical tomb paintings in which the skills of the theatrical scene designer, the landscape artist, and the figure painter are combined.*

In about 1723 Canaletto produced his first views of Venice that can be dated on topographical grounds. Henceforth, such subjects would constitute the principal theme of his paintings. Among the earliest documented views are a set of four canvases, executed in 1725–26 for the Lucchese merchant Stefano Conti and now in the Pinacoteca Giovanni e Marella Agneli, Turin. By this time Canaletto was already commanding high prices from his clients. In the following four years or so Canaletto painted a series of large-scale views of the center of Venice (now in the English Royal Collection) for Joseph Smith (ca. 1674–1770), the future British consul at Venice, as well as for a few other clients (Smith thereafter became a broker between the artist and the English travelers who were to be his chief clients for the rest of his life).

The artist's early paintings were based on the careful observation of nature and carried out in thick brushstrokes on dark red grounds. As his style evolved, Canaletto developed a calmer, tighter style of painting and, from the 1730s onward, abandoned the stormy, atmospheric drama of his early works for unclouded, sunny skies. This change facilitated speed of execution and allowed for more accurate typography, better suited to the taste of his clients.

With the outbreak of the War of Austrian Succession (1740–48) and the subsequent interruption of the flow of foreign visitors to Venice, Canaletto seems to have concentrated mainly on painting views of Rome, executed from drawings he had made over two decades earlier, and a group of Venetian capricci, *or artificially composed landscapes with architecture, real or imaginary, fancifully grouped. When the loss of his English clients persisted, Canaletto moved to England.*

He arrived in London in May 1746 and remained in England, apart from two short visits to Venice, until the latter part of 1755, when he finally returned to his native city. While in England he painted not only numerous views of London and its environs but also scenes from as far afield as Warwick, Cambridge, and Alnwick in Northumberland.

During his last years Canaletto turned his attention to painting capricci. *This flight from reality is reflected in the increasing mannerisms of his already formulaic style, which eventually became exaggeratedly calligraphic, composed largely of dots, flourishes, and ruled lines. When the Venetian Academy was founded in 1756, Canaletto was not chosen for membership, the rejection most likely due to the low esteem in which his type of view painting was held. At last elected to the academy in September 1763, five years before his death, Canaletto, characteristically, submitted as his reception piece a* capriccio *of a courtyard, now in the Gallerie dell'Accademia, Venice.*

EF

ABBREVIATIONS

Buttery 1987. David Buttery. "Canaletto at Warwick." *Burlington Magazine* 129 (July 1987), pp. 437–45. Reissued with revisions as *Canaletto and Warwick Castle*. Chichester, Sussex, 1992.

Constable and Links 1989. W. G. Constable. *Canaletto: Giovanni Antonio Canal, 1697–1768*. 2 vols. Oxford, 1962. Reprint of the 2nd edition (1976), revised and with a supplement by J. G. Links. 2 vols. Oxford, 1989.

Fahy 1973. Everett Fahy, in *The Wrightsman Collection*, vol. 5, Everett Fahy and Francis Watson, *Paintings, Drawings, Sculpture*. New York, 1973.

Links 1971. J. G. Links. *Views of Venice by Canaletto, Engraved by Antonio Visentini*. New York, 1971.

Moschini 1954. Vittorio Moschini. *Canaletto*. Milan, 1954.

New York 1989–90. Katharine Baetjer and J. G. Links, eds. *Canaletto*. Exh. cat., Metropolitan Museum, New York, 1989–90. New York, 1989.

Vivian 1971. Frances Vivian. *Il console Smith. Mercante e collezionista*. Vicenza, 1971.

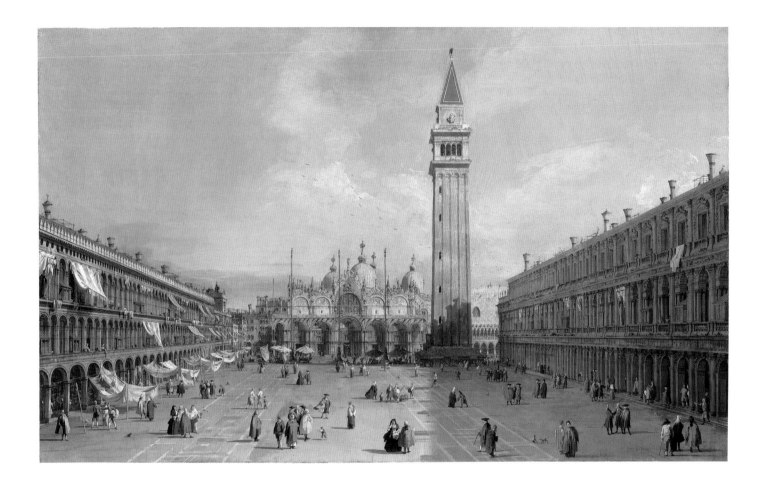

15. *Piazza San Marco, Venice*

Oil on canvas, 27 × 44 ¼ in. (68.6 × 112.4 cm)

The Metropolitan Museum of Art, New York, Purchase, Mrs. Charles Wrightsman Gift, 1988 (1988.162)

PROVENANCE

By descent to W. G. Hoffmann, Berlin (until 1939; sold to Colnaghi); [Colnaghi, London, 1939–40; sold to Barlow]; Robert (later Sir Robert) Barlow, Wendover, Buckinghamshire (from 1940); his widow, Lady Barlow, Wendover; by family descent (until 1988; sold to Newhouse and Wengraf; [Newhouse Galleries, New York, and Alex Wengraf Ltd., London, 1988; sold to the Metropolitan Museum]; purchased in 1988 with a gift from Mrs. Charles Wrightsman for the Metropolitan Museum.

EXHIBITED

Colnaghi, London, 1939.

LITERATURE

Constable and Links 1989, vol. 2, p. 188 no. 2; New York 1989–90, pp. 130–31 no. 27.

VERSIONS

AYNHOE PARK, Northampton, the late R. F. W. Cartwright (in 1995 in a private collection, Washington, D.C.). Possibly by Bellotto. Constable and Links 1989, no. 5.

BERLIN, Dmitri Tziracopoulo (in 1939). Oil on canvas, 43 ¼ × 49 ¼ in. (110 × 125 cm). Constable and Links 1989, no. 13.

CAMBRIDGE, Massachusetts, Fogg Art Museum (1943.106). Oil on canvas, 30 × 46 ¼ in. (76 × 114.5 cm). Ca. 1740. Constable and Links 1989, no. 14.

DRESDEN, Gemäldegalerie (584). Oil on canvas, 37 ¾ × 46 in. (96 × 117 cm). Constable and Links 1989, no. 10.

LONDON, Christie's, June 28, 1974, lot 78. Oil on canvas, 31 ½ × 49 ½ in. (80.1 × 125.7 cm). Constable and Links 1989, under no. 9.

LONDON, Christie's, December 8, 1995, lot 74. Oil on canvas, 23 ⅞ × 36 ½ in. (60.7 × 92.8 cm). By Bernardo Bellotto, ca. 1738. Constable and Links 1989, under no. 3.

LONDON, Sotheby's, December 3 and 4, 1997, lot 48 (one of a pair). Oil on canvas, 18 × 30 in. (46 × 76 cm). Constable and Links 1989, no. 3 ("similar in design

[to the Wrightsman canvas] but from a slightly higher viewpoint; more and larger groups of figures in the Piazza; no awnings on the windows").
LONDON, Sotheby's, July 10, 2002, lot 79. Oil on canvas, 18¼ × 29¼ in. (46.2 × 74.6 cm). Ca. 1725.
MADRID, Museo Thyssen-Bornemisza (1956.1). Oil on canvas, 55¾ × 80½ in. (141.5 × 204.4 cm). Ca. 1726/27. Constable and Links 1989, no. 1.
MILTON PARK, near Peterborough, Cambridgeshire, Fitzwilliam collection. Oil on canvas, 29½ × 41⅝ in. (75 × 106 cm). Engraved for Visentini's *Urbis venetiarum prospectus celebriores* (1742). Constable and Links 1989, no. 7.
MUNICH, Bayerische Staatsgemäldesammlungen (5914). Oil on canvas, 54 × 78¾ in. (137 × 200 cm). Replica of the Thyssen canvas. Constable and Links 1989, no. 1(a).
NEW YORK, Christie's, January 12, 1996, lot 38. Oil on canvas, 19¼ × 28¾ in. (49 × 73 cm). Constable and Links 1989, no. 8.
PARIS, Musée Jacquemart-André (9). Oil on canvas, 17¾ × 30 in. (45 × 76 cm). Constable and Links 1989, no. 6.
PENRHYN CASTLE, Wales, Lady Janet Douglas-Pennant. Oil on canvas, 24 × 37 in. (61 × 94 cm). Constable and Links 1989, no. 9.
WOBURN ABBEY, Bedfordshire, Duke of Bedford. Oil on canvas, 18½ × 31 in. (47 × 78.7 cm). Ca. 1733–36. Constable and Links 1989, no. 4.

Piazza San Marco, the principal square of Venice and the only one to be called a piazza (all the others are called *campi,* or open areas), was a subject Canaletto favored in his youth: he painted at least a dozen views of it in the 1720s and '30s. Here he depicts it on a brilliant, sunny afternoon, the blue-and-white awnings fluttering in a gentle breeze. It is filled with hawkers, beggars, lawyers, elegant ladies, children, bewigged citizens in tricornered hats, seven dogs—and no pigeons.

VEDVTA DELLA PIAZZA
Verſo la Chieſa di S. Marco
Luca Carlevarijs del et inc.

Fig. 1. Luca Carlevarijs, *Piazza San Marco*. Etching, plate, 8⅛ × 11½ in. (20.6 × 29.3 cm). The Metropolitan Museum of Art, New York, The Elisha Whittelsey Collection, The Elisha Whittelsey Fund, 1957 (57.618)

The basilica of Saint Mark's, built and rebuilt over three centuries beginning in the year 830, stands at the east end of the square. It served as the chapel in which doges were crowned and in which some of them are buried. Only in 1807 was it designated the cathedral of Venice. Constructed in the Byzantine style, the building incorporates loot gathered after the crusaders sacked Constantinople in 1204. To the right of the basilica rises the Campanile, begun in the ninth century and rebuilt after it collapsed in 1902. Farther to the right is a glimpse of the gleaming facade of the Doges' Palace. The long building on the left, running along the north side of the square, is the Procuratie Vecchie, which served as the residence for the nine Procurators of San Marco, the chief magistrates of the Republic of Venice. Erected in 1514, it replaced a twelfth-century structure that had been damaged by fire. Facing it, on the south side of the square, is the Procuratie Nuove, built between 1580 and 1640 by Palladio's pupil Vincenzo Scamozzi (1552–1616).

The vantage point for the scene was a window on an upper floor of the Procuratie Vecchie, slightly to the north of the center line of the piazza, where the Procuratie abutted San Geminiano, the small church that was demolished in 1807 to make way for the Napoleonic wing of the Palazzo Reale, which now houses the grand entrance to the Museo Correr on the west end of the square. A virtually identical view (fig. 1) appears in *Le fabriche, e vedute di Venetia,* an album of 104 etchings by Luca Carlevarijs (1663–1730), which was published in 1703.[1] While the foreshortening of the architecture is the same in both scenes, the cast shadows in the etching indicate early morning, and Carlevarijs shows a newly elected doge distributing gold and silver coins to an excited crowd. Carlevarijs's rendering of eight windows in the Campanile is accurate; Canaletto included only five. The young painter clearly took inspiration from the etching rather than from the older Carlevarijs's disproportioned oil paintings of the piazza, which show an elongated square and a truncated Campanile.[2]

The Wrightsman *Piazza San Marco* dates from the late 1720s. Its crisp style and blond tonality followed the ominous atmosphere of Canaletto's large view now in the Museo Thyssen-Bornemisza, Madrid, which can be dated precisely because it shows the piazza only partly covered with the stone paving that was laid between 1725 and 1727.[3] In the Wrightsman picture, the pavement, with its white geometric pattern, is complete. It thus predates views of the piazza in the series of twenty-four Canalettos in the collection

of the Duke of Bedford at Woburn Abbey, of the mid-1730s, as well as those in the set of eight canvases in the Fitzwilliam collection at Milton Park, two of which served as the originals for the 1742 edition of Visentini's etchings (see below). Unlike most of Canaletto's views of the piazza, the Wrightsman painting does not seem to have had a pendant or to have formed part of a series.

EF

NOTES

1. For the etching, see Isabella Reale, in *Luca Carlevarijs. Le fabriche e vedute di Venetia*, exh. cat., Udine (Venice, 1995), p. 92.
2. Compare Carlevarijs's canvas of 1709 in the Metropolitan Museum (John Pope-Hennessy, *The Robert Lehman Collection*, vol. 1, *Italian Paintings* [New York, 1987], p. 254 no. 101) and the large view he painted in about 1727 for Field Marshal Johann Matthias von der Schulenburg (sold at Christie's, London, December 10, 2003, lot 116).
3. Roberto Contini, *Seventeenth and Eighteenth Century Italian Painting: The Thyssen-Bornemisza Collection* (London, 2002), p. 258.

The Harvey Series

During the 1730s Canaletto received several commissions from Englishmen, some of them for large series of views of Venice. The fourth Duke of Bedford, for example, acquired a matching set of twenty-four views, all of which are still at Woburn Abbey in Bedfordshire, and the fourth Earl of Carlisle, a series of seventeen. Four Canalettos in the Wrightsman collection (cats. 16–19) come from a similar group of twenty, or possibly twenty-one, views, all of the same size and character, known as the Harvey series from the name of their last owner, Sir Robert Grenville Harvey (1856–1931), Langley Park, Slough, Buckinghamshire.

At least six of the paintings in the Harvey series were etched by Antonio Visentini (1688–1762) for an album of thirty-eight prints issued in three parts under the title *Urbis venetiarum prospectus celebriores*, published in 1742.[1] The album was commissioned by Joseph Smith as a repertory from which visiting tourists could select subjects they wished to have painted. The subjects appear over and over again with slight variations in Canaletto's work and were repeated by later imitators and copyists. The first part of the album—called *Prospectus magni canalis venetiarum*—was published in 1735. It consists of fourteen etchings of paintings acquired from Consul Smith by George III in 1762–63 and now in the English Royal Collection. It is likely that the originals from which the additional twenty-four etchings in the 1742 edition of Visentini's album were made also belonged to Smith, if the phrase on the title page of the album—"in Aedibus Josephi Smith Angli"—is to be

believed. In addition, one of the Wrightsman Canalettos, which was originally prepared for an etching that was never executed (cat. 19), seems likely to have been Smith's.

Until recently it was unclear how the Harvey series reached England. W. G. Constable, the doyen of Canaletto studies, believed it was purchased in Venice by the last Duke of Buckingham and Chandos (1823–1889), inherited by his daughter, and then descended to members of her husband's family.[2] Francis Russell, however, has surmised that the original owner was the third Duke of Marlborough (1706–1758), based on the history of a group of sporting pictures by John Wootton (d. 1756) formerly at Langley Park.[3] The Woottons were acquired by Sir Robert Harvey in 1788 when he purchased the house—and all of its contents—from the fourth Duke of Marlborough (1738–1817); the Canalettos must have been acquired the same way. Moreover, Russell observed that the third Duke of Buckingham's sister, Diana (d. 1735), was the first wife of John, fourth Duke of Bedford, who, in 1733/36, bought the set of Canalettos at Woburn Abbey mentioned above; so the fashion for Canaletto ran in the family. The Marlborough provenance has since been confirmed by John Harris, who discovered in the Buckinghamshire Record Office an apparently unique copy of a printed list of the paintings at Langley, which is attached to an insurance valuation of the 1890s. Five views of Venice are listed in the drawing room, followed by a note stating that "The Pictures and others by Canaletto were bought with the house from the

Duke of Marlborough in 1788. In an old inventory they are described as 'twenty views in fine frames.'"[4]

Only circumstantial evidence supports dating for the Harvey series. There are Harvey originals for etchings in both the second and third series of the *Prospectus*, so they all presumably were completed before 1742, the date of publication. How long before is uncertain. The rather stronger coloring and less blond tonality of the Harvey paintings as compared, for instance, with the originals of the first fourteen etchings, published in 1735, suggest a date a few years later than this, perhaps soon after 1735, though doubtless the execution of so large a series must have been spread over a certain period of time. Constable believed they were painted in two batches, those of the Grand Canal in 1731–32, and those of the churches and *campi* in about 1735.[5]

EF

GENERAL REFERENCES FOR THE HARVEY SERIES
K. T. Parker, *The Drawings of Antonio Canaletto in the Collection of His Majesty the King at Windsor Castle* (Oxford and London, 1948), pp. 31, 32, 36; Moschini 1954, pp. 22, 30, 38; Terisio Pignatti, *Il quaderno di disegni del Canaletto alle gallerie di Venezia* (Milan, 1958), pp. 23, 41–43; Anonymous, "Arrichimenti nelle collezioni private," *Acropoli* 3 (1963), pp. 237–46; Vivian 1971, p. 32; J. G. Links, *Canaletto and His Patrons* (London, 1977), p. 45; Constable and Links 1989, passim; New York 1989–90, pp. 177, 181.

NOTES

1. Constable and Links 1989, nos. 241, 262, 281, 283, 313, and 314. See also Vivian 1971, p. 32.
2. Constable and Links 1989, vol. 2, p. 277.
3. Francis Russell, review of *A Supplement to W. G. Constable's Canaletto: Giovanni Antonio Canal, 1697–1768*, by J. G. Links, *Burlington Magazine* 141 (March 1999), p. 181.
4. Francis Russell kindly told me about Harris's discovery in May 2000.
5. Constable and Links 1989, vol. 1, p. 112.

16. *The Grand Canal, Venice, Looking South from the Ca' da Mosto to the Rialto Bridge*

Oil on canvas, 18¼ × 30½ in. (46.4 × 77.5 cm)
Retains the eighteenth-century Venetian frame—a narrow Rococo molding with a carved leaf and flower bracketed by "C" scrolls and with acanthus leaves in the corners—that is identical to those Joseph Smith chose for the Canalettos now in the English Royal Collection and the Duke of Bedford's collection.[1]

PROVENANCE
[Joseph Smith, Venice]; ?Charles Spencer, third Duke of Marlborough, Langley Park, Slough, Buckinghamshire (d. 1758); his son George Spencer, fourth Duke of Marlborough, Langley Park (1758–88; sold to Harvey); Sir Robert Harvey, Langley Park (from 1788); by descent to Sir Robert Grenville Harvey, Langley Park (d. 1931); trustees of his estate (until about 1957); [Colnaghi, London, 1964; sold to Wrightsman, together with cat. 17]; Mr. and Mrs. Charles Wrightsman, New York (1964–his d. 1986; cat., 1973, no. 2); Mrs. Wrightsman (from 1986).

EXHIBITED
Together with cats. 17–19: Ashmolean Museum, Oxford, 1936–38; City of Birmingham Museum and Art Gallery, November 2–December 2, 1938, "An Exhibition of Treasures from Midland Homes" (one of "Twenty Views of Venice," nos. 151–55, 157–61, 164–68, and 170–74, lent by the executors of Sir Robert Grenville Harvey); Metropolitan Museum, New York, March–October 1967.

LITERATURE
Fahy 1973, pp. 26–32 no. 2; Constable and Links 1989, vol. 2, p. 305 no. 240.

VERSIONS
BERGAMO, Accademia Carrara, Guglielmo Lochis bequest (540). Oil on canvas, 24 × 35⅜ in. (61 × 90 cm). By Canaletto, early 1730s. Constable and Links 1989, no. 240(a).
ENGLAND, Lord Wharton. Oil on canvas, 17½ × 25¾ in. (44.5 × 65.5 cm). Constable and Links 1989, no. 240(b).
LONDON, Christie's, June 27, 1985, lot 6. Oil on canvas, 23 × 36½ in. (58.4 × 92.7 cm). Constable and Links 1989, pp. 733–34 no. 240*.
LONDON, Mrs. E. M. Assheton-Bennett (sold by her executors at Christie's, London, November 26, 1976, lot 26; ex-collections Rudolf Kann, Paris, and Henry Oppenheimer, London). Oil on canvas, 23¼ × 35⅞ in. (59 × 91 cm). By Bellotto, ca. 1737–40. Constable and Links 1989, no. 240(c).

This view of the business and administrative center of old Venice focuses on the foot of the Rialto bridge on the east bank, which is visible just to the left of the center of the composition. The top of the campanile of the church of San Bartolomeo, shown before its rebuilding in 1747, appears above the buildings beyond the bridge. The palace at the extreme left is the Ca' da Mosto, a thirteenth-century Veneto-Byzantine building, considerably altered today by the addition of a top story. Immediately beyond are the fifteenth-century Casa del Dolfin and the Palazzo Bollani-Erizzo, remembered today as the former residence of Pietro Aretino, the

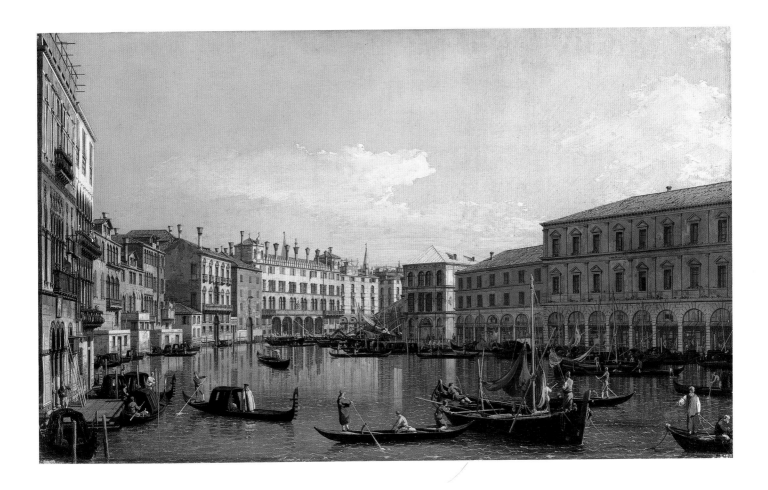

"Scourge of Princes" and notorious blackmailer; continuing on, a low, two-story house is followed by the Pesaro and Sagredo (today Civran) palaces. Farther off, the large building adjacent to the foot of the Rialto bridge is the Fondaco dei Tedeschi, now the main Venetian post office but formerly a German trading post and famous from its reconstruction in 1505 for the frescoed facade decorations by Giorgione and Titian.

To the right of the bridge is the Palazzo dei Camerlenghi, built between 1525 and 1528 by the architect Guglielmo Bergamasco (d. about 1530). Next to it, at right, is the Naranzeria (literally, the "orange store"), still the main fruit and vegetable market of Venice today. Beside it can be seen the Fabbriche Vecchie di Rialto, whose open arcades now shelter part of the fish market. At the center of the foreground are a sailing barge and a *sandaletto,* a flat-keeled boat, with gondolas and *sandaletti* dispersed about the

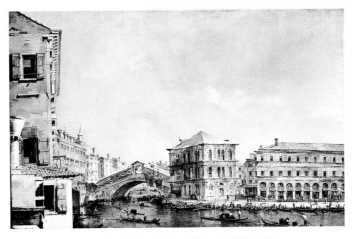

Fig. 1. Francesco Guardi, *The Grand Canal Above the Rialto.* Oil on canvas, 21 × 33¾ in. (53.3 × 85.7 cm). The Metropolitan Museum of Art, New York, Purchase, 1871 (71.119)

canal, including one in the left foreground tied up beside the steps of the Ca' da Mosto.

From the fifteenth to the end of the eighteenth century, the Ca' da Mosto was the Albergo del Leon Bianco, the most famous hotel in pre-nineteenth-century Venice, visited in January 1782 by the future czar Paul I traveling incognito as the comte du Nord with his wife, Maria Teodorovna. The emperor Joseph II was also a guest of the hotel in the eighteenth century, and shortly before it closed in the early nineteenth century, the French writer and politician Châteaubriand stayed there.[2]

At the Metropolitan Museum is a canvas by Francesco Guardi (fig. 1) showing the same scene but closer to the Rialto bridge. Guardi has taken his view from a window on the first floor of the Palazzo Bollani-Erizzo, overlooking the two-story building on the left. His canvas dates from about thirty years after Canaletto's.

EF

NOTES

1. Pippa Mason, "Smith's Picture Frames," in *A King's Purchase: King George III and the Collection of Consul Smith,* exh. cat., The Queen's Gallery, Buckingham Palace, London (London, 1993), pp. 59–62.
2. Bianca Tamassia Mazzarotto, *Le feste veneziane. I giochi popolari, ceremonie religiose e di governo* (Florence, 1961), pp. 314, 315, 330 n. 19; Eugenio Zaniboni, *Alberghi italiani e viaggiatori stranieri* (Naples, 1921), pp. 60–64.

17. *Campo Santa Maria Zobenigo, Venice*

Oil on canvas, 18 1/2 × 30 3/4 in. (47 × 78.1 cm)
In its original frame (see cat. 16).
Cleaned in 1972 by John Brealey in London.

PROVENANCE
Part of the Harvey series, see cat. 16; [Colnaghi, London, 1964; sold to Wrightsman, together with cat. 16]; Mr. and Mrs. Charles Wrightsman, New York (1964–his d. 1986; cat., 1973, no. 2); Mrs. Wrightsman (from 1986).

EXHIBITED
See cat. 16.

LITERATURE
Fahy 1973, pp. 33–37 no. 3; André Corboz, *Canaletto. Una Venezia immaginaria* (Milan, 1985), vol. 1, pp. 82, 138 n. 180, 146, 199, 336–37, and vol. 2, pp. 417, 618 no. P 172; Constable and Links 1989, vol. 2, pp. 344–45 no. 313.

ETCHING
Antonio Visentini, *Urbis venetiarum prospectus celebriores,* pt. 3 (Venice, 1742), pl. VI (fig. 1). Two drawings by Visentini for the print are in the Museo Correr and the British Museum.

VERSIONS/COPIES
BERLIN, Jaffé collection (sale, Lepke, Berlin, April 14, 1931, lot 132; sold again at Phillips, London, April 26, 1988, lot 63, and at Christie's, London, December 11, 1992, lot 26). Oil on canvas, 11 3/8 × 15 in. (29 × 38 cm). An autograph repetition of the right half of the composition, but with the facade of the church parallel to the picture plane.[1] Constable and Links 1989, no. 313(a).
NEW YORK, Alice Tully (her sale, Christie's, New York, January 11, 1994, lot 27; sold again at the Dorotheum, Vienna, October 17, 1995, lot 54). Oil on canvas, 17 1/8 × 13 1/2 in. (43.5 × 34.3 cm). A copy of the architecture, with the quay of a waterway, filled with gondolas, in the foreground.
STUTTGART, Staatsgalerie (281). Oil on canvas, 19 1/4 × 33 1/2 in. (49 × 85 cm). Constable and Links 1989, no. 313(b)2.
WASHINGTON D.C., Robert H. Smith (sale, Christie's, New York, January 26, 2005, lot 76). Oil on canvas, 19 5/8 × 33 1/8 in. (50 × 84 cm) (fig. 2). A signed work by Francesco Guardi.[2] Constable and Links 1989, no. 313(b)1.

The Baroque facade of the church of Santa Maria del Giglio, or Zobenigo, as it is popularly known in Venice, appears at the right; the *campo* of the same name is at the left. A glimpse of the Grand Canal and the *traghetto* (gondola ferry) station is just visible in the distance at the extreme left of the composition. On the far side of the canal can be seen the small house that for many years stood on the site now occupied by the Salviati glass factory. Beyond Santa Maria Zobenigo, toward the center, is the church's brick campanile with its tiled conical cap; below it are two well heads, the one on the right partly cut off by the corner of the building. Although the campanile collapsed in 1774, its base survives and is now used as a shop. Various figures, including a senator at the center foreground, and two dogs wander about.

Both the church and the square take their name, Zobenigo, from the Jubanicos, a family who died out in the twelfth century and who had founded the church as early as the ninth century. The building shown here, however, was erected between 1678 and 1683 by the architect Giuseppe Sardi (ca. 1620–1699) at the expense of the Barbaro family, whose arms appear below the central pediment of the facade. The rich decoration of this Baroque frontispiece glorifies the military prowess of Venice. In the central niche above the door is a statue of the *capitan dal mar* (admiral) Antonio Barbaro (d. 1679), flanked by figures of Honor and Virtue in smaller niches. All three statues were created by the Flemish sculptor Giusto Le Court (1627–1679). The plinths below the columns flanking these statues are carved in relief with galleys

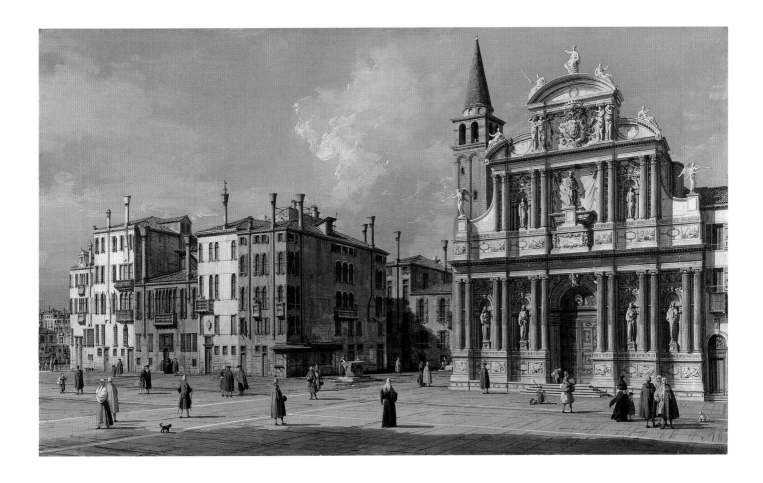

and military trophies. Below, four additional statues of members of the Barbaro family set between coupled columns are also by Le Court. The podiums on which the columns rest are carved in relief with plans of cities and fortified places: Zara (Zadar), Candia (Iráklion), Padua, Rome, Corfu, and Split. The whole decorative design of the facade has a particular appropriateness here, since the palaces at the left of the composition occupy the site of the original fortified wall of Venice, built in the tenth century by Doge Pietro Tribuno (r. 888–912).

The most unusual feature of the painting is the strange distortion Canaletto made of the space in front of the church. In reality the church stands in a *calle* (narrow Venetian passage-way), which is, and always has been, only about thirty feet wide. It would be impossible to find a vantage point in the *calle* that would take in the whole facade as Canaletto has shown it, as well as the open *campo* extending all the way over to the Grand Canal on the extreme left. The wide angle of vision and the somewhat strained perspective might awaken suspicions that the view was produced with the aid of a camera obscura. But, as Links observed, such an instrument would have been of no help here, for "it would have had to be moved up, down and sideways, and all its angles would have been wrong. Only a series of drawings and much calculation in the studio could have produced the desired result."[3]

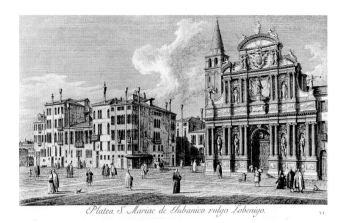

Fig. 1. Antonio Visentini, etching of the painting. Plate, 10¾ × 16¾ in. (27.4 × 42.7 cm). The Metropolitan Museum of Art, New York, The Elisha Whittelsey Collection, The Elisha Whittelsey Fund, 1949 (49.45)

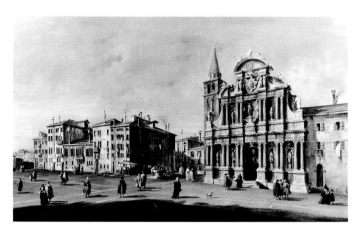

Fig. 2. Francesco Guardi, *Santa Maria Zobenigo*. Oil on canvas, 19⅝ × 33⅛ in. (50 × 84 cm). Private collection

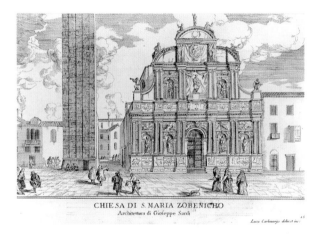

Fig. 3. Luca Carlevarijs, *Santa Maria Zobenigo*. Etching, plate, 8½ × 11½ in. (20.8 × 29.2 cm). The Metropolitan Museum of Art, New York, The Elisha Whittelsey Collection, The Elisha Whittelsey Fund, 1957 (57.618)

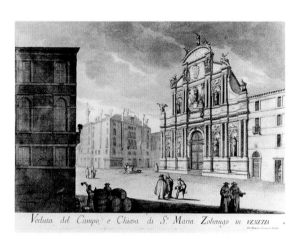

Fig. 4. Domenico Lovisa, *Campo Santa Maria Zobenigo*. Etching, plate, 14⅜ × 19⅝ in. (36.5 × 50 cm)

This view is one of the eight scenes from the Harvey series that were etched by Visentini (see p. 61). No doubt the print (fig. 1) served as a model for some of the repetitions of this subject by Canaletto's assistants. It was also copied in oil by Francesco Guardi (fig. 2).

There also are etchings of this scene by Luca Carlevarijs (1663–1730) and Domenico Lovisa (ca. 1690–ca. 1750), published in 1703 and 1730, respectively. The Carlevarijs (fig. 3) shows the facade of the church parallel to the picture plane; the Lovisa (fig. 4) shows it at the same angle as the Canaletto and includes the *campo* to the left.[4] Indeed, Canaletto may have been inspired by Lovisa's etching when he composed his painting. EF

NOTES

1. J. G. Links, *A Supplement to W. G. Constable's Canaletto: Giovanni Antonio Canal, 1697–1768* (London, 1998), p. 31, pl. 267.
2. Antonio Morassi, "Francesco Guardi as a Pupil of Canaletto," *Connoisseur* 152 (March 1963), pp. 151–52; Francesca del Torre, in *Francesco Guardi. Vedute, capricci, feste*, exh. cat., Fondazione Giorgio Cini, Venice (Milan, 1993), p. 98 no. 26.
3. J. G. Links, "Secrets of Venetian Topography," *Apollo* 90 (September 1969), p. 223. See also under cat. 8.
4. Luca Carlevarijs, *Le fabriche, e vedute di Venetia* (Venice, 1703), pl. 15, "Chiesa di S. Maria Zobenicho." Domenico Lovisa, *Il gran Teatro di Venezia; ovvero, Raccolta delle principali vedute e pitture che in essa si contengono* (Venice, 1720), pl. 10. The etchings are reproduced by André Corboz, *Canaletto. Una Venezia immaginaria* (Milan, 1985), vol. 1, p. 199, figs. 216, 217.

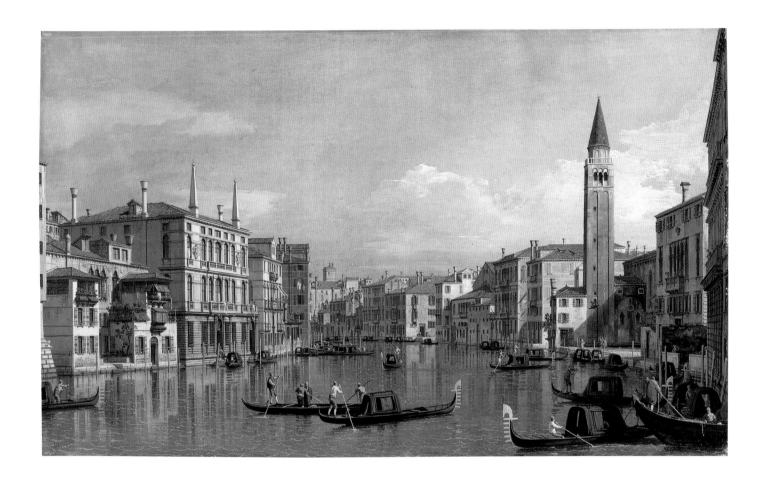

18. *The Grand Canal, Venice, Looking Southeast from the Campo della Carità to the Palazzo Venier delle Torreselle*

Oil on canvas, 18½ × 30⅝ in. (47 × 77.8 cm)

In a frame made by Julius Lowy in 1965, imitating those on cats. 16, 17. Cleaned in 1972 by John Brealey in London.

PROVENANCE
Part of the Harvey series, see cat. 16; [Colnaghi, London, 1965; sold to Wrightsman, together with cat. 19]; Mr. and Mrs. Charles Wrightsman, New York (1965–his d. 1986; cat., 1973, no. 4); Mrs. Wrightsman (from 1986).

LITERATURE
Moschini 1954, p. 30, fig. 139; Fahy 1973, pp. 38–42 no. 4; Constable and Links 1989, vol. 2, p. 283 no. 198.

Just showing at the extreme left of the composition are the rusticated remains of the already ruined Ca' del Duca, started in 1457 for the Cornaro family and continued by Francesco Sforza, duke of Milan, but never occupied by him. Beside it, with two projecting loggias, is the Palazzetto Falier, a fifteenth-century Gothic building much restored and greatly altered. Immediately beyond stands the early seventeenth-century Palazzo Giustinian or Lolin (today Levi), an early work of Baldassare Longhena (1597–1682). Farther on, in profile at the turn of the canal, is the Palazzo Cavalli, later entirely reconstructed by Baron Franchetti, after whom it is now named.

At the right we see the foreshortened facade of the Palazzo Contarini degli Scrigni, a classical building begun in 1609 from designs by Vincenzo Scamozzi (1552–1616). Beyond it is the eighteenth-century Palazzo Querini, now the British Consulate. Farther on, in shadow beside the campanile (which collapsed in 1744) of the church of the monastery of Santa Maria della Carità, can be seen a glimpse of the church itself, which is now part of the picture galleries of the Accademia. Past the campanile is the Palazzo Brandolini, and, adjacent to it, the fifteenth-century Palazzo Contarini dal Zaffo, as it appeared before extensive nineteenth-century restorations were carried out.

The Campo San Vio appears farther on as a break in the buildings, with the side of the Palazzo Barbarigo in full sunshine. A tower, tall and rectangular, rises above the structure almost exactly at the center of the composition. No longer there, the tower once formed part of the Palazzo Venier delle Torreselle, which adjoined the Palazzo Venier dei Leoni and has almost totally disappeared today, though its name is recalled by the adjacent Rio delle Torreselle.

Apparently viewed from the center of the canal, this scene is in fact based upon several drawings taken from the banks. Although the painting gives a unified impression, the left half was drawn from a house on the right bank, and the buildings on the right were drawn from at least two different vantages. The actual preparatory sketches do not survive, but it is known that Canaletto made numerous drawings, both finished ones for collectors and free outlines as studies for his paintings. Among the latter category are examples in the Cagnola sketchbook, now in the Gallerie dell'Accademia, which Canaletto used for at least two paintings in the Harvey series.[1] It seems to have been his practice to work up the rough studies in his studio, incorporating them into convincing compositions that then served as models for the paintings.

While it has been suggested that this painting gives the impression of having been made with a camera obscura,[2] it seems highly unlikely that Canaletto did so, as the optical distortions in this scene are quite arbitrary exaggerations of the heights of *some* buildings and towers; the effect is not of a broadened perspective, as it would be in a wide-angle picture. Indeed, if Canaletto used a camera obscura, he covered his tracks so carefully that it is impossible to point with certainty to any painting or even to any drawing that was evidently made with it.

This canvas is the only known example of this view in Canaletto's oeuvre. As it was not among the views Visentini etched, there seem to have been no painted repetitions of it, nor are there any workshop variants.

EF

NOTES

1. Constable and Links 1989, nos. 262, 267 (*Grand Canal, Looking Northeast from the Fondamenta della Croce* and the *Canale di Santa Chiara,* both in private collections). For a facsimile of the sketchbook, see Giovanna Nepi Scirè, *Canaletto's Sketchbook* (Venice, 1997).
2. Moschini 1954, p. 30.

19. *Campo Sant'Angelo, Venice*

Oil on canvas, $18\frac{3}{8} \times 30\frac{1}{2}$ in. (46.7 × 77.5 cm)
In a frame made by Julius Lowy in 1965, imitating those on cats. 16, 17.
Cleaned in 1972 by John Brealey in London.

PROVENANCE
Part of the Harvey series, see cat. 16; [Colnaghi, London, 1965; sold to Wrightsman, together with cat. 18]; Mr. and Mrs. Charles Wrightsman, New York (1965–his d. 1986; cat., 1973, no. 5); Mrs. Wrightsman (from 1986).

EXHIBITED
Same as cat. 16, plus: Royal Academy of Arts, London, November 27, 1954–February 27, 1955, "European Masters of the Eighteenth Century," no. 3.

LITERATURE
Moschini 1954, fig. 131; Fahy 1973, pp. 43–47 no. 5; Constable and Links 1989, vol. 2, pp. 325–26 no. 274.

This square near the Teatro La Fenice is little changed today, except for the loss of the campanile and the church of Sant'Angelo Michele, almost at the center of the composition: it was destroyed in 1837. The Oratorio dell'Annunciata, founded in the tenth century and frequented by pious Venetians to this day, stands to the right. Nearby are two rings (still in the wall) for tying up horses.[1] Set back between the two buildings is the entrance to the cloister of the former monastery of Santo Stefano, now occupied by the Venetian tax offices.

The large fifteenth-century palace at the left is the former Palazzo Zeno, today known as the Palazzo Duodo. The top of the leaning campanile of Santo Stefano can be seen above the roofs at the left. The palace on the right side of the square, with a

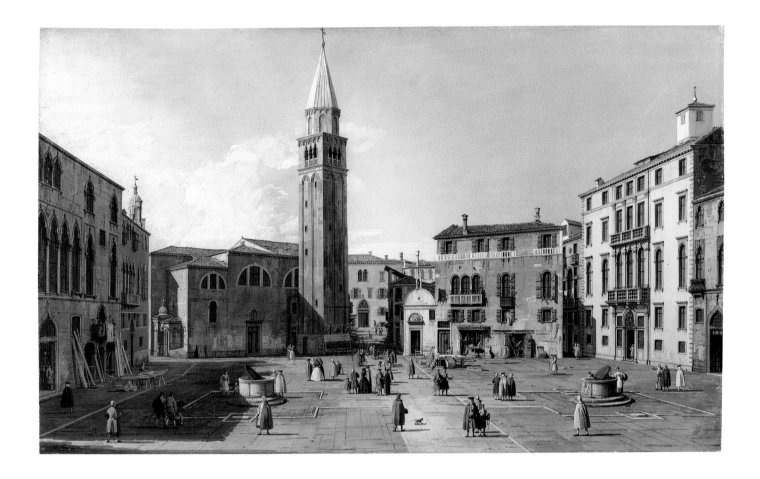

seventeenth-century frontispiece above and around the entrance, is the former Palazzo Trevisan, now the Palazzo Pisani.

Numerous groups of people are walking in the *campo,* which contains two well heads with hinged wooden lids. Around the square are several carpenters' or cabinetmakers' shops, including a prominent one at the left with planks of wood and a workbench on the pavement outside. A second, with a completed table and various articles of furniture outside, is located to the right of the oratory. Paintings displayed for sale are hung on the wall at the foot of the campanile at the center.

A series of preparatory drawings by Visentini indicates that the present painting was originally intended to be reproduced in the second edition of *Prospectus magni canalis venetiarum* (see

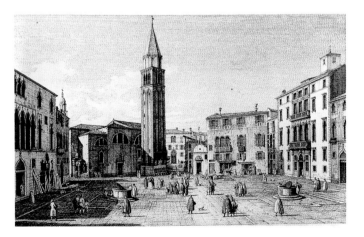

Fig. 1. Antonio Visentini, drawing of the painting. Ink on paper, 10 × 17 in. (25.4 × 43.2 cm). British Museum, London

cat. 16). Visentini made two sets of preparatory drawings for the etcher: one (in the Museo Correr) of forty-five outline drawings, and another (in the British Museum) of forty-five highly finished drawings. Although drawings were made of the present picture (fig. 1), an etching of it was not published in the album. Three other paintings were similarly omitted.[2] Since Visentini made drawings of the painting that were obviously intended for the etcher, it can reasonably be assumed that this view originally belonged to Joseph Smith, especially as the British Museum series is known to have belonged to him.

Another painting from the Harvey series for which there is a Visentini drawing has been mistakenly identified as being in the Wrightsman collection.[3] EF

NOTES

1. J. G. Links, *Canaletto* (London, 1994), p. 91.
2. F. J. B. Watson, "Notes on Canaletto and His Engravers, II: Canaletto and Visentini," *Burlington Magazine* 92 (December 1950), pp. 351–52.
3. Vivian 1971 (figs. 33, 34) captions an illustration of Canaletto's *Campo Santa Margherita* as being in the Wrightsman collection; she does not discuss the painting in her text.

20. An Island in the Lagoon with a Church and a Column

Oil on canvas, 20 × 26 ⅝ in. (50.8 × 67.6 cm)

PROVENANCE
Sir William Irby, first Lord Boston (until his d. 1775; said to have purchased it in Italy shortly after it was painted), Boston, Lincolnshire; the Barons Boston (1775–1942); George Florance Irby Boston, sixth Baron Boston, Hedsor, Buckinghamshire (d. 1941; sale, Christie's, London, March 6, 1942, lot 52, with pendant now in Saint Louis, Missouri; the pair to Leger for 504 guineas); [Leger Galleries, London]; Mrs. John Hall (in 1962); Patrick C. Hall, Longford Hall, Newport, Shropshire (sale, Sotheby's, July 6, 1966, lot 64, for £16,000, to Agnew); [Agnew's, London, 1966–67; to Rust]; David Rust, Washington, D.C. (1967–86; to Harari & Johns); [Harari & Johns Ltd., London, 1986–87; sold to Wrightsman]; Mrs. Charles Wrightsman, New York (from 1987).

EXHIBITED
British Institution, London, 1860, no. 71 (lent by Lord Boston).

LITERATURE
André Corboz, *Canaletto. Una Venezia immaginaria* (Milan, 1985), vol. 1, pp. 259, 264, and vol. 2, pp. 444, 651 no. P 312; Constable and Links 1989, vol. 1,

p. 138, and vol. 2, pp. 453–54 no. 487; New York 1989–90, pp. 221–22 under no. 62; Charles Beddington, "Bernardo Bellotto and His Circle in Italy, Part I: Not Canaletto but Bellotto," *Burlington Magazine* 146 (October 2004), p. 674.

RELATED WORK
SAINT LOUIS, Missouri, The Saint Louis Art Museum (12:1967). Canaletto, *An Island in the Lagoon with a Gateway and a Church* (fig. 1). Oil on canvas, 20 ⅛ × 27 in. (51 × 68.5 cm).

VERSION
LONDON, private collection (in 1962; formerly with Agnew, as "The Lido, Venice," attributed to Bellotto). Oil on canvas, 20 ⅛ × 28 ⅞ in. (51 × 73.5 cm). Constable and Links 1989, vol. 2, p. 419 under no. 487.

In the foreground is a canal lock, with its sluice gates at an angle to the picture plane; to the right stand a column, surmounted by a statue of a crouching figure, and a domed church. Clustered in the middle distance on the left are a bridge, farmhouse, square tower, campanile, and pyramid; on the horizon rises a city with domed churches, campanili, and unusually tall towers. Several men populate the scene: one leans on the block of stone in the lower right and stares at the viewer; another sits on the lock, his back to the viewer; a third either fishes or helps to tie up a boat; and a fourth trots away on a white horse.

This is an unusual work for Canaletto in that it is not a record of an actual place but rather an imaginary composition. Early in

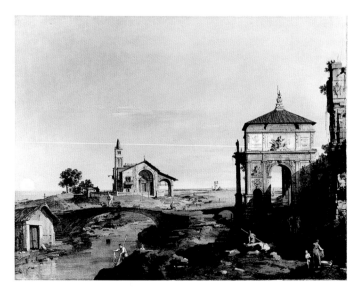

Fig. 1. Canaletto, *An Island in the Lagoon with a Gateway and a Church.* Oil on canvas, 20 ⅛ × 27 in. (51 × 68.5 cm). The Saint Louis Art Museum, Museum purchase, 1967 (12:1967)

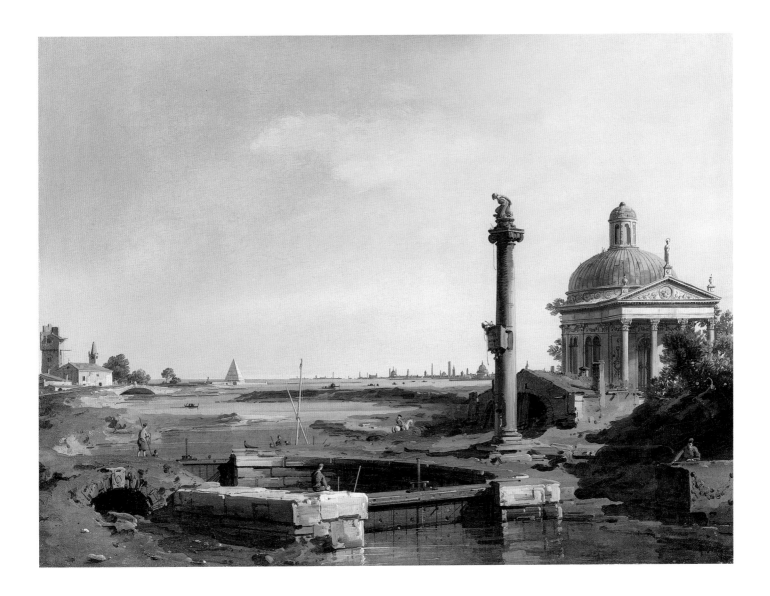

his career Canaletto had contributed imaginary architecture to the series *Tombeaux des princes,* large canvases of allegorical tomb paintings commissioned by the Irish entrepreneur Owen McSwiney in about 1726. It was not until the early 1740s, however, that Canaletto began to create the capricci that became such an important part of the paintings, etchings, and highly finished drawings that he produced for the remaining three decades of his life. Canaletto made a distinction, in the inscription on the frontispiece to his etchings, between "vedute prese da i luoghi" (topographical views) and "vedute ideate" (imaginary views). Most of his capricci consist of identifiable motifs assembled in unexpected combinations, such as the Colleoni monument in Venice, Eton College Chapel, and the Venetian lagoon. The Wrightsman capric-

cio and its pendant in the Saint Louis Art Museum (fig. 1) are completely imaginary. Whereas the domed church with the columned porch vaguely recalls the Pantheon in Rome, the pyramid that of Cestius in Rome, and the city on the horizon Padua, these elements have a dreamlike quality, far removed from the verities of topographical painting.

Certain aspects of the painting have led some scholars to question the attribution to Canaletto. The bold handling of paint, cool palette, crystalline atmosphere, dramatic shadows, low horizon, and strong diagonal movement through the composition set it apart from the artist's customary practice. No less an authority than W. G. Constable associated it with a group of paintings that have been ascribed to Canaletto's nephew Bernardo Bellotto (see

p. 75), but Constable maintained it was painted by Canaletto and tentatively dated it after the trip Canaletto and Bellotto made along the Brenta Canal to Padua in 1741/42.[1] Bellotto was amazingly precocious: by the age of fifteen he could toss off such good workshop repetitions that until quite recently they passed as originals by Canaletto. By the age of eighteen his own artistic personality began to emerge. His descriptive mentality is apparent in the four views of Venice he painted for Field Marshal von der Schulenburg, documented in November 1740, showing his predilection for a cool palette combined with a fluent technique.[2] His hand is visible in the two small pendant capricci in the Museo Civico at Asolo, once thought to be by Canaletto.[3] They are comparable to the Wrightsman painting in their lagoon settings with architectural ruins in the foregrounds on one side, the space receding diagonally to low horizons, and even include such shared motifs as the pyramid in the middle distance. The compositional similarities serve to point up their differences: the larger scale of Bellotto's figures, his layered impasto, and—a telltale mark of his —the whiplike weeds sprouting from the tops of the ruins. The Wrightsman canvas must date from this moment when uncle and nephew worked side by side, as equally talented painters, describing kindred scenes but distinguishable all the same.

EF

NOTES

1. Constable and Links 1989, vol. 1, p. 138. The examples Constable cited include two capricci with "Paduan reminiscences" (Constable's nos. 495, 497). The pendant in the Saint Louis Art Museum was attributed to Bellotto by Terisio Pignatti and Francesco Valcanover in 1976, according to Judith Walker Mann, "Baroque into Rococo: Seventeenth and Eighteenth Century Italian Paintings," *Saint Louis Art Museum Bulletin* 22, no. 2 (winter 1997), p. 47 n. 8.
2. For two of the von der Schulenburg canvases, see Bożena Anna Kowalczyk, in *Bernardo Bellotto and the Capitals of Europe,* ed. Edgar Peters Bowron, exh. cat., Museo Correr, Venice, and Museum of Fine Arts, Houston, Texas (New Haven and London, 2001), pp. 4–6.
3. Reproduced in color in Bowron, *Bernardo Bellotto,* pp. 117, 119.

21. *Warwick Castle*

Oil on canvas, 16 7/8 × 28 1/4 in. (42.9 × 71.8 cm)

PROVENANCE
Francis Greville, Baron Brooke, created 1746 Earl Brooke, 1759 Earl of Warwick, probably kept in his London residences (until his d. 1773); the Earls of Warwick, moved to Warwick Castle, Warwickshire, by 1846;[1] ownership passed in 1969 to the seventh earl's son, David Lord Brooke (who succeeded his father as the eighth Earl of Warwick in 1984); sold from Warwick Castle in 1977; Robert H. Smith, Washington, D.C. (1977–90; consigned to Carritt); [David Carritt Ltd., London, 1990; sold to Wrightsman]; Mrs. Charles Wrightsman, New York (from 1990).

EXHIBITED
Palazzo Ducale, Venice, June 10–October 15, 1967, "I vedutisti veneziani del Settecento," no. 78.

LITERATURE
Hilda F. Finberg, "Canaletto in England," *Walpole Society Annual* 9 (1921), pp. 40–41, 68; Buttery 1987, pp. 439–42, 445, fig. 14; Constable and Links 1989, vol. 2, p. 429 no. 443; *Artemis 89–90,* Annual Report for 1989–90, and Annual General Meeting, January 25, 1991 [Luxembourg, 1991], no. 10.

RELATED DRAWING
LONDON, Sotheby's, July 2, 1997, lot 53. Ink and gray wash on paper, 12 1/2 × 22 3/4 in. (31.7 × 57.8 cm). Constable and Links 1989, no. 758.

VERSIONS
MADRID, Museo Thyssen-Bornemisza (1978.13) (fig. 2). Oil on canvas, 29 1/2 × 47 1/2 in. (75 × 120.5 cm). Constable and Links 1989, no. 445.
NEW HAVEN, Connecticut, Yale Center for British Art (B1994.18.2) (fig. 1). Oil on canvas, 28 1/2 × 47 1/4 in. (72.4 × 120 cm). Constable and Links 1989, no. 444.

The Norman castle of Warwick is located in the West Midlands of England, about twenty miles southeast of Birmingham. It is seen here from the south, with two bridges on the left leading across Castle Meadow, a small island in the River Avon, and a third, much larger bridge on the far right. The earthen rampart to the west of the castle was created in the year 914 by Ethelfreda, daughter of Alfred the Great. Most of the existing building dates from the first half of the sixteenth century; Caesar's Tower, at the eastern end of the castle, was constructed in the first half of the fourteenth century. On the far right is a glimpse of the town of Warwick and the spire of Saint Nicholas Church. When Canaletto made the painting, the property belonged to Francis Greville (1719–1773), subsequently first Earl of Warwick but then known as Lord Brooke. In the late 1740s Greville hired Lancelot "Capability"

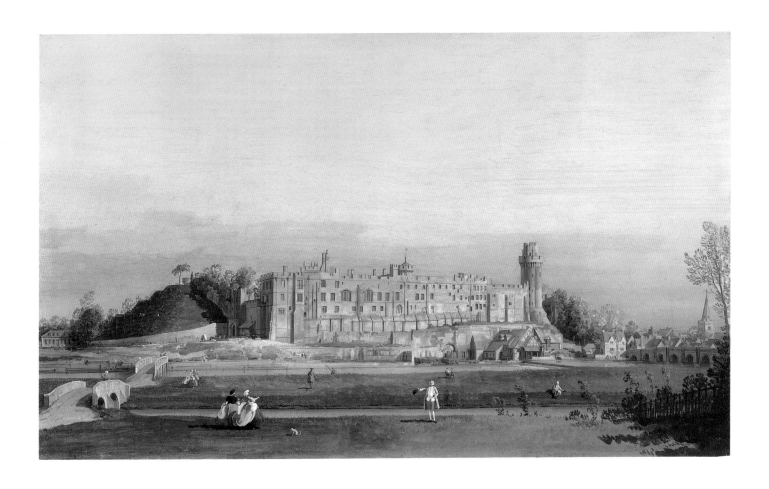

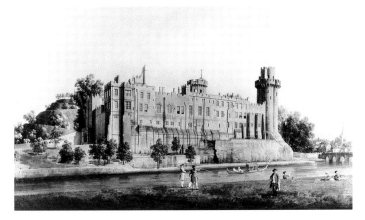

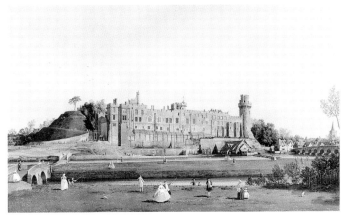

Fig. 1. Canaletto, *Warwick Castle: The South Front*. Oil on canvas, 28 ½ × 47 ¼ in. (72.4 × 120 cm). Yale Center for British Art, New Haven, Connecticut

Fig. 2. Canaletto, *Warwick Castle: The South Front*. Oil on canvas, 29 ½ × 47 ½ in. (75 × 120.5 cm). Museo Thyssen-Bornemisza, Madrid

Brown (1716–1783) as an architect and landscape gardener to renovate the castle and to carry out extensive changes in the park.

Canaletto made five paintings of the castle (three of the south front, one of the east front, and one of the courtyard) and five highly finished drawings (one of the south front, one of the east front, one of the courtyard, and two of the town). For his work at Warwick he received payments from Lord Brooke's account at Hoare's Bank in July 1748, March 1749, and March and July 1752; he also received a payment from Brooke's estate accounts in July 1748. Although it is generally agreed that the payments indicate that Canaletto made two visits to Warwick before his brief trip to Venice, in 1751, and one following his return, it is more likely that he stopped at Warwick only twice, in 1748 and again in 1752. (The first payment to Capability Brown dates from December 1749.)

The Wrightsman canvas apparently shows the castle as Canaletto first saw it in the spring of 1748, with construction work already under way beneath Ethelfreda's Mound. A canvas in the Yale Center for British Art (fig. 1) shows essentially the same scene, with more foreground, less sky, different figures, and after the replacement of the two largest windows in the state apartments. In August 1748 a visitor wrote that "the windows of it are new, but made in the Gothic style and very pretty."[2] With their bright white frames, they are quite conspicuous in the Yale painting. A version in the Museo Thyssen-Bornemisza, Madrid (fig. 2), differs from the Wrightsman and Yale paintings in having a closer viewpoint, with the castle seen at an angle: the mill and weir at the base of Caesar's Tower have been eliminated; large trees have been added below and to the left of the castle; and the Scots pine at the top of Ethelfreda's Mound and a wooden bridge on the left have been overpainted—it is an ideal view of what the grounds would look like after Brown's improvements. Scholars have speculated about which payments are for which pictures, but only the Wrightsman painting can be firmly dated because it shows the old Jacobean windows.[3]

As the painting is about one-fourth the size of the Yale and Thyssen canvases, it may be possible to identify it as the small painting for which Canaletto was paid ten guineas by one of Brooke's rent receivers on July 28, 1748. Although the estate-accounts volume describes the cash payment as "To Seign' Canal for his Drawings of Warwick Castle," Canaletto himself wrote out the receipt that the payment was for "a little picture that I painted of My Lord's castle."[4] The composition of the only extant drawing by Canaletto of the south front corresponds quite closely with that of the Yale canvas, and its highly finished character suggests that it was executed after the painting rather than as a preparatory study for it as some writers have assumed.[5] No doubt Canaletto made working drawings on the spot, similar to his free studies of the Grand Canal in the Cagnola sketchbook in the Accademia, Venice, and later used them to work up paintings and independent drawings in his London studio in Silver Street (now Beak Street, in Soho).

EF

NOTES

1. Described by H. T. Cooke, *Present State of the Castle* (Warwick [privately printed], 1846); cited by Buttery 1987, p. 445 n. 35.
2. Buttery 1987, p. 439.
3. Buttery (ibid., 1987, pp. 438–41) proposed the Wrightsman picture probably was the first, followed by the Yale, and then the Thyssen-Bornemisza versions, but in a later publication (*Canaletto and Warwick Castle* [Chichester, Sussex, 1992], pp. 22–27), he revised the order, placing the Yale canvas last and connecting it with the March 1749 payment; Julia Marciari Alexander (in Malcolm Warner and Julia Marciari Alexander, *This Other Eden: Paintings from the Yale Center for British Art,* exh. cat., Art Gallery of New South Wales, Sydney; Queensland Art Gallery, Brisbane; and Art Gallery of South Australia, Adelaide [New Haven and London, 1998], p. 78) also called the Yale canvas "the last in the series of three views."
4. "A di 28 Luglio 1748 Londra. Ricevo Io Giò: Antonio Canal dal fator del Ecc.ᵐᵒ Milord Bruk. dieci ginè, e queste per il prezzo di un quadretto da me dipinto con la vista del Castello di detto Milord." The receipt, in the Warwick County Record Office, was published by Buttery 1987, p. 439. Links ("Canaletto, 1975–1988: A Review," in Constable and Links 1989, vol. 1, p. lxvi) argued that the receipt for ten guineas was for the Wrightsman canvas.
5. Buttery 1987, p. 442, and Roberto Contini, *Seventeenth and Eighteenth Century Italian Painting: The Thyssen-Bornemisza Collection* (London, 2002), p. 266.

BERNARDO BELLOTTO

(1722–1780)

The great Venetian view painter known in Germany, eastern Europe, and Russia as Canaletto, Bernardo Bellotto spent most of his life working as a court painter in northern Europe. He was the son of the eldest of Canaletto's three sisters, Fiorenza Domenica, who had married Lorenzo Bellotti. Trained in his uncle's workshop, Bernardo was enrolled in the Fraglia dei Pittori (the Venetian painters' guild) in 1738, which suggests that he had already developed into an independent painter by the age of seventeen. As a boy, he successfully imitated his uncle's brushwork and figure style, and, as a result, for a brief period their styles can be almost impossible to distinguish.

In the winter of 1740–41, Bellotto accompanied his uncle on a trip along the Brenta canal to Padua, and, in 1742, he traveled to Rome on his own, returning to Venice the following year via Florence and Lucca. The large view of the Campidoglio with Santa Maria d'Aracoeli at Petworth House (West Sussex), painted with inky shadows and lines outlining the architectural details, resulted from this trip. In 1744 Bellotto left Venice for Lombardy, where he created topographical views, such as the charming Vaprio d'Adda (Metropolitan Museum, New York), as well as magnificent views of Verona and Turin. In these townscapes Bellotto forged his personal style, showing a predilection for cool colors, especially deep greens, a fondness for intense contrasts of light and shade, and no interest in aerial perspective.

A year after Canaletto moved to England, Bellotto accepted an invitation from Frederick Augustus III (1696–1763), elector of Saxony and king of Poland, to work in Dresden. From 1747 until early 1753 Bellotto painted fourteen large views of Dresden—his finest works—to be hung in the royal paintings gallery in the Stallhof, Dresden (now in the Gemäldegalerie Alte Meister, Staatliche Kunstsammlungen, Dresden). Between 1753 and 1756 Bellotto painted another series of eleven views of the town of Pirna, and, between 1756 and 1758, five of the fortress of Königstein. In these panoramas, peasants and animals are larger in scale and more individual than those in his uncle's works, as well as more descriptive, yet without his uncle's virtuosity.

In 1756 Frederick the Great of Prussia invaded Saxony, and Augustus III fled to his other capital, Warsaw; Bellotto presumably left Dresden to complete the last of his commissions at Königstein. In 1759 he moved to Vienna, where he painted views of the newest imperial residences and city scenes for the empress Maria Theresa and views of the new Liechtenstein Garden Palace on the outskirts of Vienna for Josef Wenzel, prince of Liechtenstein. In January 1761 Bellotto settled in Munich, where he remained for less than a year before returning to Dresden.

Accepting the position of court painter to Frederick Augustus's successor, Stanisław II Poniatowski, Bellotto moved on to Warsaw in 1766. To decorate the king's palace of Ujasdów outside Warsaw, he painted large views of Rome, based on Piranesi's etchings; for the Royal Castle in Warsaw, he produced panoramic views of the city. In contrast to Canaletto, who worked for the tourist market, virtually all of Bellotto's employment was for royal residences and galleries; thus his greatest paintings remain in Dresden, Vienna, and Warsaw.

EF

ABBREVIATIONS

Kozakiewicz 1972. Stefan Kozakiewicz. *Bernardo Bellotto*. 2 vols. London, 1972.

Venice, Houston 2001. Edgar Peters Bowron, ed. *Bernardo Bellotto and the Capitals of Europe*. Exh. cat., Museo Correr, Venice, and Museum of Fine Arts, Houston. New Haven and London, 2001.

22. *Pirna: The Obertor from the South*

Oil on canvas, 18 ¼ × 30 ¾ in. (46.4 × 78.1 cm)
The Metropolitan Museum of Art, New York, Wrightsman Fund, 1991 (1991.306)

PROVENANCE

?Count Ozarowski, Warsaw (Czernaików); [K. Majewski, Warsaw; probably until about 1925]; private collection (about 1925–about 1967; sold to Gregor); Dr. Horst Gregor, Berlin (about 1967–87; sold to Pokutta); [Norbert Pokutta, Munich, 1987; sold to Speelman]; [Edward Speelman, London, 1987–90; half share sold to Harari & Johns] [Edward Speelman and Harari & Johns, London, 1990–91; sold to the Metropolitan Museum]; purchased in 1991 through the Wrightsman Fund for the Metropolitan Museum.

LITERATURE

Edgar Peters Bowron, review of *Bernardo Bellotto: Dresda, Vienna, Monaco (1747–1766)*, by Alberto Rizzi, *Burlington Magazine* 140 (January 1998), p. 48.

VERSIONS/COPIES

ALUPKA, Ukraine, Alupka State Museum. Oil on canvas, 53 ⅛ × 94 ⅞ in. (135 × 241 cm). Kozakiewicz 1972, no. 208.

BERLIN, Kaiser Friedrich Museum (503 C; destroyed in 1945). Oil on canvas, 18½ × 30¾ in.(47 × 78 cm). In place of the carriage on the left, a woman rides a white horse to the left; two figures converse in center foreground. Kozakiewicz 1972, no. 209.

DRESDEN, Gemäldegalerie Alte Meister, Staatliche Kunstsammlungen (624). Oil on canvas, 53⅛ × 92⅞ in. (135 × 236 cm). A carriage approaches from the left, preceded by a runner. Kozakiewicz 1972, no. 207.

LENINGRAD, Soviet Government museum sale (Lepke, Berlin, November 6–7, 1928, lot 352). Oil on canvas, 23¼ × 33½ in. (59 × 85 cm). Kozakiewicz 1972, no. 495.

MUNICH, art market (in 1967). Oil on canvas, 17¾ × 25⅞ in. (45.2 × 65.7 cm). By an early nineteenth-century imitator of Bellotto. Kozakiewicz 1972, no. 496.

ETCHING

Bernardo Bellotto, *Pirna: The Obertor from the South*. Plate, 13⅝ × 20⅝ in. (34.6 × 52.4 cm). Inscribed: *Vue de La Ville de Pirne devant la porte nommé OberThor, avec La forteresse Sonnestein. Peint et gravé par Ber: Bellotto dit Canaletto Pein:R:* (fig. 1).

This view takes its name from the tower rising above the gatehouse in front of the fortified walls of the town of Pirna. The high building on the hill to the right is the castle of Sonnestein. To the left of the Obertor, silhouetted against the sky, are the roof and bell tower of the Marienkirche, and on the far left is the spire of the Rathaus. A coach-and-four with three passengers approaches from the left; various figures stand about in the foreground, including a well-dressed couple who converse on the left. When the picture was painted, Pirna was a small town on the Elbe, about ten miles southeast of Dresden. In 1826 the Obertor and the walls were demolished to make way for expanding suburbs; today the area is engulfed in an industrial zone of Dresden.

On April 26, 1753, Bellotto was issued a warrant addressed to the bailiff of Pirna, instructing the local officials to assist the artist while he made drawings of the town.[1] In the following three years, Bellotto produced eleven panoramic views of the town and its castle. As with the artist's earlier paintings of Dresden, he made a set of replicas—almost simultaneously—for the prime minister, Count Heinrich Brühl. The elector's painting of Pirna with the Obertor is still in Dresden; the Brühl variant was acquired by Catherine the Great, who purchased most of the prime minister's collection from his heirs in 1768. The view of the Obertor was deposited in the Pushkin Museum, Moscow, in 1930 and was transferred to the Alupka State Museum (Alupka, Ukraine) in 1956.

The royal and the Brühl canvases are in a large format, almost all of them about 53 inches high and 94 inches wide (135 by 240 centimeters). The present painting, like most of the replicas that Bellotto painted for ordinary paying customers, is cabinet size, about 19 by 31½ inches (48 by 80 centimeters). These small replicas could have been painted anytime between 1753, when Bellotto started the large-format series, and 1758, when he moved to Vienna, or between 1762 and 1767, when he returned to Dresden for his second Saxon period. All of the autograph replicas agree in details of the architecture, although there are variations in the staffage. To judge from Bellotto's increasingly broader handling of paint, they probably date from about 1755–56.

The view of the Obertor is also the subject of one of Bellotto's five etchings of Pirna (fig. 1), which—because they bear the combined royal arms of Saxony and Poland and the title "Peintre royal" on the plate—can be dated to before 1763. (Both of Bellotto's Dresden patrons, Augustus III and Count Brühl, died in October 1763.) EF

NOTE

1. April 26, 1753. "Auf allerduchlauchtigste hiermit ergehende Verordnung hat der Amtmann Crusius in Pirna, auch sämtliche Vasallen und Gerichtsobrigkeiten, dem Königl. Hofmahler Bernardo Belotto Canaletto, welchem die Fertigung derer Zeichnungen über die Situations derer Gegenden um Pirna und sonst aufgetragen worden, auf dessen besonderes Anmedlen, mit allem Verlangenden ohnweigerlich zu assistieren, und ihme auf keinerlei Weise noch Wege etwa hinderlich zu sein, vielmehr mit allem enforderlichen, sonder die mindeste Widerrede oder Aufenthalt an Hand zu gehen." Briefe, Erlasse und sonstige Schreiben an Künstler betr. (Letters, edicts, and other writings concerning the artist), fol. 97ff., Hauptstaatsarchiv, Dresden, loc. 8575. Published by Moritz Stübel, "Der jüngere Canaletto und seine Radierungen," *Monatshefte für Kunstwissenschaft* 4 (1911), p. 474.

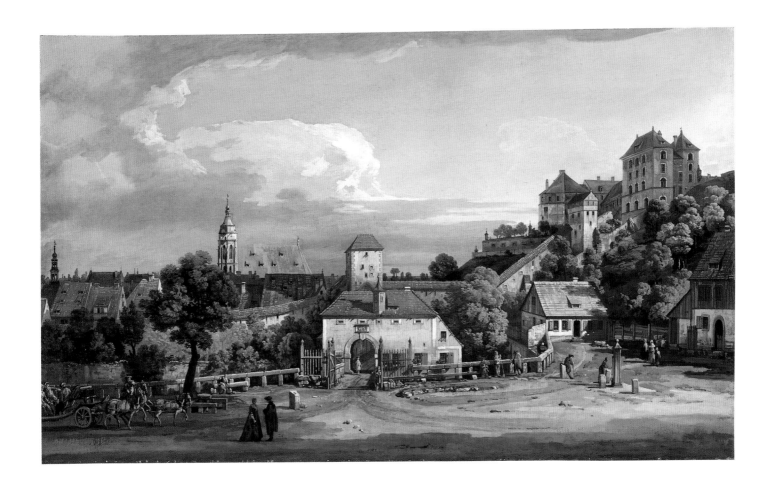

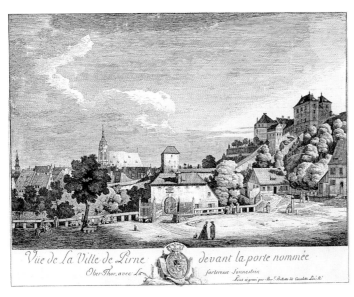

Vue de La Ville de Pirne devant la porte nommée
Ober-Thor, avec La forteresse Sonnestein
Peint et gravé par Ber.d Belloto dit Canaletti Peins.r.R.l

Fig. 1. Bernardo Bellotto, *Pirna: The Obertor from the South*. Etching, plate,
13⅝ × 20⅝ in. (34.6 × 52.4 cm). The Metropolitan Museum of Art, New York,
Harris Brisbane Dick Fund, 1953 (53.601.329)

FRANCESCO GUARDI

(1712–1793)

Francesco Guardi is renowned chiefly for townscapes that convey the watery atmosphere of his native Venice, so very different in style and in mood from Canaletto's precise records of the city. A mature artist before he began to paint his evanescent views, Guardi spent the first half of his life as an anonymous assistant to his much older brother Gianantonio (1699–1760), a figure painter who provided altarpieces for unimportant churches and small cult paintings for private individuals. The degree to which the Guardi brothers actually collaborated on the same paintings is not easily determined. Francesco's earliest signed work, A Saint in Ecstasy, in the museum at Trent, is a fairly conventional picture based, apparently, on an etching after Giovanni Battista Piazzetta (1683–1754) and probably dates from soon after 1740. Although Francesco was still producing Baroque figure paintings such as A Miracle of a Dominican Saint of 1763, now in the Kunsthistorisches Museum, Vienna, after his brother's death, he had already, in about 1750, begun a more individualistic career by creating landscapes, either copied from or in the style of Marco Ricci (1676–1730), as well as interiors in the manner popularized by Pietro Longhi (1702–1785).

Some of Guardi's first views were copied from Canaletto's works or based on etchings after them (see cat. 17). There seems, however, to be little basis for the assertion that Guardi was a "good pupil of the celebrated Canaletto," as the Venetian Senator Pietro Gradenigo wrote in his diary in 1764.[1] The early scenes are frequently signed or initialed as though to draw public attention to his name as an independent artist, a habit that he seems to have abandoned as he established himself.

In spite of these attempts to emulate Canaletto, Guardi never achieved the success of his predecessor. While he enjoyed some popularity with the English in the second half of the eighteenth century, the rise of Neoclassicism turned their attention increasingly toward antiquity. Rome rather than Venice became the focal point of the Grand Tour. In any case, Guardi's painting was of a far more Rococo character than Canaletto's and therefore less likely to appeal to the nascent Neoclassical taste.

Guardi rarely dated his work, but a sufficient number of his paintings are datable on historical, topographical, or other external grounds to establish a reasonably coherent chronology of his stylistic development. His early landscapes, generally painted on a dark reddish bole ground, have turbulent skies and a charged atmosphere. The pair of large canvases at Waddesdon Manor, Oxfordshire, are characteristic of this phase. With the passage of time Guardi adopted a lighter palette, as may be seen in the series of twelve paintings (in the Louvre and other French museums) taken from Giambattista Brustolon's etchings after drawings by Canaletto of the Feste Dogale (ceremonies at the installation of the doge), published between 1763 and 1766. Guardi's change in style is evident in his works commemorating the trip to Venice in 1782 by the Russian grand duke Paul Petrovich and his wife—the so-called Conti del Nord—and in the views, commissioned by the city of Venice, recording the visit of Pope Pius VI in the same year.

Guardi did not become a member of the Accademia until 1784, when he was seventy-two years old. He seems to have had no assistants apart from his son Giacomo (1764–1835), who appears to have inserted figures in a number of his father's late works as well as to have completed paintings and drawings left unfinished at his death. The activity of Francesco Guardi's younger brother, Nicolò, remains to be defined. His sister, Maria Cecilia, married Giambattista Tiepolo (see p. 84) in 1719.

EF

ABBREVIATIONS

Chiovaro 2001. Simonetta Chiovaro, ed. Ville venete. La provincia di Treviso. Venice, 2001.

Fahy 1973. Everett Fahy, in The Wrightsman Collection, vol. 5, Everett Fahy and Francis Watson, Paintings, Drawings, Sculpture. New York, 1973.

Haskell 1960. Francis Haskell. "Francesco Guardi as Vedutista and Some of His Patrons." Journal of the Warburg and Courtauld Institutes 23 (1960), pp. 256–76. Reprinted in Francis Haskell, Patrons and Painters, pp. 373–75. London, 1963.

Morassi 1973. Antonio Morassi. Guardi. Antonio e Francesco Guardi. 2 vols. Venice, 1973.

NOTE

1. Lina Livan, ed., Notizie d'arte tratte dai Notatori e dagli Annali del N. H. Pietro Gradenigo (Venice, 1942), p. 106, entry for April 25, 1764.

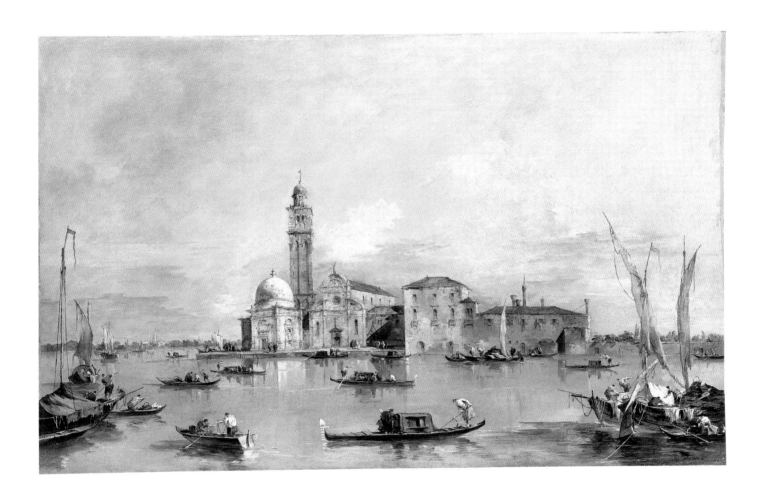

23. *The Island of San Michele, Venice*

Oil on canvas, relined, 19 × 30 ¾ in. (48.3 × 78.1 cm)
The painting was cleaned, relined, and coated with Ketone resin in December 1983 by Robert Shepherd in London. Painted on a gray ground, the picture has suffered from some deterioration along the bottom edge and along both sides, possibly as a result of damp under the stretcher bars. Otherwise the paint surface is well preserved.

PROVENANCE
[Arthur Tooth & Sons, London]; Walter Dunkels, England; S. Messer, Esq., Sussex; [Edward Speelman, Ltd., London; sold to Wrightsman, 1984]; Mr. and Mrs. Charles Wrightsman, New York (1984–his d. 1986); Mrs. Wrightsman (from 1986).

LITERATURE
Morassi 1973, vol. 1, pp. 250–51, 431 no. 650, and vol. 2, fig. 610; Luigina Rossi Bortolatto, *L'opera completa di Francesco Guardi* (Milan, 1974), p. 101 no. 195.

RELATED WORKS
AMSTERDAM, Rijksmuseum (A 3403). Oil on canvas, 5 ½ × 8 ½ in. (14 × 21.5 cm). Based on the Visentini etching (fig. 1). Morassi 1973, no. 653.
LONDON, Christie's, July 6, 1990, lot 79. Oil on canvas, 11 ⅞ × 18 ¼ in. (30.2 × 46.4 cm). The island is seen from the south, with the facade of the church in shadow; an extensive view of Murano occupies the left half of the composition.
MILAN, ex-collection Senator d'Adda. Oil on canvas, 10 ¼ × 13 ⅜ in. (26 × 34 cm). Similar to the London version. Morassi 1973, no. 651.
NEUILLY-SUR-SEINE, comte Guy du Boisrouvray (sale, Sotheby's, New York, October 27, 1989, lot 72). Oil on canvas, 6 × 8 ½ in. (15.2 × 21.6 cm). A late

work, the view is taken from the northwest, as in the Visentini etching (fig. 1). Morassi 1973, no. 652.

NEW YORK, George A. Hearn (d. 1913). Recorded in Frick Art Reference Library negative no. 12141. A weak version of the Visentini etching (fig. 1).

The church of San Michele in Isola and the adjoining former Camaldolensian monastery stand on the island of San Michele, which lies in the lagoon between the northeast side of Venice and the island of Murano. Designed in 1469 by Mauro Codussi (ca. 1440–1504), the church was the first and one of the most beautiful to be built in Venice in the Renaissance style. Although the facade of Istrian limestone vaguely recalls the austere facade of Leon Battista Alberti's Tempio Malatestiano at Rimini, built in 1450, it is capped with a semicircular Veneto-Byzantine gable. The brick campanile is an earlier structure, completed in 1460. The lofty interior of the church was originally graced with Giovanni Bellini's marvelous altarpiece of the *Resurrection of Christ* (ca. 1480) and Cima da Conegliano's *Sacra conversazione* (ca. 1495), both now in the Gemäldegalerie, Berlin. The hexagonal Emiliana Chapel, with its unusual limestone dome, was added to the complex in 1530 by the architect Guglielmo Bergamasco. In 1837 the canal separating San Michele from the neighboring island of San Cristoforo della Pace was filled in to form the municipal cemetery, now the resting place of many non-Italian luminaries.

While not a particularly favorite subject of painters, the island does appear in panoramic views of the lagoon taken from the Fondamente Nuove, such as those of the early 1720s by Gaspar van Wittel (1653–1736)[1] and Canaletto[2] and the much later ones by Francesco Tironi (ca. 1745–1797).[3] Not only was it the subject of

paintings by Guardi in the collection of John Strange, the British Resident in Venice,[4] but a glimpse of it also can be seen in one of Guardi's earliest view paintings, formerly in the collection of the comte du Boisrouvray, Neuilly-sur-Seine.[5] There the roof of San Michele in Isola and its campanile rise in the middle distance behind the island of San Cristoforo. The du Boisrouvray canvas also shows Codussi's dome, which, curiously, is not depicted in the Wrightsman painting.

The Wrightsman canvas is unique in that it presents a frontal view of San Michele: all the others show the island at an oblique angle from the northwest, giving prominence to the Emiliana Chapel, as seen in Visentini's etching (fig. 1), which served as a prototype for countless copyists.[6] The canvas probably dates from the early 1770s, making it an example of the artist's early maturity as a view painter.[7] Apparently, it does not have a pendant.

EF

NOTES

1. Giuliano Briganti, *Gaspar van Wittel* (Milan, 1996), p. 250 nos. 319–21.
2. For the Canaletto now in the Dallas Museum of Art, see Katharine Baetjer and J. G. Links, *Canaletto*, exh. cat., Metropolitan Museum, New York (New York, 1989), p. 138 no. 30; for another early example, see Irina Artemieva, in *Capolavori nascosti dell'Ermitage. Dipinti veneti del Sei e Settecento da Pietroburgo*, exh. cat., Castello di Udine (Milan, 1998), no. 120.
3. Jan Lauts, *Katalog: Alte Meister bis 1800*, Staatliche Kunsthalle Karlsruhe (Karlsruhe, 1966), vol. 1, p. 296, and vol. 2, p. 231, ill.
4. Strange mentioned a painting by Guardi of this subject in his house in Venice that he did not wish to sell, and in his sale in London on December 10, 1789, lot 221 was "Ten views of the different islands round Venice" by Guardi; see Haskell 1960, p. 269.
5. Sold at Sotheby's, New York, October 27, 1989, lot 76; offered there again, January 28, 2000, lot 88. Not to be confused with the much smaller late view of the island also formerly in the du Boisrouvray collection, listed here in Related Works. See Ewoud Mijnlieff, in *Painters of Venice: The Story of the Venetian "Veduta,"* ed. Bernard Aikema and Boudewijn Bakker, exh. cat., Rijksmuseum, Amsterdam (Amsterdam and The Hague, 1990), p. 217 no. 39.
6. The etching is part of a series of twenty views of the lagoon islands that was published in Pasquali's 1738 edition of Francesco Guicciardini's *Della istoria d'Italia*. They were reissued in 1777 as an album, *Isolario veneto* (see the fascimile, *Isolario veneto. Venti prospettive incise da Antonio Visentini*, ed. Dario Succi [Ponzano (Treviso), 2002]).
7. Morassi 1973, p. 431, states that it dates from the artist's youthful middle period; Luigina Rossi Bortolatto, *L'opera completa di Francesco Guardi* (Milan, 1974), p. 101, places it in the artist's first maturity.

Fig. 1. Antonio Visentini, *The Island of San Michele*. Etching, plate, 3⅛ × 6⅞ in. (8 × 17.4 cm). The Metropolitan Museum of Art, New York, Gift of Robert L. Manning and Bertina Suida Manning, in memory of William E. Suida, 1983 (1983.1216[18])

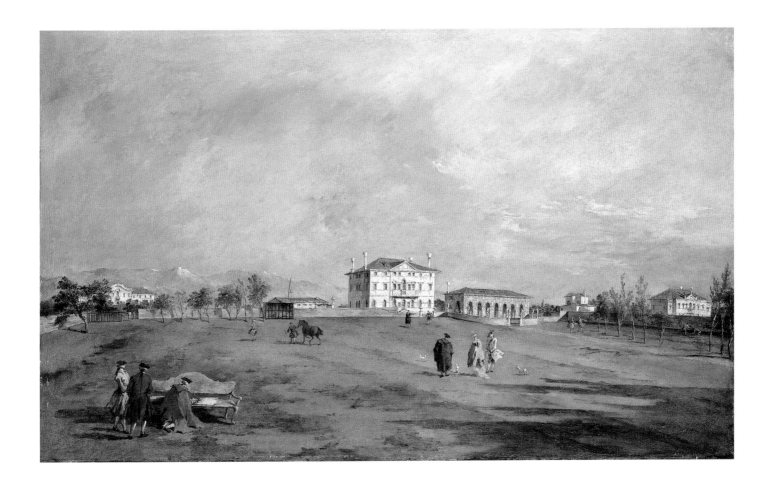

24. *The Villa Loredan, Paese*

Oil on canvas, 19 × 30 ¾ in. (48.3 × 78.1 cm)
Cleaned in 1941 or 1942 by Norman Hulme in London.

PROVENANCE
John Strange, Venice (his posthumous sale, European Museum, London,
May 27, 1799, either lot 49, "A superb chateau in the environs of Padua,
Guardi," lot 187, "A view near Padua Mr. Strange country seat, Guardi," or
lot 200, "A view near Padua, Mr. Strange's country house, Guardi"—none of
which apparently were sold;[1] Christie's, London, March 15, 1800, either one of
lot 97, "Guardi A pair of views near Padua, Mr. Strange's country house," or
one of lot 99, "Guardi Two, a superb chateau and companion, in the envi-
rons of Padua"); Colonel Milligan of Caldwell Hall, Burton-on-Trent,
Nottinghamshire (his sale, Christie's, London, March 13, 1883, either one of
lot 358, "A Pair of Views of Country seats near Venice with figures 20 × 24,"
or one of lot 359, "A Pair of Ditto," all four to Davies, for 700 guineas);
[Charles Davies, London]; [Colnaghi, London];[2] Harold Sidney Harmsworth,
first Viscount Rothermere (d. 1940);[3] private collection, London (1955);
[Herbert N. Bier, London; sold to Wrightsman, 1968]; Mr. and Mrs. Charles
Wrightsman, New York (1968–his d. 1986; cat., 1973, no. 12); Mrs.
Wrightsman (from 1986).

EXHIBITED
Royal Academy of Arts, London, November 27, 1954–February 27, 1955,
"European Masters of the Eighteenth Century," no. 89; Kunsthaus, Zurich,
1955, "Schönheit des 18. Jahrhunderts: Malerei, Plastik, Porzellan,
Zeichnung," no. 134 (lent by a private collector, London).

LITERATURE
Antonio Morassi, "Settecento inedito (II): VIII, Quattro 'Ville' del Guardi,"
Arte veneta 4 (1950), pp. 50–56; J. Byam Shaw, *The Drawings of Francesco Guardi*
(London, 1951), p. 65 no. 30; Rodolfo Pallucchini, *La pittura veneziana del
Settecento* (Venice, 1960), p. 248; J. G. Links, "Secrets of Venetian
Topography," *Apollo* 90 (September 1969), pp. 227–29; Fahy 1973, pp. 106–15
no. 12; Morassi 1973, vol. 1, pp. 255–56, 437 no. 682; Chiovaro 2001, pp. 393, 400.

The garden facade of the Villa Loredan, a three-storied block in
the Palladian style with a central triangular pediment, is seen across
a broad lawn. It is flanked on the right by an arcaded *barchessa* (rus-
tic storehouse) within a curved wall pierced by a gate. Farther to
the right are a sixteenth-century oratory and the Villa Pellegrini,

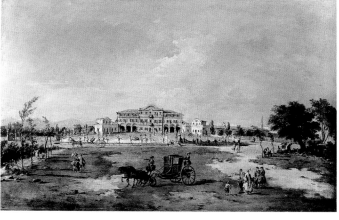

Fig. 1. Francesco Guardi, *The Villa Loredan*. Oil on canvas, 18¼ × 30⅛ in. (46.5 × 76.4 cm). Collection of James Fairfax, Bowral (New South Wales)

Fig. 2. Francesco Guardi, *The Villa del Timpano Arcuato*. Oil on canvas, 18⅞ × 30¾ in. (48 × 78 cm). Private collection

now the town hall of Paese. On the left is a low building beyond the garden wall, at the end of which is an aviary in which a golden pheasant can be recognized. Beyond the trees at the left is the Villa Pisani Sagredo, also known as the Villa del Timpano Arcuato because of its curved pediment. The season is early autumn, for the leaves are just turning brown, and the bluish foothills of the Alps in the distance are touched with the first snow.

In the foreground at the left, an artist, presumably Francesco Guardi himself, wearing a red cloak, kneels before a garden seat on which he is sketching the scene on an unusually large sheet of paper. Standing, watching him, are two men, one dressed in brown with his back to the spectator, the other in pale yellow in profile facing right. In the middle distance, two men and a woman, who wears a pale blue cloak over a pink skirt and a feathered headdress, play with three dogs, one of which begs upright on its hind legs. Farther off are other figures, one of them leading a horse.

This painting is one of a set of four views by Guardi, of identical dimensions, three of which represent villas at Paese, a village also known as Villa di Villa, about five miles from Treviso on the road to Castelfranco Veneto, and a fourth that depicts the courtyard of the Palazzo Contarini dal Zaffo in Venice (figs. 1–3). They are the only known painted views of this type by the artist. Drawings related to the paintings also survive: three of the entrance facade of the villa (fig. 4), two of the Villa del Timpano Arcuato, two of the courtyard of the Palazzo Contarini, as well as two of the rolling countryside seen from windows of the villa (fig. 5).[4] There may have been drawings of the garden facade of the villa that correspond more or less with the Wrightsman painting,

but if so, their whereabouts are unknown. A drawing of the entrance facade of the villa in the Ashmolean Museum, Oxford, bears the following inscription, which establishes the locality of the scene: "View of the Seat of S.E. Loredano at Paese near Treviso, at present in the possession of John Strange, Esq[r]. N.B. grass ground within the Fence; without, the post road from Treviso to Bassan."[5]

John Strange (1732–1799), diplomat, author, antiquarian, naturalist, and connoisseur, was the penultimate British Resident at Venice, from 1773 until 1790. He collected old master as well as modern paintings and drawings and was a patron of Guardi, some fifteen of whose paintings were among Strange's collection when he died. Like most English diplomatists of his day living in Italy, he dabbled in art dealing and, for instance, supplied six paintings by Guardi to Thomas Martyn, a Fellow of Sidney Sussex College, Cambridge.[6] While one of the figures in the foreground watching Guardi may indeed be Strange, the circumstances concerning the commission of the painting are not known, so one cannot be sure. Moreover, it is not clear why the set of four view paintings in Strange's possession included one of the courtyard of the Palazzo Contarini dal Zaffo, a fifteenth-century palace that was acquired in 1783 by the Manzoni, a family of rich silk merchants.

The villa seen here was commissioned in about 1719 by a member of the Loredan family from Giorgio Massari (1687–1766), a Venetian architect who often collaborated with Tiepolo.[7] Sometime before 1779 Count Gerolamo Antonio Loredan sold it to the marchese Giuseppe de Canonicis,[8] who also owned the Villa Pellegrini visible on the far right of the Wrightsman canvas,

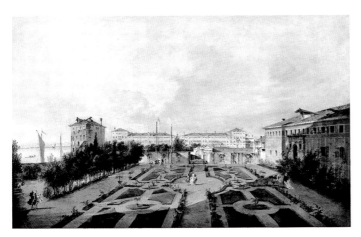

Fig. 3. Francesco Guardi, *The Garden of the Palazzo Contarini dal Zaffo*. Oil on canvas, 18 ⅞ × 30 ¾ in. (48 × 78 cm). The Art Institute of Chicago, Gift of the Marian and Max Ascoli Fund (1991.112)

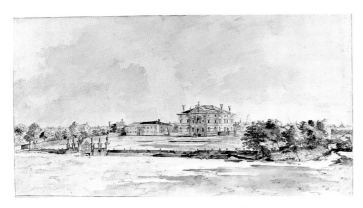

Fig. 4. Francesco Guardi, *The Entrance Facade of the Villa Loredan*. Pen and brown ink, brown wash, white gouache, over black chalk, 15 ½ × 30 ¼ in. (39.4 × 76.8 cm). The Metropolitan Museum of Art, New York, Rogers Fund, 1937 (37.165.69)

Fig. 5. Francesco Guardi, *View from a Window of the Villa Loredan*. Pen and brown ink with brown wash, 14 ¾ × 27 ¾ in. (37.5 × 70.5 cm). Ashmolean Museum, Oxford

and it may have been from his family that Strange rented the villa as a summer retreat during his official appointment at Venice. Although the villa was destroyed sometime before 1833, some of its outbuildings—including the *barchessa*—survive.[9]

The building history of the Villa Pellegrini indicates that the Loredan painting was done in the early 1780s: construction had begun in 1778, and the villa was occupied by its first inhabitants by 1783.[10] This dating is supported by the style of the costumes on the figures in the picture and by the woman's coiffure: her hair is piled up in a narrow shape with feathers or flowers on top in a manner that became fashionable in 1775 in Paris and somewhat later in other European centers.[11] EF

NOTES

1. Haskell 1960, p. 270 n. 64, believed these three views of Strange's country house "near Padua" are not to be confused with Guardi's views of his house "at Paese near Treviso"; the confusion of the name of a small and unfamiliar village in the Veneto, Paese, with the widely known city of Padua by the auctioneer preparing the catalogue of the earlier sale is readily understandable.

2. According to Winslow Ames ("The 'Villa dal Timpano Arcuato' by Francesco Guardi," *Master Drawings* 1, no. 3 [autumn 1963], p. 37), Rothermere acquired them from Colnaghi.

3. They are not listed in Paul G. Konody's catalogue, *Works of Art in the Collection of Viscount Rothermere* (London, 1932), nor were they included in the posthumous sale of part of the Rothermere collection at Christie's on December 19, 1941, although there were fifteen paintings by Guardi in the sale.

4. Antonio Morassi, *Guardi. Tutti i disegni di Antonio, Francesco e Giacomo Guardi* (Venice, 1975), pp. 153–55 nos. 419–26. For a discussion of the drawings, see J. Byam Shaw, *The Drawings of Francesco Guardi* (London, 1951), p. 65 no. 30. Richard Beresford and Peter Raissis (*The James Fairfax Collection of Old Master Paintings, Drawings and Prints,* exh. cat., Art Gallery of New South Wales, Sydney [Sydney, 2003], p. 100) believe the drawing of the view south over the plain of the Veneto (fig. 5) was taken from "possibly one of the upper-floor windows of the Villa Pisani Sagredo."

5. K. T. Parker, *Catalogue of the Collection of Drawings in the Ashmolean Museum*, vol. 2, *Italian Schools* (Oxford, 1956), p. 510. The inscription is in Strange's hand.

6. On Strange as a patron, see Haskell 1960, pp. 268–70.

7. Antonio Massari, *Giorgio Massari. Architetto veneziano del Settecento* (Vicenza, 1971), p. 34.

8. Giuseppe Mazzotti, *Le ville venete* (Treviso, 1952), p. 435.

9. Antonio Morassi, "Settecento inedito (II): VIII, Quatro 'Ville' del Guardi," *Arte veneta* 4 (1950), p. 56. According to Chiovaro 2001, p. 393, the *barchessa* was nearly totally destroyed by a fire in 1902 and then rebuilt.

10. Chiovaro 2001, p. 397.

11. F. J. B. Watson, "The Gulbenkian Guardis," *Burlington Magazine* 109 (February 1967), p. 98.

GIOVANNI BATTISTA TIEPOLO

(1696–1770)

Giovanni Battista Tiepolo was the last of the great Venetian painters and the greatest Italian painter of the eighteenth century. Although he is usually classified as a Rococo artist, his enormous frescoes were painted in the grand tradition of Paolo Veronese (ca. 1528–1588), Pietro da Cortona (1596–1669), and Luca Giordano (see p. 53). When he was very young he entered the studio of Gregorio Lazzarini (1655–1730); at eighteen he was an independent artist, and a year later he received his first recorded commission, the lunette Sacrifice of Abraham in the church of the Ospedaletto, Venice. Painted on a dark ground with harsh contrasts of light and shadow, it shows the influence of the tenebrist works of Giambattista Piazzetta (1683–1754).

The artist's earliest frescoes, such as the Glory of Saint Theresa in the vault of a side chapel of the church of the Scalzi, Venice (shortly after 1720), were painted with Girolamo Mengozzi Colonna (1688–1766), a specialist in quadratura (feigned-architecture painting) with whom Tiepolo collaborated for the next twenty years and without whose technical skill the daring illusionism of Tiepolo's mature work would have been far less effective. Between 1726 and 1728 Tiepolo executed frescoes in the cathedral and archbishop's palace at Udine, in which his personal idiom of light-filled, airy compositions gradually emerged. During the 1730s and 1740s he perfected his style in a prodigious series of frescoes for palaces, villas, and churches in Milan, Bergamo, and the Veneto. His masterpiece of this period is the fresco decoration of the central hall of the Palazzo Labia, Venice (see cat. 25). In 1750 Tiepolo was called to execute the greatest undertaking of his career, the frescoes in the archbishop's palace at Würzburg (see cat. 27). Returning to Venice in the autumn of 1753, Tiepolo decorated several villas in the Veneto and painted altarpieces for a number of churches, the most impressive being the huge altarpiece of Saint Thecla Freeing Este from the Plague in the cathedral of Este (1759).

In 1761 Charles III of Spain invited Tiepolo to Madrid, where he frescoed three ceilings in the recently built royal palace (see cat. 28); in addition, he painted seven altarpieces for the church of San Pascual at Aranjuez, the sketches for which reveal an almost mystic intensity (following Tiepolo's death in Madrid, the altarpieces were replaced with paintings by Anton Raphael Mengs [1728–1779] and his followers). During his lifetime Tiepolo's works were sought outside northeast Italy only by the courts of Spain and Russia and the German principalities.

His sphere of activity never extended to the intellectual centers of Paris, London, and Rome, the strongholds of Neoclassicism.

Tiepolo married Maria Cecilia Guardi, the sister of the painters Francesco and Giovanni Antonio Guardi (see p. 78). They had nine children, two of whom, Domenico (see p. 103) and Lorenzo (1736–1776), became painters who helped to complete many of their father's late works.

EF

ABBREVIATIONS

Fahy 1973. Everett Fahy, in The Wrightsman Collection, vol. 5, Everett Fahy and Francis Watson, Paintings, Drawings, Sculpture. New York, 1973.

Fort Worth 1993. Giambattista Tiepolo: Master of the Oil Sketch, ed. Beverly Louise Brown. Exh. cat., Kimbell Art Museum, Fort Worth, Texas. Milan, New York, and Fort Worth, 1993.

Levey 1986. Michael Levey. Giambattista Tiepolo: His Life and Art. New Haven and London, 1986.

Morassi 1962. Antonio Morassi. A Complete Catalogue of the Paintings of G. B. Tiepolo, including Pictures by His Pupils and Followers Wrongly Attributed to Him. London, 1962.

Pedrocco 1993. Filippo Pedrocco, in Massimo Gemin and Filippo Pedrocco, Giambattista Tiepolo. I dipinti: Opera completa. Venice, 1993.

Rotterdam 1996. Bernard Aikema and Marguerite Tuijn. Tiepolo in Holland: Works by Giambattista Tiepolo and His Circle in Dutch Collections. Exh. cat., Museum Boijmans Van Beuningen, Rotterdam. Rotterdam, 1996.

Venice, New York 1996–97. Giambattista Tiepolo, 1696–1770, ed. Keith Christiansen. Exh. cat., Museo del Settecento Veneziano—Ca' Rezzonico, Venice, and The Metropolitan Museum of Art, New York; 1996–97. New York, 1996.

Würzburg 1996. Tiepolo in Würzburg: Der Himmel auf Erden, ed. Peter O. Krückmann. Exh. cat., Residenz Würzburg. 2 vols. Munich and New York, 1996.

25. The Meeting of Antony and Cleopatra

Oil on canvas, 18¼ × 26¼ in. (46.4 × 66.7 cm)
Discolored varnish was removed in 1968 by Mario Modestini.

PROVENANCE
Angelo della Vecchia, Vicenza (by 1750); ?Huges Fourau,[1] Paris (his sale, Hôtel Drouot, Paris, March 1–2, 1869, lot 90); Rt. Hon. George Augustus Frederick

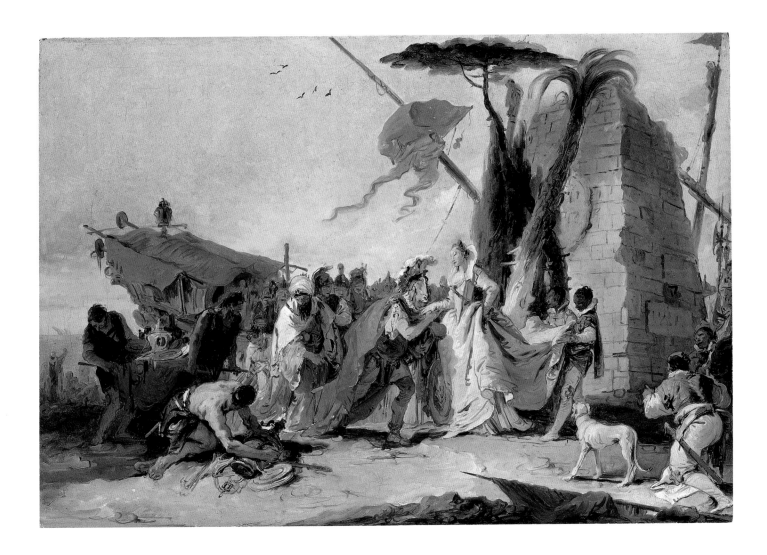

Cavendish Bentinck, London and Brownsea Island (his sale, Christie's, London, July 8–14, 1891, lot 600, to Colnaghi); [Colnaghi, London]; Baron Henri James de Rothschild, Paris (by 1909–d. 1946); his son, Baron Philippe de Rothschild (1946–68); [E. V. Thaw, New York, 1969; sold to Wrightsman]; Mr. and Mrs. Charles Wrightsman, New York (1969–his d. 1986; cat., 1973, no. 24); Mrs. Wrightsman (from 1986).

EXHIBITED
Petit Palais, Paris, 1935, "Exposition de l'art italien de Cimabue à Tiepolo," no. 445; Palazzo Giardini, Venice, 1951, "Mostra del Tiepolo," no. 66; Galerie Cailleux, Paris, 1952, "Tiepolo et Guardi: Exposition de peintures et dessins provenant de collections françaises publiques et privées," no. 30; Galerie des Beaux-Arts, Bordeaux, 1956, "De Tiepolo à Goya," no. 54; L'Oeil Galerie d'Art, Paris, 1967, "Venice: Eighteenth Century Venetian Paintings and Drawings," no. 21; Metropolitan Museum, New York, January 30–March 21, 1971, "Oil Sketches by Eighteenth Century Italian Artists from New York Collections," no. 32.

LITERATURE
Pompeo Molmenti, *G. B. Tiepolo. La sua vita e le sue opere* (Milan, 1909), p. 75; Roberto Longhi, *Viatico per cinque secoli di pittura veneziana* (Florence, 1946), p. 41; F. J. B. Watson, "Reflections on the Tiepolo Exhibition," *Burlington Magazine* 94 (February 1952), p. 44 n. 8; Morassi 1962, pp. 2, 43; Michael Levey, *Tiepolo: Banquet of Cleopatra,* Charlton Lectures on Art delivered at the University of Newcastle in 1963 (Newcastle upon Tyne, 1965), unpaginated; Fahy 1973, pp. 219–31 no. 24; George Knox, "Giambattista Tiepolo: Variations on the Theme of Anthony and Cleopatra," *Master Drawings* 12 (winter 1974), pp. 381, 383–85, 387; Terisio Pignatti, "Tiepolo a Palazzo Labia," in Terisio Pignatti, Filippo Pedrocco, and Elisabetta Martinelli Pedrocco, *Palazzo Labia a Venezia* (Turin, 1982), pp. 74–77; Levey 1986, pp. 145, 156–57, 160, 164; Beverly

Louise Brown, in Fort Worth 1993, pp. 252–55 and nn. 18–22 under nos. 35–37; Pedrocco 1993, pp. 397, 400 no. 379a, 418; Andrea Bayer, in Venice, New York 1996–1997, p. 32 under the year 1747; Jaynie Anderson, *Tiepolo's Cleopatra* (Melbourne, 2003), pp. 34, 125–26, 142; Adriano Mariuz, *Le storie di Antonio e Cleopatra. Giambattista Tiepolo e Girolamo Mengozzi Colonna a Palazzo Labia* (Venice, 2004), pp. 29–32.

DRAWINGS

FLORENCE, Museo Horne (6326). *Artavasdes Surrendering to Antony.* Brown ink and wash on paper, 15 × 11¼ in. (38 × 28.5 cm) (fig. 5).
LONDON, Victoria and Albert Museum (D.1825.159-1885). *Cleopatra.* Pen and wash, 8⅞ × 6¼ in. (22.6 × 15.8 cm).
LONDON, Victoria and Albert Museum (D.1825.186-1885). *Antony and Cleopatra with a Page.* Pen and wash over black chalk, 11⅞ × 8⅜ in. (30.2 × 21.2 cm).
LONDON, Victoria and Albert Museum (D.1825.221-1885). *Antony and Cleopatra.* Pen and wash over black chalk, 10¼ × 7½ in. (26.2 × 19 cm).
NEW YORK, Metropolitan Museum, Rogers Fund, 1937 (37.165.10). *The Meeting of Antony and Cleopatra.* Brown ink and black chalk on paper, 16 × 11½ in. (40.6 × 29.2 cm).
NEW YORK, Woodner Family Collections. *The Meeting of Antony and Cleopatra.* Brown ink and black chalk on paper, 14 × 10¼ in. (35.5 × 26.1 cm).

COPY

DÜSSELDORF, private collection (in 1962). Oil on canvas, 38⅝ × 57⅞ in. (98 × 147 cm).
EUROPE, private collection (in 1974). Attributed to Domenico Tiepolo or Francesco Lorenzi, *A Kneeling Page.* Copied after the Wrightsman sketch.[2]

The basic authority for the story of Antony and Cleopatra is the first-century Greek biographer Plutarch, yet so many other writers have retold and elaborated the tale that it is impossible to identify the literary sources that Tiepolo used when he painted this dazzling *modello,* or preparatory oil sketch. The story essentially concerns Cleopatra VII (68–30 B.C.), the last of the Ptolemaic dynasty to rule Egypt. She used her beauty and charm to obtain military alliances, first with Julius Caesar (100–44 B.C.), by whom she had a son, Caesarion, and then with Marc Antony (ca. 82–30 B.C.), by whom she had three more children. Antony ruled the eastern half of the Roman Empire, and, during the more than ten years that he spent with Cleopatra, he was at war with Octavian, ruler of the western half. Antony was finally defeated and took his own life. Cleopatra then sought to charm Octavian but was rejected and committed suicide rather than endure the humiliation of being the prize of his triumphal entrance into Rome.

Historically, the couple met a number of times at ports and harbors. The encounter depicted here is usually assumed to be their first meeting, in 41 B.C., at Tarsus in Cilicia (southern Turkey), but in fact it was Cleopatra, not Antony, who arrived there by sea. More likely the picture represents Antony's return to Alexandria in 34 B.C., following his campaigns in western Asia, when he presented Cleopatra with booty and the captive king of Armenia, Artavasdes, the bearded figure in the painting to the left of Antony, wearing a gold robe and a white turban.[3]

The Wrightsman *modello* is one of several pictures that Tiepolo painted during the 1740s on the theme of Antony and Cleopatra: these include a small canvas of the *Banquet of Cleopatra* in the Musée Cognac-Jay, Paris, of 1743/44; a much larger canvas based on the same design in the National Gallery of Victoria, Melbourne, of about the same date; a pair of huge canvases of the *Meeting*

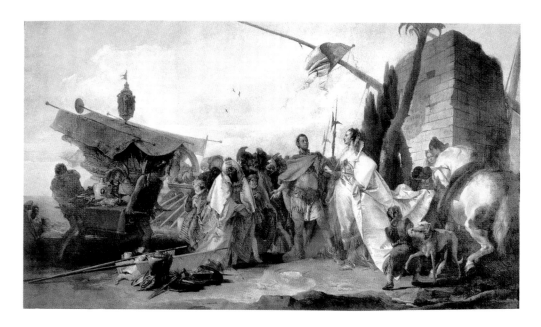

Fig. 1. Giambattista Tiepolo, *The Meeting of Antony and Cleopatra.* Oil on canvas, 11 ft. 1 in. × 19 ft. 8¼ in. (338 × 600 cm). Gosudarstvennyj Muzej-usadba (Country Estate Museum), Arkhangelskoye

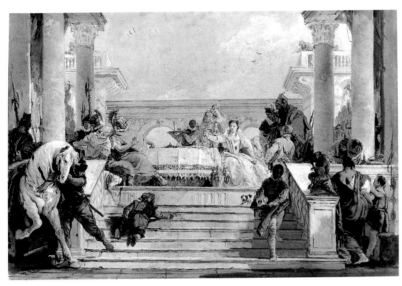

Fig. 2. Giambattista Tiepolo, *The Banquet of Cleopatra*. Oil on canvas, 18¼ × 26¼ in. (46.3 × 66.7 cm). National Gallery, London

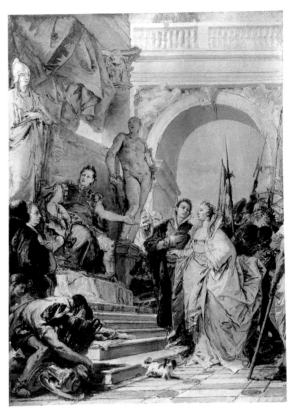

Fig. 4. Giambattista Tiepolo, *The Continence of Scipio*. Oil on canvas, 23¾ × 15¾ in. (60.3 × 40.1 cm). Nationalmuseum, Stockholm

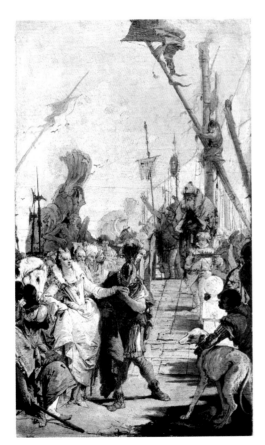

Fig. 3. Giambattista Tiepolo, *The Meeting of Antony and Cleopatra*. Oil on canvas, 26¼ × 15⅛ in. (66.8 × 38.4 cm). National Gallery of Scotland, Edinburgh

(fig. 1) and the *Banquet* in the former Yousoupoff country estate at Arkhangelskoye, near Moscow; and the celebrated frescoes on the walls of the central hall of the Palazzo Labia, Venice, probably painted in 1746/47. Two pairs of preparatory oil sketches survive for these pictures: the Wrightsman canvas and the *Banquet of Cleopatra* in the National Gallery, London (fig. 2), and a similar set with vertical compositions divided between the National Gallery of Scotland, Edinburgh (fig. 3), and the University Museum, Stockholm.

There has been some debate about the purpose of the Wrightsman and London *modelli*. Although they have traditionally been presumed to be preparatory studies for the main frescoes in the Palazzo Labia, the current consensus is that they were made for the canvases at Arkhangelskoye.[4] The latter were purchased in 1800 by Prince Nicolai Yousoupoff (1750–1831) for his palace in Saint Petersburg and were moved subsequently to Arkhangelskoye.[5] The Edinburgh and Stockholm *modelli* are unquestionably studies for the Labia frescoes.

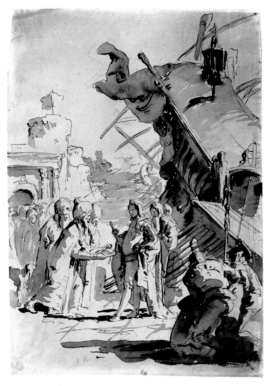

Fig. 5. Giambattista Tiepolo, *Artavasdes Surrendering to Antony*. Brown ink and wash on paper, 15 × 11¼ in. (38 × 28.5 cm). Museo Horne, Florence

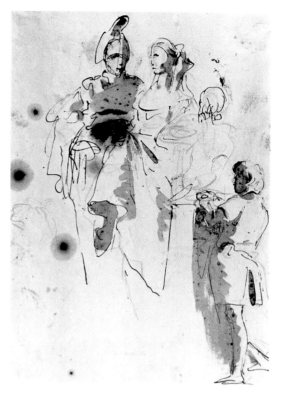

Fig. 6. Giambattista Tiepolo, *Antony and Cleopatra with a Page*. Pen and wash over black chalk, 10⅜ × 7½ in. (26.2 × 19 cm). Victoria and Albert Museum, London

The style of the Wrightsman and London *modelli* is typical of Tiepolo's work of the early 1740s. In motif and mode of execution, they are comparable to the fluid oil sketches that he made for frescoes in the Villa Cordellina at Montecchio Maggiore, near Vicenza, on which he was working in October 1743. The striking similarity between Cleopatra, with her blackamoor pages, and the bride in Tiepolo's *modello* for the *Continence of Scipio* in the Villa Cordellina (fig. 4) makes it clear that the Wrightsman painting was conceived at about the same time as the frescoes, that is, in about 1742 or 1743 at the latest. So long as the Russian canvases were regarded as works of 1747, the date said to be painted on the Arkhangelskoye *Meeting*, the Wrightsman and London sketches seemed to be too early to be associated with them. But if the Russian canvases were begun three or four years earlier and only delivered in 1747, then the connection is plausible.[6]

As a subject, the Meeting of Antony and Cleopatra is unusual. It does not appear to have been previously depicted in the visual arts; the customary pendant to the *Banquet of Cleopatra* was the scene of her suicide. No preliminary pen-and-ink sketches for the *Meeting,* such as Tiepolo's exploratory compositional drawings for

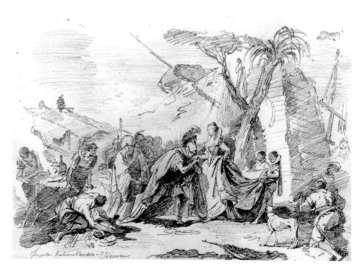

Fig. 7. Jean Honoré Fragonard, Copy of the painting. Red chalk, 9 × 11½ in. (22.7 × 29.2 cm). The Norton Simon Museum, Pasadena, California

the *Banquet,*[7] are known. Two large studies for the central figures are relatively finished drawings: one in the Metropolitan Museum shows Antony kissing Cleopatra's hand with the truncated pyramid seen in the Wrightsman *modello* lightly indicated behind them, and the other, almost identical drawing in the Woodner Family Collections shows Cleopatra in profile precisely as she appears in the Wrightsman *modello.*[8] A related drawing in the Museo Horne, Florence, of Orientals offering keys to a Roman general (fig. 5) may be an early idea for a pendant to the *Banquet,* perhaps depicting Artavasdes surrendering to Antony.[9] Its style is consistent with the Metropolitan and Woodner sketches, and both the stern of the galley, with its fluttering canopy and lantern, and the two crouching figures in the lower-right corner reappear in the Wrightsman painting. Two drawings of a Roman soldier and a lady (fig. 6) show the evolution of Tiepolo's ideas from the Wrightsman *modello* to the canvas at Arkhangelskoye.[10]

During the eighteenth century the Wrightsman and London *modelli* belonged to Angelo della Vecchia, a lawyer in Vicenza, who owned several paintings by Tiepolo. During the first week of July, 1751, Charles Nicolas Cochin the Younger (see p. 192) visited Vecchia's palace (now the Palazzo Romanelli) and saw some oil sketches by Piazzetta and Tiepolo; he wrote that the latter were especially well composed and full of life.[11] Almost exactly to the day ten years later, two other Frenchmen took notice of the *modelli*: the young Fragonard (1732–1806), then traveling round Italy with the Abbé de Saint Non (1727–1791), copied the *Meeting* in a red-chalk drawing that he inscribed "Tiepolo. Palazzo Vecchia. Vicence" (fig. 7); the Abbé wrote in his diary that the "prodigiously rich" lawyer had collected some delightful paintings, including "two lively sketches, one of the Meeting of Antony and Cleopatra, the other of the feast that celebrated queen gave for the Roman general. Compositions filled with fire and genius."[12]

EF

NOTES

1. Huges Fourau is listed as a former owner by Morassi 1962, p. 43. The dimensions of "Le débarquement de Cléopâtre" in Fourau's sale catalogue are 67 centimeters high by 42 centimeters wide, the measurements of an upright rectangle. It is possible, however, that the dimensions were mistakenly reversed, in which case there would be little question about the provenance. Beverly Louise Brown, in Fort Worth 1993, p. 255 n. 1 under nos. 35–37, has suggested that Fourau's picture is the *ricordo* of the Labia fresco in the Musée des Beaux-Arts, Strasbourg, but it measures only 55 by 36 centimeters (see Alain Roy and Paula Goldenberg, *Les peintures italiennes du Musée des Beaux-Arts: XVI*e*, XVII*e *& XVIII*e *siècles* [Strasbourg, 1996], p. 155).

2. George Knox, "Giambattista Tiepolo: Variations on the Theme of Anthony and Cleopatra," *Master Drawings* 12 (winter 1974), p. 383, fig. 9, dates the drawing between 1740 and 1744.

3. The subject of the *Meeting* was so identified, in a discussion of a large canvas by Tiepolo to which this *modello* is related (see n. 4), by Igor Grabar, "The Tiepolos at Arkhangelskoye and Tiepolo's Self-Portrait" (in Russian) *Iskusstvo* 10 (March–April 1947), pp. 63–81.

4. The Wrightsman *modello* was first recognized as a *modello* for the Arkhangelskoye *Meeting* by Francis Watson in the exhibition catalogue *Italian Art and Britain,* Royal Academy of Arts, London (London, 1960), p. 172 under no. 415. Arguments that it is a preparatory study for the Labia fresco were first advanced by Michael Levey, *Tiepolo: Banquet of Cleopatra,* Charlton Lectures on Art delivered at the University of Newcastle in 1963 (Newcastle upon Tyne, 1965), unpaginated.

5. The repeated conveyance of the canvases to Arkhangelskoye from Saint Petersburg and back again is recounted by George Knox, "Anthony and Cleopatra in Russia: A Problem in the Editing of Tiepolo Drawings," in *Editing Illustrated Books,* ed. William Blissett (New York, 1980), p. 40. For recent speculation about their original location, see Stéphane Loire and José de Los Llanos, in *Giambattista Tiepolo, 1696–1770,* exh. cat., Musée du Petit Palais, Paris (Paris, 1998), pp. 180–82 nos. 52–53. They suggest that the Russian paintings were commissioned by Carlo Cordellina, a friend of Angelo della Vecchia, a former owner of the Wrightsman and London *modelli,* for his villa at Montecchio Maggiore.

6. This proposal was made by Adriano Mariuz, *Le storie di Antonio e Cleopatra. Giambattista Tiepolo e Girolamo Mengozzi Colonna a Palazzo Labia* (Venice, 2004), p. 80 n. 31, who observed that the figures of Antony and Cleopatra in the Arkhangelskoye *Meeting* are almost literal quotations of the bride and groom in the fresco of the *Continence of Scipio* in the Villa Cordellina.

7. The compositional drawings are in the Victoria and Albert Museum, London, and the Nationalmuseum, Stockholm, the latter inscribed with the date 1743. See George Knox, *Catalogue of the Tiepolo Drawings in the Victoria and Albert Museum* (London, 1960), p. 57 no. 85, and Per Bjurström, *Dürer to Delacroix: Great Master Drawings from Stockholm,* exh. cat., Kimbell Art Museum, Fort Worth, Texas (Fort Worth, 1985), no. 30.

8. Jacob Bean and William Griswold, *Eighteenth Century Italian Drawings in The Metropolitan Museum of Art* (New York, 1990), pp. 236–37 no. 233. George Knox, in *The Touch of the Artist: Master Drawings from the Woodner Collections,* exh. cat., ed. Margaret Morgan Grasselli, National Gallery of Art, Washington, D.C. (Washington, D.C., 1995), p. 295 no. 82.

9. Licia Ragghianti Collobi, *Disegni della Fondazione Horne in Firenze,* exh. cat., Palazzo Strozzi, Florence (Florence, 1963), no. 137, identified the subject as the consignment of the keys of a Turkish city to a Venetian admiral.

10. George Knox, *Catalogue of the Tiepolo Drawings in the Victoria and Albert Museum,* 2nd ed. (London, 1975), p. 51 nos. 69 and 70, observed that "the types suggest an early study for a 'Meeting of Anthony and Cleopatra.'" His number 177—"A Lady Wearing a Gown with a High Collar and Pointed Bodice"—also is related to the Cleopatra studies.

11. "Plusieurs esquisses: une paroît de *Luca Giordano;* les autres sont de *Piazzetta* & de *Tiepoletto.* Elles son très-bien composées, & spirituellement touchées, particuliérement celle de *Tiepoletto.*" Charles Nicolas Cochin, *Voyage d'Italie; ou, Recueil de notes sur les ouvrages de peinture & de sculpture, qu'on voit dans les principales villes d'Italie* (Paris, 1758), vol. 3, col. 181, reprinted in *Le voyage d'Italie de Charles-Nicolas Cochin (1758),* ed. Christian Michel (Rome, 1991), p. 393.

12. "Deux petites Esquisses piquantes, don l'une est l'Entrevüe d'Antoine et de Cléopâtre, et l'autre le Festin que cette Reine célèbre donna au Général Romain. Compositions pleines de feu et de Génie." Jean Claude Richard de Saint Non, *Panopticon italiano. Un diario di viaggio ritrovato, 1759–1761,* ed. Pierre Rosenberg, with Barbara Brejon de Lavergnée, revised ed. (Rome, 2000), p. 224; the drawing is catalogue number 244 (on p. 394).

26. A Female Allegorical Figure

Oil on canvas, gold ground, oval, 32 × 24⅞ in. (81.3 × 63.2 cm)
The Metropolitan Museum of Art, New York, Gift of Mr. and Mrs.
Charles Wrightsman, 1984 (1984.49)

PROVENANCE
?Palazzo Cornaro, Campo San Polo, Venice; Baroness Renée de Becker, New York (sold to Rosenberg & Stiebel); [Rosenberg & Stiebel, New York, until 1958; sold to Balsan]; Mrs. Jacques Balsan, New York (1958–d. 1964); [sale, Christie's, London, June 23, 1967, lot 71, as "The Property of a Lady," to Agnew for Wrightsman for £5,500]; Mr. and Mrs. Charles Wrightsman, New York (1967–84); their gift in 1984 to the Metropolitan Museum.

LITERATURE
Morassi 1962, pp. 1, 34, 70; Bernard Aikema, in Rotterdam 1996, p. 158.

RELATED WORKS
AMSTERDAM, Rijksmuseum (A 3437). Giambattista Tiepolo, *A Female Allegorical Figure (Fortitude?)*. Oil on canvas, gold ground, oval, 31⅞ × 25⅝ in. (81 × 65 cm) (fig. 2).
AMSTERDAM, Rijksmuseum (A 3438). Giambattista Tiepolo, *A Female Allegorical Figure (Prudence?)*. Oil on canvas, gold ground, oval, 31⅞ × 25⅝ in. (81 × 65 cm) (fig. 1).
NEW YORK, Metropolitan Museum (1997.117.8). Giambattista Tiepolo, *A Female Allegorical Figure*. Oil on canvas, gold ground, oval, 35½ × 28⅝ in. (90.2 × 72.7 cm) (fig. 3).

This oval canvas and three others just like it survive from a decorative ensemble: two of the ovals (figs. 1, 2) belong to the Rijksmuseum, Amsterdam, and the fourth (fig. 3) recently was bequeathed to the Metropolitan Museum by Lore Heinemann. All of them represent single female nudes seated on banks of clouds floating before gold backgrounds. As the figures are seen from below, the ovals probably were installed above doors or some other architectural focal point of a room in a Venetian palace. Although the paintings frequently are called grisailles, strictly speaking they are *camaïeux,* executed in cream-colored (not gray) monochrome tones, simulating sculptural relief to produce a cameo-like effect.

Dark shadows in burnt umber painted on the gold emphasize the silhouettes of the figures and the outlines of the clouds. The shadows fall to the right in the Wrightsman oval and in one of the Rijksmuseum ovals (fig. 1), to the left in the Heinemann oval (fig. 3) and in the other Rijksmuseum oval (fig. 2). This suggests that the painter took note of the fall of light, probably from a single window, from the right on one pair of ovals on a wall in their original setting and from the left on the other pair on the opposite

Fig. 1 (at left). Giambattista Tiepolo, *A Female Allegorical Figure (Prudence?)*. Oil on canvas, gold ground, oval, 31⅞ × 25⅝ in. (81 × 65 cm). Rijksmuseum, Amsterdam

Fig. 2 (at right). Giambattista Tiepolo, *A Female Allegorical Figure (Fortitude?)*. Oil on canvas, gold ground, oval, 31⅞ × 25⅝ in. (81 × 65 cm). Rijksmuseum, Amsterdam

Fig. 3. Giambattista Tiepolo, *A Female Allegorical Figure.* Oil on canvas, gold ground, oval, 35 ½ × 28 ⅝ in. (90.2 × 72.7 cm). The Metropolitan Museum of Art, New York, Bequest of Lore Heinemann, in memory of her husband, Dr. Rudolf J. Heinemann, 1996 (1997.117.8)

wall. The painter also responded to the effect of natural light by varying the thickness of the paint: in the Wrightsman oval, for example, heavy impasto on the woman's cheek, vase, and drapery would have glistened as it caught more light than the thinly painted areas.

Because of the generic character of the objects the figures carry, it is difficult to establish precisely what they symbolize. The figure holding a club in one of the Rijksmuseum canvases (fig. 2) has been identified tentatively as Fortitude, while the other (fig. 1), pointing to a tablet (or mirror?), has been cautiously designated as Prudence.[1] Although the figure in the Wrightsman canvas has been called Temperance, the vase she holds is no more indicative of her identity than the urn on which the figure in the Heinemann oval (fig. 3) rests her hand.[2]

The *Allegorical Figures* in Amsterdam were catalogued by the Rijksmuseum as works by Domenico Tiepolo (see p. 103), an attribution that was corrected when Antonio Morassi recognized the Heinemann canvas as the work of Giambattista.[3] There is less agreement about the dating. Morassi initially suggested the

decade of the 1750s but subsequently proposed the 1740s. More recently, Bernard Aikema has favored a later date, considering the canvases close in style to Tiepolo's frescoes of 1757 in the Villa Valmarana, near Vicenza, and to those of the mid-1760s formerly in the Palazzo Onigo, Treviso.[4] A dating in the early 1740s, however, is preferable. Not only is the fluid handling of the figures in the ovals comparable to that of documented works of 1743, such as the frescoes in the Villa Cordellina at Montecchio or the lateral canvases of the ceiling of the Scuola del Carmine in Venice, but only in this period did Tiepolo have a penchant for single figures in monochrome on gold backgrounds, as in the *Four Seasons* on the pendentives of one of the ceilings in the Palazzo Papadopoli, Venice, which he decorated in 1741, or in the *Four Continents* on the ceiling of the main hall of the Villa Cordellina, which he mentioned in a letter of October 26, 1743.[5]

The Rijksmuseum pair carried a traditional provenance from the Palazzo Labia, Venice.[6] As Aikema observed, this is unlikely. A room in the Palazzo Labia, the Sala degli Specchi (Hall of Mirrors), has nineteenth-century replacements for missing overdoors of the same format as the *Allegorical Figures,* but there are only two of them, and they were executed in fresco.[7] It is possible, however, that the four ovals were part of the decoration of another Sala degli Specchi in Venice. In the late 1730s and early 1740s, the Cornaro family remodeled their imposing Renaissance palace on the *campo* San Polo, commissioning leading artisans in stucco and glass decoration and trompe l'oeil painting to ornament the primary rooms. For the new Sala degli Specchi on the upper of the two main floors of the palace, Tiepolo painted the glorious canvases of the story of Rinaldo and Armida, now in the Art Institute of Chicago. In an eighteenth-century inventory of the Palazzo Cornaro a San Polo, Tiepolo's paintings in the Sala degli Specchi included "quattro sopraporte di chiaro scuro bassorilievo" (four overdoors imitating monochrome relief), a description that well suits the Wrightsman *Allegorical Figure* and its companions.[8] On stylistic grounds the Chicago canvases are dated about 1742–45, which coincides with the probable date of the ovals.

At some point in the nineteenth century, the Palazzo Cornaro was modernized, and all the paintings on canvas were dispersed. The fate of the four ovals during this period has not been traced. Morassi's statement that they were among the nineteen Tiepolos that Dr. Waagen saw in the mid-nineteenth century in the collection of Edward Cheney can be discounted.[9] According to Waagen,

Cheney's pictures were "sketches for ceilings" (not single figures), and none of the Tiepolos in the sale of Cheney's collection corresponds to the *Allegorical Figures*.[10]

EF

NOTES

1. Bernard Aikema, in Rotterdam 1996, p. 160.
2. Ibid., p. 158, and Bernard Aikema, in *Italian Paintings from the Seventeenth and Eighteenth Centuries in Dutch Public Collections*, ed. Bernard Aikema et al. (Florence, 1997), p. 160 n. 1. It was called a "River Goddess Seated on a Cloud Holding a Pitcher" in the 1967 sale catalogue (see Provenance, above).
3. Rijksmuseum, *Catalogus van de tentoongestelde schilderijen, pastels en aquarellen* (Amsterdam, 1951), p. 176; Antonio Morassi, *G. B. Tiepolo: His Life and Work* (London, 1955), caption to fig. 55 opposite p. 33.
4. Bernard Aikema, in *Italian Paintings from the Seventeenth and Eighteenth Centuries*, p. 160.
5. Gino Fogolari, "Giambattista Tiepolo. Lettere inedite a Francesco Algarotti," *Nuova antologia* 7 (September 1942), p. 34.
6. Rijksmuseum, *Catalogue of Paintings* (Amsterdam, 1960), p. 301; the provenance from Palazzo Labia is repeated by Anna Pallucchini, *L'opera completa di Giambattista Tiepolo* (Milan, 1968), p. 121 no. 228.
7. Bernard Aikema, in Rotterdam 1996, p. 158. See also Elisabetta Martinelli Pedrocco, "L'arredo del palazzo," in Terisio Pignatti, Filippo Pedrocco, and Elisabetta Martinelli Pedrocco, *Palazzo Labia a Venezia* (Turin, 1982), p. 232.
8. Giandomenico Romanelli, "Giambattista Tiepolo e i Cornaro di San Polo," in *Giambattista Tiepolo nel terzo centenario della nascita. Atti del convegno internazionale di studi,* Venice, Vicenza, Udine, and Paris, October 29–November 4, 1996, ed. Lionello Puppi (Padua, 1998), vol. 1, p. 222. Romanelli does not mention the ovals now divided between Amsterdam and New York; the connection was reported, however, by Keith Christiansen, in "Recent Acquisitions: A Selection, 1996–1997," *The Metropolitan Museum of Art Bulletin* 55, no. 2 (fall 1997), p. 41.
9. Gustav Friedrich Waagen, *Galleries and Cabinets of Art in Great Britain; Being an Account of More Than Forty Collections of Paintings, Drawings, Sculptures, MSS., &c., Visited in 1854 and 1856* (London, 1857), p. 173.
10. Edward Cheney, Badger Hall, Shropshire, sale, Christie's, London, April 29, 1885, lots 158–70.

27. Allegory of the Planets and Continents

Oil on canvas, 73 × 54⅞ in. (185.4 × 139.4 cm)
Inscribed at the sides: EVROPA / AFRICAE / AMERICA / ASIA.
The Metropolitan Museum of Art, New York, Gift of Mr. and Mrs. Charles Wrightsman, 1977 (1977.1.3)

PROVENANCE
Giovanni Domenico Tiepolo, Venice (d. 1804); his former widow, Margherita Moscheni, Venice (1804); Antonio Canova, Venice (1804–22; inv. no. 8); Samuel Ware, Hendon Hall, London (by 1850–60; manuscript cat., 1850, no. 210); Charles Nathaniel Cumberlege-Ware, Hendon Hall (1860–about 1870); C. F. Hancock, Hendon Hall (by 1890); Hendon Hall Hotel (by 1923–54); [art market, London, 1954–56]; [Rosenberg & Stiebel, New York, and Fritz and Peter Nathan, Zurich, 1956; sold to Wrightsman]; Mr. and Mrs. Charles Wrightsman, New York (1956–77; cat., 1973, no. 25); their gift in 1977 to the Metropolitan Museum.

EXHIBITED
Metropolitan Museum, New York, January 30–March 21, 1971, "Oil Sketches by Eighteenth Century Italian Artists from New York Collections," no. 27; Museo del Settecento Veneziano—Ca' Rezzonico, Venice, September 5–December 9, 1996, and Metropolitan Museum, New York, January 24–April 27, 1997, "Giambattista Tiepolo, 1696–1770," no. 49 (shown in New York only).

LITERATURE
Edward T. Evans, *The History and Topography of the Parish of Hendon, Middlesex* (London, 1890), pp. 239–40; Antonio Morassi, "Some 'Modelli' and Other Unpublished Works by Tiepolo," *Burlington Magazine* 97 (January 1955), p. 4 n. 1; Max H. von Freeden and Carl Lamb, *Das Meisterwerk des Giovanni Battista Tiepolo: Die Fresken der Würzburger Residenz* (Munich, 1956), pp. 29, 53–61, 80, 84, 87–88, 91, 93, 102; Morassi 1962, pp. 37, 68; Fahy 1973, pp. 232–47 no. 25; Frank Büttner, *Giovanni Battista Tiepolo: Die Fresken in der Residenz zu Würzburg* (Würzburg, 1980), pp. 94, 97–122; Levey 1986, pp. 191, 194–95; Svetlana Alpers and Michael Baxandall, *Tiepolo and the Pictorial Intelligence* (New Haven, 1994), pp. 74, 129–30, 135, 142; Pedrocco 1993, pp. 426–27 no. 415a; Frank Büttner, in Würzburg 1996, vol. 2, pp. 57–60; Peter Krückmann, in Würzburg 1996, vol. 1, pp. 34–36; Giuseppe Pavanello, *Canova collezionista di Tiepolo* (Venice, 1996), pp. 8, 21, 27; Keith Christiansen, in Venice, New York 1996–97, pp. 286, 302–11 no. 49; Peter Stephan, *"Im Glanz der Majestät des Reiches": Tiepolo und die Würzburger Residenz—die Reichsidee der Schönborn und die politische Ikonologie des Barock* (Weissenhorn, 2002), vol. 1, pp. 72, 151, 154.

Tiepolo's frescoes at Würzburg mark the crowning achievement of his brilliant career. They were commissioned by Carl Philipp von Greiffenclau, who reigned as prince-bishop of Würzburg from 1749 to 1754. Early in the summer of 1750, Greiffenclau invited Tiepolo to provide the decorations for the new Residenz, the archbishop's palace, which had recently been built by the Bohemian architect Johann Balthasar Neumann (1687–1753). A contract was drawn up, and, on October 12, 1750, Tiepolo signed it in Venice;

two months later, he and his sons Domenico (see p. 103) and Lorenzo (1736–1776) departed for Franconia.[1] They worked there without interruption for more than three years.

Their first undertaking was to decorate the Kaisersaal, the octagonal banqueting hall of the Residenz, with an illusionistic ceiling and two large frescoes on the walls relating to the life of Holy Roman Emperor Frederick Barbarossa (r. 1155–90). Although the frescoes were not completed until July 4, 1752, during the winter of 1751–52 Tiepolo turned his attention to the design of the ceiling over the magnificent ceremonial staircase leading up from the ground-floor entrance to the Kaisersaal on the main floor. According to the court record book, after lunch on April 21, "His Grace and members of his entourage saw the plans of the painter Tiepolo for the main staircase, and then went for a stroll in the garden."[2] The plans they saw probably included the present sketch (some writers believe there may have been more than one). A further document records that on June 30 the prince-bishop commissioned Tiepolo to paint the entire vault over the staircase "in accordance with the approved sketch, employing all the skill at his disposal and following his customary style."[3] The actual contract for the ceiling, however, was not drawn up until July 29, 1752; the delay may be explained perhaps by alterations that were made to Tiepolo's original scheme.

The sketch depicts Apollo about to embark on his daily course across the sky. The deities surrounding Apollo symbolize the planets, and the allegorical figures on the cornice represent the Four Continents; the pairs of monochrome male nudes in the corners were executed in stucco by Antonio Bossi (1699–1764). Just below Apollo, the butterfly-winged Horae, or Hours, prepare to harness the four horses of his golden quadriga, which is being pushed into place by two putti. Mars and Venus recline below Apollo. To the right are three winged figures, the Fates—Clotho, Lachesis, and Atropos; below them are the Keres, or Furies, who execute the will of the Fates. In the uppermost part of the sky flies Mercury. Below him is Diana, goddess of the moon, identified by the crescent above her head. Jupiter sits beside an eagle with his cupbearer Ganymede, Saturn and Vulcan beneath him.

Each of the Continents, identified by inscriptions on the molding, is personified by a female figure, whose attributes were based on Cesare Ripa's *Iconologia* and travel books.[4] Europe is a mature woman seated beside a model of a classical temple, serenaded by the Arts. The continent of Africa is represented by a Negress on a caravan camel, which rests on the ground. America is a dark-skinned woman wearing a feather headdress and sitting on a crocodile near a pile of severed heads. Asia rides an elephant with bells dangling from its ears.

This iconographical program was not unusual during the seventeenth and eighteenth centuries. Less than two decades earlier, Tiepolo himself had used a similar scheme for the ceiling of the Palazzo Clerici, Milan, which is decorated with the Course of the Sun on Olympus.[5] The same idea appears in the ceiling over the grand staircase of the Schönborn Castle at Pommersfelden: it was painted between 1717 and 1718 by Johann Rudolf Byss (1660–1738) with a fresco of Apollo and the planet divinities. The Schönborns were closely associated with Würzburg, several of them having served there as prince-bishops, and, as Pommersfelden is only a few miles away from Würzburg, Tiepolo and his patron certainly would have known it.

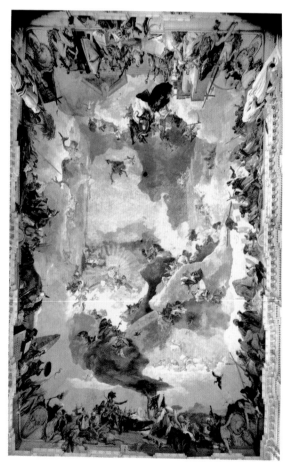

Fig. 1. Giambattista Tiepolo, *Allegory of the Planets and Continents*. Fresco, 100 ft. × 62 ft. 4 in. (30.5 × 19 m). Residenz, Würzburg

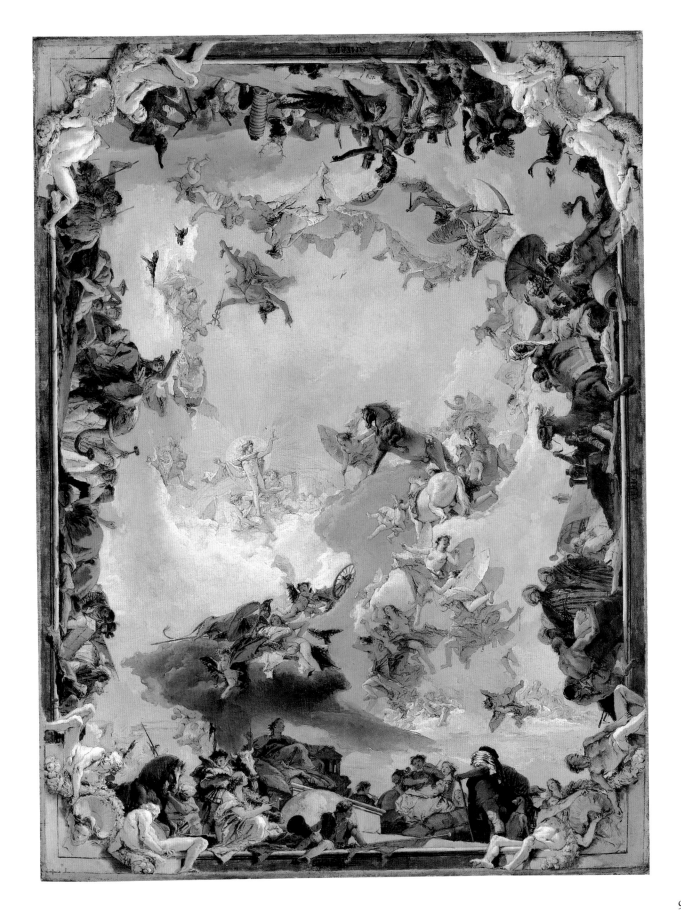

Although the Schönborn fresco is a mediocre work, it is of interest because Byss published an explication of it,[6] which could equally be applied to Tiepolo's ceiling. The pagan divinities in Byss's fresco stand for the planets of the solar constellation: as the sun illuminates the universe, so Apollo casts light on the planet deities who revolve around him in a constellation-like pattern. Apollo is also surrounded by minor Olympian figures, such as Hebe, the Fates, and the Furies, as well as a number of smaller, unidentifiable characters. Finally, at Pommersfelden, Apollo sheds light on the Four Continents at the four sides.

Many minor differences between Tiepolo's preparatory canvas and the Würzburg fresco (fig. 1) reflect revisions that normally occur when any composition is magnified from modest dimensions to an enormous expanse. There is, however, one significant change: the sketch does not show a likeness of the prince-bishop, whereas in the fresco Greiffenclau's portrait is conspicuously displayed in a medallion held by Fame in the allegorical group of Europe. When Tiepolo painted the *modello* the plan may have been to place the portraits of the prince-bishop and his retinue on the walls below the ceiling, but the idea was discarded. In the final arrangement, Europe and America were reversed, and contemporary portraits, including those of Tiepolo, his two sons, and Balthasar Neumann, were added to the Europe group. By introducing the prince-bishop's portrait, the iconography of the ceiling fresco becomes a startling flattery. Classical deities and the four corners of the earth pay homage to the relatively unimportant Greiffenclau, who, had he not been Tiepolo's patron, would be forgotten today.

It has been suggested that the Wrightsman painting is not the work of Giambattista Tiepolo but of his precocious son Domenico, who was twenty-five years old when the *modello* was presented to the prince-bishop.[7] During the first year at Würzburg, Domenico executed three overdoors in the Kaisersaal, one of which bears his signature and the date 1751. In these he reveals himself a deft imitator of his father's style. It is altogether improbable, however, that Tiepolo would have entrusted his son with painting the *modello* for the most important commission of his entire career. EF

NOTES

1. Marina Magrini, in *Lettere artistiche del Settecento veneziano,* ed. Alessandro Bettagno and Marina Magrini (Vicenza, 2002), vol. 1, p. 53.
2. "Nach dem Speisen sahe Celsissimus mit der Suite das project von der Haupstiege so der Maler Diepolo entworffen, und giengen darnach im Garten spazieren." Staatsarchiv Würzburg, MS. q. 176c, fol. 392, *Tagebuch Spielbergers,* entry for April 21, 1752; see Tilman Kossatz, in Würzburg 1996, vol. 2, p. 174, document 26.
3. "Dem gnädigst approbirten Sciço künstlich, und nach seiner bekannten force und gewohnheit zu mahlen." Staatsarchiv Würzburg, HKP 1752, fol. 276a, entry for June 30, 1752; see Tilman Kossatz, in Würzburg 1996, vol. 2, p. 174, document 27.
4. Mark Ashton, "Allegory, Fact, and Meaning in Giambattista Tiepolo's Four Continents in Würzburg," *Art Bulletin* 60 (March 1978), pp. 109–25.
5. See Paolo D'Ancona, *Tiepolo in Milan: The Palazzo Clerici Frescoes* (Milan, 1956).
6. *Fürtrefflicher Gemähld- und Bilder-Schatz, so in denen Gallerie und Zimmern des Churfürstl. Pommersfeldtischen . . . Privat-Schloss finden ist* (Bamberg, 1719).
7. George Knox, review of *Das Meisterwerk des Giovanni Battista Tiepolo: Die Fresken der Würzburger Residenz,* by Max H. von Freeden and Carl Lamb, *Burlington Magazine* 99 (April 1957), p. 129, and Francis Watson, "G. B. Tiepolo: Pioneer of Modernism," *Apollo* 77 (March 1963), pp. 247–48.

28. *The Apotheosis of the Spanish Monarchy*

Oil on canvas, oval painted surface, 33 ⅛ × 27 ⅛ in. (84.1 × 68.9 cm)
The Metropolitan Museum of Art, New York, Gift of Mr. and Mrs. Charles Wrightsman, 1980 (1980.363)

PROVENANCE
Giovanni Domenico Tiepolo, Venice (d. 1804); ?his former widow, Margherita Moscheni, Venice (1804); Baron Ferdinand von Stumm-Holzhausen, Madrid, Florence, and Schloss Holzhauden, Hessen, Germany (probably by 1892–d. 1925); [Van Diemen, Berlin]; Jakob Goldschmidt, Berlin and Bern (until 1937; one of three works sold with acc. no. 1997.117.7 for a total of £8,000, to Internationale Antiquiteitenhandel, Amsterdam); [Internationale Antiquiteitenhandel, Amsterdam, 1937; one of three works sold with acc. no. 1997.117.7 for a total of £12,000, to Becker]; Baroness Renée de Becker, Brussels and New York (1937–after 1955; sold to Rosenberg & Stiebel); [Rosenberg & Stiebel, New York, after 1955–59; sold to Speelman]; [Edward Speelman, London, 1959–60; sold to Wrightsman]; Mr. and Mrs. Charles Wrightsman, New York (1960–80; cat., 1973, no. 26); their gift in 1980 to the Metropolitan Museum.

EXHIBITED
Metropolitan Museum, New York, July 1–September 1, 1960, "Paintings from Private Collections: Summer Loan Exhibition," no. 119; Metropolitan Museum, New York, January 30–March 21, 1971, "Oil Sketches by Eighteenth Century Italian Artists from New York Collections," no. 30; Museo del Settecento Veneziano—Ca' Rezzonico, Venice, September 5–December 9, 1996, and Metropolitan Museum, New York, January 24–April 27, 1997, "Giambattista Tiepolo, 1696–1770," no. 54b (shown in New York only).

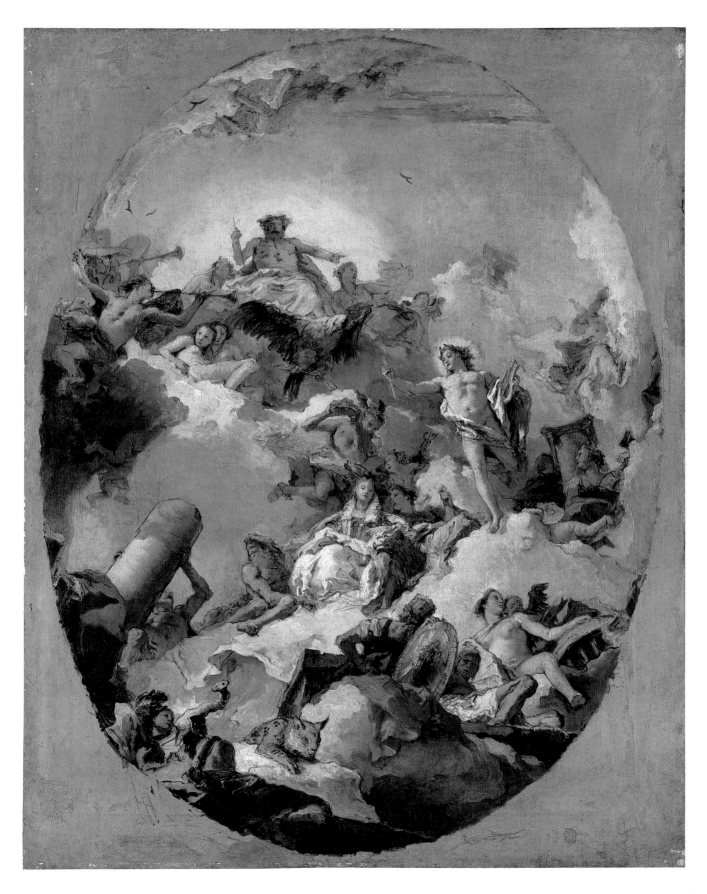

LITERATURE

Antonio Morassi, *Tiepolo* (Bergamo, 1943), p. 48 no. 125; Francisco Javier Sánchez Cantón, *J. B. Tiepolo en España* (Madrid, 1953), pp. 17–18; Morassi 1962, pp. 21, 33, 37; Fahy 1973, pp. 248–56 no. 26; Levey 1986, pp. 263–64; Jesús Urrea, in *Venezia e la Spagna* (Milan, 1988), p. 242; Beverly Louise Brown, in Fort Worth 1993, pp. 310–12 under no. 56; Pedrocco 1993, p. 488 no. 518b; Keith Christiansen, in Venice, New York 1996–97, pp. 286, 328, 329–33 no. 54b; Giuseppe Pavanello, *Canova collezionista di Tiepolo* (Venice, 1996), p. 10.

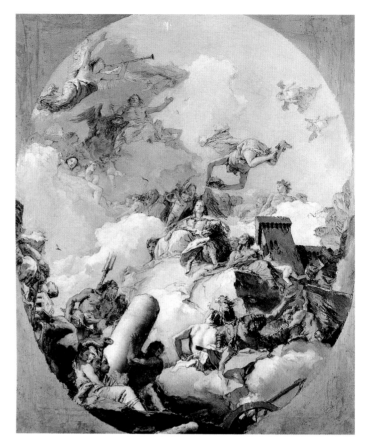

Fig. 1. Giambattista Tiepolo, *The Apotheosis of the Spanish Monarchy*. Oil on canvas, oval painted surface, 32⅛ × 26⅛ in. (81.6 × 66.4 cm). The Metropolitan Museum of Art, New York, Rogers Fund, 1937 (37.165.3)

In December 1761 Charles III of Spain commissioned Tiepolo to decorate the throne room of his newly erected palace in Madrid with a vast fresco (dated 1764), comparable in size to the ceiling over the grand staircase of the Residenz at Würzburg (see cat. 27). The success of the *Wealth and Benefits of the Spanish Monarchy under Charles III* led to two further commissions, the frescoes *Aeneas Conducted to the Temple of Venus,* on the ceiling of the Sala de Guardias, or guardroom, and the *Apotheosis of the Spanish Monarchy* (fig. 2), on the ceiling of the Saleta, or small room, adjacent to the throne room. Tiepolo and two of his sons, Domenico (see p. 103) and Lorenzo (1736–1776), arrived in Madrid on June 4, 1762, and all the frescoes were completed, at the latest, by November 1766, when scaffolding was removed from the guardroom, the last room to be completed.[1]

Subject matter and iconography of such large frescoes traditionally would have been laid down in detail by the patron, but, because of Tiepolo's prestige, it seems the artist himself enjoyed considerable freedom in elaborating the general theme of the glorification of Spain. Oil sketches for the three frescoes survive. For the throne room, there is the large canvas (almost as big as the Wrightsman *modello* for the Würzburg ceiling) in the National Gallery of Art, Washington, D.C., which Tiepolo completed before leaving Venice. For the smaller rooms, there are two pairs of *modelli,* all painted in Madrid. The pair for the guardroom is divided between the Museum of Fine Arts, Boston, and the Fogg Art Museum, Cambridge, Massachusetts. The pair for the Saleta are both in the Metropolitan Museum, one having been purchased by the Museum from the marquis de Biron in 1937 (fig. 1) and the other presented to the Museum by the Wrightsmans in 1980.

As in all the frescoes, the ceiling in the Saleta depicts a considerable number of mythological and allegorical figures—many of them recognizable, some more obscure. A key to their identity is found in Antonio Ponz's description of the royal palace, written ten years after the completion of the frescoes, and in the more detailed guide written for King Ferdinand VII in 1829.[2] Once the individual figures are identified, the general meaning of the ceiling is clear: Tiepolo has depicted, in allegorical terms, the worldwide supremacy that Spain once possessed through her colonies. Jupiter, majestically presiding over the universe, commands Mercury, bearing a crown, and Apollo, bearing a scepter, to bestow on the personification of Spain power over her dominions in Europe, America, and Africa. In the Grand Manner, soon to be eclipsed by the rising popularity of the Neoclassicists, Tiepolo celebrated the mighty Spanish empire, which, ironically, was already entering its final decline.

The *modelli* for the Saleta are upright oval compositions painted on rectangular pieces of canvas, both almost the same size, containing essentially the same figures, arranged in three groups receding in space, to make essentially the same statement. Near the bottom on the left of the Wrightsman sketch is Hercules, the mythological protector of Spain, holding a column representing

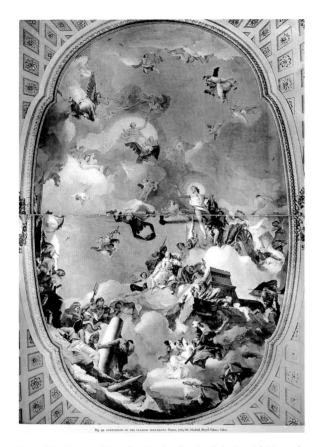

Fig. 2. Giambattista Tiepolo, *The Apotheosis of the Spanish Monarchy* (ceiling of the Saleta). Fresco, Palacio Real, Madrid

However, more details of the Biron sketch reappear on the Saleta ceiling. Obviously, ideas from both were utilized simultaneously when Tiepolo painted the fresco.

Because of his age, then about seventy, Tiepolo is sometimes said to have relied on his sons for much of the execution of the fresco; nonetheless it is perfectly unified in character, carried out in the father's distinguished manner. The preparatory sketches, on the other hand, reveal the full, unadulterated mastery of his final period. In contrast to his earlier works, the colors are pale, approaching, in many areas, a luminous beige monochrome (which is enhanced by the light, biscuit-color ground on which they are painted). The brushwork, while losing none of the exuberant brio of his earlier handling, is sparing, wavering, almost trembling, all of which heightens the ethereal character of the airborne figures. Finally, although the sketches deal exclusively with pagan and allegorical themes, they partake of the same depth of feeling as Tiepolo's late religious works for the monastery at Aranjuez.

EF

NOTES

1. Catherine Whistler, review of *Giambattista Tiepolo. I dipinti: Opera completa,* by Massimo Gemin and Filippo Pedrocco, *Burlington Magazine* 137 (September 1995), pp. 626–27.
2. Antonio Ponz, *Viaje de España en que se dà noticia de las cosas mas apreciables, y dignas de saberse, que hay en ella* (Madrid, 1776), vol. 6, pp. 19–20, and Francisco José Fabre, *Descripcion de las alegorías pintadas en las bóvedas del Real Palacio de Madrid* (Madrid, 1829), pp. 99–105.

the Straits of Gibraltar. To the right are three female figures personifying three of the Four Continents: America, wearing blue feathers; Europe, above the pediment of a small classical building; and Africa, with an elephant headdress. Farther to the right, the woman seated behind the crenellated tower symbolizes the Old Kingdom of Castile. Next to her sprawls Mars, his face in the shadow of his shield; the nude woman above him is Venus. In the center, the Spanish Monarchy is flanked by a lion and Neptune; behind the Monarchy, the woman holding a serpent personifies Prudence. Mercury is identified by his winged hat and heels, Apollo by his scepter and lyre. Jupiter presides from above, seated before a golden aureole.

There are quite a few differences between the sketches, the most notable being the absence of Apollo in the Biron canvas. Since he figures so prominently in the finished fresco, the Wrightsman painting probably was the later of the two *modelli*.

29. *The Flight into Egypt*

Oil on canvas, 23⅝ × 16¼ in. (60 × 41.3 cm)

PROVENANCE

[Niccolò Leonelli, Saint Petersburg (1814–his d. 1816)]; his sale, Salle Philharmonique, Saint Petersburg, May 14–23, 1817, lot 140, as "La Ste. Famille dans un paysage, et un ange prosterné devant elle. Esquisse d'un très grand mérite"]; State Museum, Poltava, Ukraine (until 1929); private collection, the Netherlands (in 1938); Mr. and Mrs. David Birnbaum (later changed to Bingham), Felden Lodge, Boxmoor, Hertfordshire; [Art Gallery A.G., Zug, Switzerland (Anthony Speelman, London), 1982; sold to Wrightsman]; Mr. and Mrs. Charles Wrightsman, New York (1982–his d. 1986); Mrs. Wrightsman (from 1986).

EXHIBITED

Museum Boymans [Museum Boijmans Van Beuningen], Rotterdam, June 25–October 15, 1938, "Meesterwerken uit vier eeuwen, 1400–1800," no. 189; Museo del Settecento Veneziano—Ca' Rezzonico, Venice, September 5–December 9, 1996, and Metropolitan Museum, New York, January 24–April 27, 1997, "Giambattista Tiepolo, 1696–1770," no. 57d (shown in New York only).

LITERATURE

N. S. Trivas, "Masterpieces from Dutch Private Collections at the Boymans Museum, Rotterdam," *Connoisseur* 102 (September 1938), p. 121; Antonio Morassi, *G. B. Tiepolo: His Life and Work* (London, 1955), p. 150; Anna Pallucchini, *L'opera completa di Giambattista Tiepolo* (Milan, 1968), p. 133; Levey 1986, p. 269; Beverly Louise Brown, in Fort Worth 1993, p. 324; Pedrocco 1993, p. 498 no. 533; Keith Christiansen, in Venice, New York 1996–97, pp. 338–43 no. 57d; Burton Fredericksen, "Niccolò Leonelli and the Export of Tiepolo Sketches to Russia," *Burlington Magazine* 144 (October 2002), pp. 623, 624.

RELATED WORKS

BELLAGIO, Bellagio Study and Conference Center. Giambattista Tiepolo, *The Rest on the Flight into Egypt*. Oil on canvas, 23⅝ × 17¾ in. (60 × 45 cm).
LISBON, Museu Nacional de Arte Antiga. Giambattista Tiepolo, *The Flight into Egypt* (fig. 1). Oil on canvas, 22½ × 17⅜ in. (57 × 44 cm).
STUTTGART, Staatsgalerie (3303). Giambattista Tiepolo, *The Rest on the Flight into Egypt* (fig. 2). Oil on canvas, 21⅞ × 16⅜ in. (55.5 × 41.5 cm).

The Flight into Egypt, based on the Gospel of Saint Matthew (2:13–15), was a favorite subject of seventeenth- and eighteenth-century painters, and Tiepolo was no exception. In fact, he was the last great master to explore the theme.[1] Throughout his career he was drawn to the subject, treating it in one of his earliest paintings (about 1720), now in the Fine Arts Gallery, San Diego, California; in six marvelous pen-and-ink drawings (ca. 1735) from the dismembered album that once belonged to Prince Alexis Orloff; and in the altarpiece (about 1745) in the small church of Santi Massimo e Osvaldo in Padua. He executed the present can-

vas, and three other closely related paintings of the Flight and the Rest on the Flight, during the very last years of his life.

In a rocky landscape, the Virgin, Saint Joseph, and a donkey stare at a guardian angel, who prostrates himself on the ground before them on the bank of a river (probably the Jordan or the Nile) that they have just crossed. The boatman bows his head in reverence; in the lower right there is a stone with an illegible inscription. The related canvases (see Related Works, above) variously show the Holy Family in a boat punted across the river by the angel (Museu Nacional de Art Antiga, Lisbon; fig. 1); pausing on the crest of a hill overlooking a city reminiscent of Madrid (Bellagio Study and Conference Center, Bellagio); and resting in a menacing mountain landscape (Staatsgalerie, Stuttgart; fig. 2).

The four canvases recall the suite of twenty-four etchings by Tiepolo's son Domenico (see p. 103) that were gathered in an

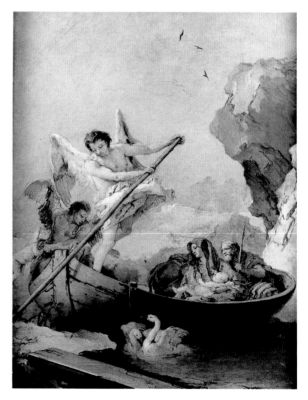

Fig. 1. Giambattista Tiepolo, *The Flight into Egypt*. Oil on canvas, 22½ × 17⅜ in. (57 × 44 cm). Museu Nacional de Arte Antiga, Lisbon

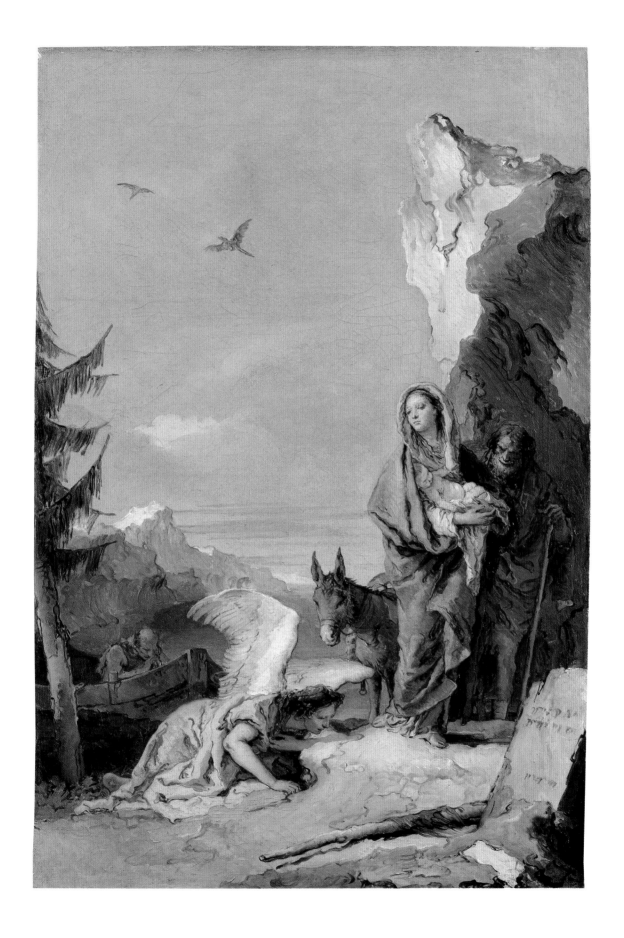

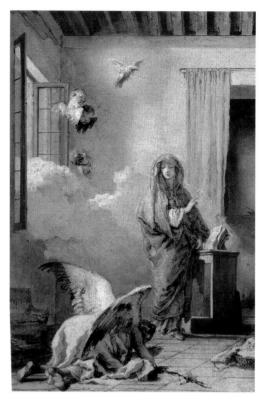

Fig. 2 (at left). Giambattista Tiepolo, *The Rest on the Flight into Egypt*. Oil on canvas, 21⅞ × 16⅜ in. (55.5 × 41.5 cm). Staatsgalerie, Stuttgart

Fig. 3 (at right). Giambattista Tiepolo, *The Annunciation*. Oil on canvas, 26⅜ × 16 in. (67 × 40.5 cm). Duquesa de Villahermosa, Pedrola

album titled *Idee pittoresche sopra la fuga in Egitto* (Picturesque Ideas on the Flight into Egypt), published in 1753 with a dedication to the prince-bishop of Würzburg.[2] Following the accounts of the Flight into Egypt in the *Golden Legend* and the Apocrypha of the New Testament, Domenico's etchings show Saint Joseph rousing his young wife and child from their comfortable Venetian-looking quarters, escaping with them at night from a stable where they picked up a donkey, traveling overland and across bodies of water, and finally reaching the safety of a walled town. Some writers believe Tiepolo's four canvases formed a similar narrative series, perhaps intended for the decoration of a small chapel.[3] This is unlikely, even though all four are almost exactly the same size and share the same handling and mood, because the protagonists are depicted inconsistently: Saint Joseph, for example, appears as a young man in the Bellagio canvas and as an old man in the Lisbon and Wrightsman pictures. Most likely the paintings are variations on a theme, similar to Tiepolo's countless sketches of the Holy Family that show his inexhaustible inventiveness.[4]

The dating of the painting to near the end of Tiepolo's life is confirmed by the affinity of its style to that of his *modelli* for the altarpieces of San Pascual Baylon (Courtauld Gallery, London) as well as by the similarities of the composition to those of a pair of small canvases from Tiepolo's Spanish period, the *Annunciation* (fig. 3) and *Abraham Visited by Angels* (collection of the duquesa de Villahermosa at Pedrola, near Zaragoza). The poses of the statuesque Virgin and the prostate angel in the Wrightsman canvas echo those of the Virgin, angels, and Abraham in the Villahermosa pictures. They share, moreover, the same silvery tonality and trembling yet sure handling of paint that distinguish Tiepolo's final easel paintings. EF

NOTES

1. Herman Voss, "Die Flucht nach Aegypten," *Saggi e memorie di storia dell'arte* 1 (1957), pp. 56–59.
2. For reproductions, see H. Diane Russell, *Rare Etchings by Giovanni Battista Tiepolo and Giovanni Domenico Tiepolo*, exh. cat., National Gallery of Art, Washington, D.C. (Washington, D.C., 1972), nos. 59–92.
3. Morassi 1962, pp. 5, 16; Pedrocco 1993, p. 497; Margherita Giacometti, in *The Glory of Venice: Art in the Eighteenth Century*, ed. Jane Martineau and Andrew Robison, exh. cat., Royal Academy of Arts, London, and National Gallery of Art, Washington, D.C. (New Haven and London, 1994), p. 504; Filippo Pedrocco, *Giambattista Tiepolo* (Milan, 2002), p. 311.
4. Beverly Louise Brown, in Fort Worth 1993, p. 324; Keith Christiansen, in Venice, New York 1996–97, p. 338.

GIOVANNI DOMENICO TIEPOLO

(1727–1804)

Giandomenico Tiepolo was the son of Giovanni Battista Tiepolo (see p. 84) and Cecilia Guardi, the sister of the view painter Francesco Guardi (see p. 78). The course of his career was determined largely by that of his father: he spent the better part of his life executing projects designed by Giambattista, traveling with him to assist with vast commissions in Würzburg (1750–52) and Madrid (1762–70). After his father's death in 1770, he lost heart and painted less and less. He married only in 1776.

Trained in the family workshop, Domenico did not develop a style of his own until he was about thirty years old. His earliest independent works include an altarpiece of 1748 in the church of San Francesco di Paola, Venice, closely related to his father's religious works, and a series of fourteen oil paintings of the Stations of the Cross in the church of San Polo, Venice, which he published as a set of etchings in 1749. At Würzburg, in addition to assisting his father with frescoes, Domenico executed on his own three large overdoors in oil on canvas for the Kaisersaal of the Residenz, one of which is signed and dated 1751, and several easel paintings for private individuals. All of these works are barely distinguishable from those of his father.

Although he could paint in his father's grand manner if the commission called for allegorical or religious subjects, Domenico showed a personal interest in scenes of daily life and gradually evolved a distinctive manner for portraying them. In 1757 he collaborated with his father on the decoration of the Villa Valmarana, near Vicenza, painting in the Foresteria, or guest house, exotic chinoiserie, pastoral subjects, and episodes drawn from contemporary Venetian theater that differ strikingly from his father's grandiloquent frescoes illustrating Tasso's Jerusalem Delivered in the main building of the villa. Starting in late 1762 Domenico worked for eight years with his father in Madrid, helping with the execution of ceiling frescoes in the royal palace and independently creating eight altarpieces for the church of San Filippo Neri.

Domenico's later career, after his father died in Madrid, is marked by a few undistinguished altarpieces and the ceilings of the church of San Lio, Venice, and the Doges' Palace, Genoa, for which only the modello survives (Metropolitan Museum, New York). During this period Domenico's talents are best displayed in the fanciful pen-and-ink drawings he made of satyrs, Commedia dell'Arte characters, and contemporary Venetian subjects. Among his last works are frescoes of the life of Punchinello and other secular scenes, painted for his own amusement in the Tiepolo family villa at Zianigo, near Murano (and now in the Ca' Rezzonico, Venice). These charming paintings reveal Domenico's skill as an ingenious illustrator of everyday life.

EF

ABBREVIATIONS

Fahy 1973. Everett Fahy, in The Wrightsman Collection, vol. 5, Everett Fahy and Francis Watson, Paintings, Drawings, Sculpture. New York, 1973.

London, Washington 1994–95. Jane Martineau and Andrew Robison, eds. The Glory of Venice: Art in the Eighteenth Century. Exh. cat., Royal Academy of Arts, London, and National Gallery of Art, Washington, D.C., 1994–95; New Haven and London, 1994.

Mariuz 1971. Adriano Mariuz. Giandomenico Tiepolo. Venice, 1971.

Morassi 1941. Antonio Morassi. "Domenico Tiepolo." Emporium 93 (June 1941), pp. 264–82.

Wolk-Simon 1996–97. Linda Wolk-Simon. "Domenico Tiepolo: Drawings, Prints, and Paintings in The Metropolitan Museum of Art." The Metropolitan Museum of Art Bulletin 54, no. 3 (winter 1996–97), pp. 4–68.

30. A Dance in the Country

Oil on canvas, 29 3/4 × 47 1/4 in. (75.6 × 120 cm)
Painted canvas wrapped around the stretcher suggests that the picture was originally about one and a half inches higher and perhaps one inch wider than it is now.
The Metropolitan Museum of Art, New York, Gift of Mr. and Mrs. Charles Wrightsman, 1980 (1980.67)

PROVENANCE
Johann Heinrich Merck, Darmstadt (until d. 1791); his daughter, Adelheid Merck, Darmstadt (1791–d. 1845); by descent to Dr. and Frau C. E. Merck, Darmstadt (by 1909–until at least 1919); Frau Caroline Reinhold-Merck (until 1963; sale, Sotheby's, London, July 3, 1963, lot 75, as "A Venetian Carnival Scene with Dancers," for £72,000, to Rosenberg & Stiebel for Wrightsman); Mr. and Mrs. Charles Wrightsman, New York (1963–80; cat., 1973, no. 27); their gift in 1980 to the Metropolitan Museum.

EXHIBITED
Metropolitan Museum, New York, March–October 1967; Indiana University
Art Museum, Bloomington, September 2–October 6, 1979, Stanford
University Museum of Art, November 13–December 30, 1979, and The Frick
Collection, New York, January 22–March 30, 1980, "Domenico Tiepolo's
Punchinello Drawings" (not in catalogue; shown in New York only).

LITERATURE
Pompeo Molmenti, *G. B. Tiepolo. La sua vita e le sue opere* (Milan, 1909), p. 206;
Morassi 1941, pp. 271, 282 n. 7; Mariuz 1971, pp. 44, 48, 50, 130; Fahy 1973,
pp. 269–78 no. 27; Wolk-Simon 1996–97, pp. 27–30; Alessandro Ballarin, in
Colección Cambó, exh. cat., Museo del Prado, Madrid, and Museu Nacional
d'Art de Catalunya, Barcelona (Madrid, 1990), pp. 346, 348, 350, 354; Stéfane
Loire, in Adriano Mariuz and Giuseppe Pavanello, eds., *Tiepolo. Ironia e
comico*, exh. cat., Fondazione Giorgio Cini, Venice (Venice, 2004), p. 149.

RELATED WORKS
BARCELONA, Museu Nacional d'Art de Catalunya, Cambó bequest (64989).
Domenico Tiepolo, *The Minuet* (fig. 1). Oil on canvas, 31½ × 42⅞ in. (80 ×
109 cm).
PARIS, Musée du Louvre (RF 1938-100). Domenico Tiepolo, *The Minuet* (fig. 2).
Oil on canvas, 31¾ × 43½ in. (80.5 × 110.5 cm).

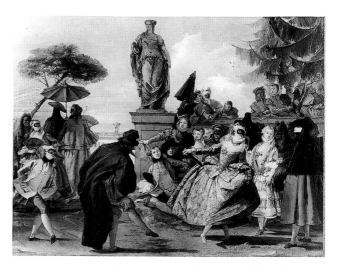

Fig. 1. Domenico Tiepolo, *The Minuet*. Oil on canvas, 31½ × 42⅞ in.
(80 × 109 cm). Museu Nacional d'Art de Catalunya, Barcelona

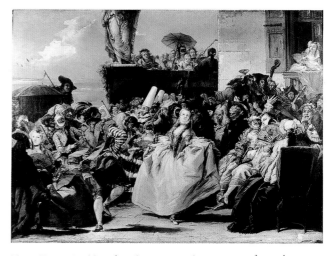

Fig. 2. Domenico Tiepolo, *The Minuet*. Oil on canvas, 31¾ × 43½ in.
(80.5 × 110.5 cm). Musée du Louvre, Paris

During the summer Venetians customarily went on *villeggiatura*,
an extended country holiday on the mainland, where the air was
more salubrious than in the crowded city of Venice. There they
enjoyed a leisurely way of life, occasionally enlivened by colorful
traveling troupes of Commedia dell'Arte actors. Domenico
Tiepolo's painting shows a party of elegant Venetians enjoying
music performed by one of these troupes. These entertainments
occurred at almost any time of day, whenever the actors could
attract an audience. In the Wrightsman picture it appears to be
late morning, the time when Venetians gathered outdoors to
drink hot chocolate. Apparently they are watching the conclusion
of one of these performances; often the Commedia dell'Arte
characters ended their bawdy skits with a minuet.

The dancing couple—the young man in a scarlet suit and a red
cap with black feathers and the actress in a yellow dress—are the
lovers Lelio and Isabella (sometimes called Octavio and Lucia),
the only actors in the troupe who did not wear masks.
Recognizable in the crowd of onlookers are other Commedia
dell'Arte characters: Columbine, the masked woman behind the
dancers; Punchinello, the mountebank with a crooked nose and
tall white hat at the center (a second Punchinello is visible behind
him); the Doctor, the sinister figure in the black robe and floppy
hat of a pedagogue; Coviello, the bass player at the right, with
feathers sprouting from his hat; Harlequin, the acrobat in motley-

colored clothes with a bat tied to his side, climbing the ladder lean-
ing against one of the trees; and, possibly, Pasquariello, the masked
man talking to the woman seated on the right, wearing a ruff and
a close-fitting cap.

Domenico also treated the dance theme in a fresco in the
Foresteria of the Villa Valmarana, near Vicenza,[1] and in three pairs
of oil paintings: one set in the Museu Nacional d'Art de Catalunya,
Barcelona (fig. 1); a second in the Musée du Louvre, Paris (fig. 2);
and a third in a private collection.[2] In the Barcelona and Paris pairs,
the dance scenes are pendants to canvases showing a quack doc-

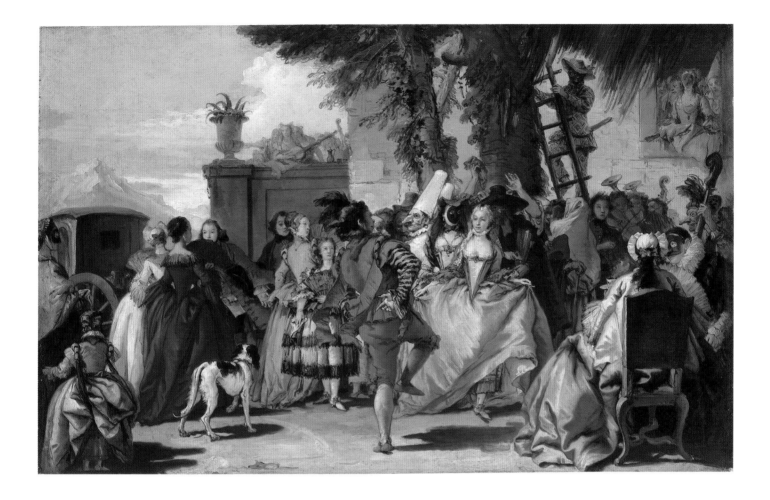

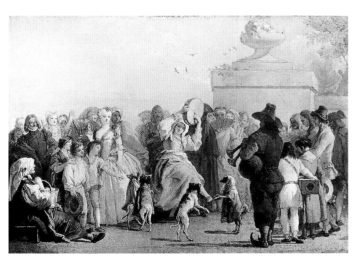

Fig. 3. Domenico Tiepolo, *The Dancing Dogs*. Oil on canvas, 13 × 19 ¼ in. (33 × 49 cm). Private collection (in 1970)

tor advertising his wares in a Venetian square. In the privately owned pair, the *Minuet* is coupled with a picture of dancing dogs (fig. 3). If the Wrightsman picture had a pendant, no record of it exists.

The Barcelona *Minuet* painting and the Valmarana fresco have similar compositions, in which Pantalone, a rich old bearded man, dances with Columbine in a walled garden filled with fashionably dressed Venetians. The compositions of the Paris and Wrightsman canvases are closely related to each other as well and share several details: the dancing lovers; the woman seated on the extreme right, enjoying a cup of steaming chocolate; the girl in the gray-and-white–striped dress, standing in the center and holding an opened fan; the building with its open window and raised terrace; and the carriage parked on the extreme left. Yet they differ in many respects. Above all, the Paris painting is the more crowded of the two, while only the Wrightsman picture shows—to name only the most conspicuous variations—the small girl in the left foreground, seen from behind, who wears a pale lilac dress that is

Fig. 4. Domenico Tiepolo, *Ball at the Ridotto*. Brown ink on paper, 5⅛ × 10½ in. (12.9 × 26.8 cm). Courtauld Institute of Art Gallery, London, Princess Gate Collection

Fig. 5. Domenico Tiepolo, *Rear Part of a Carriage*. Red chalk, on the reverse of the sheet shown in fig. 4

caught up by a dark green ribbon attached to her shoulders; the black and white spaniel; and the pair of tree trunks, with Harlequin climbing the ladder leaning against it.

Multiple Punchinellos appear in both the Wrightsman and the Paris pictures, two and four, respectively. A rather unscrupulous character, Punchinello seems to have held a special fascination for Domenico, who made a cycle of highly finished drawings of 102 scenes from Punchinello's life and decorated a room in the Tiepolo family villa at Zianigo with frescoes of him.[3]

The Barcelona, Paris, and Valmarana paintings were executed before Domenico left Venice for Madrid in 1762. The date of the Barcelona *Minuet,* 1756, is inscribed on its pendant. The Paris *Minuet,* which belonged to the wealthy Venetian collector and writer Francesco Algarotti, probably dates from ten years before his death in 1764; its pendant, also in the Louvre, is inscribed *LIIII,* which has been interpreted to mean 1754.[4] (Although the authenticity of the inscription has been questioned, the style of the Paris canvas is typical of Domenico's oil paintings of the mid-1750s.) The Valmarana fresco is signed and dated 1757. Domenico painted the privately owned pair of canvases in Madrid during the 1760s.

There is no firm evidence for dating the Wrightsman painting, but it is related stylistically to the artist's two *Stories of Abraham* in the Carandini collection, Rome, and the *Encampment of Gypsies* in the Landesmuseum in Mainz, which Domenico painted at Würzburg, sometime before he returned to Venice in 1753.[5] Like the Wrightsman canvas, they are rich and creamy in consistency, painted liberally in bold, fluid brushstrokes. The early dating of the Wrightsman picture is supported by its German provenance. If indeed painted there, it would represent an astonishing evocation of Domenico's homeland. Displaying his special gift for describing his contemporaries, it is probably one of the earliest of his paintings of everyday life.

A drawing by Domenico Tiepolo in the Courtauld Institute of Art Gallery (fig. 4) is also related. It shows a richly appointed Venetian interior with a couple dancing before a crowd of elegant people wearing three-cornered hats. On the verso is a black-chalk drawing of a carriage (fig. 5), very much like the one in the Wrightsman painting. Because of the dancing woman's coiffure, the sheet has been dated before 1760.[6]

EF

NOTES

1. Mariuz 1971, pl. 91.
2. Ibid., pl. 193.
3. The cycle of drawings was the subject of an exhibition in 1979 at the Indiana University Art Museum and the Stanford University Museum of Art, accompanied by the catalogue, Adelheid M. Gealt and Marcia E. Vetrocq *Domenico Tiepolo's Punchinello Drawings* (Bloomington, Indiana, 1979). The Wrightsman painting was added to the exhibition when it was shown at The Frick Collection the following year.
4. Mariuz 1971, pp. 131–32; Catherine Whistler, in London, Washington 1994–95, p. 504 no. 222.
5. Mariuz 1971, pls. 57, 58, 82.
6. James Byam Shaw, *The Drawings of Domenico Tiepolo* (London, 1962), pp. 47, 86 no. 62.

31. *The Departure of the Gondola*

Oil on canvas, 14 ⅛ × 28 ¾ in. (35.7 × 72.5 cm)
Signed on placard attached to column on the left: Domᵒ. | Tiepolo
(fig. 1).

PROVENANCE
Andrés Antonio Salabert y Arteaga, eighth marqués de la Torrecilla (by 1910–
d. 1925); his sister, María de la Concepción Pérez de Guzmán el Bueno y
Salabert, Madrid (from 1925); her son, Luis Figueroa y Pérez de Guzmán el
Bueno, ninth conde de Quintanilla, Madrid (by 1951–59); [M. Knoedler & Co.,
New York, 1959; sold to Wrightsman]; Mr. and Mrs. Charles Wrightsman,
New York (1959–his d. 1986; cat., 1973, no. 28); Mrs. Wrightsman (from 1986).

EXHIBITED
Palazzo Giardini, Venice, 1951, "Mostra del Tiepolo," no. 122 *bis*;
Metropolitan Museum, New York, July–September 1960, "Paintings from
Private Collections: Summer Loan Exhibition," no. 120.

LITERATURE
Eduard Sack, *Giambattista und Domenico Tiepolo: Ihr Leben und ihre Werke*
(Hamburg, 1910), pp. 120, 210 no. 447; Morassi 1941, pp. 274–75; Giuseppe
Fiocco, "Tiepolo in Spagna," *Le arti* 5 (October–November 1942), pp. 9, 10;
Mariuz 1971, pp. 70, 71, 130; Fahy 1973, pp. 269–78 no. 28; Filippo Pedrocco,
Disegni di Giandomenico Tiepolo (Milan, 1990), p. 15; Wolk-Simon 1996–97, p. 33.

COPIES
FRANKFURT AM MAIN, Gustav M. Schneider (in 1925).¹ Oil on canvas, 16 ⅝ ×
28 in. (42.3 × 71 cm).
LONDON, Sotheby Parke Bernet, May 9, 1979, lot 226. Oil on canvas, 14 ×
28 ¾ in. (35.6 × 73 cm).
WHEREABOUTS UNKNOWN (in 1937). A "miserable" copy, attributed to Lorenzo
Tiepolo.²

A Venetian couple, dressed in costumes typical of the carnival sea-
son, are about to step into a gondola by the side of a canal in front
of the entrance to a walled garden. They wear *tricorni*, black
three-cornered hats used by both men and women in eighteenth-
century Venice, and *baute*, characteristically Venetian garments of
black cloth worn about the lower part of the face and over the
shoulders and chest. The man wears a *moreta*, a white Venetian
mask that covers only half of the face. The woman has one too,
propped on top of her *tricorno*. She wears a *tabarro* (a type of black
cape), a pale pink dress with large cuffs of white lace at her
elbows, and long white gloves. Behind her, to the right, a young
man, wearing a bright scarlet jacket and a powdered wig, holds
up her cape; in front of her, to the left, a bareheaded *gondoliere*
steadies the boat and extends his arm to assist her. A second *gon-
doliere* stands on the platform at the stern of the gondola.

Along the *fondamenta*, or paved street running along the canal,
there are various groups of onlookers: another couple, clad like
the pair boarding the gondola, stand on the extreme left; three
youths lean on the railing of the *fondamenta,* as, immediately
behind them, a pair of women walk to the right wearing pink and
yellow shawls over their heads; three men in fancy matching
outfits stand by the monumental archway; and several women
spectators, wearing masks and shawls over their heads, stand on
the right. Running parallel to the *fondamenta* is a white wall
pierced by a grille through which a garden is visible and by an
archway surmounted by a broken pediment through which
another wall with an arched opening can be seen. On the far left
are two colossal columns, perhaps part of the portico of a building.

Masks were worn during special periods announced officially
by the Venetian Republic, especially during carnival, which in
Venice started early and lasted from Saint Stephen's Day,
December 26, until the beginning of Lent. Lower-class young
men and boys did not participate in the masquerade. The *gondo-
lieri* of Venetian families wore handsome costumes that repeated
the colors of the families' coats of arms. In the *Departure of the
Gondola*, the pale blue, gold, and white of the *gondolieri*'s richly
textured knickers reappear on the four *palafitte* (the striped posts
between which the gondola is moored) and in the attire of the
three young men standing by the archway. It has been suggested
that the latter are young aristocrats, but since their costumes
repeat the colors of the household, they must be liveried servants.

Within Domenico Tiepolo's oeuvre, the *Departure of the
Gondola* is exceptional because of the delicacy with which it is

Fig. 1. Detail of signature

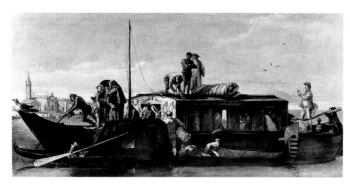

Fig. 2. Domenico Tiepolo, *The Burchiello*. Oil on canvas, 15 × 30⅞ in. (38 × 78.3 cm). Kunsthistorisches Museum, Vienna

painted. By contrast, the other Wrightsman painting by Domenico, the *Dance in the Country* (cat. 30), is boldly rendered in large brush-strokes and heavy impasto. Perhaps because of its refined quality, the *Departure of the Gondola* has been published several times as a work by Domenico's father, Giambattista. Indeed, it has the cool silvery tonality of Giambattista's sketches for the Aranjuez altar-pieces. Yet it is signed (fig. 1), and there can be no doubt that Domenico was responsible for its design and execution. Although Domenico's Spanish output remains to be carefully analyzed, it would appear that he was susceptible to his father's late manner, and the style of the *Departure of the Gondola* tends to support the hypothesis that it was painted during the mid-1760s in Madrid.

The *Departure of the Gondola* is often said to be the pendant to a painting in the Kunsthistorisches Museum, Vienna, that is closely related in subject, style, and horizontal format (fig. 2). The Vienna canvas is slightly larger than than Wrightsman painting—an inch taller and two inches wider, a negligible difference for paintings of this age. It represents the *burchiello*, a large omnibus boat that plied the Brenta canal between Venice and Padua.[3] Although the pictures make a plausible pairing of upper- and lower-class transport, there is no record of their ever having been together. The *Burchiello*

almost certainly remained in Domenico's possession until his death in Venice, whereas the Wrightsman painting has a Spanish provenance.[4] While there is no record of the *Burchiello* in Spain, Domenico may have painted both pictures in Madrid as nostalgic evocations of Venice when he was far from home.

During the eighteenth century, paintings of everyday life were popular, and several Venetian artists—among them Pietro Longhi (1702–1785) and Francesco Guardi (see p. 78) and his brother Antonio (1699–1760)—painted social gatherings in domestic interiors. These charming scenes often have a faintly theatrical air, a quality not shared by the *Departure of the Gondola*, though it is carefully composed with an almost symmetrical arrangement of spectators looking toward the center. It captures the actuality of a fleeting moment, enlarging upon the glimpses of ordinary life that appear in Venetian topographical views, such as the etchings (fig. 3) of Michiel Giovanni Marieschi (1710–1743) in which elegant women board gondolas.[5] EF

NOTES

1. Georg Swarzenski, *Ausstellung von Meisterwerken alter Malerei aus Privatbesitz* (Frankfurt am Main, 1926), p. 78 no. 225, pl. 89.
2. Giuseppe Fiocco, "Giambattista Tiepolo in Spagna," *Nuova antologia* 15 (April 1937), p. 333.
3. The similarity of the *Departure of the Gondola* and the *Burchiello* was first observed by Morassi 1941, pp. 274–75. The pairing with the *Burchiello* is cautiously accepted by Adriano Mariuz, in London, Washington 1994–95, p. 508.
4. The Vienna picture remained in Domenico's possession until his death. See the correspondence between Antonio Canova (1757–1822) and the little-known painter Ferdinando Tonioli (ca. 1755–1811) cited by Adriano Mariuz and Marina Magrini, in *Splendori del Settecento veneziano*, ed. Giovanna Nepi Sciré and Giandomenico Romanelli, exh. cat., Museo del Settecento Veneziano–Ca' Rezzonico, Gallerie dell'Accademia, and Palazzo Mocenigo, Venice (Milan, 1995), p. 386; Giuseppe Pavanello, *Canova collezionista di Tiepolo* (Venice, 1996), pp. 18, 22, 69 n. 27.
5. The Marieschi etching and the Wrightsman painting were first juxtaposed by Gino Fogolari, "In tabarro e bauta," *Illustrazione italiana*, no. 18 (May 3, 1925), p. 1.

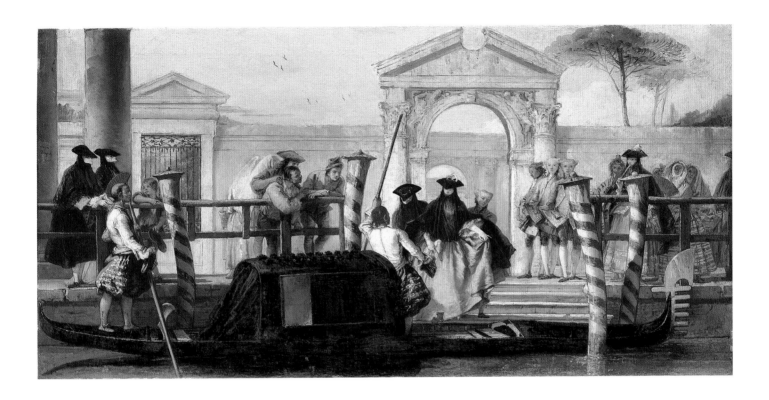

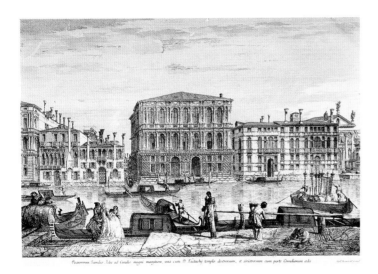

Fig. 3. Michiel Giovanni Marieschi, *Ca' Pesaro on the Grand Canal*. Etching, plate, 12½ × 18⅜ in. (31.7 × 46.8 cm). The Metropolitan Museum of Art, New York, Rogers Fund, 1969 (69.551)

MARCANTONIO FRANCESCHINI

(1648–1729)

One of the most sought-after fresco decorators of his time, Marcantonio Franceschini received his training in the tradition of earlier Bolognese classicists from Carlo Cignani (1628–1719). Working as Cignani's chief assistant in the 1670s, Franceschini executed frescoes based on Cignani's cartoons. He also married Cignani's cousin, the sister of a fellow studio assistant, Luigi Quaini (1643–1717), who throughout his career would paint the architectural and landscape backgrounds of Franceschini's pictures. In 1680 Franceschini received wide recognition for the elegant style of his first independent commission, the ceiling frescoes in the Palazzo Ranucci (now the Palazzo di Giustizia), Bologna. Numerous large-scale frescoes followed, together with commissions for cabinet pictures and altarpieces, the most famous being the Death of Saint Joseph (1686), still in situ in the church of Corpus Domini, Bologna. Between 1692 and 1700 Franceschini shipped to Vienna twenty-six large canvases illustrating episodes from the myths of Diana and Venus to decorate the summer palace of Prince Johann Adam von Liechtenstein (now the Liechtenstein Museum, Vienna). In 1696 he frescoed the vast ceiling of the reception hall of the Palazzo Ducale in Modena, and, in 1702–4, the Sala del Maggior Consiglio of the Palazzo Ducale in Genoa. He is said to have turned down an invitation from Charles II of Spain to become his court painter, a position subsequently filled by Giordano (see p. 53).

Franceschini's polished idiom, with planar figural arrangements and carefully delineated contours, can be seen either as a harbinger of Neoclassicism, the style that would dominate European art of the second half of the eighteenth century, or as the last bloom of the classical tradition initiated in Bologna by Annibale Carracci (1560–1609), Domenichino (see p. 38), and Guido Reni (see p. 45). What is certain is that his elegant style starkly contrasted with the dark manner and loaded brushstrokes of his slightly younger contemporary, Giuseppe Maria Crespi (1665–1747), a descendant of the other Bolognese artistic lineage, that of Ludovico Carracci (1555–1619) and the young Guercino (see p. 27). EF

ABBREVIATIONS

Miller 1970. Dwight Miller. "Two Early Paintings by Marcantonio Franceschini and a Gift of the Bolognese Senate to Pope Clement XI." *Burlington Magazine* 112 (June 1970), pp. 373–78.

Miller 2001. Dwight C. Miller. *Marcantonio Franceschini*. Turin, 2001.

32. *The Last Communion of Saint Mary of Egypt*

Oil on copper, 16¾ × 21⅜ in. (42.5 × 54.3 cm)
The Metropolitan Museum of Art, New York, Wrightsman Fund, 1996 (1996.9)

PROVENANCE

[Francesco Ruvinetti, until about 1709; sold by or through him together with its pendant for 80 "luigi" to the Senate of Bologna]; Senate of Bologna (1709; given to Clement XI); Pope Clement XI (Giovanni Francesco Albani), Rome (from 1709–d. 1721); ?Henry R. Willett, Brighton (before d. 1905); Canon Robert Wadnan, Saint Joseph's Presbytery, Bridgewater, England (until d. 1914; sale, Puttick and Simpson, London, October 16, 1914, lot 74, as "Flemish School," to Grace); Lionell P. Grace, London (1914–probably until d. 1919); [?sale, Sotheby's, London, as by "Albani," to Pope-Hennessy]; Sir John Wyndham Pope-Hennessy, London, later New York, later Florence (by 1961–d. 1994); Michael Mallon, Florence (1994–96; sale, "The Collections of the Late Sir John Wyndham Pope-Hennessy," Christie's, New York, January 10, 1996, lot 103, for $112,500, to Agnew); [Agnew, New York, 1996; sold to the Metropolitan Museum]; purchased in 1996 with a gift from the Wrightsman Fund by the Metropolitan Museum.

LITERATURE

Giampietro Zanotti, *Storia dell'Accademia Clementina di Bologna* (Bologna, 1739), vol. I, pp. 223–24; Miller 1970, pp. 373–78; Donatella Biagi, in *La raccolta Molinari Pradelli. Dipinti del Sei e Settecento*, exh. cat., Palazzo del Podestà, Bologna (Florence, 1984), p. 104; Miller 2001, pp. 76, 98, 221, 236, 237.

According to an elaborate legend that arose in the Middle Ages and had a remarkable popularity and diffusion all over Christendom, Mary of Egypt was a harlot at Alexandria who underwent a sudden conversion as she was about to enter the Church of the Holy Sepulcher in Jerusalem, supposedly in about the year 430. Withdrawing across the River Jordan, for the next forty-odd years she lived a solitary life of penitence in the desert. When the holy monk and priest Zosimus encountered her, haggard and naked except for her own hair, he threw his mantle over

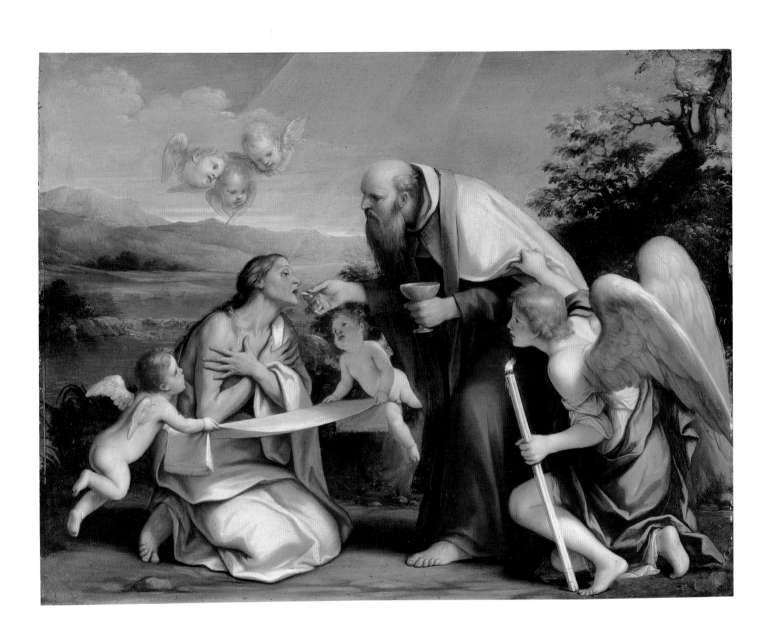

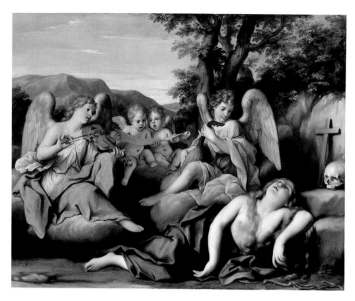

Fig. 1. Marcantonio Franceschini, *The Ecstasy of Mary Magdalen*. Oil on copper, 16½ × 21¾ in. (42 × 55.3 cm). Collezione Molinari Pradelli, Marano di Casternaso (Bologna)

her and gave her communion. In this compact, luminous painting, the barefoot, bearded Zosimus administers the host with the aid of an angel who holds a lighted candle and pulls back Zosimus's cope; two putti suspend the humeral veil beneath the eucharistic bread; and three cherubs hover above the saint's head. The River Jordan is portrayed with a broad waterfall below an expanse of blue mountains.

In art, Mary of Egypt is often coupled with Mary Magdalen, the latter always appearing younger and physically more attractive, as Pier Francesco Mola (see p. 50), for example, shows her in a pair of roundels now in a Swiss private collection.[1] Indeed, the Wrightsman picture initially had a pendant depicting the Magdalen collapsed on the ground, listening to divine music; it is painted on a piece of copper the same size as the Wrightsman work and with figures on the same scale (fig. 1). The pair was last recorded together in 1709.[2]

Giampietro Zanotti, Franceschini's friend and biographer, reports in his history of the Accademia Clementina that the pictures were painted in 1680 and that they later were purchased by the Senate of Bologna, which presented them to Pope Clement XI.[3]

Dwight Miller, the doyen of Franceschini studies, was able to confirm Zanotti's story with his discovery of the correspondence between the Bolognese Senate and its ambassador to the papal court, Count Filippo Aldovrandi.[4] In the hope of enlisting the pope's support for the founding of an art academy, the Senate offered the pictures as a diplomatic gift to the pope's two nephews, who were briefly in Bologna in the spring of 1709. The nephews refused the gift, in consideration of Clement's stringent efforts to avoid nepotism. But the Senate persisted and shipped the paintings to Rome, where the pope was so overcome by their beauty that he accepted the gift himself and sponsored the academy, which, in recognition of his endorsement, was named the Accademia Clementina, Bologna's first official art academy.

The pictures embodied the classical tradition the academy was meant to uphold: Franceschini was the best pupil of Cignani, who in turn was the star pupil of Francesco Albani (1578–1660), one of the distinguished followers of Annibale Carracci, founder of the Bolognese school. Following Cignani's tenure as the first director, Franceschini headed the academy from 1719 to 1722. The gift of the two paintings may also have led to the pope's subsequent patronage of Franceschini. In the spring of 1711 he commissioned the artist to make thirteen large cartoons for mosaics in a chapel in Saint Peter's. During the fifteen months Franceschini spent in Rome, the pope knighted him, and nine years later made him a member of the Militia of Saint Benedict.

EF

Notes

1. Jean Genty, *Pier Francesco Mola nelle collezioni private svizzere*, exh. cat., Bruno Scardeoni Antiquario, Lugano (Lugano, 1986), pp. 24–27.
2. According to a nineteenth-century manuscript excerpted by Miller 1970, pp. 373 n. 3 and 374 n. 14, the paintings were purchased in June 1709 from Francesco Ruvinetti, about whom nothing is known. Maestro Molinari Pradelli acquired the pendant at the Dorotheum in Vienna in 1963.
3. Giampietro Zanotti, *Storia dell'Accademia Clementina di Bologna* (Bologna, 1739), vol. 1, pp. 223–24: "Del MDCLXXX dipinse su due piastre di rame santa Maddalena in estasi con alcuni Angli intorno, e santa Maria Egiziaca comunicata dall'Abate Zosimo, le quali pitture furono poi comperate dal Senato di Bologna per farne dono a Papa Clemente XI, che molto ne fu contento."
4. Miller 1970.

PETER PAUL RUBENS

(1577–1640)

Born at Siegen in Westphalia, Peter Paul Rubens spent most of his life in Antwerp, his family's native city. After receiving a classical education at the Latin school of Rombaut Verdonck, Rubens trained under three painters, the most prominent of whom was Otto van Veen (1556–1629). He became a master in the Antwerp painters' guild in 1598 and two years later departed for Italy.

For the next eight years Rubens was employed by Vincenzo I Gonzaga, duke of Mantua. As court painter he made formal portraits of the Gonzaga family and acted as the curator of the duke's collection. He also performed diplomatic services for the duke, which included traveling in 1603 from Mantua to Madrid with presents for the Spanish court. In 1608, just as he was completing the high altarpiece of the Chiesa Nuova in Rome, Rubens was called back to Antwerp by reports of his mother's imminent death.

Deciding to settle in Antwerp, Rubens married Isabella Brandt (1591–1626) in 1609. Appointed court painter to Archduke Albert and Archduchess Isabella, the Spanish governors of the Netherlands, he quickly established himself as the leading painter in his homeland, producing magnificent altarpieces for churches in Antwerp and Ghent.

A great impresario, Rubens worked with a number of assistants, whom he supervised carefully. His large studio included the young Van Dyck (see p. 123), Jacob Jordaens (1593–1678), and Frans Snyders (1579–1657), as well as a number of less famous men who carried out the master's designs, faithfully imitating his personal style. In 1620 Rubens began his first vast decorative project, the thirty-nine ceiling paintings and two major altarpieces for the Jesuit church at Antwerp. This was followed in 1622 with a commission from Louis XIII of France to design twelve tapestries depicting the life of Constantine. For the gallery of Marie de' Medici in the Luxembourg Palace, Paris, he produced, between 1622 and 1625, twenty-one enormous canvases celebrating her life.

From 1628 to 1630 Rubens was involved in diplomatic attempts to bring peace to the Netherlands during the Thirty Years' War (1618–48). He spent nine months as a secret envoy in Madrid, and in 1629 he visited England, where he was knighted by Charles I for devising a plan to exchange ambassadors between England and Spain. As a result of his contact with the English king, he was asked to decorate the Banqueting House at Whitehall Palace, London, with nine large ceil-ing canvases. In 1635 he supervised the temporary decorations prepared for the state entry into Antwerp of Cardinal Infante Ferdinand, brother of Philip IV and successor to the Archduchess Isabella as governor of the Netherlands.

Rubens's first wife died in 1626, leaving him a widower with three children. Four years later he married Helena Fourment (1614–1673), the inspiration for many of his late paintings. For her, he purchased Het Steen, the château of Elewijt, the setting of some of his most romantic landscape paintings. During the last eighteen months of his life he suffered from gout and painted only intermittently.

Throughout his career Rubens worked with unbelievable drive and creativity; the sheer magnitude of his output was overwhelming. His exuberant compositions, with their energy, color, and wealth of pictorial invention, epitomize the Baroque spirit.

EF

ABBREVIATIONS

Fahy 1973. Everett Fahy, in *The Wrightsman Collection*, vol. 5, Everett Fahy and Francis Watson, *Paintings, Drawings, Sculpture*. New York, 1973.

Jaffé 1989. Michael Jaffé. *Rubens. Catalogo completo*. Trans. Germano Mulazzani. Milan, 1989.

Liedtke 1984. Walter A. Liedtke. *Flemish Paintings in The Metropolitan Museum of Art*. 2 vols. New York, 1984.

Oldenbourg 1921. Rudolf Oldenbourg, ed. *P. P. Rubens: Des Meisters Gemälde in 538 Abbildungen*. 4th ed. Klassiker der Kunst in Gesamtausgaben 5. Stuttgart, Berlin, and Leipzig, 1921. (1st ed., by Adolf Rosenberg, 1905).

Renger 2002. Konrad Renger, with Claudia Denk. *Flämische Malerei des Barock in der Alten Pinakothek*. Cologne, 2002.

Rooses 1886–92. Max Rooses. *L'oeuvre de P. P. Rubens: Histoire et description de ses tableaux et dessins*. 5 vols. Antwerp, 1886–92.

Vienna, New York 2004–2005. Anne-Marie Logan, with Michiel C. Plomp. *Peter Paul Rubens: The Drawings*. Exh. cat., Albertina, Vienna, and The Metropolitan Museum of Art, New York; 2004–2005. New York, 2005.

Vlieghe 1987. Hans Vlieghe. *Rubens Portraits of Identified Sitters Painted in Antwerp*. Corpus Rubenianum Ludwig Burchard, part 19, vol. 2. Brussels, 1987.

33. *Portrait of a Woman, probably Susanna Lunden*

Oil on wood, 30¼ × 23⅝ in. (76.8 × 60 cm)

The panel, which has been thinned and cradled, is composed of two vertical boards, with an original added strip, consisting of three pieces of wood, at the bottom 3¾ in. (9.5 cm) high. Radiographs (fig. 1), made in 1967, reveal that the veil was added after the head was completed.

The Metropolitan Museum of Art, New York, Gift of Mr. and Mrs. Charles Wrightsman, 1976 (1976.218)

PROVENANCE
Joanna Ludovica Josepha du Bois, Lady of Vroylande and Roosenbergh, Antwerp (until 1777; her estate sale, Antwerp, July 7, 1777, lot 1, for fl. 1,900); comtesse d'Oultremont (by 1831–her d.; upon division of her property, to du Bois d'Edeghem); comtesse du Bois d'Edeghem; [art market, Paris, sometime between 1865 and 1870; to Rothschild]; baron Gustave de Rothschild, Paris; his daughter, baronne Berthe Juliette Leonino (until d. 1896); her daughter, baronne Antoinette Leonino (until 1959; sold to Hoogendijk); [D. A. Hoogendijk, Amsterdam, 1959–66; sold to Wrightsman]; Mr. and Mrs. Charles Wrightsman, New York (1966–76; cat., 1973, no. 21); their gift in 1976 to the Metropolitan Museum.

EXHIBITED
Metropolitan Museum, New York, March–October 1967.

LITERATURE
Rooses 1886–92, vol. 4 (1890), pp. 316–17; Fahy 1973, pp. 195–204 no. 21; Liedtke 1984, vol. 2, pp. 172–76; Jaffé 1989, p. 297 no. 867.

VERSIONS/COPIES
ANTWERP, Mme Moons-Van Staelen.[1]
DRESDEN, Gemäldegalerie (971). A copy, in reverse. Oil on wood, 30⅛ × 23⅝ in. (76.5 × 60 cm).
LONDON, Sotheby's, July 10, 1968, lot 89 (not illustrated).[2] Oil on wood, 28 × 21½ in. (71.1 × 54.6 cm). Ex-collections F. Kleinberger, Paris (in 1935); A. Seligman, Paris; De Nayette, Paris.

Fig. 1. Radiograph of the head

When this portrait was first cited in print, the sitter was not unreasonably called Rubens's second wife, Helena Fourment; there is something to be said for the resemblance between the sitter and Helena, who is depicted in the other Wrightsman painting by Rubens (cat. 34).[3] Scholars, however, quickly rejected this identification, and most of them now agree that it represents Helena's sister Susanna (1599–1628). Long before Rubens married Helena, the sisters were on close terms with the painter's family because their eldest brother, Daniel Fourment (1592–1648), was married to Rubens's first wife's sister, Clara Brandt. In 1617 Susanna Fourment married Raymond del Monte, who left her a widow four years later; their only child, Clara (1618–1657), married Albert (1614–1657), Rubens's eldest son from his first marriage. Susanna's second husband was Rubens's good friend Arnold Lunden.

Susanna actually had six sisters: in addition to Helena, there were Clara (b. 1593), Joanna (b. 1596), Maria (b. 1601), Catherina (b. 1603), and Elizabeth (b. 1609). Rubens painted a portrait of Clara and as many as seven of Susanna (four of them are listed in the inventory of the artist's possessions at the time of his death).[4] No portrait of Clara has ever been identified, and there is no documented portrait by Rubens of Susanna, but Gustav Glück advanced the hypothesis that her features can be recognized in several paintings and drawings by Rubens.[5] Among the generally accepted portraits of Susanna are a half-length likeness in the Louvre and a drawing (fig. 2) in the Albertina, Vienna.[6] Moreover,

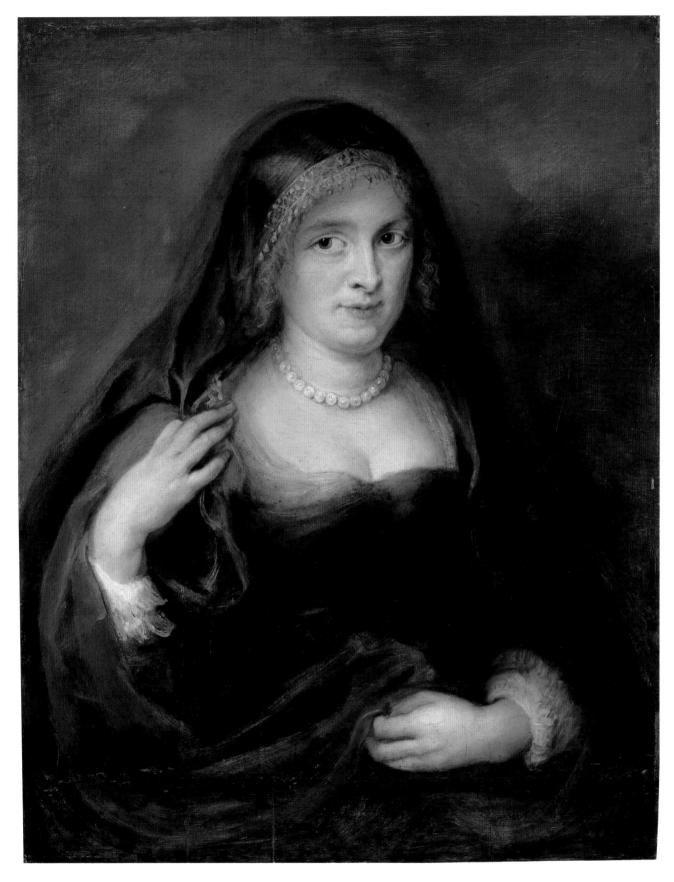

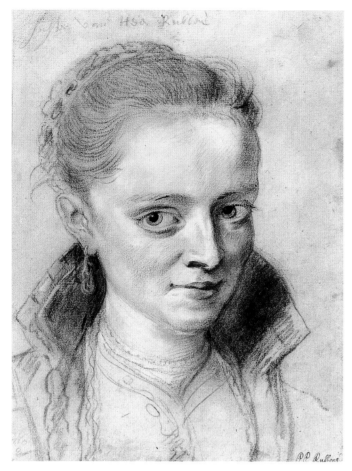

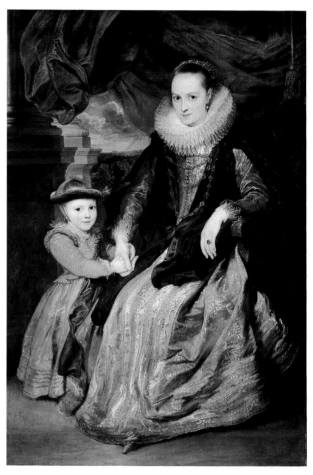

Fig. 2. Peter Paul Rubens, *Susanna Fourment*. Red, black, and white chalk on paper, 13 ½ × 10 ¼ in. (34.3 × 26 cm). Albertina, Vienna

Fig. 3. Antony van Dyck, *Susanna Fourment and Her Daughter, Clara*. Oil on canvas, 67 ¾ × 46 ⅛ in. (172.1 × 117.1 cm). National Gallery of Art, Washington, D.C.

Susanna Fourment is plausibly believed to have been the model for both a painting by Rubens of a shepherdess and the *Chapeau de paille*, Rubens's masterpiece of the early 1620s now in the National Gallery, London.[7] A full-length seated portrait by Van Dyck of a young woman with a little child, in the National Gallery of Art, Washington, D.C. (fig. 3), also represents Susanna.[8]

Technical evidence supports the identification of the sitter in the present portrait as Susanna Fourment. Radiographs (fig. 1) reveal that initially Rubens did not intend to show her wearing a veil. Instead, he began by painting her hair combed back behind the ear in the Antwerp fashion of the early 1620s. Not only is the ear completely visible, but a pendant pearl earring can also be seen; Susanna wears the same kind of earring in the Albertina drawing (fig. 2). In that work the head is seen from almost the same angle as it is in the Wrightsman painting, making the resem-

blances between the drawing and the X-ray image even more suggestive. The drawing might even be a preliminary study for the portrait, which Rubens then changed when he added the veil and the lovely hand holding it back.

Although the Wrightsman portrait has been dated as early as 1612 and as late as 1635, its style falls between these two extremes.[9] It is painted in the solid, unbroken manner characteristic of the beginning of Rubens's middle period, the time of his Jesuit Church altarpieces. The modeling of the flesh and the fluid treatment of the veil are altogether looser than the firm handling of paint seen, for example, in Rubens's portrait of Emperor Augustus, executed in 1619 and formerly in the Bildergalerie von Sanssouci, Potsdam.

The dating in the mid-1620s suggested by style is supported by two biographical facts: first, as Susanna was born in 1599, she would have been in her early twenties at the time of the painting

(and while it is admittedly difficult to judge precisely the age of people in seventeenth-century portraits, the sitter does appear to be in her early twenties); second, Susanna wedded her second husband on March 8, 1622, so the ring prominently displayed in the painting might refer to this marriage. While some scholars have associated the somber black dress and veil with mourning, following the death, probably in 1621, of Susanna's first husband,[10] the gold-lace fringe on the veil is in fact typical of Spanish mantillas fashionable in countries under Spanish domination. Besides, both the string of pearls and the sitter's fetching smile would be inappropriate for a widow. EF

NOTES

1. Rooses 1886–92, vol. 4 (1890), p. 163.
2. Published by August L. Mayer, "The Portrait of Helene Fourment in a Black Mantilla by Rubens," *Burlington Magazine* 67 (November 1935), p. 224.
3. Karl Woermann, *Katalog der königlichen Gemäldegalerie zu Dresden* (Dresden, 1887), pp. 316–17.
4. Jean Denucé, *The Antwerp Art-Galleries: Inventories of the Art-Collections in Antwerp in the Sixteenth and Seventeenth Centuries* (The Hague, 1932), p. 78, nos. 63 [*sic*; 64], 69, 70.
5. Gustav Glück, *Rubens, Van Dyck und ihr Kreis* (Vienna, 1933), pp. 118–48.
6. Musée du Louvre, Paris (1796); Albertina, Vienna (17651). For the latter, see Anne-Marie Logan and Michiel C. Plomp, in Vienna, New York 2004–2005, pp. 242–43 no. 83.
7. Hans Vlieghe, "Some Remarks on the Identification of Sitters in Rubens' Portraits," *Ringling Museum of Art Journal*, 1983, pp. 106–15, especially p. 108. The *Shepherdess* was sold at Christie's, London, on December 13, 1996, lot 42. For the *Chapeau de paille*, see Gregory Martin, *The Flemish School, Circa 1600–Circa 1900,* National Gallery Catalogues (London, 1970), pp. 175–76.
8. Nora De Poorter, in Susan J. Barnes et al., *Van Dyck: A Complete Catalogue of the Paintings* (New Haven and London, 2004), p. 98.
9. Oldenbourg 1921, pl. 58; and Rooses 1886–92, vol. 4 (1890), p. 162, respectively.
10. Jacob Burckhart, *Erinnerungen aus Rubens* (Vienna, 1938), pp. 201 n. 90, 436. See also Fahy 1973, p. 199.

34. *Rubens, His Wife Helena Fourment, and Their Daughter Clara Joanna*

Oil on wood, 80 ¼ × 62 ¼ in. (203.8 × 158.1 cm)

The exact arrangement of the components of the panel is concealed by cradling. Results of the technical examination at the Metropolitan Museum were published in an exhaustive catalogue entry by Walter Liedtke.[1] Radiographs (fig. 1) reveal that at some stage there was a large arch above the heads of Rubens and Helena. Initially, Rubens's head faced out toward the viewer and his right hand rested on his chest. In completing the painting, the artist raised his head several inches and turned it toward his wife. As a result, he became taller, and the elongated passage between his knees and waist was covered with drapery. The painting was cleaned in 1977 by Mario Modestini.

The Metropolitan Museum of Art, New York, Gift of Mr. and Mrs. Charles Wrightsman, in honor of Sir John Pope-Hennessy, 1981 (1981.238)

PROVENANCE

The children of Rubens and Helena Fourment, Antwerp (1640–); ?Rubens's nephew Philip Rubens, Antwerp (in 1676); the city of Brussels (until about 1706/8; given to, or expropriated by, Churchill); John Churchill, first Duke of Marlborough, Blenheim Palace, near Woodstock, Oxfordshire (about 1706/8–d. 1722); the Dukes of Marlborough, Blenheim Palace (1722–1883; cat., 1861, p. 23); George Charles Spencer-Churchill, eighth Duke of Marlborough, Blenheim Palace (1883–84; sold, together with *Helena Fourment with Frans Rubens* [Louvre, Paris], for Fr 1,375,000, to Rothschild); baron Mayer Alphonse de Rothschild, Paris (1884–d. 1905); his son, baron Édouard de Rothschild, Paris (1905–d. 1949); his widow, baronne Germaine de Rothschild, Paris (1949–d. 1975); her estate, 1975–76; [Wildenstein, Paris and New York, 1976–78; sold to Wrightsman]; Mr. and Mrs. Charles Wrightsman, Palm Beach, Florida, and New York (1978–81); their gift in 1981 to the Metropolitan Museum in honor of John Pope-Hennessy.

EXHIBITED

British Institution, London, 1865, no. 52; Orangerie des Tuileries, Paris, June–August 1946, "Les chefs-d'oeuvre des collections privées françaises, retrouvés en Allemagne par la Commission de Récupération Artistique et les Services Alliés," no. 69.

LITERATURE

Marlborough Jewels and Pictures, Add. MSS 9125, British Museum, London; Rooses 1886–92, vol. 4 (1890), pp. 263–64 no. 1052; Oldenbourg 1921, pp. 447, 472; Jacques Foucart, "Un nouveau Rubens au Louvre: Hélène Fourment au carrosse," *La revue du Louvre,* 1977, pp. 343–44, 346–47, 352 nn. 8, 19, 27, 28, p. 353 n. 31; Liedtke 1984, vol. 1, pp. 176–87; Vlieghe 1987, pp. 27, 97, 136, 159, 161, 166, 170–73 no. 141, 174; Jaffé 1989, pp. 62, 64, 375 no. 1401; Walter A. Liedtke, in *Flemish Paintings in America: A Survey of Early Netherlandish and Flemish Paintings in the Public Collections of North America,* ed. Guy C. Bauman and Walter A. Liedtke (Antwerp, 1992), pp. 12, 214–16; Anne-Marie Logan and Michiel C. Plomp, in Vienna, New York 2004–2005, pp. 39, 239, 255.

Fig. 1. Composite radiographs of the Wrightsman painting

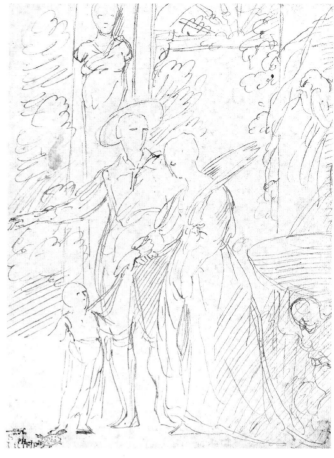

Fig. 2. Attributed to Matthias Jansz. van den Bergh. Copy of the Wrightsman painting. Traces of black chalk and brown ink on paper, 7¼ × 5½ in. (18.5 × 141 cm). Fitzwilliam Museum, Cambridge

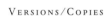

VERSIONS/COPIES

CAMBRIDGE, Fitzwilliam Museum (PD.44-1961). Attributed to Matthias Jansz. van den Bergh. Traces of black chalk and brown ink on paper, 7¼ × 5½ in. (18.5 × 141 cm) (fig. 2).[2]

FARMINGTON, Connecticut, The Lewis-Walpole Library. John Eccardt, *Charles and Mary Churchill*. Oil on canvas, dated 1750.[3]

WHEREABOUTS UNKNOWN. Bust-length figure of Helena, known in at least five versions, the best one of which was last recorded in 1965 in a private collection in Brussels.[4]

PRINTS

James McArdell (1728–1765). Mezzotint, plate, 19⅞ × 14⅛ in. (50.6 × 35.9 cm).
Charles Phillips (1737–1783). Mezzotint, sheet, 15⅛ × 11 in. (38.4 × 27.9 cm).

This glorious painting depicts Rubens with his second wife and one of their children. Rubens's first wife, Isabella Brandt, had died in 1626, and for the next four years he traveled abroad on diplomatic assignments in Spain and England. Then, in December 1630,

at the age of fifty-three, he married Helena Fourment (1614–1673), the sixteen-year-old daughter of a prosperous tapestry merchant and the sister of the recently deceased Susanna Fourment (see cat. 33). In an often-quoted letter to his famous friend Nicolas-Claude Fabri de Peiresc, Rubens wrote, "I decided to marry again, since I never have been attracted to the abstinent life of the celibate, thinking that, if we must give first place to continence [in Latin] *we may enjoy licit pleasures with thankfulness*. I have taken a young bride of a good but middle-class family, though everyone tried to persuade me to make a court marriage. But I feared [in Latin] *pride, that inherent vice of the nobility, particularly in that sex*. So I chose someone who would never blush to find me with brush in hand. And the truth is, I am too fond of my freedom to exchange it for the embraces of an old woman."[5]

The marriage was a happy one. Over the next ten years, Helena bore five children, the last one eight months after Rubens

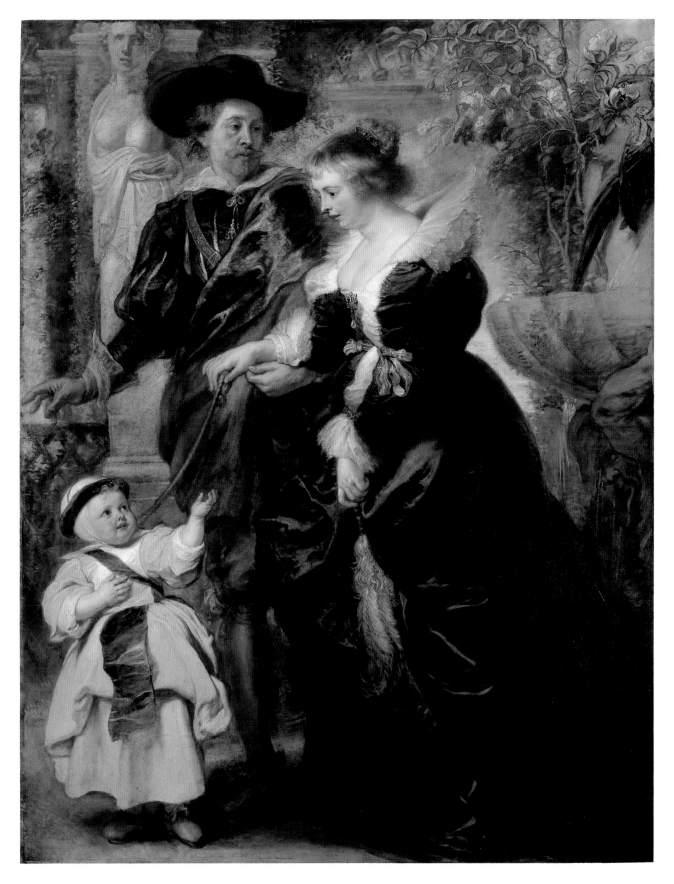

Fig. 3. Peter Paul Rubens, *The Crowning of Saint Catherine, with Saints Apollonia and Margaret*. Oil on canvas, 73¾ × 62¾ in. (187.3 × 159.4 cm). Toledo Museum of Art, Toledo, Ohio

Fig. 4. Detail of fig. 3

had died. Which child is depicted here has been the subject of some debate. Theoretically, it could be a son or a daughter because boys and girls in the Netherlands wore dresses until they were about five years old, and blue sashes were worn by boys and girls alike.[6] Most writers have assumed the child is the firstborn, Clara Joanna (b. January 18, 1632), but others have argued that it is the second, Frans (b. July 12, 1633); the third, Isabella Helena; or even the fourth, Peter Paul (b. March 1, 1637). Common sense, however, favors the eldest, as it would be odd to depict one of the younger children without the others. Moreover, the style of the painting decisively favors the firstborn.

During the last years of his life, Rubens's style changed dramatically, due in part to his renewed acquaintance with the works of Titian (ca. 1490–1576), which he saw again in the late 1620s at the courts of Philip IV and Charles I. The strong local colors and sculptural modeling of Rubens's earlier work gave way to a lighter palette and astonishingly free brushwork, applied with ever greater delicacy and thinness as the decade of the 1630s progressed. The style of the Wrightsman family portrait is typical of the beginning of this final phase, comparable to that of the *Crowning of Saint Catherine* (fig. 3) in the Toledo Museum of Art, which was commissioned in 1631 but not completed until 1633.[7] Helena's pose and expression in the Wrightsman painting are so similar to those of the Saint Margaret (fig. 4) in the Toledo altarpiece that Helena must have served as a model for the saint in the altarpiece. The dating suggested by style is also confirmed by motifs that appear in Rubens's works of the early 1630s, such as the *Walk in the Garden* (fig. 5), an intriguing painting, begun in the spring of 1631 and finished later by an assistant,[8] or the celebrated *Garden of Love* (Museo del Prado, Madrid), in which the poses of the strolling couples, particularly the one on the left side of the composition, recall the amorous way Rubens stands back and gazes at his wife.

Furthermore, Helena's and Rubens's facial features inevitably changed as they grew older, and their apparent ages in the present painting support a date in the early 1630s. This can be seen in the way Helena matures from the girlish bride in the Rubens's portrait of her in 1631 (Alte Pinakothek, Munich);[9] to the portrait of her in 1635, seated with her nude son Frans on her lap (Alte Pinakothek, Munich);[10] to the caring mother with two of her children in the portrait of about 1636 (Musée du Louvre, Paris); to *Het Pelsken*, the extraordinary full-length late painting of her standing nude wrapped in a piece of fur (Kunsthistorisches Museum,

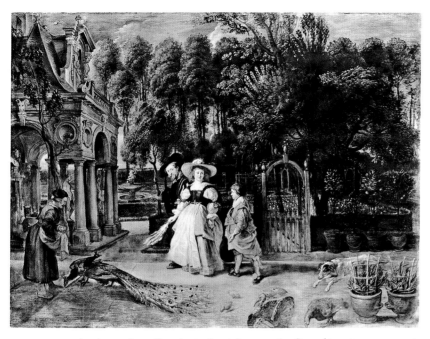

Fig. 5. Peter Paul Rubens, *The Walk in the Garden*. Oil on wood, 38 ⅜ × 51 ½ in. (97.5 × 130.7 cm). Alte Pinakothek, Munich

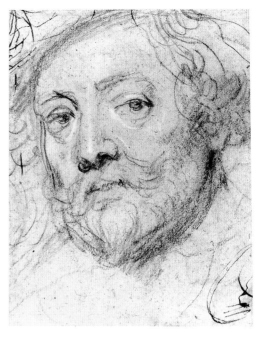

Fig. 6. Peter Paul Rubens, *Self-Portrait*. Black chalk, heightened with white, on paper, 7 ⅞ × 6 ¼ (20 × 16 cm). Royal Library, Windsor

Vienna). By the same token, Rubens no longer looks like the youthful artist of the early *Self-Portrait* at Windsor Castle,[11] nor do his features closely resemble those of the *Self-Portrait* in the Rubenshuis, Antwerp, which was painted in the 1620s.[12] The Rubenshuis *Self-Portrait* was used for the *Walk in the Garden* (fig. 5), and it also probably served Rubens for the first version of the Wrightsman painting, revealed in radiographs (fig. 1); Rubens painted over it with a fresh likeness of himself, a good six inches higher, turning his head to the right so that his gaze falls lovingly on his new wife. Attempts to date the Wrightsman painting to the late 1630s on the basis of the presumed similarity between the appearance of Rubens's face in the radiograph and the puffy features of the aging artist in a drawing in the Royal Library, Windsor Castle (fig. 6), are unconvincing.[13] Instead, the Windsor drawing prepares for the great late *Self-Portrait* in the Kunsthistorisches Museum, Vienna, in which the angle of the head is the same, and painful infirmity has caught up with the sixty-three-year-old artist.

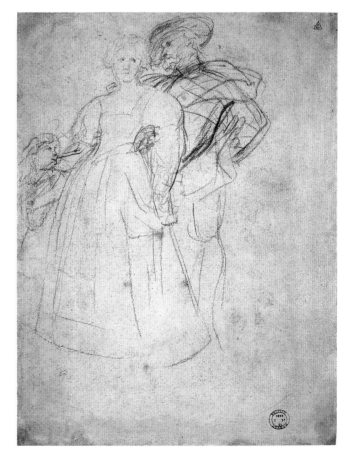

Fig. 7. Peter Paul Rubens, *Rubens, Helena Fourment, and Nicholaas Rubens*. Black and red chalk on paper, 15 × 11 ½ in. (38.1 × 29.4 cm). British Museum, London

Rubens enriched the meaning of his family portrait by combining it with elements of the Garden of Love theme in which couples stroll or dally in Arcadian settings; Michael Jaffé cited Dürer's engraving known as the *Promenade* as a source for Rubens's composition,[14] but the subject matter appears in countless late medieval and Renaissance tapestries, cassoni panels, and prints. Over two decades before Rubens painted the Wrightsman family portrait, he explored the iconography in his marvelous painting of himself with his first wife, the *Self-Portrait with Isabella Brandt in the Honeysuckle Bower* (Alte Pinakothek, Munich).[15] In the Wrightsman painting he elaborated upon the theme with the inclusion of the seminude caryatid, the fountain basin attached to the column on the right, and the parrot climbing in the roses, all symbols of love and motherhood.

A drawing in the British Museum showing Rubens standing behind Helena with a child at her side (fig. 7) has been tentatively identified as a preparatory study for the Wrightsman painting.[16] However, the child in the sketch comes up to Helena's waist, making it much more likely to be a study for the *Walk in the Garden* (fig. 5), in which Rubens portrayed Nicolaas, the younger of his sons by his first marriage, strolling with his father and his young stepmother.[17]

The early history of the painting remains to be clarified; exactly how and when it reached England is not known. According to one tradition, it came from Tervueren, the château outside Brussels where paintings from the imperial collections were stored for safekeeping after the outbreak of the War of Spanish Succession. The only pictures by Rubens that the Duke of Marlborough is known to have acquired from Tervueren, however, were two altarpieces that he selected in May 1708.[18] Alternatively, a tradition going back to the late eighteenth century has it that Marlborough received the painting as a gift from the city of Brussels.[19] This could have occurred following his victories at Ramillies, in 1706, or at Oudenrarde, in 1708; on both occasions Marlborough entered Brussels as a conqueror and was received by the Council and Deputies of State.[20] In any event, Marlborough acquired the painting before he was disgraced on the last day of 1711.

EF

NOTES

1. Liedtke 1984, pp. 177–79.
2. See *Drawings from the Collection of Louis C. G. Clarke, L.L.D., 1881–1960,* exh. cat., Fitzwilliam Museum, Cambridge (Cambridge, 1981), pp. 8–9 (as Anthony van Dyck), and Michiel C. Plomp, in Vienna, New York 2004–2005, pp. 39, 56 n. 20, who tentatively attributed the drawing to Matthias Jansz. van den Bergh (1615–1687).
3. John Cornforth, "The Cowles-Lewis House, Farmington," *Country Life* 163 (April 27, 1978), p. 1153, fig. 9.
4. For the copies, see Vlieghe 1987, pp. 173–74. The version in a private collection in Brussels was published by Leo van Puyvelde, "Un important portrait d'Hélène Fourment par Rubens," *Revue belge* 34 (1965), pp. 5, 8. Liedtke 1984, p. 182, suggested that the missing original may be an autograph study for the Wrightsman painting.
5. *Correspondance de Rubens et documents épistolaires concernant sa vie et ses oeuvres,* ed. Max Rooses and Charles Louis Ruelens (Antwerp, 1909), vol. 6, p. 82; *The Letters of Peter Paul Rubens,* ed. and trans. Ruth Saunders Magurn (Cambridge, Massachusetts, 1955), p. 393.
6. Vlieghe 1987, p. 173 n. 2.
7. *European Paintings,* The Toledo Museum of Art (Toledo, Ohio, 1976), pp. 146–47.
8. Renger 2002, pp. 284–87 no. 313.
9. Ibid., pp. 258–63 no. 340.
10. Ibid., pp. 266–69 no. 315.
11. Vlieghe 1987, pp. 153–57 no. 135.
12. For the dating of the Rubenshuis *Self-Portrait,* see Kristin Lohse Belkin, in Kristin Lohse Belkin, Fiona Healy, and Gregory Martin, *A House of Art: Rubens as Collector,* exh. cat., Rubenshuis, Antwerp (Schoten, 2004), p. 236.
13. Liedtke 1984, p. 181, tentatively suggested that the Windsor drawing was a study for the overpainted self-portrait; see also Anne-Marie Logan and Michiel C. Plomp, in Vienna, New York 2004–2005, p. 255.
14. Michael Jaffé, "Ripeness Is All: Rubens and Hélène Fourment," *Apollo* 107 (April 1978), pp. 290–93.
15. Renger 2002, pp. 253–55 no. 334.
16. Anne-Marie Logan and Michiel C. Plomp, in Vienna, New York 2004–2005, p. 239.
17. Vlieghe 1987, no. 139a, correctly associated it with the Munich *Walk in the Garden.*
18. Louis Gachard, "Les tableaux de Rubens et de van Dyck enlevés de Bruxelles par le duc de Marlborough," *Rubens–bulletijn* 2 (1883), pp. 281–82.
19. The belief that it was given to the first Duke of Marlborough "by the Town of Brussels" first appears in *A New Pocket Companion for Oxford . . . to Which Are Added, Descriptions of . . . Blenheim, Ditchley, Heythrop, Nuneham and Stow* (Oxford, 1783), p. 100, and it is repeated in many subsequent guidebooks.
20. Lionel Cust, "Notes on Pictures in the Royal Collections—XX: The Equestrian Portraits of Charles I by Van Dyck," *Burlington Magazine* 18 (January 1911), p. 208.

ANTHONY VAN DYCK

(1599–1641)

The most important seventeenth-century Flemish painter after Rubens (see p. 113), Anthony van Dyck was born in Antwerp and began his training there at the age of ten with Hendrik van Balen (ca. 1575–1632). At the age of nineteen he became a master in the Antwerp painters' guild, and two years later he was mentioned as one of Rubens's assistants in the contract for the ceiling paintings of the Jesuit church in Antwerp. Van Dyck's early paintings suggest that by this time he had already been closely associated with Rubens for several years, since his figure compositions from this period are demonstrably dependent upon Rubens. Yet his own artistic personality was quite unlike Rubens's robust, worldly character. Introspective and melancholic by temperament, Van Dyck never rivaled Rubens's broad range of artistic expression. His forte was portraiture, and, perhaps because his personality was less overpowering than that of Rubens, he responded with greater sensitivity to his sitters.

In November 1620 Van Dyck went to England to work for the court of James I (1566–1625); he left after a brief stay of four months, however, apparently returning to Antwerp. By November 1621 he was in Italy, where he was to spend the next four years. Working chiefly in Genoa, Van Dyck also visited Venice, Bologna, Florence, and Rome. He traveled to Sicily in 1624 and painted the altarpiece Saint Rosalie Interceding for the Plague-Stricken of Palermo, *the* modello *for which is in the Metropolitan Museum. But it was with the splendid full-length portraits he created for the Genoese aristocracy that the future of his career was determined. Although he was to paint the occasional religious or mythological subject, Van Dyck gave most of his time and energy to portraiture, specializing in a highly elegant and psychologically perceptive style.*

By 1628 Van Dyck had reestablished himself at Antwerp. The regent of the Spanish Netherlands, Archduchess Isabella, gave him a gold chain for his portrait of her (Galleria Sabauda, Turin), and by 1630 he was described as her court painter. During this period he completed the large altarpiece of the Ecstasy of Saint Augustine *(Koninklijk Museum voor Schone Kunsten, Antwerp) and the poetic* Rinaldo and Armida *(Baltimore Museum of Art).*

Van Dyck was invited to London in April 1632 to become "principalle Paynter in Ordinaire" to Charles I (1600–1649), who knighted him on July 5 of that year. In return for a royal pension, Van Dyck painted portraits of the king's family and the court. He was in

Brussels in 1634 to paint a portrait of the Cardinal-Infante Ferdinand of Spain (Museo del Prado, Madrid), the new governor-general of the Netherlands. By the summer of 1635 he had come back to England, but, sensing the king's insecure position, he sought employment on the continent; he made an unsuccessful bid to assume the position left vacant by Rubens's death in 1640. He also went to Paris, hoping to gain the commission to decorate the Grande Galerie of the Louvre, but the job had already been assigned to Poussin (see p. 136). Suffering from poor health, Van Dyck again returned to London and died there in December 1641.

EF

ABBREVIATIONS

Fahy 1973. Everett Fahy, in *The Wrightsman Collection*, vol. 5, Everett Fahy and Francis Watson, *Paintings, Drawings, Sculpture*. New York, 1973.

Millar 1969. Oliver Millar. "Notes on Three Pictures by Van Dyck." *Burlington Magazine* III (July 1969), pp. 414–18.

Millar 2004. Oliver Millar, in Susan J. Barnes et al., *Van Dyck: A Complete Catalogue of the Paintings*. New Haven and London, 2004.

35. *Queen Henrietta Maria*

Oil on canvas, 41 5/8 × 33 1/4 in. (105.7 × 84.5 cm)

Inscribed F.14 (the number in the Barberini *fidecommesso*, or trust). The original canvas, which is folded over the stretcher on all four sides, is attached to a relining canvas. It is covered with signatures left by Italian and foreign visitors to the Galleria Palazzo Barberini. Evidently, the picture was displayed at an angle to the wall, enabling tourists to autograph it. The earliest signatures date from the second decade of the twentieth century, indicating perhaps when the canvas was relined. A photograph showing the appearance of the picture before it was moved in 1934 from Rome to Florence was made by Alinari (negative no. 28609). The portrait was cleaned in October 1968 by John Brealey in London. Radiographs, made at the Metropolitan Museum in February 1969, disclose no changes or alterations that are not clearly visible to the naked eye.

PROVENANCE

Cardinal Francesco Barberini, Rome (1637–d. 1679; inv. 1649, as "Un quadro con cornice d'albuccio intagliata e tutta dorata mezza figura in tela la Regina d'Inghilterra alto palmi quattro e mezzo e largo p^mi quattro," hanging in the cardinal's quarters in the Cancelleria); principessa Olimpia Giustiniani

Barberini, Rome (inv. 1730, no. 933); Barberini family (inv. 1812, no. 135; inv. 1817, no. 14; inv. 1844, no. 148); principe Tommaso Corsini, Florence (1934–68); [P. & D. Colnaghi & Co., Ltd., London, 1968–69, sold to Wrightsman]; Mr. and Mrs. Charles Wrightsman, New York (1969–his d. 1986; cat., 1973, no. 31); Mrs. Wrightsman (from 1986).

EXHIBITED
The Tate Gallery, London, November 15, 1972–January 14, 1973, "The Age of Charles I: Painting in England, 1620–1649," no. 88.

LITERATURE
Filippo Mariotti, *La legislazione delle belle arti* (Rome, 1892), p. 127; Anonymous, in *Gazzetta ufficiale del regno d'Italia* 12, no. 107 (May 5, 1934), p. 2261, list B, no. 13; Leo van Puyvelde, *La peinture flamande à Rome* (Brussels, 1950), p. 174; Millar 1969, pp. 417–18; Fahy 1973, pp. 297–308 no. 31; Millar 2004, pp. 9, 526 no. IV.123.

VERSIONS/COPIES
(With the exception of the Romanelli painted for Cardinal Antonio Barberini, the following copies presumably were based on a replica that remained in England.)
AMSTERDAM, Christie's, October 13, 1998, lot 22 (property of Baron van Zuylen). Oil on canvas, 42 1/8 × 33 7/8 in. (107 × 86 cm).
ARUNDEL CASTLE (Sussex), Duke of Norfolk.
DEVON (Pennsylvania), Clifford H. Harding (his estate, Sotheby's, New York, October 14, 1992, lot 234; ex-collections William K. Vanderbilt, Paris; H. S. Keesing). Oil on canvas, 50 × 41 in. (127 × 104 cm).
DUNROBIN CASTLE, Golspie, Sutherland (Scotland), Countess of Sutherland. Oil on canvas, 43 × 33 in. (109.2 × 83.8 cm).
EASTNOR CASTLE (Herefordshire), James Hervey Bathurst.
EUREKA SPRINGS (Arkansas), private collection.
HAMPDEN HOUSE, Earl of Buckinghamshire (in 1898); Miss Z. Newman (Sotheby Parke Bernet, London, July 7, 1982, lot 21). Oil on canvas, 84 × 48 in. (213.4 × 121.9 cm). Based on the Warwick Castle version.
HINTON SAINT GEORGE, Earl Poulett (before 1882).
KILKENNY CASTLE, Kilkenny (Ireland). Based on the Warwick Castle version; attributed to James Gandy.
LONDON, National Portrait Gallery (227). Oil on canvas, 43 × 32 1/2 in. (109.2 × 82.6 cm).
LONDON, Christie's, December 10, 1971, lot 83 (property of the Rt. Hon. the Lord Margadale of Islay). Oil on canvas, 41 × 31 in (104.1 × 78.7 cm).
LONDON, Sotheby's, April 4, 1962, lot 86. Oil on canvas, 26 1/2 × 22 in. (67.3 × 55.9 cm).
LONDON, Sotheby's, November 12, 1997, lot 37. Oil on canvas, 41 1/2 × 33 in. (105.4 × 83.8 cm).
LOUISVILLE (Kentucky), private collection "from South America via Miami" (in 1974). Oil on canvas, 29 3/4 × 23 1/2 in. (75.6 × 59.7 cm).
MELBOURNE (Derbyshire), Lt. Col. Sir Howard Kerr. Oil on canvas, 34 × 27 1/2 in. (86.4 × 69.9 cm).
MELBURY HOUSE (Dorset), Earl of Ilchester.
NEW YORK, Christie's, October 12, 1989, lot 157 (ex-collection Sir Lewes T. L. Pryse). Oil on canvas, 29 × 24 1/2 in. (73.6 × 62.2 cm).
NORTHWICK PARK (Oxfordshire), Capt. E. G. Spencer Churchill (Christie's, London, June 19, 1959, lot 6; Christie's, November 14–15, 1974, lot 296). Oil on canvas, 27 1/2 × 21 in. (69.9 × 53.3 cm).
OXFORD, Saint John's College.
PARIS, Pereire collection, sale *chez* M. Charles Pillet, March 6–9, 1872, lot 119. Oil on canvas, 39 3/8 × 32 5/8 in. (100 × 83 cm).
ROME, Cardinal Francesco Barberini's brother, Cardinal Antonio Barberini, Rome (in 1639). By Giovanni Francesco Romanelli (ca. 1610–1662).

ROME, Vito Memeli (in 1970). Oil on canvas, 39 3/8 × 29 1/2 in. (100 × 75 cm).
VADUZ, the Principality of Liechtenstein. Oil on canvas, 38 3/4 × 32 1/8 in. (98.5 × 81.5 cm).
WARWICK CASTLE (Warwickshire), the Tussaud's Group. Oil on canvas, 50 × 32 in. (127 × 81.3 cm), later enlarged to 88 × 51 1/2 in. (223.6 × 130.8 cm).
WHEREABOUTS UNKNOWN, Mrs. Randolph. Part of a double portrait with Charles I. Photograph in Witt Library, London.
WILTON HOUSE (Salisbury), Earl of Pembroke.

MINIATURES
BOUGHTON (Northamptonshire), Duke of Buccleuch.
LONDON, The Royal Collection (RCIN 421746). Enamel, oval, 1 1/2 × 1 1/4 in. (3.8 × 3.2 cm). Style of Jean Petitot (1607–1691).[1]

ETCHING
Wenceslaus Hollar (1607–1677). Plate, 6 1/8 × 4 5/8 in. (15.6 × 11.9 cm). Inscribed: *Ant: van dyck pinxit, W. Hollar fecit / 1641.*[2]

Henrietta Maria (1609–1669), the queen consort of Charles I of England, was born in the Louvre and was named after both of her parents, Henry IV of France (1553–1610) and Marie de' Medici (1573–1642). At the age of fifteen she was married to the king of England. Their first years together were unhappy, because the Duke of Buckingham, a favorite of the king, did all within his power to generate distrust of the young and inexperienced queen, a practicing Roman Catholic who spoke little English. After the assassination of Buckingham in 1628, the king seems genuinely to have fallen in love with his young bride. She bore him nine children, some of whom were to be the subjects of Van Dyck's most beguiling group portraits.

In the Wrightsman portrait Henrietta Maria is a woman of twenty-seven, expecting the birth of her sixth child, Princess Anne, born March 17, 1637. As the Civil War approached, she threw herself into English politics, seeking foreign aid to overthrow the Parliamentarians. In 1642 she sailed to Amsterdam and pawned a great part of the English crown jewels. Returning to England with munitions, she was nicknamed "La Generalissima" because of the military schemes she urged upon her mild-tempered husband. When the Royalist position became hopeless, she fled to France. She was living in the Louvre when she received word that her husband had been beheaded at Whitehall on January 30, 1649.

A devout Catholic, Henrietta Maria spent her remaining years trying to convert her children to the Church of Rome and arranging advantageous marriages for them. After the Restoration in 1660, she returned to England for a brief period, taking up residence

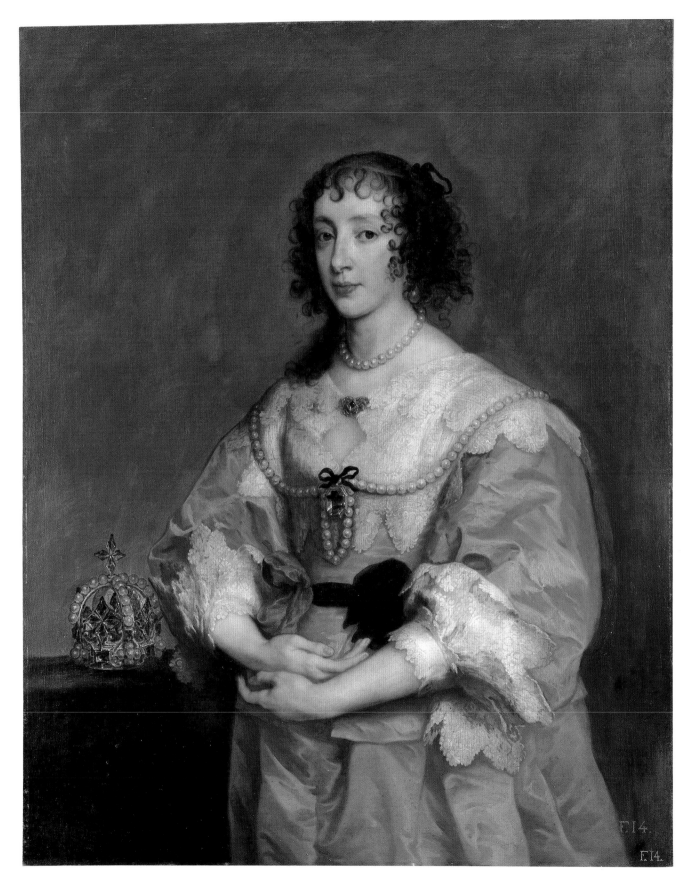

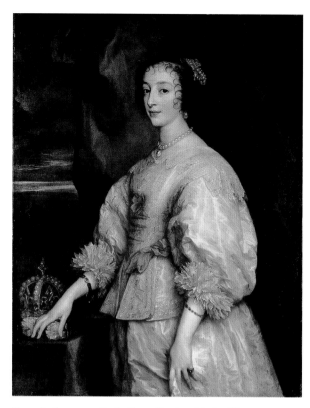

Fig. 1. Anthony van Dyck, *Queen Henrietta Maria*. Oil on canvas, 42¾ × 33⅞ in. (108.6 × 86 cm). Royal Collection, Windsor

there in 1662. Three years later she left London for the last time and retired to her château at Colombes, near Paris.

Henrietta Maria was painted by Van Dyck many times. His first portrait of her appears in the "greate peece," the large canvas of the king and queen with their two eldest children (Royal Collection, London), executed shortly after the artist settled in England. On May 7, 1633, he was paid for nine portraits of Charles I and his wife.[3] The queen is said to have given Van Dyck no less than twenty-five sittings, and his account of unpaid bills in 1638–39 lists thirteen portraits of "la Reyne": "dressed in blue, price thirty pounds"; "dressed in white, price fifty pounds"; "for presentation to her sister-in-law, the Queen of Bohemia"; "for presentation to the Ambassador Hopton"; and so forth.[4]

These portraits do not represent fresh and original essays. Most of them probably were repetitions—made by assistants to satisfy the demand for likenesses of her from family and friends—of one or another of the five basic formats the artist had devised for the queen. The existing portraits thus can be classified according to

their prototypes, most of them established early in Van Dyck's time in London: the three-quarter-length in white (fig. 1), originally placed in the King's Bedchamber at Whitehall and now at Windsor; the three-quarter-length in the collection of the Earl of Radnor at Longford Castle (Wiltshire); the three-quarter-length in blue, of which the autograph version is not at present known; the full-length in state robes in the Schlossmuseum, Oranienburg; and the full-length in a hunting costume with her dwarf, Sir Geoffrey Hudson (fig. 2), in the National Gallery of Art, Washington, D.C.

For the Wrightsman picture, Van Dyck used the same format he had invented four years earlier for the Radnor portrait, showing the queen standing slightly in front of the imperial crown, with her hands held one above the other at her waist. While the poses are the same, the plain background, the saffron yellow dress with its broad white lace cuffs and collar, the coiffure, and the queen's engaging expression mark it as a new creation. A completely autograph work, it displays all the evidence of the master's brushwork, including conspicuous alterations that only he would have made, such as the large pentimento running down the side of the queen's left sleeve (originally the sleeve was about an inch wider). Similarly, the collar on her left shoulder was lowered, and there are slight changes in the outline of her right sleeve. A copyist would not have reproduced these changes, as they became noticeable only long after the portrait was completed and the underpainting gradually became visible with age. Further evidence that this is a primary version can be seen in the way the artist applied the background color. When the queen gave her first sitting, he merely laid in the paint immediately around her head. Then, at a later stage, he filled in the rest of the background but did not quite match the color, so that the first patch is somewhat darker, resembling an opaque halo around the head. Another feature indicating Van Dyck's own work is the incomplete preparation of the canvas: a margin roughly three inches wide on all four sides of the canvas is unprimed. A painter setting out to copy the composition would have prepared the entire canvas at once, whereas Van Dyck, being uncertain of the ultimate dimensions of the picture, filled in these margins after he had completed the figure.

The present portrait was executed in 1636 as a gift for Francesco Barberini (1597–1679). As Cardinal Protector of England and Scotland, he sought to improve relations between Charles I and

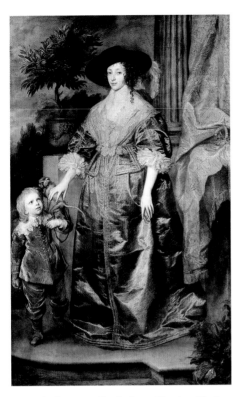

Fig. 2. Anthony van Dyck, *Queen Henrietta Maria and Sir Jeffrey Hudson*. Oil on canvas, 86¼ × 53⅛ in. (219.1 × 134.9 cm). National Gallery of Art, Washington, D.C., Samuel H. Kress Collection

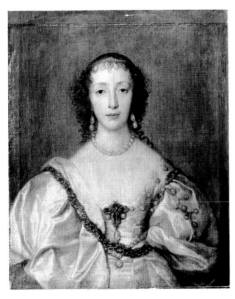

Fig. 3. Anthony van Dyck, *Queen Henrietta Maria*. Oil on canvas, 31 × 25⅞ in. (78.7 × 65.7 cm). The Royal Collection, London

the Church of Rome. Knowing of the king's voracious appetite for collecting art, the cardinal sent a large group of Italian pictures to the queen; they reached England in 1636 and gave much pleasure to the royal family.[5] In December of the same year, George Con, a papal agent to the court of Saint James's and the queen's personal confessor, reported to Cardinal Barberini, "The Queen has not yet wanted me to present her the letter of Your Eminence, because having been apprised of its contents and knowing that I would ask Her Majesty for permission to take leave from her, she is delaying until her portrait is finished."[6]

As Oliver Millar first observed, the portrait mentioned by Con is probably the present painting, which may well have been intended as a token of appreciation. The year after Cardinal Barberini's pictures arrived in England, Henrietta Maria prepared a display of them in her chapel at Somerset House,[7] and the following year she entrusted him with the responsibility of commissioning from Guido Reni (see p. 45) a large painting for the ceiling of the bedroom of her house at Greenwich.[8] Cardinal Barberini had also arranged for Gianlorenzo Bernini (1598–1680) to carve a bust of Charles I, which, unfortunately, was lost in the fire that destroyed Whitehall Palace in 1698.[9] Henrietta Maria admired it so much that she solicited through the cardinal "her own portrait" by Bernini, for which Van Dyck painted his last portraits of her, a frontal view (fig. 3) and two profiles, to serve as guides for the sculptor. EF

NOTES

1. Graham Reynolds, *The Sixteenth and Seventeenth-Century Miniatures in the Collection of Her Majesty the Queen* (London, 1999), p. 254 no. 349.
2. *The New Hollstein: Dutch and Flemish Etchings, Engravings and Woodcuts, 1450–1700*, vol. 11, pt. 5, *Anthony van Dyck*, comp. Simon Turner and ed. Carl Depauw (Rotterdam, 2002), p. 184. The etching depicts Henrietta Maria's head and shoulders, with the pearl necklace and upper torso unfinished.
3. Michael Jaffé, in *Encyclopedia of World Art*, vol. 4 (New York, 1961), col. 532.
4. Carola Oman, *Henrietta Maria* (New York, 1936), p. 81.
5. Rudolf Wittkower, "Inigo Jones—'Puritanissimo Fiero,'" *Burlington Magazine* 90 (January 1948), pp. 50–51.
6. B.V. cod. Barb. Lat. 8637, fol. 340, transcripts of the Barberini archives, Public Record Office, London; quoted by Millar 1969, p. 417.
7. Gordon Albion, *Charles I and the Court of Rome: A Study in Seventeenth Century Diplomacy* (Louvain, 1935), p. 396.
8. Andaleeb Badiee Banta, "A 'Lascivious' Painting for the Queen of England," *Apollo* 159 (June 2004), pp. 66–71.
9. Rudolf Wittkower, *Gian Lorenzo Bernini: The Sculptor of the Roman Baroque* (London, 1955), pp. 200–201.

MICHIEL SWEERTS

(1618–1664)

A peripatetic Flemish (not Dutch, as is often said) painter, Michiel Sweerts ranged from his native Brussels to Rome and Marseilles, to Aleppo and Isfahan, and even as far as Goa, the Portuguese colony on the western coast of India. Nothing is known of his early life. In 1646, at the age of twenty-eight, he was listed in a census as a Catholic living with a fellow artist in Rome; the following year he was recorded as an aggregato (associate) of the Accademia di San Luca, the artists' guild. He remained in Rome until at least 1652 and probably until 1654 or 1655, his stay there coinciding with the presence of Velázquez (1599–1660), Poussin (see p. 136), and Claude Lorrain (1600–1682). Sweerts painted a portrait of Prince Camillo Pamphilj, a nephew of Innocent X (r. 1644–55), and "a canvas of the dead Christ laid out with two nude angels, larger than life."[1] The pope bestowed a knighthood on him, an honor Rubens (see p. 113) and Van Dyck (see p. 123) had previously enjoyed.

By 1656 Sweerts had returned to Brussels, where he founded an academy of life drawing and joined the Brussels Guild of Painters, but three or four years later he moved to Amsterdam. A Lazarist priest who met Sweerts in the summer of 1661 recorded that he experienced a "miraculous conversion" and "eats no meat, fasts almost every day, gives his possessions to the poor, and takes communion three or four times a week."[2] He became a lay member of the Société des Missions-Étrangères, followers of Saint Vincent de Paul (d. 1660), and joined their evangelical mission to China. On the overland journey through Syria he became unstable ("not the master of his own mind")[3] and, somewhere between Isfahan and Tabriz, was dismissed. He then made his way to the Portuguese Jesuits in Goa and is reported to have died there at the age of forty-six.

The bulk of Sweerts's work dates from the late 1640s and early 1650s, when he resided in Rome. His most ambitious painting, long ascribed to Poussin, is the large canvas of the Plague in an Ancient City, now in the Los Angeles County Museum of Art. But most of his Roman works are similar to those of the Bamboccianti, the rowdy Dutch followers of Pieter van Laer (ca. 1592/95–1642), nicknamed Bamboccio, or "disfigured puppet," who specialized in small picturesque scenes of street and domestic life. Sweerts's canvases are more monumental, and he imbues the commonplace with an almost classical gravity. EF

ABBREVIATIONS

Amsterdam, San Francisco, Hartford 2002. Guido Jansen and Peter C. Sutton. *Michael Sweerts (1618–1664)*. Exh. cat., Rijksmuseum, Amsterdam, Fine Arts Museums of San Francisco, and Wadsworth Atheneum Museum of Art, Hartford, Connecticut. Zwolle, 2002.

Kultzen 1996. Rolf Kultzen. *Michael Sweerts, Brussels 1618–Goa 1664*. Doornspijk, 1996.

NOTES

1. Jonathan Bikker, "Sweerts's Life and Career: A Documentary View," in Amsterdam, San Francisco, Hartford 2002, p. 28.
2. Kultzen 1996, p. 8.
3. Ibid., p. 10.

36. Clothing the Naked

Oil on canvas, 32 1/4 × 45 in. (81.9 × 114.3 cm)
Cleaned in 1982 by John Brealey.
The Metropolitan Museum of Art, New York, Gift of Mr. and Mrs. Charles Wrightsman, 1984 (1984.459.1)

PROVENANCE
Lothar Franz Graf von Schönborn, Schloss Weissenstein, near Pommersfelden (by 1719–d. 1729; inv., 1719, undesignated locations, no. 57, as "Der Verlohrne Sohn mit seinem Bruder von der gleichen Grösse. V. Chavalier Schvvarz"); Grafen von Schönborn, Schloss Weissenstein (from 1729); by descent to Grafen von Schönborn-Weisentheid, Schloss Weissenstein (by 1861–1942; cat., 1861, no. XI, as "Portrait d'un homme et d'un jeune garçon," by Christoph. Schwarz; cat., 1894, as by Michael Sweerts); Dr. Karl Graf von Schönborn-Weisentheid, Schloss Weissenstein and Schloss Weisentheid (1942–at least 1970); [Michael Tollemache Ltd., London, until 1981; sold to Wrightsman]; Mr. and Mrs. Charles Wrightsman, New York (1981–84); their gift in 1984 to the Metropolitan Museum.

EXHIBITED
Museum Boymans-van Beuningen, Rotterdam, 1958, "Michael Sweerts en tijdegenoten," no. 55; Museo di Palazzo Venezia, Rome, 1958–59, "Michael Sweerts e i bamboccianti," no. 56.

LITERATURE
Wilhelm Martin, "Michiel Sweerts als schilder: Proeve van een biografie en een catalogus van zijn schilderijen," *Oud Holland* 25 (1907), p. 153 no. 22; Walter A. Liedtke, "*Clothing the Naked* by Michiel Sweerts," *Apollo* 117 (January 1983), pp. 21–23; Kultzen 1996, pp. 5 n. 34, 57 n. 17, 73–74, 75, 115, 125–26 no. 120; Eric M. Zafran, "Michael Sweerts in America: Collecting, Commerce and Scholarship," in Amsterdam, San Francisco, Hartford 2002, p. 63.

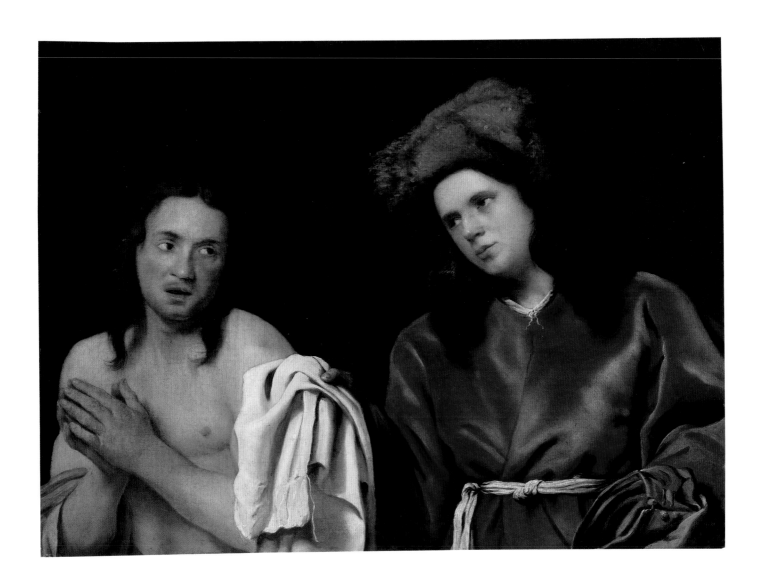

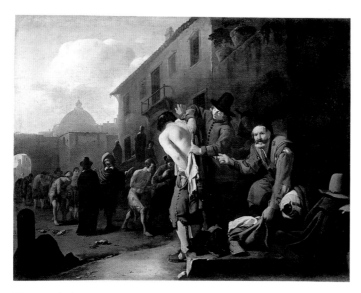

Fig. 1. Michiel Sweerts, *Clothing the Naked*. Oil on canvas, 29⅛ × 39 in. (74 × 99 cm). Rijksmuseum, Amsterdam

The subject is one of the Seven Acts of Mercy that Christ enumerates at the Last Judgment: "For I was ahungered, and ye gave me meat: I was thirsty, and ye gave me drink: I was a stranger, and ye took me in: naked, and ye clothed me: I was sick, and ye visited me: I was in prison, and ye came unto me" (Matthew 25:35–36). The seventh act, Burying the Dead, has no biblical source; it was added to the others early in the Middle Ages. In his homeland Sweerts would have been familar with innumerable examples of the theme illustrated in various media and formats; in Italy he would have seen it depicted in such different ways as the fresco cycle by Domenico Ghirlandaio (1449–1494) and his workshop in the oratory of San Martino dei Buonomini, Florence, where each act is presented in a separate fresco, or the altarpiece by Caravaggio (1571/72–1610) in the church of the Misericordia, Naples, where the Seven Acts are compressed into one canvas. Individual acts were also frequently represented as other subjects, including Saint

Martin dividing his cloak and giving it to a beggar, or the Good Samaritan helping a stranger.

In the Wrightsman picture, Sweerts illustrates the subject with a lifesize, half-length, well-dressed young man handing a white shirt and a pair of gray trousers to a naked man, who clasps his hands in prayer. The men have portrait-like features, and their faces are more highly finished than the lightly modeled drapery, almost suggesting that the canvas is unfinished.

Sweerts also depicted the subject in a set of seven matching canvases, of slightly smaller size, which were reunited in the recent Sweerts retrospective.[1] The act of Clothing the Naked (fig. 1) is portrayed with smaller full-length figures in an Italian square. A young man in a tall hat helps a man put on a shirt and jacket, while in the middle ground two other men in hats stand by a group of scantily clad beggars.

On the basis of style, it is generally agreed that the Wrightsman picture dates from Sweerts's stay in Amsterdam, probably shortly before he left for China in 1661. What is still debated is whether it was conceived as an isolated composition or as part of a series, of which the other canvases either have not survived or were never finished. A set of Seven Acts of Mercy by Sweerts is recorded in 1686 in an inventory of Joseph Deutz, an Amsterdam merchant, who, with his four brothers, had business dealings with Sweerts in Rome between 1646 and 1650. Sweerts acted as an agent for the Deutz brothers, negotiating with papal customs officials concerning shipments of textiles, purchasing antique sculpture for them, and buying paintings by contemporary artists in Rome; he also painted portraits of at least three of the Deutz brothers.[2]

EF

NOTES

1. See Guido Jansen, in Amsterdam, San Francisco, Hartford 2002, pp. 81–93 no. V.
2. Jonathan Bikker, "The Deutz Brothers, Italian Paintings and Michiel Sweerts: New Information from Elisabeth Coymans's *Journael*," *Simiolus* 26 (1998), pp. 282, 307, 308.

JOHANNES VERMEER

(1632–1675)

A younger contemporary of Rembrandt (1606–1669) and Frans Hals (1581/85–1666), Johannes Vermeer was born at Delft, where he lived in relative obscurity, working as an art dealer and innkeeper. He painted comparatively few pictures; only about thirty-five are regarded as authentic by modern scholars. Of these, sixteen are signed and two are dated.

Vermeer's short career can be divided roughly into three periods. During the first, from about 1655 to 1660, he painted large-scale figures in a Baroque manner inspired by the northern followers of Caravaggio (1571/72–1610). Then, during the 1660s, he evolved his distinctly personal style in a series of small, flawlessly composed pictures of reticent figures, mostly women, engaged in leisurely activities. In the final period, the early seventies, he emphasized the abstract elements of his style, producing a few pictures that, though lacking the naturalness of his earlier work, display a brilliant, artificial beauty.

The paintings of the first period show some affinity with the work of Carel Fabritius (1622–1654), the great Rembrandt student who settled at Delft in about 1650. Although there is no documentary evidence to link Vermeer and Fabritius, they shared an interest in perspective and luminous effects. Vermeer's earliest dated picture, the Procuress of *1656 (Gemäldegalerie, Dresden), recalls Fabritius in the play of daylight over large figures, broadly painted with a surprisingly rich palette of warm browns, bright yellows, and reds.*

To the decade of the sixties belong Vermeer's undisputed masterpieces. Their perfection is unrivaled by any Dutch contemporary. Usually they show one or two figures, isolated in an interior softly lit by an open window, standing in quiet poses, often with an air of detachment. Frequently, the objects in the foreground are unfocused, to enhance the illusion of space. While Vermeer painted the same type of pictures as Pieter de Hooch (1629–1684), Gerard ter Borch (1617–1681), Gabriel Metsu (1629–1667), and Nicholas Maes (1632–1693), he ennobled the subject matter of their genre scenes, giving a sense of dignity to the most trivial of daily activities.

In rendering the glittering highlights in his pictures, Vermeer employed a kind of pointille *technique, applying thick dots of bright color over darker areas. These dots give the impression of sparkling objects without changing their basic color values or dissolving them in light. The technique may have been inspired by Vermeer's experiments with the camera obscura. In his paintings of the early sixties, such as* the Maidservant Pouring Milk *(Rijksmuseum, Amsterdam), these points are rendered in thick impasto, so that they stand out from the surface of the canvas, exuding a rich painterly viscosity. During the last period of his career, Vermeer applied them as flat disks of light, imparting to the late paintings a strange schematic quality.*

Vermeer's pictures of the seventies lack the sensuous qualities of his earlier work. The forms in them are rendered with hard edges, and the textures and colors have a brilliant, enamel-like consistency. Characteristic of this late style are the Love Letter, *in the Rijksmuseum, and the* Allegory of Catholic Faith, *in the Metropolitan Museum.*

EF

ABBREVIATIONS

Fahy 1973. Everett Fahy, in *The Wrightsman Collection*, vol. 5, Everett Fahy and Francis Watson, *Paintings, Drawings, Sculpture*. New York, 1973.

Montias 1989. John Michael Montias. *Vermeer and His Milieu: A Web of Social History*. Princeton, New Jersey, 1989.

New York, London 2001. Walter Liedtke, with Michiel C. Plomp and Axel Rüger. *Vermeer and the Delft School*. Exh. cat., The Metropolitan Museum of Art, New York, and National Gallery, London. New York and New Haven, 2001.

Thoré 1859. Étienne-Joseph-Théophile Thoré [William Bürger, pseud.]. *Études sur les peintres hollandais et flamands: Galerie d'Arenberg à Bruxelles, avec le catalogue complet de la collection*. Paris, Brussels, and Leipzig, 1859.

37. *Study of a Young Woman*

Oil on canvas, 17 1/2 × 15 3/4 in. (44.5 × 40 cm)
Signed at upper left: IVMeer. [initials in monogram] (fig. 1).
Cleaned in New York in 1952 by Alain Boissonas. Contrary to some assertions,[1] the painting was found to be relatively well preserved when it underwent extensive technical examinations at the Metropolitan Museum in 1955 and 1970. Radiographs reveal that there are few paint losses. The picture has suffered, however, from surface abrasion. Microscopic examinations show that the best-preserved parts are the darker areas of the mantle, which still retains much of its blue glazing. There is a narrow band of dark paint along the left border, perhaps once covered by a frame. At first glance, however, the band might be construed to be a trompe l'oeil shadow of the frame. Such a device

was a common trick with portrait painters since the time of Corneille de Lyon (ca. 1510–1575), and, while it does appear in some paintings by Rembrandt's followers, this effect is definitely unintentional in the Wrightsman Vermeer.

The Metropolitan Museum of Art, New York, Gift of Mr. and Mrs. Charles Wrightsman, in memory of Theodore Rousseau Jr., 1979 (1979.396.1)

PROVENANCE
?Pieter Claesz. van Ruijven, Delft (until d. 1674); ?his widow, Maria de Knujt, Delft (1674–d. 1681); ?their daughter, Magdalena van Ruijven, Delft (1681–d. 1682), and her widower, Jacob Abrahamsz. Dissius, Delft (1682–d. 1695; his estate sale, Amsterdam, May 16, 1696, possibly lot 38); ?Dr. Luchtmans (until 1816; sale, Rotterdam, April 20–22, 1816, lot 92, as "J. van der Meer de Delft . . . Le Portrait d'une jeune personne," 17 × 15 in. [43.2 × 38.1 cm], for 3 florins); Auguste Marie Raymond, prince d'Arenberg, Brussels (by 1829–d. 1833; cat., 1829, no. 53); his family, Brussels (1833–75; cat., 1859, no. 35); Engelbert-Marie, ninth duc d'Arenberg, Brussels, and Schloss Meppen and Schloss Nordkirchen, Germany (1875–d. 1949); Engelbert-Charles, tenth duc d'Arenberg (1949–early 1950s; sold to German Seligman); [Jacques Seligmann & Co., New York, early 1950s–1955; sold to Wrightsman]; Mr. and Mrs. Charles Wrightsman, Palm Beach, Florida, and New York (1955–79; cat., 1973, no. 32); their gift in 1979 to the Metropolitan Museum in memory of Theodore Rousseau Jr.

EXHIBITED
Kunsthalle, Düsseldorf, 1904, "Kunsthistorische Ausstellung," no. 398; Metropolitan Museum, New York, June–November 1955, April–October 1957, May–October 1967; National Gallery of Art, Washington, D.C., May–November 1956; Mauritshuis, The Hague, June–September 1966, and Orangerie des Tuileries, Paris, September–November 1966, "Cinq siècles de peinture: Dans la lumière de Vermeer," no. 7 (no. 6 in Dutch venue); Metropolitan Museum, New York, March 8–May 27, 2001, and National Gallery, London, June 20–September 16, 2001, "Vermeer and the Delft School," no. 75 (shown in New York only).

LITERATURE
Thoré 1859, pp. 31, 34–36, 140 no. 35; Gustave Friedrich Waagen, *Handbook of Painting: The German, Flemish, and Dutch Schools* (London, 1860), vol. 2, p. 352; Charles Blanc, *Histoire des peintres de toutes les écoles: École hollandaise* (Paris, 1861), vol. 2, p. 4; Ronald Gower, *The Figure-Painters of Holland* (London, 1880), pp. 67, 111; Cornelis Hofstede de Groot, "Johannes Vermeer," *Die graphischen Künste* 18 (1895), pp. 20, 22–24; Fahy 1973, pp. 309–21 no. 32; Albert Blankert, with contributions by Rob Ruurs and Willem L. van de Watering, *Vermeer of Delft: Complete Edition of the Paintings* (Oxford, 1978), p. 59 no. 30; Montias 1989, pp. 196–97, 221, 265–66; Arthur K. Wheelock Jr., *Vermeer: The Complete Works* (New York, 1997), p. 56; Walter Liedtke, in New York, London 2001, pp. 166, 388, 389–93 no. 75.

LITHOGRAPH
Lithographies d'après les principaux tableaux de la collection de S.A.S. Monseigneur le prince Auguste d'Arenberg, avec le catalogue déscriptif (Brussels, 1829), p. 10, no. 53.

COPIES
Art market (in 1939), "a mediocre, modern version."[2]
Art market, Germany (in 1964).

The Wrightsman Vermeer is an almost lifesize depiction of a beguiling individual in light blue untailored drapery isolated against a neutral background. It is simply the head and bust of a young woman, unaccompanied by the domestic settings seen in most of Vermeer's works. With her head turned three-quarters over her left shoulder, she gazes directly at the viewer. Her dark brown hair is drawn back from her high forehead and gathered at the crown of her head, from which a pale yellow cloth falls down her back. A glimpse of one of her hands is visible at the bottom of the picture; at her throat is a white collar; and a large pearl hangs from her left earlobe.

The pale tonality and balanced structure of the design are typical of Vermeer's work toward the end of the 1660s.[3] The single dated picture of this period, the *Astronomer* (1668) in the Louvre, displays a similar restrained style. Although it represents a small figure in an interior, all the elements of its composition give the maximum impression of geometric order and clarity. The paint surface is delicate, thin, and evenly balanced; the colors, though necessarily more varied than those in the Wrightsman picture, possess a comparable muted character.

Although the Wrightsman painting has often been called a portrait—J. Michael Montias claimed it was "a portrait if there ever was one"[4]—for Vermeer's contemporaries it was a *tronie,* a face or a bust-length figure study of an intriguing character in a curious costume. Popularized in Holland by Rembrandt and his circle, *tronies* were collectors' items produced for the open market, such as Rembrandt's *Noble Slav* (Metropolitan Museum) or Govaert Flinck's *Saskia as a Shepherdess* (Herzog Anton Ulrich Museum, Brunswick).[5] The Wrightsman Vermeer belongs to this tradition, in that the sitter wears a classical costume, far removed from contemporary seventeenth-century Dutch dress.

While not portraits per se, *tronies* nevertheless were based on live models. The idiosyncratic features of the Wrightsman girl—the relatively wide, flat face and small nose—can be seen in the

Fig. 1. Detail of the signature

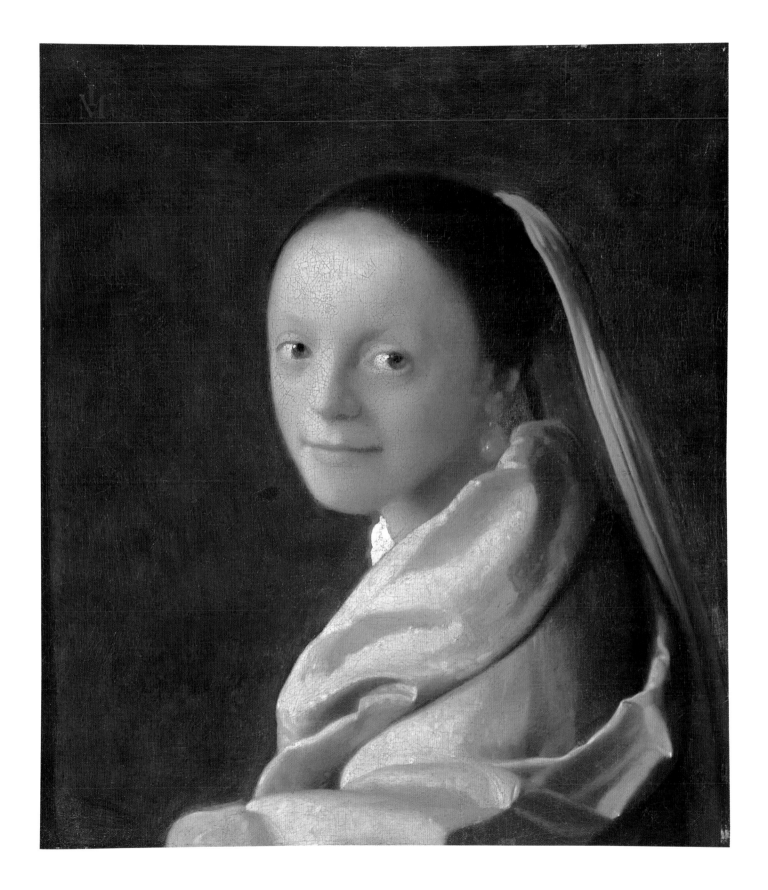

young woman in Vermeer's *Lute Player* in the Metropolitan Museum and in *A Lady Writing* (fig. 2) in the National Gallery of Art, Washington, D.C. Given the reuse of the same model, she probably was an acquaintance of Vermeer's or even a member of his family. He married in April 1653, so his oldest daughter, Maria, would not have been much older than fifteen in 1668, the probable date of the painting. It is difficult to ascertain the precise age of the sitter, but she could be in her midteens.

Within Vermeer's oeuvre there are three other paintings of isolated busts of young women: a pair of pictures in the National Gallery of Art, Washington, D.C., painted on small wooden panels with heavy globules of saturated pigment (figs. 4, 5), and the *Girl with a Pearl Earring* (fig. 3) in the Mauritshuis, The Hague. The familiar Vermeer lion-back chairs and tapestries in the backgrounds of the Washington pictures set them apart from the simple format of the Wrightsman picture.[6] The painting in the Hague, on the other hand, is on a canvas almost the same size as the Wrightsman painting, and it too has a plain background. Moreover, both the Hague and Wrightsman paintings bear the same peculiar abbreviation of Vermeer's signature: the monogram of his initials *IVM* and the letters *eer* (fig. 1).

The Wrightsman canvas played a part in the rediscovery of the artist almost a hundred and fifty years ago. In 1858, writing under the pseudonym William Bürger, the French critic Théophile Thoré could name only three paintings by Vermeer—the *View of Delft* (Mauritshuis, The Hague) and the *Little Street* and the *Maidservant Pouring Milk* (both Rijksmuseum, Amsterdam), whose author he singled out for the first time as a "great artist, an incomparable original, an unknown of genius."[7] The following year, in his catalogue of the Arenberg collection, Thoré added the Wrightsman painting, calling it a "head, unbelievably fanciful and pale as if struck by a moonbeam."[8]

Thoré observed that the painting may have been one of the twenty-one Vermeers sold at auction in Amsterdam in 1696. The Vermeers were the property of Jacob Dissius, the son-in-law of Pieter van Ruijven (1624–1674), a Delft collector who seems to have acquired as much as half of the artist's production.[9] The auction included three *tronies*:

> Lot 38. A *tronie* in antique costume, uncommonly artistic, 36 florins ("Een Tronie in Antique Kledern, ongemeen Konstig. 36–0")

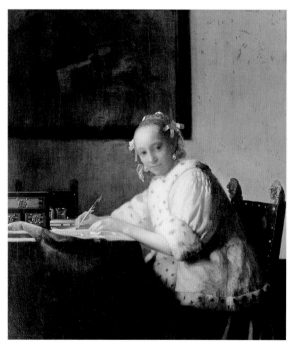

Fig. 2. Johannes Vermeer, *A Lady Writing.* Oil on canvas, 18 ⅛ × 14 ⅛ in. (46 × 36 cm). National Gallery of Art, Washington, D.C., Gift of William Waldron Havemeyer and Horace Havemeyer, Jr., in Memory of Their Father, Horace Havemeyer

Fig. 3. Johannes Vermeer, *Girl with a Pearl Earring.* Oil on canvas, 18 ¼ × 15 ¾ in. (46.5 × 40 cm). Mauritshuis, The Hague

Fig. 4 (at left). Johannes Vermeer, *Girl with a Red Hat*. Oil on wood, 9 × 7⅛ in. (23 × 18 cm). National Gallery of Art, Washington, D.C., Andrew W. Mellon Collection

Fig. 5 (at right). Johannes Vermeer, *Girl with a Flute*. Oil on wood, 7⅞ × 7⅛ in. (20 × 18 cm). National Gallery of Art, Washington, D.C., Widener Collection

Lot 39. Another by the same Vermeer. 17 florins ("Nog een dito Vermeer. 17-0")

Lot 40. A pendant of the same. 17 florins ("Een werga denzelven. 17-0")

Although the brevity of these catalogue descriptions does not allow a positive identification of the paintings, it is possible that the Wrightsman canvas was lot 38, the *"tronie* in antique costume, uncommonly artistic,"* because all of the other extant Vermeers depict young women in seventeenth-century dress; only the young woman in the Wrightsman painting wears antique or classical clothing.

When Thoré wrote about the Wrightsman painting, he likened it to *"la prestigieuse Joconde, de Léonard,"* a comparison that is not altogether far-fetched.[10] The painting does possess something of the mysterious effect of Leonardo's masterpiece: light passes into shadows with almost imperceptible transitions, and the eyes have a hypnotic insistence. Mona Lisa's pose was adapted by Raphael for his celebrated portrait of Baldassare Castiglione in the Louvre, which Rembrandt famously copied in a rapid pen-and-ink sketch (Albertina, Vienna) when it passed through a sale in Amsterdam. It may be coincidental, but the presentation of the figure in the Wrightsman picture follows the same format.[11]

EF

NOTES

1. Edward Verrall Lucas, *Vermeer of Delft* (London, 1922), p. 31; Benedict Nicolson, "Vermeer and the Future of Exhibitions," *Burlington Magazine* 108 (August 1966), p. 397; and Piero Bianconi, *The Complete Paintings of Vermeer* (New York, 1970), p. 21.
2. A. B. de Vries, *Jan Vermeet van Delft* (Amsterdam, 1939), p. 84.
3. Arthur K. Wheelock Jr., *Vermeer: The Complete Works* (New York, 1997), p. 56, dates it 1667–68. Walker Liedtke, in New York, London 2001, p. 389, places it about 1665–67.
4. Montias 1989, p. 196.
5. Jaap van der Veen, "Faces from Life: *Tronies* and Portraits in Rembrandt's Painted Oeuvre," in Albert Blankert, with contributions by Marleen Blokhuis et al., *Rembrandt: A Genius and His Impact,* exh. cat., National Gallery of Victoria, Melbourne, and National Gallery of Australia, Canberra (Melbourne, Sydney, and Zwolle, 1997), pp. 69–80.
6. For a thorough discussion of the sometimes disputed Washington pictures, see Arthur K. Wheelock Jr., *Dutch Paintings of the Seventeenth Century*, The Collections of the National Gallery of Art: Systematic Catalogue (Washington, D.C., 1995), pp. 382–93.
7. "Mais voici un autre grand artiste, un original incomparable, un inconnu du génie." Théophile Thoré [William Bürger, pseud.], *Musées de la Hollande*, vol. 1, *Amsterdam et La Haye* (Paris, 1858), pp. 272–73.
8. Thoré 1859, p. 35 ("La tête, extrêment fantastique et pâle comme sur un rayon de lune"), quoted by Ivan Gaskell, *Vermeer's Wager: Speculations on Art History, Theory and Art Museums* (London, 2000), pp. 118–21, who gives an excellent account of Thoré's notices of Vermeer.
9. Gerard Hoet and Pieter Terwesten, eds., *Catalogus of naamlyst van schilderyen* (Amsterdam, 1752), vol. 1, p. 36.
10. Théophile Thoré [William Bürger, pseud.], "Van der Meer de Delft," *Gazette des beaux-arts* 21 (December 1, 1866), p. 545.
11. Walter Liedtke, *A View of Delft: Vermeer and His Contemporaries* (Zwolle, 2000), p. 243, noted the affinity of the format of the Wrightsman Vermeer with that of Rembrandt's *Self-Portrait* of 1640 (National Gallery, London), which in turn was based on Raphael's *Baldassare Castiglione* (Louvre).

NICOLAS POUSSIN

(1594–1665)

The greatest French painter of the seventeenth century, Nicolas Poussin was born in the village of Villers, near Les Andelys in Normandy, but spent most of his life working in Rome. A highly literate and intellectual artist, he was the exponent of classicism in the Baroque era. His art, often concerned with philosophical ideas, is poetically rendered in carefully deliberated compositions painted with great sensitivity.

In Paris Poussin studied under Ferdinand Elle (ca. 1585–1637) and Georges Lallemand (d. 1636), mediocre painters of the second School of Fontainebleau who practiced an outmoded Mannerist style. Not until he arrived in Rome at the age of thirty did he embark upon his formative studies of the great Italian Renaissance masters and the antique. Inspired by Titian's Bacchanals, then in the Vigna Ludovisi in Rome, and Bellini's Feast of the Gods, in the Aldobrandini collection, Poussin gradually evolved a highly individualistic style, combining the classical design of Raphael's great frescoes and the sensuous coloring of Titian's masterpieces. He worked in the studio of Domenichino (see p. 38), the most classically oriented contemporary Italian painter, and, in 1627, produced his first major Roman picture, the Death of Germanicus, now in the Minneapolis Institute of Arts. His first public commission was the Martyrdom of Saint Erasmus (1628–29), a large altarpiece ordered for a prominent location in Saint Peter's basilica that demonstrated his ability to work in the flamboyantly Baroque style of his Italian contemporaries.

In 1630 Poussin suffered a grave illness; when he recovered, his career took a new direction. Turning down large public commissions, he devoted himself to creating smaller pictures for knowledgeable private patrons, among them Cassiano dal Pozzo (1588–1657), secretary to Cardinal Francesco Barberini, and a growing number of French collectors. He immersed himself in Leonardo da Vinci's treatises, investigated the relationship between expressive gestures and inward emotions (the affetti), and took an almost archaeological interest in ancient sculpture. His major works of the 1630s include a set of Seven Sacraments for dal Pozzo and a pair of Bacchanals commissioned in 1636 by Cardinal Richelieu (1585–1642).

Poussin returned to France in 1640 to work for Louis XIII, who gave him the title Premier Peintre du Roi and a handsome pension. In return he was required to execute large decorative schemes for which he was temperamentally unsuited: the embellishment of the Orangerie in the Luxembourg Palace, Paris, and the Grande Galerie in the Louvre, as well as large altarpieces and designs for tapestries. He also encountered the envy of painters already established in Paris, notably Simon Vouet (1590–1649) and Jacques Fouquières (d. 1659), who conspired against him. Incapable of coping with these uncongenial conditions, Poussin returned to Rome after eighteen months of working for the king.

Considered a great master in Rome, he was elected president of the Accademia di San Luca but declined the honor. His reputation there was rivaled only by that of Pietro da Cortona (1596–1669), whose major works are large frescoes totally unlike Poussin's complex and carefully executed easel paintings. Toward the end of his life, Poussin worked in an increasingly austere and restrained style, an extension of the cerebral approach underlying all his work. His late pictures are also remarkable for their serenity as well as for the contemplative mood of their landscape backgrounds. EF

ABBREVIATIONS

Blunt 1966. Anthony Blunt. The Paintings of Nicolas Poussin: Critical Catalogue. 2 vols. London, 1966.

Fahy 1973. Everett Fahy, in The Wrightsman Collection, vol. 5, Everett Fahy and Francis Watson, Paintings, Drawings, Sculpture. New York, 1973.

Rosenberg and Prat 1994. Pierre Rosenberg and Louis-Antoine Prat. Nicolas Poussin, 1594–1665: Catalogue raisonné des dessins. 2 vols. Milan, 1994.

38. The Companions of Rinaldo

Oil on canvas, 46½ × 40¼ in. (118.1 × 102.2 cm)

A label (fig. 1) on the stretcher is inscribed in an eighteenth- or early nineteenth-century hand: Carolus . Et . Hubertus . ut . Tassus . / Cecinit . Rinaldum . Liberaturi . / Poussinus . Pinx.[1]

The picture was relined, probably for the first time, in the eighteenth century.[2] The scalloped edges of the original canvas indicate that it has not been cut down to any considerable extent, since the scalloped pattern was formed when the canvas was nailed to the original stretcher.[3] X-rays confirm that the paint is solidly preserved. The most conspicuous pentimento is the changed position of Carlo's sword, which was first painted in a lower position.

The Metropolitan Museum of Art, New York, Gift of Mr. and Mrs. Charles Wrightsman, 1977 (1977.1.2)

Fig. 1. Label on the stretcher

PROVENANCE

Cassiano dal Pozzo, Rome (d. 1657); his brother, Carlo Antonio dal Pozzo, Rome (until d. 1689; as "un autre [du poussin] representant les deux chevalier qui vond delivrer Renaud des enchantements darmide");[4] his son, Gabriele dal Pozzo, Rome (1689–d. by January 1695; posthumous inv., 1695, no. 85, "Altro . . . con Carlo e Ubaldo che vanno da Rinaldo del Pusino"); his son, Cosimo Antonio dal Pozzo, Rome (until 1723; sold to Bufalo); marchese Ottavio Rinaldo del Bufalo, Rome (1723–at least 1731; no longer in collection in 1740); ?Count Aloys Thomas Raimond von Harrach, Vienna (probably purchased in late 1731 or 1732 [Harrach was viceroy of the Kingdom of Naples 1728–32]); counts von Harrach, Vienna (by 1738; inv., 1745 and 1749, no. 74; cat., 1856, no. 200, as by Le Sueur; cat., 1897, no. 199, as by Le Sueur; cat., 1926, no. 199, as by Poussin; cat., 1960, pp. 9, 59); Countess Stephanie Harrach, Vienna (until 1967; sold to Wildenstein); [Wildenstein, New York, 1967–68; sold to Wrightsman]; Mr. and Mrs. Charles Wrightsman, New York (1968–77; cat., 1973, no. 18); their gift in 1977 to the Metropolitan Museum.

EXHIBITED

Kunsthistorisches Museum, Vienna, December 1, 1935–February 28, 1936, "Poussin," no. 2; Kunstmuseum, Bern, December 21, 1947–March 31, 1948, "Europäische Barockmalerei aus Weiner Privatgalerien: Czernin, Harrach, Schwarzenberg," no. 37; Musée du Louvre, Paris, May–July 1960, "Exposition Nicolas Poussin," no. 32; Galeries Nationales du Grand Palais, Paris, January 29–April 26, 1982, Metropolitan Museum, New York, May 26–August 22, 1982, and Art Institute of Chicago, September 18–November 28, 1982, "France in the Golden Age: Seventeenth-Century French Paintings in American Collections" (not in catalogue; shown in New York only).

LITERATURE

Walter Friedlaender, "Nicolas Poussin," in Allgemeines Lexikon der bildenden Künstler, ed. Ulrich Thieme and Felix Becker, vol. 27 (Leipzig, 1933), vol. 27, p. 324; Walter Friedlaender and Anthony Blunt, The Drawings of Nicolas Poussin: Catalogue raisonné (London, 1949), vol. 2, pp. 21, 23; Sheila Somers Rinehart, "Poussin et la famille dal Pozzo," in Nicolas Poussin, ed. André Chastel, international colloquium, Paris, September 19–21, 1958 (Paris, 1960), vol. 1, p. 29; Rensselaer W. Lee, "Armida's Abandonment: A Study in Tasso Iconography before 1700," in De artibus opuscula XL: Essays in Honor of Erwin Panofsky, ed. Millard Meiss (New York, 1961), vol. 1, pp. 347–48; Denis Mahon, "Poussiniana: Afterthoughts Arising from the Exhibition," Gazette des beaux-arts, 6th ser., 60 (July–August 1962), pp. 53–55; Blunt 1966, pp. 141–42 no. 205; Anthony Blunt, Nicolas Poussin, The A. W. Mellon Lectures in the Fine Arts, 1958, National Gallery of Art, Washington, D.C., 2 vols. (New York and London, 1967 [Pallas Athene ed., London, 1995]), vol. 1, p. 148; Fahy 1973, pp. 159–68 no. 18; Arnauld Bréjon de Lavergnée, "Tableaux de Poussin et d'autres artistes français dans la collection Dal Pozzo: Deux inventaires inédits," Revue de l'art, no. 19 (1973), p. 83; Doris Wild, Nicolas Poussin (Zurich, 1980), vol. 1, pp. 55, 68, and vol. 2, pp. 71, 317 no. 71.

The painting illustrates an episode from Torquato Tasso's heroic poem Gerusalemme Liberata. First published in 1580, it combines an account of the First Crusade with imaginary adventures and love stories. One of the heroes, Rinaldo, is abducted by the pagan sorceress Armida, who becomes infatuated with him and carries him off to her palace on the island of Fortune. There she casts a spell on him, making him fall in love with her. Two Christian knights, Carlo and Ubaldo, come to persuade Rinaldo to rejoin his fellow crusaders. Their way to Armida's palace is blocked by a dragon. It is this scene that is shown in the painting.

Poussin based other paintings on the poem, such as Armida Discovering Rinaldo on the Battlefield (Dulwich Picture Gallery, London; Pushkin Museum, Moscow) and Armida Carrying the Wounded Rinaldo Off to Her Palace (Gemäldegalerie, Berlin), but as they differ from the present painting in style and dimensions, they cannot have formed a unified cycle. Similarly, a drawing by Poussin in the Louvre, showing Carlo and Ubaldo leading Rinaldo off the island, a subject that conceivably could have formed a pendant, is too late to be associated with the painting.[5]

Tasso's poem enjoyed a great vogue among seventeenth-century painters, who often depicted the amorous side of Rinaldo's adventures; the Companions of Rinaldo, however, appears to be a unique example of the Christian knights coming to Rinaldo's rescue. The choice of subject is typical of Poussin: he was drawn to the powerful confrontation of man and monster that he could illustrate in grand, exalted terms. In the painting he follows Tasso's words quite closely (canto XV, verses 47, 49). Carlo has unsheathed his sword and holds it ready at his side, while Ubaldo raises a magic golden wand. The other figure in the painting, the mysterious woman seated in the boat, is the goddess Fortuna, who led Carlo and Ubaldo to the island. The poet gives a long account of her strangely colored dress (canto XV, verses 4–5). Inspired by this passage, Poussin depicted the goddess's garment in changeant hues ranging from pale violet and scarlet and gold to a shimmering blue. In addition to the printed word, Poussin was influenced by illustrated editions of the poem. He borrowed the motifs of the coiled dragon, the classical costumes, and even the cavernous setting by the sea from one of the three

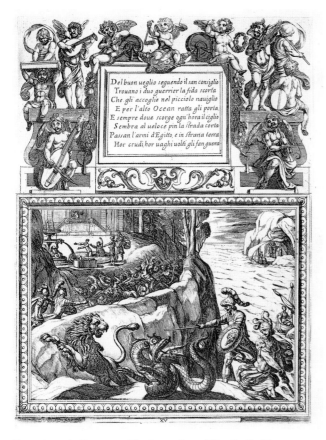

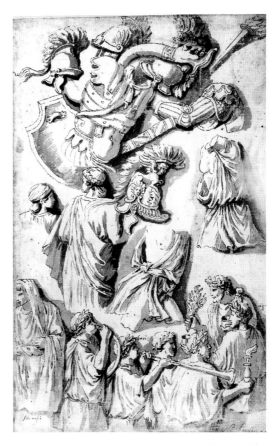

Fig. 2. Antonio Tempesta, *The Companions of Rinaldo*. Etching, 13 × 18¼ in. (33 × 46.3 cm). From Tasso, *Gerusalemme Liberata* (Rome, before 1630), pl. XV. The Metropolitan Museum of Art, New York, Elisha Whittelsey Fund, 1951 (51.501.4052)

Fig. 3. Nicolas Poussin, *Reliefs on the Column of Trajan*. Ink on paper, 12⅞ × 8⅛ in. (32.7 × 20.6 cm). Musée des Beaux-Arts, Valenciennes

sets of etchings (fig. 2) that Antonio Tempesta (1555–1630) made between 1607 and 1630.[6] Other details seem to have been derived from classical antiquities. The helmets and the armor resemble those on a sheet of drawings that Poussin made after a print of a relief on the Column of Trajan (fig. 3).[7] Even closer parallels for the poses and costumes of the two knights may be found in reliefs on the column for which no drawings by Poussin survive.[8] The helmets also are quite similar to those on a sheet of drawings that Poussin made after a large engraving that Giovanni Battista Ghisi (1520–1582) made of a naval battle by Giulio Romano (ca. 1499–1546).[9] For the design of the antique bark, Poussin turned to a fragmentary sarcophagus (fig. 4) formerly in Rome and now in Venice, or one like it.[10]

The dating of the picture has given rise to some speculation. Otto Grautoff's suggestion that it belongs to the years 1630–35 has been qualified by later writers, who differ about precisely when it falls in this lustrum.[11] Anthony Blunt, in the catalogue for the first

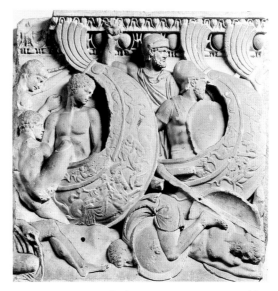

Fig. 4. Greco-Roman, third century, *A Naval Battle*. Marble, 33⅞ × 31½ in. (86 × 80 cm). Museo Archeologico Nazionale, Venice

Poussin retrospective, dated it 1630–33, and in a more recent publication proposed 1633–35.[12] On the other hand, Denis Mahon argued persuasively that it was done shortly before 1633.[13] The year is crucial because, while there are few securely datable works from this period, in 1633 Poussin did sign and date the large *Adoration of the Magi* now at Dresden. The *Adoration* marks a new stage in Poussin's development toward greater spatial clarity and the use of firmly modeled figures seen in full daylight, as opposed to the warm, romantic twilight that bathes the figures in the *Companions of Rinaldo*. The vertical composition and the dimensions of the present picture are also similar to those of works such as the *Arcadian Shepherds,* at Chatsworth, and the *Inspiration of the Lyric Poet,* in the Landesgalerie, Hannover. After the early 1630s, Poussin does not return to this format. EF

Notes

1. Probably copied from an inscription on the back of the original canvas before it was relined. Other paintings by Poussin in the dal Pozzo collection are similarly inscribed on the back in Latin, boldly printed in Roman capitals with a punctuation dot between each word. For a reproduction of one, see Denis Mahon, "The Dossier of a Picture: Nicolas Poussin's *Rebecca al Pozzo,*" *Apollo* 81 (March 1965), p. 204, fig. 5.

2. According to Dr. Robert Keyszelitz, Gemälderestaurator of the Harrach Gallery (letter, November 30, 1968), the picture was restored at the beginning of the twentieth century. It also was cleaned shortly before the 1960 Poussin retrospective (Denis Mahon, "Poussin's Early Development: An Alternative Hypothesis," *Burlington Magazine* 102 [July 1960], p. 300).

3. For a detail photograph of the upper-right edge of the canvas, see Fahy 1973, p. 167. Jacques Thuillier *(L'opera completa di Poussin* [Milan, 1974], pp. 94, 130 no. 74, and *Nicolas Poussin* [Paris, 1994], p. 253 no. 106) believes the canvas was trimmed at the top and cut down considerably at the sides because it is described in the 1695 dal Pozzo inventory as a "toile d'empereur" (horizontal picture approximately one by one and a quarter meters [40 × 50 in.]).

4. Robert de Cotte, "Mémoire des tableaux qui sont dans la maison du chevalier du Puis [dal Pozzo]," ca. 1689 (Bibliothèque Nationale, Paris, MS. Fr 9447, fol. 201–13; the first chapter is published by Philippe de Chennevières, in *Recherches sur la vie et les ouvrages de quelques peintres provinciaux de l'ancienne France* [Paris, 1854], pp. 152–53).

5. Walter Friedlaender and Anthony Blunt, *The Drawings of Nicolas Poussin: Catalogue Raisonné* (London, 1949), vol. 2, pp. 21, 23; Rosenberg and Prat 1994, vol. 1, p. 612.

6. Fahy 1973, p. 164; Jonathan Unglaub, "Poussin's Purloined Letter," *Burlington Magazine* 142 (January 2000), p. 38.

7. Rosenberg and Prat 1994, p. 370 no. 194.

8. Salomon Reinach, *Répertoire de reliefs grecs et romains,* vol. 1 (Paris, 1909), pp. 314 no. 34, 358 no. 84; Karl Lehmann-Hartleben, *Die Trajanssäule: Ein römisches Kunstwerk zu Beginn der Spätantike* (Berlin, 1926), pls. XL, CVI.

9. The drawing appeared at Christie's, London, on July 10, 2001, lot 94. It was known from a copy published in Rosenberg and Prat 1994 (vol. 2, p. 1016 no. R 899), who dated this sheet about 1635 but propose a slightly earlier dating, about 1632–35, for other copies by Poussin of the same engraving.

10. Georg Kauffmann, "Poussins letztes Werk," *Zeitschrift für Kunstgeschichte* 24 (1961), pp. 113–14; Carl Robert, *Die antiken Sarkophag-Reliefs,* vol. 3, part 2 (Berlin, 1904), p. 366 no. II, and suppl., pl. B, fig. 11; also reproduced in Fahy 1973, p. 165, fig. 7.

11. Otto Grautoff, *Nicolas Poussin: Sein Werk und sein Leben* (Munich, 1914), vol. 1, p. 110, and vol. 2, pp. 66–67.

12. Anthony Blunt, *Exposition Nicolas Poussin,* exh. cat., Musée du Louvre, Paris (Paris, 1960), p. 69 no. 32; Blunt 1966, pp. 141–42 no. 205.

13. Mahon, "Poussin's Early Development," p. 53.

EUSTACHE LE SUEUR

(1616–1655)

The son of a wood turner from Picardy, Eustache Le Sueur was born in Paris and, like many French painters active in Paris in the mid-seventeenth century, trained under Simon Vouet (1590–1649). His first recorded works are a series of painted cartoons for tapestries illustrating Francesco Colonna's Hypnerotomachia Poliphili, *a commission that Vouet had passed on to him. Executed between about 1636 and 1645, the cartoons show Le Sueur's gradual evolution from the decorative dynamics of his master to his personal idiom, a curious combination of rigid classicism and almost sentimental tenderness. He abandoned his affinity with the French Caravaggesques, best seen in his group portrait* A Gathering of Friends, *in the Louvre; not surprisingly, he also ignored Rubens's Baroque canvases for Marie de' Medici's gallery in the Luxembourg Palace.*

Between 1645 and 1648 Le Sueur executed a cycle of twenty-two paintings illustrating the life of Saint Bruno for the Charterhouse of Paris. Influenced by the lucid structure of Poussin's compositions, the Saint Bruno series—now in the Louvre—was the basis for his contemporary fame as a painter of devout meditation. Together with other artists, he provided paintings for the Hôtel Lambert on the Île Saint-Louis, Paris (ca. 1646–48 and 1652; now in the Louvre). One of the twelve founders of the Académie Royale de Peinture et de Sculpture in 1648, Le Sueur was appointed Peintre Ordinaire du Roi in 1649, the year of his only signed and dated work, Saint Paul at Ephesus, *a large canvas (now in the Louvre) offered to the cathedral of Notre-Dame de Paris by the guild of goldsmiths. After his death at the age of thirty-eight, his works were quickly overshadowed by the relaxed classicism of Charles Le Brun (1619–1690), but the delicate sentiments of Le Sueur's art found a new audience in the eighteenth century: for Diderot he was the "Sublime Le Sueur! Divin Le Sueur," while Président de Brosses called him the "Raphaël de la France."*

EF

ABBREVIATION

Mérot 1987. Alain Mérot. *Eustache Le Sueur (1616–1655)*. Paris, 1987. Reprinted 2000.

39. *The Rape of Tamar*

Oil on canvas, 74½ × 63½ in. (189.2 × 161.3 cm)
The painting was cleaned by Frank Zuccari shortly before the Museum acquired it in 1984.
The Metropolitan Museum of Art, New York, Purchase, Mr. and Mrs. Charles Wrightsman Gift, 1984 (1984.342)

PROVENANCE
Nourri, Paris (his sale, Paris, February 24, 1785, lot 104, as by Eustache Le Sueur "fait dans l'école de Vouet . . . une composition de trois figures dans un intérieur enrichi d'architecture; l'on voit sur le devant une femme assise à qui un soldat presente une coupe d'une main, et tient de l'autre un poignard; 71 pouces de haut sur 57 pouces 6 lignes de large" [76 × 61 in. (193 × 154.9 cm)]; for 400 livres [Fr. 396] to Folliot); private collection (until 1983; sale, Christie's, London, December 2, 1983, lot 45, as "Tarquin and Lucretia" from the circle of Simon Vouet; for £108,000, to Stair Sainty Matthiesen); [Stair Sainty Matthiesen, New York, and Colnaghi, New York, London, and Paris, 1983–84; sold to the Metropolitan Museum]; purchased in 1984 by the Metropolitan Museum through a gift from Mr. and Mrs. Charles Wrightsman.

LITERATURE
Mérot 1987, pp. 1, 33, 168 no. *11, colorpl. 1, fig. 2; Nicholas H. J. Hall, ed., *Colnaghi in America: A Survey to Commemorate the First Decade of Colnaghi New York* (New York, 1992), p. 131.

When this brilliantly colored canvas appeared at public auction in 1983, it was catalogued as a painting of Tarquin and Lucretia from the circle of Simon Vouet. Almost immediately, however, it was recognized as an early work by Vouet's student Le Sueur, and the identification of the subject was questioned. The facial types and the palette of raspberry red, bright blue, ocher, and pale yellow are characteristic of Le Sueur. On the other hand, the energetic poses of the almost lifesize figures, set before a heavily draped canopy bed, recall Vouet's compositions of the 1620s, such as his lost painting of the *Death of Lucretia*, known from an engraving by Claude Mellan (fig. 1). The affinity with Vouet suggests a fairly early date in Le Sueur's career, probably while he was still working in Vouet's studio.

At first glance, the painting appears to represent the rape of the virtuous Roman matron Lucretia. Yet according to Livy (*History of Rome* 1.58), Tarquin threatened to slay Lucretia's male servant and, if she did not submit to him, to declare that he had discovered them together in bed. The servant in the present painting is a young woman, not a man; moreover, it is unclear why the rapist holds a cup in his left hand. An alternative subject might be the story of Amnon and Tamar, a rare Old Testament subject that calls for nude figures.[1] Amnon, who had fallen in love with his half-

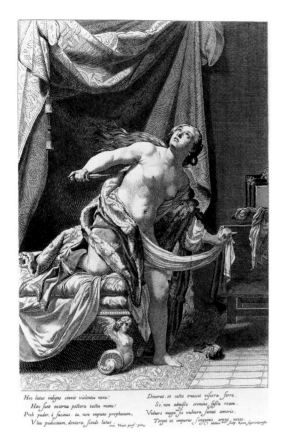

Fig. 1. Claude Mellan, engraving after Simon Vouet's painting *The Death of Lucretia*. Plate, 17 ⅛ × 11 ¼ in. (43.6 × 28.5 cm). The Metropolitan Museum of Art, New York, Harris Brisbane Dick Fund, 1945 (45.97[76])

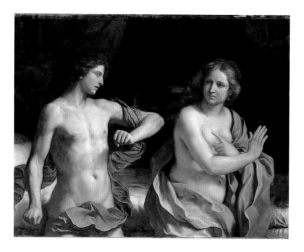

Fig. 2. Guercino, *Amnon and Tamar*. Oil on canvas, 48 ½ × 62 ⅜ in. (123 × 158.5 cm). National Gallery of Art, Washington, D.C.

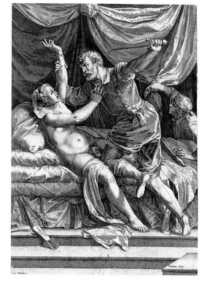

Fig. 3. Cornelius Cort, engraving after Titian's painting *The Rape of Lucretia*. Plate, 14 ⅝ × 10 ⅝ in. (37.2 × 26.8 cm). The Metropolitan Museum of Art, New York, The Elisha Whittelsey Collection, The Elisha Whittelsey Fund, 1949 (49.97.539)

sister Tamar, told his father, King David, that he was ill and requested that she prepare his food. When they were alone, he then coerced her to sleep with him, but overcome with revulsion for what he had done, he then forced her to leave him (2 Samuel 13:1–22). The preparation of a meal may explain the presence of the cup and the overturned urn of water in the foreground. The Bible also speaks of Tamar's "garment of divers colors," which accords with the woman's ocher dress and blue mantle. But there is no mention of a dagger. Indeed, in the few known depictions of Tamar and Amnon, artists such as Guercino (see p. 27; fig. 2) portray the most unusual element of the story, Amnon repudiating Tamar after he had slept with her. The flailing arms and violent action in Le Sueur's painting recall the *Rape of Lucretia* that Titian (ca. 1490–1576) painted in 1571 for Philip II of Spain (now in the Fitzwilliam Museum, Cambridge). Le Sueur might have seen the workshop version of it in the collection of Cardinal Mazarin

(now in the Musée des Beaux-Arts, Bordeaux) or Cornelis Cort's engraving after the original (fig. 3).

Although the original destination of the Wrightsman painting is unknown, it is likely to have formed part of a decorative cycle installed in the wainscoting of a sumptuous room in a Parisian townhouse. The fluted pilasters of the painted architecture recall the grandiloquent interiors of the buildings of Louis Le Vau (1612–1670), the architect of the Hôtel Lambert, for which LeSueur would later produce some of his finest works.

EF

NOTE

1. Mérot 1987, p. 168, reports that this identification was made by Alistair Laing. For a discussion of other paintings of the subject, see Diane De Grazia, in *Italian Paintings of the Seventeenth and Eighteenth Centuries,* The Collections of the National Gallery of Art: Systematic Catalogue (Washington, D.C., 1996), pp. 163–69, especially p. 168 nn. 14 and 16.

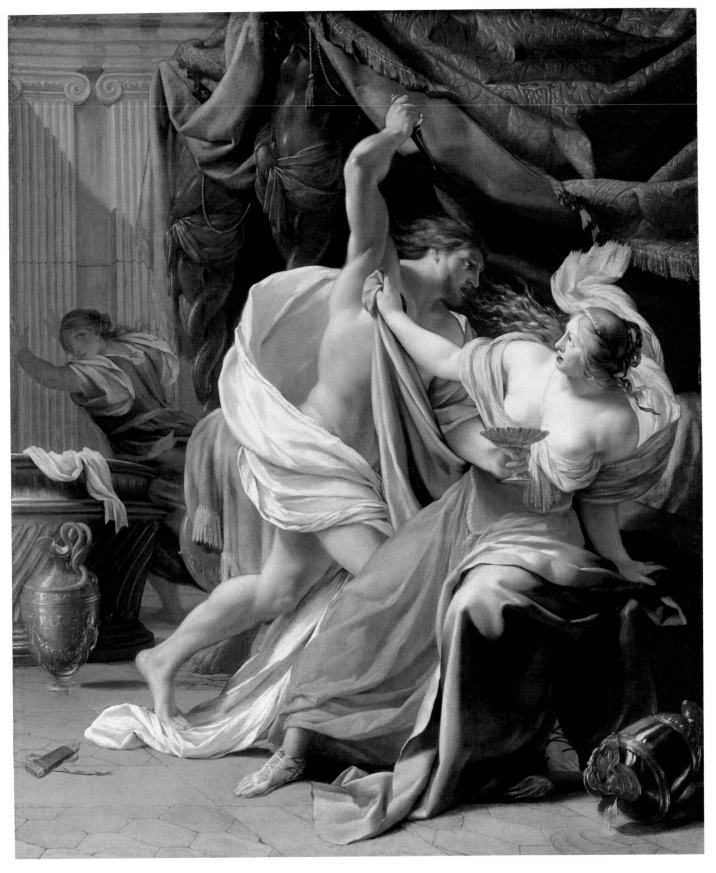

SEBASTIAN STOSKOPFF

(1597–1657)

Sebastian Stoskopff was baptized a Lutheran in Strasbourg, then an independent city with a German culture in what is now northeastern France. His first master was Friedrich Brentel (1580–1651), a local engraver and miniaturist. In 1615 he was apprenticed to the painter Daniel Soreau (d. 1619), a Lutheran refugee from the southern Netherlands who had settled in Hanau, near Frankfurt. There the young Stoskopff became acquainted with the still lifes of the Frankfurt painter Georg Flegel (1563–1638). Following Soreau's death in 1619, Stoskopff stayed in Hanau for another two years; in 1620–21, after he was refused permission to open a workshop in Frankfurt, he moved to Paris, where he remained for twenty years, except for a trip to Italy in 1629.

In the French capital Stoskopff associated with expatriate Flemish artists, such as Pieter van Boeckel (1610–1673; known in France as Pierre Boucle), who had settled in the Saint-Germain-des-Près district, which was outside the jurisdiction of the painters' guild; he was strongly influenced by the French still-life painters Lubin Baugin (ca. 1610–1663), Jacques Linard (ca. 1660–1645), Pierre Dupuis (1610–1682), François Garnier (d. 1672), and Garnier's daughter-in-law Louise Moillon (1610–1696). While his earliest signed work is a feebly painted flower piece in the Musée des Beaux-Arts, Strasbourg, most of his early efforts are simple still lifes of fruit painted on small panels about eight by twelve inches in size. By the mid-1620s Stoskopff produced more ambitious kitchen still lifes, often with a single carp.

A large Vanitas of 1641 (Musée des Beaux-Arts, Strasbourg) marks a change to grander compositions, with baskets of Venetian-style glasses, sumptuous pieces of silver, and prints by Rembrandt and other contemporaries. With works such as his painting depicting Michel Dorigny's engraving after Simon Vouet's Triumph of Galatea pinned to a wall (Kunsthistorisches Museum, Vienna), he helped establish the trompe l'oeil still life. In 1655 Count John of Nassau-Idstein, who had a collection of more than three hundred paintings, invited Stoskopff to settle in Idstein (near Frankfurt), where he died two years later.

EF

ABBREVIATION

Hahn-Woernle 1996. Birgit Hahn-Woernle. *Sebastian Stoskopff, mit einem kritischen Werkverzeichnis der Gemälde.* Stuttgart, 1996.

40. *Still Life with a Nautilus, Panther Shell, and Chip-Wood Box*

Oil on canvas, 18 ½ × 23 ⅜ in. (47 × 59.4 cm)
The Metropolitan Museum of Art, New York, Wrightsman Fund, 2002 (2002.68)

PROVENANCE
Private collection, France; [Galerie Joseph Hahn, Paris, by 1982–85; sold to private collector, Germany]; private collection, Germany (1985–2001; on loan to the Historisches Museum, Frankfurt am Main; in 2001, sold to Kilgore); [Jack Kilgore & Co., New York, 2001–2002; sold to the Metropolitan Museum]; purchased by the Metropolitan Museum in 2002 through the Wrightsman Fund.

EXHIBITED
Paul Rosenberg & Co., New York, March 16–May 1, 1982, "Four Guest Galleries from Paris and Paul Rosenberg & Co.: French Painting, 1600–1900," no. 5; Grand Palais, Paris, September 20–October 7, 1984, "XIIᵉ Biennale Internationale des Antiquaires"; Stedelijk Museum Het Prinsenhof, Delft, June 10–August 29, Fogg Art Museum, Cambridge, Massachusetts, October 1–November 27, and Kimbell Art Museum, Fort Worth, Texas, December 10, 1988–January 29, 1989, "A Prosperous Past: The Sumptuous Still Life in the Netherlands, 1600–1700," no. 13; Národní Galerie v Praze (National Gallery in Prague), Prague, March 10–May 8, 1994, "Georg Flegel, 1566–1638: Zátiší," no. 75; Musée de l'Oeuvre Notre-Dame, Strasbourg, March 15–June 15, 1997, and Suermondt Ludwig Museum, Aachen, July 5–October 5, 1997, "Sébastien Stoskopff, 1597–1657: Un maître de la nature morte," no. 6.

LITERATURE
Sam Segal, *A Prosperous Past: The Sumptuous Still Life in the Netherlands, 1600–1700*, exh. cat., Stedelijk Museum Het Prinsenhof, Delft, Fogg Art Museum, Cambridge, Massachusetts, and Kimball Art Museum, Fort Worth, Texas (The Hague, 1989), pp. 88, 231 no. 13; Hahn-Woernle 1996, p. 152 no. 23; Michèle-Caroline Heck, in *Sébastien Stoskopff, 1597–1657: Un maître de la nature morte*, exh. cat., Musée de l'Oeuvre Notre-Dame, Strasbourg, and Suermondt Ludwig Museum, Aachen (Paris, 1997), pp. 143–44 no. 6.

The Alsatian painter Stoskopff fell into oblivion in the eighteenth century, only to be rediscovered in 1931 when Hans Haug, the first director of the Musée de l'Oeuvre Notre-Dame in Strasbourg, bought one of his paintings. Stoskopff attracted more interest following Charles Sterling's legendary *Exposition de la Réalité* at the Musée du Louvre in 1934, where his mysterious still lifes were seen alongside works by the Le Nain brothers and Georges de La Tour (see p. 146).

The Wrightsman still life is an unusually fine example of Stoskopff's most French-inspired work in its simplicity and allusive combination of seemingly unrelated objects. Before a plain black background are arranged three objects: a chip-wood box, with its lid askew, a polished nautilus shell (*Nautilus pompilius*), and a panther shell (*Cypraea mauritiana*). The box was common in this period and appears frequently in still lifes of the seventeenth century. The shells, coming from the Indian and Pacific oceans, were collector's items. As costly objects, with their sheen of mother-of-pearl, they could be seen as symbols of vanity.

The picture, neither signed nor dated, probably was painted in the late 1620s. It is more sophisticated than the two dated works of 1625, the *Still Life with a Candle and Books* (Museum Boijmans Van Beuningen, Rotterdam) and the *Still Life with a Baguette and Fish* (private collection, Paris), and not yet touched by Stoskopff's later striving for grandeur, as seen in the *Five Senses* of 1633 (Musée des Beaux-Arts, Strasbourg). Stoskopff's preoccupation with light is paramount: objects seem mysteriously to hold and transmit it.

EF

145

GEORGES DE LA TOUR

(1593–1652)

Georges de La Tour holds a unique place in the history of seventeenth-century painting. Unlike his French contemporaries who were drawn to Paris or Rome, he remained in the provinces and developed an isolated, enigmatic style. The subject matter of his paintings was restricted to the traditional Caravaggesque repertory of cardsharps, fortune-tellers, beggars, and austere religious scenes such as the penitence of single saints. He was not a portraitist, and he did not attempt history or landscape painting. The essence of his art was its utter simplicity: he concentrated upon the human figure, showing it in quiet and undramatic situations, reducing it to generalized forms that have an almost abstract clarity. His works, some of which have been confused with those of Zurbarán and Velázquez, possess a deeply spiritual character and a solemn, monumental grandeur.

La Tour was born at Vic-sur-Seille in the former, independent duchy of Lorraine, between northeastern France and the Protestant states of western Germany. Nothing is known about his artistic education; he is mentioned for the first time as a painter in his marriage contract in 1616. Four years later he settled at Lunéville and established a workshop with apprentices. La Tour spent most of the rest of his life there, and from the start he appears to have enjoyed a high reputation; in the early 1620s Duke Henri II of Lorraine (r. 1608–24) bought two of his pictures for remarkably high prices. During the 1630s the duchy was caught up in the Thirty Years' War, eventually falling into the hands of the French. In late 1638 or early 1639 La Tour spent six weeks in Paris; it was probably about this time that he presented a Night Scene *with* Saint Sebastian *to Louis XIII. Six years later his name is listed at Lunéville with the title Peintre Ordinaire du Roi. During the last decade of his life, La Tour painted for Henri, Maréchal de La Ferté-Sénectère, the French governor of Lorraine, several expensive canvases paid for by public taxes: a* Nativity *(1644), a* Saint Alexis *(1649), a* Saint Sebastian *(1650), and a* Denial of Saint Peter *(1652). Although the subjects of these canvases correspond with some of the known works by La Tour, there is no way to prove that any of the surviving pictures are the ones mentioned in the documents.*

Despite decades of research, the chronology of La Tour's work remains debatable. Only two of his surviving paintings are dated, and both of them are late: the Repentant Saint Peter *(Cleveland Museum of Art) of 1645 and the* Denial of Saint Peter *(Musée des Beaux-Arts, Nantes) of 1650, two years before his death at the age of fifty-nine. The*

more realistic pictures, generally day-lit scenes such as the Musicians' Quarrel *in the J. Paul Getty Museum, Los Angeles, and the* Old Man *and* Old Woman *in the Fine Arts Museums of San Francisco, California Legion of Honor, are thought to date from before 1630. The more abstract works, such as* Sebastian Tended by Saint Irene *in the Louvre and the* Newborn Child *in the Musée des Beaux-Arts, Rennes, are usually assigned to the last decade of his life. These are nocturnal scenes—referred to as* nuits *in seventeenth-century inventories—in which a candle, night light, or torch is the sole source of illumination, serving to model the figures as well as to endow the pictures with a haunting, spiritual quality, the hallmark of La Tour's art.*

EF

ABBREVIATIONS

Fahy 1973. Everett Fahy, in *The Wrightsman Collection*, vol. 5, Everett Fahy and Francis Watson, *Paintings, Drawings, Sculpture*. New York, 1973.

Paris 1997. Jean-Pierre Cuzin and Pierre Rosenberg. *Georges de La Tour*. Exh. cat., Galeries Nationales du Grand Palais, Paris. Paris, 1997.

Pariset 1962. François-Georges Pariset. "La Madeleine aux deux flammes: Un nouveau Georges de La Tour?" *Bulletin de la Société de l'Histoire de l'Art Français*, 1961 (pub. 1962), pp. 39–44.

Washington, Fort Worth 1996–97. Philip Conisbee, ed. *Georges de La Tour and His World*. Exh. cat., National Gallery of Art, Washington, D.C., and Kimbell Art Museum, Fort Worth, Texas; 1996–97. Washington, D.C., 1996.

41. *The Penitent Magdalen*

Oil on canvas, 52 1/2 × 40 1/4 in. (133.4 × 102.2 cm)
Discolored varnish was removed in 1962.[1] The painting was treated again in 1970 at the Metropolitan Museum by Hubert von Sonnenburg, who removed some of the restoration in the craquelure in the face, exposing the clear tonality of the original paint.
The Metropolitan Museum of Art, New York, Gift of Mr. and Mrs. Charles Wrightsman, 1978 (1978.517).

PROVENANCE
Private collection, France, "bordering the Lorraine"[2] (by at least 1890; the Côte d'Or in 1920, where it remained until 1963;[3] sold to Heim); [Galerie

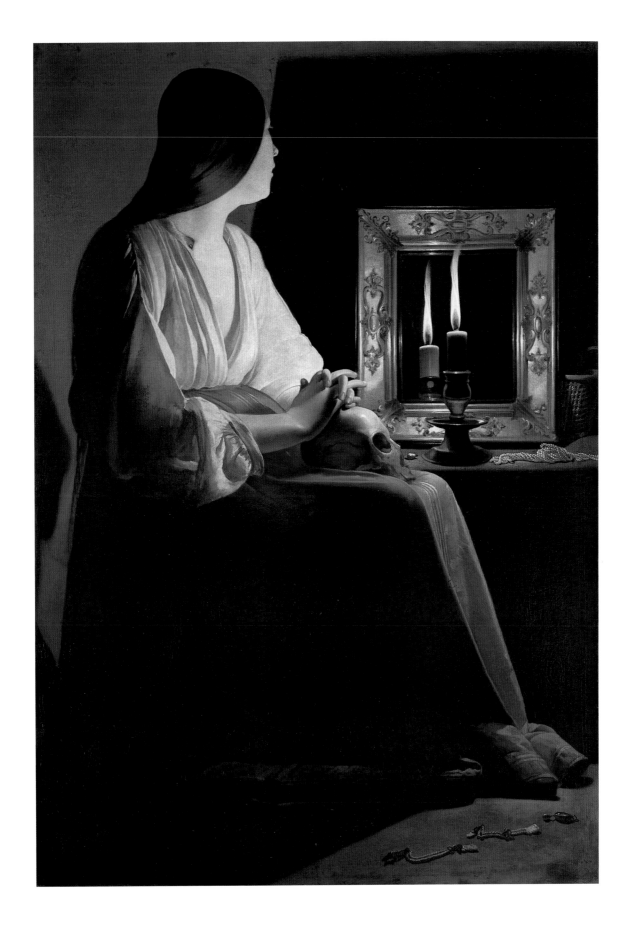

Heim, Paris, 1963; sold to Wrightsman]; Mr. and Mrs. Charles Wrightsman, New York (1963–78; cat., 1973, no. 15); their gift in 1978 to the Metropolitan Museum.

EXHIBITED

Metropolitan Museum, New York, March–October 1967; Metropolitan Museum, New York, October 5–November 10, 1971, "The Painter's Light," no. 7; Orangerie des Tuileries, Paris, May 10–September 25, 1972, "Georges de La Tour," no. 19; Galeries Nationales du Grand Palais, Paris, October 3, 1997–January 26, 1998, "Georges de La Tour," no. 39; Metropolitan Museum, New York, February 10–March 15, 1998, "Conversion by Candlelight: The Four Magdalens by Georges de La Tour (1593–1652)," no. 4.

LITERATURE

Pariset 1962, pp. 39–44; Pierre Rosenberg and Jacques Thuillier, *Georges de La Tour,* exh. cat., Orangerie des Tuileries, Paris (Paris, 1972), p. 177 no. 19; Fahy 1973, pp. 135–43 no. 15; Pierre Rosenberg and François Macé de Lépinay, *Georges de La Tour: Vie et oeuvre* (Fribourg, 1973), pp. 56–57, 148–49, 154 no. 40; Philip Conisbee, in Washington, Fort Worth 1996–97, pp. 109, 111–13, 114; Paris 1997, pp. 53, 186, 199, 202–5 no. 39.

VERSIONS

LOS ANGELES, The Los Angeles County Museum of Art (M.77.73). *The Magdalen with the Smoking Flame* (fig. 4). Oil on canvas, 46⅛ × 36⅛ in. (117 × 91.8 cm). Paris 1997, no. 33.

NEUILLY-SUR-SEINE, Hôtel des Ventes de Neuilly, June 23, 1998. *The Magdalen Reading.* Oil on canvas, 31⅞ × 41 in. (81 × 104 cm).
PARIS, Musée du Louvre (RF 1949-11). *The Magdalen with a Lamp* (fig. 3). Oil on canvas, 50⅜ × 37 in. (128 × 94 cm). Paris 1997, no. 46.
WASHINGTON, D.C., National Gallery of Art, Ailsa Mellon Bruce Fund (1974.52.1). *The Repentant Magdalen* (fig. 2). Oil on canvas, 44½ × 36½ in. (113 × 92.7 cm). Paris 1997, no. 2.

The Magdalen had a special significance in France, since she was believed to have traveled to Marseilles and died in a mountain retreat near Aix-en-Provence; her relics are preserved at Vézelay. Tradition associates her with the woman who wept at the foot of the Cross at the Crucifixion and with the person to whom Christ appeared after his Resurrection. A redeemed sinner, she washed Christ's feet with ointment and her flowing hair. In the seventeenth century her penitence was a popular subject, inspiring religious writers as well as poets and painters, such as Simon Vouet (1590–1649) and Philippe de Champaigne (see p. 151).[4] Vouet's paintings of the Magdalen express the erotic overtones associated with the subject, equivocating between sincere religious medita-

Fig. 1. Philippe de Champaigne, *The Penitent Magdalen.* Oil on canvas, 45½ × 34¼ in. (115.5 × 87 cm). Museum of Fine Arts, Houston, Texas

Fig. 2. Georges de La Tour, *The Repentant Magdalen.* Oil on canvas, 44½ × 36½ in. (113 × 92.7 cm). National Gallery of Art, Washington, D.C.

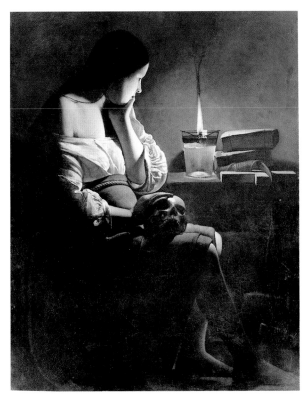

Fig. 3. Georges de la Tour, *The Magdalen with a Lamp*. Oil on canvas, 50⅜ × 37 in. (128 × 94 cm). Musée du Louvre, Paris

Fig. 4. Georges de La Tour, *The Magdalen with the Smoking Flame*. Oil on canvas, 46⅛ × 36⅛ in. (117 × 91.8 cm). Los Angeles County Museum of Art, Los Angeles

tion and voluptuousness for its own sake. In this context it is remarkable how profoundly chaste La Tour's *Magdalens* are. Philippe de Champaigne's renditions of the subject (fig. 1) are notable for the intense realism with which he conveys spiritual transcendence, in contrast to La Tour's simplified forms.

Georges de La Tour's paintings of the Magdalen are relatively modern discoveries. The first to come to public notice, the *Repentant Magdalen* (fig. 2) now in the National Gallery of Art, Washington, D.C., also known as the Fabius *Magdalen* after the name of a previous owner, was found in 1936; the second, the *Magdalen with a Lamp* or Terff *Magdalen* (fig. 3), now in the Louvre, a year later; the present painting, sometimes called the *Magdalen with Two Flames*, in 1961; and the *Magdalen with the Smoking Flame* (fig. 4), in the Los Angeles County Museum of Art, in 1972. A fifth composition, the *Magdalen Reading*, turned up in a sale in 1981, but doubts exist as to whether it is a copy or a poorly preserved original.[5]

It was characteristic of La Tour's creative process to concentrate upon a theme and make different renderings of it, often portraying the same subject with significant alterations in design and mood. The four indisputably autograph *Magdalens* are similar upright compositions, representing the saint as a seated, full-length figure, yet showing different aspects of her reformed life. The earliest, in terms of her conversion, is the Wrightsman composition, illustrating her renunciation of the worldly life. Its spellbinding effect depends upon subtle contrasts: between the shadows on the wall and the lit profile; between the skull and the jewelry scattered on the table and on the floor; and between the flame, emblem of the brevity of life, and its reflection in the splendid silver mirror. The next stage, seen in the closely related Louvre and Los Angeles canvases (figs. 3, 4), depicts the Magdalen in a cell with a still life of sacred books, a cross, a scourge, and an oil lamp with a smoking flame. One hand rests on the skull in her lap, the other touches her face, full of contrition. The last stage, as portrayed in the Washington canvas (fig. 2), shows the saint as a hermit contemplating the vanity of life: the light is behind the skull, which we see reflected in the mirror. Of all the different versions, the Wrightsman canvas is the most elegant, largely because of its luxurious trappings and the graceful turn of the head, but it is no less convincing than the others as a depiction of spiritual atonement.

The mirror frame seen here is similar to one depicted in a portrait of Anna Eleonora Sanvitale, dated 1562, by Girolamo Mazzola Bedoli, in the Galleria Nazionale, Parma.[6] The appliqué decoration on the frame of the mirror resembles the ormolu work on a cabinet in the Bayerisches Nationalmuseum, Munich, by Christoph Angermair (ca. 1580–1633) or his circle.[7] The discarded earrings are identical to those worn by the seated woman in La Tour's *Cheat with the Ace of Clubs* in the Kimbell Art Museum, Fort Worth.[8]

In the absence of documentary evidence, the dating of La Tour's *Magdalens* must remain speculative. Two *Magadelens* are mentioned in early sources, but neither of them can be connected with the surviving canvases.[9] According to recent theories about the artist's chronology, the Wrightsman canvas is placed about 1640.[10]

EF

NOTES

1. According to François-Georges Pariset, "La Madeleine aux deux flammes," *Le pays lorrain,* 1962, p. 162, the painting was cleaned in 1962 and found to be in generally good condition.
2. Pariset 1962, p. 39.
3. According to Jacques Thuillier, *Georges de La Tour* (Paris, 1992), p. 290, it was discovered in the Côte d'Or by H[ubert] Comte in 1961.

4. Françoise Bardon, "La thème de la Madeleine pénitente au XVII^{ème} siècle en France," *Journal of the Warburg and Courtauld Institutes* 31 (1968), pp. 274–306.
5. Sale, Maître Claude Aguttes, Clermont-Ferrand, September 26, 1981; it was offered again at the Hôtel des Ventes de Neuilly, Neuilly-sur-Seine, June 23, 1998.
6. Fahy 1973, p. 142, credits Benedict Nicolson with the observation. The portrait is illustrated in Armando Ottaviano Quintavalle, *Mostra parmense di dipinti noti ed ignoti dal XIV al XVIII secolo,* exh. cat., Galleria Nazionale, Parma (Parma, 1948), pl. 30.
7. Paul Levi called attention to the Munich cabinet, according to Benedict Nicolson and Christopher Wright, *Georges de La Tour* (London, 1974), p. 39, figs. 76, 77 (details of the mirror and the Munich cabinet).
8. Jean-Pierre Cuzin and Pierre Rosenberg, in Paris 1997, p. 202.
9. "Un tableau représentant la sainte Magdelaine" by La Tour belonged to Chrétien de Nogent (d. 1638), chamberlain of the duc de Lorraine and resident of Lunéville; see Marie-Thérèse Aubry and Jacques Choux, "Documents nouveaux sur la vie et l'oeuvre de Georges de La Tour," *Le pays lorrain,* 1976, pp. 155–58. Another "Magdeleine dans une nuit," along with other paintings by La Tour, was recorded in 1661 in the collection of the recently deceased Nancy merchant César Mirgodin and his widow, Anne Polatel, and probably belonged to Mirgodin by 1643; see Michel Sylvestre, "Georges de La Tour: Nouveaux documents," *Bulletin de la Société de l'Histoire de l'Art Français,* 1983 (pub. 1985), p. 53.
10. Philip Conisbee, in Washington, Fort Worth 1996–97, pp. 109, 111–12, 114, and caption to fig. 70 ("early to middle 1640s"); Jean-Pierre Cuzin and Pierre Rosenberg, in Paris 1997, p. 202, place it close to the *Dream of Saint Joseph* and *Saint Joseph as a Carpenter,* both of which they date to about 1640.

PHILIPPE DE CHAMPAIGNE

(1602–1674)

Born in Brussels, Philippe de Champaigne was trained there by local painters. Influenced by the sensitive rendering of atmosphere in the landscapes of Jacques Foucquier (1590–1659), whom he followed, in 1621, to Paris, Champaigne became the greatest French portrait painter of the seventeenth century and a leading painter of religious subjects and classical landscapes (he also became a naturalized Frenchman in 1629). In 1625 he worked with the young Poussin (see p. 136) on the decorations in the Luxembourg Palace for Marie de' Medici, who appointed Champaigne her official painter. In the 1630s he competed with Simon Vouet (1590–1649) on a series of lifesize portraits for Cardinal Richelieu's Galerie des Hommes Illustres in the Palais Cardinal (now the Palais Royal), Paris, and in the late 1630s he painted Louis XIII Crowned by Victory and the full-length Cardinal Richelieu, both now in the Louvre. In these formal portraits and in the altarpieces of this period, Champaigne follows the example not so much of Rubens (see p. 113) but of Frans Pourbus the Younger (1569–1622), whose smooth and polished handling of paint Champaigne continued to emulate throughout his career. Following the deaths of Richelieu (1642) and Louis XIII (1643), his most important patron was Louis XIII's widow, Anne of Austria, who employed Champaigne in the decoration of her private oratory in the Palais Royal and commissioned him to paint a series of large landscapes with small figures of hermit saints for her apartment in the Benedictine convent of Val-de-Grâce, Paris.

During the 1640s Champaigne was drawn to Jansenism, the strict Roman Catholic reform movement centered in the convent of Port Royal, near Versailles. In keeping with the Jansenists' ascetic principles of a return to greater personal holiness, his style became increasingly static and restrained. The portraits of this period, especially half-lengths such as that of Jean Baptiste Colbert (1655) in the Metropolitan Museum, are increasingly sober, showing the sitters dressed in black against gray backgrounds. The artist's masterpiece of this time is the Ex Voto of 1662 in the Louvre, in which portraiture and a religious theme commemorate the miraculous recovery from paralysis of one of Champaigne's daughters, a nun at Port Royal. Late in his career he continued to paint noble landscapes, among them Christ Healing the Blind (ca. 1660) in the Timken Museum of Art, San Diego, California. A founding member of the Académie Royale in 1648, he delegated late commissions to his nephew, Jean Baptiste de Champaigne (1631–1681).

EF

ABBREVIATIONS

Allden and Beresford 1989. Mary Allden and Richard Beresford. "Two Altar-pieces by Philippe de Champaigne: Their History and Technique." Burlington Magazine 131 (June 1989), pp. 395–406.

Champier 1900. Victor Champier and G.-Roger Sandoz. Le Palais-Royal d'après des documents inédits (1629–1900). Vol. 1, Du Cardinal de Richelieu à la Révolution, by Victor Champier. Paris, 1900.

Dorival 1972. Bernard Dorival. "Les oeuvres de Philippe de Champaigne sur le sujet de l'Annonciation." Bulletin de la Société de l'Histoire de l'Art Français, 1970 (pub. 1972), pp. 45–71.

Dorival 1976. Bernard Dorival. Philippe de Champaigne, 1602–1674: La vie, l'oeuvre, et le catalogue raisonné de l'oeuvre. 2 vols. Paris, 1976.

Ingamells 1989. John Ingamells. The Wallace Collection: Catalogue of Pictures. Vol. 3, French before 1815. London, 1989.

Pericolo 2005. Lorenzo Pericolo. "Two Paintings for Anne of Austria's Oratory at the Palais Royal, Paris: Philippe de Champaigne's 'Annunciation' and Jacques Stella's 'Birth of the Virgin.'" Burlington Magazine 147 (April 2005), pp. 244–48.

Sauval 1724. Henri Sauval. Histoire et recherches des antiquités de la ville de Paris. 3 vols. Paris, 1724.

42. The Annunciation

Oil on wood, 28⅛ × 28¾ in. (71.4 × 72.9 cm); painted surface, 27⅛ × 27¾ in. (69 × 70.5 cm)

The panel, which consists of six vertical oak members, has been thinned to .5 cm, cradled, and trimmed on all edges. Inscribed on the base of the prie-dieu: P. CHAMPAIGNE P. On the back of the panel are red wax seals with the arms of the ?Khiening[1] and Henri families and the collector's mark of Jean-François-André Duval.

Cleaned shortly after it was sold at auction in 2003. A pentimento below the angel's left foot indicates that the angel originally stood on the pavement.

The Metropolitan Museum of Art, New York, Wrightsman Fund, 2004 (2004.31)

PROVENANCE

Commissioned for the oratory of the queen mother Anne of Austria, Palais Royal, Paris (about 1644); Louis Philippe Joseph, duc d'Orléans, Palais Royal, Paris (by at least 1788, probably until d. 1793);[2] Cabinet de M*** (?La Bas),[3] until 1793; sale, Paillet, Paris [April 26–27 on catalogue frontispiece, but sale postponed], May 10, 1793, lot 33, oil on canvas, 26 × 26 pouces (28 × 28 in. [71.1 × 71.1 cm]), sold for 1370 livres; ?Khiening, Carintha, Austria (?from 1793); Jean-François-André Duval, Saint Petersburg (until 1816) and Ghent (1816–45;

sold entire collection to Morny); Charles-Auguste-Louis-Joseph de Morny, duc de Morny, Paris (1845–46; "Duval" sale, Phillips, London, May 12–13, 1846, lot 72, sold for £12); private collection (sale, Fischer, Lucerne, November 8–16, 2003, lot 1018, sold for SF 550,000 to Williams); [Adam Williams Fine Art, New York, 2003–4; sold to the Metropolitan Museum]; purchased in 2004 by the Metropolitan Museum through the Wrightsman Fund.

LITERATURE
Sauval 1724, vol. 2, p. 169; Dorival 1976, vol. 2, pp. 17, 140 no. 255.

RELATED COMPOSITIONS
CAEN, Musée des Beaux-Arts. Oil on canvas, 117 × 99¼ in. (297 × 252 cm), ca. 1633–34. Dorival 1976, fig. 20.
CLERMONT-FERRAND, Church of Notre-Dame-du-Port. Oil on wood, ca. 1640? Dorival 1976, fig. 22.
LONDON, Wallace Collection (P134). Oil on canvas, 131⅝ × 84½ in. (334.3 × 214.5 cm), ca. 1643–48 or later. Dorival 1976, fig. 24.
MONTRÉSOR (Indre-et-Loire), parish church. Oil on canvas, 84⅝ × 66⅞ in. (215 × 170 cm), ca. 1640. Dorival 1976, fig. 21.
TOULOUSE, Musée des Augustins. Oil on canvas, 47¼ × 59 in. (120 × 150 cm), ca. 1640. Dorival 1976, fig. 23.
PRIVATE COLLECTION (Christie's, November 21, 1959, lot 28; Christie's, London, November 24, 1967, lot 61). Oil on canvas, oval, 37⅜ × 50¾ in. (95 × 129 cm), ca. 1640. Dorival 1976, fig. 26.

ENGRAVING
Klauber, after a drawing by Michailoff. Dated 1812 (then in the "Cabinet de M. Duval, S. Petersbourg"). Plate, 8⅞ × 6 in. (22.5 × 15.2 cm). Published in the "Duval" sale catalogue, 1846.

Philippe de Champaigne painted more *Annunciations* than any other subject: pre-Revolutionary sources mention at least seventeen examples, ten of which survive today.[4] The present one came to light in 2003, having been known only from a line engraving made in 1812, when the painting was in a private collection in Saint Petersburg. In 1976 Bernard Dorival, the doyen of Philippe de

Fig. 1. Philippe de Champaigne, *The Marriage of the Virgin*. Oil on wood, 28⅛ × 56½ in. (71.5 × 143.4 cm). Wallace Collection, London

Champaigne studies, identified the painting in the engraving as either the *Annunciation* by Champaigne formerly in the Carmelite convent in the Faubourg Saint-Jacques, Paris, or the *Annunciation* once recorded in the cathedral of Notre-Dame, Paris. Neither proposal is convincing: the Carmelite pictures, a cycle of the Life of the Virgin that Champaigne painted for Marie de' Medici between 1628 and 1631, are large canvases (each roughly eleven feet high and ten feet wide), not small panels, and the *Annunciation* formerly in Notre-Dame was a cartoon by Charles Poërson (1609–1667) for a tapestry.[5]

The Wrightsman *Annunciation* is painted on a small oak panel, similar to other pictures that were made for the oratory in the Palais Royal of Anne of Austria (1601–1666), daughter of Philip III of Spain and widow of Louis XIII. For years the *Annunciation* for the oratory was thought to be the large canvas in the Wallace Collection, London;[6] only recently were doubts expressed about this identification, when the Wrightsman *Annunciation* was recognized to be on the same scale as another panel in the Wallace Collection, the *Marriage of the Virgin* (fig. 1), which came from the oratory.[7]

All documents concerning the oratory are lost, but some idea of its decoration can be gleaned from a brief description in Henri Sauval's *Histoire et recherches des antiquités de la ville de Paris,* published in 1724. Sauval wrote, "Around the walls of the oratory are pictures, painted in competition by Champagne, Vouet, Bourdon, Stella, Lahire, Corneille, Dorigni, and Paerson, representing the life and attributes of the Virgin."[8] Thus we know the paintings were parceled out to a team of artists comprising Champaigne and Vouet, who had contributed to Richelieu's Galerie des Hommes Illustres in the Palais Royal, and six or seven younger artists: Sébastien Bourdon (1616–1671), Jacques Stella (1596–1657), Laurent de La Hyre (1606–1656), Michel I Corneille (1602–1664), Michel Dorigny (1617–1665), Charles Poërson, and probably Jacques Sarrazin (1588/92–1660).[9] Rather than hiring one artist to make all the paintings, a competition was set up, presumably to get the work done quickly and to inspire the painters to do their best.

Sauval specifies the subject of only one of the pictures: a *Flight into Egypt* by Bourdon in the Louvre (fig. 2), painted on an oak panel the same height and almost the same width as the Wrightsman painting. Other works from the oratory are listed in an inventory of the paintings in Palais Royal drawn up in 1788; it includes another panel by Bourdon, the *Presentation of Christ in the Temple,* also in the Louvre (fig. 3) and exactly the same size as

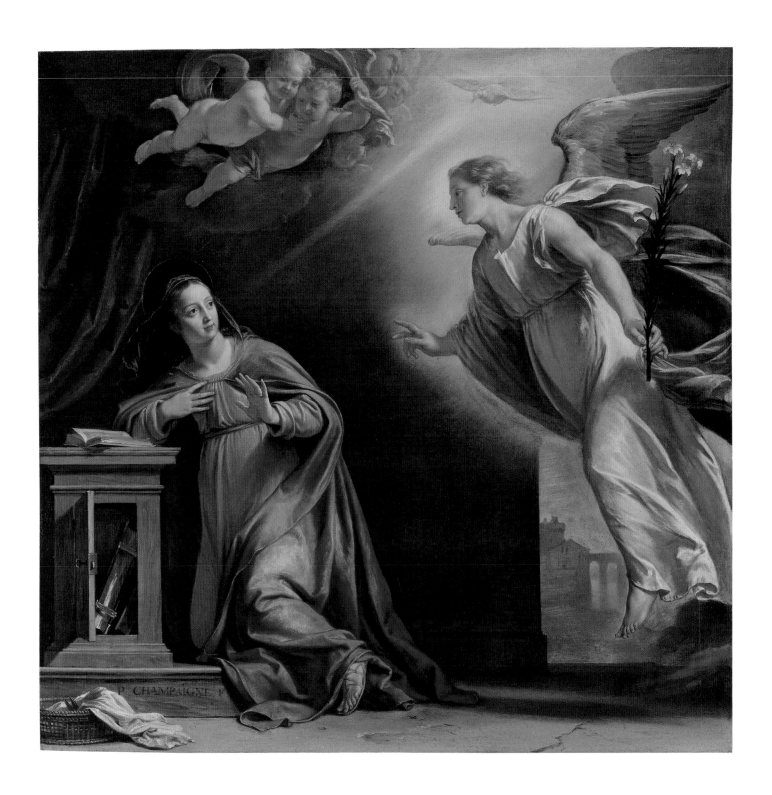

Fig. 2. Sébastien Bourdon, *The Flight into Egypt.* Oil on wood, 27½ × 24 in. (70 × 61 cm). Musée du Louvre, Paris

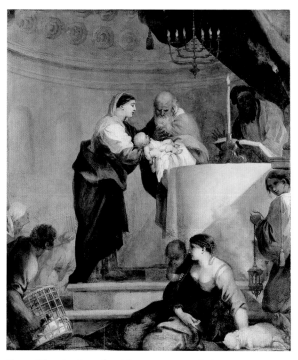

Fig. 3. Sébastien Bourdon, *The Presentation of Christ in the Temple.* Oil on wood, 28 × 24 in. (71 × 61 cm). Musée du Louvre, Paris

his *Flight into Egypt;* a *Death of the Virgin* by Sarrazin and a *Visitation* by La Hyre, both missing;[10] and Champaigne's *Marriage of the Virgin* (fig. 1), mentioned above, which is the same height as the other panels but twice as wide. When the latter appeared in the Pourtalès sale in 1865, it was identified as the altar frontal from the oratory.[11] A *Birth of the Virgin* by Jacques Stella recently acquired by the Musée des Beaux-Arts, Lille, and another panel by Stella, a *Presentation of the Virgin in the Temple* formerly in the Suida-Manning Collection, Forest Hills, New York, may also have belonged to the cycle.[12] The inscription on an engraving of Vouet's *Assumption of the Virgin* (fig. 4) identifies the picture as belonging to Anne of Austria's oratory.[13] Because of its size, a fairly large canvas (76¾ × 50¾ in. [194.9 × 128.9 cm]), and its date, 1644, it must have been the oratory's altarpiece. Vouet, Louis XIII's favorite artist and the oldest member of the team, may have been in charge of the oratory project.

Although none of Champaigne's *Annunciations* are dated, their chronology is suggested by the change in their style from the exuberant version in the Musée des Beaux-Arts, Caen, with its ornate prie-dieu and the dramatic lighting of its figures, to the sober *Annunciation* in the Wallace Collection, London, in which the Virgin and archangel stand in restrained poses. The Caen version

probably dates from shortly after 1633, the Wallace version from the mid-1640s or later.[14] The Wrightsman picture falls between them. Its setting is a room bare of all furnishings except a green hanging, a plain wooden prie-dieu that also serves as a cupboard for the Virgin's books, and the sewing basket on the masonry floor; through the portal is a glimpse of some buildings and an arched bridge spanning the Seine. Hovering in midair and holding a lily, the archangel Gabriel appears before the Virgin with the message, "Behold, thou shalt conceive in thy womb, and bring forth a son, and shalt call his name Jesus" (Luke 1:31). A supernatural radiance surrounds the angel, and light beams from the Holy Ghost toward the Virgin's head. A transitional work, it is symptomatic of the trend in Parisian painting of the 1640s toward a chaste classical style, tempered in Champaigne's case by Flemish figure types. The face of the Virgin, for example, looks like a portrait, perhaps of a member of Champaigne's family; she has the same girlish features as the protagonist of the *Marriage of the Virgin* (fig. 1). While the painting is not yet in the severe style associated with Jansenists at Port Royal, the calm composition anticipates that of an etching by Jean Morin after an *Annunciation* by Champaigne in the *Heures de Port-Royal,* published in 1650.[15]

The decoration of the oratory, a small private chapel on an inner courtyard of the Palais Royal,[16] has been connected with the 20,000 livres that the queen received from the royal treasury on September 11, 1645.[17] The paintings, however, must have been commissioned earlier, as Vouet's *Assumption* is inscribed 1644. Plans for the oratory may have been made soon after Richelieu's death on December 4, 1642. He bequeathed the palace to the king, and Anne of Austria was only too eager to exchange her antiquated quarters in the Louvre for more comfortable rooms in Richelieu's palace. Louis XIII survived Richelieu by a mere five months, dying on May 14, 1643. Anne of Austria and her two young sons, Louis Dieudonné (b. 1638), the future Louis XIV, and Philippe (b. 1640), the future duc de Orléans, moved into the Palais Royal on October 7, 1643. She was granted full powers as regent by the Parlement of Paris, and, with the support of Cardinal Mazarin, governed France from the Palais Royal through the first years of the Fronde, the revolt of discontented nobles against royal authority. On January 6, 1649, she fled from Paris to Fontainebleau, never to return to her quarters in the Palais Royal. With peace, on October 21, 1652, she took up residence in the ground-floor apartment in the Louvre traditionally assigned to queen mothers. Her apartment in the Palais Royal was dismantled in about 1752, when the architect Contant d'Ivry remodeled the building.[18]

EF

NOTES

1. In a possibly related circumstance, the copy of the 1793 sale catalogue in the Akademie der Bildenden Künste, Vienna, belonged to M. König.
2. Mentioned in a list of pictures to be sold in England, which was drawn up in March 1788 and published in Champier 1900, p. 521; not included in earlier inventories.
3. Possibly Le Bas, as Lugt claims, but, according to the Getty Provenance Index, the owner's name is also cited in surviving catalogues as Le Brun, Valkers, and Valguerse.
4. Dorival 1972, p. 50.
5. Dorival 1976, vol. 2, p. 140 no. 255. Dorival (1976, vol. 2, p. 18) also states that the *Annunciation* in the Musée des Beaux-Arts, Caen, was painted for Notre-Dame.
6. Casimir Stryienski, *La galerie du régent Philippe, duc d'Orléans* (Paris, 1913), pp. 99, 179 no. 357; Duval 1976, vol. 2, p. 20 no. 24.
7. Allden and Beresford 1989, pp. 395–96; Ingamells 1989, pp. 110, 112 n. 16.
8. "L'oratoire est environné de tableaux, où Champagne, Vouet, Bourdon, Stella, Lahire, Corneille, Dorigni & Paerson, ont peint en concurrence la vie & les attributs de la Vierge." Sauval 1724, vol. 2, p. 169.
9. For the 1788 inventory, see Champier 1900, p. 521. Sauval does not mention Sarrazin, but Ingamells 1989, p. 95 nn. 7, 9, noted his *Death of the Virgin* in the 1788 inventory of paintings in the Palais Royal.
10. For La Hyre's *Visitation*, see Pierre Rosenberg and Jacques Thuillier, *Laurent de La Hyre, 1606–1656: L'homme et l'oeuvre* (Geneva, 1988), no. X16, and see also no. X17.
11. Catalogue for the sale of the estate of comte James Alexandre de Pourtalès-Gorgier, Paris, February 6, 1865, lot 140.
12. Pericolo 2005, p. 248.
13. It was engraved by Michel Dorigny in 1647 with the inscription: HANC TABVLAM ANNA AVSTRIACA AVGVSTA GALLIARVM REGINA ET/RECTRIX IN PRECARIO SUO PIETATIS MONVMENTVM CONSECRAVIT (Anne of Austria, august queen and regent of the French, consecrates this painting in her oratory as a token of her piety).
14. Ingamells 1989, pp. 111, 112 n. 8.
15. Dorival 1976, vol. 2, fig. 254.
16. Allden and Beresford 1989, p. 395; Pericolo 2005, p. 245, located the queen's apartment on the north side of the palace, facing the garden.
17. The 20,000 livres were for "ouvrages de menuiserie, peinture et dorure et autres qui sont à faire dans la gallerie et appartement de ladicte dame Reyne au pallais royal" (Bibliothèque Nationale, Paris, MS. fr. 10413, fol. 13v); quoted by Ingamells 1989, p. 95 n. 12.
18. Tony Sauvel, "L'appartement de la Reine au Palais-Royal," *Bulletin de la Société de l'Histoire de l'Art Français,* 1968 (pub. 1970), pp. 65–79.

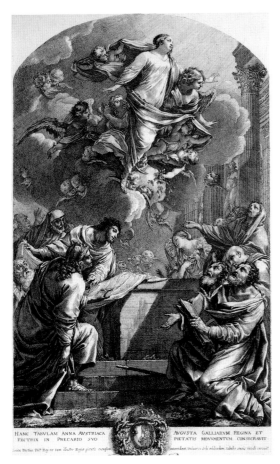

Fig. 4. Michel Dorigny, engraving after Simon Vouet's painting *The Assumption of the Virgin*. Plate, 21⅜ × 12⅝ in. (54.2 × 32 cm). The Metropolitan Museum of Art, New York, Harris Brisbane Dick Fund, 1945 (45.97[38])

GILLES ALLOU

(1670–1751)

Little is known about the life and works of the portraitist Gilles Allou. He was made a member of the prestigious Académie Royale de Peinture et de Sculpture, but not until age forty-one and only after protracted efforts. His application for membership in 1710 was approved after deliberation, which resulted in the unusual requirement that he present three reception pieces rather than the customary two. Upon submission of the three assigned portraits, depicting academicians Antoine Coysevox (1640–1720), Antoine Coypel (1661–1722), and Bon Boullogne (1649–1717; all Musée National du Château, Versailles), Allou was granted full membership in 1711. The Salon livrets (booklets) for the years 1737–42 list about thirty portraits by Allou, although the majority are untraced today. PS

43. *Portrait of Antoine Coysevox*

Pen and brown ink, brush and gray and brown wash, white gouache, on blue laid paper, faded to brown, 6⅞ × 5¼ in. (17.4 × 13.3 cm)
Inscribed in pen and brown ink on the reverse of the old mount: Portrait du célèbre Antoine Coysevox, Sculpteur / natif de Lyon en 1640 et mort en 1720. à 80 ans / les jardins et la grande gallerie de versailles sont / ornés de ses ouvrages. / il a aussi exécuté ces magnifiques groupes placés / à l'entré du jardin des thuilleries représentant l'un / la renomée sur un cheval aîlé; l'autre Mercure / sur Pégase. / Ce grand homme relevoit l'éclat de son rare mérite, / par un dehors simple, une probité scrupuleuse, et / une modestie aimable. il fut élevé a la dignité de / Chancellier dans l'académie de Peinture et Sculpture / qui le recut dans son sein en 1676.
The Metropolitan Museum of Art, New York, Gift of Mr. and Mrs. Charles Wrightsman, 1971 (1971.206.1).

PROVENANCE
[Galerie Cailleux, Paris]; [Michael Hall, New York, 1969; sold to Wrightsman]; Mr. and Mrs. Charles Wrightsman, New York (1969–1971); their gift in 1971 to the Metropolitan Museum.

EXHIBITED
Metropolitan Museum, New York, January 18–April 16, 1972, "Drawings Recently Acquired, 1969–1971," no. 60.

LITERATURE
Jacob Bean, *Fifteenth–Eighteenth Century French Drawings in The Metropolitan Museum of Art* (New York, 1986), p. 20 no. 2; Thierry Bajou, "Le portrait

d'artiste dans la seconde moitié du XVIIᵉ siècle," in *Visages du Grand Siècle: Le portrait français sous le règne de Louis XIV, 1660–1715*, exh. cat., Musée des Beaux-Arts, Nantes, and Musée des Augustins, Toulouse (Paris, 1997), p. 118 n. 14.

RELATED WORKS
VERSAILLES, Musée National du Château (MV 3579). Gilles Allou, *Portrait of Antoine Coysevox* (fig. 1). Oil on canvas, 50¾ × 37¾ in. (129 × 96 cm).

This sheet relates to Allou's portrait of the sculptor Antoine Coysevox (1640–1720; fig. 1), one of the three reception pieces he submitted to the Académie Royale in 1711 (all three paintings are now in the Musée National du Château, Versailles).[1] The practice of assigning senior academicians as subjects for the reception pieces of aspiring portrait painters was established in 1655.[2] It both facilitated the judging of resemblance and provided for the halls of the academy a gallery of illustrious members.

The fact that the academy required three reception pieces from Allou rather than the customary two must reflect some reservations on the part of the academicians regarding his candidacy. Records of the deliberation make note of the fact that his was considered an exceptional case and would not affect the number of portraits (two) expected of future aspirants.[3]

Coysevox was one of the most talented sculptors active during the reign of Louis XIV. Born in Lyon, the son of a joiner, Coysevox entered the studio of Louis Lerambert II (1620–1670) in Paris in 1657. First distinguishing himself with a series of penetrating portrait busts of prominent court figures, he expanded his repertoire to include funerary, decorative, and garden sculpture. His commissions at Versailles included sculptural elements for the Escalier des Ambassadeurs (destroyed 1750), the Grande Galerie, and the façade of the Cour de Marbre, as well as the *Triumph of Louis XIV*, a large stucco relief depicting the king on horseback for the Salon de la Guerre. Among his most admired outdoor sculptures are the monumental marble equestrian figures of Fame and Mercury completed in 1702 for the Abreuvoir in the park of the royal château at Marly, moved to the entrance of the Tuileries gardens in Paris in 1719 and transferred to the Louvre in 1986.[4] The large number of reduced replicas made of *Fame* and *Mercury* (including a set in the Metropolitan Museum)[5] attest to their popularity. The

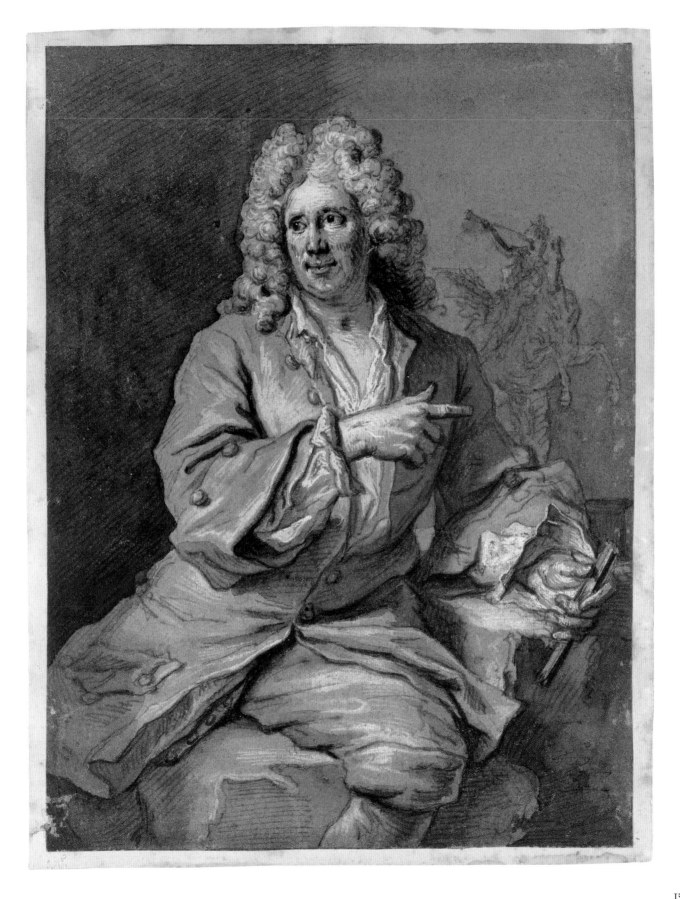

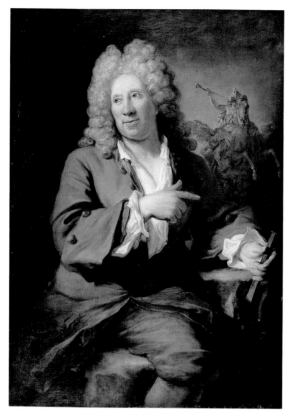

Fig. 1. Gilles Allou, *Portrait of Antoine Coysevox.* Oil on canvas, 50¾ × 37¾ in. (129 × 96 cm). Musée National du Château, Versailles

In contrast to the studies that survive for religious and historical subjects, portrait drawings are rare, and the majority depict details such as hands or drapery or are monochrome replicas for the use of engravers.[7] The Wrightsman sheet has been described as preparatory by Jacob Bean,[8] and subtle differences between drawing and canvas would seem to support this idea: the shift in the position of *Fame,* for instance, as well as the pentimenti in the fingers of Coysevox's left hand and the smaller size of the sitter's head proportionate to the body. Thierry Bajou has since proposed that the drawing may instead be a record of the Versailles painting,[9] although ultimately a greater knowledge of Allou's working methods is necessary before such a question can be resolved. At present, only a handful of drawings bear attributions to Allou.[10]

PS

NOTES

1. *Les peintres du roi, 1648–1793,* exh. cat., Musée des Beaux-Arts, Tours, and Musée des Augustins, Toulouse (Paris, 2000), p. 250 nos. R190–92.
2. Thierry Bajou, "Le portrait d'artiste dans la seconde moitié du XVIIᵉ siècle," in *Visages du Grand Siècle: Le portrait français sous le règne de Louis XIV, 1660–1715,* exh. cat., Musée des Beaux-Arts, Nantes, and Musée des Augustins, Toulouse (Paris, 1997), pp. 107–18.
3. Anatole de Montaiglon, ed., *Procès-Verbaux de l'Académie Royale de Peinture et de Sculpture, 1648–1793,* vol. 4 (Paris, 1881), pp. 109, 126–27.
4. Musée du Louvre, Département des Sculptures, *Sculpture française II: Renaissance et temps modernes* (Paris, 1998), vol. 1, p. 172 no. MR 1824.
5. Everett Fahy, in *The Wrightsman Collection,* vol. 5, Everett Fahy and Francis Watson, *Paintings, Drawings, Sculpture* (New York, 1973), pp. 380–85 nos. 46 A,B.
6. Although it is difficult to judge from a black-and-white photograph, Xavier Salmon describes the *Fame* group in the Versailles canvas as painted to suggest bronze (correspondence, April 8, 2004).
7. Emmanuel Coquery, "La fabrique du portrait," in *Visages du Grand Siècle,* pp. 138–43.
8. Jacob Bean, *Fifteenth–Eighteenth Century French Drawings in The Metropolitan Museum of Art* (New York, 1986), p. 20 no. 2.
9. Thierry Bajou, "Le portrait d'artiste," p. 118 n. 14.
10. See Per Bjurström, *French Drawings: Eighteenth Century* (Stockholm, 1982), no. 789, and Pierre Rosenberg, review of *French Drawings: Eighteenth Century,* by Per Bjurström, *Master Drawings* 22 (spring 1984), pp. 64–65. A *Portrait de Madame de Monsaux* attributed to Allou appeared at auction in 2003 (Piasa, Paris, June 19, 2003, lot 91).

inclusion of a bronze replica of the Marly *Fame* in the background of Allou's portrait of Coysevox,[6] positioned to sound her trumpet directly in his direction, both identifies and flatters the sitter, who was a respected former director of the Académie Royale at the time Allou was seeking to join its ranks.

Allou's composition conforms to models of artists' portraits well established by the early eighteenth century. The seated Coysevox is shown at three-quarter length against a neutral background. In his left hand is a toothed chisel (or *gradine*), the tool of his profession, while his right hand indicates an easily identifiable work. As a further reference to his profession and its materials, Coysevox sits not on a chair but on a rough-hewn block of stone.

JEAN ANTOINE WATTEAU

(1684–1721)

Watteau was born at Valenciennes, a Flemish town that was ceded to France six years before he was born. As a result, the artist was regarded by his contemporaries and later eighteenth-century writers as a peintre flamand. *Flemish art, particularly the work of Rubens (see p. 113) and the genre painter David Teniers the Younger (1610–1690), had a deep influence upon his choice of subjects and his style. Trained at Valenciennes by an obscure religious painter before moving to Paris in about 1702, Watteau there entered the studio of Claude Gillot (1673–1722), a designer of theatrical scenes and painter of subjects from the Italian* commedia dell'arte, *with its stock characters of Harlequin, Columbine, and Gilles. In about 1707 he joined Claude III Audran (1658–1734), a decorative painter, who, as concierge of the Luxembourg Palace, gave Watteau free access to Rubens's great canvases of the Marie de' Medici cycle. Although he was nominated for membership in the Académie Royale de Peinture et de Sculpture in 1712, it was not until 1717 that he presented his diploma picture, the celebrated* Pilgrimage to the Island of Cythera, *now in the Louvre (a later version, painted for the collector Jean de Jullienne, is in Berlin). Because of its wistful mood and distinctive subject, Watteau became the first artist to be elected to the academy as a painter of* fêtes galantes, *a genre he perfected in numerous scenes of fashionable people out in the countryside, enjoying music and conversation. In 1719 he went to London to seek treatment for tuberculosis, probably from Dr. Richard Mead, the famous physician and collector, and returned to Paris in failing health before September 1720. It was then that he painted the shop sign known as the* Enseigne de Gersaint, *now at Schloss Charlottenburg, Berlin.*

Most of Watteau's pictures were composed from drawings, which he kept by the hundreds. Executed in red chalk and graphite, they are generally studies of figures, heads, hands, and draperies that he could reuse in different compositions. He died traveling to Valenciennes, believing he would be cured there. Immediately after his death, many of his drawings were engraved, thus ensuring his widespread influence.

EF

ABBREVIATIONS

Fahy 1973. Everett Fahy, in *The Wrightsman Collection*, vol. 5, Everett Fahy and Francis Watson, *Paintings, Drawings, Sculpture*. New York, 1973.

Rosenberg and Prat 1996. Pierre Rosenberg and Louis-Antoine Prat. *Antoine Watteau, 1684–1721: Catalogue raisonné des dessins*. 3 vols. Milan, 1996.

Washington, Paris, Berlin 1984–85. Margaret Morgan Grasselli and Pierre Rosenberg. *Watteau, 1684–1721*. Exh. cat., National Gallery of Art, Washington, D.C., Galeries Nationales du Grand Palais, Paris, and Schloss Charlottenburg, Berlin; 1984–85.Washington, D.C., 1984.

44. *Study of a Woman's Head and Hands*

Red and white chalk and graphite on off-white laid paper, 7½ × 5 in. (19 × 12.7 cm)
Inscribed in pen and brown ink on the back of the mount: donné a mon ami Bouchardy / Le mercredi des cendres 1816 / Bhy [?] Julien Léopold Boilly (fig. 1).

PROVENANCE
Julien Léopold Boilly, called Jules Boilly (by 1816); Étienne Bouchardy; George Deligand; Jacques Mathey, Paris (by 1951); [Knoedler, London and New York, 1954–58; sold to Wrightsman]; Mr. and Mrs. Charles Wrightsman, New York (1958–his d. 1986; cat., 1973, no. 41); Mrs. Wrightsman (from 1986).

EXHIBITED
Galerie Cailleux, Paris, April 1951, "Le dessin français de Watteau à Prud'hon," no. 156; Royal Academy of Arts, London, November 27, 1954–February 27, 1955, "European Masters of the Eighteenth Century," no. 291; Knoedler, London, June 12–July 9, 1958, "Old Master, Impressionist, and Contemporary Drawings," no. 3; National Gallery of Art, Washington, D.C., June 17–September 23, 1984, Galeries Nationales du Grand Palais, Paris, October 23, 1984–January 28, 1985, and Schloss Charlottenburg, Berlin, February 22–May 26, 1985, "Watteau, 1684–1721," no. 92.

LITERATURE
Edmond de Goncourt, *Catalogue raisonné de l'oeuvre peint, dessiné et gravé d'Antoine Watteau* (Paris, 1875), p. 280 no. 559; K. T. Parker and J. Mathey, *Antoine Watteau: Catalogue complet de son oeuvre dessiné* (Paris, 1957), vol. 2, p. 312 no. 578; Fahy 1973, pp. 350–52 no. 41; Margaret Morgan Grasselli, in Washington, Paris, Berlin 1984–85, pp. 167–68 no. 92; Rosenberg and Prat 1996, vol. 2, pp. 960–61 no. 566.

ETCHING
Figures de différents caractères, de paysages, & d'etudes dessinées d'après nature par Antoine Watteau (Paris, Audran and F. Chereau [1728]), pl. 182 (fig. 2).

Fig. 1. Inscription on back of mount

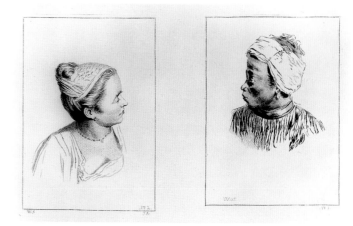

Fig. 2. Jean Audran after Watteau, engravings of *Head of a Woman* and *Head of a Young Negro*. Sheet, 12⅝ × 19¼ in. (32 × 49 cm). The Metropolitan Museum of Art, New York, Purchase, Harris Brisbane Dick Fund, 1928.(28.100[2], pl. 182)

COPY

CAMBRIDGE, Massachusetts, Fogg Art Museum (1956.246). Red, black, and white chalk, 6⅛ × 8⅜ in. (15.6 × 21.3 cm); copied with the head of another woman (fig. 3).[1]

Watteau's working procedure was to make drawings from life, usually of individual details, and then to incorporate them in larger compositions painted in his studio. On a given page of his sketchbook, he would often record more than one pose, or, as in the present example, draw the head and hands separately. Here the head and shoulders of the woman are observed from a slightly different angle than the hands; the head is viewed from above, whereas the hands are seen almost at eye level. The hands also give the impression of being slightly larger in scale than the woman's head.

The pose and shape of the woman's head are similar to those of a woman seen in two closely related canvases in the Wallace Collection, London (*Les Champs Elisés,* P389; *Fête in a Park,* P391). The gesture of one of the hands corresponds, in reverse, with that of one of the hands of an actress in *Love in the Italian Theater* in the Gemäldegalerie, Berlin.[2]

Seven years after Watteau's death, an engraving of this drawing was published by Jean Audran (1667–1756) in a two-volume collection of prints after Watteau's work (fig. 2). In the copy of this sheet (fig. 3) the hands were omitted.

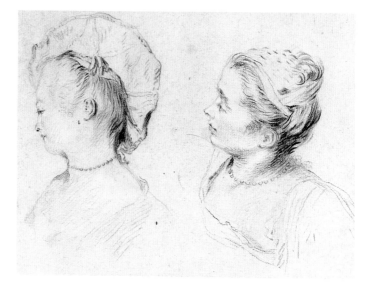

Fig. 3. Copy after Watteau, *Two Studies of Women's Heads*. Red and black chalk on paper, 6⅛ × 8⅜ in. (15.6 × 21.3 cm). Fogg Art Museum, Cambridge, Massachusetts

EF

NOTES

1. Rosenberg and Prat 1996, vol. 3, p. 1176 no. R 102.
2. This was first observed by Margaret Morgan Grasselli, in Washington, Paris, Berlin 1984–85, p. 167.

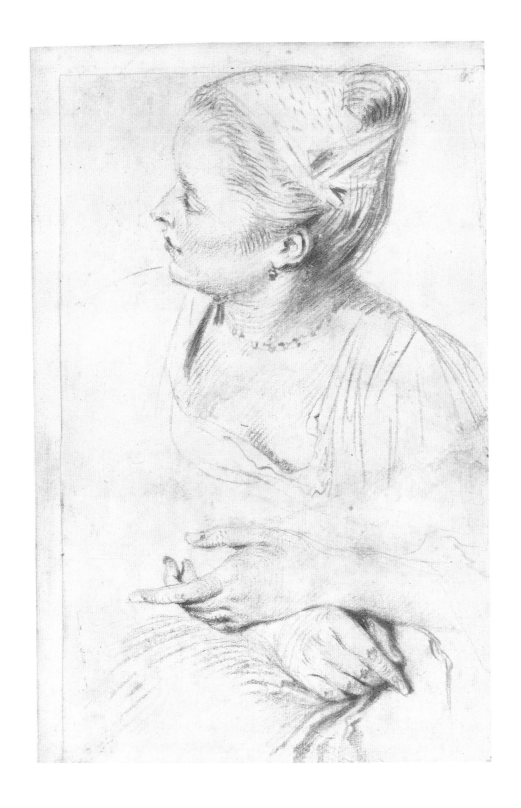

JEAN FRANÇOIS DE TROY
(1679–1752)

One of the most versatile French painters of the first half of the eighteenth century, Jean François de Troy was born in Paris, the son of the portraitist François de Troy (1645–1730). Under his father's auspices, de Troy went to Rome in 1699 and was given a room at the French Academy. On the basis of his painting Niobe and Her Children, now in the Musée Fabre, Montpellier, he was elected a member of the French Academy in July 1708. During the following decade he painted a small number of tableaux de mode, a type of painting of aristocratic life that he seems to have invented. These cabinet pictures represent fashionable people in interior settings or formal parks where they court, play games, or read aloud to one another. Ultimately based on the fêtes galantes of Watteau (see p. 159) and Nicolas Lancret (1690–1743), and on seventeenth-century Dutch genre painting, de Troy's pictures of this sort differ from their prototypes in the extraordinary detail of the clothing and furnishings. They also are autobiographical in the sense that de Troy, reputedly a man of charm, moved freely in the worldly circle depicted within them.

As a result of his success at the Salon of 1725, at which he exhibited seven paintings, three of them tableaux de mode, de Troy received a commission for his first major history painting, The Plague at Marseilles, dated 1726 and now in the Musée des Beaux-Arts, Marseilles. Depending in part on the tradition of the great Venetians and on Rubens (see p. 113), it demonstrates his mastery of large-scale, dramatic compositions. In 1729, however, de Troy suffered a major disappointment when the commission for the ceiling of the Hall of Hercules at Versailles was awarded to François Lemoyne (1688–1737). Forced to turn from large paintings (to which his talents were well suited), de Troy worked during the 1730s on pictures of relatively modest dimensions, many of which were incorporated as decorative panels in private interiors. It was not until 1734 that he was given a royal commission—several sets of allegorical paintings for royal apartments at Versailles and Fontainebleau. When Lemoyne was made first painter to the king in 1736, de Troy turned to designing tapestries for the Gobelins factory; following his success there, he was appointed director of the French Academy in Rome. Holding that position from 1738 until his death in 1752, de Troy played an influential role as a teacher and as a contributor to Roman artistic life.

EF

ABBREVIATIONS

Fahy 1973. Everett Fahy, in The Wrightsman Collection, vol. 5, Everett Fahy and Francis Watson, Paintings, Drawings, Sculpture. New York, 1973.

Leribault 2002. Christophe Leribault. Jean-François de Troy (1679–1752). Paris, 2002.

45. The Declaration of Love

Oil on canvas, 25⅝ × 21 in. (65.1 × 53.3 cm)
Inscribed on the young woman's wristband: DETROY.

46. The Garter

Oil on canvas, 25½ × 21⅛ in. (64.8 × 53.7 cm)
Signed on the baseboard beneath the console: DETROY. 1724.
Pentimenti in the tiles beneath the woman's shoes show that her right foot originally rested on the floor and that the left foot was extended slightly forward.

PROVENANCE
?Frederick the Great, Rheinsberg and Potsdam (by 1754–d. 1786); ?Kaiser Wilhelm I, Berlin; Carl Ludwig Kuhtz (by 1883–d. 1889; his posthumous sale, Lepke, Berlin, February 15, 1898, lots 37, 38, to Huldschinsky, The Declaration for Fr 17,625, The Garter for Fr 16,562); Oscar Huldschinsky (1898–1928; sale, Cassirer & Helbing, Berlin, May 10, 1928, lots 64, 65, to Thyssen-Bornemisza); Baron Heinrich Thyssen-Bornemisza, the Netherlands and, from 1933, Castagnola, Switzerland (1928–d. 1947); Baron Hans Heinrich Thyssen-Bornemisza, his brother and two sisters; [Rosenberg & Stiebel, New York, in partnership with Pinakos (Rudolf J. Heinemann), 1949–56; sold to Wrightsman]; Mr. and Mrs. Charles Wrightsman, New York (1956–his d. 1986; cat., 1973, nos. 29–30); Mrs. Wrightsman (from 1986).

EXHIBITED
Place Dauphin, Paris, June 1724, probably only The Declaration of Love;[1] Académie Royale de Peinture et de Sculpture, Salon Carré, Palais du Louvre, Paris, 1725; Königliche Akademie der Künste, Berlin, 1883, "Die Ausstellung von Gemälden älterer Meister im Berliner Privätbesitz," nos. 46, 47; Kaiser Friedrich Museum, Berlin, 1906, "Ausstellungen von Werken alter Kunst aus dem Privatbesitz der Mitglieder des Kaiser Friedrich-Museums-Vereins," nos. 144, 145; Neue Pinakothek, Munich, 1930, "Sammlung Schloss Rohoncz: Gemälde," nos. 329, 330; Royal Academy of Arts, London, January 6–March 3, 1968, "France in the Eighteenth Century," nos. 669, 670 (The Garter is erroneously reported to be dated 1752).

LITERATURE

Anonymous review in the *Mercure de France,* September 1725, reprinted in *Le Salon de 1725,* ed. Georges Wildenstein (Paris, 1924), pp. 39–40; Wilhelm von Bode and Robert Dohme, "Die Ausstellung von Gemälden älterer Meister im Berliner Privatbesitz," *Jahrbuch der Königlich Preussischen Kunstsammlungen* 4 (1883), p. 254; Wilhelm von Bode, ed., *Die Sammlung Oscar Huldschinsky* (Frankfurt am Main, 1909), pp. 26–27; Gaston Brière, "Detroy," in *Les peintres français du XVIIIᵉ siècle: Histoire des vies et catalogue des oeuvres,* ed. Louis Dimier, vol. 2 (Paris, 1930), pp. 6, 40 nos. 84, 85; Charles Sterling, *Chefs d'oeuvre de l'art français,* exh. cat., Palais National des Arts [Musée National de l'Art Moderne, Palais de Tokyo], Paris (Paris, 1937), p. 77 nos. 148, 149; Fahy 1973, pp. 280–96 nos. 29, 30; Leribault 2002, pp. 58–59, 268, 269–70 nos. P. 113a,b, p. 437.

VERSIONS/COPY

VERSAILLES, Hôtel des Chevau-Légers, December 16, 1973, lot 117 (ill.). A partial copy of *The Garter,* 23⅞ × 19⅝ in. (60.5 × 50 cm).
WILLIAMSTOWN, Massachusetts, Williams College Museum of Art (80.17.1 and 2). Oil on canvas, each 25⅝ × 21½ in. (65 × 54.5 cm). Faithful replicas, rather dry in execution, without signature or date, executed in de Troy's studio either by the artist or under his supervision.[2]

Fig. 2. Bracket clock. Oak and gilt bronze, 35 × 22½ in. (88.9 × 57.2 cm). Wallace Collection, London

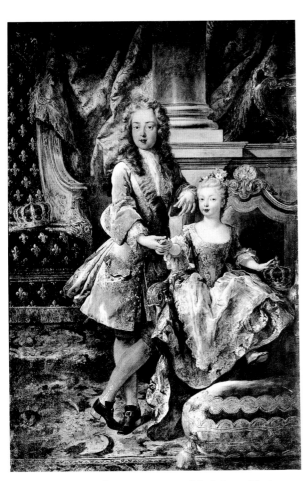

Fig. 1. Jean François de Troy, *Louis XV and the Infanta of Spain.* Oil on canvas, 76¾ × 50¾ in. (195 × 129 cm). Galleria Palatina, Florence

The Declaration of Love and *The Garter* were conceived as a pair intended to complement each other: in the *Declaration* the poses of the young man and woman create a diagonal that runs from the lower left of the painting to the upper right, balancing the opposing diagonal of the poses in the *Garter.* De Troy has painted the rooms' furnishings in such detail that the clothing and many of the objects can be identified. In the *Declaration,* for example, the colors of the marble pedestal next to the canapé echo those of the porphyry vase with gilt-bronze mounts resting on it. The vase reappears in de Troy's official portrait of the thirteen-year-old Louis XV and the six-year-old Infanta of Spain, painted in 1723 on the occasion of their short-lived engagement (fig. 1). (The young king sports shoes with red-lacquer heels like those worn by the suitor in the *Garter.*) In addition, a large painting with a Rococo frame set into the wall is a lost mythological canvas by de Troy of Mars embracing Venus in a landscape.[3] The gilt-bronze clock on top of the bookcase can be associated with a clock design attributed to André Charles Boulle (1642–1732). Several examples of the clock are known; one in the Wallace Collection (fig. 2) is inscribed on the back plate *Martinot aux Galleries du Louvre 1726* (evidently de Troy knew a slightly earlier version, since the *Garter* is dated 1724).

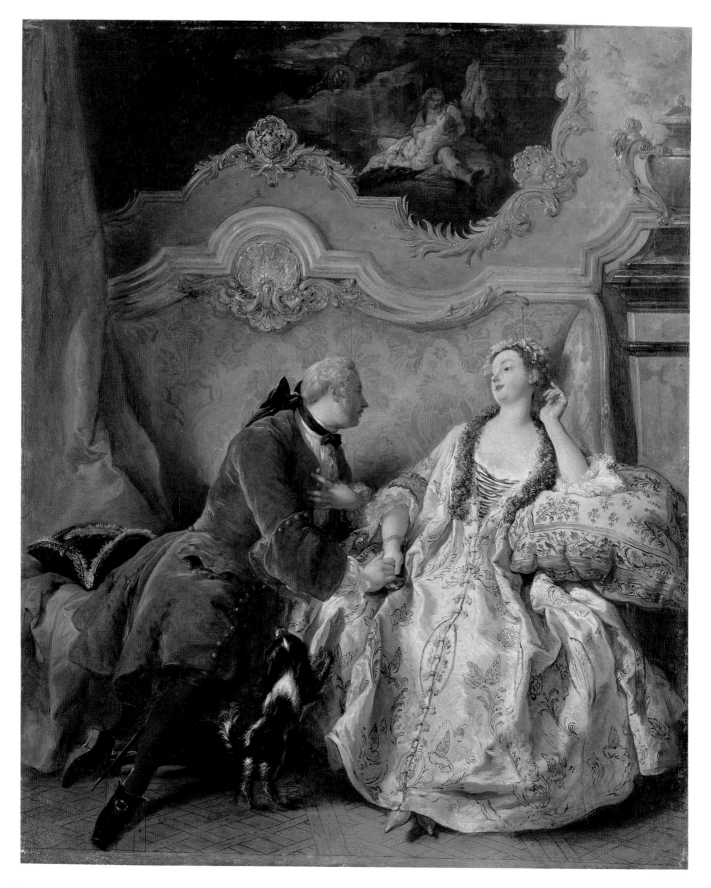

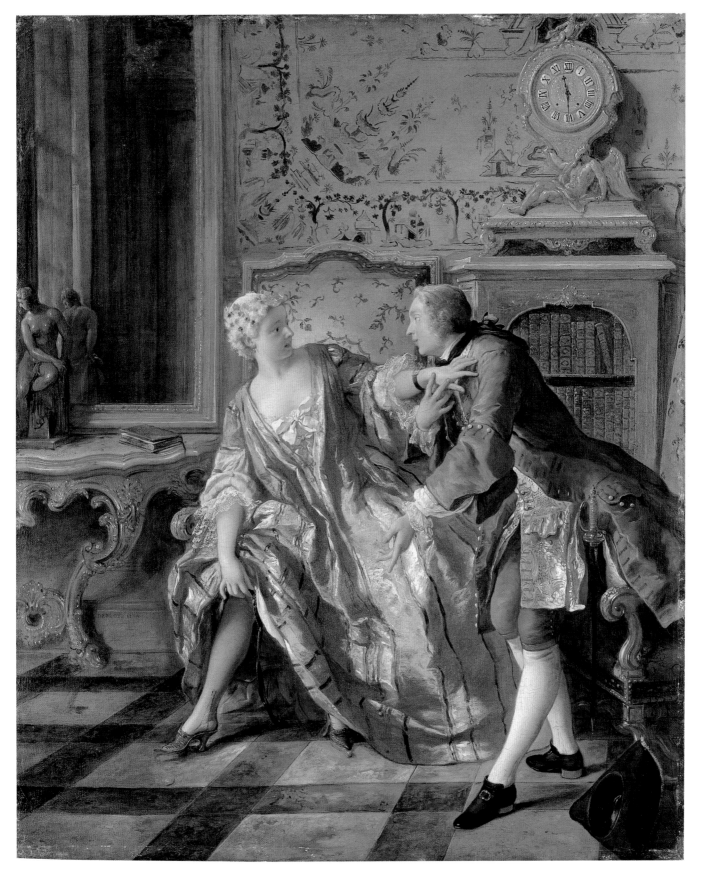

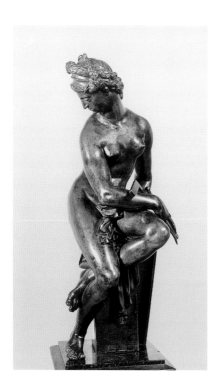

Fig. 3. Attributed to Adriaen de Vries, Statuette of Architecture. Bronze, height 21 ¼ in. (54 cm). Whereabouts unknown

The clock also appears in his painting *The Reading of Molière,* formerly in the Cholomondely collection, and in his *Lady Attaching a Bow to a Gentleman's Sword,* dated 1734, formerly in the collection of Baron Louis de Rothschild, Vienna. A statuette of a seated nude female figure on the console table closely resembles a bronze statuette of Architecture (fig. 3) based on a prototype by Giovanni Bologna (1529–1608); indeed, it appears to be almost identical (unfortunately, the instruments in her hands are not visible in the painting).[4]

Beneath the outward decorum of the settings in both pictures lurks an implied sensuality. The scantily clad lovers in the landscape painting in the *Declaration* obviously comment upon the elegantly clad couple on the canapé. In the *Garter,* the statuette of the nude woman may hint at the young man's thoughts: he probably would subscribe to the thesis of Love conquering Time, the theme symbolized by the gilt-bronze figures on the clock behind him. The bearded man with wings represents Saturn, or, as he is popularly known, Father Time, the Grim Reaper. In his outstretched hand a pair of scales reminds us that all things are measured in the balance of time. The cupid surmounting the clock signifies Love's triumph over Time's final activity, Death, for in his left hand we see the scythe he has stolen from Saturn.

EF

NOTES

1. *The Declaration of Love* is described in the *Mercure de France* 2 (June 1724), p. 1391: "On voyoit de M. de Troye, le fils, déjà connu par de plus grands ouvrages, un Tableau qui fait beaucoup d'honneur à son pinceau, par l'entente & le goût galant & vrai dont il est composé. C'est un jeune Cavalier en habit de velours, don l'étoffe est veritablement moëlleuse, auprès d'une Dame assise sur un canapé." Quoted in Leribault 2002, p. 58. In all likelihood *The Garter* was not shown, perhaps because of its risqué subject.

2. Richard Rand, in *Intimate Encounters: Love and Domesticity in Eighteenth-Century France,* exh. cat., Hood Museum of Art, Dartmouth College, Hanover, New Hampshire; Toledo Museum of Art, Toledo, Ohio, and Museum of Fine Arts, Houston, Texas (Hanover and Princeton, 1997), pp. 104–8, and Leribault 2002, pp. 270, 271.

3. Jacques Vilain, letter, September 1972, kindly pointed out that the figures were engraved by Caylus. The print and an anonymous painting based on it are published by Pierre Rosenberg, "La donation Herbette," *La revue du Louvre et des musées de France,* 1976, pp. 93–94, figs. 1, 4.

4. Hans R. Weihrauch (*Europäische Bronzestatuetten, 15.–18. Jahrhundert* [Brunswick, 1967], p. 353, fig. 426) believed the prototype was a work by Adriaen de Vries (ca. 1560–1626), a Dutch sculptor who was trained in Florence by Giovanni Bologna.

NICOLAS DE LARGILLIERRE
(1656–1746)

Nicolas de Largillierre was one of the most successful portrait painters in France during the reigns of Louis XIV and Louis XV. Following the Flemish tradition of Rubens (see p. 113) and Van Dyck (see p. 123), he specialized in sumptuous portraits, which were sought by the haute bourgeoisie. He painted their elaborate costumes and trappings with a brio matched only by his friend and almost exact contemporary, Hyacinthe Rigaud (1659–1743).

Born in Paris, Largillierre moved at the age of three with his family to Antwerp, where he eventually was apprenticed for about six years to Anthony Goubaud (1616–1698), a minor Flemish artist. In 1675 he went to England and spent four years working in the studio of Sir Peter Lely (1618–1680). All that survives from this period are still lifes in the Flemish manner, such as the Vase of Flowers and a Dead Peacock, signed and dated 1678, in the Devonshire Collection, Chatsworth. Fleeing the persecution of Catholics in England, Largillierre returned to Paris, where he enjoyed the protection of two influential artists, Adam François van der Meulen (1623–1690) and Charles Le Brun (1619–1690).

Quickly establishing himself as a major talent, Largillierre became a member of the French Academy in 1686, with a portrait of Le Brun as his reception piece. He held the titles of peintre d'histoire and peintre de portraits and received several important commissions from the city of Paris. The only one of these to survive is the Échevins of the City of Paris before Sainte-Geneviève, which was painted in 1696 and now hangs in the church of Saint-Étienne-du-Mont, Paris.

Largillierre's clients were primarily of the middle class, whereas Rigaud received most of his commissions from members of the court and nobility. Confiding to his biographer Dézallier d'Argenville that he preferred this state of affairs, Largillierre noted that with the bourgeoisie "les soins en étoient moins grands, & le payement plus prompt."[1] He worked with such speed and ease that Pierre Jean Mariette reported that there were more than 1,200 portraits by his hand in Paris alone.[2]

The eclecticism of Largillierre's portraits was a result of his training in several different countries. Throughout his career he remained indebted to Rubens, inspired by his rich textures and brilliant palette. Yet Largillierre's portraits owe their formats and general designs to Van Dyck's and Lely's allegorical portraits. The special combination Largillierre made of these styles became the foundation of French por-traiture of his time. A precursor of the French eighteenth-century man-ner, he introduced a highly polished and derivative style of portraiture to the country at a moment when it best embodied the spirit of Versailles and Louis XIV.

EF

ABBREVIATIONS

Fahy 1973. Everett Fahy, in *The Wrightsman Collection*, vol. 5, Everett Fahy and Francis Watson, *Paintings, Drawings, Sculpture*. New York, 1973.

Paris 2003. *Nicolas de Largillierre, 1656–1746*. Exh. cat., Musée Jacquemart-André, Paris. Paris, 2003.

NOTES

1. A.-J. Dézallier d'Argenville, *Abrégé de la vie des plus fameux peintres*, rev. ed. (Paris, 1762), vol. 4, p. 298.
2. *Abécédario de P. J. Mariette et autres notes inédites de cet amateur sur les arts et les artistes* [Paris, 1753], ed. Philippe de Chennevières and Anatole de Montaiglon (Paris, 1851–60), vol. 3, p. 61.

47. *André François Alloys de Theys d'Herculais* (1692–1779)

Oil on canvas, 54¼ × 41½ in. (137.8 × 105.4 cm)
Inscribed on the back of the original canvas (no longer visible): peint per N. de Largillierre / 1727.
Cleaned and relined shortly before it entered the Wrightsman collection.
The Metropolitan Museum of Art, New York, Gift of Mr. and Mrs. Charles Wrightsman, 1973 (1973.311.4)

PROVENANCE
Amaury Alloys d'Herculais (1928); sale, Palais Galliéra, Paris, March 30, 1963, lot 27, as "André François Alloys de Theys d'Herculais au Siège de Fontarabie," for Fr 54,000 to Seligman; [Germain Seligman, New York, 1963–64; sold to Wrightsman]; Mr. and Mrs. Charles Wrightsman, New York (1964–73; cat., 1973, no. 14); their gift in 1973 to the Metropolitan Museum.

EXHIBITED
Petit Palais, Paris, May–June 1928, "Exposition N. de Largillierre," no. 62; Metropolitan Museum, New York, 1968–73.

LITERATURE
Camille Gronkowski, "L'exposition N. de Largillierre au Petit Palais," *Gazette des beaux-arts*, 5th ser., 17 (June 1928), p. 322; Helmut Nickel, *Warriors and Worthies: Arms and Armor through the Ages* (New York, 1969), p. 103; Fahy 1973, pp. 127–33 no. 14; Myra Nan Rosenfeld, *Largillierre and the Eighteenth-Century Portrait,* exh. cat., Montreal Museum of Fine Arts (Montreal, 1981), pp. 269, 383.

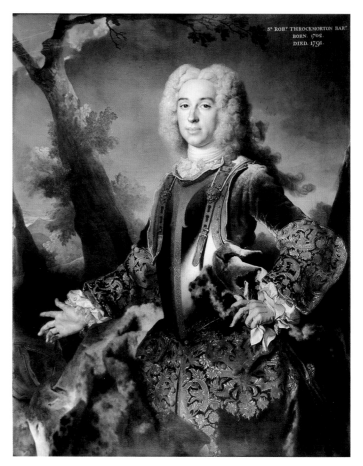

Fig. 1. Nicolas de Largillierre, *Sir Robert Throckmorton*. Oil on canvas, 53 ¼ × 41 ¼ in. (135.3 × 104.8 cm). H. M. Treasury and the National Trust, Coughton Court, near Alcester, Worcestershire

In the possession of the d'Herculais family for generations, this painting was always thought to be a portrait of André François Alloys de Theys d'Herculais (1692–1779). In 1727, when Largillierre signed and dated the reverse, d'Herculais would have been about thirty-five years old. He came from a bourgeois family in the region of Grenoble. His father, Claude Alloys (d. 1698), held several important posts in the service of Louis XIV; his mother was Marie de Theys de Tournet.1 In 1725 d'Herculais held the rank of captain of the cavalry regiment of Clermont-Condé. According to family tradition, he participated in the Battle of Fontarabia, which took place in June 1719, when French forces besieged and captured this small northern Spanish town, thus helping to protect the throne of France from Philip V's claim to succession. It may be this campaign that is represented in the background of the portrait.

The painting belongs to the genre of military portraiture, of which the picture by Paris Bordon (cat. 3) is an earlier example. The costume is not one that d'Herculais would have worn in combat. His sword is ceremonial, and his freshly powdered wig is obviously inappropriate for the battlefield. His wig and greatcoat are actually part of the *grand habit,* or formal attire, worn in the early eighteenth century. His helmet and ornate breastplate are merely allegorical attributes: the helmet is a *bourguignotte* of the first half of the seventeenth century and was no longer in use by 1700. The same breastplate—with the gold pattern down the center and along the edges and with the over-the-shoulder straps fastened with lion's-head buckles—reappears in three nearly identical contemporary portraits by Largillierre: *Jacques François Léonor de Goyon-Matignon, Duc de Valentinois,* collection of the late Prince Rainier III of Monaco, dated 1718; *Sir Robert Throckmorton* (fig. 1), signed and dated 1729; and *Louis de Lamorelie,* formerly with the Galerie Trotti, Paris. The artist may have owned the armor and kept it in his studio for clients who wished to be portrayed in this manner.

Produced when the artist was over seventy years old, the portrait exemplifies the quiet, restrained style with which he ushered in the Régence period. It would not be until the 1740s that Nattier (see p. 176), Largilliere's competitor among society portraitists of the next generation, would attain comparable mastery.2

EF

NOTES

1. Camille Blanchard, "Notes brèves sur la famille dauphinoise 'Les Alloys d'Herculais' originaires des vallés cédées par le Traité d'Utrecht en 1713," *Les Procès-Verbaux de l'Académie Delphinale*, 7th ser., vols. 1 and 2, (1956–57), pp. XLIV–XLVII.
2. Dominique Brême, in Paris 2003, p. 168.

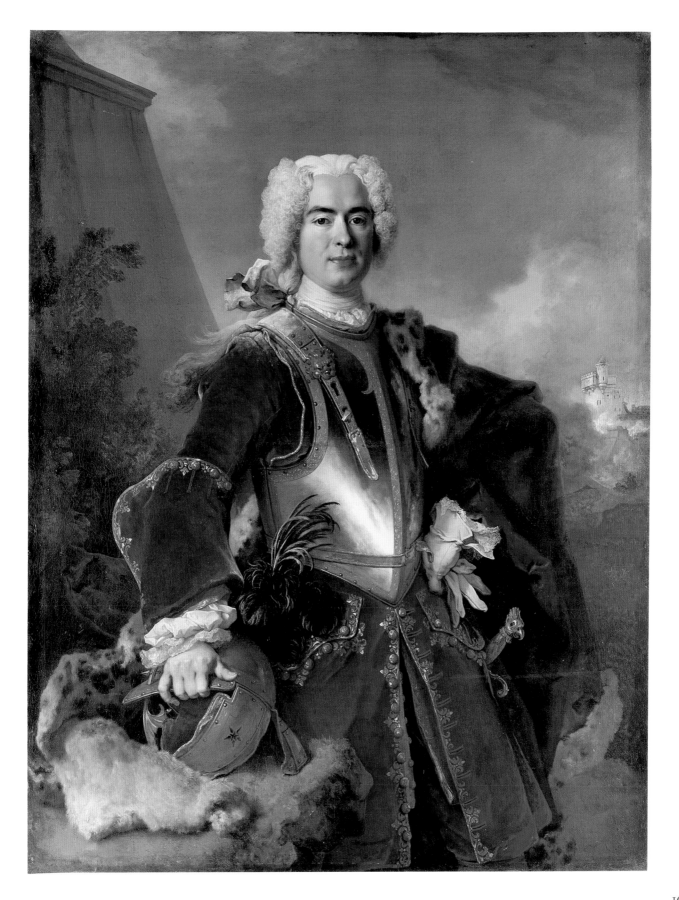

FRANÇOIS BOUCHER

(1703–1770)

François Boucher played a leading role in the formulation of the Rococo idiom in France. Assimilating elements from many disparate sources, he forged an influential manner marked by a high-toned palette and a repertoire of easily recognizable figures types, at once rustic and refined. The loves of the gods and the idyllic pastoral provided the majority of his subjects, and his inventions saw extensive replication in the form of tapestries, porcelain, and reproductive prints, which further spread his style abroad.

Although Boucher won the Prix de Rome in 1723, funds for a study trip were not made available by the Crown. For the next five years he supported himself as a printmaker and designer of book illustrations, eventually saving the money to finance his own journey to Rome. In Italy from 1728 to 1731, Boucher was more smitten with masters of the Italian Baroque than he was with either antiquity or the Renaissance, to judge from his surviving copies.

Returning to Paris in 1731, Boucher turned his attention to mythological painting, supplying large-scale decorative cycles as well as cabinet pictures to a diverse clientele, ranging from Parisian collectors to the court of Louis XV and foreign heads of state. Outside the genre of history painting, he created idealized landscapes as settings for the amorous adventures of silk-clad shepherds and shepherdesses as well as more rustic scenes inspired by Giovanni Benedetto Castiglione (1609–1664). In 1734 he became a member of the Académie Royale, moving up in the ranks until he was appointed director of the academy and Premier Peintre du Roi in 1765.

PS

48. *Young Man Wearing a Beret*

Red, black, and white chalk on beige antique laid paper, 4⅝ × 3⅝ in. (11.6 × 9.2 cm)
The collector's mark of A. Mouriau (Lugt 1853) at lower left in black ink.
The Metropolitan Museum of Art, New York, Gift of Mrs. Charles Wrightsman, 2004 (2004.475.4)

PROVENANCE
A. Mouriau, Brussels (Lugt 1853); his collection sale, Hôtel Drouot, Paris, March 11–12, 1858, lot 322 (as by Watteau); sale ("collection d'un amateur"), Hôtel Drouot, Paris, November 6, 1964, lot 104, pl. XIV (as Watteau [?], possibly Nicolas Lancret); [Charles E. Slatkin Galleries, New York]; [Stair Sainty Matthiesen, New York, 1987; sold to Wrightsman]; Mrs. Charles Wrightsman, New York (1987–2004); her gift in 2004 to the Metropolitan Museum.

EXHIBITED
Charles E. Slatkin Galleries, New York, April 15–May 14, 1966, "Drawings/Pastels/Watercolors," no. 57; National Gallery of Art, Washington, D.C., December 23, 1973–March 17, 1974, and The Art Institute of Chicago, April 4–May 12, 1974, "François Boucher in North American Collections: 100 Drawings," no. 1; Stair Sainty Matthiesen, New York, September 30–November 25, 1987, "François Boucher: His Circle and Influence," no. 4.

LITERATURE
Regina Shoolman Slatkin, "Portraits of François Boucher," *Apollo* 94 (October 1971), pp. 285–86, 290, fig. 22, 291 nn. 21–22; Beverly Schreiber Jacoby, *François Boucher's Early Development as a Draughtsman, 1720–1734* (New York and London, 1986), pp. 242–43 no. I.C.2; Pierre Rosenberg and Louis-Antoine Prat, *Antoine Watteau, 1684–1721: Catalogue raisonné des dessins* (Milan, 1996), vol. 3, p. 1328 no. R 673 (as a rejected drawing, location unknown); Emmanuelle Brugerolles, ed., *François Boucher et l'art rocaille dans les collections de l'École des Beaux-Arts*, exh. cat., École Nationale Supérieure des Beaux-Arts, Paris (Paris, 2003), pp. 42 n. 31, 80, ill. 5.

A survey of the various attributions and titles this sheet has borne suggests something of the mystery that has surrounded the drawing as well as the interest it has elicited. Catalogued in 1858 as a work by Antoine Watteau (see p. 159) and in 1964 as possibly by Watteau but more likely by his follower Nicolas Lancret (1690–1743), the drawing was first attributed to Boucher presumably by Regina Slatkin in 1966. In both 1858 and 1964 the subject of the sheet was described as a young girl. The change in gender was proposed by Slatkin at the same time she identified Boucher as the author;[1] the two ideas are not unrelated, as the young male figures who populate Boucher's pastorals are often effeminate in their features. In 1971 Slatkin further claimed that the Wrightsman drawing was not just a head of a boy but a youthful self-portrait.[2] Although this idea has occasionally been repeated, for the most part it has not been upheld by subsequent scholars.[3]

As an early *trois crayons* (three chalks) drawing, dated variously to 1725–1728, this study inevitably figures in discussions of the relationship of Boucher to Watteau. Sometime in the early to mid-1720s Boucher was hired by Jean de Jullienne (1686–1766) to take part in the ambitious project of etching Watteau's graphic oeuvre, following the artist's death in 1721. This sustained and intimate contact with Watteau's drawings has long been considered central

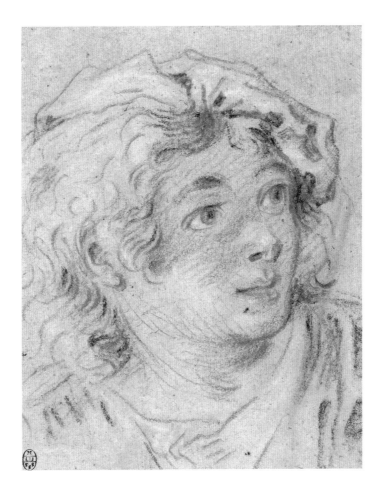

to Boucher's artistic development. Yet, as Boucher's various early manners have become better known, it is surprising how little his graphic style before his trip to Italy in 1728 can be said to resemble that of Watteau. Beginning in the mid-1730s Boucher made frequent use of red, black, and white chalk for figure and head studies, but only a handful of sheets in this technique are associated with the period when he was copying Watteau's drawings. Indeed, the Wrightsman sheet has no close parallels among Boucher's works from the 1720s in terms of type or technique.

According to an early biography, Jullienne employed Boucher not only to etch Watteau's drawings but also to make drawn copies.[4] The possibility that the Wrightsman sheet, which cannot be connected to any surviving painting by Boucher and does not appear to be drawn from life, may be inspired by the work of an earlier artist should be considered. In addition to those by Watteau, Boucher would have been acquainted with *trois crayons* drawings by Charles de La Fosse (1636–1716), Antoine Coypel (1661–1722), and Rubens (see p. 113). The type of floppy beret worn by the boy can be found in works by both Watteau and La

Fosse. In fact, the young page at the center of La Fosse's *Adoration of the Magi* (Louvre)[5] offers a close precedent for this figure type.

PS

NOTES

1. *Drawings / Pastels / Watercolors*, exh. cat., Charles E. Slatkin Galleries, New York (New York, [1966]), no. 57, pl. 53b.
2. Slatkin, "Portraits of Boucher," pp. 285–86. It was further postulated by Alan Wintermute in 1987 that the drawing might be "possibly identifiable" with no. 3376 in the 1810 Bénard catalogue of the Paignon-Dijonval sale ("Le portrait de Boucher, la tête seulement, aux crayons de trois couleurs sur papier gris"), although the dimensions given for that drawing were 5 pouces × 5 pouces; see *François Boucher: His Circle and Influence*, exh. cat., Stair Sainty Matthiesen, New York (New York, 1987), p. 18 no. 4.
3. For instance, Marianne Roland Michel refered to the subject as a self-portrait in her essay in *François Boucher et l'art rocaille, dans les collections de l'École des Beaux-Arts,* ed. Emmanuelle Brugerolles, exh. cat., École Nationale Supérieure des Beaux-Arts, Paris (Paris, 2003), p. 42, while elsewhere in the same catalogue Françoise Joulie used the title "Jeune homme au béret" (p. 80).
4. From a eulogy published in *Galerie françoise*, 1771, and reprinted in Alexandre Ananoff, *François Boucher* (Lausanne and Paris, 1976), vol. 1, pp. 133–34. The author's name was given as Restout.
5. Illustrated in Pierre Rosenberg, *From Drawing to Painting: Poussin, Watteau, Fragonard, David, and Ingres* (Princeton, New Jersey, 2000), p. 129.

CARLE VANLOO

(1705–1765)

A versatile draftsman, engraver, and painter who worked in oil, pastels, and fresco and excelled in history, mythological, and religious pictures as well as in portraiture, Carle (Charles Andre) Vanloo was a member of a dynasty of Dutch artists who were active throughout Europe in the seventeenth and eighteenth centuries. He was born in Nice, and, after his father's death in 1712, he was raised by his elder brother in Rome, where he studied with the painter Benedetto Lutti (1666–1724). Returning to France in 1719, he assisted his brother on the restoration of the Galerie François I in the château of Fontainebleau. In 1724 he won the Prix de Rome but did not take up the prize until 1728, when he traveled to Italy with his contemporary, and later rival, Boucher (see p. 170). He immediately established his reputation as a painter of large-scale decorations with his fresco of the Apotheosis of Saint Isidore on the ceiling of the nave of the church of San Isidoro, Rome (1729). From 1732 to 1734 he worked at Turin for Charles Emanuel III, duke of Savoy, painting a ceiling fresco in the Palazzo Mauriziano at Stupinigi, near Turin, and eleven scenes from Tasso's Gerusalamme liberata for the salon of the Palazzo Reale, Turin, all in situ. Settling in Paris in 1734, Vanloo was admitted to the Académie Royale the following year, appointed professor there in 1737, and later named Premier Peintre du Roi in 1762.

In 1736 Vanloo received his first royal commission: the Bear Hunt (Musée de Picardie, Amiens) for the Galerie des Chasses Exotiques in Louis XV's apartment at Versailles. Initially the decoration consisted of six canvases executed by Jean François de Troy (see p. 162), Jean Baptiste Pater (1695–1736), Nicolas Lancret (1690–1743), Boucher, and Charles Parrocel (1688–1752), son of the famous painter of battle scenes, Joseph Parrocel. Two years later Vanloo was commissioned to add to the Galerie his extraordinary Ostrich Hunt (Musée de Picardie, Amiens). From exotic hunting scenes Vanloo went on to paint full-length portraits of Queen Marie Leczinski and Louis XV, both now in the Musée National du Château, Versailles. For Madame de Pompadour's château of Bellevue, he painted the famous set of four canvases of children personifying painting, sculpture, architecture, and music (1752–53), now in the Fine Arts Museums of San Francisco, California Legion of Honor.

In his day Vanloo was also famous for his turqueries, such as the charming Pasha Having His Mistress's Portrait Painted (Virginia Museum of Fine Arts, Richmond), executed in 1737, the same year as the Wrightsman picture. As a religious painter, he is remembered for his six scenes from the Life of Saint Augustine in the choir of Notre-Dame-des-Victoires, Paris (1746–55) and the series of the Life of the Virgin in Saint-Sulpice (ca. 1748).

EF

ABBREVIATIONS

Atlanta 1983. Eric M. Zafran. *The Rococo Age: French Masterpieces of the Eighteenth Century.* Exh. cat., High Museum of Art, Atlanta, Georgia. Atlanta, 1983.

Bottineau 1962. Yves Bottineau. *L'art d'Ange-Jacques Gabriel à Fontainebleau (1735–1774).* Paris, 1962.

Engerand 1901. Fernard Engerand. *Inventaire des tableaux commandés et achetés per la direction des Bâtiments du Roi.* Paris, 1901.

Nice, Clermont-Ferrand, Nancy 1977. Marie-Catherine Sahut. *Carle Vanloo: Premier peintre du roi (Nice, 1705–Paris, 1765).* With an introduction by Pierre Rosenberg. Exh. cat., Musée Chéret, Nice, Musée Bargoin, Clermont-Ferrand, and Musée des Beaux-Arts, Nancy. Nice, 1977.

49. *The Hunt Breakfast*

Oil on canvas, 23 ¼ × 19 ½ in. (59.1 × 49.5 cm)
Cleaning by Alain Goldrach, shortly after it was acquired by Colnaghi, revealed the original curved contours of the top and bottom of the composition.
The Metropolitan Museum of Art, New York, Wrightsman Fund, 1995 (1995.317)

PROVENANCE

[Wildenstein, Paris, until 1909]; David David-Weill, Paris (1926–41; sold to Wildenstein); [Wildenstein, New York, 1941–43; sold to Brewster]; Robert Dows Brewster, New York (1943–d. 1995; posthumous sale, Sotheby's, New York, May 19, 1995, lot 113, for $244,500, to Colnaghi); [Colnaghi, New York, 1995; sold to the Metropolitan Museum]; purchased by the Metropolitan Museum in 1995 with a gift from the Wrightsman Fund.

EXHIBITED

High Museum of Art, Atlanta, Georgia, October 5–December 31, 1983, "The Rococo Age: French Masterpieces of the Eighteenth Century," no. 46.

LITERATURE

Gabriel Henriot, *Collection David Weill,* vol. 1, *Peintures* (Paris, 1926), pp. 371–72; Louis Réau, "Carle Vanloo (1705–1765)," *Archives de l'art français,* n.s., 19

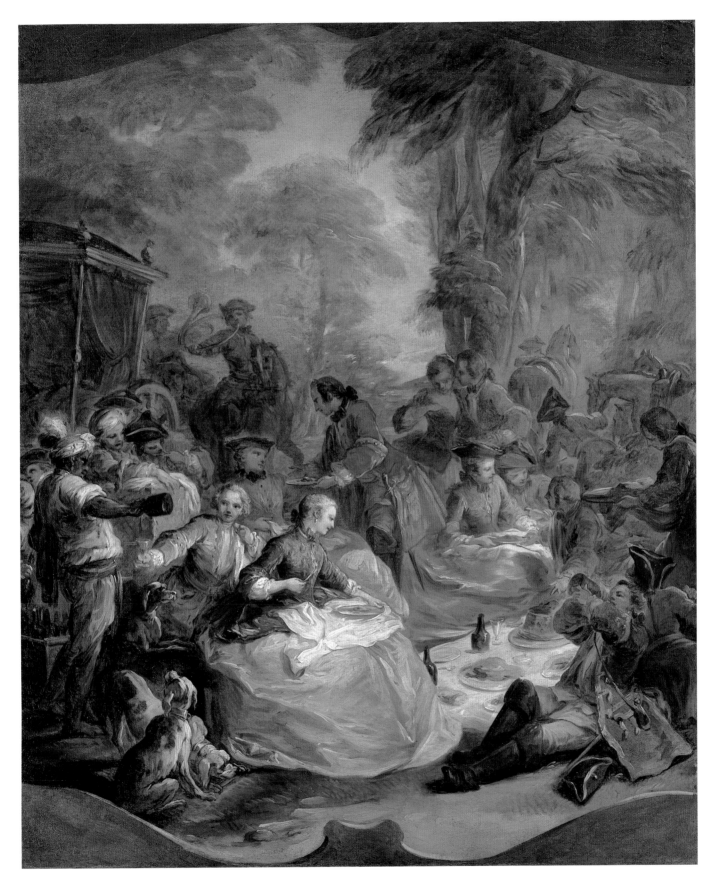

(1935–37; pub. 1938), p. 68 under no. 122 and p. 69 no. 124 (where it is confused with a painting by Jacob Vanloo in the Musée Condé, Chantilly); Marie-Catherine Sahut, in Nice, Clermont-Ferrand, Nancy 1977, p. 42 no. 50; Eric M. Zafran, in Atlanta 1983, pp. 9, 15, 113 no. 46.

RELATED WORK
PARIS, Musée du Louvre (6279). Carle Vanloo, *The Hunt Breakfast*. Oil on canvas, 86⅝ × 98⅜ in. (220 × 250 cm). Signed and dated 1737.

Unlike his father, who spent most of his time at Versailles, Louis XV preferred to move with his court from one major royal château to another. An avid hunter, he especially enjoyed the vast hunting grounds at Fontainebleau. To make the antiquated château more comfortable, he commissioned separate living quarters for himself, the queen, and the dauphine, to the designs of the great architect Ange Jacques Gabriel (1698–1782), working with his father Jacques V Gabriel and overseen by Philippe Orry, Directeur-Général des Bâtiments du Roi.[1] In the king's apartment, which occupied two floors facing the garden of the Orangerie, there were dining rooms on the ground floor, a large one and, contiguous to it, a smaller one that also served as an office.[2] The walls of the large dining room were decorated with sizable canvases painted in 1737—and exhibited at the Salon in July of that year—by de Troy, Parrocel, and Vanloo;[3] for Vanloo, the commission immediately followed the success of his first contribution to the Galerie des Chasses Exotiques in Louis XV's apartment at Versailles. On one wall of the dining room, opposite the windows, Vanloo's *Hunt Breakfast* (fig. 1) and Parrocel's *Halt of the King's Grenadiers*, both now in the Louvre, were set into paneling with shaped openings, as a drawing in the Archives Nationale, Paris, shows;[4] two paintings by de Troy, the *Luncheon near a Farm*, now also in the Louvre, and the *Death of a Stag*, present whereabouts unknown, presumably faced one another from the end walls.[5]

This small painting is undocumented, but it is universally accepted as an autograph sketch for Vanloo's *Hunt Breakfast*. Similar oil sketches by de Troy are in the Wallace Collection, London; an oil sketch for Parrocel's canvas was recorded in 1748.[6]

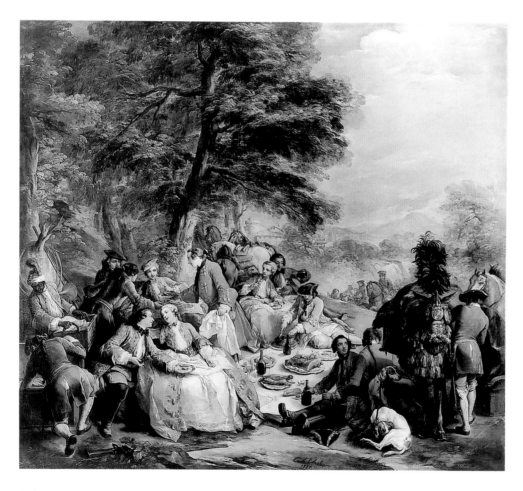

Fig. 1. Carle Vanloo, *The Hunt Breakfast*. Oil on canvas, 86⅝ × 98⅜ in. (220 × 250 cm). Musée du Louvre, Paris

As Eric Zafran observed, no two figures are the same, although the general idea for the composition remains the same: a group of hunters is seated on the grass, gathered round a cloth spread on the ground at the right, echoing the diagonal arrangements of the figures toward the middle ground, where the horses wait. In the finished picture this diagonal is more emphatic, opening up the middle ground to show more hunters and their dogs approaching. Large trees evenly distributed in the sketch are confined to the left half of the finished canvas, and the carriage, which brought the ladies to join the men for the meal, and the pair of horsemen with hunting horns were omitted. The finished picture has been cut down at the top by perhaps as much as a foot, and it no longer has the curved contours at the top and bottom that are indicated in the sketch; in the 1737 inventory of the paintings in the new apartments at Fontainebleau, the top is said to be arched.[7]

On December 4, 1737, Vanloo received 3,000 livres for the large painting, and, the following day, another 1,000 for alterations that he made.[8] It is not known what the changes were; perhaps they were adjustments to make the picture balance Parrocel's asymmetrical composition, which portrays the commander de Creil with some of his soldiers before Philisbourg.[9]

Vanloo's depiction of young people enjoying a meal in the open air evokes the world of Watteau's *fêtes galantes,* especially his *Halt during the Hunt,* of about 1720, in the Wallace Collection, London. It is, however, a new subject for art—specifically, the pleasures of the hunting party. One of the earliest examples of this novel genre is François Lemoyne's *Hunting Party,* of 1723 (known in two versions: Alte Pinakothek, Munich, and Museu de Arte de São Paulo). These large-scale decorations, according to Colin Bailey, "bore witness to a flowering of genre painting on a monumental scale." Pictures of hunt meals enjoyed a vogue in the 1720s and 1730s, then disappeared shortly thereafter.[10]

EF

NOTES

1. Bottineau 1962, p. 39.
2. For the layout of the apartment, see ibid., pp. 35–39. The large dining room was known both as the "grande salle à manger" and the "salle des buffets."
3. Engerand 1901, pp. 380–81, 463, 474–75.
4. The unpublished drawing is described by Jean-Pierre Cuzin, "Le *Déjeuner de chasse* de Jean-François de Troy (1679–1752) peint pour Fontainebleau," *Revue du Louvre: La revue des musées de France,* March 1991, p. 44.
5. The paintings were reinstalled in a new dining room in 1748 and remained there until September 18, 1793. Vanloo's canvas was stored in the warehouses of the Bâtiments du Roi at Fontainebleau until 1846, when it was transferred to Paris, relined, and, two years later, placed in the Louvre, where it was frequently copied by aspiring artists. See Marie-Catherine Sahut, in Nice, Clermont-Ferrand, Nancy 1977, p. 42.
6. For the de Troys, see John Ingamells, *The Wallace Collection: Catalogue of Pictures,* vol. 3, *French before 1815* (London, 1989), pp. 335–37. The Parrocel sketch was lent by a M. de la Tour to the Salon of 1748, according to Engerand 1901, p. 380.
7. Engerand 1901, p. 475: "cintré par en haut"; the dimensions are listed as "haut de 7 pieds 7 pouces sur 7 pieds 9 pouces."
8. Sahut, in Nice, Clermont-Ferrand, Nancy 1977, p. 42; the bonus was paid "en considération des dépenses qu'il a faites pour aller sur les lieux pour les changemens d'un grand tableau représentant une halte de chasse, qu'il a fait pour les petits apartemens du chaù de Fontainebleau pend. la année."
9. Engerand 1901, p. 380.
10. Colin B. Bailey, "Surveying Genre in Eighteenth-Century French Painting," in Colin B. Bailey, Philip Conisbee, and Thomas W. Gaehtgens, *The Age of Watteau, Chardin, and Fragonard: Masterpieces of French Genre Painting,* exh. cat., National Gallery of Canada, Ottawa, National Gallery of Art, Washington, D.C., and Gemäldegalerie, Staatliche Museen zu Berlin (Ottawa, 2003), p. 13.

JEAN MARC NATTIER

(1685–1766)

Jean Marc Nattier came from a family of artists: his mother was a miniaturist and his father was a portraitist of modest talent. He attended the Académie Royale in Paris, where he won the Premier Prix de Dessin in 1700. As a young man he made red-chalk drawings for engravings after the state portrait of Louis XIV by Hyacinthe Rigaud (1659–1743) and the Marie de' Medici cycle by Rubens (see p. 113), both now in the Musée du Louvre. He declined an invitation to study at the French Academy in Rome, preferring to pursue a career in Paris. As a result of the success of his Russian court portraits, executed in Amsterdam in 1717 and now in the Hermitage, Peter the Great invited Nattier to work in Saint Petersburg, but again the artist chose to remain in Paris.

Although he was received into the Académie Royale as a history painter (with Perseus Turning Phineus into Stone, 1718; Musée des Beaux-Arts, Tours), Nattier opted to make his living as a portraitist. By the late 1730s he had evolved an elegant form of mythological portraiture, more in keeping with the spirit of the age than the somewhat ponderous styles of Rigaud and Nicolas de Largillierre (see p. 167). A number of his sitters, not infrequently reclining in surprisingly informal positions, wear vaguely classicizing costumes and hold attributes to indicate their roles as, for example, Flora or Dawn or Hercules. Nattier's portraits of "Mesdames," the daughters of Louis XV, date from the early 1740s; that of Queen Marie Leczinski, one of the most beguiling likenesses of the eighteenth century, from 1748. During the last decade of his life the artist's popularity declined as the more naturalistic portraits of his son-in-law Louis Tocqué (1696–1772) and the pastelist Maurice Quentin de La Tour (1704–1788) came into fashion. Three years before his death, the bedridden painter was forced by financial circumstances to put up for sale all of his paintings, drawings, prints, bronzes, and porcelains as well as his impressive personal library. EF

ABBREVIATION

Versailles 1999. Xavier Salmon. Jean-Marc Nattier, 1685–1766. Exh. cat., Musée National du Château, Versailles. Paris, 1999.

50. Marie Thérèse Geoffrin (1715–1791), Marquise de La Ferté-Imbault

Oil on canvas, oval, 18¼ × 14¾ in. (46.4 × 37.5 cm)
Inscribed at lower left: Nattier p.x./1739 (fig. 1).

PROVENANCE
Gordon Bennett; [Galerie Cailleux, Paris, until 1963; sold to Wrightsman]; Mr. and Mrs. Charles Wrightsman, New York (1963–his d. 1986); Mrs. Wrightsman (from 1986).

LITERATURE
Versailles 1999, pp. 123–25, 303.

The marquise de La Ferté-Imbault was the daughter of Mme Geoffrin (1699–1777), famous for her salon, where she entertained the Encyclopédistes—including Diderot and Voltaire—and some of the leading artists of her day. Marie Thérèse (given the same first names as her mother) married the marquis de La Ferté-Imbault, great-grandson of the Maréchal d'Estampes, in 1733, at the age of eighteen. Although he died three years later, his name lifted her to the ranks of the nobility, his family having been given a dukedom in the sixteenth century by Francis I.

All her life, even while married, the marquise lived with her mother in the Hôtel de Rambouillet; the house in which she was born and died still stands at 374 rue Sainte-Honoré in Paris. Relations between mother and daughter were strained. Each lived independently, and each had her own salon, the mother surrounded by intellectuals, the marquise—a woman of unflinching frankness—keeping company with a circle of deeply religious friends, such as Maurepas, Cardinal de Bernis, and the duc de Nivernais, who strongly opposed the principles of the Enlightenment so enthusiastically espoused by her mother's circle. The marquise also had friends among the aristocracy, including the old, exiled King Stanislas Leczinski, Louis XV's father-in-law.

In one of her notebooks Mme Geoffrin wrote, "I was painted by Nattier in 1738 and my daughter in 1740. I was born June 2, 1699; my daughter April 20, 1715."[1] While the prime version of the portrait of Mme Geoffrin is lost, that of her daughter from 1740

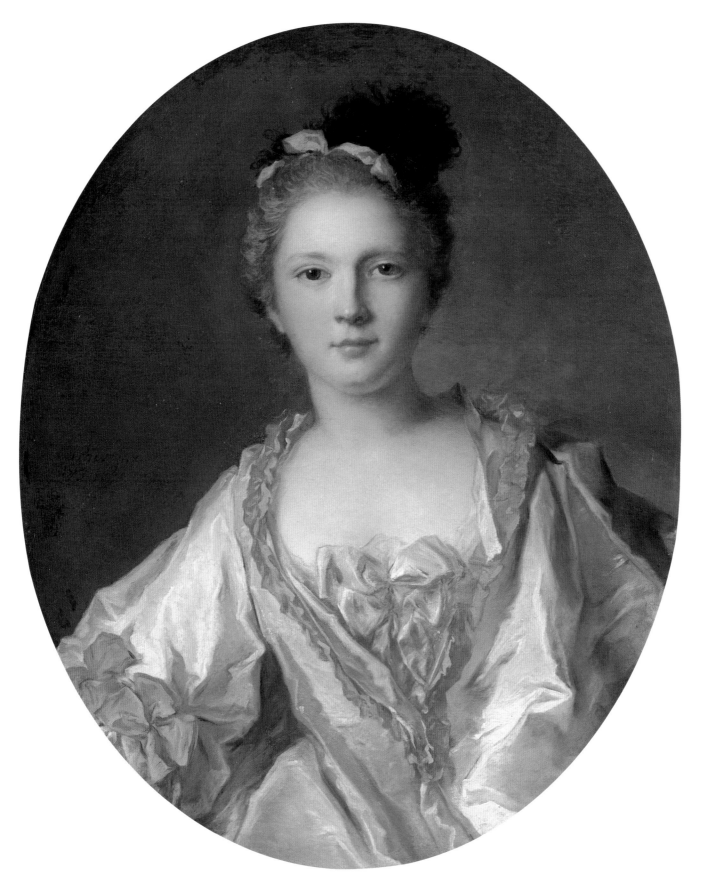

Fig. 1. Detail of signature and date

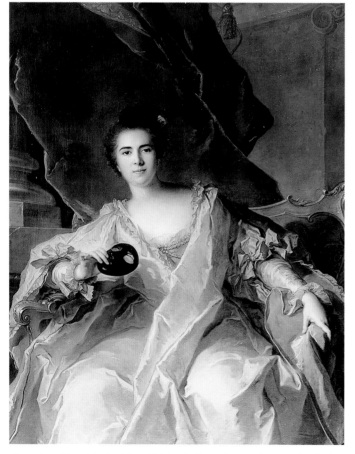

Fig. 2. Jean Marc Nattier, *Marie Thérèse Geoffrin, Marquise de La Ferté-Imbault.* Oil on canvas, 57 1/8 × 44 1/4 in. (145 × 113.5 cm). Tokyo Fuji Art Museum

(fig. 2) remained with the daughter's second husband's descendants until 1985.[2] It is a large, almost three-quarter-length depiction of the sitter dressed in a ball gown and holding a *loup* (a black velvet mask) that casts a shadow on her bodice. In removing the mask from her face, Marie Thérèse symbolically reveals Truth, a theme consistent with her reputation.

The Wrightsman oval has been called a preparatory sketch for the large portrait,[3] but it is too highly finished to be considered a sketch. Nattier's true sketches are quickly blocked-out life studies made to capture a likeness, with no painted backgrounds and little or no indication of the sitter's costume. The present canvas, dated a year before he executed the large portrait, could more accurately be called a preliminary work. Nattier certainly referred to it as he created the second painting. The poses are similar—in both pictures the marquise leans back slightly to the left—and the costume, a full white gown trimmed with salmon pink ribbons at the edge of the neckline and in the hair, is virtually the same: the pink bows on the right arm in the oval portrait reappear on the left arm in the later portrait, while the loose white ribbon falling over the left shoulder in the oval is seen on the right shoulder in the larger work. Yet the differences are striking: in the oval, the hair, for example, is rather light and well powdered, the eyebrows are a light gray, and the eyes are blue, whereas in the portrait of 1740 the hair and eyebrows are almost black, the eyes dark brown. Furthermore, the apparent age of the sitter varies dramatically: in the Wrightsman oval the twenty-four-year-old widow has an almost girlish appearance, while in the portrait painted probably only months later she gazes at us with the self-confidence of a mature woman.[4]

EF

NOTES

1. The notebook belongs to the d'Estampes family and is quoted in Pierre de Nolhac, *J.-M. Nattier: Peintre de la cour de Louis XV* (Paris, 1905), p. 52.
2. Versailles 1999, p. 123.
3. Philippe Renard (*Jean-Marc Nattier [1685–1766]: Un artiste parisien à la cour de Louis XV* [Saint-Rémy-en-l'Eau, 1999], p. 66) calls it an "esquisse de la marquise de [*sic*] Ferté Imbault pour le grand tableau de 1740."
4. The Wrightsman portrait cannot be the "réplique du visage" of the 1740 portrait noticed by Georges Huard in the collection of the marquis d'Estampes, Paris ("Nattier," in *Les peintres français du XVIIIe siècle: Histoire des vies et catalogue des oeuvres,* vol. 2, ed. Louis Dimier [Paris, 1930], p. 126 no. 92) because its dimensions (33 × 27 cm) are too small.

JEAN-BAPTISTE PERRONNEAU

(1715–1783)

Like his main rival, Maurice Quentin de La Tour (1704–1788), Jean-Baptiste Perronneau focused on portraiture at a time when the genre eclipsed even history painting in popularity. He first trained with printmaker Laurent Cars (1699–1771) before switching to the studio of portrait painter Hubert Drouais (1699–1767). From Drouais, Perronneau learned to paint in both oil and pastel. In 1746, for his debut at the biennial Salon sponsored by the Académie Royale de Peinture et de Sculpture, Perronneau submitted five portraits, three of them in pastel. Although he continued occasionally to paint in oil, pastel would become his preferred medium.

With La Tour well established in court circles and the upper echelons of Paris society, Perronneau found his clientele largely among members of the bourgeoisie and families from the provinces. He married Louise Charlotte Aubert in 1754, eventually producing six children. It was perhaps his need to support such a large family that accounted for his impressive productivity. Contemporary mentions and surviving portraits document the artist's presence in Toulouse, Lyon, Bordeaux, Orléans, Abbeville, The Hague, Rotterdam, Amsterdam, Rome, Turin, and Saint Petersburg.

Although Perronneau's portraits were rarely psychologically penetrating, they often succeeded at conveying the outward personality of the sitter, from the haughty demeanor of a successful businessman to the innocent charm of a young girl playing with a cat. His compositions were simple and straightforward. Sitters were typically depicted bust or half length, against solid backgrounds, and with few, if any, accessories. His work was admired above all for its dazzling technique and exquisite color harmonies. PS

51. Olivier Journu (1724–1764)

Pastel on paper, mounted on canvas, 22⁷⁄₈ × 18½ in. (58.1 × 47 cm)
Signed and dated in graphite at upper right: Perroneau / 1756.
The Metropolitan Museum of Art, New York, Wrightsman Fund,
2003 (2003.26)

PROVENANCE
Bonaventure Journu (1717–1781), the sitter's brother, Bordeaux (until his d. 1781); his son, Bernard Journu-Auber, later comte de Tustal and Pair de France (until his d. 1816); his daughter, Geneviève, Madame Jean-Baptiste Jacques Le Grix de La Salle; her granddaughter, Louise Le Grix, comtesse de Tustal, Château du Petit Verdus, Sadirac (near Bordeaux); Camille Groult, Paris (by 1896–his d. 1908); Mme Camille Groult, Paris; by descent to Bordeaux Groult, Paris (until 2002); sale, Sotheby's, Paris, June 27, 2002, lot 39; [Artemis, Munich and New York, 2002–2003; sold to the Metropolitan Museum]; purchased in 2003 by the Metropolitan Museum through the Wrightsman Fund.

EXHIBITED
Galerie Georges Petit, Paris, May 18–June 10, 1908, "Cent pastels du XVIIIᵉ siècle," no. 100 (as "Portrait d'homme à la rose, lent by Mme X . . . ," date erroneously recorded as 1751).

LITERATURE
Maurice Tourneux, "Jean-Baptiste Perronneau," *Gazette des beaux-arts*, 3rd ser., 15 (February 1896), p. 135; Léon Roger-Miles, *Maîtres du XVIIIᵉ siècle: Cent pastels* (Paris, 1908), p. 87, ill. (as "Portrait de Charles-Louis-Génu Soalhat, Chevalier de Mainvilliers, lent by Mme X. . ."); Léandre Vaillat and Paul Ratouis de Limay, *J.-B. Perronneau (1715–1783): Sa vie et son oeuvre* (Paris, [1909]), pp. 32, 96, 130, 144 no. 67, pl. 43 (no. 100 was presumably identical with no. 67, an error caused by the incorrect date [1751] printed in the 1908 exhibition catalogue); Louis Paraf, "Sur trois pastels de Perronneau de la collection Groult," *Bulletin de la Société de l'Histoire de l'Art Français*, 1910, p. 251 (rejecting the previous identification of the sitter, and proposing instead M. Tassin de la Renardière); Léandre Vaillat and Paul Ratouis de Limay, *J.-B. Perronneau (1715–1783); Sa vie et son oeuvre*, 2nd ed. (Paris and Brussels, 1923), pp. 67, 89–90, 217–18, 222; [Maurice Meaudre de Lapouyade], "Une visite à l'exposition d'iconographie bordelaise," *Revue philomatique de Bordeaux et du sud-ouest*, April–June 1928, pp. 53–54 (identifying the sitter as a member of the Journu family [the work exhibited was a reproduction, not the original pastel]); Y. Jubert, "Les modèles bordelais de Jean-Baptiste Perronneau," *La petite Gironde*, August 2, 1941, ill. (cited in Sotheby's, Paris, sale cat., June 27, 2002, lot 39); Maurice Meaudre de Lapouyade, "Perronneau à Bordeaux," published posthumously from a 1947 manuscript in *Le port des Lumières*, exh. cat., Musée des Beaux-Arts, Bordeaux (Bordeaux, 1989), vol. 1, *La peinture à Bordeaux, 1750–1800*, pp. 77–80 no. 11 (reproduction exhibited; sitter identified as Olivier Journu); Christine Debrie, *Le pastel du XVIIIᵉ au XXᵉ siècle à travers les acquisitions du Musée Antoine Lécuyer, 1978–1993*, exh. cat., Musée Antoine Lécuyer, Saint-Quentin (Saint-Quentin, 1993), p. 10.

Purchased by Camille Groult, an early twentieth-century collector of Rococo art, from the Château du Petit Verdus, outside Bordeaux, this pastel was later lent by Groult's widow to a famous 1908 exhibition of one hundred pastels held at the Galerie Georges Petit in Paris. The identity of the sitter was not then known, and he was christened *L'homme à la rose*, undoubtedly adding to his allure. His limpid, aquamarine eyes directly engage the viewer, and his pink velvet jacket is embellished with the charming addition of three freshly cut tea roses tucked into a buttonhole.

Indeed, these two colors, blue green and dusty pink, both favorites of the Rococo period, represent virtually the entire palette of this refined portrait. Léandre Vaillat and Paul Ratouis de Limay's study of Perronneau's life and work was published the following year, in 1909. Anyone who had seen the 1908 exhibition, they wrote, would surely recall "un délicieux portrait . . . qui troubla bien des coeurs sensibles, et charma tous les yeux par son accord de rose et de vert."[1]

The identity of the sitter as Olivier Journu was ultimately established by Maurice Meaudre de Lapouyade. It turned out that Groult had purchased the pastel from descendants of the sitter's family, and Meaudre de Lapouyade, native of the Bordeaux region, had access both to the oral tradition of the family as well as to earlier inventories of their collection. His manuscript on Perroneau's work in Bordeaux was completed in 1947 and deposited in the Municipal Library of Bordeaux, but published only posthumously, in 1989.[2]

Perronneau traveled extensively to find work, and art historians have debated whether this resulted from La Tour's monopolization of the portrait market in the capital, a preference for a certain type of patrons, or simply a peripatetic nature. In any case, his travels brought numerous commissions. Perronneau's pride in the results of his efforts in the provinces is evident in his practice of borrowing some of these portraits from their owners to exhibit at the biennial Paris Salons. In Bordeaux, where the Wrightsman portrait was painted, his work was well received, and Perronneau made several visits there between 1747 and 1769.[3]

This elegant likeness of Bernard Journu, known as Olivier, is the earliest known portrayal of a member of the Journu family by Perronneau. They were evidently pleased with it and went on to commission portraits of at least six additional family members over the decade that followed. The family is first recorded in Bordeaux in the early years of the eighteenth century, when two brothers, Bernard and Claude Journu, arrived from Lyon to set up shop as merchants. The Journu brothers eventually became very wealthy. According to his will, Claude Journu fathered eighteen children and built two impressive residences in Bordeaux. Olivier, his sixth son, was born on August 23, 1724, and would have been thirty-one or thirty-two years old at the time he was portrayed by Perronneau.

It was the third son of the family, Bonaventure Journu, born in 1717, who became the most prominent; Perronneau painted his portrait in oil in 1767 (Fogg Art Museum, Cambridge, Massachusetts).

Its dimensions make it the largest of the Journu group. Bonaventure is shown in three-quarter length, gesturing toward shells from his collection of natural-history objects.[4] Following his mother's death in 1771, the family portraits must have gone to Bonaventure, for it was through his son Bernard Journu-Auber that the group was passed down.[5]

For over a decade the family continued to commission portraits of the Journu siblings when Perronneau visited the city. In addition to depictions of Olivier and Bonaventure, Meaudre de Lapouyade catalogued portraits of Angélique Journu, Mme Molles (b. 1720); Jean Journu, called Hollandais (b. 1723); Jacques Journu, Abbé Journu-Dumoncey (b. 1733); and Marie-Angélique Journu (b. 1735), as well as a Rembrandtesque oil of Mme Journu at age seventy-four, which Perronneau included with his Salon submissions of 1769.[6] Judging from Perronneau's work, they were a handsome family, the men distinguished by their long faces, broad foreheads, and square jaws. Among the brothers, Olivier, with his relaxed pose and touches of *point d'Alençon* lace and pink roses, seems most at ease with his own charms.

PS

NOTES

The research for this entry was assembled by Katharine Baetjer, who proposed the acquisition of the pastel in 2003.

1. "a delicious portrait . . . that was truly disconcerting to tender hearts and charmed all eyes with its harmony of pink and green." Léandre Vaillat and Paul Ratouis de Limay, *J.-B. Perronneau (1715–1783): Sa vie et son oeuvre* (Paris, [1909]), p. 32.

2. He had earlier identified the sitter more generally as a member of the Journu family. See [Maurice Meaudre de Lapouyade], "Une visite à l'exposition d'iconographie bordelaise," *Revue philomatique de Bordeaux et du sud-ouest*, April–June 1928, pp. 53–54.

3. See Maurice Meaudre de Lapouyade, "Perronneau à Bordeaux," published posthumously from a 1947 manuscript, in *Le port des Lumières*, exh. cat., Musée des Beaux-Arts, Bordeaux (Bordeaux, 1989), vol. 1, *La peinture à Bordeaux, 1750–1800*, pp. 51–129.

4. Oil on canvas, 39½ × 31¾ in. (100.4 × 80.6 cm), Bequest of Grenville L. Winthrop, 1943.270. Also at the Fogg Art Museum are Perronneau's portraits of Mme Claude Journu (1943.271) and Jacques Journu, Abbé Journu-Dumoncey (1943.272); see Edgar Peters Bowron, *European Paintings before 1900 in the Fogg Art Museum: A Summary Catalogue including Paintings in the Busch-Reisinger Museum* (Cambridge, Massachusetts, 1990), pp. 124, 217.

5. For the early provenance of the group, see Meaudre de Lapouyade, "Perronneau à Bordeaux," p. 79.

6. Ibid., pp. 81–84 nos. 12–13, 99–102 nos. 21–22, and 117–21 nos. 30–31. Perronneau may well have sent the portrait of Olivier Journu to the Salon of 1757, but the *livret* of that year groups together his entries under no. 56, "plusieurs portraits en pastel."

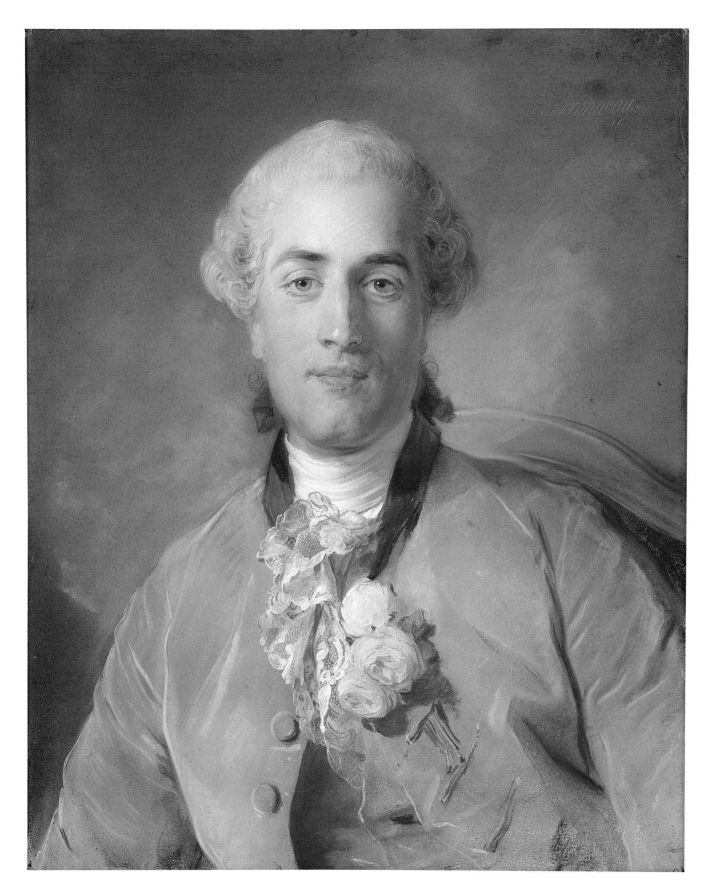

JEAN-NICOLAS SERVANDONI

(1695–1766)

The son of an Italian mother and a French father who worked as a stagecoach driver, Servandoni became one of the most brilliant and sought-after designers of the eighteenth century. He took on a great variety of projects, for patrons in various countries, yet the majority were of an ephemeral nature and left little, if any, physical record. His career began in Rome, where he was taught by the architectural engraver Giuseppe Ignazio Rossi (d. before 1739) and appears to have known Giovanni Paolo Panini (1691–1765), painter of views and architectural capricci. He must also have been exposed to the elaborate festival architecture and dramatic theater designs popularized by the Galli-Bibiena family of artists.

By 1724 Servandoni was in Paris, where his stage designs for the Opéra and the Académie Royale de Musique brought him great acclaim. He was recruited to create designs for royal festivals and by 1731 had gained admittance to the Académie Royale de Peinture et de Sculpture as a painter of ancient ruins. Servandoni's talent for set design translated well into the world of princely galas. For the courts of France, Lisbon, London, Brussels, Dresden, and Vienna, Servandoni designed and orchestrated the construction of temporary architecture and fireworks as well as settings for regal celebrations and spectacles. For several years he also ran his own theater in the Salle des Machines in the Tuileries garden in Paris, producing shows with innovative special effects.

Although he was not formally trained as an architect, Servandoni entered and won the competition to design the façade of the church of Saint Sulpice in Paris in 1732. The popularity of his design, with its precocious classicism and austerity, quite a contrast to the dramatic asymmetry of his stage designs, earned him the title Architecte du Roi and many commissions for buildings in Paris and around France. Charles de Wailly (1729–1798) and Jean-François-Thérèse Chalgrin (1739–1811) were among his students.

Alongside these many demands on his time, Servandoni was also active as a painter in oil and gouache of architectural capricci, an area in which his knowledge of Roman antiquity, combined with his facility with perspective, resulted in an apparent ease of invention. His work in this genre demonstrates a clear debt to Panini, whose compositions freely quoted and rearranged the well-known architectural and sculptural monuments of ancient Rome for decorative effect. Like Panini, he animated these tumbled and overgrown remnants of the past with small, picturesque groupings of staffage, although, as Dezallier d'Argenville pointed out in his long and otherwise laudatory life of the artist, Servandoni, like many landscape specialists, had little talent for painting the human figure.[1] Surprisingly, paintings and drawings remain one of the least-studied aspects of Servandoni's career. Few of the works he submitted to the biennial Salons held at the Louvre can be traced today, and those that survive rarely have dates or subjects precise enough to be linked with contemporary descriptions.[2] Nonetheless, his paintings clearly played a role in expanding the taste for scenes of ancient ruins and paved the way for the successful careers of artists such as Pierre Antoine de Machy (1723–1807) and Hubert Robert (see p. 185).

PS

ABBREVIATION

Rome, Dijon, Paris 1976. *Piranèse et les français, 1740–1790.* Exh. cat. Académie de France, Rome, Palais des États de Bourgogne, Dijon, and Hôtel de Sully, Paris. Rome, 1976.

NOTES

1. Antoine-Nicolas Dezallier d'Argenville, *Vies des fameux architectes depuis la renaissance des arts, avec le description de leurs ouvrages* (Paris, 1787), vol. 1, p. 466.
2. Rome, Dijon, Paris 1976, p. 330 (biography by Marianne Roland Michel), and Pierre Rosenberg, ed., *La donation Jacques Petithory au Musée Bonnat, Bayonne: Objets d'art, sculptures, peintures, dessins,* exh. cat., Musée du Luxembourg, Paris (Paris, 1997), p. 112.

52. Architectural Capriccio with a Monumental Arch

Gouache with touches of gum arabic on antique laid paper, 18½ × 26 in. (47 × 66 cm)

PROVENANCE
[Didier Aaron & Cie., Paris; sold to Wrightsman]; Mrs. Charles Wrightsman, New York (from 1998).

RELATED WORKS
PRIVATE COLLECTION, France. Jean-Nicolas Servandoni, *Architectural Capriccio with an Obelisk*. Gouache, 18½ × 26 in. (47 × 66 cm).

Few eighteenth-century artists who made their careers as painters of ruins and passed through Rome escaped the influence of Giovanni Paolo Panini (1691–1765), and Servandoni was no exception. Only four years separated the two in age, and Servandoni would have encountered only Panini's very early work, but his compositional structures and use of staffage are clearly indebted to Panini's model. The Wrightsman gouache is typical in its use of a ruin as a screen with an archway that frames an ancient monument, in this case a distant arch and tiny figures suggesting a deep recession of space. Antique sculptures flank the archway: on the

Fig. 1. Jean-Nicolas Servandoni, *Architectural Capriccio with an Obelisk*. Gouache, 18½ × 26 in. (47 × 66 cm). Private collection, France

left, one of the *Dioscuri* (horse tamers) from the Piazza Quirinale in Rome, and, on the right, a statue of a seated draped figure on a plinth.

Judging from its scale and execution, the Wrightsman *Capriccio* should be considered a finished work and not a preparatory effort for an oil painting. The choice of gouache as a medium enabled Servandoni to work quickly and to achieve a sunny, unmuddied palette. In its coloring, his work may have been influenced by Marco Ricci (1676–1730), who used gouache on leather to create hundreds of luminous, high-keyed landscapes. At Didier Aaron & Cie., the Wrightsman *Capriccio* had been paired with a pendant,

Architectural Capriccio with an Obelisk (fig. 1).[1] The similarities in composition, technique, tonality, and scale of the two works suggest that they may well have been intended as a pair. The obelisk, like the arch, is set in brilliant sunshine and seen through an off-center archway. In the foreground, staffage figures, sculpture both freestanding and in niches, and figural bas-reliefs all animate the imaginary, soaring ruins. The architecture conveys less of the sense of an interior than of successive planes pierced by openings, reminiscent of theatrical backdrops. For Servandoni, antique Rome served as a rich mine of motifs and fragments that he used as building blocks in his own constructions, ordered by compositional strategies derived from his work designing architecture, theater sets, and festivals.

With the exception of the painting the artist submitted as his reception piece in 1731, *Architecture avec ruines d'un temple ionique et obélisque* (Louvre, on deposit since 1872 to the École des Beaux-Arts, Paris), paintings and drawings by Servandoni are difficult to date. The small group of extant works show little stylistic evolution, and the titles of the paintings in early records tend to be somewhat generic. Works like the Wrightsman *Capriccio* are closely tied to Servandoni's designs for theater sets, but he was active in both areas simultaneously, so the connection sheds no light on the sheet's date. PS

NOTE

1. Signed at lower right, *Servandony*. The gouache was sold to a French private collector in March 2004. Didier Aaron has not supplied any prior provenance for the pair.

HUBERT ROBERT

(1733–1808)

Hubert Robert was the most prolific and most imaginative painter of ruins working in France during the Enlightenment, a period when the subject enjoyed a great vogue, fueled both by antiquarian interests and by a taste for the picturesque. His fluent ease of invention grew out of the wide repertoire of classical motifs he assimilated during his Italian sojourn, which lasted from 1754 to 1765, one of the longest and most fecund of any artist of his generation.

Robert's early training did not follow the typical path promoted by the Académie Royale. Unlike his contemporaries at the Académie de France, Robert had been sent to Rome not at the king's expense but rather under the protection of a private benefactor. His father, Nicolas Robert, was valet to François Joseph de Choiseul, marquis de Stainville (1700–1770), whose son, Étienne-François de Choiseul, comte de Stainville, later the duc de Choiseul (1719–1785), would become the minister of foreign affairs. The Stainville-Choiseul household recognized Robert's talents early on, first sponsoring his classical education and then sending him to study in the atelier of sculptor Réné Michel, called Michel-Ange Slodtz (1705–1764), in Paris. When the comte de Stainville was appointed French ambassador to the Holy See, Robert accompanied him to Rome.

Although no works survive that can be dated prior to his departure for Rome, Robert must already have been an accomplished draftsman and painter, if we are to judge from the warm reception he received from Charles Joseph Natoire, director of the French Academy, and from the commissions directed to him by discerning Parisian collectors during this time. Even though he had never studied at the École Royale des Élèves Protégés in Paris, nor competed for the Prix de Rome, he was awarded official standing as a Pensionnaire du Roi at the academy in 1759 through a special dispensation by Abel-François Poisson de Vandières, marquis de Marigny, the Surintendant des Bâtiments. When his term expired in 1763, funds to extend his stay were made available by Jacques-Laure Le Tonnelier, Bailli de Breteuil, ambassador to Malta.

Back in Paris, Robert became a full member of the Académie Royale in 1766 and began to exhibit regularly at the biennial Salons held at the Louvre. His background in painting ruins shaped Robert's novel approach to the Parisian landscape, of which he not only depicted real views but also sought out scenes of demolition (the creation of temporary ruins) and produced imaginary vistas that envisioned monuments of contemporary Paris, such as the Grande Galerie of the Louvre, as future ruins. In addition, he began to take on large-scale decorative commissions, including a series featuring the Roman ruins of Languedoc (Louvre), and was active as a garden designer for the French court and aristocratic houses in and around Paris. His gardens à l'anglais were steeped in the same aesthetic sensibility as his paintings of picturesque and overgrown landscapes.

Robert's work for the French court and aristocracy made his position difficult following the fall of the Bastille in 1789. Despite his efforts to paint several canvases with Revolutionary subjects and thus show alliance with the new government, he was imprisoned during the Terror. He did have access to art materials in prison, however, and his drawings survive as a poignant record of this period of his life. Even after his release, the themes of imprisonment and freedom continued to appear in his work, albeit on a more symbolic level. Ultimately, Robert's work transcended the archaeological and decorative tendencies of the genre and used the vocabulary of ruins to create images rich in metaphor and poetry. PS

53. *Capriccio with an Ancient Temple*

Watercolor over pen and black ink, traces of black chalk underdrawing on off-white antique laid paper, 22⅜ × 16⅜ in. (56.7 × 41.6 cm)
Inscribed in pen and black ink on the tomb at right, illegible with the exception of the date: 1758.

PROVENANCE
Countess Mona Bismarck, Paris; her estate sale, Sotheby's, Monaco, November 29, 1986, lot 45; [Didier Aaron & Cie., Paris; sold to Wrightsman]; Mrs. Charles Wrightsman, New York (from 1987).

When Robert arrived in Rome in November 1754, he must already have found his calling, for he was described by Charles Joseph Natoire, director of the French Academy, as a young man "qui a du goût pour peindre l'architecture."[1] His earliest dated drawings are from 1756. Executed with great care in pen and wash, they feature imposing, crumbling ruins that dwarf the small figures in antique dress.[2] Very much in the style of Giovanni Paolo Panini (1691–1765) or Charles-Louis Clérisseau (1721–1820), their scale and high degree of finish suggest that they were made for collectors. By 1758 Robert had also begun to produce plein-air studies in red chalk made in and around Rome.[3] These sparkling, sunlit studies record the major buildings, statues, and antique ruins of Rome and were no doubt an important resource for Robert in the creation of *capricci* (or imaginary views).

Robert habitually signed and dated his drawings, often letting his signature masquerade as an inscription on an antique block or architectural fragment. On the Wrightsman sheet, the numbers *1758* can be made out on the tomb at lower right. In February of the following year, Natoire described Robert as working with an "infinite ardor" in the genre of Panini.[4] Yet even if Panini's name would remain linked to the genre, Robert had already begun to stake out an original style: in the present drawing, one can see his distinctive hand in the delicate use of watercolor and ink line and in the figural groupings, which are dominated by women and children in simple, timeless dress (as opposed to Panini's preference for staffage in historical or religious dress). Only Robert's figure of the old man, leaning on a staff and receiving alms on the steps of the temple, has close parallels in Panini's oeuvre.

Here Robert has assembled various architectural and sculptural elements into a harmonious aesthetic grouping, the very randomness of their juxtaposition suggestive of their neglect and decay over time. This melancholy theme, that once-great empires can lie forgotten, is reinforced by the types of figures included, typically going about their daily life, while clambering over or leaning against ancient ruins, oblivious to their past grandeur. The motifs of the classical temple front, the curved arcade, the tomb, and the statue of the lion would prove to be favorites of Robert, appearing again and again in his invented scenes for decades after returning to France.

PS

NOTES

1. "who has a penchant for painting architecture." Anatole de Montaiglon and Jules Guiffrey, eds., *Correspondance des directeurs de l'Académie de France à Rome avec les surintendants des bâtiments* (Paris, 1887–1912), vol. 11 (1901), p. 59. In this letter Natoire does not give Robert's name, but refers to him as a young man under the protection of the French ambassador.
2. See Marianne Roland Michel, in *Oeuvres de jeunesse de Watteau à Ingres*, exh. cat., Galerie Cailleux, Paris (Paris, 1985), nos. 34–35, and *J. H. Fragonard e H. Robert a Roma,* exh. cat., Académie de France, Rome (Rome, 1990), pp. 54–55 no. 2, fig. 2a.
3. The date on a red-chalk drawing of the Loggia of Saint Peter's (Louvre) was read by Victor Carlson as "1757" in 1978, but as "1759" by Catherine Boulot and Jean-Pierre Cuzin in 1990. See Victor Carlson, *Hubert Robert: Drawings and Watercolors,* exh. cat., National Gallery of Art, Washington, D.C. (Washington, D.C., 1978), p. 28 no. 1, and *J. H. Fragonard e H. Robert a Roma,* pp. 66–67 no. 17.
4. De Montaiglon and Guiffrey, *Correspondance des directeurs,* vol. 9 (1899), p. 262.

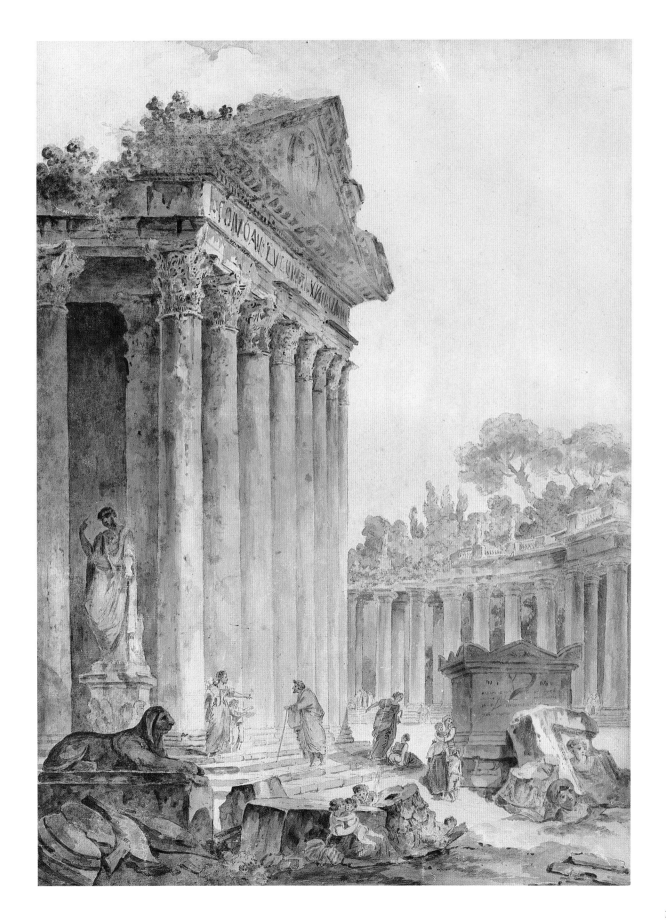

187

JEAN-BAPTISTE LE PRINCE

(1734–1781)

Born to a family of artisans in the provincial city of Metz in north-eastern France, Jean-Baptiste Le Prince found a sponsor in the Maréchal de Belle-Isle, governor of Metz, who brought him to Paris about 1750 and arranged for him to enter the studio of François Boucher (see p. 170). Then at the height of his fame, Boucher was favored by patrons such as Madame de Pompadour, and his work was in demand by French and foreign courts alike. Not only did Le Prince thoroughly absorb Boucher's repertoire of motifs, he also displayed a facility with oil paint akin to that of his master. His painterly sur-faces, with their fluid brushwork and high-keyed palette, embodied the Rococo style popularized by Boucher at mid-century.

At age twenty-two, Le Prince left Paris for the court in Saint Petersburg, following two older siblings already established there. His five-year sojourn in Russia would prove seminal to his career. Upon his return to the French capital in 1762, Le Prince focused his production almost exclusively on Russian-subject genre scenes, working from a base of drawings and costumes that he had brought back with him.[1] Parisian audiences, predisposed to new forms of exoticism by the cur-rent vogues for chinoiserie and turquerie, provided an avid market for Le Prince's production. In addition to drawings and paintings, Le Prince created an estimable oeuvre of prints, mostly in the new medium of aquatint, of which he was an early practitioner. His imagery found further dissemination in the form of book illustration, ceramics, and tapestries.[2] His Jeux russiens (Russian entertainments) was among the most successful sets of tapestry designs woven by the Beauvais manufactory in the eighteenth century.

Beginning in 1765, when he exhibited no less than fifteen russeries at the Salon, including his reception piece for the Académie Royale, The Russian Baptism (Louvre), Le Prince's submissions to the bien-nial exhibitions held at the Louvre continued to be numerous and inspired by his Russian experience. Denis Diderot, whose initial appraisal of Le Prince in 1765 had been largely favorable, mounted an increasingly vituperative campaign against the artist in his Salon reviews of 1767 and 1769. At the core of his complaint was Le Prince's lack of realism in portraying the Russian people. Diderot wrote in 1767, "If a Tartar, a Cossack, a Russian saw this, he'd say to the artist: You've pillaged our wardrobes, but haven't a clue about our feel-ings."[3] Yet the criteria that lay behind Diderot's judgment were largely irrelevant to Le Prince, whose aim was not realism but a reformulation of Boucher's pastorals à la russe, often around Rousseauian themes.[4] By the 1770s Le Prince's work gradually shed its Russian veneer, turn-ing instead to landscapes and pastorals set on French soil. Ill health forced him to resettle in Saint-Denis-du-Port, near Lagny, where he died in 1781 at the age of forty-nine .

PS

ABBREVIATIONS

Hédou 1879. Jean Le Prince et son oeuvre, suivi de nombreaux documents inédits. Paris, 1879. Reprint: Jules Hédou. Jean-Baptiste Le Prince, 1734–1781, peintre et graveur: Étude biographique et catalogue raisonné de son oeuvre gravé, suivi de nombreux documents inédits. Amsterdam, 1970.

Metz 1988. Jean-Baptiste Le Prince. Exh. cat., Musée d'Art et d'Histoire, Metz. Metz, 1988.

Standen 1985. Edith Appleton Standen. European Post-Medieval Tapestries and Related Hangings in The Metropolitan Museum of Art. 2 vols. New York, 1985.

NOTES

1. Many such items are detailed in Le Prince's Inventaire après décès and estate sale, both reprinted in Hédou 1879, pp. 247–53 and 306–12.
2. Le Prince's book illustrations for Chappe d'Auteroche's Voyage en Sibérie were the focus of an exhibition, "Drawings by Jean-Baptiste Le Prince for the 'Voyage en Sibérie,'" Rosenbach Museum and Library, Philadelphia, October 17, 1986–January 4, 1987, Frick Art Museum, Pittsburgh, January 29–March 29, 1987, and Frick Collection, New York, April 21–June 14, 1987. For Le Prince's russeries as models for Sèvres, see Carlo Christian Dauterman, "Sèvres Figure Painting in the Anna Thompson Dodge Collection," Burlington Magazine 118 (November 1976), pp. 753–62. For the tapestries, see Hubert Delesalle, "Les tapisseries de Beauvais au XVIIIᵉ siècle: Les jeux russiens, d'après Jean-Baptiste Le Prince," Bulletin des musées de France II, nos. 6–7 (August–September 1946), pp. 47–48 (sum-mary of a thesis of 1944).
3. Diderot on Art, ed. and trans. John Goodman, vol. 2, The Salon of 1767 (New Haven and London, 1995), p. 182.
4. The conflicting agendas of the artist and the philosophe are examined in Perrin Stein, "Le Prince, Diderot et le débat sur la Russie au temps des Lumières," Revue de l'art, no. 112 (1996), pp. 16–27.

54. The Musician

Oil on canvas, 24¼ × 17½ in. (61.6 × 44.5 cm)
Signed and dated at lower right: JB Le Prince / 1769.

PROVENANCE
Private collection, United Kingdom; [Wildenstein, London, by 1983; sold to
Wrightsman]; Mr. and Mrs. Charles Wrightsman, New York (1983– his
d. 1986); Mrs. Wrightsman (from 1986).

EXHIBITED
Museo de Bellas Artes, Caracas, May 24–June 24, 1977, "Cinco siglos de arte
frances," no. 24; Wichita Art Museum, Wichita, Kansas, September 16–October
7, 1979, "300 Years of French Painting"; Wildenstein, London, June 1–July 31,
[1983?], "La Douceur de Vivre: Art, Style, and Decoration in XVIIIth Century
France."

LITERATURE
Standen 1985, vol. 2, p. 554 and n. 6 (incorrectly described as a watercolor).

RELATED WORK
NEW YORK, Metropolitan Museum (60.620.130). Jean-Baptiste Le Prince, *La
Musicienne*, 1768. Etching and aquatint, 9½ × 6⅝ in. (24.2 × 16.9 cm).
NEW YORK, Metropolitan Museum (48.139). Designed by Jean-Baptiste Le
Prince, *The Repast* (fig. 1). Beauvais tapestry, wool and silk, in production
between 1769 and 1793. 12 × 20 ft. (3.66 × 6.1 m).

VERSIONS/COPIES
A half-size version depicting a standing female musician in an interior was
exhibited in the 1769 Salon, where it was sketched by Gabriel de Saint-Aubin
in the margin of his *livret*; see Émile Dacier, *Catalogues de ventes et livrets de Salons
illustrés par Gabriel de Saint-Aubin,* vol. 2, *Livret du Salon de 1769* (Paris, 1909),
illustrated on p. 16 of the *livret*. An image of the painting, signed and dated
1769, can be found in the *Documentation* of the Département des Peintures,
Musée du Louvre, Paris.[1] Another version, perhaps a copy of the painting
exhibited in the 1769 Salon, was sold as "attributed to Le Prince" at the Hôtel
Drouot, Paris, on March 6, 1968, lot 107, and again on April 8, 1981, lot 23.

Jean-Baptiste Le Prince's colorful and lushly painted canvas of a
young Russian woman playing a stringed instrument is connected
to the artist's most ambitious venture of the 1760s, the six-panel
series of tapestry designs for the Beauvais manufactory repre-
senting the *Jeux russiens,* or Russian entertainments. Le Prince's
richly detailed exotic pastorals followed closely in the tradition of
his master, Boucher, whose *Fêtes italiennes* and *La tenture chinoise*
had both proven very successful commercially for Beauvais.
When Boucher was appointed *inspecteur sur les ouvrages* at the
Crown-backed Gobelins manufactory in 1755, he agreed to sever
all ties with the rival manufactory Beauvais,[2] leaving a creative
vacuum. With the *Jeux russiens,* Beauvais found suitable designs

to fill this gap; the series was woven in at least thirteen sets
between 1769 and 1793.[3] Unlike Boucher, who sometimes submit-
ted sketches for employees of the tapestry works to copy as full-
scale cartoons,[4] Le Prince created his paintings as full-scale
cartoons; the three panels he exhibited at the 1767 Salon were all
eleven pieds high (over eleven feet).[5] Unfortunately, the method of
weaving at Beauvais required that the canvases be cut into strips
(a fragment from the central strip of the *Fortune Teller* survives at
the Musée Départemental de l'Oise, Beauvais).[6]

Le Prince's *Musician* relates to a figure standing to the left in
The Repast (figs. 1, 2), one of six compositions that made up the
Jeux russiens set. As part of the outdoor entertainment represented
in the tapestry, a tent has been erected amid a stand of trees, and

Fig. 1. Designed by Jean-
Baptiste Le Prince, *The
Repast.* Beauvais tapestry,
woven 1771–72. Wool and
silk, 12 × 20 ft. (3.66 ×
6.1 m). The Metropolitan
Museum of Art, New
York, Gift of Mary
Brewster Jennings, in
memory of her husband,
Oliver G. Jennings, 1948
(48.139)

Fig. 2. Detail of fig. 1

Fig. 3 Jean-Baptiste Le Prince, *La Musicienne,* 1768. Etching and aquatint, 9½ × 6⅝ in. (24.2 × 16.9 cm). The Metropolitan Museum of Art, New York, The Elisha Whittelsey Collection, The Elisha Whittelsey Fund, 1960 (60.620.130)

a pleasure boat is moored nearby. Platters of food have been laid out by servants in the foreground, and a group of musicians sit on the ground at the left, their instruments neglected as they gaze in rapt attention at the woman playing what the artist called a "balalaye."[7] Today the word *balalaika* is used to describe a Russian folkloric stringed instrument with a triangular body; the oval shape of the instrument depicted by Le Prince corresponds more closely to a dömbra, a lutelike instrument that often has a pear-shaped body.[8]

The Wrightsman picture is dated 1769, the same year that Le Prince submitted a painting titled *Une Russienne jouant de la Guitarre* to the Salon. The two are not the same, however, for the exhibited work was little more than half the size, and, judging from the sketch made by Gabriel de Saint-Aubin (see p. 195) in the margin of the 1769 Salon *livret* (booklet), it placed the standing musician in an interior.[9] In a characteristically minute annotation just above the title in the *livret,* Saint-Aubin observed that the woman was left-handed.[10] Her left-handedness may not have been so much intentional as the result of the dependency of both the

Wrightsman painting and the 1769 exhibited version on a drawing or drawings made in preparation for the *Jeux russiens.*[11] Tapestries woven at Beauvais reversed the compositions of their painted models. The single figure of the standing musician was also translated into aquatint by Le Prince, whose print *La musicienne* (fig. 3) bears the date 1768. In the aquatint version the woman is playing right-handed, as the intaglio printing process, like the weaving process at Beauvais, would have reversed the direction of the preparatory drawing. The date of the Wrightsman canvas—1769— would appear to preclude it as a model for the print and would also make a preparatory role for the tapestry highly improbable, as weaving began in 1769. Most likely the Wrightsman *Musician* and the smaller Salon version were created as independent cabinet paintings, perhaps based on the large canvas cartoon before it left his studio or after a common preparatory drawing.

PS

NOTES

1. Seemingly cut from an old book, the illustration bears a caption identifying the sitter as Princess Izabela Czartoryska (née Fleming, 1746–1835).
2. *François Boucher, 1703–1770,* exh. cat., The Metropolitan Museum of Art, New York, Detroit Institute of Arts, and Grand Palais, Paris (New York, 1986), pp. 30, 328–29.
3. Standen 1985, vol. 2, p. 554. For four additional examples of surviving pieces from the series in the Musée des Tapisseries, Aix-en-Provence, see *Exotisme et tapisseries au XVIII^e siècle: Musée Départemental de la Tapisserie,* exh. cat., Centre Culturel et Artistique Jean-Lurçat, Aubusson (Aubusson, 1983), p. 15 no. 8. In addition to the cartoons for the six panels, Le Prince provided designs for *garnitures,* smaller tapestries for upholstering chairs, sofas, and so on.
4. This issue is discussed in Edith A. Standen, "Some Notes on the Cartoons Used at the Gobelins and Beauvais Tapestry Manufactories in the Eighteenth Century," *J. Paul Getty Museum Journal* 4 (1977), pp. 25–28.
5. *Explication des peintures, sculptures et gravures, de messieurs de l'Académie Royale* (Paris, 1767), reprinted in *Collection des livrets des anciennes expositions depuis 1673 jusqu'en 1800,* no. 24, *Exposition de 1767* (Paris, 1870), pp. 22–23 nos. 85–87.
6. Metz 1988, no. 32.
7. See, for example, *Le Joueur de Balalaye,* the legend on a print depicting a Russian man playing an identical instrument, in Hédou 1879, p. 161 no. 145.
8. Metz 1988, introduction. See also *The New Grove Dictionary of Musical Instruments,* ed. Stanley Sadie (London and New York, 1984), vol. 1, pp. 113–14 and 583. The dömbra is described as usually having two strings and, interestingly in regard to the Le Prince, being played left-handed.
9. Émile Dacier, *Catalogues de ventes et livrets de Salons illustrés par Gabriel de Saint-Aubin,* vol. 2, *Livret du Salon de 1769* (Paris, 1909), illustration corresponding to p. 16 of the *livret.* The dimensions are given as "Un pied de haut, sur 10 pouces de large."
10. Ibid., p. 78 (p. 16 of the *livret*).
11. Mary-Elizabeth Hellyer, author of "Recherches sur Jean-Baptiste Le Prince, 1734–1781" (thesis, Université Paris-Sorbonne, 1982), is not aware of any preparatory drawings for this figure (correspondence, April 10, 2004). The Wrightsman painting is catalogued on p. 326.

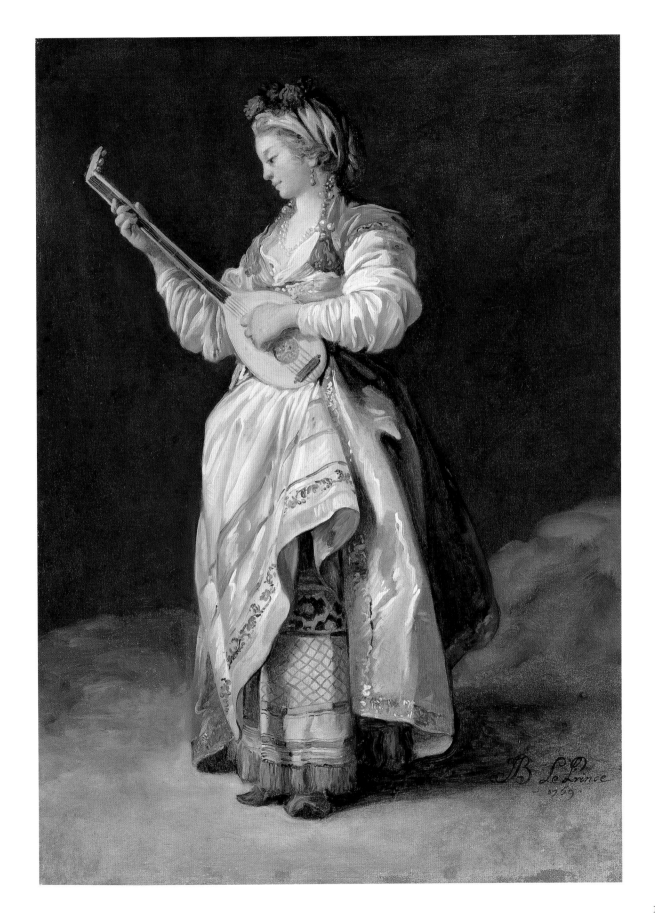

CHARLES-NICOLAS COCHIN THE YOUNGER

(1715–1790)

As the well-educated son of Charles-Nicolas Cochin I, engraver and academician at the Académie Royale, Cochin fils enjoyed official favor and advanced quickly. He worked, beginning in 1737, as draftsman for the Menus Plaisirs, recording celebrations and major events of the court in large-scale, exquisitely detailed drawings and prints. His connections and achievements made him a logical choice to accompany Abel-François Poisson de Vandières, brother of Madame de Pompadour and future marquis de Marigny, on a Grand Tour of Italy in 1749. The two became friends, and, following Marigny's appointment as Directeur des Bâtiments du Roi upon their return in 1751, Cochin's position in the official arts establishment was assured. He was made Garde des Dessins du Roi in 1752 and Secrétaire Perpétuel of the Académie in 1755. Between 1755 and 1770 Cochin exerted broad control over arts administration, primarily through orchestrating and doling out royal commissions.

Cochin's influence was equally felt through his writings on art theory and aesthetics. Although he did not seek to challenge the preeminence of history painting within the hierarchy of the genres, his rejection of the idealized, his praise of naturalism and the direct observation of nature, and his emphasis on le faire, or handling, led him to champion Jean Siméon Chardin (1699–1779) and Joseph Vernet (1714–1789), two of his friends whose specialties—still life and landscape, respectively—counted among the lower genres. Ultimately, little of Cochin's own output meshed with his stated aesthetic ideals, an irony due in large part to the economic necessity of taking on commissions. Least conducive perhaps to working from nature was the genre of book illustration, for which he received over two hundred commissions during the course of his career. The facet of Cochin's production most allied with his theories was the artist's long-running project of recording in chalk the likenesses of a wide spectrum of his contemporaries.

PS

ABBREVIATION

Michel 1993. Christian Michel. *Charles-Nicolas Cochin et l'art des Lumières.* Rome, 1993.

55. Portrait of Pierre Antoine de Boyer du Suquet

Graphite on off-white antique laid paper, diameter 2¾ in. (7 cm) Signed and dated in graphite at center, below image: C.N. Cochin f. 1776. Inscribed on an old label pasted on the back of the mount: Antoine de Boyer du Suquet +1806 / (fils de Jaques de B. et de Marie Magd. de / Gérard du Barry) / cap. aux grenadiers, chevalier de Saint Louis, ép. Adélaïde de Bauldry de / Bellengreville / (dont Marie, dame de Feugré née en 1772, aïeule de Martial / et Louis de la Fournière) / (et gd mère de Mme de Belot).

PROVENANCE
?The sitter's family (until his d. 1806); to his daughter, Marie Cousin, née de Boyer du Suquet (b. 1772); ?by descent (Marie Cousin is described in the inscription on the verso as grandmother of Martial and Louis de la Fournière and of Mme de Belot); Frederick J. Cummings, New York (until 1989); [W. M. Brady & Co., Inc., New York, 1989; sold to Wrightsman]; Mrs. Charles Wrightsman, New York (from 1989).

EXHIBITED
W. M. Brady & Co., Inc., New York, May 10–26, 1989, "Master Drawings, 1700–1890," no. 10.

Cochin's small-scale portrait drawings span his career and constitute a major part of his legacy. Even though they were created over four decades, they adhere to his chosen format with little variation. Executed usually in graphite or black chalk, they typically show the subject in profile, set in oval or circular frames (later in life Cochin did produce some black-chalk, bust-length, three-quarter-view portraits in rectangular frames). It has often been assumed that Cochin's adoption of the profile-medallion format was inspired by antique cameos he would have seen in Italy,[1] and, indeed, the timing of their appearance in his repertoire would seem to support this idea. The Salon of 1753, the first following his trip to Italy with the future marquis de Marigny, included as Cochin's sole entry forty-six medallion portraits.[2]

Much of the motivation behind Cochin's production of hundreds of portrait drawings over a long period of time can be deduced from the subjects chosen and the history of ownership. Clearly some were made of friends or family, and others as commissions, while, in addition, a large group seems to have been

envisioned as a series featuring luminaries in the arts, government, and finance. Several hundred were engraved (by Cochin and others), and as prints they would have found a ready market based on the fame of the subjects.[3] The weekly salons of Mme Marie Thérèse Geoffrin (1699–1777) afforded Cochin access to men of letters, highly placed officials, and foreign dignitaries.[4] Many of the drawings apparently stayed with Mme Geoffrin, for descendants of her daughter, Mme de La Ferté-Imbault (see cat. 50), sold a group of forty-three in 1921.[5]

If Cochin began making portraits of his friends and colleagues as a pleasant pastime in the 1750s, he may ultimately have continued out of financial need. When Jean Baptiste Marie Pierre (1714–1789) was appointed Premier Peintre du Roi in 1770 and Charles-Claude de Flahaut, comte de la Billarderie d'Angiviller, replaced Marigny as the Directeur des Bâtiments du Roi in 1773, Cochin found his official backing considerably diminished. In the last two decades of his career, Cochin frequently turned his talents to portraiture and the design of book illustrations, pursuits that produced income and proved well suited to his controlled and highly legible technique as a draftsman.

For the round medallions surrounding his portraits, Cochin began by drawing two concentric framing lines in graphite: the inner line would be thick on one side, gradually thinning by the opposite side, while the outer line would do the opposite.[6] The profile format naturally emphasized physiognomy over expression. In the case of the Wrightsman sheet, Cochin carefully marked the contours of the sitter's high forehead, aquiline nose, and strong jaw. Although the elaborate coiffure and costume are carefully delineated, they do not distract from the subject's strong features and amiable expression. A lightly shaded background creates a sense of shallow relief. As was his normal practice, Cochin signed and dated the drawing just below the image but, as it was not intended for engraving, did not specify the name of the sitter.

An inscription attached to the back of the mount gives the name of the sitter as Antoine de Boyer du Suquet and his date of death as 1806 and provides additional biographical information, which, because it was apparently written at a time when his great-granddaughter was living, may not be completely reliable. In the inscription Boyer du Suquet is described as captain of the grenadiers and chevalier de Saint Louis,[7] married to Adélaïde de

Bauldry de Bellengreville, and father of a daughter, Marie. A marriage record from the parish of Offranville, near Dieppe, confirms much of this information. On August 13, 1771, Antoine Deboyes, son of Jacques Deboyes and Marie Madeleine de Gérard du Barry, native of Saint-Cyprien in the Périgord, married Marie Anne Adélaïde Bauldry of Dieppe-Saint-Jacques.[8] The couple had four children, two of whom died young, a third emigrated to Manitoba, and the eldest, Marie de Boyer (born 1772), married Louis Henry Nicolas Cousin in 1795.[9] It must have been this Marie who inherited her father's portrait and who is referred to in the etiquette on the back of the mount. For Cochin to have encountered him in 1776, Boyer du Suquet was presumably in either Paris or The Hague, where Cochin spent portions of June and July as part of his commission to engrave Joseph Vernet's *Ports of France*.[10]

Although they grew out of an antiquarian interest, Cochin's medallion portraits were nonetheless stylistically avant-garde and would eventually fuel the taste for profile portraits as an aspect of Neoclassical style. The format would be adopted not just by portraitists such as Henri-Pierre Danloux (1753–1809) and Louis-Rolland Trinquesse (1745–ca. 1800) but also, on occasion, by Jacques-Louis David (see p. 252) and Ingres (see p. 292). Shedding the artifice and attributes of Baroque and Rococo portraiture and looking instead to antique models, Cochin's portrait drawings projected a cool, rational, objective approach compatible with Enlightenment ideals. PS

NOTES

1. In support of this frequently cited influence, Sophie Raux pointed to "plusieurs médailles en or et argent," and "une boîte contenant un nombre d'empreintes en souffre de pierres gravées antiques," lots 11 and 12, respectively, of Cochin's estate sale, held in Paris on June 21, 1790; see Sophie Raux, *Catalogue des dessins français du XVIIIe siècle de Claude Gillot à Hubert Robert*, Palais des Beaux-Arts, Lille (Paris, 1995), p. 82 no. 15 and n. 2.

2. *Explication des peintures, sculptures, et autres ouvrages de messieurs de l'Académie Royale* (Paris, 1753), reprinted in *Collection des livrets des anciennes expositions depuis 1673 jusqu'en 1800*, no. 17, *Exposition de 1753* (Paris, 1869), p. 36 no. 179.

3. Christian Michel has published a list of the sitters of Cochin's engraved portraits grouped by profession; see Michel 1993, pp. 617–26.

4. Ibid., p. 121.

5. Collection of the comte de La Bédoyère, sale, Galerie Georges Petit, Paris, June 8, 1921, lots 9–51.

6. A compass hole at the center of the composition reveals Cochin's method of drawing the frames.

7. Boyer du Suquet does not appear, however, in Alexandre Mazas, *Histoire de l'ordre royal et militaire de Saint-Louis depuis son institution en 1693 jusqu'en 1830*, finished by Théodore Anne, 2nd ed., 3 vols. (1860–61; reprint, Versailles, 2002).

8. See the "Relevés des mariages de la paroisse d'Offranville, réalisé par Dominique Losay" (http://geneanormandie.free.fr/releves/xoffranville-DG.htm).

9. See "La descendance d'Estienne Asselin, travaux de Dominique Losay" (http://huguenots-france.org/france/normandie/caux/asselin/index.htm). In this genealogy, Boyer is referred to as Pierre Antoine de Boyer. According to Hyacinthe des Jars de Keranrouë, following Périgord custom, Pierre Antoine de Boyer, seigneur du Suquet, would have used the first name Antoine, and his wife, Marie Anne Adélaïde Bauldry (or Baudry?) would have used the first name Adélaïde (correspondence, March 27, 2004). This observation is in keeping with the inscription on the verso of the Wrightsman drawing that refers to the sitter and his wife as Antoine and Adélaïde.

10. See Michel 1993, pp. 398–99.

GABRIEL JACQUES DE SAINT-AUBIN

(1724–1780)

Gabriel de Saint-Aubin was born to a family of artistic bent, whose members included embroiderers, porcelain painters, draftsmen, and engravers. Setting out to become a history painter, he trained with Étienne Jeaurat (1699–1789) and Hyacinthe Colin de Vermont (1693–1761), both academicians at the Académie Royale in Paris. After failing to win the Grand Prix, Saint-Aubin abandoned this course, exhibiting and teaching at the Académie de Saint Luc instead.

Endowed with a fertile imagination and a natural facility for drawing but with little patience for its conventional application, Saint-Aubin completed few oil paintings and left only a small oeuvre of etchings. His drawings range from thumbnail sketches in the margins of sale catalogues to watercolors and gouaches depicting crowded public events set in contemporary Paris. Observers described Saint-Aubin's drawing as ceaseless, almost involuntary, and the evidence of the thousands of drawings remaining in his studio at his death, never developed into paintings or prints, would seem to support this view.

An indefatigable chronicler of city life, Saint-Aubin took an interest in all manner of Enlightenment activity in the French capital, from theater to science, from art to the pursuit of leisure. Although his subject matter was often pioneering, Saint-Aubin's work was more subjective than documentary, frequently employing a fluid mix of allegory and current events that had few parallels in the eighteenth century. For many of the sheets, either the settings are well known or Saint-Aubin's habit of inscribing and dating his sketches allow the subject to be identified; others, however, lack such hints, their once topical subjects rendered opaque to modern viewers.

PS

ABBREVIATIONS

Dacier 1909. Émile Dacier. *Catalogues de ventes et livrets de Salons illustrés par Gabriel de Saint-Aubin.* Vol. 2, *Livret du Salon de 1769.* Paris, 1909.

Dacier 1929–31. Émile Dacier. *Gabriel de Saint-Aubin: Peintre, dessinateur et graveur (1724–1780).* 2 vols. Paris and Brussels, 1929–31.

David 2000. Sophie David. "Jean-Baptiste D'Huez: Sculpteur du roi (1729–1793)." *Bulletin de la Société de l'Histoire de l'Art Français,* 1999 (published 2000), pp. 107–34.

Fahy 1973. Everett Fahy, in *The Wrightsman Collection,* vol. 5, Everett Fahy and Francis Watson, *Paintings, Drawings, Sculpture.* New York, 1973.

Livret 1769. *Explication des peintures, sculptures et gravures, de messieurs de l'Académie Royale.* Paris, 1769. Reprinted in *Collection des livrets des anciennes expositions depuis 1673 jusqu'en 1800,* no. 30, *Exposition de 1769.* Paris, 1870.

Sahut 1996. Marie-Catherine Sahut. "Gabriel de Saint-Aubin: *Vue du Salon du Louvre en 1779.*" In Musée du Louvre, *Nouvelles acquisitions du Département des Peintures, 1991–1995,* pp. 135–45. Paris, 1996.

56. Allegory of Louis XV as Patron of the Arts with Paintings and Sculpture from the Salon of 1769

Oil paint over black chalk underdrawing, areas of paper reserve, on off-white laid paper, mounted on pasteboard, varnished, 8⅜ × 5⅝ in. (21.4 × 14.4 cm)
Inscribed in paint at left center: [illegible] cogit egistas; at center right: 21.X.1769.

PROVENANCE
Sale, Ader Picard Tajan, Hôtel Drouot, Paris, November 27, 1990, lot 106; [Emmanuel Moatti, Paris, 1990–91; sold to Wrightsman]; Mrs. Charles Wrightsman, New York (from 1991).

LITERATURE
David 2000, p. 114 n. 38, figs. 12a and 12b.

Ironically, it was Gabriel de Saint-Aubin, whose aspirations to become a member of the Académie Royale were never realized, who provided posterity with visual records of the appearance and audience of the biennial Salons held by the academy in the Salon Carré of the Palais du Louvre to showcase new work by its members. In addition to making thumbnail sketches in the margins of the Salon *livrets* (booklets) of many of the individual paintings, sculptures, and prints exhibited, he produced, beginning in 1753 and continuing until his death in 1780, a series of views of the exhibition as an event, remarkable for their evocation of atmosphere and diversity of approach. In keeping with his artistic temperament, Saint-Aubin did not render the Salons simply as interiors or fashionable gatherings but as public arenas, where the ephemeral confluence of art, audience, and reaction were all captured on paper in a spirit of reportage enriched by allegorical commentary.[1]

The Wrightsman sheet is a hybrid of these two types of works. What may well have been begun as a sheet of unrelated studies in red and black chalk of works on view in the Salon Carré in late summer of 1769 was transformed into an illusionistic three-dimensional space by the addition of several allegorical elements in oil paint. If the date inscribed on the drawing, October 21, 1769, was indeed the date the drawing was finished, this would indicate that Saint-Aubin added the oil paint approximately three weeks after the closing of the exhibition.[2]

Despite the transformations wrought by the artist in his second campaign of working on the sheet, the forms preclude read-ing the composition as a continuous logical space. The sculptures depicted in the two upper bands of the composition would not have been mounted on shelves on the wall but would have been on tables in the center of the room.[3] Moreover, the relative proportions are inaccurate. Félix Lecomte's *Offrande au Dieu Pan* (top register, second from the right) is listed in the *livret* as 18 pouces high,[4] while Martin-Claude Monot's *Femme Egyptienne* (directly to its left) was measured at around 3 pieds high,[5] or, roughly, double the height.

Since the composition likely evolved from a sheet of sketches, it is unclear how much meaning should be assigned to the choice of works depicted. The *livret* for the 1769 Salon included 204 entries for paintings, 31 for sculpture, 23 for prints, and 2 for tapestry. Here sculpture predominates; do the specific objects reflect groups in the Salon installation or Saint-Aubin's personal preferences? Reading left to right, beginning at the top, one can observe that examples by individual sculptors are grouped together: three by d'Huez, one by Lemoyne II, two by Monot, two by Lecomte, and (below) two by Gois (works are identified in detail in the Appendix below). Sculptures of smaller format, which would have been exhibited on tables, were indeed displayed in groupings by artist in the Salon.[6] Except for two busts in marble (Appendix, nos. 4 and 8), the other sculptures appear to be sketches or models, although this imbalance, of preparatory versus finished works, was true of the Salon overall. Saint-Aubin's attentiveness to describing the sculptor's medium should also be noted; he switches from black to red chalk for d'Huez's *Venus* (Appendix, no. 3) and Lecomte's *Offrande au Dieu Pan* (Appendix, no. 7), both items indicated in the *livret* as sketches in terracotta.

Only three paintings are included. Hugues Taraval's oval canvas of a female bather can be made out at lower left. For the pair above, only the image on the left can be identified; it is Pierre-Antoine Baudouin's *The Honest Model* (fig. 1), after Greuze's entries, one of the most written-about works exhibited in 1769.[7] Saint-Aubin transcribed here the Latin inscription that appeared as a legend attached to the top of the frame in the Salon, "Quid non cogit egestas?"[8] His interest in this phrase is further underlined in his illustrated copy of the *livret,* where he transcribed the Latin and added a literal French translation, "Que ne oblige indigence,"[9]

Fig. 1. Pierre-Antoine Baudouin, *The Honest Model*, 1769. Gouache with touches of graphite on vellum, 16 × 14 1/16 in. (40.6 × 35.7 cm). National Gallery of Art, Washington, D.C., Gift of Ian Woodner (1983.100.1)

or, in English, "What indigence won't drive us to." Although the subtleties of Baudouin's subject were debated in the contemporary critical literature,[10] the general theme was the shame of a young girl from a proper family reduced to such disreputable employment as modeling nude. While the girl's plight may well have elicited in the viewer the moral virtue of pity, such sentiments could easily coexist with a salacious enjoyment of the scene. One wonders if Saint-Aubin simply found Baudouin's subject titillating and intriguing, as did many of his fellow Salongoers, or if the query "what will poverty not force one to do?" had a more personal resonance for Saint-Aubin, whose career was, as far as we know, largely lacking in critical or commercial success.

Taken together, the sculpture and paintings represented by Saint-Aubin in this allegory of the 1769 Salon display a marked preference for the comely female subject and a lesser interest in the ambitious subjects of ancient history that represented the apex of the academic hierarchy of the genres. To put his choices in perspective, one should recall that the Salon of 1769 was the last

to be headed by François Boucher (see p. 170) as Premier Peintre du Roi; he would die the following year. It was also, famously, the Salon to which Jean-Baptiste Greuze submitted his ill-fated *Septimius Severus and Caracalla,*[11] representing his unsuccessful bid to be received into the academy as a history painter. Market forces and changing tastes are to some degree reflected in the 1769 *livret,* where portraits, scenes of genre, landscape, and still life far outnumbered subjects drawn from history or mythology. The situation was deplored by certain critics, Denis Diderot notable among them. He began his review of the exhibition with "Le pauvre Sallon que nous avons eu cette année! Presqu'aucun morceau d'histoire, aucune grande composition"[12] and went on to bemoan the fact that private and foreign patronage often sent works abroad or otherwise kept them out of public view.

If Saint-Aubin began the Wrightsman sheet as sketches made on the spot in the Salon Carré—and he must have, for many of the sculptures are presented from different vantage points than those seen in his *livret* sketches—then, back in the studio, he must have decided to introduce a layer of commentary to his observations with the addition of allegorical details in oil paint. A young woman and a putto present to the viewer a group of oval portrait profiles. The largest is clearly Louis XV presented *all'antica* in a crown of laurels, the stern angle of his eyebrow and the curved nose both recognizable from coins and prints.[13] With their lack of distinguishing detail, one can only guess at the subjects of the other three portraits. The two small ones depict a man and a woman, apparently young. Could they be the dauphin (future Louis XVI) and Marie Antoinette (to be married the following year)? The partially obscured medallion behind represents a young woman with a long neck. Could it be the comtesse du Barry, installed as official mistress to the king in April of 1769?

Airborne, above the oval portrait of the king, appears an allegorical figure of the arts, the two putti alongside her bearing what look to be sculptor's tools, the hammer and the chisel, suggesting that the juxtaposition of the king's effigy with works from the Salon is not accidental. The allegories of the arts present the prominent image of the king as their patron, responsible for the flourishing of the arts as seen in the biennial Salon held at the Louvre, displaying for the public the productive talents of the Académie Royale. Even if he never joined the ranks of the *académiciens,* Saint-Aubin thrilled to the biennial exhibits of contemporary art held within the Salon Carré, an interest shared by many members of the eighteenth-century public, demon-

Fig. 2. Detail, upper-left section of *Allegory of Louis XV*

strated by the steady growth of attendance figures and critical literature in the decades before the French Revolution.[14]

<div style="text-align: right">PS</div>

Appendix: Identification of Works Represented

The identification of the sculptures and paintings depicted by Saint-Aubin has been greatly facilitated by the copy of the Salon *livret* containing the artist's thumbnail sketches preserved in the Bibliothèque Nationale de France, Département des Estampes, Paris. For works described in this appendix as sketched in the Salon *livret*, see Dacier 1909. Facsimiles of the illustrated pages are tipped into Dacier's book on unnumbered pages; therefore, the page numbers cited are those of the *livret*.[15]

Sculptures

1. (Fig. 2, left)
Jean-Baptiste d'Huez (1728–1793)
"*Un Enfant qui court,* Modèle de 26 pouces de proportion, qui doit être exécuté en marbre."
No. 213 of the Salon *livret,* faintly sketched in the left margin, p. 35.
Untraced.
David 2000, p. 128 no. 28.
The finished marble, dated 1773, was acquired by the Musée des Beaux-Arts, Arras, in 1968 (968.14.1); see David 2000, p. 129 no. 31, fig. 11.

2. (Fig. 2, second from left)
Jean-Baptiste d'Huez
"*La Fontaine des Grâces,* Esquisse."
No. 214 of the Salon *livret,* sketched from two different angles in the left and right margins, p. 35.
Untraced.
David 2000, pp. 128–29 no. 29.

3. (Fig. 2, center)
Jean-Baptiste d'Huez
"*Vénus demandant des armes à Vulcain pour son fils,* Modèle de 26 pouces de proportion."
No. 212 of the Salon *livret*.
Untraced.
David 2000, p. 128 no. 27. Commissioned in November 1764 for the Bosquet de

la Paix in the gardens of the Château de Choisy. Probably terracotta. A larger plaster model was exhibited in the 1771 Salon; see David 2000, p. 129 no. 30.

4. (Fig. 2, second from right)
Jean-Baptiste Lemoyne II (1704–1778)
"*Le Portrait de Mme la Comtesse d'Egmont,* Buste en Marbre."
No. 205 of the Salon *livret,* sketched in left margin, p. 32.
Untraced.
A terracotta bust of Mme d'Egmont is in the Nationalmuseum, Stockholm, but it differs in certain details from Saint-Aubin's sketch.

5. (Fig. 2, right)
Martin-Claude Monot (1733–1803)
"*Une Tête de Bacchante dans une douce ivresse,* En Marbre, de grandeur naturelle."
No. 231 of the Salon *livret*. In the copy illustrated by Saint-Aubin, the word "marbre" on p. 38 is crossed out and "plâtre" written in; see Dacier 1909, p. 85.

Fig. 3. Detail, upper-right section of *Allegory of Louis XV*

Fig. 4. Detail, second band from top, left side, of *Allegory of Louis XV*

Untraced.

A marble of the same title was exhibited in the Salon of 1773. Known versions of this subject include one in the collection of Edward R. Lubin Inc., in 1963 (illustrated in an advertisement in *Connoisseur* 154 [October 1963], p. LXXXI) and another in the Huntington Library and Art Collections, San Marino, California (see R. R. Wark, *Sculpture in the Huntington Collection* [San Marino, 1959], pp. 73–74, pl. XXXIII). If Saint-Aubin was correct in indicating that the work exhibited in 1769 was plaster, it may have been a model for one of these. Both the Huntington and ex-Lubin works have drapery over one breast, in contrast to Saint-Aubin's sketch, although it is not inconceivable that Saint-Aubin took some liberties in making his copies.

6. (Fig. 3, left)
Martin-Claude Monot
"Une Figure de femme Egyptienne, D'environ 3 pieds de haut."
No. 234 of the Salon *livret*, sketched on p. 38 at the left margin in profile, and again, partially cropped, at the right margin of the verso of flyleaf 7.
Untraced.

7. (Fig. 3, center)
Félix Lecomte (1737–1817)
"Offrande au Dieu Pan, Esquisse en terre cuite de 18 pouces de haut."
No. 227 of the Salon *livret*, lightly sketched in the right margin of p. 37 and at center of flyleaf 6.
Untraced.

8. (Fig. 3, right)
Félix Lecomte
"Une Tête d'après nature, En Marbre, de grandeur naturelle."
No. 228(?) of the Salon *livret*, sketched left of center on flyleaf 6. (Dacier 1909, p. 88, mistakenly gives the number as 224.)
Untraced.

9 and 10. (Fig. 4)
Étienne-Pierre-Adrien Gois (1731–1823)
"La Justice and *La Prudence,* Modèles en plâtre. Ils sont exécutés en Pierre, de 9 pieds de proportion, au couronnement de la porte de l'Hôtel de M. le Comte de Saint-Florentin."
Nos. 218 and 219 in the Salon *livret*.
Untraced.
Designed by Jean-François-Thérèse Chalgrin (1739–1811) between 1767 and

Fig. 5. Detail, central section, left half, of *Allegory of Louis XV*

1770, the building, also called the Hôtel Talleyrand, is today the American Consulate. Chalgrin's drawing of the elevation is in the Bibliothèque Nationale, Paris.

Paintings

11. (Fig. 5, upper left)
Pierre-Antoine Baudouin (1723–1769)
Le Modèle honnête
No. 68 in the Salon *livret,* sketched in the right margin, p. 15, and left margin (somewhat unfinished) of flyleaf 6.
National Gallery of Art, Washington, D.C., Gift of Ian Woodner (1983.100.1)
Next to the title of the gouache on p. 15, Saint-Aubin transcribed a line of Latin, "Quid non cogit egestas" and, above, a French translation, "Que ne oblige indigence." The Latin phrase was displayed above the picture in the Salon, as noted in various contemporary sources.[16]

12. (Fig. 5, upper right)
Unidentified.
The Baudouin gouache had a pendant, *Le jardinier galant,* illustrated by Saint-Aubin on flyleaf 4 (No. 69 of the *livret*), but the composition does not seem to correspond. It may be Amédée Vanloo's *L'Hymen veut allumer son Flambeau à celui de l'Amour* (sketched by Saint-Aubin on p. 10 of the Salon *livret*).

13. (Fig. 5, lower left)
Hugues Taraval (1729–1785)
"Une Baigneuse, Tableau ovale."
No. 133 in the Salon *livret,* sketched in the right margin, p. 23.
Untraced.

NOTES

1. Saint-Aubin's depictions of the Salons are catalogued in Dacier 1929–31, vol. 2, pp. 141–44 nos. 793–800. See also Sahut 1996. The more quotidian views of the Salons engraved by Pietro Antonio Martini (1738–1797) did not appear until 1785 and 1787, as pointed out by Sahut 1996, p. 136.
2. The Salon traditionally opened on August 25, saint day of Saint-Louis and fête day of the king, and typically remained on view for about five weeks; see Sahut 1996, p. 136.
3. The manner in which the exhibited works were customarily installed can be seen in the large watercolor *Vue du Salon de 1767,* private collection,

Paris; see *Diderot et l'art de Boucher à David: Les Salons, 1759–1781,* exh. cat., Hôtel de la Monnaie, Paris (Paris, 1984), p. 91 no. 27.
4. *Livret* 1769, p. 37 no. 227.
5. Ibid., p. 237 no. 234.
6. Sahut 1996, p. 138.
7. Published most recently in Colin B. Bailey, ed., *The Age of Watteau, Chardin, and Fragonard: Masterpieces of French Genre Painting,* exh. cat., National Gallery of Canada, Ottawa, National Gallery of Art, Washington, D.C., and Staatliche Museen zu Berlin, Gemäldegalerie (New Haven and London, 2003), pp. 240–41 no. 60 (entry by Margaret Morgan Grasselli).
8. This inscription is noted and various interpretations offered by Louis Petit de Bachaumont (1690–1771) in his *Mémoires secrets*; see Bernadette Fort, ed., *Les Salons des "Mémoires secrets," 1767–1787* (Paris, 1999), p. 59.
9. Dacier 1909, p. 77.
10. See [Daude de Jossan], *Lettres sur les peintures, gravures et sculptures qui ont été exposées cette année au Louvre par M. Raphael . . . ,* [Deloynes no. 192] (Paris, 1769), pp. 35–36, and Des Boulmiers, "Exposition des peintures, sculptures et gravures de messieurs de l'Académie Royale dans le Salon du Louvre, 1769," manuscript [Deloynes no. 199], pp. 323–24, published in *Mercure de France,* October 1769.
11. *Livret* 1769, p. 27 no. 151.
12. Denis Diderot, *Salons,* ed. Jean Seznec, vol. 4, *1769, 1771, 1775, 1781* (Oxford, 1967), p. 65.
13. Jacques-Nicolas Roëttiers de la Tour (1736–1788), for instance, exhibited a medal of Louis XV in the 1769 Salon (no. 241 in the *livret*), perhaps similar to the bronze medallion now in the Louvre, Paris; see Musée du Louvre, Département des Sculptures, *Sculpture Française II: Renaissance et temps modernes* (Paris, 1998), vol. 2, p. 568, RF 3024. One can also point to Charles-Nicolas Cochin's profile *Portrait of Louis XV,* engraved by Benoît-Louis Prévost, and illustrated in Samuel Rocheblave, *Les Cochin* (Paris, 1893), p. 69, or the many coins designed by Jean and Benjamin Duvivier bearing profile likenesses of the king; see Henry Nocq, *Les Duviviers—Jean Duvivier, 1687–1761, Benjamin Duvivier, 1730–1819: Essai d'un catalogue de leurs oeuvres* (Paris, 1911).
14. See Udolpho van de Sandt, "La fréquentation des Salons sous l'Ancien Régime, la Révolution et l'Empire," *Revue de l'art,* no. 73 (1986), pp. 43–48, and Neil McWilliam, ed., *A Bibliography of Salon Criticism in Paris from the "Ancien Régime" to the Restoration, 1699–1827* (Cambridge, 1991).
15. For their advice and assistance, I would like to acknowledge Esther Bell, Katherine Holmgren, Emmanuel Moatti, Pierre Rosenberg, Marie-Catherine Sahut, and Guilhem Scherf.
16. Dacier 1909, p. 77 n. 1.

57. *Placets de l'officier Desbans* (Petitions by the Officer Desbans to Queen Marie Antoinette and King Louis XVI)

A quarto volume of twenty-two pages, bound in red morocco leather with the arms of Marie Antoinette on the cover, 14¾ × 9⅜ in. (36.5 × 23.7 cm). Beginning on page 5, each illustrated page has a border of five narrow lines—colored in sepia, bright red, yellow, and bluish green. There are fifteen pictorial decorations by Saint-Aubin—one oval, four roundels, and ten rectangles—as well as decorative head- or tailpieces. Most of the pages with illustrations are divided into three parts: title, illustration, and explication. The text was lettered with elaborately decorative penmanship in a variety of colors. Many of the drawings are signed and dated 1775.

PROVENANCE
Marie Antoinette (1775—d. 1793); baron Jérôme Pichon (d. 1897); ?Adolphe de Rothschild, Paris (d. 1900), Paris; his great-nephew, baron Maurice de Rothschild, Château de Pregny, near Geneva (d. 1957); his nephew, baron Philippe de Rothschild, Paris (by 1963); [Rosenberg & Stiebel, New York, 1963; sold to Wrightsman]; Mr. and Mrs. Charles Wrightsman, New York (1963–his d. 1986; cat., 1973, no. 38); Mrs. Wrightsman (from 1986).

LITERATURE
Roger Portalis, *Les dessinateurs d'illustrations au dix-huitième siècle* (Paris, 1877), vol. 2, p. 570; Dacier 1929–31, vol. 2, pp. 21, 104, 187–88 no. 1025*; Fahy 1973, pp. 340–44 no. 38.

This booklet consists of two *placets* (petitions), addressed to Marie Antoinette and Louis XVI by an army officer called Desbans. The booklet requests his promotion to a lieutenant-colonelcy, which he had reason to believe had been promised by Louis XV in 1770. In order to ensure that his request would attract the attention of the king and queen, Desbans commissioned Saint-Aubin to decorate his petitions with drawings celebrating the royal couple.

Although the *placets* were published in some detail by Dacier, Desbans's first names and details of his career have remained unknown.[1] It is possible, however, to suggest that he was Edme Louis Desbans.[2] Born in 1728, Desbans began his military career in 1743 as a musketeer; eventually he served as a volunteer to the Dauphin and as an aide-de-camp to the Maréchal de Maillebois. On May 10, 1778, he became the commandant of the de Bassigny garrison. His long-sought-for lieutenant-colonelcy was finally awarded him on January 22, 1779; he retired from the military at this rank in 1788. Three years later he was granted an honorary promotion to *maréchal de camp*.

In the following description of the booklet, the blank pages are omitted.

Flyleaf. Inscribed in ink across the upper-left corner: *nᵒ o - / [?£] 50,000–En assignats*.[3] / / In graphite, from the top: <u>14</u> / *7. 4. 74. ioss. // sieur Desbans // 13* [circled].

Page facing flyleaf. Inscribed in ink on a piece of paper mounted on the page: *ce Dessein Est d un grand detail Et j'en / attendois un grand Succes, aiant Eté fait / quelques jours apres Le Sacre sur un sim- / ple / petit croquis en Mine de plomb moins grand / que La Main de La Decoration de L'Eglise / de Rheims; Mais n'aiant pas Eté donné / dans La chaleur du moment cela a beaucoup / perdu de Son prix. — quoique, si cela / — / a quelque Merite En Soy, il reste toujrs[sic] / Le Même. c'Est un Spectacle dont je / N'ai pas Eté temoin, et dont j ai Eté Le / 1ᵉʳ Dessinnateur.*
(This drawing is very detailed, and I expected to have a great success with it, since it was done a few days after the coronation from a simple little sketch in black lead, less than the size of one's hand, of the decoration of the Reims church; but not having been presented in the heat of the moment, it has lost much in its value—although, if it has any merit in itself, that always stays the same. It was a spectacle of which I was not a witness and of which I was the first draftsman.)[4] / / Inscribed below in graphite directly on the page: *Voir p. 10 verso* (See p. 10 verso).

1. Inscribed in ink: *CET OUVRAGE ayant été commencé et / fini sous le Ministére de M. le Comte / Du Muy, l'Officier qui prend la liberté de / le prèsenter à SA MAJESTÉ, toujours / dans les mêmes circonstances où il se / trouvoit alors, n'a pas crû y devoir rien / changer.*
(This work having been begun and finished under the ministry of M. le Comte Du Muy, the officer who takes the liberty of presenting it to Her Majesty, being still in the same circumstances in which he then found himself, has not considered that anything in it should be changed.) / / Inscribed *1776* below in graphite.

Louis Nicolas de Félix Du Muy served as minister of war at the time this petition was created and was responsible for military reforms that placed the petitioner in an awkward position. At his coronation, Louis XVI elected Muy to the position of marshal,

Feder und Bensel haben nur disen
Altar hergestellet.
Aber die in unseren Hertzen sind
von dero Tugen und Güte
aufgerichtet.

PROJETTE.
dans un Moment que n'oubliera
Jamais SA MAJESTÉ le 13 Janvier 1775
COMMENCÉ.
le lendemain 14
FINI
le 26 Juin suivant 1775.

CECY N'EST POINT

Le Tribut ambitieux et intéressé d'un jeune Artiste
qui ne voit la gloire que dans les suffrages
DE LA REINE.

C'EST LE JUSTE ET DERNIER EFFORT

d'un ancien Militaire qui ne voit
le bonheur que dans le Service.
DU ROI.

honoring the promise of his father, the late Dauphin. On April 7, 1775, Muy was appointed minister, a position that was short-lived, owing to his death in October of that year. The date 1776 inscribed below the text is thus incorrect.

2. Inscribed in German in a horizontal cartouche, beneath the queen's intertwined initials *MA*, composed of stylized flora and surmounted by a putto carrying a pennant emblazoned with fleurs-de-lis over a crown of flaming hearts: *Feder und Bensel haben nur disen / Altar hergestellet. / Aber die in unseren Hertzen f[s]ind / von dero Tugen und Güte / aufgerichtet.*
(Pen and brush only have created this altar. But those in our hearts have by your virtue and goodness been erected.)
Reverting to French, immediately below on the drapery suspended from the "altar": *PROJETTÉ. / dans un Moment que n'oubliera / jamais SA MAJESTÉ le 13 Janvier 1775 / COMMENCÉ / le lendemain 14 / FINI / le 26 Juin suivant 1775. // CECY N'EST POINT / Le Tribut ambitieux et intéressé d'un jeune Artiste / qui ne voit la gloire que dans les suffrages / DE LA REINE. // C'EST LE JUSTE ET DERNIER EFFORT / d'un ancien Militaire qui ne voit / le bonheur que dans le Service / DU ROI.*
(Planned in a moment that Her Majesty will never forget, January 13, 1775; begun the next day, the 14th, finished June 26, 1775. This is in no way the ambitious and self-interested tribute of a young artist who sees glory only in the approbation of the queen. It is the just and final effort of an old soldier who sees happiness only in the service of the king.)

The German in the cartouche may have been used to attract the attention of the Austrian princess. The text on the drapery refers to the passage of time during which the queen's petition (the first part of the booklet) was executed. January 13, 1775, was the day Marie Antoinette received an ovation at the Paris Opéra.[5]

3. Inscribed both in the oval image (on the document presented to the queen) and on the pedestal below: *A LA REINE* (To the queen)// On the drapery suspended from beneath the pedestal: *D'AIGNE SA MAJESTÉ / Recevoir / Avec Indulgence le plus pur et le plus respectueux Hommage. / JE N'AI / D'autre prétention que ce qui m'a été promis / D'autre ambition que pour un second moi-même / D'autre protection que la Justice / ET LA VÉRITÉ.*
(May Her Majesty deign to receive with indulgence the purest and most respectful homage. I have no other claim but that which was

promised me, no other ambition but for a second self, no other protection than Justice and Truth.)

In the oval medallion Desbans presents his petition to Marie Antoinette before a view of the park and the garden facade of the Versailles palace. The medallion rises from the smoke of an urn placed on a circular plinth inscribed. It is surrounded by a pale blue trellis of rose garlands, with birds and butterflies fluttering above. The medallion, executed in black ink and gray washes, measures 3¾ by 3 in. (9.5 by 7.6 cm).

5. Inscribed: *DE VAINS ORNEMENS / Ne tiennent point lieu de Droits, un Militaire de / 30 ans de Service, n'ignore point cette Vérité. / TROP HEUREUX / S'ils peuvent aumoins les faire connoitre! / LES DÉCORATIONS / pour les qu'elles cet Officier réclame une / attention plus particuliere, dans ce faible Ouvrage, sont* [words underlined in graphite:] *celles de la page 12, les seules / qui puissent justifier son espoir.*
(Vain ornaments in no way take the place of rights; a soldier with 30 years' service is not unaware of this Truth. [He will be only] too happy if they can at least make those rights known! The decorations for which this officer seeks special attention in this slight work are those of page 12 [according to the artist's numbering, or page 33] the only ones that can vindicate his hopes.)

7. Inscribed: *A LA REINE // MADAME // L'Honneur et l'Amour paternel, amenent aux pieds de VÔTRE MAJESTÉ, le plus tendre / des Péres et (j'ose le dire) l'un des meilleurs Soldats que le roi ait dans ses Troupes / Si l'ardeur héréditaire, que j'ai toujours eüe, et que j'ai encore pour son service; Si la voix de / la Nature à la quelle il est si doux de céder, m'emportoient à la plus légere altération des / faits, que je vais mettre sous les yeux de VÔTRE MAJESTÉ, je me croirois dès lors; / Oui, je me croirois indigne du moindre des ses regards, mais c'est la vérité même, MADAME, / comme vous allés le voir, qui vous présentera mes Titres: C'est la Justice en personne qui va plaider ma cause au Tribunal de vôtre Cœur Magnanime et Sensible: le mien pourroit-il- / se fermer à quelque raïon d'esperance? Que dis-je? Tout ne justifie-t-il pas l'excés de la / confiance qui l'anime, quand mes intérêts sont remis en des mains aussi chéres à / VÔTRE MAJESTÉ. // Je Suis avec le plus profond Respect, / DE VÔTRE MAJESTÉ, / MADAME / Le Très Humble & Très Obéissant / Serviteur & Sujet le plus / Fidelle.*
(To the queen. Madam, Honor and paternal love bring to the feet of Your Majesty the tenderest of fathers and (I dare to say it) one of the best soldiers that the king has in his troops. If the heredi-

tary zeal that I have always had and still have for his service; if the voice of nature, to which it is so sweet to yield, were inclining me to make the slightest alteration in the facts that I shall be setting before Your Majesty's eyes, I should think myself from then on— yes, I should think myself unworthy of the least of her glances; but it is Truth itself, Madam, as you shall see, who will present you with my claims. It is Justice in person who is going to plead my cause at the tribunal of your magnanimous and feeling heart; may my own enclose some ray of hope? What shall I say? Does not everything justify the overwhelming confidence that animates it, when my interests are placed in hands as dear to Your Majesty? Madam, I am with the deepest respect, Your Majesty's very humble and obedient servant and most loyal subject.)

The name of the petitioner at the bottom of the page was lightly scratched out, probably by a collector who wished to eliminate all traces of the provenance.

10. Inscribed: *Rien n'est beau que le vrai, le vrai seul est aimable / Il doit regner partout et même dans la fable. // Les quatre Médaillons qui suivent sont liés par un seul et même sujet, dont celui qui / ose les présenter, espere que la fiction sera pardonnée au motif qui l'anime. // Tous les autres desseins présentent differents objets détachés entr'eux, dont la vérité, et / l'application seront sensibles, et palpables aux yeux de tous les lecteurs.*
(Nothing is beautiful but the true, the true alone is lovable; it must reign everywhere, and even in fable. The four medallions that follow are linked by one and the same subject; he who dares to present them hopes that their fictional nature will be excused by the motive that inspires them. All the other drawings present different, independent subjects, the truth and application of which will be evident and palpable to the eyes of every reader.)

11. (Numbered 1 by the artist). Inscribed: *La Justice et la Verité, présentent le S^r [name erased] à la REINE, avec le Mémoire / de ses services en datte du premier Mars 1743. / La REINE marque sa surprise, du long oubli où est demeuré cet Officier, qui joint / l'ancienneté du service aux bons témoignages, et à la Naissance. / SA MAJESTÉ veut bien s'engager envers la Justice et la Vérité à en parler au Roi.*
(Justice and Truth present Sieur [Desbans—erased but faintly legible] to the queen, with the memorandum of his services dated March 1, 1743. The queen indicates her surprise at the long period of neglect in which this officer, who combines length of service with

good testimonials and with birth, has remained. Her Majesty is pleased to undertake to Justice and Truth to speak of it to the king.)

The scene takes place in a circular salon with an open passage, guarded by a soldier, adjacent to a gallery that recalls the Hall of Mirrors. The rare cushion upholstery of the folding chair can be seen to the right of the queen, who is seated on a throne. Initialed on the folding stool next to the queen: *G d S A*. The roundel, executed in black ink and gray washes, has a diameter of 4½ in. (11.5 cm); it was cut out and pasted onto the page.

13. (Numbered 2 by the artist). Titled: *BIENFAISANCE DE LA REINE*. (Beneficence of the queen.) Inscribed in the rectangle below the drawing: *Toutes les Classes de ses sujets, Militaires, Habitants des Campagnes, de tout âge, / de toutes conditions, sont l'objet de la Bienfaisance de SA MAJESTÉ. / La Générosité sans bornes de cette Princesse, est designée par les deux Cornes / d'abondance, qui forment les bras de son Trône. / POINT DE MALHEUREUX SOUS SON REGNE, QUE CEUX QUI NE LUI SONT PAS CONNUS.*
(Every class of her subjects, soldiers, peasants, of all ages and conditions, are the object of Her Majesty's beneficence. The boundless generosity of this princess is denoted by the two cornucopias that form the arms of her throne. None is unhappy under her reign save those who are not known to her.)

The pedestal beneath the throne is inscribed: *la reigne decend de son trône pour faire du bien* (the queen descends from her throne to do good), and farther to the right: *G d S A* and below it *Gabriel . . . f[eci]t 1775* (Gabriel made [it] 1775). The fort, to the left of the throne, recalls Vauban, a reference to the petitioner's military career. Executed in black ink and gray washes, the drawing measures 4¼ by 6⅜ in. (11.5 by 16.1 cm); it was cut out and pasted onto the page.

15. (Numbered 3 by the artist). Inscribed: *La REINE veut bien avoir la bonté de donner au ROI le Mémoire du S^r / [name erased], à l'effet de lui faire obtenir la Lieutenance-Colonelle d'un Régiment- / Provincial qui lui a été promise. M. le Maréchal Du Muy, convient que la Justice / ainsi que la Vérité sont pour cet Officier. Une Retraite survient l'Employ est /donné au s^r Desbans.*
(The queen is pleased to be so good as to give the king the memorandum of Sieur / [Desbans—erased but faintly legible] with a view to obtaining for him the lieutenant-colonelcy of a provincial regiment / that he was promised. M. le Maréchal Du Muy agrees

5

11

13

15

17

27

206

11, detail (actual size)

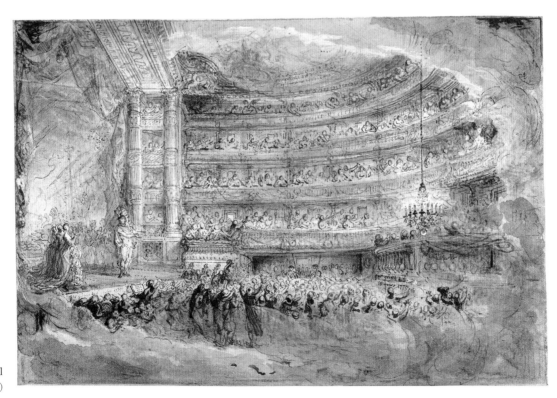

that Justice / as well as Truth are on the side of this officer. A retirement takes place. The post is given to Sieur Desbans.)

The roundel portrays the queen handing the petition to the king, who is accompanied by Muy, cited on page 1. The flat desk with a *cartonnier* may be one that belonged to Louis XVI as the monogram *LA* (for Louis Auguste) appears within the marquetry on the side of the *cartonnier*. On the desk is a clock surmounted by the heraldic Gallic rooster, a beehive in straw, and a cannon (or perhaps a plow). The style of the pair of chairs is more up-to-date, with tapering spiral legs, skirts, and soft cushions. In the taste of Jean Charles Delafosse (1734–1791), they are identical to a model delivered by Louis Delanois (1731–1792) to Madame du Barry in 1769.

Executed in black ink and gray washes, with a diameter of 4⅛ in. (10.5 cm), the drawing was cut out and pasted onto the page.

17. (Numbered 4 by the artist). Titled: *GOÛT DE LA REINE POUR LES ARTS.* (The queen's taste for the arts.) Inscribed in the rectangle below the illustration: *Tous les Arts épuisent à l'envie leurs prodiges, pour plaire à leur / Protectrice éclairée. / Les Hommes de génie dans touts le genres, ne naissent plus pour / l'oubli, pour l'infortune, encore moins pour le mépris. / Si l'action d'Acheres n'est pour ainsi dire qu'indiquée dans un très / petit tableau; c'est un sacrifice à la modestie de la Reine, qui ne veut / d'autre récompense de ses bienfaits, que le plaisir de les répandre. / Des differens Génies des Arts, l'un lui consacre son pinceau, l'autre / son burin; l'autre dans l'excès d'une juste reconnoissance, baise / avec transport les mains de cette Princesse.*
(All the arts exhaust their marvels in vying with one another to please their enlightened protectress. Men of genius of every kind are no longer born for oblivion, for misfortune, still less for contempt. If the occurrence at Achères is so to speak merely indicated in a very small picture, it is a sacrifice to the modesty of the queen, who wants no other reward for her good deeds than the pleasure of spreading them. Among the different geniuses of the arts, one dedicates his brush to her, another his burin; another, carried away with rightful gratitude, in ecstasy kisses the hands of this princess.)

The painting on the easel establishes the connection between Marie Antoinette's double role as protector of the arts and as a model of human compassion by depicting the future queen consoling a family of peasants who have just lost their father in a hunting accident at Achères in the forest at Fontainebleau.[6] Inscribed *1773 G de S . . .* , it is copied from a gouache painting by

the artist.[7] The base of the queen's throne is dated *1775.* Dacier misread it as 1776.[8] The drawing, which was pasted onto the page, measures 4½ by 6⅜ in. (11.4 by 16.2 cm).

19. (Numbered 5 by the artist). Inscribed: *Cet Officier bien moins occupé de lui même quand il a demandé à servir, que / de l'Education de sa famille, y a consacré la moité de sa solde: Avec ce secours, / et son Economie, il a donné, ainsi qu'on le voit dans ce Medaillon, les meilleurs / Maitres de la Province à sa fille agée de 12 ans. la reconnoissance engage cette jeune / Personne à faire une copie du Portrait de la REINE, dont l'ouvrage est fort applaudy. / A 18 ans ses Pére et Mére la conduisent à Versailles bien plus pour admirer leur / Auguste Bienfaitrice, que pour y voir la plus brillante Cour de l'Univers.*
(This officer, much less concerned with himself when he asked to serve than with the education of his family, has devoted to this one-half of his pay. With this aid and with his savings, he has, as can be seen in this medallion, given his twelve-year-old daughter the best provincial teachers. Gratitude prompts this young person to make a copy of the portrait of the queen, the result of which is greatly praised. When she is eighteen, her father and mother take her to Versailles, rather to admire their august benefactress than to see there the most brilliant court in the world.)

The unopened music book on the harpsichord is inscribed *GLUK*, which refers to Christoph Willibald Gluck (1714–1787), a composer not appreciated by the Parisian public but who was protected by the queen and who had served the Austrian court in Vienna for a decade; a putto points to Vienna on the globe. The young girl sits on a Louis XIV style chair, and the harpsichord stand is also out-of-date. The drawing is executed in black ink and gray washes, with a diameter of 4⅛ in. (10.5 cm).

21. (Numbered 6 by the artist). Titled: *AMOUR DE LA REINE POUR LA FRANCE.* (The queen's love for France.) Inscribed in the rectangle below the drawing: *L'Autriche en larmes fait à la France le plus rare de tous les présens. / La France tend les bras à sa SOUVERAINE, et la reçoit avec les transports de la / plus vive reconnoissance. / LA REINE s'y precipite avec ceux de l'Amour et de la Joÿe, dans le dessein de / fonder son bonheur sur le bonheur de la France; sentimens d'une vérité déja / attestée par mille faits non équivoques en deux années de Regne.*
(Austria in tears makes France the rarest of all presents. France offers her aid to her sovereign and receives her with transports of

the liveliest gratitude. The queen hastens forward with those of Love and Joy, intending to build her happiness on the happiness of France—sentiments the truth of which is already attested by a thousand unequivocal deeds in two years of reign.)

Inscribed illegibly on the tail of the eagle; below the figure of Austria: . . . / *autriche* / . . . ; and in the shadow of the cloud, lower center: *Gabriel*; the rectangular drawing measures 4⅜ by 6¼ in. (11.1 by 16 cm).

23. (Numbered 7 by the artist). Inscribed: *La copie du Portrait de la REINE faite par cette jeune Personne a été / mise sous les yeux de SA MAJESTÉ qui a la bonté d'en marquer sa satisfaction / à l'Auteur pendant son diné. Cet honneur que veut bien lui faire la REINE, / la fait connoitre: ses Parens trouvent à la marier avec un homme de naissance / attaché par un service spécial et militaire à la personne de SA MAJESTÉ: fixée / ainsi dans la Résidence de son Auguste Bienfaitrice, rien ne manque plus à ses / vœux. Son Père au comble des siens, rejoint son Corps, où il fait le chemin dont / ses Services le rendent susceptible. // C'est ainsi qu'une simple Lieutenance-Colonelle, promise depuis cinq ans, et / obtenüe par la Reine, devient la source du bonheur d'une Maison ancienne qui alloit / tomber dans l'oubly.*

(The copy of the queen's portrait done by this young person has been shown to Her Majesty, who has the kindness to indicate her satisfaction with it to the author in the course of her dinner. This honor that the queen is pleased to do her makes her known, and her parents arrange to marry her with a man of good birth attached in professional and military service to the person of Her Majesty. Once she is placed thus in the residence of her august benefactress, none of her wishes remains to be realized. Her father, his own wishes more than satisfied, rejoins his corps, where he follows the path for which his services qualify him. It is thus that a simple lieutenant-colonelcy, promised for five years, and obtained by the queen, becomes the source of happiness for an ancient house that was about to fall into oblivion.) Lower right, indicating the continuation of the text on the verso: *RIEN.* (Nothing.)

The illustration is a rare depiction of the royal meal known as the *Grand couvert ordinaire*, a ceremonial repast in the antechamber of the queen's apartment at which the public and members of the queen's household were seated on folding stools in a semicircle in front of the royal table, a practice that Marie Antoinette did not appreciate but was obliged to respect in keeping with ancient

customs and semireligious rituals. The headwaiter, with a baton hanging from his left wrist, stands behind the queen and directs the waiters that serve her. Two waiters present a dampened napkin to the queen brought to the table between two plates, in order to moisten the hands at the beginning of the meal. All of the objects of the dinner service, referred to as *du prêts*—a pile of plates, platters, etc.—are displayed on a buffet covered with a tablecloth with visible pleats, reflecting fresh laundry. An identical tablecloth has been draped over the queen's table, a rectangular board measuring 80 by 50 inches, supported by trestles. We are able to distinguish a rich, round terrine with an elaborate cover, and a so-called *cadenet*, a locked metallic box of silverware, with spice compartments and the other condiments on its square tray meant to carry a second napkin to protect the bread, as well as a saltcellar and silverware. Not a single glass is placed on the table, this being the request of the queen, who drinks the contents and hands the empty glass to the server without placing it on the table. The queen, dressed in finery, sits in her chair, similar to those in the on medallion on page 15, and has placed the point of a large napkin into the cleavage of her bodice, with the body of the napkin generously hanging down over her dress. The queen's napkins were, in fact, quite large, measuring 47 by 35 inches (the famous napkin known as *de la Reine,* and believed to have been Marie Antoinette's, was ordered by Louis XV in 1732.[9]

The roundel, dated below the queen's chair *1775,* was executed in black ink and gray washes, with a diameter of 4⅛ in. (10.6 cm).

24. Inscribed: *Rien sans doute n'égale la témérité avec la quelle j'ose entretenir depuis si long- / -tems SA MAJESTÉ d'un pur songe; mais est-il chimere que ne puisse elever dans / la tête d'un brave Soldat l'AMOUR de la Gloire, et dans celle d'un bon Pére, l'Amour / de sa Fille? // QUE MON CŒUR // Que mon Etat, Que mes Sentiments soient connus // MON PARDON M'EST ASSURÉ.*

(Nothing no doubt equals the boldness with which I have dared to engage for so long Her Majesty's attention with a pure dream; but is it an idle fancy to raise in the head of a brave soldier the love of glory and in that of a good father, the love of his daughter? Let my heart, my condition, my sentiments be known and my pardon is assured.)

25. (Numbered 8 by the artist). Titled: *FÊTE / en l'honneur de la Reine.* (Fete in honor of the queen.) Inscribed in the rectangle

25

29

36

37

40

41

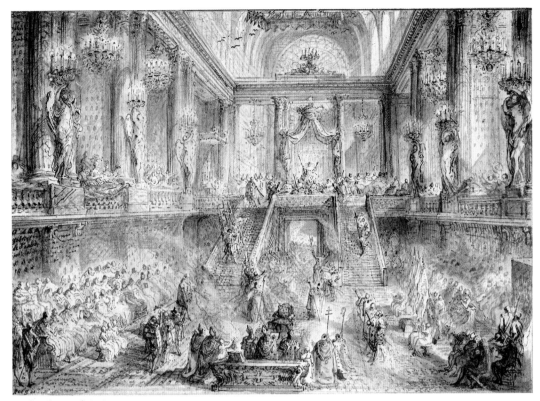

30, detail (actual size)

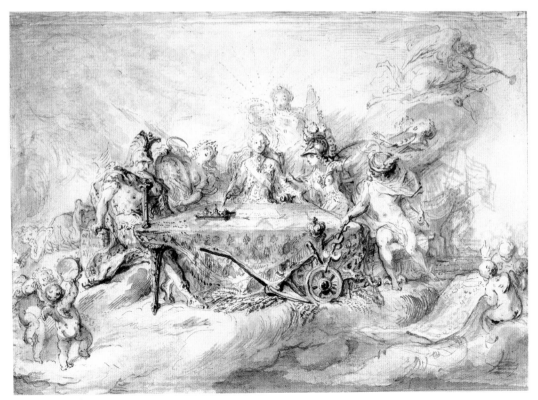

36, detail (actual size)

below the illustration: *Au defaut des talens de l'Esprit, favorisé par la nature d'une âme sensible, / et la plus reconnoissante qui fût jamais, cet Officier retabli dans son pre- / -mier état, après trois réformes, institue dans sa famille une fête en mémoire / des Bienfaits de SA MAJESTÉ. / Chaque année le 2 Novembre [year erased] et le 16 May [year erased] il rassemble tous ses / parents et amis à cet éffet, et ces deux jours épo- ques si chères à la France, ne / sont consacrés qu'a la joye, à la recon- noissance, à l'amour de la Patrie & du Souverain. / C'est là que payant à l'envy, par des chants aussi simples, qu'ingénus, à chacune / des ver- tus de la REINE, le tribut du cœur et de la vérité, on se permet avec trans- / -port, loin de cette Princesse un encens légitime et désintéressé, qu'on se garde- / -roit bien de faire fumer aux yeux de sa modestie.*

(Lacking the talents of the intellect, but blessed by nature with the most feeling and grateful spirit that ever was, this officer, restored, after three military reforms, to his earlier state, establishes a fete in his family to commemorate Her Majesty's favors. Every year on November 2 [year erased] and May 16 [year erased] he gathers all his relatives and friends for this purpose, and these two historic days so dear to France are devoted to nothing but joy, gratitude, and love of country and of the sovereign. It is there that we vie with one another in songs as simple as they are artless to pay to each of the queen's virtues the tribute of the heart and of truth, and joyously take the liberty, far from this princess, of rendering her a just and disinterested eulogy, an incense that one would refrain from burning in the presence of her modesty.)

The dates mentioned in the text are those of Marie Antoinette's birthday, November 2, 1754, and her marriage at Versailles, May 16, 1770. Dated *177?* on the end of the bench on which the woman spectator (the queen?) is seated. Cut out and pasted onto the page, it measures 4 ½ by 6 ¼ in. (11.5 by 16 cm).

27. (Numbered 9 by the artist). Titled: *AMOUR DES FRANÇOIS POUR LA REINE ? // 13. Janvier // 1775.* (The love of the French for the queen, January 13, 1775.) Inscribed in the rectangle below the illustration: *Chantons, célébrons nôtre Reine, / L'Himen qui sous ses loix l'enchaine, / Doit nous rendre à jamais heureux! // Iphigenie, Acte II. Scene III. // Époque à jamais mémorable! Scene plus puissante mille fois sur mon ame sensible, / que le sacrifice d'une Héroïne fabuleuse, et toute la magie des sons du Cheval.ᵉʳ Gluck. / Non, MADAME, jamais larmes plus délicieuses n'ont coulé de mes yeux que dans / ce moment si doux à votre cœur, et au cœur de vos sujets. / VÔTRE MAJESTÉ doit croire, qu'on connoit point de plaisirs de cette nature, / qu'on ne goute point une joie aussi douce sans aimer avec transport son ROI, sa / REINE et sa Patrie. // FIN / du Placet à la Reine.*

(Let us sing, let us celebrate our queen. Hymen who binds her under her laws must make us forever happy! Iphigénie,[10] Act II. Scene III. A date forever memorable! A scene a thousand times more potent in its effect on my feeling soul than the sacrifice of a mythical heroine, and all the magic of the sounds of the chevalier Gluck. No, Madam, never have more exquisite tears flowed from my eyes than in this moment so sweet to your heart and to the heart of your subjects. Your Majesty must believe that one knows no pleasures of this kind, one tastes no joy as sweet without passionately loving one's king, one's queen, and one's country. End of the petition to the queen.)

The illustration depicts Marie Antoinette attending one of the first performances of Gluck's "Iphigenia in Aulis" at the Paris Opéra on January 13, 1775, in semi-incognito dress. This event inspired the idea to create the petition. It also illustrates the queen's first public appearance in Paris after her accession. Consistent with his usual attention to detail, Saint-Aubin, who was most likely present at the performance, illustrates the unfolding events of the evening of January 13, at the memorable ovation to the queen, recorded in Louis Petit de Bachaumont's *Mémoires secrets.*[11]

Marie Antoinette's presence and support of the production were well received by the public but required certain adjustments that might have affected Gluck, whose musical reforms were not always popular in Paris. The scene Saint-Aubin chose to represent—the embarkation of the Greeks—pays homage to the queen in the second balcony, surrounded by the comtes de Provence and d'Artois, as well as Madame, wife of the former, all distinctly identifiable in the small illustration. Attached to the Palais Royal, the theater was commissioned by the duc d'Orléans, so it was logical that he sat in the box located below the stage box and in front of the first balcony; he and his entourage wearing their ribbons of honor are clearly recognizable. Built by the architect Pierre Louis Moreau-Desproux (1727–1793) between 1764 and 1770, after a fire had ruined the previous building, it too was destroyed by a fire in 1781. Its design was previously known only from engraved plans. Like the Versailles Opéra, which was inaugurated a few weeks later for the marriage of Marie Antoinette to the Dauphin, the Paris Opéra had wide balconies instead of Italian-style boxes.

Dated above the highest balcony: *13 Janvier 1775*; signed on the right beneath the first balcony: *par gabriel d. S . . . /18 juin 1775.*

Executed in an elaborate technique of black ink, gray washes, and white highlights, the drawing measures $4^{7}/_{8}$ by $7^{1}/_{4}$ in. (12.3 by 18.5 cm).

28. Inscribed: *Élever des prétentions sans droits, solliciter des graces / sans titres, ce seroit bâtir sur le sable. / D'AIGNE le plus juste des Souverains jetter un coup d'œil sur ceux / que je vais mettre icy sous les yeux de VÔTRE MAJESTÉ, et sous les siens! / HELAS, C'est un des plus anciens Soldats de ses Troupes (reste ignoré / d'un sang accoutumé à couler depuis plusieurs siecles pour ses glorieux / Prédecesseurs.) / C'EST un Pére malheureux et sensible; Une Mère tendre et vertueuse; / Une Enfant, le plus cher et le plus intéressant objet de toutes leurs pensées, / qui embrassent les genoux du plus puissant Monarque de l'univers. / D'UN MOT, que dis-je; d'un seul regard CE ROI, l'amour de son / Peuple, peut faire trois heureux!.......... le refusera-t-il à la JUSTICE, / à LA VÉRITÉ à la.. REINE...?......NON..... Tout me dit, qu'une / Illustre Princesse, née pour fair adorer ses loix, voudra bien par une bonté / sans exemple,* faire de mon second Medaillon, une réalité. // ☞ *au 2. Medaillon.*

(To raise claims without rights, solicit favors without entitlement, that would be to build on sand. May the most just of sovereigns deign to cast an eye on those that I shall be placing here before the eyes of Your Majesty, and of his own people! Alas, it is one of the oldest soldiers in his troops (the unknown remnant of a line accustomed for several centuries to shed its blood for his glorious predecessors). It is an unhappy and feeling father; a mother tender and virtuous; a child, the dearest and most absorbing object of their every thought, who clasp the knees of the mightiest monarch in the universe. With one word, how shall I say it? with a single look this king, the love of his people, can make three persons happy! . . . will he refuse it to Justice, to Truth, to the . . . Queen . . . ? . . . No . . . Everything tells me that an illustrious princess, born to make his laws adored, will with unparalleled kindness be willing to make of my second medallion a reality. // ☞ to Medallion 2.)

Inscribed in graphite in the margin: *page ?* Inscribed in rectangle with tailpiece: *Nœuds Fortunés, Alliance Auguste / Vous êtes l'infaillible prèsage du bonheur de la France. / une Voix sécrete / dit tout bas à mon cœur, que vous le serés aussi du mien. / VIVE LE ROI, VIVE LA REINE. // Tout ce qui suit n'a été imaginé et éxecuté que depuis le Sacre.*

(Felicitous ties, august alliance, you are the infallible omen of the happiness of France. A secret voice whispers in my heart that

you will also be that of mine. Long live the king, long live the queen. All that follows has been conceived and executed only since the coronation.)

This is the end of the petition, completed in its original form on June 26, 1775 (according to the inscription on page 2). The eagle and rooster bound by garlands symbolize the alliance between Austria and France, sealed by the marriage of Marie Antoinette to the Dauphin in 1770.

29. (Numbered 10 by the artist). The text is laid out as part of the composition, at the center of which is a large green fleur-de-lis enclosing the words: *PLACET / AU / ROI* (Petition to the king). Issuing from the fleur-de-lis are garlands of pink and yellow flowers, two of which terminate above with profile portrait medallions of Louis XVI and Marie Antoinette to right and left, respectively; descending from the fleur-de-lis is a garland from which are suspended profile portrait medallions of the king's two brothers, the comte de Provence, later Louis XVIII (1755–1824), and the comte d'Artois, later Charles X (1757–1836), to right and left, respectively, with between them a medallion showing a seated infant above the inscription *Spes praevia gallis* (anticipated hope of the Gauls) with an anchor, symbol of hope, in the background. Inscribed at the top by the medallions of the sovereigns: *C'EST UNE TÉMÉRITÉ / Sans doute dans un Sujét, d'offrir / des Portraits aussi peu ressemblans / A SES AUGUSTES MAITRES: // MAIS // le plaisir que se fait quelques fois la Nature de former des / Ouvrages pour la honte et le désespoir de l'Art, doit faire l'excuse d'un simple / Militaire qui n'en connoit point d'autre — que de les bien Servir, / ET DE DONNER SA VIE POUR EUX.*

(It is audacious no doubt in a subject to present portraits so little resembling his august masters, but the pleasure that Nature sometimes takes in forming works to the shame and despair of Art must be the excuse of a simple soldier who knows no more than to serve them well and to give his life for them.)

At the bottom: *PRINCES GÉNÉREUX // Noble Appuy des Lys, Couple Auguste, Pour rendre mon Succès certain: Daignés prendre ma cause en main, Je ne prétends rien que de juste.*

(Princes of the blood royal, noble support of the lilies [of France], august couple, in order to ensure my success, deign to take my cause in hand; I claim only what is just.)

This is the title page of a second petition, which was prepared after the first one failed to achieve its goal. The baby in the medal-

lion in the bottom center, wearing the order of the Holy Spirit, was identified by Dacier as the duc d'Angoulême, first child of the comte d'Artois, born August 6, 1775.[12] The royal couple's first child, Marie Thérèse Charlotte, was not born until 1778, followed by their two sons, in 1781 and 1785. Executed in watercolors, the overall dimensions of the design are 11⅛ by 2¾ in. (28.2 by 7.1 cm).

30. Titled: *Couronnement de sa Majesté / A Rheims le 12 Juin 1775.* (Coronation of His Majesty / at Reims, June 12, 1775.) Inscribed below the illustration: *Quelle Épôque! . . . Quels momens pour le Prince, et pour les Sujets! Quel délicieux combat / d'attendrissement et d'amour des deux parts: Qu'est-il besoin de confier au marbre, ou à / l'airain, le souvenir d'un Èvénement dont l'Histoire ne donna jamais d'exemple; il est gravè / en traits immortels dans les cœurs de tous les Français. / Non jamais Pharamond portè sur le Bouclier par nos Pères, n'y parut sous de plus brillans / et de plus doux auspices. / Heureux les Français qui ont pû être les témoins du plus noble, et du plus touchant de / tous les Spectacles. / Si c'etoit, au plus capable de sentir dans toute son étendüe la douceur d'un si juste / entousiasme, que dut appartenir de préférence la grace que je reclame, Quel autre que / moi auroit plus de droit au succès! // ☞ Ce Dessein le premier qui ait été fait de cette Cérémonie Auguste, ne l'a été que sur un simple recit verbal, et sans en avoir été témoin.*

(What a date! . . . What moments for the prince and for his subjects! What a delightful contest of tenderness and love on the two sides. What need is there to confide to marble or bronze the memory of an event unprecedented in history: it is engraved in immortal strokes in the hearts of all the French. Never did Pharamond borne aloft by our fathers appear under more brilliant and more gracious auspices. Happy the French who could be witnesses of the noblest and most touching of all spectacles. If the favor that I seek should belong by preference to the one most capable of feeling in every fiber of his being the sweetness of such justifiable enthusiasm, who else but I would have more right to success? ☞ This drawing, the first that was made of this august ceremony, was done only from a simple verbal report, and without having been a witness of it.) Following the second line, traces of an inscription in graphite remain.

Although Saint-Aubin declares that he based his illustration of the coronation of Louis XVI on secondhand reports, it is difficult to believe that he did not witness the actual event. His illustration was the first depiction of the ceremony to be displayed publicly, and it was the first rendering with such accurate details often neglected by other illustrators. Other designers, such as François-Joseph Bélanger (1744–1818), Jean-Michel Moreau "le Jeune" (1741–1814), and Charles Emmanuel Patas (1744–1802), were unable to portray it as precisely.

The artist selected a perspective from the balcony of the Gothic apse, which is decorated in modern style. He directs our attention to the sanctuary entrance and even sketches the decoration of the inner facade with its niches and figures. In the foreground is the throne at which the king, dressed in complete regalia, has just been crowned. The flight of doves underneath the vault determines this precise ceremonial moment. The triumphant colonnade, with the throne in the center, accommodates the attachment of a large canopy, which would later be used during the Assembly of Notables in 1787, as well as for the opening of the States-General two years later at Versailles. This recycling reflects the economic concerns of the department of Menus-Plaisirs; the colonnade and the balustrade decoration in the cathedral were first erected in 1770 for the ballroom built on the stage at the Versailles Opéra. Queen Marie Antoinette and her entourage sit in one of the deep boxes of the cathedral, its balustrade recognizable by the fringed tapestry elegantly draped over it. She is attending the coronation as a spectator, in accordance with the king's decision not to crown her. The large engraving of 1779, which was executed by Moreau le Jeune and intended to be integrated into his fictional *Livre du Sacre*, idealizes the scene reproduced by Saint-Aubin. One of several drawings of the coronation by Bélanger is conserved at Waddesdon Manor (fig. 1); both it and an engraving by Patas idealize this interior.[13] Only Saint-Aubin's design reflects the intricate decoration of the design that many eyewitnesses, such as the duc de Croy and the writer Marmontel, have reported. Apart from a few inaccuracies concerning the number of boxes, Saint-Aubin did not omit a single element of decoration, including a lateral altar to the left of the triumphal arch and the exact location of the participants in the ceremony. The monumental candlesticks in the form of two interlaced women, in the taste of Clodion (1738–1814), enhance the lighting of the dark decoration. Saint-Aubin, among all other illustrators of this interior, is the only one who has represented these light-holders in accurate scale and proportion.[14]

The drawing, executed in black ink and gray washes with heavy white highlighting, measures 4¾ by 6¾ in. (12.1 by 17 cm).

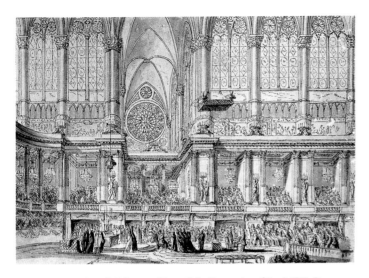

Fig. 1. François-Joseph Bélanger, *View of the Coronation of Louis XVI*. Pen, black ink, and gray wash on paper. The Rothschild Collection (The National Trust), Waddesdon Manor, Buckinghamshire

31. (Numbered 11 by the artist). Inscribed: *AU ROI // SIRE // PERMETTÉS à un de vos plus anciens et plus zêlés Serviteurs, de se / jetter aux pieds de VÒTRE MAJESTÉ. / Le 10 Mars 1770, en considération de mes longs services, j'obtins une / promésse par Ecrit au nom du feu ROI vôtre Ayeul d'un Commandement / de Bataillon de Milices. / En 1771, les Milices furent formées en Régimens Provinciaux, je / m'attendois justement à y avoir une Lieutenance-Colonelle, je fus passé sous / silence. / L'année d'après, il fût créé, cinq Regimens nouveaux du même genre, je / fus encore oublié. / Depuis ce tems, jusqu'à ce jour, j'ai sollicité en vain l'effet de la promesse / qui m'a été faite en 1770, et je n'ai eû, de trois Ministres consécutifs, que / de nouvelles promesses sans aucuns éffets. / SIRE, je suis pére de famille, sans fortune et d'un âge déja avancé. J'adore / la gloire, je ne la vois que dans vôtre service: C'est pour elle que je l'ai embrassé, / je voudrois mourir entre ses bras: en fin, SIRE, mon Etât fait celui de mes enfans. / JE SUPPLIE VÒTRE MAJESTÉ, de m'accorder la Lieutenance-Colo- / -nelle, dont j'ai la promésse par écrit, et dont mes services, et l'attention que je n'ai jamais cessé de donner à mes devoirs me rendent susceptible.*

(To the king, Sire, permit one of your oldest and most zealous servants to throw himself at Your Majesty's feet. On March 10, 1770, in view of my long service, I obtained a promise in writing in the name of the late king, your grandfather, of a command in the battalion of the militia. In 1771, the militia was formed into provincial regiments: I expected with reason to be given a lieutenant-colonelcy therein; I was passed over in silence. The following year, five new regiments of the same kind were created; I was again forgotten. From that time until the present day I have begged in vain for the execution of the promise that was made to me in 1770, and I have had, from three successive ministers, nothing but new promises without any results. Sire, I am the father of a family, without riches and already advanced in years. I adore glory and see her only in your service: it is for her that I embraced it; I would wish to die in her arms. In a word, Sire, my condition governs that of my children. I appeal to Your Majesty to grant me the lieutenant-colonelcy that was promised me in writing and for which my services and the attention that I have never ceased to devote to my duties renders me qualified.)

32. Inscribed: *m.ᴿ DE CHEVERT ayant appris que la croix de S.ᵗ Louis étoit refusée au S.ʳ* [name erased] */ sur la fin de l'année 1758, écrivit de son propre mouvement, ce qui suit à Monsieur le / Marèchal de BELLISLE.*

(M. de Chevert, having learned that the cross of Saint Louis had been denied Sieur [name erased] toward the end of the year 1758, wrote of his own accord as follows to Monsieur le Maréchal de Bellisle.)

Inscribed in graphite on the same line: *. . . meme de cet officier* (same as this officer). *// NOUS Lieutenant-Général des Armées du Roi, &ᵃ..... Déclarons par le présent, avoir / employé trés utilement le Sʳ* [name erased], *dans l'expédition du Bois d'Hastembeck, et l'avoir / compris pour la croix de Sᵗ. Louis dans les graces que nous demandâmes à la / Valeur et l'intelligence avec la qu'elle il y remplit tous les ordres dont nous le chargeâmes / dans cette Bataille, nous oblige à assurer Monsieur le Marèchal, que nous croyons ce brave / Officier trés susceptible de la croix, quoiqu'il n'ait que 15. ans de service, en foi de quoi nous / avons signé le présent. fait à Paris le 27. Mars 1769. signé CHEVERT. // Six jours aprés SA MAJESTÉ, daigna honorer cet Officier de la Grace qu'il demandoit.*

(We, lieutenant-general of the armies of the king, etc. . . . declare by the presents that we made very effective use of Sieur [name erased] in the action fought at Hastembeck Wood,[15] and included him for the cross of Saint Louis among the favors we requested of the court. The courage and intelligence with which he carried out all the orders we charged him with in this battle compel us to assure Monsieur le Maréchal that we believe this brave officer to

215

be highly qualified for the cross, even though he has only fifteen years of service. In witness whereof we have signed the presents. Given in Paris, March 27, 1769. Signed: *CHEVERT*. Six days later His Majesty deigned to honor this officer with the favor that he requested.) Inscribed in graphite on the line below, faintly legible: *Et qui avait Eté refusée* (and that had been denied).

33. (Numbered 12 by the artist). Inscribed: *EXTRAIT / D'une partie des piéces justificatives de ce placet // Promesse / Au nom du Roi du 14. Avril 1770. / Sur le compte, Monsieur, que j'ai rendu au ROI de vos Services, SA MAJESTÉ a bien voulu / vous donner l'assurance du Commandement dun des Bataillons des Milices du Languedoc / lorqu'on les assemblera, & je vous en donne avis avec plaisir . . . &.ᵃ signé Le Duc de Choiseul.*

(Extract of part of the documentary evidence in support of this petition. Promise. In the name of the king, April 14, 1770. With regard, Sir, to the account of your services that I have conveyed to the king, His Majesty has been pleased to give you the assurance of the command of one of the battalions of the militia of Languedoc when they have been mustered, & I give you notice of this with pleasure . . . etc. Signed: the duc de Choiseul.) //

Lettre / De M. le Prince de Beauvau du 12 Novembre 1771. / J'ai pris, Monsieur, les informations les plus exactes, sur les moyens de faire valoir vos demandes; / je me suis assuré dans les Bureaux de la Guerre, que vous étiés, très bien noté, et que vous êtes inscrit / sur l'Etat pour une Lieutenance-Colonelle en pied: patientés encore quelquetems, et soyés sur que / je ne cesserai de m'employer avec tout le zéle possible, pour vôtre succés, &ᵃ.. signé le Prince de Beauvau.

(Letter. From M. le prince de Beauvau, of November 12, 1771. I have obtained, Sir, the most precise information on the means to advance your requests; I have been assured in the War Office that you were very favorably noticed, and that you are inscribed on the list for a lieutenant-colonelcy of the foot: continue to be patient for a time, and be sure that I shall not cease to exert myself for your success with all possible zeal, etc. Signed: the prince de Beauvau.) //

Lettre / De M. le Marquis de Monteynard du 4 Aoust 1772. &.ᵃ / Je connois parfaitement Monsieur, tous les Titres que vous avés, pour obtenir la Lieutenance-Col.ᵉ / que vous sollicités: Je serai toujours très empressé à faire valoir vos droits &ᵃ je vous aurois prouvé / mon Zéle, sans la Réforme des Grenadiers de France: Mais ne doutés pas de mon attention, des / qu'il y aura une vacance de cet Emploi, pour vous donner des preuves, &ᵃ signé le Marquis de Monteynard.

(Letter. From M. le marquis de Monteynard, of August 4, 1772, etc. I am perfectly aware, Sir, of all the claims you have to obtain the lieutenant-colonelcy that you seek. I shall always be assiduous in asserting your rights, etc. I would have given proof of my zeal had it not been for the reform of the French Grenadiers. But do not doubt my concern to give you proof as soon as there is a vacancy for this post, etc. Signed: the marquis de Monteynard.) //

Lettres du même Ministre. / Des 4 Septembre 1772 & 15 Avril 1773. / Je n'ai point oublié, Monsieur, les promesses qui vous ont été faites par écrit et verbales d'un Emploi / supérieur dans les Régimens Provinciaux: Si vous n'avez pas été employé jusqu'icy, ce n'est point / ma faute, je vous connois pour un trés bon Officier, et vous pouvez compter, que des que la cir- / constance sera favorable, je vous placerai avec plaisir. signé le Marquis de Monteynard.

(Letters from the same minister of September 4, 1772, & April 15, 1773. I have not forgotten, Sir, the promises made to you verbally and in writing of a senior post in the provincial regiments. If you have not been engaged hitherto, it is in no way my fault: I know you for a very good officer, and you can be certain that as soon as the circumstances are favorable, I shall be glad to place you. Signed: the marquis de Monteynard.) //

J'OBSERVE SUR CES LETTRES / 1° Que la circonstance a été plus d'une fois favorable sans aucun fruit pour moi. / 2° Que M. le Duc D'aiguillon, & M. le Marechal du Muy, m'ont confirmé souvent les mêmes promesses. / 3° Qu'àprès de si longs Services, & d'aussi bons témoignages, je ne suis presque pas plus avancé que / le premier Mars 1743, quand je suis entré au Service.

(I note from these letters: 1. That circumstances have more than once been favorable without any advantage to me. 2. That M. le duc d'Aiguillon & M. le Maréchal Du Muy have often confirmed these promises. 3. That after such a long period of service & such good testimonials, I am not much further forward than on March 1, 1743, when I entered the service.)

35. (Numbered 13 by the artist). Inscribed: *SIRE // Assez malheureux pour ne pouvoir par la disposi- / -tion des nouvelles Ordonnances de VÔTRE MAJESTÉ / donner tous les instans de ma vie à son service, qu'il / me soit permis au moins d'occuper mon cruel loi- / -sir de l'Eclat de son Regne, et de tracer cy après / à ma manière et sans adulation une foible idée / du bonheur de vos Peuples.*

(Sire, Unhappy as I am not to be able by means of new orders from Your Majesty to spend every moment of my life in his ser-

vice, let me at least be allowed to occupy my cruel leisure with the brilliance of his reign, and to portray below, in my own manner and without flattery, a pale notion of the happiness of your people.)

36. Titled: *Le Roi Louis xvi // En son Conseil D'Etat.* (King Louis XVI in his Council of State.) *Inscribed below the illustration: // La Déesse Cerés, à la droite du Prince en son Conseil: Elle lui présente le medaillon / du Monarque qu'il a choisy pour son modéle, et qui a toujours, ainsi que lui, regardé / l'Agriculture, comme la premiere source du bonheur des hommes. / PALLAS Déesse de la Sagesse, est l'Ame de tous les projets du ROI, Déesse à la fois / des Sciences et des beaux arts, elle les rassemble tous autour de Trône, et elle prèside / aux nobles amusemens de SA MAJESTÉ. / LE DIEU Mercure, qui fait fleurir les Arts par le commerce, montrant avec son / Caducée la Couronne Royale placée sur la Charrüe, annonce ainsi le tendre Amour / de SA MAJESTÉ pour les habitans des Campagnes, et le desir sincère qu'il a de leur / bonheur. / LE DIEU Mars, enfin, appuié sur son Epée, annonce par son attitude tranquille, mais terrible, qu'il est toujours prêt à la tirer pour la défense du Prince et de / son Etât. Les Génies qu'on voit sur le devant, indiquent le triomphe des Arts, / la Gloire des Peuples, et leur tranquilité sous le Gouvernement de sa Majesté.*

(The goddess Ceres, at the right hand of the prince in his council: she shows him the medallion of the monarch whom he has chosen as his model, and who always considered agriculture, as he does, to be the principal source of men's happiness. Pallas, goddess of wisdom, is the moving spirit of all the king's projects; goddess both of the sciences and of the fine arts, she gathers them all around the throne, and she presides over the noble diversions of His Majesty. The god Mercury, who causes the arts to flourish through commerce, indicating with his caduceus the royal crown placed on the plow, thus proclaims His Majesty's tender love for the peasantry and the sincere wish he has for their happiness. The god Mars, finally, leaning on his sword, announces by his calm yet awesome attitude that he is always ready to draw it in defense of the prince and of his state. The geniuses seen in the foreground show the triumph of the arts, the glory of the people, and their peaceful existence under His Majesty's government.)

The king, who is presiding at the council table, is crowned by the allegorical figure of glory, assisted by Minerva, Mercury, the arts and fame; Ceres presents him with a medallion showing the bust of Henry IV and several allegorical figures embodying the

goals of the new regime. The book on which Mars rests his right hand, with its inscribed cover, is the *Ordonnances de Louis XVI*. In a fold of Mars's cloak, the initials *S. A.* Below the book are the initials *S. A.* The drawing, which is pasted onto the page, measures 4⅜ by 6⅜ in. (11.2 by 16.3 cm).

37. (Numbered 14 by the artist). Titled: *PRIÉRE / Pour le Roi.* (Prayer for the king.) *Inscribed below the illustration: Ô DIEU; qui par une protection toute particuliere, avés bien / voulu veiller sur ma conservation au milieu des hazards, / que mon devoir de Sujet, et de Citoyen ma fait braver pour / MON ROI et pour MA PATRIE; GRAND DIEU, qui / avez joint à cette Grace, celle de me rendre Témoin du plus / beau des Regnes; daignés entendre ma prière, Conservés, / Ô MON DIEU, conservés LE ROI, LA REINE, et toute / L'AUGUSTE FAMILLE ROYALE; mettés le comble / à vôtre amour pour le Peuple Français, en accordant au digne / et Jeune SOUVERAIN que vous lui avés donné dans vôtre / bonté, la Carriere la plus fortunée, la plus glorieuse, et la / plus longue que jamais vous ayez accordé à aucun mortel. // . D . S . F . R . [? (Que) Dieu Sauve la France et le Roi].*

(O God, who by a very special protection has seen fit to watch over my preservation amidst the dangers that my duty as a subject and as a citizen have caused me to brave for my king and my country; great God, who has joined to this grace that of rendering me a witness of the most splendid of reigns, deign to hear my prayer. Preserve, O my God, preserve the king, the queen, and all the august royal family. Set the seal on your love for the French people in granting the young and worthy sovereign whom in your goodness you have given it, the happiest, most glorious, and longest career that you have ever granted any mortal. D.S.F.R. [?God save France and the king].)

The petitioner prays to God, kneeling with his arms outstretched before a large cross with the south facade of the Versailles palace in the distance, recognizable by the projecting mass of the chapel. Executed on a piece of paper 4¼ by 6¼ in. (10.7 by 15.8 cm), the drawing was pasted onto the page and extended on the left and at the bottom, making its overall dimensions 4⅝ by 6½ in. (11.7 by 16.6 cm).

40. Titled: *RETOUR DE SA MAJESTÉ / de Son Sacre à Rheims.* (His Majesty's return from his coronation at Reims.) *Inscribed below the illustration: TRIOMPHES ANTIQUES / de la Grece et de Rome, Qu'etes vous auprés / de celui-cy? De farouches Vainqueurs n'en /*

58. L'Escalier (The Curving Stair)

Black chalk, pen and black and brown ink, watercolor, and touches of gouache, on off-white laid paper, $7\frac{5}{8} \times 5$ in. (19.5 × 12.6 cm)
Signed and dated in pen and gray ink at lower right: 1778 [partially obscured] / G dSA / 1779. Illegible graphite inscription at upper left. Possibly the mark of E. Calando (Lugt 837), partially visible at lower left.
The Metropolitan Museum of Art, New York, Gift of Mrs. Charles Wrightsman, 2004 (2004.475.5)

PROVENANCE
E. Calando, Paris ([Lugt 837], until d. 1899); his estate sale, Hôtel Drouot, Paris, December 11–12, 1899, lot 201; sale, Hôtel Drouot, Paris, December 19, 1919, lot 12; Richard Owen, Paris; John Nicholas Brown (1927–79); on loan to the Fogg Art Museum, Cambridge, Massachusetts (March 13–November 2, 1929); on wartime loan to the Joslyn Art Museum, Omaha, Nebraska (January 5, 1941–November 11, 1944); John Nicholas Brown estate (1979–86); [David Tunick, Inc., New York, 1986; sold to Wrightsman]; Mrs. Charles Wrightsman, New York (from 1986); her gift in 2004 to the Metropolitan Museum.

EXHIBITED
Hôtel Jean Charpentier, Paris, April 7–29, 1925, "Exposition des Saint-Aubin," no. 80 (lent by Richard Owen); Fogg Art Museum, Cambridge, Massachusetts, summer 1962, "Forty Master Drawings from the Collection of John Nicholas Brown," no. 31.

LITERATURE
Dacier 1929–31, vol. 2, p. 77 no. 471.

This charming vignette of a stylish young woman and a small boy hurrying up a curving stone stair has the air of observed reality shared by many of Saint-Aubin's views of the French capital. Although fantasy and reality are frequently intermingled in his larger compositions, a great number of the smaller sketches must have been inspired simply by everyday scenes witnessed in the streets, parks, and other public spaces of Paris. The artist's brother Charles-Germain de Saint-Aubin (1721–1786) described Gabriel's passion for drawing as almost involuntary, saying he drew "at all times, and in all places."[1]

Though Saint-Aubin may well have observed such a scene, his use of the rounded stone archway as a framing device and the upward curve of the stair, moving from dark to light, all display a strong awareness of Rococo aesthetic principles. The curved compositional axis is reinforced by the progress of the pair as they move upward toward a diffused, blurred light. The playful dog jumping near their feet suggest their errand as one of pleasure, while the woman near the top of the stairs carrying a long object is perhaps doing her shopping. Drawings such as this one support our view of Saint-Aubin as a prowler of the city's public spaces, paper and chalk always on hand to capture an elegant or amusing figure going about his or her daily life. The painterly touches of pen and wash were presumably added back in the studio.

The illegible inscription at the upper left may have offered clues to the location of the scene. It has not been identified by modern scholars, although Dacier's description of the stairs as subterranean is reinforced by the irregularity of the rough-hewn stones elsewhere in the arch and along the stairs. The architectural column along the right margin, with its alternating bands of rusticated decoration, is reminiscent of the Italianate stonework at Marie de' Medici's Luxembourg Palace.

PS

NOTE

1. From a biographical caption inscribed by Charles-Germain in the album *Livre des Saint-Aubin* (Musée du Louvre, Paris), illustrated in Pierre Rosenberg, *Le livre des Saint-Aubin* (Paris, 2002), pp. 66–67 no. 15.

vice, let me at least be allowed to occupy my cruel leisure with the brilliance of his reign, and to portray below, in my own manner and without flattery, a pale notion of the happiness of your people.)

36. Titled: *Le Roi Louis xvi // En son Conseil D'Etat.* (King Louis XVI in his Council of State.) *Inscribed below the illustration: // La Déèsse Cerés, à la droite du Prince en son Conseil: Elle lui présente le medaillon / du Monarque qu'il a choisy pour son modéle, et qui a toujours, ainsi que lui, regardé / l'Agriculture, comme la premiere source du bonheur des hommes. / PALLAS Déesse de la Sagesse, est l'Ame de tous les projets du ROI, Déesse à la fois / des Sciences et des beaux arts, elle les rassemble tous autour de Trône, et elle prèside / aux nobles amusemens de SA MAJESTÉ. / LE DIEU Mercure, qui fait fleurir les Arts par le commerce, montrant avec son / Caducée la Couronne Royale placée sur la Charrüe, annonce ainsi le tendre Amour / de SA MAJESTÉ pour les habitans des Campagnes, et le desir sincére qu'il a de leur / bonheur. / LE DIEU Mars, enfin, appuié sur son Epée, annonce par son attitude tranquille, mais terrible, qu'il est toujours prêt à la tirer pour la défense du Prince et de / son Etât. Les Génies qu'on voit sur le devant, indiquent le triomphe des Arts, / la Gloire des Peuples, et leur tranquilité sous le Gouvernement de sa Majesté.*

(The goddess Ceres, at the right hand of the prince in his council: she shows him the medallion of the monarch whom he has chosen as his model, and who always considered agriculture, as he does, to be the principal source of men's happiness. Pallas, goddess of wisdom, is the moving spirit of all the king's projects; goddess both of the sciences and of the fine arts, she gathers them all around the throne, and she presides over the noble diversions of His Majesty. The god Mercury, who causes the arts to flourish through commerce, indicating with his caduceus the royal crown placed on the plow, thus proclaims His Majesty's tender love for the peasantry and the sincere wish he has for their happiness. The god Mars, finally, leaning on his sword, announces by his calm yet awesome attitude that he is always ready to draw it in defense of the prince and of his state. The geniuses seen in the foreground show the triumph of the arts, the glory of the people, and their peaceful existence under His Majesty's government.)

The king, who is presiding at the council table, is crowned by the allegorical figure of glory, assisted by Minerva, Mercury, the arts and fame; Ceres presents him with a medallion showing the bust of Henry IV and several allegorical figures embodying the goals of the new regime. The book on which Mars rests his right hand, with its inscribed cover, is the *Ordonnances de Louis XVI.* In a fold of Mars's cloak, the initials *S. A.* Below the book are the initials *S. A.* The drawing, which is pasted onto the page, measures 4⅜ by 6⅜ in. (11.2 by 16.3 cm).

37. (Numbered 14 by the artist). Titled: *PRIÉRE / Pour le Roi.* (Prayer for the king.) Inscribed below the illustration: *Ô DIEU; qui par une protection toute particuliere, avés bien / voulu veiller sur ma conservation au milieu des hazards, / que mon devoir de Sujet, et de Citoyen ma fait braver pour / MON ROI et pour MA PATRIE; GRAND DIEU, qui / avez joint à cette Grace, celle de me rendre Témoin du plus / beau des Regnes; daignés entendre ma prière, Conservés, / Ô MON DIEU, conservés LE ROI, LA REINE, et toute / L'AUGUSTE FAMILLE ROYALE; mettés le comble / à vôtre amour pour le Peuple Français, en accordant au digne / et Jeune SOUVERAIN que vous lui avés donné dans vôtre / bonté, la Carriere la plus fortunée, la plus glorieuse, et la / plus longue que jamais vous ayez accordé à aucun mortel. // . D . S . F . R . [? (Que) Dieu Sauve la France et le Roi].*

(O God, who by a very special protection has seen fit to watch over my preservation amidst the dangers that my duty as a subject and as a citizen have caused me to brave for my king and my country; great God, who has joined to this grace that of rendering me a witness of the most splendid of reigns, deign to hear my prayer. Preserve, O my God, preserve the king, the queen, and all the august royal family. Set the seal on your love for the French people in granting the young and worthy sovereign whom in your goodness you have given it, the happiest, most glorious, and longest career that you have ever granted any mortal. D.S.F.R. [?God save France and the king].)

The petitioner prays to God, kneeling with his arms outstretched before a large cross with the south facade of the Versailles palace in the distance, recognizable by the projecting mass of the chapel. Executed on a piece of paper 4¼ by 6¼ in. (10.7 by 15.8 cm), the drawing was pasted onto the page and extended on the left and at the bottom, making its overall dimensions 4⅝ by 6½ in. (11.7 by 16.6 cm).

40. Titled: *RETOUR DE SA MAJESTÉ / de Son Sacre à Rheims.* (His Majesty's return from his coronation at Reims.) Inscribed below the illustration: *TRIOMPHES ANTIQUES / de la Grece et de Rome, Qu'etes vous auprés / de celui-cy? De farouches Vainqueurs n'en /*

devoient les Palmes qu'au ravage de l'Uni- / vers . . . LOUIS ne fonde sa Gloire que sur / la Prosperité de son Païs. / Leur Félicité, étoit de commander à des Peuples / Esclaves, celle de LOUIS de Regner sur un / Peuple libre. / Leurs Conquêtes étoient l'Or et les Trésors / du Monde, celles de LOUIS les cœurs de / tous ses Sujéts.

(Ancient triumphs of Greece and Rome—What are you beside this? Fierce conquerors owed the palms of victory only to laying waste the universe . . . Louis establishes his glory only on the prosperity of his peace. Their felicity was to rule peoples enslaved, that of Louis is to reign over a free people. Their conquests were the gold and treasures of the world, those of Louis the hearts of all his subjects.)

The king's chariot is decorated with his monogram: double, interlaced *L*s surrounding the letter *A* for Auguste and the numeral *XVI* below. In the background to the left, one sees the facade of Reims Cathedral, although the right side resembles the colonnade of the still unfinished church of Saint-Geneviève (the future Panthéon) with the old tower of the church, dedicated to the patron saint of Paris. Dated on the base of the plinth, lower left: *1775*. Cut out and pasted onto the page, the drawing measures 2½ by 6¼ in. (6.5 by 16 cm).[16]

41. (Numbered 15 by the artist). Titled: *CONCLUSION GÉNÉRALE.* (General conclusion.) Inscribed below the illustration: *CE DOUBLE PLACET par sa forme inusitée, / ayant arrêté quelques instans les regards des deux Princes fréres / de SA MAJESTÉ, ils daignent à cette occasion adrésser la parole à / l'Auteur dans la Gallerie de Versailles, vous ne pouvés, lui dit l'un / de ces Princes, compter sur vôtre remplacement dans les Régimens / Provinciaux, puisque le ROI vient de les Reformer.*

(This double petition, having by its unusual form at times attracted the attention of the two princes, brothers of His Majesty, they deign on this occasion to speak to the author in the gallery at Versailles: You cannot, says one of the princes, count on your reinstatement in the provincial regiments, since the king has just reformed them.)

L'OFFICIER / MONSEIGNEUR, dans le malheur de cette Réforme la troisiéme que / J'éprouve, il ne me reste qu'un seul party, ce seroit d'étre jugé digne / d'occuper une place, charge, ou Employ quelconque, soit dans la / Maison du ROI, soit dans l'une des PRINCES SES AUGUSTES FRERES, / soit dans celle ᵈᵉ MONSEIGNEUR LE DUC D'ANGOULÊME, lors quelle se / fera . . .

(The officer: Your Royal Highness, in the misfortune of this reform, the third that I have experienced, there remains for me only a single course: to be judged worthy to occupy a place, office, or some employment whether in the king's household, or in that of one of the princes, his august brothers, or in that of his grace the duc d'Angoulême, when this is formed . . .) / /

LE PRINCE. / Mais vous trouverés tout remply dans les deux Maisons. (The prince: But you will find everything filled in both households.) *L'OFFICIER. / En ce cas MONSEIGNEUR, je n'en demande que l'Expectative sans nuls / Émolumens: L'honneur de tenir par quelque service à l'Auguste / MAISON ROYALE ne fût-ce que par un fil suffira à mon bonheur, / et à mon Ambition.*

(The officer: In that case, Your Royal Highness, I ask only for the prospect without any emolument: the honor of being connected by some service with the august royal house, if only by a thread, will be enough for my happiness and my ambition.)

LES PRINCES, daignent recevoir cette Demande avec bonté, et / n'y donnant point une Exclusion formelle; Cet Officier se retire comblé / de l'honneur, qu'il vient de recevoir, et le cœur plein d'Espérance. (The princes deign to receive this request with kindness and without giving it a formal refusal. This officer withdraws, overcome with the honor he has just received and with his heart full of hope.)

The last illustration and its text are an enigma. Most of the manuscript was prepared during the first six months of 1775, but the duc d'Angoulême, the eldest son of the comte d'Artois, was born on August 6, 1775, thus proving that this page was added at a later date, when the petitioner, presumably not having been given a favorable hearing by Louis XVI, decided to solicit a position with the king's brothers, or perhaps, the newborn prince. The text also refers to reforms instituted by the minister of war, the Maréchal Du Muy, who died in October 1775.

The artist's observation of the details of the scene is remarkably precise: he distinguishes, for example, between the two types of table sconces, or *guéridon porte-girandoles*, that were used to light the Hall of Mirrors; they were based on models by Augustin Pajou (the woman carrying a cornucopia) and Jacques Gondoin (the group of children).[17] Another surprising detail is a blocked passage with a partition painted in trompe l'oeil in the arcade located between the Hall of Mirrors and the Salon of Peace, which was reattached to the queen's apartment during the reign of Marie Leczinski.[18] In the background, a group of people leave

the Salon de l'Œil-de-Boeuf. Inscribed along the bottom: *221 pied de long 32 pied de large 37 du haut* (221 feet long, 32 feet wide, 37 high); cut out and pasted onto the page, the drawing measures 2½ by 6¼ in. (6.5 by 15.9 cm).

EF/AG

NOTES

The authors wish to thank Mary Laing, Asher Miller, and Rebecca Tilles for their contributions to this entry.

1. Dacier 1929–31, vol. 2, p. 187 no. 1025.
2. Émile Franceschini, in *Dictionnaire de biographie française*, ed. Roman d'Amat and R. Limouzin-Lamothe, vol. 10 (Paris, 1965), col. 1199.
3. Paper currency issued by the Revolutionary government, 1789–96.
4. When Dacier catalogued the booklet, he described this note as a loose leaf, inserted at the illustration *Couronnement de Sa Majesté* (page 30 of the *Placets*). The handwriting, though old, was not Saint-Aubin's but was undoubtedly copied from the artist's original text "car c'est lui qui parle" (for it is he who speaks); Dacier 1929–31, vol. 2, p. 188.
5. See page 27 of the *Placets*, numbered 9 by the artist.
6. Émile Dacier, "Gabriel de Saint-Aubin peintre," *Revue de l'art ancien et moderne* 31 (February 1912), p. 124, reports that Saint-Aubin's painting *Le trait de bienfaisance de la reine à Fontainebleau* was exhibited at the Salon of the Académie de Saint-Luc in 1774; Dacier 1929–31, vol. 2, p. 104 no. 595, says it was shown at the Salon du Colisée in 1776 (no. 224). Its present whereabouts are unknown. A sketch of this subject in brown wash dated 1773 was in the collection of baroness Élie de Rothschild (d. 2003); it is reproduced in Philippe Huisman and Marguerite Jallut, *Marie-Antoinette: L'impossible bonheur* (Lausanne, 1970), p. 76. An engraving by A. Duclos, of 1775, was published in M. Fromageot, *Annales du règne de Marie-Thérèse* (Paris, 1781), pp. 246–49.
7. Dacier 1929–31, vol. 2, p. 104 no. 595.
8. Dacier, "Gabriel de Saint-Aubin," pp. 124, 131. This page of the *Placets* was first reproduced and discussed by Albert Vauflart and Henri Bourin, *Les portraits de Marie-Antoinette: Étude d'iconographie critique* (Paris, 1910), vol. 2, p. 90, pl. XXIX.
9. See Marguerite Prinet, "Le linge du roi," and Béatrix Saule, "Tables royales à Versailles, 1682–1789," in *Versailles et les tables royales en Europe: XVIIᵉᵐᵉ–XIXᵉᵐᵉ siècles,* exh. cat., Musée National de Château de Versailles (Paris, 1993), pp. 41–68 and 124–27.
10. This was "Iphigénie en Aulide" (1774). Gluck was to write "Iphigénie en Tauride" in 1799.
11. Louis Petit de Bachaumont, *Mémoires secrets pour servir à l'histoire de la république des lettres en France, depuis MDCCLXII jusqu'à nos jours,* vol. 7 (London, 1777), pp. 300–302, under the date January 14, 1775.
12. Dacier 1929–31, vol. 2, p. 188.
13. An almost identical drawing by Bélanger belongs to the Metropolitan Museum. See Jacob Bean and Lawrence Turčić, *15th–18th Century French Drawings in The Metropolitan Museum of Art* (New York, 1986), pp. 22–23 no. 7.
14. The ceremonial details of the coronation are described in Alain Gruber, *Les grandes fêtes et leurs décors à l'époque de Louis XVI* (Geneva, 1972), pp. 88–102, figs. 59–61.
15. The Prussian village of Hastenbeck, now a suburb of Hamelin, was the site of a battle on July 26, 1757, early in the Seven Years' War (1756–63), between the French and the Anglo-Hanoverian forces, the latter under the command of the duke of Cumberland, the second surviving son of George II. Outnumbered, Cumberland withdrew and in September 1757 signed the convention of Kloster-Zeven, abandoning Hanover and Brunswick to the French.
16. A preparatory study for this illustration belongs to the Rijksmuseum, Amsterdam; see Denys Sutton, *France in the Eighteenth Century*, exh. cat., Royal Academy of Arts, London (London, 1968), p. 118 no. 639.
17. See Pierre Verlet, *Le mobilier royal français* (Paris, 1945), pp. 59–60.
18. Pierre Verlet, *Le château de Versailles* (Paris, 1985), pp. 398, 592.

58. L'Escalier (The Curving Stair)

Black chalk, pen and black and brown ink, watercolor, and touches of gouache, on off-white laid paper, 7⅝ × 5 in. (19.5 × 12.6 cm)
Signed and dated in pen and gray ink at lower right: 1778 [partially obscured] / G dSA / 1779. Illegible graphite inscription at upper left. Possibly the mark of E. Calando (Lugt 837), partially visible at lower left.
The Metropolitan Museum of Art, New York, Gift of Mrs. Charles Wrightsman, 2004 (2004.475.5)

PROVENANCE
E. Calando, Paris ([Lugt 837], until d. 1899); his estate sale, Hôtel Drouot, Paris, December 11–12, 1899, lot 201; sale, Hôtel Drouot, Paris, December 19, 1919, lot 12; Richard Owen, Paris; John Nicholas Brown (1927–79); on loan to the Fogg Art Museum, Cambridge, Massachusetts (March 13–November 2, 1929); on wartime loan to the Joslyn Art Museum, Omaha, Nebraska (January 5, 1941–November 11, 1944); John Nicholas Brown estate (1979–86); [David Tunick, Inc., New York, 1986; sold to Wrightsman]; Mrs. Charles Wrightsman, New York (from 1986); her gift in 2004 to the Metropolitan Museum.

EXHIBITED
Hôtel Jean Charpentier, Paris, April 7–29, 1925, "Exposition des Saint-Aubin," no. 80 (lent by Richard Owen); Fogg Art Museum, Cambridge, Massachusetts, summer 1962, "Forty Master Drawings from the Collection of John Nicholas Brown," no. 31.

LITERATURE
Dacier 1929–31, vol. 2, p. 77 no. 471.

This charming vignette of a stylish young woman and a small boy hurrying up a curving stone stair has the air of observed reality shared by many of Saint-Aubin's views of the French capital. Although fantasy and reality are frequently intermingled in his larger compositions, a great number of the smaller sketches must have been inspired simply by everyday scenes witnessed in the streets, parks, and other public spaces of Paris. The artist's brother Charles-Germain de Saint-Aubin (1721–1786) described Gabriel's passion for drawing as almost involuntary, saying he drew "at all times, and in all places."[1]

Though Saint-Aubin may well have observed such a scene, his use of the rounded stone archway as a framing device and the upward curve of the stair, moving from dark to light, all display a strong awareness of Rococo aesthetic principles. The curved compositional axis is reinforced by the progress of the pair as they move upward toward a diffused, blurred light. The playful dog jumping near their feet suggest their errand as one of pleasure, while the woman near the top of the stairs carrying a long object is perhaps doing her shopping. Drawings such as this one support our view of Saint-Aubin as a prowler of the city's public spaces, paper and chalk always on hand to capture an elegant or amusing figure going about his or her daily life. The painterly touches of pen and wash were presumably added back in the studio.

The illegible inscription at the upper left may have offered clues to the location of the scene. It has not been identified by modern scholars, although Dacier's description of the stairs as subterranean is reinforced by the irregularity of the rough-hewn stones elsewhere in the arch and along the stairs. The architectural column along the right margin, with its alternating bands of rusticated decoration, is reminiscent of the Italianate stonework at Marie de' Medici's Luxembourg Palace.

PS

NOTE

1. From a biographical caption inscribed by Charles-Germain in the album *Livre des Saint-Aubin* (Musée du Louvre, Paris), illustrated in Pierre Rosenberg, *Le livre des Saint-Aubin* (Paris, 2002), pp. 66–67 no. 15.

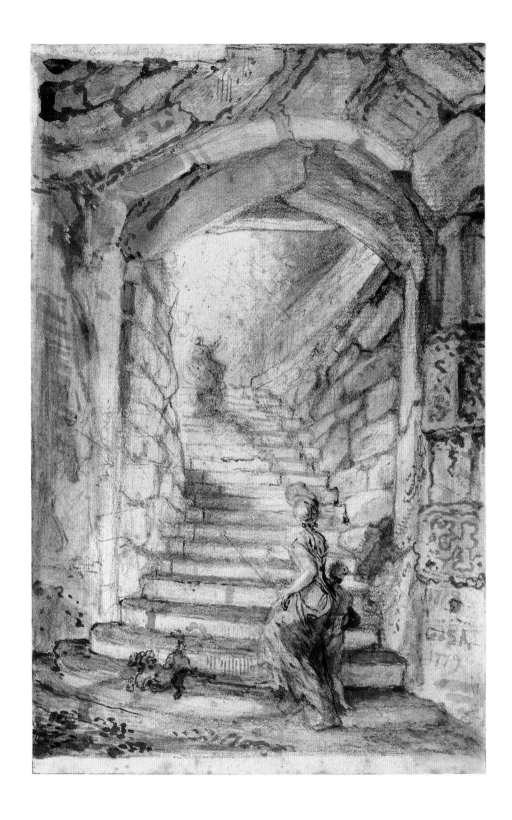

AUGUSTIN DE SAINT-AUBIN

(1736–1807)

Augustin de Saint-Aubin was the sixth born in a family of seven children, all of them artistic to various degrees. Their father, Gabriel Germain de Saint-Aubin (1696–1756), was an embroiderer to the king. The eldest, Charles-Germain (1721–1786), also designed embroidery and other forms of ornament for the court. Second born was Gabriel (see p. 195). Brother Louis-Michel (1731–1779) supplied designs to the Sèvres porcelain factory. Drawings by Charles-Germain, Gabriel, Augustin, and some of their lesser-known siblings were collected by Charles-Germain and mounted in an album titled Livre des Saint-Aubin, now in the Louvre.[1]

Augustin received his earliest training from his brother Gabriel before going on to study with the reproductive printmakers Étienne Fessard (1714–1777) and Nicolas-Henry Tardieu (1674–1749). Although he was approved by the Académie Royale in 1771 and would exhibit drawings and prints at the biennial Salons from 1771 to 1793, Augustin never submitted the reception piece required to become a full academician. His aesthetic was in many ways the opposite of his brother Gabriel's: whereas Gabriel was inventive and highly original, picking novel subjects, fluidly mixing allegory and reality, and experimenting with different combinations of media and techniques, Augustin worked in a refined and delicate style within clearly established formats.

In 1776 Augustin de Saint-Aubin was appointed Dessinateur et Graveur de la Bibliothèque Royale and shortly afterward began to work in the same capacity for the duc d'Orléans, whose large collection of antique gems he etched. Over 1,300 works by and after Augustin are recorded in Emmanuel Bocher's 1879 catalogue. While he also designed medals and genre vignettes, Augustin is best remembered for his exquisite portraits, in both drawings and prints, an emphasis evident in the works he selected for his submissions for the biennial Salons held at the Louvre.[2]

PS

ABBREVIATION

Bocher 1879. Emmanuel Bocher. Les gravures françaises du XVIII^e siècle. Vol. 5, Augustin de Saint-Aubin. Paris, 1879.

NOTES

1. See Pierre Rosenberg, Le livre des Saint-Aubin (Paris, 2002).
2. They are listed chronologically in Bocher 1879, pp. 231–34.

59. Profile Portrait of a Woman

Graphite, red and black chalk, with touches of blue wash, on off-white antique laid paper, oval, 6 × 5 in. (15.3 × 12.8 cm)

PROVENANCE
Camille Groult, Paris; his collection sale, Galerie Charpentier, Paris, March 21, 1952, lot 56, pl. XXVIII; sale (various owners), Galerie Charpentier, Paris, November 30, 1955, lot 13; Mme Marcel Guiot, Paris (in 1959); [Galerie Cailleux, Paris; sold to Humann]; Christian Humann, New York; [Didier Aaron, 1987; sold to Wrightsman]; Mrs. Charles Wrightsman, New York (from 1987).

EXHIBITED
Galerie Madame Marcel Guiot, Paris, November 20–December 19, 1959, "De Watteau à Picasso: Le charme dans le dessin français," no. 31.

Although he did not formally study with Charles-Nicolas Cochin the Younger (see p. 192), Augustin de Saint-Aubin made many etchings after Cochin's portrait drawings, and it is Cochin, more than Augustin's brother Gabriel, who should be considered his primary artistic mentor. Indeed, Cochin's medallion-format profile portraits, inspired by antique examples, would have a strong influence on French conceptions of portraiture throughout the second half of the eighteenth century. This debt notwithstanding, a difference of aesthetic temperament distinguished their portrait drawings: Cochin's are characterized by a simplicity of approach and a monochrome palette, while those by Saint-Aubin demonstrate a somewhat less severe, more decorative technique, often with diaphanous touches of color. In the Salon livrets (booklets), this use of media, described as "graphite mixed with a little pastel,"[1] was frequently specified in connection with Saint-Aubin's portraits even when the identity of the sitter was not.

The result, as embodied in the Wrightsman sheet, achieves an equilibrium between the Rococo sensibility and the fashionable taste for the antique, a combination very much to the liking of Augustin's contemporaries. Touches of red chalk add bloom to the complexion and the lips and draw attention to the spray of roses at the sitter's neckline. A transparent blue wash is employed for the dress and the flower's leaves. The use of the oval rather than round format expands the focus from simple facial physiognomy; traces of the preliminary sketch visible in the margin indi-

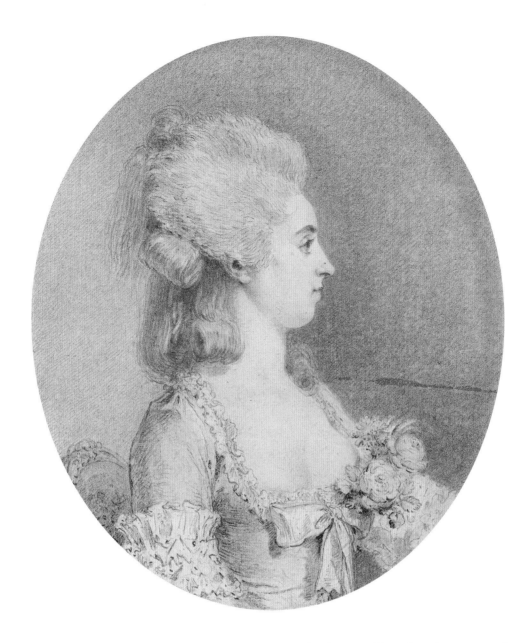

cate that Saint-Aubin first made a rough half-length study of the figure before establishing the oval border and bringing its interior to a high level of finish. The low décolletage and the juxtaposition of the nipple and the rosebud follow a well-established paradigm of feminine beauty.

As the Wrightsman drawing was never engraved and bears no inscription, it has not been possible to identify the sitter.[2] Nonetheless, the clothing and hairstyle offer clues as to the date of the sheet. Hairstyles with the essential combination of frizzed hair on the top and sides of the head and large set curls around the neck made their first appearance about 1780 in France, where they were sometimes referred to by the name *hérisson,* or hedgehog.[3] Although the frizzed hairstyle remained popular for a number of years, the dress would not have been worn after 1789, suggesting a date of circa 1780–89 for the drawing; assuming the sitter was depicted in the latest fashions, however, the years 1780–82 would be a more likely time frame. PS

Notes

1. See Bocher 1879, pp. 232–34.
2. Although in the past the portrait has been referred to as a presumed likeness of the artist's wife, comparison with the physiognomy of known portraits does not support this idea.
3. Plates featuring popular hairstyles for 1780 can be found in *Galerie des modes et costumes français dessinés d'après nature* (Paris, 1779–80), vol. 2, pls. 200–204. See also the dress in the upper-left medallion of plate 202; it has a square, lace-edged décolletage very similar to the dress in the Wrightsman drawing.

JEAN-ÉTIENNE LIOTARD

(1702–1789)

Born to a French Huguenot family that had settled in Geneva after the revocation of the Edict of Nantes (1685), Liotard trained briefly with miniaturist Daniel Gardelle (1679–1753) before coming to Paris in 1723 to apprentice with Jean-Baptiste Massé (1687–1767), a miniature painter and engraver. He quickly surpassed his teachers in the perfection of his technique and his astounding ability to capture a likeness. Of a peripatetic nature, Liotard traveled to Naples in 1735 with the comte de Puisieux, French ambassador to the city, then the following year accepted the offer of William Ponsonby, later second Earl of Bessborough, to accompany him on his Grand Tour of Greece and Turkey.

It was the exoticism of the Ottoman Empire, above all, that captured Liotard's imagination. He brought back to Europe not only a large group of precisely observed red- and black-chalk drawings of Turkish and Western sitters in simple interiors enlivened by richly patterned Ottoman textiles but also trunks of clothing and accessories. For many years after, he sported Turkish garb and a long beard, cultivating an eccentric persona that contributed to his renown in European courts.

After returning to Europe, Liotard's travels took him to Vienna, Venice, Darmstadt, Paris, London, and The Hague. Even if his reception by local artists was not always warm, his facility for unembellished resemblance inevitably won him numerous portrait commissions. Among his most popular works, often reprised in several versions, were his brilliant, almost shadowless exotic genre scenes rendered in a pastel technique of breathtaking fidelity to the tactile surfaces depicted. Late in life Liotard returned to Geneva, where he made portraits of friends and family members and produced a series of still lifes in pastel and oil, hauntingly spare in their presentation.

PS

ABBREVIATIONS
Bull 2002. Duncan Bull, with the assistance of Tomas Macsotay Bunt. *Jean-Étienne Liotard (1702–1789).* Rijksmuseum Dossiers. Zwolle, 2002.
Geneva, Paris 1992. Anne de Herdt. *Dessins de Liotard: Suivi du catalogue de l'oeuvre dessiné.* Exh. cat. Musée d'Art et d'Histoire, Geneva, and Musée du Louvre, Paris. Geneva and Paris, 1992.

60. *Woman in Turkish Dress, Seated on a Sofa*

Pastel over red chalk underdrawing on parchment, 23 × 18 ⅝ in. (58.5 × 47.2 cm)

PROVENANCE
Charles Agee Atkins, New York; [J. Barry Donahue Fine Arts, Inc., New York, 1983; sold to Wrightsman]; Mr. and Mrs. Charles Wrightsman, New York (1983–his d. 1986); Mrs. Wrightsman (from 1986).

RELATED WORK
PARIS, Musée du Louvre, Département des Arts Graphiques (RF 1388). Jean-Étienne Liotard, *Young Woman in a Turkish Interior* (fig. 3). Counterproof in red and black chalk, retouched in red chalk, on white antique laid paper, 8 ⅜ × 6 in. (21.2 × 15.2 cm).

VERSIONS
AMSTERDAM, Rijksmuseum. Jean-Étienne Liotard, *Woman in Turkish Dress, Seated on a Sofa* (fig. 2). Pastel on parchment, 39 ⅜ × 29 ½ in. (100 × 75 cm).
GENEVA, Musée d'Art et d'Histoire (1930-20). Jean-Étienne Liotard, *Woman in Turkish Dress, Seated on a Sofa* (fig. 1). Pastel on parchment, 9 ¼ × 7 ½ in. (23.5 × 19 cm).
PRIVATE COLLECTION. Jean-Étienne Liotard?, *Woman in Turkish Dress, Seated on a Sofa.* Oil on canvas, 23 ⅞ × 19 ⅞ in. (60.7 × 50.4 cm).

This enigmatic composition of a beautiful but melancholic young woman in exotic dress exists in at least three versions, testimony to its popularity among Liotard's patrons. The group has engendered a long-running debate among scholars over issues of dating, chronology, and the identity of the sitter. The Wrightsman pastel is closest to a smaller pastel on parchment in the Musée d'Art et d'Histoire, Geneva (fig. 1).[1] A larger version, also pastel on parchment, in which the ripped-up letter on the carpet is replaced by a vase of flowers, is in the Rijksmuseum, Amsterdam (fig. 2).[2] Finally, a singular treatment of the composition in oil paint, with a wall added to the sitter's right, placing her in a corner, is accepted by Renée Loche, Marcel Roethlisberger, and Anne de Herdt but is considered a copy by Alastair Laing.[3] All are ultimately based on a lost red- and black-chalk drawing made by Liotard during his stay in the Levant (1738–42), known through a counterproof in the Louvre (fig. 3).[4] Despite variations in size and coloring, all of the pastels closely follow the chalk drawing; Liotard added only the richly colored carpet and the still-life elements placed on it.

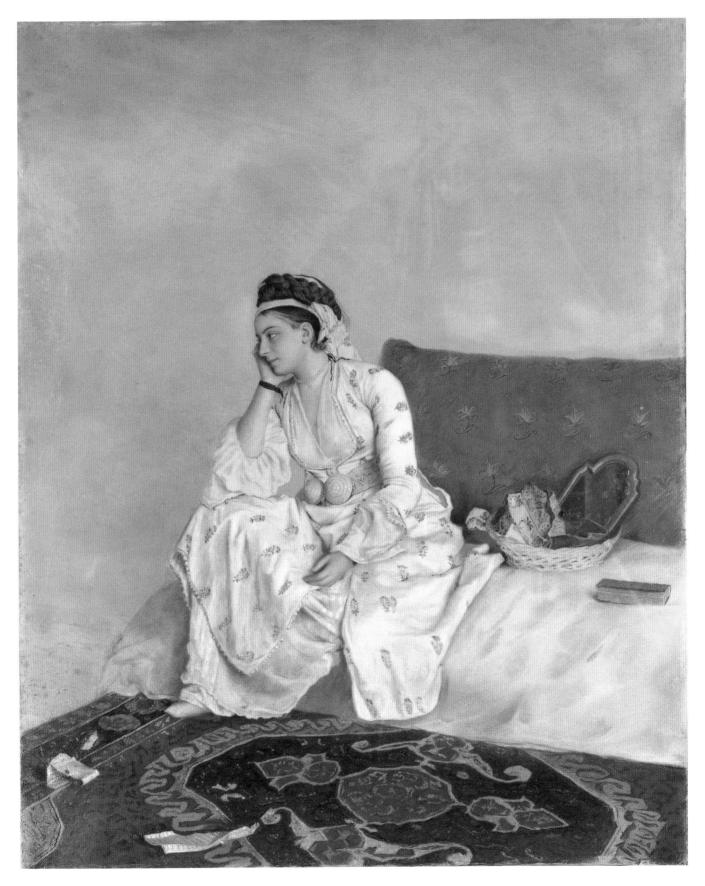

Fig. 1. Jean-Étienne Liotard, *Woman in Turkish Dress, Seated on a Sofa*. Pastel on parchment, 9¼ × 7½ in. (23.5 × 19 cm). Musée d'Art et d'Histoire, Geneva (1930-20)

Fig. 2. Jean-Étienne Liotard, *Woman in Turkish Dress, Seated on a Sofa*. Pastel on parchment, 39⅜ × 29½ in. (100 × 75 cm). Rijksmuseum, Amsterdam (SK-A-240)

It is known from inscriptions on some of his drawings that Liotard occasionally drew local women in their native dress on his travels through Italy and Greece. The numerous drawings from his stay in the Ottoman Empire, however, are much more likely to depict European women or local non-Muslim women who would permit themselves to be drawn unveiled. Intriguingly, an inscription (although not in the hand of the artist) on the back of the frame of the Geneva pastel gives the name of the sitter as Mimica.[5] The composition presumably would have been considered simply as a genre scene were it not for the caption on a reproductive print—by Richard Houston, after the Rijksmuseum version—identifying the sitter as Mary Gunning, countess of Coventry (1732–1760), a legendary English beauty.[6] The whole group came to be referred to as portraits of the countess of Coventry until 1988, when Danielle Buyssens proposed that only the Amsterdam version portrayed the countess, while the rest reused the composition but depicted other sitters,[7] a theory

accepted by de Herdt in 1992. Alastair Laing rejected this idea later in 1992, when he pointed out that the Liotard pastels much more closely resemble one another than they do any known portrait of Mary Gunning and that it was common practice for print publishers to add apocryphal names of celebrated figures as captions to images to enhance sales.[8] Indeed, many of Liotard's exotic genre scenes exist in multiple versions produced for the European market, whereas he typically invented new poses for each portrait sitter.

The pose, with its echoes of Dürer's *Melancholia,* and the still-life elements, like the mirror, that are associated with *vanitas* subjects, have led some scholars to see in Liotard's composition an eighteenth-century interpretation of Melancholy.[9] While such symbols were undoubtedly consciously employed by Liotard, the narrative touch of the torn-up letter and the sitter's wistful gaze would have summoned up in Enlightenment viewers not so much the abstract concept of melancholy but the pervasive fictional

Fig. 3. Jean-Étienne Liotard, *Young Woman in a Turkish Interior*. Counterproof in red and black chalk, retouched in red chalk, on white antique laid paper, 8⅜ × 6 in. (21.2 × 15.2 cm). Musée du Louvre, Département des Arts Graphiques, Paris (RF 1388)

the composition of the Geneva pastel (including the torn-up letter), yet in certain localized areas gives the appearance of being unfinished. Specifically, the parallel pleats in the white fabric just below the sitter's left hand, the red flowers on the cushion against the wall, the line distinguishing the wall from the floor on the left side of the composition, and the woman's shadow on the wall are all treated more summarily in the New York version than in the Geneva pastel. Small areas that give the appearance of being less than fully realized, it should be emphasized, are characteristic of Liotard's working method and are common in his pastel oeuvre. Most notable in its absence here is the woman's shadow against the wall, an important element in the Geneva composition, functioning like a phantom companion, emphasizing both her solitary condition and the other for whom she presumably pines.

PS

NOTES

1. Geneva, Paris 1992, pp. 136–37 no. 69, and *Jean-Étienne Liotard, 1702–1789, dans les collections des Musées d'Art et d'Histoire de Genève*, exh. cat., Musées d'Art et d'Histoire, Geneva (Geneva and Paris, 2002), p. 65.
2. Geneva, Paris 1992, p. 136 under no. 69, ill.; Bull 2002, pp. 22–25 no. 17.
3. Renée Loche and Marcel Roethlisberger, *L'opera completa di Liotard* (Milan, 1978), p. 101 no. 127; Geneva, Paris 1992, p. 134 no. 68; and Alastair Laing, "Geneva and Paris: Liotard," *Burlington Magazine* 134 (November 1992), p. 749.
4. RF 1388; see Geneva, Paris 1992, pp. 134–35 no. 69.
5. Loche and Roethlisberger transcribe the inscription as, "Mimica pastel peint / Pastel de p^sse Darmstat / Jean Etienne Liotard 1749," suggesting that the Geneva pastel may have been made for the princess Caroline de Hesse-Darmstadt. The year 1749 would predate Liotard's stay in London. See Loche and Roethlisberger, *Liotard*, p. 101 no. 26.
6. Geneva, Paris 1992, p. 136. The mezzotint is illustrated in Bull 2002, p. 26.
7. Danielle Buyssens, *Peintures et pastels de l'ancienne école genevoise, XVIIᵉ–début XIXᵉ siècle*, Musée d'Art et d'Histoire, Geneva (Geneva, 1988), no. 184.
8. Laing, "Geneva and Paris: Liotard," p. 749. Duncan Bull concurred in 2002; see Bull 2002, p. 26.
9. This reading, first advanced by Yvonne Boerlin, is cited in Geneva, Paris 1992, p. 136.
10. See Ali Behdad, "The Eroticized Orient: Images of the Harem in Montesquieu and His Precursors," *Stanford French Review* 13 (fall–winter 1989), pp. 109–26; Julia V. Douthwaite, *Exotic Women: Literary Heroines and Cultural Strategies in Ancien Régime France* (Philadelphia, 1992); and Perrin Stein, "Exoticism as Metaphor: *Turquerie* in Eighteenth-Century French Art" (Ph.D. dissertation, Institute of Fine Arts, New York University, 1997).
11. Bull 2002, pp. 23, 25.

treatments of romance and intrigue set in the harem that were found in contemporary fiction, theater, and art.[10]

Although Liotard's early training included miniature painting and printmaking, in the technique of pastel he seems to have been self-taught, and the porcelain-like polish he achieved in his surfaces was without precedent. In the New York and Geneva variants of *Woman in Turkish Dress,* Liotard unified the composition by limiting his palette to pearly gray whites, turquoise, and brick red, achieving an exquisite balance of sumptuously patterned fabric with the quasi-immaterial expanse of empty wall. The Amsterdam version is in a different palette, emphasizing the blue and the white and reducing the role of red, though it is, at least to some degree, unfinished, as noted by Duncan Bull.[11] Loche and Roethlisberger in 1978, followed by de Herdt in 1992, have all assigned the Geneva version a date of about 1750 and the Amsterdam version a slightly later date of 1752–54. The Wrightsman version would logically fall between those two dates; it follows

61. Portrait of a Man

Red and black chalk on off-white laid paper, verso worked in black chalk (in area corresponding to the sitter's jacket on the recto),[1] 9½ × 7⅜ in. (24.1 × 18.7 cm)

The Metropolitan Museum of Art, New York, Gift of Mrs. Charles Wrightsman, 2000 (2000.7)

PROVENANCE
Descendant of the André family of bankers in Geneva and Paris until 1999 (per Christie's); sale, Christie's, New York, January 28, 1999, lot 153, to Wrightsman; Mrs. Charles Wrightsman, New York (from 1999); her gift in 2000 to the Metropolitan Museum.

Throughout his mature years, Liotard made two types of portrait drawings: studies for pastels, which were typically on blue paper, quickly and emphatically executed, often stumped on the verso and incised for transfer; and smaller, more detailed drawings in red and black chalk, sometimes accented with watercolor, and often intended as autonomous works. These finished drawings, among which the present sheet should be counted, are often worked on the versos with broad areas of chalk or wash, corresponding to areas of flesh, clothing, and hair, which add subtle nuances of depth or hue to the tones on the recto.[2]

Although the handsome subject of the Wrightsman sheet has not been identified, the consignor to the Christie's sale in 1999, in whose family the drawing had been passed down, was described as a descendant of the André family, bankers in Geneva and Paris. Anne de Herdt has since conducted research on the André family and concluded that its male members in the mid-eighteenth century were too numerous to even propose a name.[3] Nonetheless, the aristocratic bearing, high forehead, strong jaw, and direct gaze allow the viewer to infer something of the personality of the sitter, who comes across in Liotard's direct presentation as a confident man of the world.

Using only two colors of chalk, Liotard has rendered the flesh, hair, and elegant attire of his sitter with impressive naturalism. The strong lines of the face are modeled in lightly applied hatching marks. Black chalk mixes with the red in areas of shadow as well as along the jaw line and upper lip to suggest new growth since the sitter's last shave. A simple black coat left unbuttoned reveals a richly brocaded jacket beneath. Men's fashion changed little over the middle decades of the eighteenth century. Nor did Liotard's manner in red and black chalk undergo major stylistic evolution during the central years of his maturity. Until more information can be found on the sitter, caution would advise us to propose a broad range of possible dates for the sheet, somewhere between 1750 and 1770. PS

NOTES

1. The drawing is laid down. The artist's treatment of the verso was determined by Marjorie Shelley, Sherman Fairchild Conservator in Charge, Department of Paper Conservation, Metropolitan Museum, who examined the drawing by infrared camera and by transmitted light in September 2002.
2. This practice is discussed by Marcel G. Roethlisberger, in "The Unseen Faces of Jean-Étienne Liotard's Drawings," *Drawing* 11 (January–February 1990), pp. 97–100.
3. Correspondence, September 12, 2002.

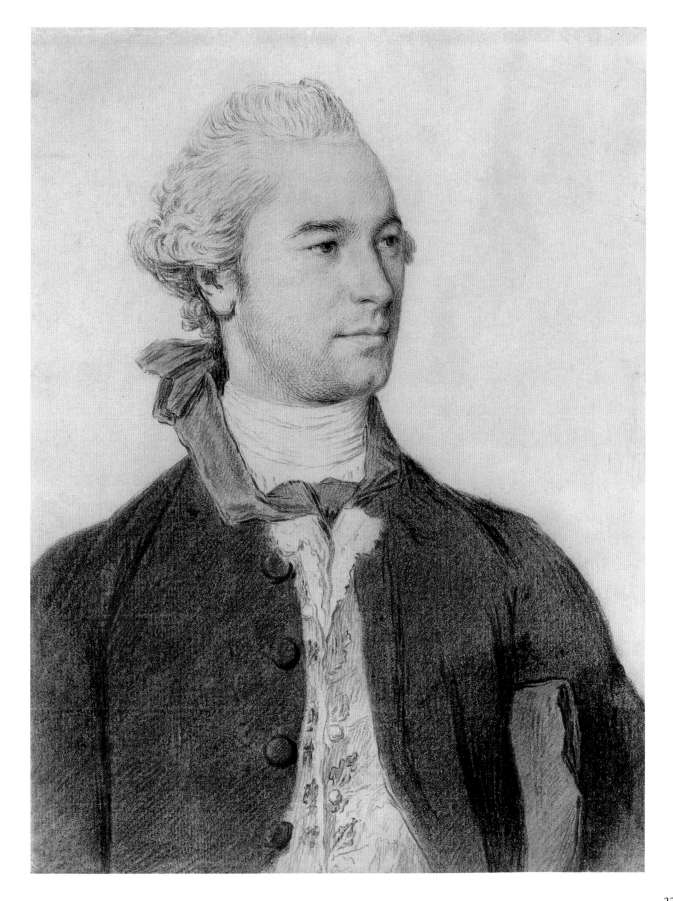

FRANCIS WHEATLEY

(1747–1801)

Born in London to a family of craftsmen (his father was a master tailor), Francis Wheatley learned the rudiments of painting from Daniel Fournier (1710–1766), then entered Shipley's Academy, where his drawings won successive prizes (in 1762, 1763, and 1765) at the Society for the Encouragement of Arts, Manufactures, and Commerce. He reportedly studied under a "Mr. Wilson," possibly the portrait painter, etcher, and scientist Benjamin Wilson (1721–1788), and traveled abroad in 1763, probably to the Low Countries and France, where he could have seen La Piété Filiale *(now in the Hermitage) by Jean-Baptiste Greuze (1725–1805) in the Paris Salon.*

Wheatley enrolled in London's new Royal Academy schools in 1769 and in 1770 was elected a fellow of the Incorporated Society of Artists, where he became a director in 1774. Between 1771 and 1773 he collaborated with John Hamilton Mortimer (1740–1779) on the ceiling of the saloon at Brocket Hall, Hertfordshire. Mortimer's lively handling of paint and masterful depiction of fabrics would inspire Wheatley's own style, as demonstrated by such small-scale, full-length portraits as the Family Group *(ca. 1775–80) in the National Gallery of Art, Washington, D.C. The conversation pieces, or small-scale, informal group portraits of Johann Zoffany (1733–1810), would provide further models.*

In 1779 Wheatley traveled to Dublin, fleeing his London creditors— and an angry husband—accompanied by a woman who claimed to be his wife (she was in fact married to the artist John Alexander Gresse [1740–1790]; later, sometime before 1788, Wheatley would legitimately marry the flower painter Clara Maria Leigh [d. 1838], with whom he had four children). In Ireland, Wheatley attempted his first large-scale subject pictures and made his name with The Irish House of Commons *of 1780 (Leeds City Art Gallery, Lotherton Hall), an impressive orchestration of 148 individual portraits. Returning to London in 1783, he began to work for the influential print publisher Alderman John Boydell (1719–1804), best known for his ambitious (if ultimately financially ruinous) scheme to commission leading artists to paint scenes from Shakespeare for exhibition in a specially constructed gallery (opened 1789) and reproduction in a luxury folio of engravings (published 1802). Wheatley would contribute thirteen scenes to the project.*

Although Wheatley continued to prepare small-scale, full-length portraits until the end of the 1780s, his attention became increasingly occupied by other subjects. In paintings such as John Howard

Visiting and Relieving the Miseries of a Prison *(Earl of Harrowby, Sandon, Staffordshire, exhibited at the Royal Academy in 1788) and in numerous exhibition watercolors of genre subjects, Wheatley offered a British counterpart to the sentimental scenes of Greuze. Wheatley was elected an associate member of the Royal Academy in 1790 and became a full academician in 1791. His final years, although plagued by debt and crippling gout, gave rise to his best-known works, the* Cries of London, *a series of fourteen paintings (Upton House, Warwickshire, the National Trust, exhibited at the Royal Academy 1792–95) and twelve related engravings (published with captions in English and French between 1793 and 1797) that depict merchants—many of them attractive young women—selling their wares.*

EEB

ABBREVIATIONS

Roberts 1910. William Roberts. *F. Wheatley, R.A.: His Life and Works, with a Catalogue of His Engraved Pictures.* London, 1910.

Webster 1965. Mary Webster. *Francis Wheatley, R.A., 1747–1801: Paintings, Drawings and Engravings.* Exh. cat., Adelburgh Festival of Music and the Arts, and City Art Gallery, Leeds. Leeds, 1965.

Webster 1970. Mary Webster. *Francis Wheatley.* London, 1970.

62. *Conversation Piece of the Saithwaite Family*

Oil on canvas, 38¾ × 50 in. (98.5 × 127 cm)

PROVENANCE
Sale, Christie's, London, November 25, 1977, lot 94 (£12,000, as "A Family Group . . . in an interior, painted circa 1787"); [Leger Galleries, London, by 1982]; [Hirschl & Adler Galleries, New York, 1982, in association with Leger Galleries, London; sold to Wrightsman]; Mr. and Mrs. Charles Wrightsman, New York (1982–his d. 1986); Mrs. Wrightsman (from 1986).

EXHIBITED
Hirschl & Adler Galleries, New York (in association with Leger Galleries, London), October 6–November 6, 1982, "British Life through Painters' Eyes, 1740–1840, and Some Aspects of Dutch Landscape, 1640–1680," no. 7.

Nothing is known of the family depicted in this "conversation piece," or small-scale, informal group portrait.[1] The surname

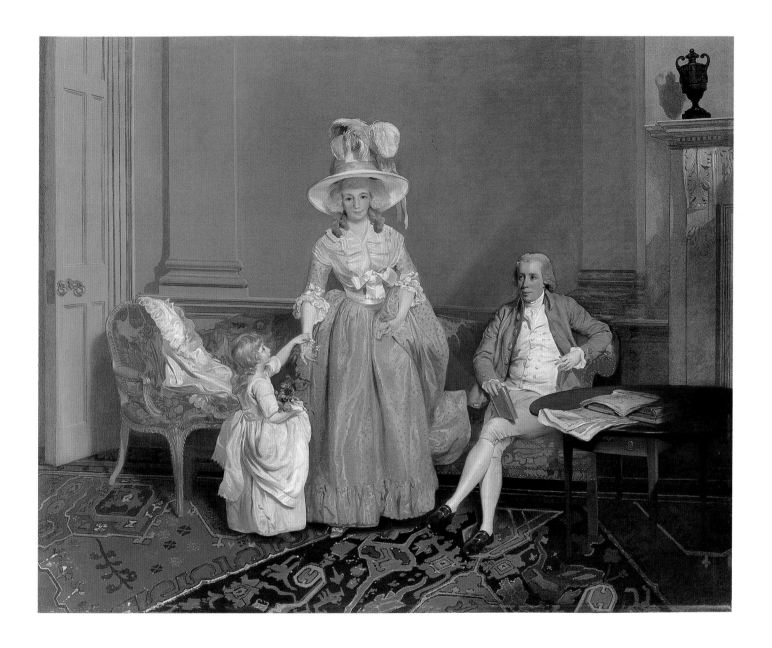

"Saithwaite" (also spelled "Saithwait" or "Seathwaite") is common in Lancashire, suggesting that Wheatley might possibly have encountered the family on his way to or from Ireland in 1779 or 1783, or—more likely—during his excursion to the northwest of England in 1784.[2] The broad, confident handling of paint and the types of clothing, furniture, and architecture depicted here all support a date in the mid-1780s.

Mrs. Saithwaite's splendid hat, with its ostrich feathers and ribbons, recalls one worn by Sarah Siddons (née Kemble, 1755–1831)

in a portrait by Thomas Gainsborough (ca. 1783–85, National Gallery, London). Such dramatic millinery was not reserved for actresses, however: high hats had become the general fashion, complementing the exaggerated heights of women's hairstyles, which peaked (literally) during the 1770s and 1780s, assisted by padding and emphasized by powdering and decoration.[3] The ostrich feathers that Georgiana, fifth duchess of Devonshire (1757–1806), popularized as hair ornaments in the mid-1770s migrated onto hats in the following decade.[4] Wheatley depicted

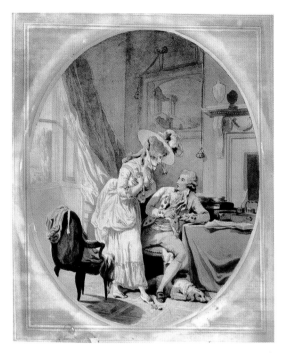

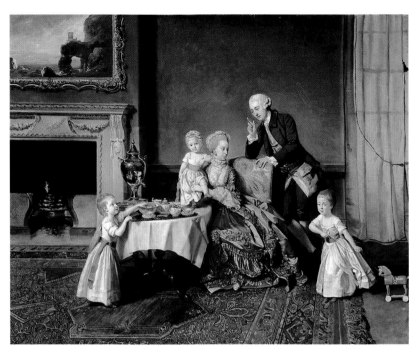

Fig. 1. Francis Wheatley (1747–1801), *A Lover's Anger*. Pen and gray ink and watercolor over graphite, 12⅜ × 10 in. (31.4 × 25.4 cm). Engraved by P. Simon, 1786. Private collection

Fig. 2. Johann Zoffany (1733–1810), *John Peto, 14th Lord Willoughby de Broke, and His Family*, ca. 1766. Oil on canvas, 39½ × 49½ in. (100.3 × 125.7 cm). J. Paul Getty Museum, Los Angeles (96.PA.312)

such plumed chapeaus with some frequency during the 1780s. In one example, *A Lover's Anger*, he not only repeated the hat and shoes worn by Mrs. Saithwaite but also draped the figure's shawl over a corresponding chair and placed her within a similar room, distinguished by a carved mantelpiece supporting a vase (fig. 1).[5] A related engraving bears the publication date of August 29, 1786, providing a further clue to the probable dating of the present work.

The evident care with which Wheatley rendered the elegant vase in this family portrait invites closer examination. At first glance, its black matte surface suggests that it is a piece of "Black Basalt" (also called "Egyptian black" or "Etruscan ware"), a refined stoneware colored with cobalt and manganese oxides, invented by Josiah Wedgwood (1730–1795) in 1768.[6] While the knobbed lid, scroll handles, and festoon swag generally resemble those found on various examples produced by Wedgwood & Bentley, and by their major rivals in the production of ornamental and useful blackwares, Humphrey Palmer (Hanley, Staffordshire, active ca. 1760–78) and James Neale (a former employee of Palmer, who took over his works in 1776), the painting's vase finds no exact match among ceramics of the period.[7] Instead, Wheatley may have illustrated a wooden object, a less expensive alternative to

stoneware but one that would nevertheless have served to indicate the owners' refined, classicizing taste.[8]

The vibrant, patterned carpet sends a similar message. Long imported as luxury furnishings, carpets moved from Britain's tabletops to its floorboards only in the early eighteenth century.[9] By 1780, however, foreign visitors admired their prevalence in British homes.[10] Not surprisingly, the "Turkey carpet" became a ubiquitous component of the conversation piece, a virtuoso element of perspective and design attempted by virtually every practitioner of the genre, including Gawen Hamilton (1697–1737), William Hogarth (1697–1764), Francis Hayman (1708–1776), Arthur Devis (1712–1787), Joseph Francis Nollekens (1702–1748), and Johann Zoffany (fig. 2).[11] Wheatley, who typically placed his subjects in a landscape, rose to the occasion with this rare interior view, capturing the recognizable geometry of a medallion Uşak carpet, a style (named for its place of earliest manufacture) featuring a large central medallion with projecting finials on a patterned field containing additional medallions. From its relatively coarse design, the Saithwaites' carpet can be identified as an eighteenth-century example manufactured in Western Anatolia, rather than a British product in the Turkish style.[12]

Although Wheatley lavished attention on the furnishings of the room, he brought his closest scrutiny to bear on the sitters themselves. Beautifully painted in confident, sparkling tones, the family, with its compelling interactions, provides one final insight into the social context—and probable dating—of the Wrightsman portrait. The man, despite his sympathetic, rosy countenance, appears closed off, blocked by the table and immobilized by crossed legs. The woman, in contrast, encircled by the broad circumference of her modish attire, expands to fill the middle of the composition. She is unquestionably the center of attention. As the man observes, the child looks into the woman's face and proffers flowers, but it is the viewer's eye the woman meets. Has she risen from the sofa to greet a visitor? The gesture with which she gathers her skirt in her left hand suggests that she was recently seated, while the hat on her head and the wrap she has discarded on the armchair imply that she accompanied the child outdoors. The precise narrative is lost, but the essential message remains clear: this woman is the mistress of her house. And so she should have been. By the third quarter of the eighteenth century, women exercised greater control over household arrangements and purchases than ever before.[13] Encouraged by merchants and guided by new special-interest magazines directed at female readers, women oversaw interior decoration that had formerly been determined by men, often as part of larger architectural programs.[14] Her personal biography may remain unknown, but Wheatley's painting assures us that, by the mid-1780s, Mrs. Saithwaite had come into her own.

EEB

Notes

1. Unfortunately, no sitter-books by Wheatley survive, and the painting's provenance before 1982 remains unknown. The title of the portrait is traditional.

2. Mary Webster dates the trip—intended to sketch landscapes for engraving—to the summer of 1784 on the basis of a drawing of Keswick, Cumberland, dated to that year, and a *View of Lancashire* exhibited at the Royal Academy in 1785; Webster 1965, p. 9. Although Wheatley exhibited two paintings titled "Portraits of a family; small whole-length" at the Royal Academy in 1778 (nos. 333 and 334), the present work is unlikely to be identified with either. Wheatley exhibited a relatively small proportion of his total oeuvre and may not have shown the Wrightsman painting;

moreover, as discussed in the text, the painting's style and its most conspicuous objects point to a later date.

3. Aileen Ribeiro, *The Art of Dress: Fashion in England and France, 1750–1820* (New Haven and London, 1995), p. 72.

4. For the duchess of Devonshire's plumed hairstyle, see Aileen Ribeiro, *The Dress Worn at Masquerades in England, 1730 to 1790, and Its Relation to Fancy Dress in Portraiture* (New York and London, 1984), p. 34. For one German visitor's comments on the ostrich feathers he saw in 1775, see *Lichtenberg's Visits to England, as Described in His Letters and Diaries,* trans. and ed. by M. L. Mare and W. H. Quarrell (Oxford, 1938), pp. 89–90.

5. Webster 1970, no. E27, ill. p. 65. Similar hats also appear in *The Disaster* (1788) and *Summer* (engraved in 1789); see Webster 1970, nos. 68, ill. p. 139, and E33 (illustrated in Roberts 1910, opposite p. 30).

6. Geoffrey A. Godden, *An Illustrated Encyclopedia of British Pottery and Porcelain* (London, 1966), p. xix; Diana Edwards, *Black Basalt: Wedgwood and Contemporary Manufacturers* (Woodbridge, Suffolk, 1994), p. 25.

7. For a Wedgwood & Bentley basalt vase (ca. 1771–80, collection Godden of Worthing), see Godden, *British Pottery and Porcelain,* p. 342, fig. 601. For a blackware vase of similar shape, decorated with a relief scene of *Venus and Cupid at Vulcan's Smithy* by John Voyez, manufactured in 1769 by Humphrey Palmer (British Museum [K.11]), see Edwards, *Black Basalt,* p. 217, fig. 337. For basalt vases in the Wedgwood manner by J. Neale, Hanley (ca. 1776–78, City Museum and Art Gallery, Stoke-on-Trent), see Godden, *British Pottery and Porcelain,* p. 247, fig. 435. For more on both Palmer and Neale, see Diana Edwards, *Neale Pottery and Porcelain: Its Predecessors and Successors, 1763–1820* (London, 1987).

8. I am grateful to Jessie McNab, Associate Curator, Department of European Sculpture and Decorative Arts, Metropolitan Museum, for suggesting that the vase was probably wooden.

9. Charles Saumerez Smith, *Eighteenth-Century Decoration: Design and the Domestic Interior in England* (New York, 1993), p. 228.

10. Ibid., p. 229.

11. For the tradition of the conversation piece, see George Charles Williamson, *English Conversation Pictures of the Eighteenth and Early Nineteenth Centuries* (London, 1931), and Ralph Edwards, "Georgian Conversation Pictures," *Apollo* 105 (April 1977), pp. 252–61. Of course, European artists of other national schools also painted similar carpets. A medallion Uşak carpet appears in Laurent Pécheux's *Maria Luisa of Parma (1751–1819), Later Queen of Spain* of 1765 (Metropolitan Museum, 26.260.9). For more on the rich topic of the depiction of Turkish carpets in Western paintings of the Renaissance and Baroque eras, see John Mills, *Carpets in Pictures,* Themes and Painters in the National Gallery, ser. 2, no. 1 (London, 1975), and Michael Franses and John Eskenazi, *Turkish Rugs and Old Master Paintings,* exh. cat., Colnaghi, London and New York (London, 1996).

12. I am grateful to Daniel Walker, formerly Patti Cadby Birch Curator in Charge, Department of Islamic Art, Metropolitan Museum, for sharing his thoughts on the carpet in this picture. For more on this type of carpet, its importation into northern Europe between ca. 1500–ca. 1900, and its British-made counterparts, see Maurice Sven Dimand, *Oriental Rugs in The Metropolitan Museum of Art* (New York, 1973), pp. 183–92; Donald King and David Sylvester, *The Eastern Carpet in the Western World from the Fifteenth to the Seventeenth Century,* exh. cat., Hayward Gallery, London (London, 1983), pp. 73–75; see also Smith, *Eighteenth-Century Decoration,* pp. 228–29.

13. Smith, *Eighteenth-Century Decoration,* p. 233.

14. Ibid., p. 234.

LOUIS DE CARMONTELLE

(Louis Carrogis, 1717–1806)

Born Louis Carrogis, the son of a Paris cobbler, Louis de Carmontelle adopted a more elevated-sounding surname, hid his humble beginnings, and was able by virtue of his wit and talents to become a fixture at the d'Orléans court, second in brilliance only to that of Versailles. His first known employment was as tutor to the son of Charles Louis, duc de Luynes (later duc de Chevreuse). During the Seven Years' War, he joined the Dragons d'Orléans regiment of the French army, where he worked as an aide-de-camp and topographical draftsman and amused his fellow officers with his facility at caricature. In 1763, after the war, his protector, comte Emmanuel Louis de Pons-Saint-Maurice, recommended him to Louis Philippe, duc d'Orléans (1725–1785), who appointed him tutor to his son, Louis-Philippe-Joseph, duc de Chartres (1747–1793). Carmontelle soon became indispensable to the ducal household, where he took on tasks ranging from garden design (including the Parc Monceau in Paris) to the staging of amusing little plays based on proverbs.

Carmontelle exploited to great advantage his ability to sketch portraits very quickly; according to Friedrich Melchior Grimm, they were typically executed in under two hours.[1] Drawn in red and black chalk, often with the addition of watercolor, these images were of a uniform size and scale. The sitters typically appear full length, either seated or standing, indoors or out, and, in almost all instances, with their faces in profile. Although he made the drawings primarily for himself, Carmontelle would produce replicas for sitters who desired them. Assembled into thirteen chronological albums, beginning with a work dated 1758,[2] they numbered 750 at the time of his death in 1806. As Carmontelle's primary artistic legacy, the drawings offer a matchless view of life at one of France's most illustrious courts. The artist's visual record presents not only members of the ducal household but the full range of society figures who passed through: French and foreign aristocracy; high-ranking military, government, and religious figures; financiers; and personalities from the world of arts and letters as well as celebrities of music, dance, and theater. While the project as a whole can be viewed as a unique visual chronicle of court life, it had the added benefit for Carmontelle of providing entrée into the highest echelons of Enlightenment society, a milieu he clearly relished, to judge from his sensitive and charming portrayals.

PS

ABBREVIATIONS

Gruyer 1902. F.-A. Gruyer. *Chantilly: Les Portraits de Carmontelle.* Paris, 1902.

Lédans 1807. Richard de Lédans. "Appel nominal des portraits composant le Receüil de feu Mr. de Carmontelle." Paris, 1807. Manuscript, Musée Condé, Chantilly. The original is unpaginated. Page numbers refer to a manuscript copy made in 1902 by Gustave Macon, conservateur-adjoint, Musée Condé, which bears the title "Catalogue des portraits dessinés et peints par Louis Carrogis de Carmontelle."

NOTES

1. Quoted in Gruyer 1902, p. ii.
2. For a description of the original albums, see Lédans 1807. Drawings with somewhat earlier dates are known as well, among them the 1755 *Emmanuel Louis de Pons* (Musée Condé, Chantilly), illustrated in Gruyer 1902, p. 134 no. 186, and Laurence Châtel de Brancion, *Carmontelle au jardin des illusions* (Château de Saint-Rémy-en-l'Eau, 2003), p. 17.

63. *Jean-Pierre de Bougainville (1722–1763)*

Red and black chalk, graphite, and watercolor on white antique laid paper, $11\frac{7}{8} \times 7\frac{3}{8}$ in. (30 × 18.9 cm)

Inscribed in pen and brown ink on lower margin of mount: Mr de Bougainville L'aîné, de L'académie française; at lower right corner: 1760. Inscribed on the verso of the mount: 428 Sn 112 mr. de bougainville l'aîné homme du rare mérite qui mourut trop jeune pour les sciences et pour les lettres, il était de l'académie française. Carmontelle délineavit ad vision 1760.

The Metropolitan Museum of Art, New York, Gift of Mrs. Charles Wrightsman, 2004 (2004.475.6)

PROVENANCE

Collection of the artist (until d. 1806); his estate sale, Paris, April 17, 1807, to Lédans; Pierre-Joseph Richard de Lédans (until his d. 1816); his estate sale, Paris, December 3–18, 1816 (possibly part of lot 531, "Cent cinquante-deux portraits d'hommes ou de femmes de tous Etats . . . ," to La Mésangère); Pierre de La Mésangère (1761–1831); ?his estate sale, Paris, July 18–23, 1831 (part of lot 304, "cinq cent vingt portraits dessinés et gouachés"; ?to Duff); ?John Duff; by descent to Major Lachlan Duff Gordon-Duff; ?[Colnaghi, 1877]; sale, Christie's, New York, January 12, 1995, lot 109 (as "property of a gentleman"); [Hazlitt, Gooden & Fox, London; sold to Wrightsman]; Mrs. Charles Wrightsman, New York (from 1997); her gift in 2004 to the Metropolitan Museum.

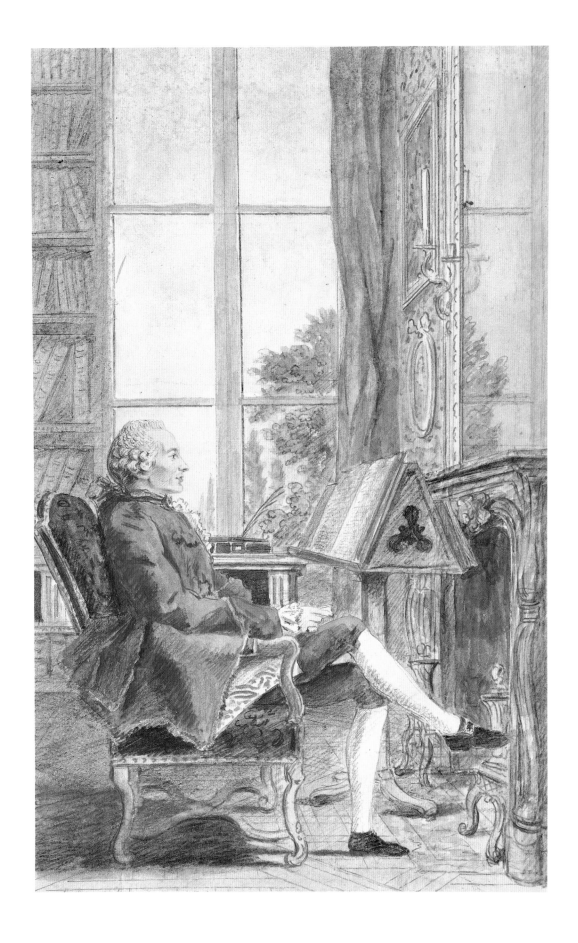

Although biographies of Carmontelle state that he was serving as an aide-de-camp in the French army between 1758 and 1763,[1] the date inscribed on the mount of this portrait, 1760, along with many other dated drawings in the Musée Condé, Chantilly, suggests that he did not serve continuously. The sitter, Jean-Pierre de Bougainville, died in 1763 at age forty; thus, this likeness would have been produced before Carmontelle entered the service of the duc d'Orléans. The inscription on the mount has its source in an annotated manuscript list of the sitters made near the end of the artist's life by his friend Richard de Lédans, who acquired all thirteen albums of drawings after Carmontelle's death. They were acquired in turn by Pierre de La Mésangère, editor of a fashion journal, at Lédans's estate sale, after a sale to the Bibliothèque Impériale fell through.[2] According to Gruyer, it was Mésangère who disassembled Carmontelle's albums and remounted the 750 sheets onto green mounts, which he inscribed following Lédans's manuscript.[3]

According to a longer inscription on the back of the mount, Jean-Pierre de Bougainville was "a man of rare merit who died too young." In the description of drawings in Carmontelle's albums penned by Lédans in 1807, after the artist's death, the Wrightsman drawing appears as number 171, "M. de Bougainville l'aîne. Il était de l'Académie française. Il mourut jeune, et les lettres firent une perte réelle" (Mr. de Bougainville the elder. He was a member of the French Academy. He died young, and it was a real loss for the world of letters). Jean-Pierrre was the eldest of three children born to Pierre-Yves de Bougainville and Marie-Françoise d'Arboulin, a family thought to have come from Picardy. He proved to be an exceptional student and in 1745 was named to the Académie des Inscriptions, where he became Secrétaire Perpétuel in 1754. With the backing of Madame de Pompadour, he was elected to the Académie Française the same year. His younger brother, Louis-Antoine de Bougainville, achieved even greater fame, first as a colonel in the French army fighting the British in Canada, then as a navigator, leading a sailing mission around the world (the flowering plant bougainvillea was named after him, as were various geographical features encountered during the expedition). In 1760, the year Carmontelle drew Jean-Pierre, Louis-Antoine returned from Canada after having been taken prisoner by the British.[4] Carmontelle must have drawn the younger de Bougainville around the same time, for his portrait is listed as number 172 on Lédans's list (Carmontelle's impression of Louis-Antoine, however, was far from favorable,

judging from the Lédans manuscript's lengthy account of his character and how he could be found in the Tuileries, holding forth and bragging of his adventures).[5]

Here the elder Bougainville is surrounded by signs of his scholarly pursuits. In a library with floor-to-ceiling bookcases, he sits before a fireplace with an open book on a reading stand; behind him is an elegant ebony and gilt writing table. Tall windows and a large mirror over the fireplace allow light to flood the room, creating the perfect environment for an Enlightenment man of letters. From his air of contentment, one imagines that it was a happy time for Bougainville, his place in society established by his two prestigious appointments, and his younger brother recently returned from a distant war.

As was his practice, Carmontelle first laid out the drawing in chalk and graphite, making use of a straightedge for the architectural elements. The sitter is positioned in profile, parallel with and close to the picture plane, his planarity counteracting the sense of recession suggested by the interior perspective. Profile portraits, by their very nature, are rarely psychologically penetrating, but, by showing the sitter engaged in an activity or thought and not explicitly aware of the viewer, they can take on an unguarded and therefore intimate character. Despite his avoidance of his subjects' gaze, Carmontelle was adept at capturing personality expressed in body language. Friedrich Melchior Grimm, in 1763, described Carmontelle's "singular talent for seizing the air, the bearing, and the liveliness of features"[6] of his sitters. In the case of Bougainville, his activity is not social but cerebral, and his bearing suggestive of cultured ease.

PS

NOTES

1. Gruyer 1902, pp. iii–iv.
2. This provenance is always given in the literature of the Chantilly drawings. In fact, the catalogue of Lédans's estate sale mentions only a group of 152 drawings by Carmontelle, although Mésangère's sale catalogue included 520 drawings by the artist. Presumably this was an error, or perhaps some were sold to Mésangère *hors catalogue*. Further research remains to be done on the early provenance of Carmontelle's drawings.
3. Gruyer 1902, pp. viii–ix.
4. For both brothers, see *Dictionnaire de biographie française*, ed. Michel Prevost and Roman d'Amat, vol. 6 (Paris, 1954), p. 1287. A biography of Jean-Pierre de Bougainville also appears on the website of the Académie Française.
5. Lédans 1807, pp. 49–50 no. 172. The drawing is not at Chantilly and must have been sold, as was the Wrightsman sheet.
6. Quoted in Gruyer 1902, p. ii.

64. Woman Playing the Violin, Seen from the Front

Red and black chalk, graphite, and watercolor, on white antique laid paper, 10 ¼ × 6 ¼ in. (25.9 × 16 cm)
Inscribed in graphite on the sheet of music: SONATA.I. TARTINI.

65. Woman Playing the Violin, Seen from the Back

Red and black chalk, graphite, gouache, and watercolor, on white antique laid paper, 10 ¼ × 6 ⅜ in. (25.9 × 16.3 cm)

PROVENANCE
?Collection of the artist (until his d. 1806); ?his estate sale, Paris, April 17, 1807, perhaps to Lédans; ?Pierre-Joseph Richard de Lédans (1736–1816); ?his estate sale, Paris, December 3–18, 1816 (possibly part of lot 531, "Cent cinquante-deux portraits d'hommes ou de femmes de tous Etats . . . ," perhaps to Mésangère); ?Pierre de La Mésangère (1761–1831); ?Mme A. Dumas (in 1933); private collection (in 1951); [Galerie Cailleux, Paris]; private collection; [Hazlitt, Gooden & Fox, London; sold to Wrightsman]; Mrs. Charles Wrightsman, New York (from 1997).

EXHIBITED
Possibly Galerie André Weil, Paris, November 14–28, 1933, "Louis de Carmontelle: Lecteur du duc d'Orléans (1717–1806)," nos. 79, 80; Galerie Cailleux, Paris, April 1951, "Le dessin français de Watteau à Prud'hon," nos. 27, 28 (lent from a private collection).

Musicians figure prominently in Carmontelle's portrait drawings throughout his career and, with the implied action of playing their instruments, provide some of his livelier subjects. Although he would depict the young Mozart,[1] for the most part his subjects were aristocratic amateurs; in cultured households, such performances were a favored form of entertainment. The Wrightsman pair of drawings, showing a standing woman playing the violin—once in three-quarter view and once from the back—is unusual in that the mounts bear neither inscription nor date. They can, however, be compared stylistically to an early group of drawings Carmontelle made when he was employed as a tutor in the household of the duc de Chevreuse. Many of these are dated in or about 1758 and share the high horizon line, blank background, and patterned floor of the Wrightsman pair. In general, watercolor is added more sparingly in the early drawings, allowing the red and black chalk to predominate. Moreover, Carmontelle's preference for profile portraits had not yet become entrenched, and one sees a number of three-quarter views. The

Portrait of Madame de Montainville Playing the Guitar (fig. 1),[2] *Mademoiselle Grimperel Playing the Viola da Gamba,* and *Mademoiselle de la Perrière Holding a Fan*[3] all show their subject in three-quarter view.[4] The second sheet of the Wrightsman pair, the image of the same woman seen from behind, is a daring idea for a pendant and without parallel in Carmontelle's published oeuvre.

The sitter wears a blue-green-and-white-striped *robe à la française,* a style in which pleats fall straight from the shoulders down the back, and panniers create a broad silhouette for the hips. Although this style was popular over many years, it was generally displaced by the *robe à la polonaise* beginning in the mid-1770s. A similar dress is worn by Mlle de la Perrière in her portrait.[5] The sheet music visible on the stand in the drawing of the woman seen

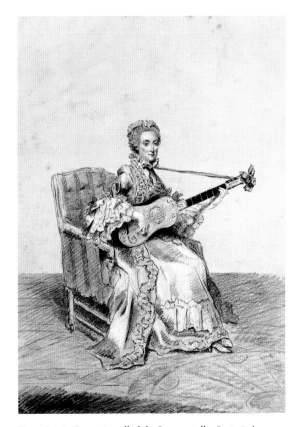

Fig. 1. Louis Carrogis, called de Carmontelle, *Portrait de Madame de Montainville*, 1758. Red and black chalk, graphite, and watercolor, 10 ⅛ × 7 in. (25.6 × 17.7 cm). Rijksmuseum, Amsterdam

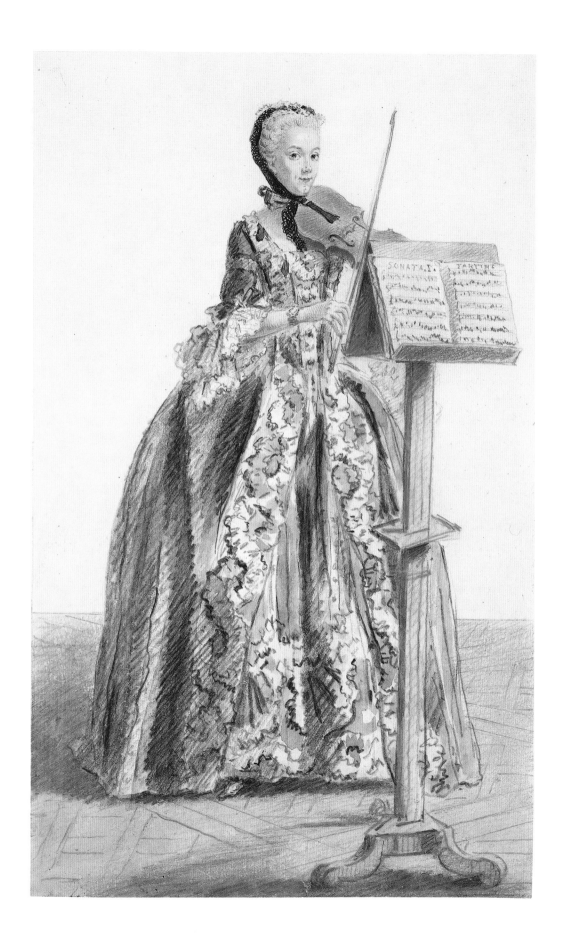

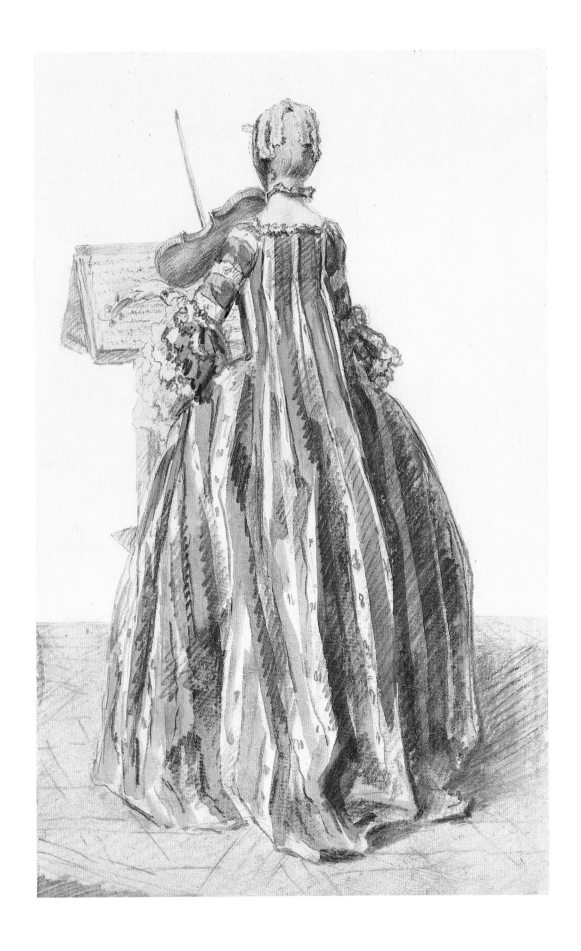

239

from the front is inscribed, *SONATA.I / TARTINI*. Giuseppe Tartini (1692–1770), a violinist, composer, and teacher active in Padua, was well known throughout Europe. He composed over 170 sonatas for violin.[6]

These two drawings may have stayed in the artist's collection, as the green mounts resemble those made by Pierre de La Mésangère, despite their lack of inscriptions (see cat. 63). Although their subsequent history is not known, an intriguing mention can be found in the unillustrated supplement of a catalogue of an exhibition of Carmontelle's work that was held at the Galerie André Weil in Paris in 1933. A pair of drawings, both entitled *Portrait de dame jouant du violon,* was listed as having been lent by Mme Alexandre Dumas.[7] PS

NOTES

1. See Gruyer 1902, pp. 308–10 no. 418.
2. R. J. A. te Rijdt, *De Watteau à Ingres: Dessins français du XVIIIe siècle du Rijksmuseum Amsterdam,* exh. cat., Rijksmuseum, Amsterdam, and Institut Néerlandais, Paris (Paris and Amsterdam, 2003), pp. 181–84 no. 59.
3. Both were sold at Christie's, New York, January 13, 1993, lots 92, 93.
4. All three are described in Richard de Lédans's manuscript at the Musée Condé (Lédans 1807, p. 14 nos. 22, 23, 25) as part of the album containing drawings from 1758–59, but no corresponding drawings remain at Chantilly, which suggests that they were sold by Pierre de La Mésangère.
5. Christie's, New York, January 13, 1993, lot 93.
6. *The New Grove Dictionary of Music and Musicians,* ed. Stanley Sadie, 2nd ed. (London and New York, 2001), vol. 25, pp. 1008–14.
7. *Louis de Carmontelle: Lecteur du duc d'Orléans (1717–1806),* exh. cat., Galerie André Weil, Paris (Paris, 1933), nos. 79, 80. Alexandre Dumas was born in Villers Côtterets, the location of one of the d'Orléans residences, and had some connections with the d'Orléans family.

ANTOINE-LOUIS-FRANÇOIS SERGENT-MARCEAU

(1751–1847)

Born to a family of limited means in the city of Chartres and apprenticed to an engraver at an early age, Antoine-Louis-François Sergent moved to Paris in 1768 to study with Augustin de Saint-Aubin (see p. 222). Like Saint-Aubin, Sergent was active as both a draftsman and a printmaker, and his early style is often reminiscent of his master. After three years in the capital, Sergent returned to Chartres. His early work focused on the production of color prints, with his first major collection, Portraits des grands hommes, des femmes illustres et sujets mémorables de l'histoire de France, appearing between 1787 and 1791. While his style as a draftsman was formed in the late Rococo period and would stay fairly consistent throughout his career, his subject matter underwent a dramatic transformation during the Revolution, as entertaining genre scenes gave way to more sober and topical imagery.

A highly political figure, Sergent was a committed Jacobin and lived in Paris throughout the events of the Revolution. His etchings of four Revolutionary scenes appeared not long after the storming of the Bastille in 1789.[1] Like his more famous contemporary Jacques-Louis David (see p. 255), Sergent was made a member of the National Convention and held several important posts in the years following the Revolution. As a montagnard, he was among those who voted in favor of regicide, although, to his credit, he appears to have played a role in saving a number of individuals from execution, among them his fellow artist Hubert Robert (see p. 185). As a member of the committee for public instruction, he was influential in saving certain art monuments, including Chartres Cathedral, from destruction and was among the founders of the Musée Français, the forerunner of the Musée du Louvre.[2]

After the fall of Robespierre, Sergent fled to Switzerland with his wife, Marie-Jeanne-Louise-Françoise-Suzanne Champion de Cernel (née Marceau-Desgraviers; 1753–1834). They adopted Republican names, Androphile (friend of man) and Emira (anagram of Marie), and Sergent appended Marceau to his last name, partly out of respect for his wife's brother, a Republican general, whose portrait Sergent etched in 1798. Although he returned to Paris once more, he was accused of taking part in a plot to assassinate Napoleon in 1801 and had to flee the country a second time, settling in northern Italy and later Nice, where he spent the remainder of his career. He continued to produce designs for series of prints and book illustrations. His Costumi dei popoli antichi e moderni published in Italy in 1813 was an illustrated work on dress. He also contributed portrait drawings to the Serie di vite e ritratti de' famosi personaggi degli ultimi tempi (Milan, 1815–18).[3]

PS

NOTES

1. The etchings accompanied Tableaux des révolutions de Paris, depuis 1789 (Paris, 1789); see Roger Portalis and Henri Béraldi, Les graveurs du dix-huitième siècle, vol. 3, pt. 2 (Paris, 1882), p. 544 no. 15.
2. For Sergent's activities during the Revolutionary period, see David L. Dowd, "'Jacobinism' and the Fine Arts: The Revolutionary Careers of Bouquier, Sergent and David," Art Quarterly 16 (autumn 1953), pp. 195–214.
3. James David Draper, "Thirty Famous People: Drawings by Sergent-Marceau and Bosio, Milan, 1815–1818," Metropolitan Museum Journal 13 (1979), pp. 113–30.

66. Interior with Two Dogs

Pen and black ink and watercolor, 4¼ × 5¾ in. (10.7 × 14.6 cm)
Inscribed in pen and brown ink below framing line at bottom center:
A Fr Sergent Delin. 1783.

PROVENANCE
[Sven Gahlin, Ltd., London, 1966; sold to Wrightsman]; Mr. and Mrs. Charles
Wrightsman, New York (1966–his. d. 1986); Mrs. Wrightsman (from 1986).

LITERATURE
James David Draper, "Thirty Famous People: Drawings by Sergent-Marceau
and Bosio, Milan, 1815–1818," *Metropolitan Museum Journal* 13 (1979), pp. 116–17,
fig. 2.

No related print is known for this charming and rather atypical drawing. Indeed, the intimacy of the view, along with its lack of narrative anecdote, suggests a specific rather than an imaginary interior. The sense that the dogs rather than the decor were the artist's focal point is supported by the angle and the cropping of the scene. Perhaps Sergent made the watercolor as a gift for a patron or a friend.

The artist's inscription gives the year as 1783. The decorative panel in front of the fireplace and the absence of rugs on the floor are both indications that the drawing was made in the summertime. The low angle of the strong sunlight suggests late afternoon. Without any evidence to the contrary, we can assume that Sergent was in Chartres in the summer of 1783 and that the room depicted belonged to a local family.

Bathed in the light of the setting sun, an Italian greyhound sleeps on the soft upholstery of a late Rococo bergère. In 1783 this type of chair, with its cabriole legs and curved arms, did not represent the latest Louis XVI style but would have been ten or more years old. On the bare tiled floor lies an elaborately shaved barbet, its head raised expectantly, as if waiting for the sleeping dog to wake up. An ancient French breed, the barbet was used as a water dog, and in the eighteenth century its coat was often clipped in a distinctive manner.

The minor differences in date of the various objects in the room contribute to the naturalness of the scene. The brecciated marble mantel with its fluted uprights and rosette ornament is the most Neoclassical element of the room. Arranged along its top in front of the gilt-framed mirror are a pair of ewers, a pair of candlesticks, and a glass vitrine to display various *objets de vertu*. Tasseled cords for calling servants hang to either side of the mirror. Up against the wall, to the right of the fireplace, are a tufted *chaise à la reine* and a birdcage atop a chiffonier, both pieces again late Rococo and slightly out-of-date by 1783.[1]

In the small area of wall above the birdcage, Sergent has detailed, in his characteristically fine ink line, a number of framed works of art. The largest, of which only a corner is visible, is—to judge from its coloring, its scale, and the heaviness of its frame—clearly an oil painting, presumably a history subject (only a man seated on a bench before a table can be made out in it). The others appear more monochrome and presumably represent prints or drawings, which were also commonly framed behind glass for display at this time. The subjects appear quite diverse: a print of *Leda and the Swan* by Augustin de Saint-Aubin (see p. 222) after a painting in the d'Orléans collection considered to be by Paolo Veronese (ca. 1528–1588),[2] and a circular profile portrait in the style influenced by the antique popularized by Charles-Nicolas Cochin II (see p. 192) but also practiced by Louis-Rolland Trinquesse (1745–ca. 1800) and Augustin de Saint-Aubin, among others. The horizontal print partially obscured by the birdcage finial seems to be Jacques Callot's etching *The Hanging* from his Miseries of War series.[3] A small vertical religious scene, likely also a print, hangs below an oval portrait of a young woman.

If Madame de Pompadour or members of the court commissioned portraits of their canine companions in oil, Sergent's charming domestic interior is an example is how the same sentiment might manifest itself on a simpler scale for less affluent patrons. In its specificity and lack of affect, the Wrightsman *Interior with Two Dogs* presents an intimate view of domestic life in the late *ancien régime*. PS

NOTES

1. I am grateful to Daniëlle Kisluk-Grosheide, Curator, Department of
European Sculpture and Decorative Arts, Metropolitan Museum, for shar-
ing her knowledge of the style and dating of the furniture.

2. The attribution to Veronese is no longer accepted today. For versions in the
Musée Fesch, Ajaccio, and formerly in the Gemäldegalerie, Dresden, see
Terisio Pignatti, *Veronese* (Venice, 1976), vol. 1, pp. 169 no. A1, 179 no. A73,
and vol. 2, figs. 719, 786. The Dresden version has been missing since

World War II; see Hans Ebert, *Kriegsverluste der Dresdener Gemäldegalerie:
Vernichtete und vermisste Werke* (Dresden, 1963), p. 155 no. 234. For the print,
which reverses the composition, as seen in the Wrightsman drawing, see
Emmanuel Bocher, *Les graveurs françaises du XVIIIe siècle,* vol. 5, *Augustin de
Saint-Aubin* (Paris, 1879), p. 160 no. 563.

3. Lieure 1349.

ANTOINE VESTIER

(1740–1824)

Active in Paris during the last quarter of the eighteenth century as a miniaturist and portrait painter, Antoine Vestier was born at Avallon, Bourgogne, the son of a local merchant. By 1760 he had moved to Paris, where he was employed by the master enameler Antoine Révérand (d. before 1764). Marrying Révérand's daughter in 1764, he was registered the same year as an "Élève de l'Académie Royale de Paris." Among his earliest known works are a pair of miniatures of himself and his wife, dated 1766 and now in the Louvre. Executed in a rather dry manner, they reflect Vestier's early training in enamel decoration. Stylistically, they recall the miniatures of the Swedish artist Peter Adolf Hall (1739–1793).

In 1776 Vestier traveled to England and visited William Peters (1742–1814), the English miniaturist. The trip acquainted him with the work of the leading English portrait painters of the period. About this time Vestier became a student of Jean Baptiste Marie Pierre (1713–1789), Premier Peintre du Roi and director of the Académie. Pierre specialized in large mythological and historical subjects that seem to have had little influence on Vestier, who devoted himself exclusively to portrait painting. During the late 1770s Vestier evolved a style close to those of Joseph Siffred Duplessis (1725–1802) and Jean-Baptiste Greuze (1725–1805), favoring a cool palette dominated by white, black, and grays evenly applied in a slick, enamel-like surface. He exhibited in the Salon de la Correspondance from 1782 until 1785, when he was presented by Duplessis as a candidate for the Académie Royale de Peinture et de Sculpture. Vestier was accepted as a member in September 1786, with portraits of the academicians Gabriel François Doyen, now in the Louvre, and Nicolas Guy Brent, in the château at Versailles.

With the advent of the French Revolution and the overwhelming popularity of Jacques-Louis David (see p. 255), Vestier's style underwent a marked change. His compositions became simpler and his handling of paint much looser. He placed less emphasis on the rendering of silks and satins and more on the character of the sitter. Two of his finest portraits were painted at this time, those of Jean Theurel, now in the Musée des Beaux-Arts, Tours, and Jean Henri Latude, in the Musée Carnevalet, Paris, both dated 1789.

Throughout his life, Vestier painted members of his family, often exhibiting these portraits at the Salon. In 1787 he painted Mme Vestier with a Child and Dog *in the engaging manner of Élisabeth Louise Vigée Le Brun (see p. 248). Vestier's popularity declined after 1790, and he was paid little for the few commissions he received. Through 1806, however, he continued to exhibit both oil portraits and miniatures in most of the Salons.* EF

ABBREVIATION

Fahy 1973. Everett Fahy, in *The Wrightsman Collection*, vol. 5, Everett Fahy and Francis Watson, *Paintings, Drawings, Sculpture*. New York, 1973.

67. *Eugène Joseph Stanislas Foullon d'Écotier (1753–1821)*

Oil on canvas, oval, 31⅝ × 25⅛ in. (80.3 × 63.8 cm)
Signed and dated at lower right, on the map cartouche: vestier / pinxit— / 1785; inscribed on book: ORDON[NANCES] / DE LA / MARINE (naval regulations); on pamphlet: MEMOIR[E] (report); on map: CARTE REDUITE DES ISLE[S DE] / LA GUADELOUPE / MARIE GALANTE ET LES SAINT[ES] / Dressé au Depon des Pl . . . / POUR LE SERVICE DE . . . / Par Ordre de M. BE . . . (Reduced map of the islands of Guadeloupe, Marie Galante, and Les Saintes, drawn up for the depository of maps [of the naval ministry], for the use of [the king's vessels], by order of M. Be[rryer . . .]).
The Metropolitan Museum of Art, New York, Gift of Mr. and Mrs. Charles Wrightsman, 1983 (1983.405)

PROVENANCE
[Galerie Heim-Gairac, Paris, in 1930; sold to Balmain]; Mme Balmain, Paris (until her d.; sold by her estate to Heim-Gairac); [Galerie Heim-Gairac, Paris]; private collection, London; [art market, London, until 1965; sale, Sotheby's, London, March 24, 1965, lot 84, for £2,000, to S. & R. Rosenberg, for Wrightsman]; Mr. and Mrs. Charles Wrightsman, New York (1965–83; cat., 1973, no. 33); their gift in 1983 to the Metropolitan Museum.

EXHIBITED
Académie Royale de Peinture et de Sculpture, Palais du Louvre, Paris, Salon of 1787, no. 148; Metropolitan Museum, New York, October 1966–October 1971; National Gallery of Art, Washington, D.C., June 5–September 6, 1976, "The Eye of Thomas Jefferson," no. 260.

LITERATURE
Comte de la Billarderie d'Angiviller, *Explication des peintures, sculptures et gravures, de messieurs de l'Académie Royale*, exh. cat. (Paris, 1787), p. 27 no. 148,

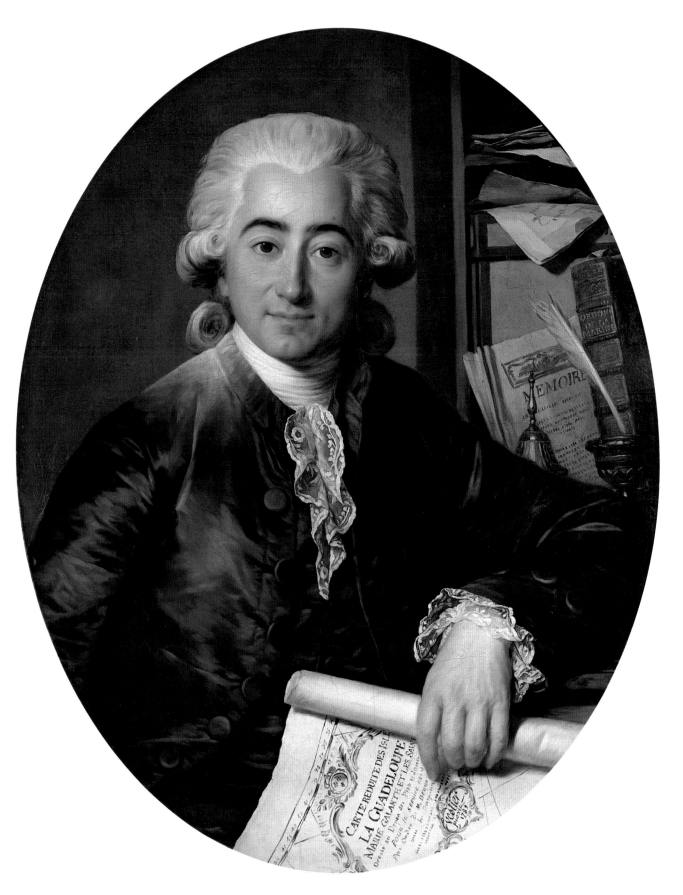

reprinted in *Collection des livrets des anciennes expositions depuis 1673 jusqu'en 1800*, no. 34, *Exposition de 1787* (Paris, 1870), p. 32 no. 148; Jules-Joseph Guiffrey, "Table des portraits exposés aux Salons du dix-huitième siècle jusqu'en 1800," *Nouvelles archives de l'art français*, 3rd ser., 5 (1889), p. 35; Fahy 1973, pp. 322–29 no. 33; Anne-Marie Passez, *Antoine Vestier, 1740–1824* (Paris, 1989), pp. 144 no. 48, 170.

Fig. 1. Map of Guadeloupe, published by Bellin, Paris, 1759. Engraving, plate, 23 × 34 in. (58.4 × 86.4 cm). New York Public Library, New York, Ford Collection, Map Division

Vestier painted this portrait in 1785, the year he became a candidate for membership in the Académie Royale de Peinture et de Sculpture. Two years later he exhibited it at the Salon, where it was described (in the catalogue) as a portrait of "M.ˣˣˣ en habit de satin noir, tenant en sa main la carte des Isles de la Guadeloupe." The painting was not heard of again until 1965, when it was offered for sale at auction as a portrait of "Foulon [*sic*] d'Écotier, Governor of Guadeloupe." In the *Almanach Royal*, only two Frenchmen are listed in 1785 as holding posts in Guadeloupe: Baron de Clugny, the governor, and Foullon d'Écotier, Maître de Requêtes, Intendant.[1] Extensive documentation concerning both men can be found in the Archives Nationale, Paris.[2] Baron Gabriel de Clugny was born in about 1725–27 and died in 1792. He was appointed governor of Guadeloupe in July 1783 and arrived in the islands in May of the following year. In his correspondence, he complains of having been in Guadeloupe without returning to France from the summer of 1784 until the spring of 1786, making it unlikely that he could be the subject of a portrait painted in Paris in 1785. In addition, the sitter is a young man, whereas Clugny would have been nearly sixty years old at the time. Eugène Joseph Stanislas Foullon d'Écotier (1753–1821), on the other hand, was named Intendant de la Guadeloupe in June 1785. He did not leave France to assume this post until November 1785, giving him opportunity to sit for Vestier in the summer or early autumn.

The son of the Intendant Général des Finances of France,[3] Foullon d'Écotier began his career in 1772, at the tender age of nineteen, serving as Conseiller au Châtelet in Paris. Achieving the position of Conseiller à la Cour des Aides de Paris in 1775, he was made Maître des Requêtes for Parlement in 1776. Finally, on June 5, 1785, Louis XVI appointed him Intendant of Gualdeloupe and its dependencies. When Foullon d'Écotier assumed his post, the islands in the French Antilles were under the jurisdiction of the Ministère de la Marine, the Maréchal de Castries.

Foullon d'Écotier served as Intendant in Guadeloupe continuously from 1785 to 1791, except for a brief period, in 1786, when he was made interim Intendant of Martinique. In 1789 a secondary

Fig. 2. Detail of fig. 1: cartouche on the map of Guadeloupe

revolution broke out in Guadeloupe, in reaction to the one taking place in France. Foullon d'Écotier, joining the patriots rather than the landowners, was eventually forced to give up his position. Returning to France in 1791, he requested that his post be renewed in service to the Republic. Although liberated by the Tribunal Révolutionnaire in 1793, he spent eighteen months in jail during the Terror. Under Napoleon he renewed his request for a post in the French Antilles, now declaring his loyalty to the empire, but he

was again refused. Finally, in 1815, he wrote to Louis XVIII and the duchesse d'Angoulême asking for his old post and, at long last, returned to Guadeloupe as Intendant in 1816. In September 1817, however, he was recalled for misappropriation of tax funds and upon his return to France declared himself bankrupt. Pleading with the Ministère de la Marine for retirement pay, he was awarded a pension by order of the king in July 1820 and, posthumously, the Cross of Saint Louis in January 1822.

This portrait, painted before his troubled career began, holds references to Foullon d'Écotier's new appointment. The book on the shelf, for instance, is one he would need in his work. Titled *Ordonnances de la Marine,* it contains regulations for administering French colonies. Next to the book is a pamphlet titled *Mémoire,* which might possibly be a copy of the report given to Baron Clugny by the Maréchal de Castries when Clugny was named governor; dated March 20, 1784, it carries instructions concerning

all branches of the administration of Guadeloupe and its dependent islands.[4] The most obvious allusion to Foullon d'Écotier's new assignment is the map, which covers the territory to be under his jurisdiction: the island of Guadeloupe, the smaller island of Marie Galante, and the cluster of tiny islands called Les Isles des Saintes. The actual map Vestier has shown (fig. 1) was published by Bellin in Paris in 1759. Vestier faithfully copied its cartouche, reproducing every detail except the Roman numerals of the date, for which he substituted his own name and the date of the portrait (fig. 2).

Vestier's clients were occasionally painted as pairs, and it is possible that he painted Foullon d'Écotier's wife. There is a portrait of a woman by Vestier with the same oval format and the same dimensions as Foullon d'Écotier's portrait (fig. 3). Sold at Hôtel Drouot, Paris, May 21, 1947 (lot 21), its present whereabouts is unknown. The woman, shown to the waist, holds a rose in her right hand, with her elbow resting on a table as she faces the viewer, echoing Foullon d'Écotier's pose in reverse. Although it is signed and dated 1787, two years after Foullon d'Écotier's portrait, there is no reason why they could not have been painted as pendants.[5] EF

NOTES

1. Laurent d'Houry, ed., *Almanach royal* (Paris, 1786), pp. 176–77.
2. Archives Nationale, Paris, folio: Marine C[7] 69 (177 pieces).
3. Archives Nationale, Paris, folio: Colonies EE 950 (539 pieces).
4. Auguste Lacour, *Histoire de la Guadeloupe,* vol. 1, *1635 à 1789* (Basse-Terre, Guadeloupe, 1855), p. 361.
5. Not all of Vestier's paired portraits bear the same dates. His matching portraits of M. and Mme Bernard de Sarrette, in the Phoenix Art Museum, Arizona, for example, are dated 1788 and 1781, respectively.

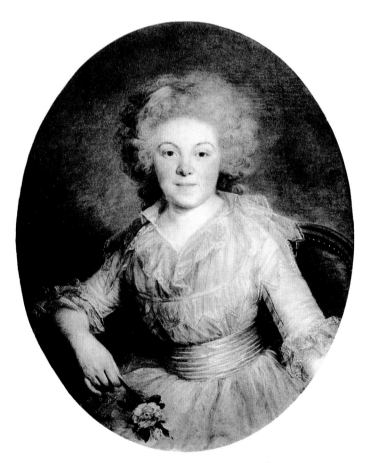

Fig. 3. Antoine Vestier, *Portrait of a Woman, possibly Mme Écotier.* Oil on canvas, 31 1/8 × 25 1/4 in. (79.1 × 64.1 cm). Present whereabouts unknown. From sale catalogue, Hôtel Drouot, Paris, May 21, 1947

ÉLISABETH LOUISE VIGÉE LE BRUN

(1755–1842)

Born to a hairdresser and Louis Vigée, a minor portrait painter who died when she was twelve, Élisabeth Louise Vigée Le Brun embarked with great determination on a career in her father's footsteps. Endowed with an outgoing personality, a strong work ethic, and a natural facility as a painter, she would become one of the most successful portraitists of the eighteenth century. By age fifteen she had already developed a clientele for her likenesses, and by age nineteen, after having her studio seized for working without a license, she became a member of the painters' guild, the Académie de Saint Luc. In 1775 she married Jean Baptiste Pierre Le Brun, a painter and art dealer as well as her family's landlord. The musical and literary salons she held were very popular, making her house a meeting place for the aristocratic and wealthy in addition to the luminaries of the fields of art, literature, and theater. From these circles she gained very highly placed patrons and was able to charge substantial prices for her work.

In 1776 Vigée Le Brun received her first royal commission, and by 1778 she had painted her first portrait from life of Marie Antoinette. Her success in this arena led to a series of commissions and, ultimately, a close association with the young queen. It was through the queen's direct intervention that Vigée Le Brun was granted membership in the prestigious Académie Royale de Peinture et de Sculpture, a body to which she had previously been denied admission based on her husband's profession. She was accepted on the same day as fellow portraitist Adélaïde Labille-Guiard, bringing to four the number of female members, the official limit.[1]

Vigée Le Brun's favored status with the royal family left her few options at the time of the French Revolution. With her young daughter, Julie, she fled France for Italy in 1789 for what would become an extended period of exile. Despite the efforts of her husband and her fellow artists, she was not allowed to return to France until 1800, when her name was struck from the official list of émigrés. Her career, however, flourished in exile. She was feted and patronized by foreign courts and aristocrats in many Italian cities as well as in Vienna, Saint Petersburg, Berlin, and elsewhere.

Eventually resettling in France, Vigée Le Brun lived to the age of eighty-seven, although her production slowed in her last decades. She devoted her final years to working on her memoirs, which began to appear in 1835. When she was at the height of her powers, in the last years of the ancien régime and during her twelve-year exile, Vigée Le Brun was admired for her skill as a colorist, the polish of her painterly surface, and her ability to render the luxurious fabrics of her sitters' costumes. Her images of women and children especially are distinguished by the freshness of their complexions and the naturalness of their comportment; their poses and fashions were often arranged by Vigée Le Brun to convey an appealing sense of timeless feminine languor.

PS

ABBREVIATION

Fort Worth 1982. Joseph Baillio, *Élisabeth Louise Vigée Le Brun, 1755–1842.* Exh. cat. Kimbell Art Museum, Fort Worth, Texas. Fort Worth, 1982.

NOTE

1. The other two were Marie Thérèse Vien, *reçue* in 1757, and Anne Vallayer-Coster, *reçue* in 1770.

68. Julie Le Brun Holding a Mirror

Oil on canvas, 28 3/4 × 23 7/8 in. (73 × 59.5 cm)
Signed and dated 1787 at the lower left.

PROVENANCE

?Collection of Joseph-Hyacinthe-François de Paule de Rigaud, comte de Vaudreuil (1740–1817);[1] comtesse de Gaujal (in 1885); [Wildenstein & Cie., Paris, 1913; sold to Féral]; Jules Féral; sale, Palais Galliera, Paris, April 6, 1976, lot 43 (as attributed to Étienne Jeaurat); [Didier Aaron, Paris, 1976]; private collection, Paris; [Didier Aaron, Paris, 1986; sold to Wrightsman]; Mrs. Charles Wrightsman, New York (from 1986).

EXHIBITED

Académie Royale de Peinture et de Sculpture, Palais du Louvre, Salon of 1787, no. 107; Musée du Louvre, Paris, 1885, "Exposition de tableaux, statues et objets d'art au profit de l'oeuvre des orphelins d'Alsace-Lorraine," no. 301 (lent by the comtesse de Gaujal).

LITERATURE

Élisabeth Louise Vigée Le Brun, *Souvenirs de Mme Vigée Le Brun* (Paris, n.d.), vol. 2, p. 363 (listed under her Salon submissions of 1787); Comte de la Billarderie d'Angiviller, *Explication des peintures, sculptures et gravures, de messieurs de l'Académie Royale*, exh. cat. (Paris, 1787), p. 20 no. 107, reprinted in *Catalogues of the Paris Salon, 1673 to 1881*, comp. H. W. Janson (New York and

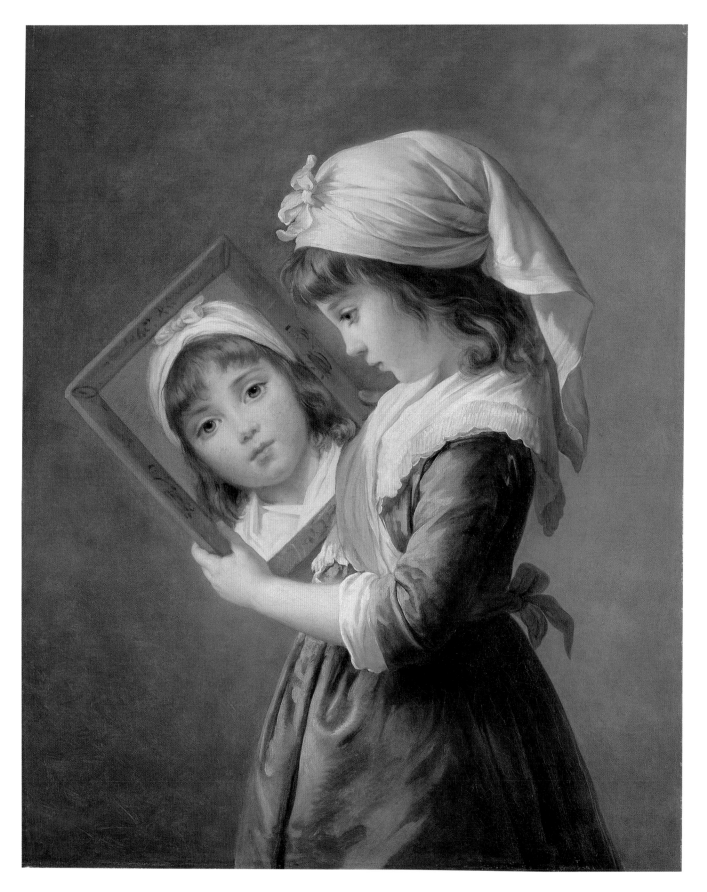

London, 1978), vol. [6], p. 20 no. 107; Pierre de Nolhac, *Madame Vigée-Le Brun: Peintre de la reine Marie-Antoinette, 1755–1842* (Paris, 1908), pp. 73–74, 152; William Henry Helm, *Vigée-Lebrun, 1755–1842: Her Life, Works, and Friendships* (London, 1915), p. xvii, ill. opp. p. 60; André Blum, *Madame Vigée-Lebrun: Peintre des grandes dames du XVIII^e siècle* (Paris, 1919), p. 98, ill. opp. p. 96; Fort Worth 1982, pp. 74–75 under no. 25; Joseph Baillio, "Vigée Le Brun and the Classical Practice of Imitation," in *Paris: Center of Artistic Enlightenment,* ed. George Mauner et al. (University Park, Pennsylvania, 1988), pp. 98, 104 n. 19, figs. 4–10; Angela Rosenthal, "Infant Academies and the Childhood of Art: Elisabeth Vigée-Lebrun's *Julie with a Mirror,*" *Eighteenth-Century Studies* 37 (summer 2004), pp. 605–28.

VERSIONS/COPIES

GENEVA, Musée de l'Horlogerie et de l'Émaillerie (inv. AD I217). Jacques Thouron (Swiss, 1740–1789), after Élisabeth Louise Vigée Le Brun, *Portrait de Jeanne Julie Louise Le Brun,* ca. 1787 (fig. 3). Miniature, enamel on copper 2⅝ × 2¼ in. (6.7 × 5.8 cm).
NEW YORK, private collection. Élisabeth Louise Vigée Le Brun, *Julie Le Brun Holding a Mirror,* ca. 1785 (fig. 2). Oil on wood, 28½ × 22½ in. (73 × 60.3 cm).

ETCHINGS

Jean-Philippe-Guy Le Gentil, comte de Paroy (1750–1824), after Élisabeth Louise Vigée Le Brun, *Portrait de la Fille de Madame Lebrun, regardant dans un miroir,* 1787. Etching and aquatint.
Horbon, after Élisabeth Louise Vigée Le Brun, *Mlle Le Brun.* Etching and aquatint.

Vigée Le Brun's only child, Jeanne Julie Louise Le Brun, was born in 1780. Although mother and daughter would ultimately become estranged, Julie—sometimes called Brunette—appears to have been doted upon as a child. She was painted by her mother throughout her childhood, including double portraits of mother and child embracing, referred to as *maternités*.[2] This flattering visual record presents an image of Julie as an endearing young girl, with large blue eyes and wavy brown hair.

The Wrightsman picture was among Vigée Le Brun's submissions to the Salon of 1787, a group that also included the artist's portrait of Marie Antoinette with her children, the 1786 *maternité,* and a small canvas of Julie resting her head on an open Bible.[3] The installation of that year's Salon is recorded in a print, *Exposition au Salon du Louvre en 1787* (fig. 1) by Pietro Antonio Martini (1738–1797). Vigée Le Brun's portrait of Marie Antoinette and her children was given a prominent place (to the left of the doorway), and the smaller canvas of Julie holding a mirror hung just alongside.

Shown three-quarter length in the simple, unadorned dress favored by her mother, Julie stands and faces to the left, her head bent down to her only accessory: a simple rectangular mirror, which she holds angled outward, toward the viewer. She is set against a loosely brushed flat background of the type popularized by Jacques-

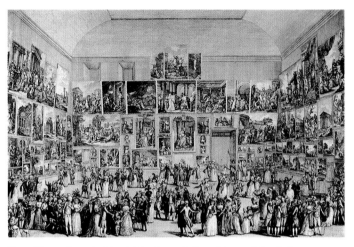

Fig. 1. Pietro Antonio Martini (1738–1797), *Exposition au Salon du Louvre en 1787,* 1787. Etching with engraving, 12⅝ × 19⅜ in. (32.2 × 49.1 cm). The Metropolitan Museum of Art, New York, The Elisha Whittelsey Collection, The Elisha Whittelsey Fund, 1949 (49.50.244)

Louis David (see p. 255). The conceit of the mirror allowed the artist to include both profile and frontal view in the same composition, even if the laws of perspective were not precisely followed.[4] Vigée Le Brun's confidence as a colorist is evident in the bold choice of red for the mirror frame, picking up the rosy highlights of the face and the detailing of the kerchief tied on Julie's head. The saturated color sets off this picture within a picture, contemplated both by Julie and by the viewer.

Fig. 2. Élisabeth Louise Vigée Le Brun, *Julie Le Brun Holding a Mirror,* ca. 1785. Oil on wood, 28¾ × 23¾ in. (73 × 60.3 cm). Private collection, New York

Fig. 3. Jacques Thouron (Swiss, 1740–1789), after Élisabeth Louise Vigée Le Brun, *Portrait de Jeanne Julie Louise Le Brun,* ca. 1787. Miniature, enamel on copper, 2⅝ × 2¼ in. (6.7 × 5.8 cm). Musée de l'Horlogerie et de l'Émaillerie, Geneva (inv. AD 1217)

An earlier autograph version of the composition exists in a New York private collection (fig. 2). The dimensions of the two are identical, although the earlier version is painted on a wooden support, while the Wrightsman version is on canvas. Several small details have been altered, from the color and design of the mirror's frame to the style of the girl's cuff, but the most notable difference between the two is the passage of time. In the Wrightsman canvas, dated 1787, Julie is seven years old. In the undated earlier version, she appears no older than five. A pastel copy of that version by *fermier-général* and *amateur* Laurent Grimod de La Reynière (private collection), dated 1786, provides a terminus ante quem for the first version.[5] Jean-Philippe-Guy Le Gentil, comte de Paroy (1750–1824), a member of the nobility and, like Grimod de La Reynière, an amateur artist, chose the image to reproduce in aquatint,[6] part of a group of wash-manner and crayon-manner prints he exhibited in the Salon of 1787.[7] (Both men held the position of *associé honoraire libre* at the Académie Royale de Peinture et de Sculpture.)

Julie was only nine when the events of 1789 caused her and her mother to flee France. They set off—along with Julie's governess—on the public coach for Italy, intending to return when political order was restored. Their exile turned out to be a long one. They stopped at Turin, Parma, and Florence en route to Rome, where they were offered housing at the Académie de France. They also spent extended periods in Vienna and Saint Petersburg, where Vigée Le Brun had no trouble finding wealthy clients. It was in the Russian capital that Julie met Gaétan Bernard Nigris, secretary to the director of the imperial theaters of Saint Petersburg. They married against the wishes of Vigée Le Brun, who had hoped for a more advantageous match for her only child. Although the marriage lasted only eight years, the rift between mother and daughter was never mended. Julie, who had inherited her father's debts, died nearly destitute in Paris in 1819. Vigée Le Brun's many charming portraits of the young Julie suggest her strong affection for her daughter as a child, and their success and popularity in the public arena of the Salons are evidence of the esteemed place of childhood in Enlightenment society.

PS

NOTES

Joseph Baillio very generously shared his research for his forthcoming monograph on Vigée Le Brun. His many contributions to the thoroughness of this entry are gratefully acknowledged.

1. This hypothesis was put forward by Joseph Baillio (conversation, April 5, 2004). Baillio pointed to the existence of a miniature version of the Wrightsman composition, by Swiss artist Jacques Thouron (1740–1789) in the Musée de l'Horlogerie et de l'Émaillerie, Geneva (inv. AD 1217). Since other paintings in the collection of Vaudreuil were copied in miniature by Thouron, the implication was that this painting also had been in Vaudreuil's collection.

2. See Fort Worth 1982, pp. 73–76 no. 25 and 119–21 no. 50, figs. 24 and 26, and the list of portraits of Julie on pp. 75–76.

3. Comte de la Billarderie d'Angiviller, *Explication des peintures, sculptures et graveurs, de messieurs de l'Académie Royale* (Paris, 1787), reprinted in *Collection des livrets des anciennes expositions depuis 1673 jusqu'en 1800,* no. 34, *Exposition de 1787* (Paris, 1870), pp. 25–26 nos. 97–108. The painting of Julie Le Brun reading the Bible was published by Joseph Baillio, "Identification de quelques portraits d'anonymes de Vigée Le Brun aux États-Unis," *Gazette des beaux-arts,* 6th ser., 96 (November 1980), p. 162, fig. 10.

4. For Baillio, the composition displays a debt to Jusepe de Ribera's *Philosopher Holding a Mirror;* see Fort Worth 1982, p. 74, fig. 25.

5. Illustrated in Colin B. Bailey, *Patriotic Taste: Collecting Modern Art in Pre-Revolutionary Paris* (New Haven and London, 2002), p. 229, fig. 209. Chapter 7, pp. 206–33, is devoted to Grimod de La Reynière as a collector.

6. The print is illustrated in Charles Pillet, *Madame Vigée-Le Brun* (Paris, 1890), p. 11. The composition has been adapted to an oval format. The comte de Paroy, it should be further noted, was a tenant of the Le Bruns at the hôtel de Lubert and second cousin of the comte de Vaudreuil, possible first owner of the Wrightsman canvas (see note 1 above). See Bailey, *Patriotic Taste,* p. 193. A clumsier variant of the print, also oval format and also in aquatint, described in the legend as "dessiné et gravé de memoire par Horban," was kindly brought to my attention by Joseph Baillio, who found an impression in the Bibliothèque Nationale, Paris.

7. Comte de la Billarderie d'Angiviller, *Explication des peintures . . . Exposition de 1787,* p. 56 no. 292.

69. *Marie Antoinette in the Park of Versailles*

Black chalk, stumped, and white chalk, on blue antique laid paper,
23⅛ × 15⅞ in. (58.9 × 40.4 cm)

PROVENANCE
?Jean-Pierre Norblin de la Gourdaine;[1] ?his son, Louis Pierre Martin Norblin (1781–1854); baronne de Connantré, Château de Connantré, Marne; her daughter, baronne Ruble; her granddaughter, Madame de Witte; the marquise de Bryas (née de Witte); [Galerie Cailleux, Paris, by 1959 (all early provenance per Cailleux)]; [William H. Schab Gallery, New York]; Christian Humann, New York (1965–82); his estate sale, Sotheby Parke Bernet, Inc., New York, April 30, 1982, lot 35 (as "Portrait of a Woman Standing in a Garden," by François-André Vincent); Joseph Baillio, New York (until 1986); Roberto Polo, New York (1986–88); M. and Mme Roberto Polo collection sale, Ader Picard Tajan, Paris, May 30, 1988, lot 24, to Wrightsman; Mrs. Charles Wrightsman, New York (from 1988).

EXHIBITED
Musée Fragonard, Grasse, July 28–September 16, 1962, "Femmes: Dessins de maîtres et petits maîtres du XVIIIᵉ siècle," no. 63 (as "Portrait présumé de Marie-Antoinette" by Vincent); William H. Schab Gallery, New York, January 1965, "Six Centuries of Graphic Arts: Prints and Drawings by Great Masters," no. 169 (as Vincent), ill. on back cover of catalogue 38; The New York Cultural Center, New York, in association with Fairleigh Dickinson University, June 27–September 3, 1972, "Collectors Anonymous: Four Private New York Collections" (as Vincent); Kimbell Art Museum, Fort Worth, Texas, June 5–August 8, 1982, "Elisabeth Louise Vigée Le Brun, 1755–1842" (not in catalogue); High Museum of Art, Atlanta, 1983, "The Rococo Age: French Masterpieces of the Eighteenth Century," no. 82.

LITERATURE
Gérard Bauër, *Dessins français du dix-huitième siècle: La figure humaine* (Paris, 1959), pl. 8 (as "Femme à l'éventail" by Vincent); Denys Sutton, "Madame Vigée Le Brun: A Survivor of the *Ancien Régime*," *Apollo* 116 (July 1982), pp. 26, 29, fig. 3; Joseph Baillio, "Propos sur un dessin de Mme Vigée le Brun," *L'oeil*, nos. 335–36 (June–July 1983), pp. 30–35, figs. 2 (detail), 4; Joseph Baillio, "French Rococo Painting: A Notable Exhibition in Atlanta," *Apollo* 119 (January 1984), p. 21; Monelle Hayot, "Le charme du XVIIIᵉ français," *L'oeil*, nos. 396–97 (July–August 1988), p. 42, ill. p. 43; Eric M. Zafran, in Jeffrey H. Munger et al., *The Forsyth Wickes Collection in the Museum of Fine Arts, Boston* (Boston, 1992), p. 115 under no. 59.

With its stately pose and lush handling, this painterly sheet depicting Marie Antoinette in the gardens of Versailles embodies all the qualities that brought success to Vigée Le Brun as a portraitist to the *ancien régime* court. The young Austrian-born Queen Marie Antoinette was a central figure in Vigée Le Brun's career, responsible in many ways both for her meteoric rise to fame and for her subsequent difficulties. While some artists, such as her friend Hubert Robert (see p. 185), at the time of the Revolution sought their survival in adaptation, Vigée Le Brun remained a staunch monarchist and found her new patrons in foreign courts and among fellow émigrés and royalist sympathizers.

When Vigée Le Brun, a young woman of twenty-three, was summoned to Versailles in 1778 to execute a full-length standing portrait of the queen, it was a distinction that must have not only propelled her career but also incited jealousy among certain members of the Académie Royale who shared her specialty. The result, a regal yet conventional standing portrait in an interior "en robe à paniers," hangs today in the Kunsthistoriches Museum in Vienna.[2] It would be the first of many such commissions for Vigée Le Brun, a challenging assignment as the public image of the foreign-born queen came increasingly under attack, and state portraits took on the burden of recovering her much-maligned reputation. The situation came to its most critical juncture at the Salon of 1785, when the exhibition of Adolf Ulrik Wertmüller's canvas of Marie Antoinette and her two children strolling in the Trianon gardens (Nationalmuseum, Stockholm) met with widespread derision, apparently for the perceived frivolity of their demeanor. To repair the damage, Vigée Le Brun was called upon to produce another portrait of the queen and her children to be ready for the following Salon in 1787. Although it was not within her power to redeem the unpopular queen, Vigée Le Brun's attempt was a tour de force of state portraiture. She presented Marie Antoinette at once as a monarch and a mother, fulfilling that natural role as promoted by Rousseau. The pyramidal composition was based on a Renaissance model, invoking Raphaelesque forerunners.

Although she painted over twenty portraits of Marie Antoinette, the Wrightsman sheet is Vigée Le Brun's only known drawing of the queen. Was it intended as an independent work or as an idea for a painted composition? Unfortunately, surviving sheets by her hand are so few that we can do little more than speculate. Although a 1780 pastel study for her reception piece, *Peace Bringing Back Plenty* (Louvre), was published by Pierre Rosenberg in 1981,[3] Vigée Le Brun does not seem to have prepared her portraits in the same manner. Indeed, with the paucity of comparable examples, it is not surprising that when the Wrightsman sheet first appeared on the French art market in 1961 it bore an attribution to

François-André Vincent (1746–1816),[4] with its true author identified by Joseph Baillio only at the time of the Christian Humann sale in 1982.

The quick pace of change in the fashion of hairstyles during the years Vigée Le Brun worked for Marie Antoinette would suggest a date of about 1780–81 for the Wrightsman drawing, just before the appearance of the frizzed bouffant (*hérisson* or hedgehog) styles of the 1780s. The queen's dress is a *robe à la polonaise,* a style that first appeared in 1775: a series of panels are looped up into large billowing forms to reveal the striped chiffon petticoat with a flounced trim. The view chosen by Vigée Le Brun draws attention to the close-fitting area around the small of the back that distinguished the silhouette of the *polonaise* from that of the *robe à la française,* which fell in pleats from the shoulders. According to Joseph Baillio, Charles-Édouard de Crespy Le Prince, in his *Chroniques sur les cours de France,* described the young queen—after her appearance in the Versailles performance of the opéra-comique *Rose et Colas*—as desiring that her portrait in her costume be done by Vigée Le Brun, and the artist then making a sketch on the spot.[5] Although this anecdote is of interest, the Wrightsman sheet could not be the one mentioned by Crespy Le Prince, as he refers to the queen's coiffure as "en cornette de paysanne," indicating a much bulkier style of bonnet than the one depicted here.[6] Nonetheless, Aileen Ribeiro has observed that the vaguely rural headdress, the puffs on the skirt, and the filmy petticoat all carry a slight suggestion of theater, or at least of an aristocratic woman playing at the pastoral.[7]

PS

NOTES

1. This drawing does not appear in Norblin's estate sale, Hôtel Drouot, Paris, February 5, 1855.
2. Fort Worth 1982, p. 63, fig. 15.
3. Pierre Rosenberg, "A Drawing by Madame Vigée-Le Brun," *Burlington Magazine* 123 (December 1981), pp. 739–40.
4. The attribution may have been based in part on a drawing of a standing woman in a garden catalogued as by Vincent in the A. Beurdeley sale, Galerie Georges Petit, Paris, March 13–15, 1905, lot 273, although that drawing—today in the Forsyth Wickes Collection, Museum of Fine Arts, Boston (65.2608)—is no longer attributed to Vincent. See Eric M. Zafran, in Jeffrey H. Munger et al., *The Forsyth Wickes Collection in the Museum of Fine Arts, Boston* (Boston, 1992), p. 115 no. 59.
5. Joseph Baillio, "Propos sur un dessin de Mme Vigée le Brun," *L'oeil,* nos. 335–36 (June–July 1983), p. 34. The Versailles performance took place in late summer 1780.
6. This point is made by Joseph Baillio in his unpublished manuscript for his catalogue raisonné, kindly made available to the author (September 12, 2003).
7. Correspondence, September 29, 2003.

JACQUES-LOUIS DAVID

(1748–1825)

Although he would eventually become the leading force of the Neoclassical style in France and author of the iconic images of the Revolutionary and Napoleonic periods, Jacques-Louis David's struggle to find his style was a protracted one. His earliest manner was firmly rooted in the late Baroque, and it was not until his third attempt in 1774 that he finally gained the Prix de Rome, entitling him to a crown-sponsored period of study at the Académie de France in Italy. Arriving in 1775 in the company of Joseph-Marie Vien, his former teacher and the newly appointed director of the French Academy, David would spend five years in Rome, where, as the evidence of surviving albums and sketchbooks suggests, he devoted most of his energies to the typical course of study assigned to French pensionnaires: copies after classical antiquities and earlier masters in addition to small, direct studies of the city and its environs.

The impact of his Roman sojourn can be felt clearly in David's work following his return to Paris in 1780. His Belisarius Receiving Alms of 1781 (Musée des Beaux-Arts, Lille) and Andromache Mourning Hector of 1783 (École Nationale Supérieure des Beaux-Arts, on deposit to the Louvre) both make effective use of planar compositions, classicizing figures, and legible gesture. The most celebrated early expression of the Neoclassical aesthetic came with David's Oath of the Horatii (Louvre) in 1785. The same classicizing sensibility also produced some of the greatest portraits of the late ancien régime, including the 1788 Antoine-Laurent Lavoisier and His Wife Marie-Anne Pierette Paulze (cat. 70).

With the events of the French Revolution, David's artistic and political careers became closely entwined. In the early years of the Republic he was made a member of the National Convention and participated in the dismantling of the Académie Royale. He memorialized on canvas such martyrs of the Revolution as Louis-Michel Lepelletier de Saint-Fargeau, Joseph Barra, and Jean-Paul Marat and organized Revolutionary festivals and pageants. However, his alignment with the Jacobins led to his imprisonment after the fall of Robespierre in 1794.

Political savvy helped David negotiate the social upheavals following the Terror. Begun while he was still in prison, the Intervention of the Sabine Women (Louvre) focused on the theme of reconciliation. David went on to become the favored painter of Napoleon, an alliance that gave rise in 1801 to Napoleon Crossing the Saint Bernard Pass (Musée National, Malmaison) and the Coronation of Napoleon of 1805–7 (Louvre). Following the restoration of the Bourbon Monarchy in 1815, the artist spent his final years in voluntary exile in Brussels. During his Paris years, David maintained a large studio and left his mark on a generation of artists, including Anne-Louis Girodet de Roucy Trioson (1767–1824), François Gérard (1770–1837), and Antoine-Jean Gros (1771–1835).

PS

ABBREVIATIONS

Michel 1993. Regis Michel, ed. David contre David: Actes du colloque organisé au Musée du Louvre par le Service Culturel du 6 au 10 décembre 1989. 2 vols. Paris, 1993.

Rosenberg and Prat 2002. Pierre Rosenberg and Louis-Antoine Prat. Jacques-Louis David, 1748–1825: Catalogue raisonné des dessins. 2 vols. Milan, 2002.

70. Antoine-Laurent Lavoisier (1743–1794) and His Wife, née Marie-Anne-Pierrette Paulze (1758–1836)

Oil on canvas, 102 1/4 × 76 5/8 in. (259.7 × 194.6 cm)

Signed, dated, and inscribed at lower left: L. David [faciebat] / parisiis anno / 1788. On the stretcher there is a torn label: Ministère de l'Education . . . / Directions des Musé[es] / Orangerie des Tuiler[ies] / Exposition: David 1948 / Titre de l'oeuvre: Pt. de Lavoisier et de sa femme / Proprietaire: Rockfeller Intitute [sic] for Medical Research / New York, 21, N.Y.; on another label: Garde Meubles / Emballage & Transport / D'Objets d'Art / Pusey / Beaumont / Crassier / 23, 25, 27 / Rue des Petites-Écuries / Paris / Portraits de Mme et Me Lavoisier.

The Metropolitan Museum of Art, New York, Purchase, Mr. and Mrs. Charles Wrightsman Gift, in honor of Everett Fahy, 1977 (1977.10)

PROVENANCE

Antoine-Laurent Lavoisier, Paris (1788–d. 1794; commissioned from the artist for 7,000 livres, paid on December 16, 1788); Mme Antoine-Laurent Lavoisier, later Countess Rumford, Paris (1794–d. 1836); her great-niece, the comtesse de Chazelles (from 1836); the Chazelles family; comte Étienne de Chazelles, Paris and the Château de la Carrière, near Aigueperse (by 1908–d. 1921; his estate until 1924); [Wildenstein, Paris and New York, 1924–25; sold to Rockefeller]; John D. Rockefeller Jr., New York (1925–27); Rockefeller

Institute for Medical Research, later Rockefeller University, New York (1927–77; sold to the Metropolitan Museum); purchased in 1977 by the Metropolitan Museum through a gift from Mr. and Mrs. Charles Wrightsman, in honor of Everett Fahy.

EXHIBITED
Exposition Universelle, Paris, May–November, 1889, "Exposition centennale de l'art français, 1789–1889," no. 234 (lent by M. Étienne de Chazelles); Musée du Jeu de Paume, Paris, April 23–July 1, 1909, "Exposition de cent portraits de femmes des écoles anglaise et française du XVIIIᵉ siècle," no. 57 (lent by Étienne de Chazelles); Palais des Beaux-Arts, Paris, April 7–June 9, 1913, "Exposition David et ses élèves," no. 20 (lent by Étienne de Chazelles); World's Fair, New York City, May–October, 1940, no. 227 (lent by Rockefeller Institute for Medical Research, New York); Palais de la Découverte, Paris, November 1943–January 1944, "Exposition à l'occasion du deuxième centenaire de Lavoisier"; Orangerie des Tuileries, Paris, June 1–September 30, 1948, "David: Exposition en l'honneur du deuxième centenaire de sa naissance," no. M.O. 23 (lent by Rockefeller Institute for Medical Research); Galeries Nationales du Grand Palais, Paris, November 16, 1974–February 3, 1975, Detroit Institute of Arts, March 5–May 4, 1975, Metropolitan Museum, New York, June 12–September 7, 1975, "French Painting, 1774–1830: The Age of Revolution," no. 33 (lent by Rockefeller University, New York); National Gallery of Art, Washington, D.C., June 5–September 6, 1976, "The Eye of Thomas Jefferson," no. 105 (lent by Rockefeller University); Musée du Louvre, Paris, and Musée National du Château, Versailles, October 26, 1989–February 12, 1990, "Jacques-Louis David, 1748–1825," no. 84.

LITERATURE
[Pierre-Jean-Baptiste Chaussard], "Notice sur David," in Le Pausanias français; ou, Description du Salon de 1806, 2nd ed. (Paris, 1808), pp. 156–57, reprinted as "Notice historique sur Louis David, peintre" in Revue universelle des arts 18 (1863–64), p. 120; Anonymous, Notice sur la vie et les ouvrages de M. J.-L. David (Paris, 1824), p. 43; A. Mahul, Annuaire nécrologique; ou, Complément annuel . . . année 1825 (Paris, 1826), p. 141; A. Th[omé de Gamond], Vie de David (Paris, 1826), p. 165; Pierre-Alexandre Coupin, Essai sur J. L. David, peintre d'histoire, ancien membre de l'Institut, officier de la Légion-d'Honneur (Paris, 1827), p. 54; Charles Blanc, Histoire des peintres français au dix-neuvième siècle (Paris, 1845), vol. 1, p. 209; Miette de Villars, Mémoires de David: Peintre et député de la Convention (Paris, 1850), p. 100; Étienne-Jean Delécluze, Louis David: Son école & son temps (Paris, 1855), p. 137 n. 1 (repr. Paris, 1983, p. 468 n. 8); Jean du Seigneur, "Appendice à la notice de P. Chaussard sur L. David," Revue universelle des arts 18 (1863–64), p. 366 (see Chaussard, "Notice sur David," 1808, above); Jacques-Louis-Jules David, Notice sur le Marat de Louis David, suivie de la liste de ses tableaux dressée par lui-même (Paris, 1867), p. 34 no. 17; M. Truchot, Les instruments de Lavoisier: Relation d'une visite à La Carrière (Puy-de-Dôme) où se trouvent réunis les appareils ayant servi à Lavoisier (Paris, 1879), pp. 1, 3–4; Jacques-Louis-Jules David, Le peintre Louis David, 1748–1825: Souvenirs & documents inédits (Paris, 1880), pp. 53, 637; Adrien Delahante, Une famille de finance au XVIIIᵉ siècle: Mémoires, correspondences et papiers de famille réunis et mis du ordre, 2nd ed. (Paris, 1881), vol. 2, pp. 547–48; Jacques-Louis-Jules David, Le peintre Louis David, 1748–1825, suite d'eaux-fortes d'après ses oeuvres (Paris, 1882), ill. (etching), listed in chronological table (n.p.); Édouard Grimaux, Lavoisier, 1743–1794, d'après sa correspondance, ses manuscrits, ses papiers de famille et d'autres documents inédits (Paris, 1888), pp. VI, 364–65, frontispiece heliogravure by Lemercier (David's receipt of payment made in the name of Lavoisier, dated December 16, 1788); Charles Saunier, Louis David (Paris, 1903), pp. 17, ill., 124; Léon Rosenthal, Louis David (Paris, [1904]), p. 165; Prosper Dorbec, "David portraitiste," Gazette des beaux-arts, 3rd ser., 37 (April 1, 1907), pp. 310 n. 1, 311, ill., 321 n. 1; Marc Furcy-Renaud, ed., "Correspondance de M. d'Angiviller avec Pierre," Nouvelles archives de l'art français, 3rd ser., 22 (1906;

published 1907), p. 264 under no. 763 (C.-E.-G. Cuvillier's letter to J.-M. Vien, August 10, 1789); Gaston Brière, "Catalogue critique des oeuvres d'artistes français réunies à l'exposition de cent portraits de femmes du XVIIIᵉ siècle," Bulletin de la Société de l'Histoire de l'Art Francais, 1909, pp. 122–24 no. 57; Albert Dreyfus, "Jacques Louis David und seine Schule," Zeitschrift für bildende Kunst, n.s., 24 (1913), pp. 278, ill., 280; Camille Gronkowski, "'David et ses élèves' at the Petit Palais," Burlington Magazine 23 (May 1913), p. 78; Léon Rosenthal, "L'exposition de David et ses élèves au Petit Palais," Revue de l'art ancien et moderne 33 (May 1913), p. 342; Charles Saunier, "David et son école au Palais des Beaux-Arts de la ville de Paris (Petit Palais)," Gazette des beaux-arts, 4th ser., 9 (May 1913), p. 376 [misnumbered 276]; Gustav Pauli, "David im Petit Palais," Kunst und Künstler 11 (August 1913), pp. 544, 546; Gaston Capon, Le portrait de M. et Mme Lavoisier par David (Paris, 1924), passim, ill. (English ed., The Portrait of Lavoisier and His Wife by Jacques-Louis David [New York, 1924], passim, ill.); Georges Grappe, "La psychologie de David," L'art vivant, December 15, 1925, p. 29, ill.; W. R. Valentiner, Jacques Louis David and the French Revolution (New York, 1929), fig. 13; Richard Cantinelli, Jacques-Louis David, 1748–1825 (Paris and Brussels, 1930), p. 104 no. 55, pl. 19; D. S. MacColl, "Jacques-Louis David and the Ducreux Family," Burlington Magazine 72 (June 1938), pp. 264, 269–70, pl. IIA; Alfred M. Frankfurter, "383 Masterpieces of Art: The World's Fair Exhibition of Four Centuries Loaned from American Public and Private Collections," Art News 38, no. 34 (May 25, 1940), p. 64, ill. p. 37; Klaus Holma, David: Son évolution et son style (Paris, 1940), pp. 53, 118 n. 58, 126 no. 61, pl. 17; John Shapley, "More Masters at the Fair," Parnassus 12, no. 5 (May 1940), p. 10, ill.; Edgar Wind, "The Sources of David's Horaces," Journal of the Warburg and Courtauld Institutes 4 (1940–41), pp. 136–38, pl. 32C; Jacques Maret, David (Monaco, 1943), p. 117, pl. 38; Douglas Cooper, "Jacques-Louis David: A Bi-Centenary Exhibition," Burlington Magazine 90 (October 1948), p. 278; David Lloyd Dowd, Pageant-Master of the Republic: Jacques-Louis David and the French Revolution (Lincoln, Nebraska, 1948), p. 19; Helen Rosenau, The Painter Jacques-Louis David (London, Paris, and Brussels, 1948), p. 26, pl. IV, fig. 1; Douglas Cooper, "Jacques-Louis David," Burlington Magazine 91 (February 1949), p. 57; Douglas McKie, Antoine Lavoisier: Scientist, Economist, Social Reformer (New York, 1952), pp. 95, 294–95, frontispiece; Denis I. Duveen, "Madame Lavoisier, 1758–1836," Chymia: Annual Studies in the History of Chemistry 4 (1953), pp. 17, 27; Denis I. Duveen and Herbert S. Klickstein, A Bibliography of the Works of Antoine Laurent Lavoisier, 1743–1794 (London, 1954), p. 158; Louis Hautecoeur, Louis David (Paris, 1954), pp. 105, 287, 305; Jack Lindsay, Death of the Hero: French Painting from David to Delacroix (London, 1960), p. 60; Anonymous, "Homage by Masterpiece," Art News 60, no. 2 (April 1961), pp. 29–30, ill.; Frederick Antal, Hogarth and His Place in European Art (London, 1962), pp. 199–200, pl. 129a; Lucien Scheler, Lavoisier (Paris, 1964), p. 150; Alvar González-Palacios, Jacques-Louis David, I maestri del colore 161 (Milan, 1966), cover ill. (color); Hugh Honour, Neo-Classicism (Baltimore, 1968), pp. 72, 198, fig. 28; Frederick Cummings, "Folly and Mutability in Two Romantic Paintings: The Alchemist and Democritus by Joseph Wright," Art Quarterly 33 (autumn 1970), pp. 256, 263, fig. 8; Robert L. Herbert, David, Voltaire, "Brutus" and the French Revolution: An Essay in Art and Politics (New York, 1972), pp. 58, fig. 29, 59, 125, 137 nn. 44, 47; Wend Graf Kalnein and Michael Levey, Art and Architecture of the Eighteenth Century in France (Harmondsworth, Middlesex, England, 1972), pp. 124, 193, 195, pl. 199; Michel Laclotte, "J.-L. David: Reform and Revolution," in The Age of Neo-Classicism, exh. cat., Royal Academy of Arts, London, and Victoria and Albert Museum, London (London, 1972), p. lxx; Werner Hofmann, "Poesie und Prosa: Rangfragen in der neueren Kunst," Jahrbuch der Hamburger Kunstsammlungen 18 (1973), pp. 191, fig. 13, 192; René Verbraeken, Jacques-Louis David jugé par ses contemporains et par la postérité, preface by Louis Hautecoeur (Paris, 1973), pp. 14, 28, 30, 32, 147, 245 no. 17, pl. 22; Daniel Wildenstein and Guy Wildenstein, eds., Documents complémentaires au catalogue de l'oeuvre de Louis David (Paris, 1973), pp. 27 under no. 205, 209 under no. 1810, 226 under no. 1938 (as no. 17);

Joachim Gaus, "Ingenium und Ars: Das Ehepaarbildnis Lavoisier von David und die Ikonographie der Museninspiration," *Wallraf-Richartz-Jahrbuch* 36 (1974), pp. 199–228, ill. p. 201; Pierre Rosenberg, "Expositions—Galeries Nationales du Grand Palais, De David à Delacroix: La peinture française de 1774 à 1830," *Revue du Louvre* 24 (1974), p. 443, 445, ill.; Charles McCorquodale, "From David to Delacroix," *Art International* 19 (June 15, 1975), pp. 24–25, ill.; Malcolm N. Carter, "What Do Museum Directors and Curators Go to See in New York?" *Art News* 75, no. 9 (November 1976), pp. 81–82, ill. p. 80; René Huyghe, *La relève de l'imaginaire—la peinture française au XIXᵉ siècle: Réalisme, romantisme* (Paris, 1976), pp. 446–47, fig. 35, colorpl. 3 (detail); Thomas B. Hess, "David's Plot," *New York Magazine,* May 9, 1977, pp. 101–3, color ill.; Henry R. Hope, "Exhibitions," *Art Journal* 37 (fall 1977), p. 66; Henri Michel, *Images des sciences: Les anciens instruments scientifiques vus par les artistes de leur temps* (Rhode-St.-Genèse, 1977), p. 77, ill.; James Parker, "The French Eighteenth-Century Rooms in the Newly Re-Opened Wrightsman Galleries," *Apollo* 106 (November 1977), p. 377, cover ill.; Richard F. Shepard, "Met Gets a David as a Gift," *New York Times,* April 30, 1977, p. C24; Denys Sutton, "In the French Taste," *Apollo* 106 (November 1977), p. 331, cover ill.; Denys Sutton, *Paris—New York: A Continuing Romance,* exh. cat., Wildenstein & Co., New York (New York, 1977), pp. 34–35, pl. XXV; George Levitine, *Girodet-Trioson: An Iconographical Study,* Ph.D. dissertation, Harvard University, Cambridge, Massachusetts, 1952 (New York and London, 1978), pp. 313–14, fig. 61; Dean Walker, in The Metropolitan Museum of Art, *Notable Acquisitions, 1975–1979* (New York, 1979), pp. 53–54, color ill.; Anita Brookner, *Jacques-Louis David* (New York, 1980), pp. 88, 90, 105, 132–33, fig. 46; Philip Conisbee, *Painting in Eighteenth-Century France* (Oxford, 1981), pp. 134, 136, fig. 110; Antoine Schnapper, *David,* trans. Helga Harrison (New York, 1982), pp. 84, 85, colorpl. 40, 92; David R. Smith, "Rembrandt's Early Double Portraits and the Dutch Conversation Piece," *Art Bulletin* 64 (June 1982), p. 279, 281, fig. 37; Michael Wilson, "A New Acquisition for the National Gallery: David's Portrait of Jacobus Blauw," *Burlington Magazine* 126 (November 1984), p. 698; Thomas E. Crow, *Painters and Public Life in Eighteenth-Century Paris* (New Haven and London, 1985), p. 231, pl. 109; Frederick Lawrence Holmes, *Lavoisier and the Chemistry of Life: An Exploration of Scientific Creativity* (Madison, Wisconsin, 1985), frontispiece (detail); Luc de Nanteuil, *Jacques-Louis David* (New York, 1985), pp. 23, 56, 68, 96, colorpl. 13; Antoine Schnapper, *1770–1830: Autour du Néo-Classicisme en Belgique,* exh. cat., Musée Communal des Beaux-Arts d'Ixelles, Brussels (Brussels, 1985), p. 32; Elmar Stolpe, *Klassizismus und Krieg: Über den Historienmaler Jacques-Louis David* (Frankfurt and New York, 1985), pp. 187–89; Simon Schama, "The Domestication of Majesty: Royal Family Portraiture, 1500–1850," *Journal of Interdisciplinary History* 17 (summer 1986), p. 180; Albert Boime, *A Social History of Modern Art,* vol. 1, *Art in an Age of Revolution, 1750–1800* (Chicago and London, 1987), pp. 411–17, fig. 5.5, and see also pp. 507–8 nn. 19–20; Yvonne Korshak, "*Paris and Helen* by Jacques Louis David: Choice and Judgment on the Eve of the French Revolution," *Art Bulletin* 69 (March 1987), p. 114 n. 46; John Leighton, *Jacques-Louis David: Portrait of Jacobus Blauw,* exh. cat., National Gallery, London (London, 1987), pp. 5–6, fig. 3; Jean-Jacques Lévêque, *L'art et la Révolution Française, 1789–1804* (Neuchâtel, 1987), pp. 140, 143, color ill.; Philippe Bordes, *David* (Paris, [1988]), pp. 48, color ill., 49; Donna Marie Hunter, "Second Nature: Portraits by J.-L. David, 1769–1792" (Ph.D. dissertation, Harvard University, Cambridge, Massachusetts, 1988), pp. 323–52, 357, 403–4 nn. 21–22, 405 n. 27, 407 n. 37, 408 n. 39, 409 n. 43, 410 n. 50, pl. 70; Régis Michel, *David: L'art et le politique* (Paris, 1988), pp. 48 color ill., 49 (color detail), 170; Claudine Billoux, *Lavoisier—ses collaborateurs et la revolution chimique: Exposition réalisée à l'occasion du bicentenaire de la publication du "Traité élémentaire de chimie,"* exh. cat., École Polytechnique, Palaiseau (Palaiseau, 1989), p. 1, no. 2, cover ill. (color); Carol S. Eliel, "Genre Painting during the Revolution and the 'Goût Hollandais,'" in *1789: French Art during the Revolution,* ed. Alan Wintermute, exh. cat., Colnaghi, New York (New York, 1989), pp. 57, fig. 12, 61 n. 54, and see also pp. 67, 112,

257; Jean-Jacques Lévêque, *La vie et l'oeuvre de Jacques-Louis David* (Paris, 1989), color ill.; Gilles Néret, *David: La terreur et la vertu* ([Paris], 1989), p. 34, color ill.; Bernard Noël, *David* (Paris, 1989), pp. 26–27, ill.; Madeleine Pinault, in *La Révolution Française et l'Europe, 1789–1799,* exh. cat., Galeries Nationales du Grand Palais, Paris (Paris, 1989), vol. 1, *Introduction générale: L'Europe à la veille de la Révolution,* p. 201 under no. 279; Warren Roberts, *Jacques-Louis David, Revolutionary Artist: Art, Politics, and the French Revolution* (Chapel Hill, North Carolina, and London, 1989), pp. 43–45, fig. 11; Denys Sutton, in *Treasures from The Metropolitan Museum of Art: French Art from the Middle Ages to the Twentieth Century,* exh. cat., Yokohama Museum of Art (Tokyo, 1989), p. 24, fig. 9; Colin B. Bailey, "David and Paris: Classicism's Most Compelling Defender," *Art International,* no. 11 (summer 1990), pp. 98–99, color ill.; Fiona Biddulph, "Spotlight on David," *Museums Journal* 90, no. 1 (January 1990), p. 25, color ill.; Philippe Bordes, "Paris and Versailles: David," *Burlington Magazine* 132 (February 1990), p. 155, fig. 103; Barbara Scott, "Letter from Paris: David's Portraits," *Apollo* 131 (February 1990), pp. 115–16, ill.; Allen Kurzweil, "Laboratory of the Soul," *Art and Antiques* 7, no. 9 (November 1990), pp. 94, 125, color ill.; Colin B. Bailey et al., *The Loves of the Gods: Mythological Painting from Watteau to David,* Galeries Nationales du Grand Palais, Paris, Philadelphia Museum of Art, and Kimbell Art Museum, Fort Worth, Texas (Fort Worth and New York, 1992), p. 509; Nicholas H. J. Hall, ed., *Colnaghi in America: A Survey to Commemorate the First Decade of Colnaghi New York* (New York, 1992), p. 22; Luc de Nanteuil, "Un grand mécène: Jayne Wrightsman," *Connaissance des arts,* no. 490 (December 1992), pp. 34, 38, fig. 2 (color); Colin B. Bailey, "'Les grands, les cordons bleus': Les clients de David avant la Révolution," in Michel 1993, vol. 1, p. 145; Bernadette Bensaude-Vincent, *Lavoisier: Mémoires d'une révolution* (Paris, 1993), ill. opp. p. 241; Arthur Donovan, *Antoine Lavoisier: Science, Administration, and Revolution* (Oxford and Cambridge, Massachusetts, 1993), pp. 238, fig. 4, 239; Jean-Claude Lebensztejn, "Histoires belges," in Michel 1993, vol. 2, p. 1017; Antoine Schnapper, "David et l'argent," in Michel 1993, vol. 2, p. 915; Christopher Lloyd, *The Queen's Pictures: Old Masters from the Royal Collection* (London, 1994), p. 74; Katharine Baetjer, *European Paintings in The Metropolitan Museum of Art by Artists Born before 1865: A Summary Catalogue,* 2nd ed. (New York, 1995), p. 386, ill., color detail (cover); Michael Kimmelman, "At the Met with Roy Lichtenstein: Disciple of Color and Line, Master of Irony," *New York Times,* March 31, 1995, p. C27; Mary Vidal, "David among the Moderns: Art, Science, and the Lavoisiers," *Journal of the History of Ideas* 56 (October 1995), pp. 595–623, ill.; Diana Barkan, review of *Histoire de la thermochimie: Prélude à la thermodynamique chimique,* by Louis Médard and Henri Tachoire, *Isis* 87 (March 1996), p. 147; Jean-Pierre Poirier, *Lavoisier: Chemist, Biologist, Economist,* trans. Rebecca Balinski (Philadelphia, 1996), pp. 1–3, 131, 244, 403, 410, 464 nn. 54, 72, fig. 1; Bertrand du Vignaud, "A David Masterpiece for the Louvre," *Christie's International Magazine* 14, no. 6 (July–August 1997), p. 46; Sophie Monneret, *David et le Néoclassicisme* (Paris, 1998), pp. 78–79, color ill.; Eberhard Roters, *Malerei des 19. Jahrhunderts: Themen und Motive* (Cologne, 1998), vol. 1, pp. 98–101, ill.; Valerie L. Hillings, "Komar and Melamid's Dialogue with (Art) History," *Art Journal* 58, no. 4 (winter 1999), p. 54; Warren Roberts, *Jacques-Louis David and Jean-Louis Prieur, Revolutionary Artists: The Public, the Populace, and Images of the French Revolution* (Albany, 2000), pp. 259, fig. 96, 318, 343 n. 34, and see also pp. 83–85, fig. 17, 115–16, fig. 33; Marco Beretta, *Imaging a Career in Science: The Iconography of Antoine Laurent Lavoisier* (Canton, Massachusetts, 2001), pp. viii, xiii, xiv, 2, 6–7, 9, 12–13, 16, 21, 25–28, 30–31, 34–37, 39–42, 64, 67–68, 82, 84, 86, 88, 90, 94, 100, 103, 115, pl. 1 (color), figs. 3, 4a, 5a, 6a, 7 (details); Thomas Crow, "Ingres and David," *Apollo* 153 (June 2001), p. 12, fig. 3 (color); Philippe Bordes, *Jacques-Louis David: Empire to Exile,* exh. cat., J. Paul Getty Museum, Los Angeles, and Sterling and Francine Clark Art Institute, Williamstown, Massachusetts (New Haven, 2005), pp. 127, 135, 286.

257

REPRODUCTIONS

The picture was engraved by Martini, Massard père, Landon, and Jules David (see Literature, above, 1882); there are heliogravures by G. Profit and Lemercier. Schnapper (see note 3, below) observes that of the numerous derivations from the painting, most copy only the bust of Lavoisier in an oval format (for a list, see Georges Duplessis and P.-André Lemoisne, *Catalogue de la collection des portraits français et étrangers conservée au Département des Estampes de la Bibliothèque Nationale,* vol. 6 [Paris, 1907], p. 87). The prototype may be a portrait by Garneray after David, engraved by P. M. Alix (Salon of 1793, no. 3001). An oval portrait of this type was sold at Hôtel Drouot, March 7, 1956, no. 106. Schnapper also mentions the copy in a private collection that bears the frame originally made for the present picture.

This is one of the grandest portraits of the eighteenth century, painted when the thirty-one-year-old David was at the peak of his powers and had become the self-appointed standard-bearer of French Neoclassicism. Lavoisier is best known today as the founder of modern chemistry, for his pioneering studies of oxygen, gunpowder, and the chemical composition of water. But support for this research—and his high position in society—came from the administrative position he had purchased, that of *fermier-générale,* a tax collector for the royal government.[1] In 1789, soon after this portrait was completed, Lavoisier's theories were published in the influential *Traité elementaire de chimie.* The illustrations in this book were prepared by his wife, who is believed to have studied with David. The tender gestures and intertwined poses in the Wrightsman picture suggest a happily married and complicitous couple, deeply engaged in each other's life. Marie-Anne-Pierrette Paulze was only thirteen when her father, a *fermier-générale,* married her to the twenty-eight-year-old Lavoisier. In the year David painted their portrait, she turned thirty, he forty-five.

Full-length standing portraits of private citizens are rare in French eighteenth-century painting, though much more frequent in British portraits of landed gentry and nobility. The air of informality and arrested, spontaneous action seems to derive from English portrait models, but the controlling reference, as Edgar Wind determined in 1947, is to the trope of "artist and his muse." Apropos the position of Mme Lavoisier in his painting, Antoine Schnapper cited Jean-François Ducis's verse, "Pour Lavoisier, soumis à vos lois / Vous remplissez les deux emplois / Et de muse et de secrétaire."[2] David had planned to exhibit the Lavoiser portrait at the Salon of 1789 along with his *Paris and Helen* (fig. 1), commissioned by the comte d'Artois, the future Charles X and brother of Louis XVI. He must therefore have intended for the obvious comparison to be drawn by spectators. Today, *Paris and Helen*

seems like a parody of the Lavoisier portrait, though the opposite could have been felt in 1789. It is also possible, as Wind suggested, that David used Hogarth's portrait of the actor David Garrick and his wife (fig. 2) as a point of departure for this work. Engravings of English portraits abounded in the studios of French artists at the time; artists as diverse as Prud'hon, Vincent, and David—and their various students—all consulted them.

Lavoisier's *habit noir,* as opposed to the colorful suits of courtiers, was the habitual, English-inspired costume of men who owed their rank to a profession or purchased office: bankers, lawyers, rich merchants, high-ranking bureaucrats. Mme Lavoisier's muslin dress is characteristic of fashionable women of her day, neither exaggerated nor excessively modest. Yet despite the avowed spontaneity of the action, both figures are dressed formally, as if for their portrait if not for the theater. Lavoisier's hair has been carefully curled and powdered, or perhaps he wears an expensive human-hair wig. Mme Lavoisier's elaborate, and supplemented, hair reflects hours of preparation, and her shawl, thrown on the chair, next to what one presumes is an album of her drawings, awaits their departure. The couple are ready to be seen in public, and are not shown in *déshabille,* as was the eighteenth-century convention for artists and scientists at work. In other words, the interruption that provides the pretext for the portrait is as carefully staged as every other aspect of the painting, from the array of instruments that would not necessarily be used together, to the red velvet cloth, inappropriate for messy scientific experiments, to the expensive gilt furniture and the invented, though stately and restrained, architecture. Mme Lavoisier recorded an experiment in her husband's actual laboratory in a drawing made in 1790–91, in which she includes herself in a pose that echoes that of her husband in David's painting (fig. 3).

The commission may have been Mme Lavoisier's idea: a letter to her of February 20, 1788, from Jean-Henri Hassenfratz (1755–1827), Lavoisier's principal collaborator, refers indirectly to her desire to honor her husband and offers suggestions.[3] If indeed Mme Lavoisier had been a student of David, the choice of artist is obvious, though no proof has yet been found of her training. But Lavoisier surely approved of the decision: he praised David as early as 1785, in remarks he penned next to the entry for the *Oath of the Horatii* in that year's Salon *livret.*[4] In fact, although the documents concerning the commission have not been found, David received 7,000 livres for the work, acknowledgment for which is documented by a receipt dated December 16, 1788.[5] This

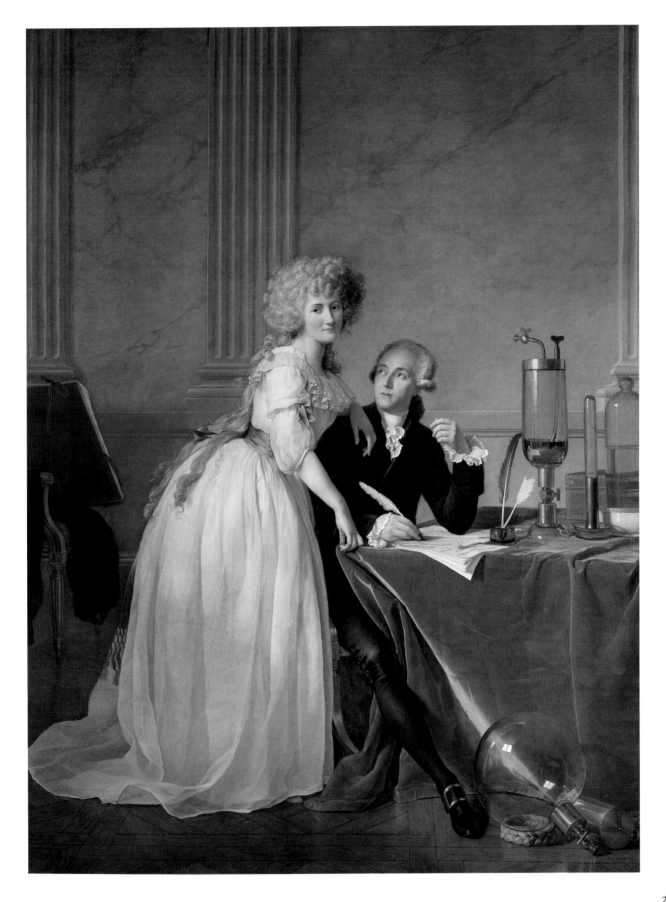

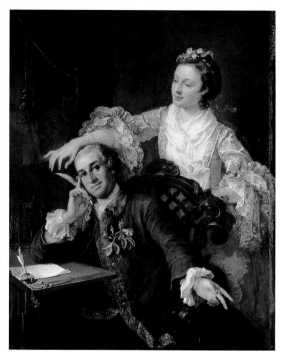

Fig. 1. Jacques-Louis David, *Paris and Helen*, 1788. Oil on canvas, 57¾ × 70⅛ in. (147 × 178 cm). Musée du Louvre, Paris (3696)

Fig. 2. William Hogarth, *David Garrick and His Wife*, 1757. Oil on canvas, 50¼ × 39⅛ in. (127.5 × 99.5 cm). Royal Collection, Windsor

was a huge sum: David had charged Louis XVI only 6,000 livres for *The Lictors Returning to Brutus the Bodies of His Sons.*[6]

Between his appointment as director of the Academy of Science in 1785 and the publication of the *Traité elementaire de chimie,* one of whose tenets is that man is part of, rather than separate from, nature, Lavoisier was the embodiment of liberal Enlightenment aspirations, and his portrait was meant to celebrate these successes. Yet historical circumstances—and public perceptions—were to change radically between December 1788 and the opening of the Salon on August 25, 1789, which was to provide a showcase for the portrait. Still another of Lavoisier's achievements during this period provided the backdrop for the painting's exclusion from the Salon. In 1782, acceding to a request of the Ferme Générale, Lavoisier submitted a report on the loss of an estimated six million livres per year in tariff revenues, which was due to difficulty in policing Paris's periphery. He recommended the construction of new walls and *barrières* around the city, with the intention of collecting taxes, establishing order, and confining heavy traffic to the outskirts. The plan was adopted by the Prévôt des Marchands in May 1784, with Claude Nicolas Ledoux (1736–1806) selected as architect. Ground was first broken

at the Salpêtrière, which came under Lavoisier's direct administration as Régisseur des Poudres et des Salpêtres (Commissioner of Gunpowder), a position he held since 1775. But Parisians, particularly the poor, tended to see themselves as imprisoned by the project, and in the groundswell of violence that overtook the city from July 10 to 15, 1789, which included the storming of the Bastille on the 14th, the *barrières* were systematically looted and burned. Then, on August 5, Lavoisier became embroiled in a political scandal that led directly to the withdrawal of his portrait from the Salon. He was accused of removing gunpowder from the Paris arsenal—leaving the city vulnerable to attack—when in fact all along he had arranged to replace weak gunpowder with higher-grade material. Arrested by order of the marquis de Lafayette (1757–1834), commander of the National Guard, he was exonerated by the Commune of Paris on August 8.[7]

Nevertheless, hoping to avoid controversy that might shut the Salon down and deprive artists of their exhibition opportunity, the organizers themselves recognized that the Lavoisier portrait could become a lightning rod. On August 10, 1789, Charles-Étienne-Gabriel Cuvillier (1728–1793), assistant to Charles-Claude d'Angiviller (1730–1809), Directeur-Général des Bâtiments du Roi, wrote to

Joseph-Marie Vien (1716–1809), president of the academy. After conveying d'Angiviller's wish to be cautious with regard to the choice of subjects to be exhibited, Cuvillier wrote:

The heading of portraits lets one more readily put oneself on guard, because in general the sitters being known, one is in the position of measuring public opinion and of not risking anything; I imagine that concerning this, M. Lavoisier will be the first to wish not to show his portrait. It is not that he could in any sense be ranked among those whom one could think badly of, but one can let him judge that. On the subject of portraits I am inclined to fear that Monsieur de Tollendal might renew the project of exhibiting this terrifying painting which it was so difficult to set aside in 1787; but, at the same time, I am reassured by the very virtue of Monsieur de Tollendal and by the loftiness of his views which will let him see at a glance the danger of furnishing more food to the fermentation. It is in this regard that I am comforted, as much as I could be, by learning that Monsieur David's painting [*Brutus*] is still far from finished; and à propos this artist, I think as you, Monsieur, that his painting of *Paris and Helen* can be exhibited without remaining fears, by suppressing the owner's name [comte d'Artois]. In this the only concern I see is the glory of the Academy and that of the artist.[8]

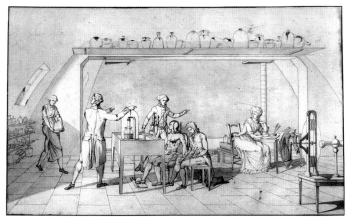

Fig. 3. Marie-Anne-Pierrette Lavoisier, *Lavoisier's Experiments on Respiration on a Subject Performing Work*. Pen and ink and wash, 8⅝ × 14⅛ in. (22 × 36 cm). Private collection

When the Salon opened, the only painting by David on display was *Paris and Helen,* but in early September this was joined by the recently finished *Lictors Returning to Brutus the Bodies of His Sons.* Indeed, there was concern in the administration about this latter painting as well, but popular will, as well as the king's, prevailed; the painting was considered by king and subjects to be patriotic. Given the controversy embroiling the Lavoisier portrait, it is worth noting the circumstances surrounding another work mentioned in Cuvillier's letter to Vien, *The Marquis de Lally-Tollendal Unveiling the Bust of His Father* (Musée de la Revolution Française, Vizille) by Jean-Baptise Claude Robin (1734–1818). Although it had been excluded at the last minute from the Salon of 1787 for political reasons—the historical subject was a singular instance of the ingratitude of the king toward the subject's father—Lally-Tollendal insisted it be included in 1789. It appeared two rows below David's *Brutus* and next to *Paris and Helen.*[9]

While writers have emphasized that David was highly sympathetic to Lavoisier, and portrayed him as an equal, that is, as an intellectual,[10] it was Lavoisier's income as a tax collector that paid for the commission. Scholars have attempted to reconcile David's actions under the Revolution with this affectionate representation of a royal tax collector, the very symbol of the regime that the Revolution sought to destroy. Yet, like his contemporary Goya, David was able to inhabit multiple spheres of life simultaneously, moving, in his art, from the intimate and domestic to grandiose propaganda, without concern for ideological consistency. And like Goya, David willingly served the institutions that he later criticized. Even Lavoisier was canny enough to serve the new regime: he tried to reform the system of weights and measures, was elected as a representative to the Paris Commune, and was named secretary of the Treasury. But as the Revolution increasingly radicalized, his history caught up with him: he was condemned to the guillotine as a former *fermier-générale,* together with his father-in-law and twenty-seven others, and executed in 1794. David belonged to the commission that signed his death warrant.

Marie-Anne, his widow, married the eccentric American inventor Count Rumford in 1804 but soon separated from him; she died in Paris in 1836. The painting, along with Lavoisier's papers and scientific instruments, descended in the family of her great-niece, named Chazelles. Some four thousand items, including some of the instruments shown in the portrait, were purchased from the Chazelles and donated to the Musée National de Techniques (Conservatoire National des Arts et Métier, Paris).

As recounted above, the portrait was withdrawn at the last minute from the Salon of 1789. It was not exhibited publicly until one hundred years later. Although it has since become one of David's most famous works, and it is justifiably considered his finest portrait, it had no immediate impact on the artists of David's generation, nor on the generation of his students.

<div align="right">GT/AEM</div>

NOTES

1. Donna Marie Hunter, "Second Nature: Portraits by J.-L. David, 1769–1792" (Ph.D. dissertation, Harvard University, Cambridge, Massachusetts, 1988), p. 329.

2. "For Lavoisier, subject to your law, you fill two posts, that of muse and of secretary"; see Antoine Schnapper, *David,* trans. Helga Harrison (New York, 1982), p. 84.

3. Madeleine Pinault, in *La Révolution Française et l'Europe, 1789–1799,* exh. cat., Galeries Nationales du Grand Palais, Paris (Paris, 1989), vol. 1, p. 201 under no. 279; see also Antoine Schnapper and Arlette Sérullaz, *Jacques-Louis David, 1748–1825,* exh. cat., Musée du Louvre, Paris, and Musée National du Château, Versailles (Paris, 1989), p. 192 no. 84.

4. The praise was qualified, since Lavoisier admired the force with which the emotions are expressed, but faulted as incorrect the "désagréable" disposition of the father and sons. This document, which also includes annotations concerning Élisabeth Vigée Le Brun (see p. 248) and others, was first published by Victor de Swarte, *Les financiers amateurs d'art au XVIᵉ, XVIIᵉ et XVIIIᵉ siècles* (Paris, 1890), pp. 162–63. See also Donna Marie Hunter, who speculates that the Lavoisiers might also have considered Vigée Le Brun as their prospective portraitist; "Second Nature," pp. 323, 403 n. 2.

5. The text of the receipt was first published by Édouard Grimaux, *Lavoisier, 1743–1794, d'après sa correspondance, ses manuscrits, ses papiers de famille et d'autres documents inédits* (Paris, 1888), pp. 364–65. The receipt was first reproduced in Gaston Brière, "Catalogue critique des oeuvres d'artistes français réunies à l'exposition de cent portraits de femmes du XVIIIᵉ siècle," *Bulletin de la Société de l'Histoire de l'Art Français,* 1909, p. 123.

6. Musée du Louvre, Paris (3693). The *Brutus* was expected for the Salon of 1787 but not delivered until 1789; see Schnapper and Sérullaz, *Jacques-Louis David,* pp. 194–200 no. 85. As Hunter discovered, 7,000 livres was also the cost of Lavoisier's expensive scientific scale.

7. On the history of the *barrières,* see E. Frémy, "L'enceinte de Paris, construite par les fermiers-généraux et la perception des droits d'octroi de la ville (1784–1791)," *Bulletin de la Société de l'Histoire de Paris et de l'Île de France* 39 (1912), pp. 115–48, which is the main source used by Anthony Vidler in *Claude-Nicolas Ledoux: Architecture and Social Reform at the End of the Ancien Régime* (Cambridge, Massachusetts, 1990), pp. 209–15ff., and see also p. 414 n. 166. An account of the July assaults on the *barrières* is given in Warren Roberts, *Jacques-Louis David and Jean-Louis Prieur, Revolutionary Artists: The Public, the Populace, and Images of the French Revolution* (Albany, 2000). On Lavoisier's advancement during this period as recounted here, see Hunter, "Second Nature," esp. pp. 328ff.

8. "L'article des portraits laisse plus de facilité à se mettre en garde, car en générale les originaux étant connus, on est en état mesurer l'opinion publique et de ne rien hasarder; j'imagine à ce sujet que M. Lavoisier sera le premier à ne pas désirer l'exposition de son portrait. Ce n'est pas qu'il soit en aucun sens au rang de ceux qu'on peut mal voir; mais on peut l'en laisser juge. J'ai sur la matière des portraits une sorte de crainte que M. de Tollendal ne reprenne le projet de faire exposer ce terrible tableau qu'il a été si difficile d'écarter en 1787; mais, en même tems, je me rassure par la vertu même de M. de Tollendal et par cette sublimité de vües qui lui fera mesurer au plus simple coup d'oeil le danger de fournir un aliment de plus à la fermentation. C'est sous ce rapport que je suis bien aise, autant que je peux l'être, de savoir le tableau de M. David encore loin d'être achevé; et, à propos de cet artiste, je pense avec vous, Mʳ, que son tableau de Pâris et Hélène peut être exposé sans laisser aucune crainte, en taisant le propriétaire. Je ne vous d'intéressant sur cet article que la gloire de l'Académie et celle de l'artiste." Marc Furcy-Renaud, ed., "Correspondance de M. d'Angiviller avec Pierre," *Nouvelles archives de l'art français,* 3rd ser., 22 (1906; published 1907), p. 264 under no. 763; translated in Robert L. Herbert, *David, Voltaire, "Brutus" and the French Revolution: An Essay in Art and Politics* (New York, 1972), pp. 124–25.

9. See Herbert, *David,* pp. 59–60.

10. For example, Thomas E. Crow, *Painters and Public Life in Eighteenth-Century Paris* (New Haven and London, 1985), p. 231.

71. *A Young Woman of Frascati*

Red chalk on off-white laid paper, framing lines in pen and brown ink, irregularly cut, 6 × 5⅜ in. (15.3 × 13.7 cm)
Annotated in pen and brown ink at lower right with the paraphs of David's two sons, Jules David (Lugt 1437), above, and Eugene David (Lugt 839), below; the stamp of Baron Roger Portalis (Lugt 2232) in black ink at lower left.

PROVENANCE

Collection of the artist (included in his *Inventaire après décès,* February 27, 1826, as part of no. 78, "un autre petit croquis aussi encadré représentant une paysanne des environs de Frascati"); his estate sale, Paris, April 17, 1826, lot 59, to M. Guéret; baron Roger Portalis, Paris; sale, Hôtel des Ventes du Vieux Palais, Rouen, October 20, 1996, lot. 64 (no catalogue); private collection, France; sale, Sotheby's, New York, January 23, 2001, lot 317; [Katrin Bellinger Kunsthandel, Munich; sold to Wrightsman]; Mrs. Charles Wrightsman, New York (from 2001).

LITERATURE

Jacques-Louis-Jules David, *Le peintre Louis David, 1748–1825: Souvenirs & documents inédits* (Paris, 1880), p. 653; Daniel Wildenstein and Guy Wildenstein, eds., *Documents complémentaires au catalogue de l'oeuvre de Louis David* (Paris, 1973), p. 238 no. 2042, item 78, and p. 245 no. 2062, item 59; Pierre Rosenberg, *From Drawing to Painting: Poussin, Watteau, Fragonard, David and Ingres* (Princeton, New Jersey, 2000), pp. 180–81, fig. 228; Rosenberg and Prat 2002, vol. 1, p. 34 no. 9.

RELATED WORKS

WHEREABOUTS UNKNOWN. Jacques-Louis David, *Paysanne italienne debout, vue de profil, tournée vers la droite.* Black chalk, 7⅞ × 4½ in. (20.1 × 11.4 cm).
WHEREABOUTS UNKNOWN. Jacques-Louis David, *Paysanne italienne debout, vue de profil, tournée vers la droite.* Black chalk, 7⅞ × 4¾ in. (19.9 × 12.1 cm).

Thoroughly fresh and charming in its direct observation, this drawing of a young Italian woman in local dress is atypical for

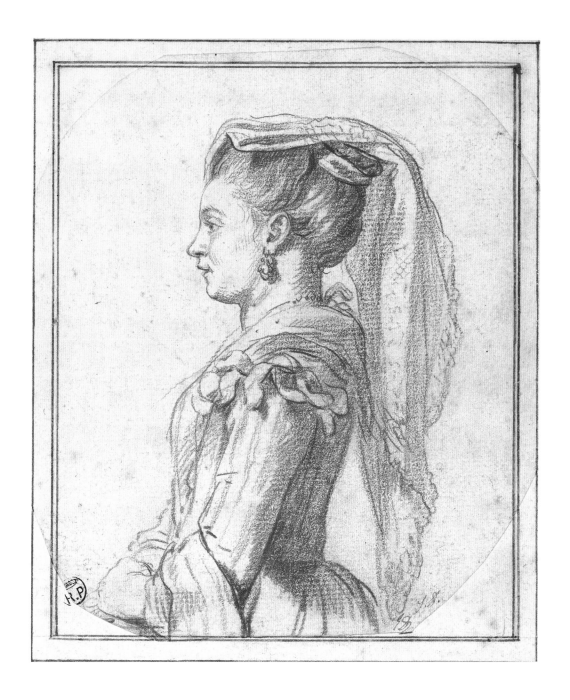

David in both its subject and its use of red chalk.[1] On the basis of style, it has been dated by Pierre Rosenberg and Louis-Antoine Prat to David's first year in Rome, about 1775–76.[2] As was his normal practice, David kept the drawing his entire life; it appears in 1826 in both the *Inventaire après décès* and his estate sale, at which time it was initialed by the artist's sons. Supported by these two documents, it was included in J.-L. Jules David's 1880 catalogue of his grandfather's oeuvre; however, it became known to modern art historians only after it appeared on the art market in 1996.[3]

Two well-established traditions are merged by David in this seemingly casual sketch. The format of the portrait drawing in profile, inspired by antique coins and cameos, was popularized by Charles-Nicolas Cochin the Younger (see p. 192) in the years before David's departure for Rome. Also relevant is the custom among French artists visiting Italy of drawing local women in regional dress, sometimes to be used later to produce sets of costume prints; one can cite as precedents Nicolas Vleughels, François Boucher (see p. 170), Jean Baptiste Marie Pierre, Jean Barbault, Jean-Baptiste Greuze, Jean-Honoré Fragonard, and François-André Vincent—the latter two having just returned from Italy the year before David left Paris. Women from Frascati in particular (variously referred to as *fille, paysanne,* or *bourgeoise*) were depicted by Vleughels, Barbault, and Greuze;[4] their distinctive costumes, with tight waists, ribbon-like decoration at the shoulder, flat head coverings that fall to a point behind the back, and three-quarter cuffed sleeves, provide a close parallel to the dress in the Wrightsman drawing, confirming the accuracy—at least in regard to the city—of the title given in the 1826 *inventaire*: "une paysanne des environs de Frascati." While the depiction of the costume is reliable, however, the subject's traditional designation as a peasant is more suspect. Her erect carriage, necklace, and earring all suggest a more elevated status.

Given the singular nature of this sheet in the artist's oeuvre, it is unlikely that David planned a series of costume prints. Two very preliminary sketches of a similar figure, facing to the right, indicate that he considered, and presumably abandoned, the idea of making a full-length drawing of this type.[5] If David's reason for making the Wrightsman drawing remains unknown, the fact that he cherished it is clear, for it is among a handful of drawings he chose to frame and hang on his walls.[6] Moreover, he must have talked about the drawing to his sons, who would otherwise have been unaware that the sitter was a native of Frascati.

PS

NOTES

1. As Pierre Rosenberg has stated, of the almost two thousand sheets known by David, the number in red chalk can be counted on one hand (*From Drawing to Painting: Poussin, Watteau, Fragonard, David and Ingres* [Princeton, New Jersey, 2000], p. 180). For two earlier examples, see Rosenberg and Prat 2002, vol. 1, pp. 29 no. 3, 31 no. 6. Since the publication of the catalogue raisonné, another album has come to light, including one additional drawing of a cow in red chalk; see Pierre Rosenberg and Benjamin Peronnet, "Un album inédit de David," *Revue de l'art,* no. 142 (2003), pp. 45–83.

2. Rosenberg and Prat 2002, vol. 1, p. 34 no. 9.

3. It first appeared in a sale in Rouen on October 20, 1996, for which no catalogue was printed; see Rosenberg and Prat 2002, vol. 1, p. 34 no. 9. The drawing then became more widely known when it was included in a sale at Sotheby's, New York, January 23, 2001, lot 317.

4. See Bernard Hercenberg, *Nicolas Vleughels: Peintre et directeur de l'Académie de France à Rome, 1668–1737* (Paris, 1975), p. 104 no. 124, fig. 137; Nathalie Volle and Pierre Rosenberg, *Jean Barbault (1718–1762),* exh. cat., Musée Départemental de l'Oise, Beauvais, Musée des Beaux-Arts, Angers, and Musée des Beaux-Arts, Valence (Beauvais, 1974), p. 49 no. 22, pl. LII; and Jean Martin, *Oeuvre de J.-B. Greuze: Catalogue raisonné* (Paris, 1908), p. 28 no. 410 (24).

Prints after costume drawings by Vleughels, Barbault, and Greuze appeared in a set of twenty-four images published in 1768 by Pierre-Étienne Moitte (1722–1780) and members of his family under the title *Divers habillements suivant le costume d'Italie: Dessinés d'après nature par J. B. Greuze . . . ornés de fonds par J. B. Lallemand et gravés d'après des dessins tirés du cabinet de M. l'abbé Gougenot.*

5. Rosenberg and Prat 2002, vol. 1, p. 35 nos. 10–11.

6. The drawing is described as framed in David's *Inventaire après décès,* reprinted in Daniel Wildenstein and Guy Wildenstein, eds., *Documents complémentaires au catalogue de l'oeuvre de Louis David* (Paris, 1973), p. 238 no. 2042, item 78 ("un autre petit croquis aussi encadré représentant une paysanne des environs de Frascati").

ADÉLAÏDE LABILLE-GUIARD

(1749–1803)

The daughter of Claude Labille (1705–1788), a Parisian haberdasher, Adélaïde Labille began her artistic training with her neighbor, miniature painter François-Élie Vincent (1708–1790). By 1769 Labille was registered as a member of the Académie de Saint Luc and had married Louis-Nicolas Guiard, a clerk from whom she would legally separate ten years later. Between 1769 and 1774 she studied pastel with Maurice Quentin de La Tour (1704–1788); in 1776, with the goal of adding oil painting to her repertoire, she entered the studio of François-André Vincent (1746–1816), the son of her first teacher.

Producing portraits in miniature, pastel, and oil, Labille-Guiard earned admittance to the Académie Royale in 1783, on the same day as Élisabeth Louise Vigée Le Brun (1755–1842), thus bringing to four—and the official limit—the number of women granted membership in the Crown-sponsored institution. She continued to campaign for equal privileges for women artists, petitioning for and eventually being granted studio space in the Palais du Louvre. Her Self-Portrait with Two Pupils of 1785 (Metropolitan Museum) gives expression to her hard-won position and her role in training younger women artists. In 1800 Labille-Guiard married François-André Vincent, her former teacher and childhood friend. PS

72. Study of a Seated Woman Seen from Behind (Marie-Gabrielle Capet)

Red, black, and white chalk on toned laid paper, 20 ½ × 18 ⅞ in. (52 × 48 cm)
Inscribed in pen and brown ink at lower left: Labille / ᶠᵐᵉ Guiard / 1789. Signed in black chalk at lower right: Labille f. Guiard.

PROVENANCE
Presumably in the artist's studio (until her d. 1803); ?her husband, François-André Vincent; collection of M. D[espris], Paris; his sale, Hôtel Drouot, Paris, May 18–19, 1921, lot 31 (as "Labille-Guyard [Madame], Etude de Femme en buste, Dessin au pastel. Signé et daté en bas, à gauche: 1789. Haut., 51 cent.; larg., 40 cent. Cadre Louis XVI en bois sculpté doré."); Mme Conti (per Passez);[1] Édouard Pape; his sale, Hôtel Drouot, Paris, April 16, 1943, lot 6; private collection, France; [Emmanuel Moatti, Paris 1994; sold to Wrightsman]; Mrs. Charles Wrightsman, New York (from 1994).

EXHIBITED
Anne-Wildenstein, New York, November 14–December 28, 1989, "The Winds of Revolution," no. 31; Emmanuel Moatti and Jack Kilgore & Co., Inc., New York, May 6–21, 1994, "Old Master Drawings," no. 28.

LITERATURE
Anne Marie Passez, Adélaide Labille-Guiard, 1749–1803: Biographie et catalogue raisonné de son oeuvre (Paris, 1973), p. 222 no. 105 (as "Portrait de Femme," present location unknown, citation of M. D[espris] sale), and p. 296 no. 178 (as "Portrait de Jeune Femme," among the "Oeuvres incertaines passées en ventes publiques," citation of Pape sale); Margaret Morgan Grasselli, in Mastery and Elegance: Two Centuries of French Drawings from the Collection of Jeffrey E. Horvitz, ed. Alvin L. Clark, exh. cat., Harvard University Art Museums, Cambridge, Massachusetts, and other cities (Cambridge, Massachusetts, 1998), p. 326, fig. 1.

The extreme paucity of drawings definitively assigned to Labille-Guiard provides scant context or precedent for the accomplishment and subtlety of this trois crayons (three chalks) study of a partially draped woman seen from behind.[2] Were it not for the signature, it might well have been mistaken for the work of her husband, François-André Vincent, one of the most talented draftsmen of his generation. The combined red, black, and white chalks, together with areas of the toned paper held in reserve, effectively evoke the warm glow of flesh tones, the loose tendrils of dark hair, and the casually arrayed folds of striped fabric. White

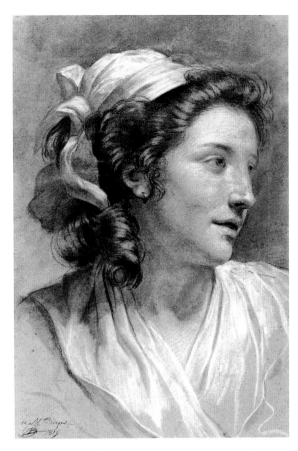

Fig. 1. François-André Vincent, *Portrait of Marie-Gabrielle Capet*. Black and white chalk on tan paper, 17⅞ × 12⅞ (45.4 × 30.7 cm). Iris and B. Gerald Cantor Center for Visual Arts at Stanford University, Palo Alto, California, Gift of Ann Bancroft Dickinson (1982.137)

highlights on the cheekbone, temple, and shoulder suggest the strong light source often favored by Labille-Guiard. An elegant drop earring provides a riveting counterpoint to the studied informality of the pose.

Although it is not a portrait in any conventional sense, the identity of the model as Marie-Gabrielle Capet (1761–1818) has been plausibly suggested by Joseph Baillio on the basis of resemblance.[3] Born in Lyon in 1761, Marie-Gabrielle Capet had by age twenty established herself in Paris in the studio of Labille-Guiard and is documented as exhibiting works at the Exposition de la Jeunesse.[4] Like her mentor, Capet specialized in portraits, working in oil, pastel, and miniature. The two were extremely close, and when Labille-Guiard married Vincent in 1800, Capet stayed on in the household, remaining even after Labille-Guiard's death in 1803 to care for Vincent until his death in 1816, two years before her own. In his final year Vincent made inscriptions in pen and brown ink

in the lower corners of many of the drawings in his studio, dedicating a number to Mlle Capet, presumably as a gift to her. Here, the inscription at lower left in pen and brown ink, a reprise of Labille-Guiard's largely illegible chalk signature at right, appears to be in his hand as well, suggesting that he retained the drawing after his wife's death.

Labille-Guiard's clientele in the 1780s was largely made up of members of the court and friends and colleagues at the Académie Royale. In 1787 she was appointed Peintre des Mesdames, official painter to Louis XVI's aunts. Many of these royal portraits were direct and sober portrayals in subdued palettes, reflecting no doubt the wishes of her sitters. In contrast to the three full-length formal portraits exhibited by Labille-Guiard in the Salon of 1789, the present sheet belongs to a genre that would have been designated as *têtes d'expression*—or simply *têtes*—in eighteenth-century catalogues and inventories. The 1779 *Delightful Surprise* (J. Paul Getty Museum, Los Angeles), fully worked in pastel and dating ten years earlier, presents a prior example of this more private side of her production.

Yet the closest parallel to the Wrightsman drawing can actually be found in Vincent's numerous bust-length studies of female models in *trois crayons* datable to the 1780s. Capet and perhaps other students of Labille-Guiard seem to have posed for both husband and wife.[5] Vincent's *Portrait of Marie-Gabrielle Capet* (fig. 1), for instance, shares many characteristics of the present sheet. His facility in chalk head studies dates back to his student years, when in 1768 he won the coveted Prix de l'Étude des Têtes et de l'Expression. With the Wrightsman drawing, one can claim that Labille-Guiard's talent in this genre was entirely the equal to that of her future husband. PS

NOTES

1. Anne-Marie Passez, *Adélaide Labille-Guiard, 1749–1803: Biographie et catalogue raisonné de son oeuvre* (Paris, 1973), p. 222 no. 105.
2. A *trois crayons* study of Marie-Gabrielle Capet and Marie-Marguerite Carreaux de Rosemond for her *Self-Portrait with Two Pupils* (1785, Metropolitan Museum of Art, New York) was acquired by the Metropolitan in 1998. See Perrin Stein and Mary Tavener Holmes, *Eighteenth-Century French Drawings in New York Collections*, exh. cat., The Metropolitan Museum of Art, New York (New York, 1999), pp. 188–90, no. 82.
3. Joseph Baillio, *The Winds of Revolution*, exh. cat., Wildenstein, New York (New York, 1989), p. 40 no. 31
4. For Capet's life and work, see Arnauld Doria, *Gabrielle Capet* (Paris, 1934).
5. Anne-Marie Passez suggests several instances where the two artists may have worked side by side on portraits of the same sitter; see Passez, *Adélaide Labille-Guiard*, p. 51.

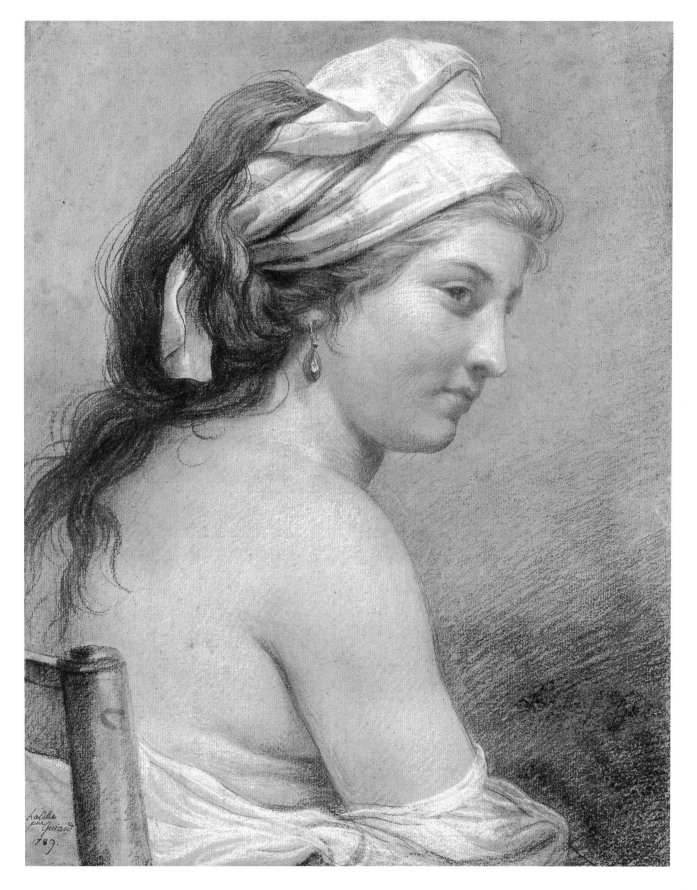

BARON GROS

(Antoine-Jean Gros, 1771–1835)

Born in Paris on March 16, 1771, Antoine-Jean Gros was taught to draw by his parents, who both painted portrait miniatures. They also amassed a considerable art collection, sold in 1788. After some time in the studio of Élisabeth Vigée Le Brun (see p. 248), Gros, not quite fifteen, enrolled at the end of 1785 as a pupil of Jacques-Louis David (see p. 255). He was admitted as a student to the Royal Academy two years later. Quickly becoming a favorite of David, he remained close to his master for the remainder of his life.

Failing to secure the Prix de Rome in 1792, Gros left for Italy on his own in January 1793, accompanying the sculptor Augustin Pajou (1730–1809) part of the way. Just before his departure, he broke relations with his best friend and colleague, François Gérard (see p. 276), who, at the Café des Cruches in the rue Saint-Louis-Saint-Honoré, had publicly suggested that Gros did not support the Revolution, leaving Gros vulnerable to charges of treason. In the nineteenth century this story became legendary. Although Gros had ties to and sympathy for the ancien régime, he was not a counterrevolutionary; Gérard, according to David, was "farouche."[1]

Gros met Josephine Bonaparte (1763–1814) in Genoa in 1796, and through this encounter became one of the most important propagandists of Napoleon's rule and the author of numerous illustrious compositions, among them Bonaparte Visting the Pest House at Jaffa (1804; Musée du Louvre) and Napoleon on the Battlefield at Eylau (1808; Musée du Louvre). David's Neoclassicism was without doubt the principal formative influence on Gros's style, but his heavy dependence on Baroque models, especially Rubens, set him apart from the rest of his fellow students. When David was obliged to leave Paris for Brussels in 1815, Gros assumed leadership of his studio and unwittingly became the keeper of David's Neoclassical aesthetic despite his own emerging Romantic style.

GT/AEM

NOTE

1. Gérard only returned to Paris in January 1793, Gros left on January 26. The story was first recorded by Charles Blanc, *Histoire des peintres de toutes les écoles: École française,* vol. 3 (Paris, 1863), p. 2, and was repeated by J.-B. Delestre, *Gros: Sa vie et ses ouvrages,* 2nd ed. (Paris, 1867), p. 122.

73. *Portrait of the Artist François-Pascal-Simon Gérard, later Baron Gérard (1770–1837)*

Oil on canvas, 22⁷⁄₈ × 18¹⁄₈ in. (55.5 × 46 cm)
The Metropolitan Museum of Art, New York, Gift of Mrs. Charles Wrightsman, 2002 (2002.441)

PROVENANCE
The sitter, baron François-Pascal-Simon Gérard, Paris (1790–d. 1837; presumably a gift of the artist, Antoine-Jean Gros); the sitter's nephew, Henri-Alexandre Gérard, later baron Gérard (by 1848–d. 1882; inherited either directly from the sitter or from the sitter's widow and maternal aunt, née Marguerite-Françoise Mattei, d. 1848); his son, Maurice-Henri-François Gérard, Maisons, Calvados; his son, François Gérard, Maisons; his daughter, the duchesse François-Charles-Jean-Marie d'Harcourt, or d'Harcourt-Beuvron; her sister, the comtesse Élie-Marie-Gabriel Dor de Lastours, née Marie Gérard; [Eric Turquin, Paris, by November 1997]; [Marlborough Fine Art, London, until 1998; sold to Wrightsman]; Mrs. Charles Wrightsman, New York (1998–2002); Mrs. Wrightsman's gift in 2002 to the Metropolitan Museum.

EXHIBITED
Palais du Trocadéro, Exposition Universelle, Paris, 1878, "Première exposition française des portraits nationaux," no. 662 (as "François, baron Gérard, à vingt ans," lent by Baron Gérard, Paris); École des Beaux-Arts, Paris, 1883, "Les portraits du siècle," no. 120; Paris, 1887, "Exposition de tableaux de maîtres anciens au profit des inondés du midi," no. 64 (lent by Baron Gérard); Galerie des Champs-Élysées, Paris, 1895, "Exposition historique et militaire de la révolution et de l'Empire," no. 774 (lent by Baron Gérard); Palais des Beaux-Arts, Paris, April 7–June 9, 1913, "Exposition David et ses élèves," no. 169 (lent by Baron Gérard); Maison de Victor Hugo, Paris, May 18–June 30, 1927, "La jeunesse des romantiques," no. 1064 (lent by Baron Gérard); Musée du Petit Palais, Paris, May–July 1936, "Gros: Ses amis, ses élèves," no. 3 (lent by Baron Gérard).

LITERATURE
[Henri-Alexandre Gérard], *Oeuvre du baron François Gérard, 1789–1836: Gravures à l'eau-forte,* 3 vols. (Paris, 1852–57), vol. 1 (1852–53), *Collection des 83 portraits historiques en pied,* frontispiece (engraving after the painting by Vallot), vol. 3 (1857), *Esquisses peintes, tableaux ébauchés,* n.p.; J. Tripier Le Franc, *Histoire de la vie et de la mort du baron Gros le grand peintre, rédigée sur de nouveaux documents et d'après souvenirs inédits* (Paris, 1880), p. 608 n. 1; Raymond Escholier, *Gros: Ses amis et ses élèves* (published in association with the Paris 1936 exhibition) (Paris, 1936), pl. 9; Raymond Escholier, *La peinture française: XIXᵉ siècle* (Paris, 1941), vol. 1, *De David à Géricault,* p. 67, ill. (as collection Baron Gérard, Paris), and see also pp. 41, ill., 66–67; Robert Baschet, "Une soirée chez le peintre Gérard, en 1826," *Arts,* no. 155 (February 27, 1948), p. 1, ill.; Alan P. Wintermute, ed., *1789: French Art during the Revolution,* exh. cat., Colnaghi, New York (New York, 1989), pp. 216, fig. 2, 217, 218 n. 8; Colta Ives, with Elizabeth E. Barker, *Romanticism and the School of Nature: Nineteenth-Century Drawings and Paintings from the Karen B. Cohen Collection,* exh. cat., The Metropolitan Museum of Art, New York (New York, 2000), p. 16 n. 2 under no. 8; Gary Tinterow, in "Recent Acquisitions: A Selection, 2002–2003," *The Metropolitan Museum of Art Bulletin* 61, no. 2 (fall 2003), pp. 28–29, color ill.

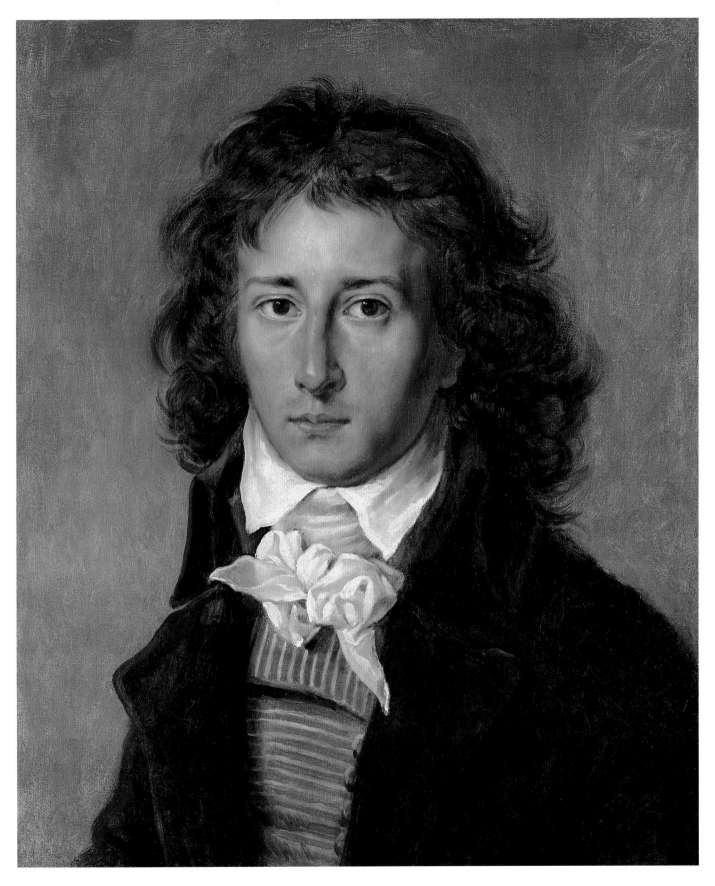

269

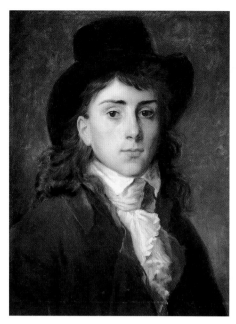

Fig. 1. François Gérard, *Portrait of Antoine-Jean Gros at the Age of Twenty*, ca. 1790–91. Oil on canvas, 23 ¼ × 18 ⅞ in. (59 × 48 cm). Musée des Augustins, Toulouse (RO 109)

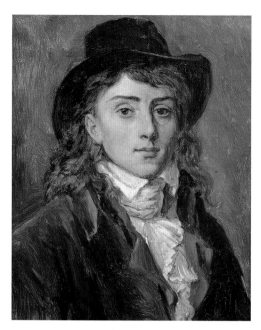

Fig. 2. François Gérard, *Portrait of Antoine-Jean Gros*, 1790. Oil on paper, mounted on canvas, 10 ¼ × 8 in. (26 × 20.3 cm). Private collection, New York

REPRODUCTIONS
Reproductive engraving by Philippe-Joseph-Augustin Vallot (1796–1870), published as a frontispiece to [Henri-Alexandre Gérard], *Oeuvre du baron François Gérard, 1789–1836: Gravures à l'eau-forte*, 3 vols. (Paris, 1852–57), vol. 1 (1852–53), *Collection des 83 portraits historiques en pied*. Oval, image, 6 ⅞ × 4 ⅞ in. (17.5 × 12.4 cm). Inscribed in the plate: Peint par Gros 1791 / Gravé par Vallot 1853.

Gros and Gérard were equally favored disciples in the rough-and-tumble fraternity that was the atelier of Jacques-Louis David (see p. 255). Intense friendships and near-fatal rivalries developed in the heady environment that mixed revolutionary politics with cut-throat professional competition. In the late 1780s Gros and Gérard were close friends; later, in the early nineteenth century, Gérard would become court portraitist to Napoleon and Josephine, while Gros would become the chief propagandist of the empire's military exploits.

David expected his students to pose for him and for each other. One former student, Étienne-Jean Delécluze (1781–1863), recalled in his history of David's studio that the painting of informal portrait heads replaced the *têtes d'expression* that had been part of academic instruction in Paris for more than a century: "They were employed to copy *a head,* for which the rules required each student to pose or to hire a model at his own expense."[1] This statement provides the pedagogical context for the present work.

Gros probably made this sensitive and delicate portrait in Paris before Gérard departed in September 1790 for a study sojourn in Rome that would last for over two years; no sketch by Gros for this portrait is known. Gérard reciprocated with the handsome portrait of Gros in the wide-brimmed hat favored by revolutionaries, now in Toulouse (fig. 1). Gérard's small sketch for that picture is in a New York private collection (fig. 2); a small replica of the Toulouse portrait is now in Versailles. Later, while in Genoa, Gros and Anne-Louis Girodet-Trioson (1767–1824) painted likenesses of each other (Musée National du Château, Versailles), similar to the portraits that he and Gérard exchanged.

A prototype for these portrait heads is David's self-portrait (fig. 3) now in the Uffizi, dated 1791 on the reverse but probably painted in May 1790. (David gave his self-portrait to Gérard in 1809 in exchange for a portrait of the sculptor Antonio Canova [1757–1822].) Gros also painted David's portrait at this time, fulfilling a request for a likeness made to David by the king of Poland. Though there is some confusion on the matter, the original picture for the Polish king may be the one now in the State Pushkin Museum, Moscow, which bears Gros's name on the reverse (fig. 4).[2]

The friendship between Gérard and Gros was broken off in January 1793, when Gérard denounced Gros for contemplating emigration before his departure for Italy, an accusation that could

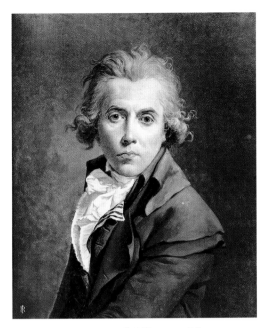

Fig. 3. Jacques-Louis David, *Self-Portrait*. Oil on canvas, 25¼ × 20⅞ in. (64 × 53 cm), 1791. Galleria degli Uffizi, Florence (1890, no. 3090)

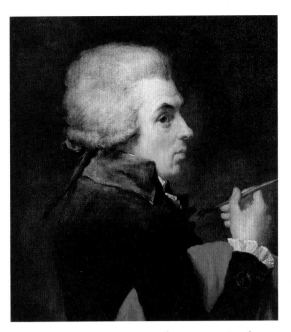

Fig. 4. Antoine-Jean Gros, *Portrait of Jacques-Louis David*, ca. 1790. Oil on canvas, 24¾ × 20½ in. (63 × 52 cm). State Pushkin Museum, Moscow (842)

have resulted in trial for treason. Although this event occurred two years after the exchange of portraits, the story has long been associated with these pictures. The artists did not attempt to repair the rift until 1815, when Gros wrote Gérard a letter on the occasion of Gros's nomination to the Institut de France:

Monsieur,

I just left the studio of M. David, our dear master, who wanted to report the good disposition of the members of the Institute toward [my candidacy], which you yourself shared, showing that you are still [my] old comrade. It is in this context, conforming to his wishes and mine, that I take this occasion to thank you. I thought you were so badly disposed toward me that I regarded the customary visit [to all the members of the Institut] as impractical. I hope that sincere thanks will repair that omission and that you will not interpret badly this initiative, which also reflects my feelings and those of our dear master, whom I have just left.[3]

Despite the long enmity, each artist kept his portrait by the other for his entire life. Gros's portrait of Gérard remained with the sitter's descendants until recently. GT

NOTES

This entry is based on my text in "Recent Acquisitions: A Selection, 2002–2003," *The Metropolitan Museum of Art Bulletin* 61, no. 2 (fall 2003), pp. 28–29, color ill.

1. "Ils étaient employés à copier *une tête,* pour laquelle chaque élève était tenu par les règlements de poser lui-même, ou de fournir un modèle mercenaire à ses frais." Étienne-Jean Delécluze, *Louis David: Son école et son temps* (Paris, 1855), p. 53.

2. The painting at the Pushkin has often been considered a self-portrait of David rather than a work by Gros. See Philippe Bordes, *Le Serment du Jeu de Paume de Jacques-Louis David: Le peintre, son milieu et son temps de 1789 à 1792* (Paris, 1983), p. 146, and Thomas Crow, *Emulation: Making Artists for Revolutionary France* (New Haven and London, 1995), p. 190. Most recently the painting has been published as by Gros himself; see Irina Koznetsova and Elena Sharnova, *France, XVI–First Half of the XIX Century: Collection of Paintings* [in Russian], State Pushkin Museum of Fine Arts (Moscow, 2001), pp. 304–6 no. 296.

3. "Je sors de chez M. David, notre cher maître, qui a bien voulu me rapporter les bonnes dispositions de MM. les membres de l'Institut, à mon égard, que vous-même les aviez partagées et vous vous étiez montré là, toujours ancien camarade; c'est sous ces auspices, conformément à ses désirs et aux miens, que je saisis l'occasion de vous remercier. Je vous pensais si mal disposé à mon égard que j'avais regardé la visite d'usage comme impracticable; je désire que des remerciements sincères réparent cette omission, et que vous n'interprétiez point mal cette demarche aussi conforme à mes sentiments qu'à ceux de notre cher maître, que je quitte à l'instant." *Correspondance de François Gérard, peintre d'histoire, avec les artistes et les personnages célèbres de son temps,* ed. Henri-Alexandre Gérard (Paris, 1867), pp. 104–5.

PIERRE-PAUL PRUD'HON
(1758–1823)

Born in Cluny, Pierre-Paul Prud'hon received his early artistic training in Dijon and Paris. Winner of the Prix de Rome in 1784, he spent four years in the Eternal City before returning to Paris to pursue his career. Eclipsed in the popular imagination by his competitor Jacques-Louis David (see p. 255), Prud'hon was in fact a highly influential artist throughout Napoleon's regime. During the empire, Prud'hon's exquisite paintings, redolent of eighteenth-century delicacy, provided an important alternative to the polished realism of David and Ingres (see p. 292) on the one hand, and to the Baroque drama of Anne-Louis Girodet-Trioson (1767–1824) and Gros (see p. 268) on the other hand. Like his contemporary Baron Gérard (see p. 276), Prud'hon brought aspects of English painting to the French school, thereby setting the stage for Romanticism in France.

Prud'hon's impact in early nineteenth-century Paris was achieved not through teaching—as was David's—but through working. He enjoyed the patronage of the emperor, the empress, and high-ranking administrative officials, among them Nicolas Frochot (1761–1828), the minister of police, and Talleyrand, in addition to rich financiers and a few families of the old guard. Thanks to this clientele, he was commissioned to design a wide range of material, from the stationery of the prefecture of Paris to ceilings in the Louvre, the wedding of Napoleon and Marie-Louise, and the cradle of the king of Rome. Along the way he also made the extraordinary allegorical scenes and ravishing drawings for which he is best known today.

GT

74. Charles-Maurice de Talleyrand-Périgord (1754–1838), Prince de Bénévent

Oil on canvas, 85 × 55⅞ in. (215.9 × 141.9 cm)
Signed at lower left, on plinth: P. P. Prud'hon pinxit. Inscribed: CHARLES MAURICE DE TALLEYRAND PÉRIGORD PRINCE DE BÉNÉVENT— / VICE GRAND ÉLECTEUR DE L'EMPIRE + 1838. (PEINT PAR PRUD'HON EN 1809.) This nineteenth-century inscription, not original to the 1817 portrait, was painted out by Hubert von Sonnenburg in 1994.
The Metropolitan Museum of Art, New York, Purchase, Mrs. Charles Wrightsman Gift, in memory of Jacqueline Bouvier Kennedy Onassis, 1994 (1994.190)

PROVENANCE
The sitter, Charles-Maurice de Talleyrand-Périgord, prince de Bénévent, Paris (1817–d. 1838; commissioned from the artist, possibly by the sitter's companion, the duchesse de Dino, for Fr 7,000); by descent, Napoléon-Louis, third duc de Talleyrand-Périgord, Château de Valençay (1838–d. 1898; his estate sale, Galerie Georges Petit, Paris, May 29–June 1, 1899, lot 21, as "Charles-Maurice, de Talleyrand Périgord, prince de Bénévent," for Fr 25,500, to Castellane); the comtesse Jean de Castellane, Paris (1899–at least 1937); by descent, ?comte François de Castellane, Paris (by 1970–91); [A. Moatti, Paris]; [Didier Aaron, Paris, 1991–92; sold to the Metropolitan Museum]; purchased in 1994 by the Metropolitan Museum with a gift from Mrs. Charles Wrightsman in memory of Jacqueline Bouvier Kennedy Onassis.

EXHIBITED
École des Beaux-Arts, Paris, May 4–July 4, 1874, "Exposition des oeuvres de Prud'hon, au profit de sa fille," no. 37 (lent by the duc de Valençay, Château de Valençay [Indre]); Palais du Trocadéro, Exposition Universelle, Paris, 1878, "Première exposition française des portraits nationaux," no. 774 (lent by the duc de Talleyrand et de Valençay, Château de Valençay [Indre]); Palais des Beaux-Arts, Paris, May–June 1922, "Exposition P.-P. Prud'hon," no. 57 (lent by the comtesse Jean de Castellane); Palais National des Arts, Paris, 1937, "Chefs d'oeuvre de l'art français," no. 210 (lent by the comtesse Jean de Castellane, Paris); Galerie Charpentier, Paris, 1952, "Cent portraits d'hommes du XIVᵉ siècle à nos jours," no. 73; Galeries Nationales du Grand Palais, Paris, September 23, 1997–January 5, 1998, Metropolitan Museum, New York, March 10–June 7, 1998, "Pierre-Paul Prud'hon," no. 135 (shown in New York only).

LITERATURE
Charles Clément, Prud'hon: Sa vie, ses oeuvres et sa correspondance (Paris, 1872), pp. 304–5 (under letter from Prud'hon to the duchesse de Dino dated April 12, 1817); Edmond de Goncourt, Catalogue raisonné de l'oeuvre peint, dessiné et gravé de P. P. Prud'hon (Paris, 1876), pp. 37, 39 no. 14; Étienne Bricon, Prud'hon: Biographie critique, Les Grands Artistes: Leur vie—leur oeuvre (Paris, [1907]), pp. 85 ill., 103; Anonymous, La renaissance de l'art français 5, no. 5 (May 1922), pp. 303, ill., 333 (special issue, "L'exposition Prud'hon"); Raymond Escholier, "Pierre-Paul Prud'hon: À propos de l'exposition du Petit-Palais," La revue de

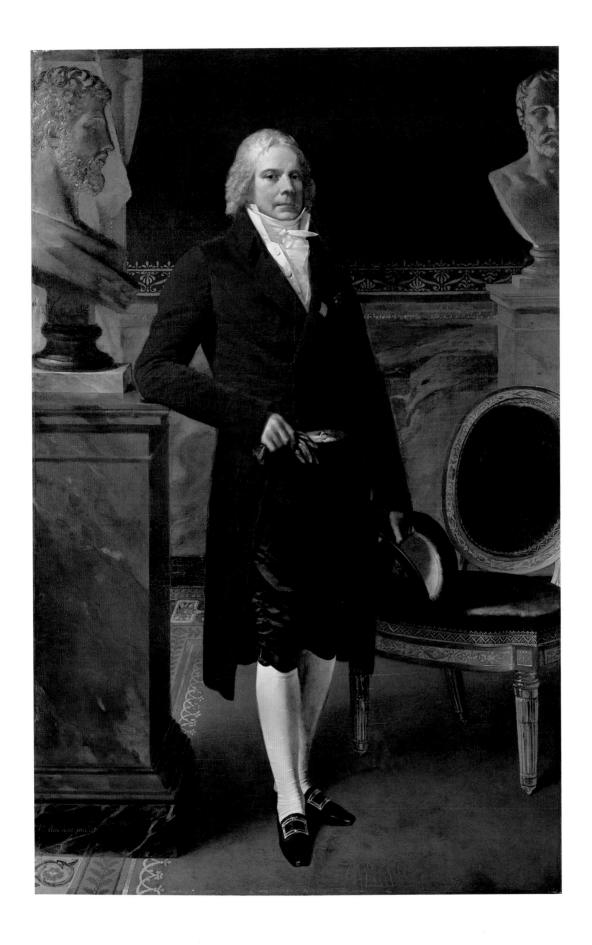

273

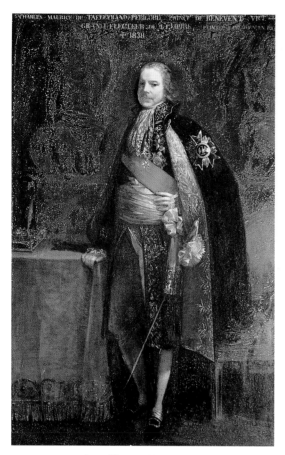

Fig. 1. Pierre-Paul Prud'hon, *Talleyrand as Minister of Foreign Affairs*, 1806. Oil on canvas, 86⅝ × 55⅛ in. (220 × 140 cm). Château de Valençay

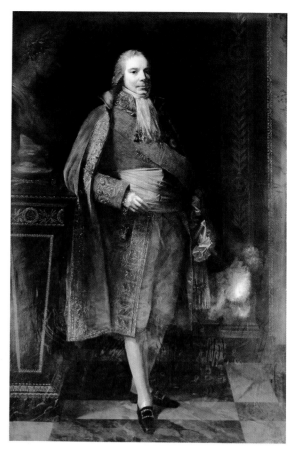

Fig. 2. Pierre-Paul Prud'hon, *Talleyrand as Grand Chamberlain*, 1807. Oil on canvas, 85 × 56¾ in. (216.5 × 144 cm). Musée Carnavalet, Paris (P.1065)

l'art ancien et moderne 42 (June–December 1922), p. 114 n. 4; Jean Guiffrey, "The Prud'hon Exhibition in Paris," *Burlington Magazine* 41 (July 1922), p. 33; Jean Guiffrey, *L'oeuvre de Pierre-Paul Prud'hon,* Archives de l'art français, n.s., 13 (Paris, 1924), pp. 239 under no. 627, 240–41 no. 631, pl. XX; Georges Lacour-Gayet, *Talleyrand, 1754–1838* (Paris, 1931), pl. III; Jean Orieux, *Talleyrand: The Art of Survival,* trans. Patricia Wolf (New York, 1974), ill.; Didier Aaron, *Catalogue* (Paris, 1992), no. 20, color ill. (detail); Gary Tinterow, in "Recent Acquisitions: A Selection, 1993–1994," *The Metropolitan Museum of Art Bulletin* 52, no. 2 (fall 1994), pp. 40–41, colorpl.; Sylvain Laveissière, *Pierre-Paul Prud'hon,* exh. cat., Galeries Nationales du Grand Palais, Paris, and The Metropolitan Museum of Art, New York (New York, 1998), pp. 25, 176, 193–96 no. 135, color ill.; Sotheby's, New York, sale cat., January 24, 2002, pp. 64–65, fig. 4 (color), under lot 76.

RELATED WORKS
PARIS, Château de Valençay (René Crozet, *Le Château de Valençay* [Paris, 1930], p. 82, ill.), possibly identical with, or a copy of, the last of three bust-length portraits listed by Jean Guiffrey ("The Prud'hon Exhibition in Paris," *Burlington Magazine* 41 [July 1922], nos. 624–26), described as "bust-length, three-quarters to the right, face forward, white hair, black suit with medal of the Legion of Honor, white tie; brown background." 12⅝ × 9½ in. (32 × 24 cm), ex-collection Marcille.

PARIS, Musée Carnavalet (P.1065). *Talleyrand as Grand Chamberlain,* 1807. Oil on canvas, 85 × 56¾ in. (216.5 × 144 cm). This and the following painting commissioned by Vivant Denon by order of Napoleon in 1806.
VALENÇAY, Château de Valençay. *Talleyrand as Minister of Foreign Affairs,* 1806. Oil on canvas, 86⅝ × 55⅛ in. (220 × 140 cm).

This lifesize portrait of Talleyrand, a brilliant political figure who served under every French ruler from Louis XVI (r. 1774–92) to Louis-Philippe (r. 1830–48), is the last of three full-length portraits painted by Prud'hon. The first two were ordered simultaneously by Dominique Vivant Denon (1747–1825), curator of the Louvre and de facto minister of the arts, by order of Napoleon (April 1806), as part of a wider commission of portraits of the current imperial ministers, destined for the Palais de Fontainebleau. The first, which depicts Talleyrand wearing the blue ceremonial costume of the minister of foreign affairs (the position he held from 1799 to 1807), was completed by the end of 1806 (fig. 1); the second,

which shows him wearing the red robes of grand chamberlain (the position he held from July 11, 1804, to January 28, 1809), was completed in 1807 (fig. 2). The pictures were, in fact, installed at the Palais des Tuileries, Galerie de Diane, in August 1807 and then transferred to the Palais de Compiègne, Salon des Grands Officiers, in May 1808. They remained there until the 1815 Bourbon Restoration made the imperial costumes embarrassingly out-of-date. Both were offered to Talleyrand, who received them in 1817.

Talleyrand was primarily responsible for persuading the allies who occupied Paris in 1814 to return the French throne to the Bourbon dynasty. As a matter of course, Louis XVIII, brother of Louis XVI, appointed him as minister of foreign affairs once again. Hence Talleyrand kept his portrait as minister (in blue robes), eventually sending it to his large estate in the Touraine, Valençay. Using as an intermediary Dorothée de Courlande, duchesse de Dino (1793–1862), the wife of his nephew and his official hostess, Talleyrand asked Prud'hon to repaint the portrait that showed him in the red robes of grand chamberlain: Talleyrand wanted to appear in modern civil dress. Because time had already transformed the paint surface with the alligator-like craquelure that has compromised many works by the artist, Prud'hon was not able to paint out the old costume. Talleyrand insisted; not wishing to anger the powerful minister, Prud'hon resorted to subterfuge, which he finally divulged in a letter to the duchesse de Dino:

[finding myself] a complete stranger to this sort of discussion . . . there is a simple means that could be used to terminate this disagreement, which I find disgreeable. I will bring back to you, Madame, Monday morning, the old portrait of the Prince, of which I was supposed to change the costume; this change would have involved all the rest [of the painting] and would have only produced a sad result, that is, a bad portrait, which makes me think that it would no longer be worthy either of the person whom it represents or of the person for whom it was destined. After spending some time testing to see what could be done, I decided to begin again [a new portrait], intending not to inform you of all these difficulties. Circumstances force me, Madame, to no longer remain silent and to make you aware that, if I do not receive a response opposed to the plans that I have the honor of sharing with you, I will accompany the porters who will be charged with the old portrait and *I will take it back in return* if you find acceptable [good] the portrait that is the object of all these difficulties.[1]

The present painting was thus delivered to the duchesse de Dino in April 1817. Annotations on a different, unpublished letter from Prud'hon to the duchess indicate that Prud'hon was to be paid 7,000 francs.[2] About this same time, Prud'hon executed a small portrait of Talleyrand's head, nearly identical to that in the present canvas. Meanwhile, the 1807 portrait in red (fig. 2) that Prud'hon took in exchange in 1817 was inherited by the artist's student and heir, Charles-Pompée Le Boulanger de Boisfrémont (1773–1838), and eventually purchased by the city of Paris in 1867.

This third canvas of Talleyrand may be considered one of the most imposing of Prud'hon's formal portraits of the great personalities of the imperial court. Showing Talleyrand not as an administrator but as one of the extraordinary intellects of his day, Prud'hon presents the witty and treacherous ambassador as a powerful savant: in a richly appointed room—perhaps one of his private chambers on the mezzanine of the Hôtel Talleyrand, the former Hôtel Saint-Florentin on the corner of the place de la Concorde—he leans on the pedestal of one bust (of Marcus Aurelius) while another (of Demosthenes?) looks on, evoking association with the heroic orators and philosophers of antiquity.

GT

NOTES

This entry is based on my text in "Recent Acquisitions, A Selection: 1993–1994," *The Metropolitan Museum of Art Bulletin* 52, no. 2 (fall, 1994), pp. 40–41.

1. "j'avais été entièrement étranger à ces sortes de discussions . . . pour vous faire part du moyen simple qui peut être employé pour terminer ce différend, très-désagréable pour moi. Je vous remettrai, Madame, lundi prochain l'ancien portrait du Prince, dont je devais changer tout l'habillement; ce changement entraînait tout le reste et présentait des difficultés qui n'auraient produit qu'un triste résultat, c'est à dire un mauvais portrait, ce qui m'a fait supposer qu'il n'aurait plus été digne ni de celui qu'il représentait, ni de celle pour qui il était destiné. Après du temps passé à essayer ce que je pourrais faire à ce sujet, je me suis décidé à le recommencer, avec l'intention de vous laisser ignorer tous ces désagréments. La circonstance me force donc, Madame, à ne plus vous les taire et à vous prévenir que, si je ne reçois pas de réponse opposée à l'intention dont j'ai l'honneur de vous faire part, j'accompagnerai les porteurs qui seront chargés de l'ancien portrait et ferai reprendre en retour, si vous le trouvez bon, celui qui est l'objet de toutes ces difficultés." Letter from Prud'hon to the duchesse de Dino dated April 12, 1817, cited by Charles Clément, *Prud'hon: Sa vie, ses oeuvres et sa correspondance* (Paris, 1872), pp. 304–5.
2. "Écrit le 17 pour fixer à 7.000 fr. le prix du portrait, payable de mois en mois." Unpublished letter kindly communicated to me by Sylvain Laveissière.

BARON GÉRARD

(François-Pascal-Simon Gérard, 1770–1837)

François Gérard was born in Rome to a French father attached to the household of the French ambassador to the Holy See and to an Italian mother; they returned to France in 1782. He studied at the Pension du Roi, founded by Abel François Poisson, marquis de Marigny (1727–1781), with the sculptor Augustin Pajou (1730–1809), and with the painter Nicolas-Guy Brenet (1728–1792) before entering the studio of Jacques-Louis David (see p. 255) in 1786. One of David's favorite pupils, Gérard assisted in painting the Death of Le Pelletier de Saint Fargeau *(1793; destroyed); despite his youthful solidarity with the Revolution, his political views became more moderate with time. Portraiture, an ascendant genre during the Directory, was Gérard's primary métier, and as a result he was showered with honors and sought out by royalty and aristocrats under every administration for the remainder of his life.* GT / AEM

75. *Madame Charles-Maurice de Talleyrand-Périgord, Princesse de Bénévent (née Catherine Noële Worlée, later Madame George Francis Grand, 1762–1835)*

Oil on unlined canvas, 88⅞ × 64⅞ in. (225.7 × 164.8 cm)
The Metropolitan Museum of Art, New York, Wrightsman Fund, 2002 (2002.31)

PROVENANCE
?The sitter's husband, Charles Maurice de Talleyrand-Périgord, prince de Bénévent (until d. 1838); his brother, comte Bozon de Talleyrand-Périgord, and his wife, *née* de Puisigneux; their daughter, Elisabeth de Talleyrand-Périgord, duchesse de Peissac-Esclignac; her daughter, Georgine Xaverine Honorine Jacqueline d'Esclignac, marquise de Persan; her son, marquis de Persan; his daughter, Marguerite de Persan, baronne Jacques Eschasseriaux; her sons, barons Philippe and Hugues Eschasseriaux, Château de Maureilhan, near Béziers (consigned to Sotheby's; sale, New York, January 24, 2002, lot 76, to the Metropolitan Museum); purchased in 2002 with a gift from the Wrightsman Fund by the Metropolitan Museum.

LITERATURE
François-Pascal-Simon Gérard, three manuscript lists of the artist's works, French private collection, 1805; Joachim Le Breton, "Beaux-arts," in *Rapport historique sur l'état des beaux-arts en France depuis 1789 et sur leur état actuel, présenté à Sa Majesté l'empereur et roi, en son conseil d'état, le 5 mars 1808* (Paris, [1809?]), reprinted in Joachim Le Breton, *Beaux-arts,* ed. Udolpho van de Sandt, Rapports à l'Empereur sur le progrès des sciences, des lettres et des arts depuis 1789, 5 (Paris, 1989), p. 124; Charles Lenormant, *François Gérard, peintre d'histoire: Essai de biographie et de critique,* 2nd ed. (Paris, 1847), p. 182; [Henri-Alexandre Gérard], *Oeuvre du baron François Gérard, 1789–1836: Gravures à l'eau forte,* 3 vols. (Paris, 1852–57), vol. 1 (1852–53), *Collection des 83 portraits historiques en pied,* n.p., ill. (etching by Adam); Henri-Alexandre Gérard and Alexandre Gérard, eds., *Lettres adressées au baron François Gérard, peintre d'histoire, par les artistes et les personnages célèbres de son temps,* 2nd ed. (Paris, 1886), vol. 2, p. 405 (under "Liste des oeuvres du baron Gérard: Portraits en pied"), and see also p. 417; H. Vollmer, in *Allgemeines Lexikon der bildenden Künstler,* ed. Ulrich Thieme and Felix Becker, vol. 13 (Leipzig, 1920), p. 436; W. de Charrière de Sévery, "George-François (-Francis) Grand, premier mari de la princesse de Talleyrand: Quelques lettres de lui écrites de 1802 à 1808," *Revue historique vaudoise* 33 (January 1925), p. 13; Vicomte de Reiset, "Le roman de la princesse de Talleyrand," *Historia,* no. 78 (May 1953), ill. p. 548 (detail); Annette Joelson, *Courtesan Princess: Catherine Grand, Princesse de Talleyrand,* new ed. (1937; Philadelphia, 1965), p. 206; Jules Bertaut, "L'extravagante Mme de Talleyrand," *Historia,* no. 245 (April 1967), p. 57, ill.; Pierre Viguié, "Le mariage de Talleyrand," *Revue de Paris,* March 1970, p. 119; Catherine Loisel-Legrand, *Autour de David et Delacroix: Dessins français du XIXᵉ siècle,* exh. cat., Musée des Beaux-Arts et d'Archéologie, Besançon, Collections du musée 4 (Besançon, 1982), under no. 83, ill.; Claire Constans, *Les peintures,* rev. ed., Musée National du Château de Versailles (Paris, 1995), vol. 1, p. 367 under no. 2081; Christopher Apostle, in "Revolution in Art," *Sotheby's Preview* (January 2002), pp. 6–7, 124–26, color ill.; [Christopher Apostle], in *Revolution in Art,* sale cat., Sotheby's New York, January 24, 2002, pp. 50, 58–65 lot 76, color ill.; Gary Tinterow, in "Recent Acquisitions: A Selection, 2001–2002," *The Metropolitan Museum of Art Bulletin* 60, no. 2 (fall 2002), p. 27, color ill.; Emmanuel de Waresquiel, *Talleyrand: Le prince immobile* (Paris, 2003), pp. 301, 672 n. 2, colorpl. XX.

PRESUMED PENDANT
Although documentation has yet to come to light, this painting may have been commissioned from Gérard as one of a pair, the second being a portrait of Talleyrand seated in his office, exhibited at the Salon of 1808, which opened on October 14, as *Portrait en pied de S. A. Mgr. le Prince de Bénévent* (no. 245). This seems to be the portrait formerly at the Château de Sagan, now in a French private collection (fig. 3).

DRAWING
BESANÇON, Musée des Beaux-Arts (D. 2040, bequest of the painter Jean Gigoux [1806–1894]). *Sheet of Studies,* black chalk on paper, 5⅜ × 8⅞ in. (13.7 × 22.4 cm) (fig. 4). Recto is a compositional study that includes all the main elements and details of the finished painting save the rear wall and carpet; on the left, two studies after sculpture. Verso contains studies of eight different Neoclassical chairs, possibly related to the study for the seated portrait of Talleyrand (fig. 5).

REDUCED REPETITION
VERSAILLES, Musée National du Château (MV 4875). A summary repetition. Oil on canvas, 12⅝ × 8⅝ in. (32 × 22 cm). See Claire Constans, *Les peintures,* rev. ed., Musée National du Château de Versailles (Paris, 1995), vol. 1, p. 368 no. 2089, ill.

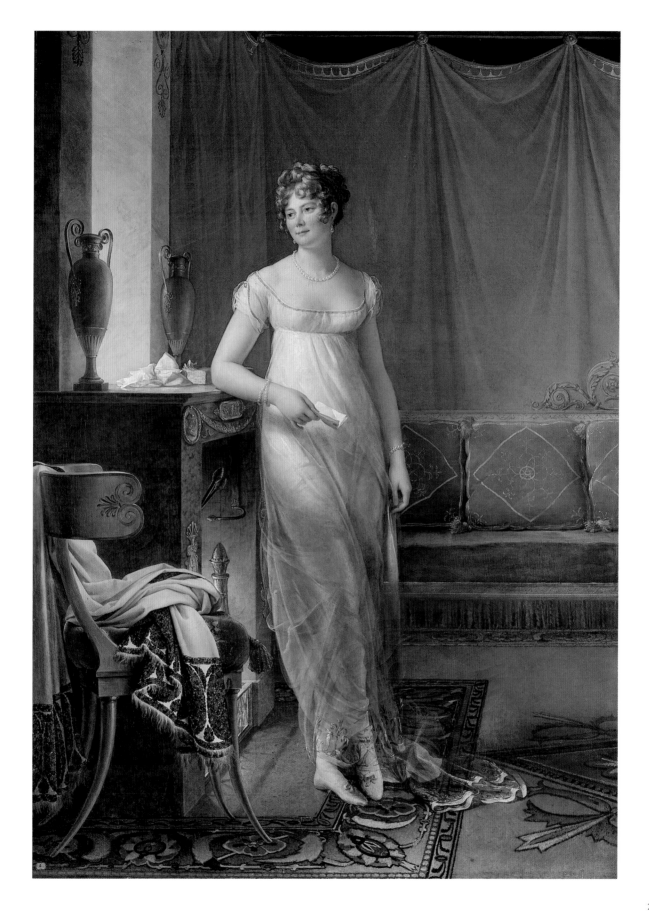

ENGRAVINGS / ETCHINGS
Dickinson (per Charles Lenormant, *François Gérard, peintre d'histoire: Essai de biographie et de critique*, 2nd ed. [Paris, 1847], p. 182); Pierre-Michel Adam, published in [Henri-Alexandre Gérard], *Oeuvre du baron François Gérard, 1789–1836: Gravures à l'eau-forte*, vol. 1, *Collection des 83 portraits historiques en pied* (Paris, 1852–53), n.p., ill.

Catherine Noële Worlée was born on November 2, 1762, to a French minor official and his wife posted to the Danish colony in Madras. At the age of fifteen she married an English civil servant of Swiss descent working in Calcutta, George Francis Grand (b. ca. 1750). Soon thereafter she became involved with Sir Philip Francis (1740–1818), an adviser to the British governor of Bengal, who was fined 50,000 rupees for the impropriety.[1] Embarrassed by the scandal, in 1780 she moved to Paris, where she flaunted her youth, beauty, and inexplicable affluence at fashionable salons.

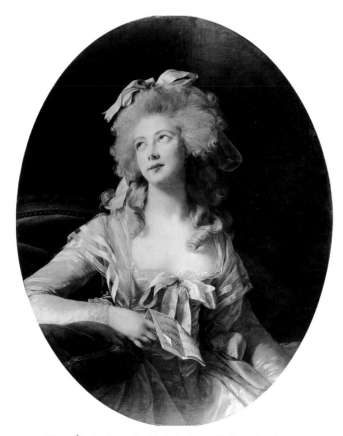

Fig. 1. Élisabeth Louise Vigée Le Brun, *Madame Grand (Catherine Noële Worlée, 1762–1835), Later Madame de Talleyrand-Périgord, Princesse de Bénévent*, 1783. Oil on canvas, 36¼ × 28½ in. (92.1 × 72.4 cm). The Metropolitan Museum of Art, New York, Bequest of Edward S. Harkness, 1940 (50.135.2)

Her portrait by Élisabeth Vigée Le Brun (fig. 1; see p. 248) attests to her lively personality and stunning looks. One of her admirers, Auguste-François, baron de Frénilly (1768–1828), described her as "a heavenly beauty, long recognized as such, radiating youth, with incomparable teeth, a transparent white complexion, and a forest of blond hair that has only been seen on her."[2]

In the late 1790s Madame Grand entered into a highly visible affair with Talleyrand, the brilliant statesman and former bishop of Autun who had become a principal figure in the emerging government. When she was arrested by the Directory on suspicion of espionage in March 1798, Talleyrand declared his interest to Paul, vicomte de Barras (1755–1829), then one of the three Directors of the eponymous government: "Citizen Director, Mme Grand has just been arrested as a conspirator. She is the least likely person in all Europe, the farthest from and least capable of involving herself in any plot; she is a very beautiful Indienne, very lazy, and the most empty-headed of all the women I have ever met. I beg your influence on her behalf, for I am sure that not even the shadow of a pretext can be found against her, so that this little affair be hushed up, as it would grieve me to see it create a noise. I love her, and I attest to you, man to man, that never in her life has she interfered in nor is she capable of interfering in any matter. She is a genuine Indienne, and you know to what degree that kind of woman is a stranger to intrigue."[3]

Estranged from her husband for ten years, Madame Grand, in 1798, obtained a divorce in absentia.[4] She may have been pregnant with the child born in 1799, whom Talleyrand raised as his own "adopted" daughter, although Grand never claimed her as her own. Elaborate negotiations with Napoleon and the Vatican were required before the former bishop was allowed to marry at Neuilly on September 10, 1802; despite the First Consul's strong reservations—he considered Catherine Grand "une veille fille," and worse, a "putain"[5]—Napoleon and Josephine signed their marriage contract.[6] At the time Catherine Grand declared many property holdings, promissory notes, and 75,000 francs in cash; she indicated that the value of her jewelry alone was 300,000 francs, an immense sum. Upon their first official reception at the Tuileries, Napoleon is alleged to have remarked, "I hope that the good conduct of citoyenne Talleyrand will cause the fickleness of Madame Grand to be forgotten." Madame Talleyrand rebounded smartly, "In that respect, I cannot do better than to follow the example of citoyenne [Josephine] Bonaparte."[7] Napoleon ensured that Madame de Talleyrand was rarely at court.

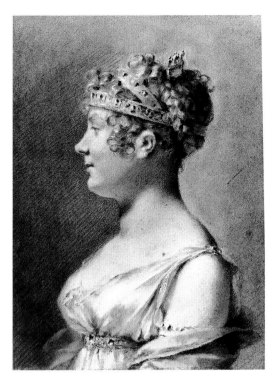

Fig. 2. Pierre-Paul Prud'hon, *Madame Charles-Maurice de Talleyrand-Périgord,* ca. 1806–7. Black and white chalk on gray paper, 9 × 7 in. (23 × 17.8 cm). State Hermitage Museum, Saint Petersburg (OR 43445).

is a cashmere paisley shawl, made fashionable after the 1798 French campaign in Egypt, a highly desirable and expensive status symbol throughout the first quarter of the nineteenth century. The costume thus cannot be dated any more precisely than the first decade of the nineteenth century.

While the portrait of Princess Talleyrand was not publicly exhibited, the presumed pendant portrait of Prince Talleyrand, usually dated 1808, was shown at the Salon of 1808. The work is reproduced here (fig. 3) in the 1825 etching by Adam (published in Henri-Alexandre Gérard's *Oeuvre du baron François Gérard, 1789–1836: Gravures à l'eau-forte* [Paris, 1852–57], vol. 1, n.p.). It seems likely that both portraits by Gérard were ordered at the same time, though the setting of the seated Talleyrand appears to be

Although the terms of the commission have not been found, it is unlikely that the Wrightsman portrait was ordered before the marriage in 1802 or after 1805, by which time Talleyrand was preoccupied with other women. (He had already taken an official mistress, Madame Dubois, when he married in 1802.)[8] The portrait is mentioned by Gérard in each of three autograph lists in a French private collection as dating to 1805;[9] this may mean that it had not yet been completed and delivered: in Lenormant's 1847 list of Gérard's work, the painting is placed among the portraits of 1805, but in the 1852–57 catalogue raisonné, it is dated 1808. A commission date of 1804–5 accords well with Talleyrand's prominence in Napoleon's new imperial court, where he served as both minister of foreign affairs and grand chamberlain.[10] The princess's costume, sheer, gold-embroidered silk voile over white satin (*tunique en grande parure*), worn with slippers without heels, is similar to those worn by Empress Josephine in her 1801 portrait by Gérard (State Hermitage Museum) and in her 1805 portrait by Prud'hon (Musée du Louvre); Prud'hon (see p. 272) also drew a bust-length portrait of Princess Talleyrand in profile around this time, in ca. 1806–7 (fig. 2). Thrown over the chair in the Wrightsman depiction

Fig. 3. Etching by Adam, after François Gérard, *Charles-Maurice de Talleyrand-Périgord (1754–1838), Prince de Bénévent,* 1825. 7⅝ × 5⅜ in. (19.4 × 13.7 cm). Published in Henri-Alexandre Gérard's *Oeuvre du baron François Gérard, 1789–1836: Gravures à l'eau-forte* (Paris, 1852–57), vol. 1, n.p.

Fig. 4. François Gérard, *Study for the Portrait of Madame Charles-Maurice de Talleyrand-Périgord, Princesse de Bénévent.* Black chalk on paper, 5⅜ × 8⅞ in. (13.7 × 22.4 cm). Musée des Beaux-Arts, Besançon (D. 2040 recto)

Fig. 5. François Gérard, *Study of Chairs for the Portrait of Madame Charles-Maurice de Talleyrand-Périgord, Princesse de Bénévent.* Black chalk on paper, 5⅜ × 8⅞ in. (13.7 × 22.4 cm). Musée des Beaux-Arts, Besançon (D. 2040 verso)

his office in the Hôtel Galliffet, which he had occupied since 1797 in his official capacity as minister of foreign affairs. The interior in which Princess Talleyrand is portrayed has not been securely identified. The distinctive window over the firebox, achieved by deviating the flues around the window frame, points to a Parisian salon rather than a room at one of Talleyrand's country houses, the Château de Sagan, and, after 1803, Valençay. Emmanuel de Waresquiel has proposed that this is the salon of the Hôtel de Créquy in the rue d'Anjou-Saint-Honoré, which Talleyrand owned from 1800 to 1812.[11] The up-to-date furnishings are elegant but restrained: the velvet upholstery and custom-woven carpet in complementary colors would have been expensive, and the gilt-painted klysmos chair very fashionable—the one surviving preparatory drawing shows sketches of alternative chairs (figs. 4 and 5 [recto/verso]). Yet the room, with its loosely draped walls in the *neo-grec* mode, is neither sumptuous nor nouveau riche. The simplicity of the general effect is markedly distinct from the elaborate interiors designed by Percier and Fontaine for Napoleon's apartments at the Tuileries, and thus may reflect a decor commissioned by bachelor Talleyrand rather than by his new wife.[12] The vases on the mantle, *tôle* rather than bronze, point to economy. But the muted pea green of the room provides a splendid

foil for the elongated figure of Princess Talleyrand. Her chaste white dress alludes to propriety and grace, while the suggestive transparency of the silk sheath and the tight-fitting bodice underscore her sensuality. By placing her next to the chimney, Gérard achieved a tour de force of illumination, lighting her smiling face with the pale gray Parisian daylight but highlighting her long legs with the warm light of the unseen fire.

By 1809 Talleyrand's affection for his wife had diminished. He took great interest in a rich noblewoman, Dorothée de Courlande (1793–1862), whom he married to his nephew Edmond de Périgord (1787–1872) that year; she became Talleyrand's official hostess when he took her to the Congress of Vienna in 1814. Nevertheless, Princess Talleyrand retained her title and privileges. Louise d'Osmond, comtesse de Boigne (1781–1866), recalled seeing her at a function in 1814: "Mme de Talleyrand, seated at one end of the two rows of armchairs, tranquilly did the honours. The remains of her great beauty adorned her stupidity with a fair amount of dignity."[13] Although Talleyrand banished his wife from Paris in 1815, she returned from London and Brussels in 1817 and lived quietly in the French capital. The whereabouts of the portrait during this period are not known, but as Princess Talleyrand predeceased her husband, he must have inherited her belongings. The canvas subsequently descended in the family of Talleyrand's brother.

GT

Notes

This entry is based on my text in "Recent Acquisitions: A Selection, 2001–2002," *The Metropolitan Museum of Art Bulletin* 60, no. 2 (fall 2002), p. 27, color ill.

1. The biographical information follows that published in Annette Joelson, *Courtesan Princess: Catherine Grand, Princesse de Talleyrand,* new ed. (1937; Philadelphia, 1965), pp. 42–47, 50–67.

2. "[b]eauté céleste et depuis longtemps reconnue telle, mais encore rayonnante de jeunesse, avec des dents incomparables, une blancheur transparante et une forêt de cheveux blonds clair qu'on n'a vu qu'à elle." *Souvenirs du [Auguste-François], baron de Frénilly, pair de France (1768–1828),* ed. Arthur Chuquet (Paris, 1908), p. 133. See also Emmanuel de Waresquiel, *Tallyrand: Le Prince immobile* (Paris, 2003), colorpl. 1.

3. "Citoyen Directeur, On vient d'arrêter Mme Grand comme conspiratrice. C'est la personne d'Europe la plus éloignée et la plus incapable de se mêler d'aucune affaire; cette une Indienne bien belle, bien paresseuse, la plus désoccupée de toutes les femmes que j'aie amais rencontrées. Je vous demande intérêt pour elle, je suis sûr qu'on ne lui trouvera point l'ombre de prétexte pour terminer cette petite affaire, à laquelle je serais fâché que l'on mît de l'éclat. Je l'aime et je vous atteste à vous, d'homme à homme, que de sa vie elle ne s'est mêlée et n'est en état de se mêler d'aucune affaire. C'est une véritable Indienne et vous savez à quel degré cette espèce de femmes est loin de toute intrigue." *Mémoires de [Paul J.-F.-N.] Barras, membre du Directoire,* ed. George Duruy, vol. 3 (Paris, 1896), p. 173 (translated in *Memoirs of Barras, Member of the Directorate,* trans. C. E. Roche, vol. 3 [New York, 1896], p. 203).

4. Waresquiel, *Talleyrand,* pp. 303–4, cites the letter of June 1800 in which she first informs her former husband of her divorce.

5. Ibid., p. 306.

6. Waresquiel underscores the fiction of the contract: Catherine lied about her age and stated that she was a widow. For his part, Talleyrand pretended that he had obtained permission from the Vatican to marry when in fact all he had obtained was "a return to secular and lay life" without the nullification of the vows he had taken as bishop. Ibid., p. 304.

7. Anecdote recounted (without citation for authorship) in W. de Charrière de Sévery, "George-François (-Francis) Grand, premier mari de la princesse de Talleyrand: Quelques lettres de lui écrites de 1802 à 1808," *Revue historique vaudoise* 33 (January 1925), pp. 14–15.

8. Waresquiel, *Talleyrand,* p. 310.

9. I thank Joseph Baillio for providing this information.

10. In Joachim Le Breton's 1809 report on the state of the arts, Gérard's portraits of the Talleyrands were listed immediately after those of the Bonapartes, an indication of Talleyrand's high rank.

11. Talleyrand acquired the Hôtel de Créquy as a home for Catherine, then his mistress, and as a second home for himself; adjacent properties were subsequently added to his holdings. His official residence was the Hôtel Gallifet (Waresquiel, *Talleyrand,* pp. 215, 300 n. 1, 301, 672). Talleyrand did not acquire the Hôtel de Saint-Florentin, on the corner of the rue de Rivoli and the place de la Concorde, until 1812. See also Jacques Hillairet, *Dictionnaire historique des rue de Paris,* 2nd ed. (Paris, 1997), vol. 1, p. 89, wherein it is stated that the house in the rue d'Anjou was occupied by an Englishman named Crawford by 1808; it was destroyed when the boulevard Malesherbes was developed in 1855.

12. On April 1, 1801, in a possibly fictive transaction prior to their marriage, Talleyrand sold Catherine all the furniture in the Hôtel de Créquy for reasons that have yet to be explained (Waresquiel, *Talleyrand,* p. 302).

13. "Madame de Talleyrand, assise au fond de deux rangées de fauteuils, faisait les honneurs avec calme; et les restes d'une grande beauté décoraient sa bêtise d'assez de dignité." *Mémoires de la comtesse de Boigne, née d'Osmond: Récits d'une tante,* ed. Jean-Claude Berchet (Paris, 1971), vol. 1, *Du règne de Louis XVI à 1820,* p. 281; translated in *Memoirs of the Comtesse de Boigne,* ed. Anka Muhlstein (New York, 2003), vol. 1, *1781–1815,* p. 141.

LOUIS-LÉOPOLD BOILLY

(1761–1845)

Louis-Léopold Boilly was born and educated around Lille, studying trompe l'oeil painting with Dominique Doncre (1743–1820) in Arras from 1778. He moved to Paris in 1785 and exhibited at the Salon between 1791 and 1824. Although his popularity declined thereafter, he was admitted to the Legion of Honor and the Institut de France in 1833. A painter in the tradition of Dutch seventeenth-century naturalism, for which he prepared by studying caricature as well as trompe l'oeil, Boilly was well known for genre scenes and for small-scale portraits, of which he may have produced thousands. His skills in these fields were combined in a select group of pictures that depict crowds in familiar contemporary settings, such as the 1803 Arrival of a Stagecoach in the Cour des Messageries (Musée du Louvre) or the Departure of the Volunteers in 1807 (Musée Carnavalet, Paris) executed four years later. Boilly's sense of humor and talent for caricature are evident in his juxtaposition of actual portraits and anonymous figures, who, as a result, tend to appear uncannily recognizable; the Gathering of Artists in Isabey's Studio of 1798 (Louvre), a group portrait of many of the leading artists of the era, was Boilly's first success in this genre.

GT/AEM

ABBREVIATIONS

Harrisse 1898. Henry Harrisse. L.-L. Boilly, peintre, dessinateur et lithographe: Sa vie et son oeuvre, 1761–1845. Paris, 1898.

Marmottan 1913. Paul Marmottan. Le peintre Louis Boilly (1761–1845). Paris, 1913.

Paris, Versailles 1989–90. Arlette Sérullaz et al. Jacques-Louis David, 1748–1825. Exh. cat., Musée du Louvre, Paris, and Musée National du Château, Versailles; 1989–90. Paris, 1989.

76. The Public at the Louvre Salon Viewing "Le Sacre" (Le public au salon du Louvre, regardant le Tableau du Sacre)

Oil on canvas, 24 ⅛ × 32 ½ in. (61.3 × 82.6 cm)
Signed and dated at lower right: L. Boilly 1810.

PROVENANCE

The artist (until 1829; his sale, Paillet, Paris, April 13–14, 1829, lot 5, as "Le tableau du Sacre, exposé aux regards du public dans le grand salon du Louvre," for Fr 615); Anatole Auguste Hulot, Paris (until d. 1891; estate sale, Galerie Georges Petit, Paris, May 9–10, 1892, lot 77, ill., for Fr 13,000); Gustave, or Gaston, du Plessis (by 1895–at least 1898); sale, Hôtel Drouot, Paris, December 10, 1982, lot 45 (color ill.), for Fr 2,450,000, to Guy Stair Sainty (in partnership with Somerville & Simpson); [Somerville & Simpson, 1983; sold to Wrightsman]; Mr. and Mrs. Charles Wrightsman, New York (1983–his d. 1986); Mrs. Wrightsman (from 1986).

EXHIBITED

Galerie Le Brun, Paris, May 17–November 19, 1826, "Exposition au profit des Grecs," no. 14 (as "Le public au salon du Louvre, regardant le Tableau du Sacre"); Galerie des Champs-Élysées, Paris, 1895, "Exposition historique et militaire de la Révolution et de l'Empire," no. 275 ("à M. Gaston Duplessis"); Metropolitan Museum, New York, June 29–September 8, 1983, June 1–September 5, 1989, June 28–September 19, 1990, and June 14–September 12, 1991.

LITERATURE

Jacques-Louis David, manuscript letter to Boilly, undated (ca. 1809–10), Fondation Custodia, Paris (autog. 7830); Charles-Henri-Joseph Gabet, Dictionnaire des artistes de l'école française, au XIXᵉ siècle: Peinture, sculpture, architecture, gravure, dessin, lithographie et composition musicale (Paris, 1831), p. 74; Louis Gonse and Jules-Joseph Guiffrey, eds., "Louis David: Lettres et documents divers (1748–1825)," Nouvelles archives de l'art français, 1874–75, p. 418 no. 4; Jacques-Louis-Jules David, Le peintre Louis David, 1748–1825: Souvenirs & documents inédits (Paris, 1880), p. 343; Harrisse 1898, pp. 24–25 n. 2, 26, 54 n. 2, 132 no. 525, ill. (as collection Gustave du Plessis); Marmottan 1913, pp. 123–25, 176, and pl. LXVI (studies); André Mabille de Poncheville, Boilly (Paris, 1931), pp. 117 n. 1, 118 (as collection Émile Delagarde); Louis Réau, "L'iconographie de Houdon," Gazette des beaux-arts, 6th ser., 9 (1933), pp. 168, 171; Ernst Goldschmidt, Frankrigs malerkunst: Dens farve, dens historie, vol. 5 (Copenhagen, 1934), pp. 140, 142, and p. 135 (ill. of related drawing); J.-J. Marquet de Vasselot, "Répertoire des vues des salles du Musée du Louvre," Archives de l'art français, n.s., 20 (1937–45; pub. 1946), p. 32 no. 63; Christiane Aulanier, Histoire du palais et du Musée du Louvre, vol. 2, Le Salon Carré (Paris, [1950]), pp. 49, 78, fig. 26; Louis Réau, Houdon: Sa vie et son oeuvre (Paris, 1964), p. 196; Daniel Wildenstein and Guy Wildenstein, eds., Documents complémentaires au catalogue de l'oeuvre de Louis David (Paris, 1973), p. 180 under no. 1545; Anonymous, "Un nouvel éclectisme chez les amateurs de peinture: Enchères record pour Boilly, 2,450,000 F," La gazette de l'Hôtel Drouot, December 17, 1982, p. 2; Alexander Apsis, "La stabilité du 19ᵉ siècle," Connaissance des arts,

282

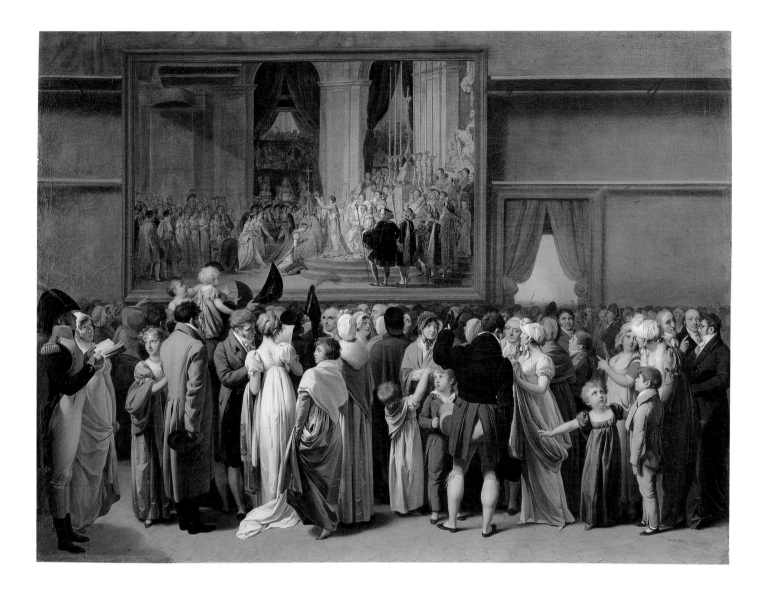

no. 372 (February 1983), p. 19, ill.; John Russell, "Revising Our Notions of Documentary Painting," *New York Times*, August 21, 1983, p. H23, ill.; Maurice Schumann, "Le tableau du Sacre exposé dans le grand salon du Louvre," in *Le prix de l'art: Guide annuel des ventes publiques* (special number of *Connaissance des Arts*), 1983, pp. 125–27, color ill.; Stair Sainty Matthiesen, *Old Master and Nineteenth Century Paintings, Drawings and Sculpture* (New York and London, n.d. [ca. 1983]), front cover (color ill.); Marianne Delafond, *Louis Boilly, 1761–1845,* exh. cat., Musée Marmottan, Paris (Paris, 1984), pp. 50–51 under nos. 24–25; Michael Miller, in *Meisterzeichnungen aus sechs Jahrhunderten: Die Sammlung Ian Woodner,* ed. Friedrich Piel, exh. cat., Albertina, Vienna, and Haus der Kunst, Munich (Cologne, 1986), p. 195 under no. 85; Roberta J. M. Olson, "Representations of Pope Pius VII: The First Risorgimento Hero," *Art Bulletin* 68 (March 1986), p. 79 n. 9; Michael Miller, in *Dibujos de los siglos XIV al XX: Colección Woodner,* exh. cat., Museo del Prado, Madrid (Madrid, 1987), p. 251 under no. 101; Michael Miller, in *Master Drawings from the Woodner Collection,* ed. Jane Shoaf Turner, exh. cat., Royal Academy of Arts, London (London, 1987), p. 226 under no. 84; Nina Athanassoglou-Kallmyer, *French Images from the Greek War of Independence, 1821–1830: Art and Politics under the*

Restoration (New Haven and London, 1989), p. 156; Carol S. Eliel, in *1789: French Art during the Revolution,* ed. Alan Wintermute, exh. cat., Colnaghi, New York (New York, 1989), pp. 94, 96, fig. 1, under no. 5; Paris, Versailles 1989–90, p. 613 under "s[ans] d[ate] [1808]"; Albert Boime, *A Social History of Modern Art,* vol. 2, *Art in an Age of Bonapartism, 1800–1815* (Chicago and London, 1990), pp. 202, 203, fig. 4.3, 668 n. 6; Karl Friedrich Schinkel, *"The English Journey": Journal of a Visit to France and Britain in 1826,* ed. David Bindman and Gottfried Riemann and trans. F. Gayna Walls (New Haven and London, 1993), p. 59 nn. 199, 202; Susan L. Siegfried, *The Art of Louis-Léopold Boilly: Modern Life in Napoleonic France* (New Haven and London, 1995), pp. xiii, 54, 95, 107, 159, 160 colorpl. 133, 162 colorpl. 135 (detail), 200 nn. 9 and 10, 211 n. 29, and see also p. 214 n. 4; Alan Wintermute and Donald Garstang, *The French Portrait, 1550–1850,* exh. cat., Colnaghi, New York (New York, 1996), pp. 68–69, fig. 49 (color); Christopher Riopelle, in *Art, the Critics' Choice: 150 Masterpieces of Western Art Selected and Defined by the Experts,* ed. Marina Vaizey (New York and Lewes, East Sussex, 1999), p. 226 (color ill.); Sophie Barthélémy, *Dessins français, XVIIᵉ–XIXᵉ siècles: Florilège de la collection du Musée des Beaux-Arts de Quimper,* exh. cat., Musée des Beaux-Arts, Quimper

(Quimper, 1999), p. 88; Alain Pougetoux, in Pierre Rosenberg et al., *Dominique-Vivant Denon: L'oeil de Napoléon*, exh. cat., Musée du Louvre, Paris (Paris, 1999), p. 366 under no. 374; Charles Ritchie, in *Art for the Nation: Collecting for a New Century*, exh. cat., National Gallery of Art, Washington, D.C. (Washington, D.C., 2000), pp. 202, 311 n. 2; Laveissière, in Sylvain Laveissière, with David Chanteranne et al., *Le Sacre de Napoléon peint par David*, exh. cat., Musée du Louvre, Paris (Paris and Milan, 2004), pp. 110–11 (color detail), 123–25, fig. 49 (color), under nos. 40–43, and see also p. 187 nn. 53, 54.

OIL STUDIES
PARIS, Musée du Louvre (RF 1721; fig. 3). Study for, or repetition of, the group consisting of the couple examining the printed key to the *Sacre,* and the male figure behind them who peers through a lorgnette, over their shoulders, known as *Les amateurs d'estampes*. Oil on canvas, 12³⁄₄ × 9⁵⁄₈ in. (32.5 × 24.5 cm). Bequeathed to the Louvre by Maurice Audéoud, 1908 (Harrisse 1898, p. 132 no. 525; Isabelle Compin and Anne Roquebert, *Catalogue sommaire illustré des peintures du Musée du Louvre et du Musée d'Orsay,* vol. 3 [Paris, 1986], p. 67, ill.).
QUIMPER, Musée des Beaux-Arts (fig. 2). Study for, or repetition of, the group consisting of the young girl with arm outstretched at right; the man seen in left profile directly behind her; and the two figures immediately to his left (Marmottan 1913, pl. LXVI, center).
WHEREABOUTS UNKNOWN. Study for, or repetition of, a group of spectators, including the man seen from behind with a spencer worn over his coat, his left hand pointing toward the *Sacre*; the boy immediately to his left holding a hat; and the girl to his left, reaching up to her mother (Harrisse 1898, p. 132 no. 526 [as collection M. le Dʳ Lemarié]).

DRAWINGS
WASHINGTON, D.C., National Gallery of Art, Woodner Collection (1991.182.8; fig. 4). Fully realized compositional study for the painting. Pen and black ink with gray wash and watercolor over traces of graphite, 23³⁄₈ × 31⁵⁄₈ in. (59.5 × 80.3 cm). Originally in the collection of Antoine-Vincent Arnault (1766–1834), secretary of the French Academy and patron of Boilly (estate sale, Coutelier, Paris, April 15–18, 1835, lot 20); W. W. Hope (sale, Pouchet, Paris, June 12, 1885, lot 32); Eugène Tondu (apparently his sale, Pillet, Paris, April 24, 1865); Émile Delgarde (by 1930); E. M. Hermes; (sale, Hôtel Drouot, Paris, November 28, 1984, lot 1, to Woodner); Ian Woodner, New York (1984–d. 1990); his daughters, Andrea and Dian Woodner, New York (1990–91); their gift in 1991 to the National Gallery of Art, Washington, D.C.
WHEREABOUTS UNKNOWN. Possibly two drawings formerly in the Paul Marmottan collection. One, a study of two women wearing bonnets seen from behind, neither of whom appear in the finished painting. The second, a study of the girl recognizable as the one at lower right in the finished painting, but in a different position, depicted partly behind an adult female figure who does not appear in the finished painting (both illustrated in Marmottan 1913, pl. LXVI).

REPRODUCTIONS
Anatole Auguste Hulot, estate sale, Galerie Georges Petit, Paris, May 9–10, 1892, lot 77, ill.
Reproductive engraving by Paul Moglia in Harrisse 1898, p. 132 no. 525, ill.

David began to work on *Le Couronnement de l'Empereur et de l'Impératrice* (fig. 1), commonly but incorrectly known as *Le Sacre,*

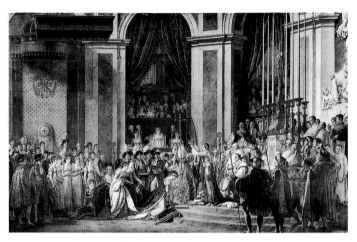

Fig. 1. Jacques-Louis David, *Le Couronnement de l'Empereur et de l'Impératrice,* 1804–8. Oil on canvas, 20 ft. 7³⁄₄ in. × 32 ft. 1¹⁄₂ in. (6.29 × 9.79 m). Musée du Louvre, Paris (3699)

in 1804.[1] He completed the vast composition—his largest—in 1807 and retouched it in 1808. The painting, commissioned by the imperial household, depicts the moment Napoleon crowned Josephine empress. It was exhibited three times: first, at the Musée Napoléon (as the Louvre was then called) from February 7 to March 21, 1808; at the Salon of 1808, from October 14, 1808, to January 1809 (no. 144); and finally at the Concours pour les Prix Décennaux, again at the Musée Napoléon, from August 25 until October 1810.[2] Presumably the retrospective nature of this last exhibition made the display of the *Sacre* possible: the show opened a full ten months after Napoleon divorced Josephine in December 1809, and almost five months after he married his second wife, Marie-Louise of Austria, in April 1810.[3]

What was to become the subject of Boilly's painting—the spectacle of Parisians in the Louvre's Salon Carré viewing David's canvas—was first noted in the press. Prior even to the official debut of the *Sacre,* Jean-Baptiste Boutard, critic for the *Journal de l'empire,* wrote, "The singular illusion produced by this coming together has struck all observers and delighted all the voters. The painting is to be found at the Salon; it will reproduce itself, more seductively than ever, when it occupies the place for which it is destined in the apartments of a palace."[4]

Boilly wrote to David to ask permission to copy the *Sacre* for his own work, but that letter is now lost. David called on Boilly to respond affirmatively; finding Boilly's studio empty, he left a delightful note:

David came to give his response to M. Boilly verbally; it will be favorable, as he has every reason to expect from someone who had always made a case for his talent, above all [from someone] wanting to treat a subject which could only flatter him infinitely. He notes that, for the moment, the picture is still rolled up since its return from the Salon; but as soon as M. Boilly needs it—that is to say a few days from now—he should feel free to come to my studio, place de Sorbonne, and there he [Boilly] will do anything necessary for his painting, whose idea is charming and which can only succeed by being treated by him.

I have already observed [the crowd looking at my painting], and we shall see if we both perceived it the same way.

David

P.-S. This does not prevent us, between now and then, from chatting together at my lodgings, rue de Seine no. 10, or at my atelier. If it's at my lodgings, it can't be after eleven o'clock.[5]

David's letter suggests that Boilly had already fixed his subject. While the occasion depicted in Boilly's painting has sometimes been called the Salon of 1810, the specific exhibition is by no means certain. Indeed, the *Sacre* was not exhibited at the Salon of 1810 but rather at a special competition that year. Boilly probably conceived his picture on the occasion of the *Sacre*'s debut at the Louvre in early 1808 and may well have made some sketches then, or when the painting was re-exhibited in October 1808 at the Salon (see figs. 2, 3). As David's letter makes plain, the Salon had already closed, in January 1809, when Boilly asked David for permission to see the painting again.

Boilly's painting is signed and dated 1810, and there is no reason to doubt this date. However, Henry Harrisse, who calls this one of the artist's "meilleures toiles" (better canvases), speculates that Boilly had not finished his painting by the end of the empire (1814); otherwise, Harrisse reasons, he would likely have exhibited it, since he was represented in the Salon regularly until 1824. This conclusion is echoed by Mabille de Poncheville, while Paul Marmottan, following the inscription, states that the painting was completed in 1810.[6]

There are more persuasive—political—reasons why Boilly may not have exhibited this painting soon after it was completed. It

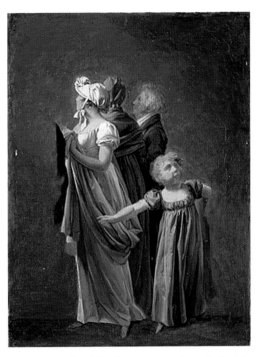

Fig. 2. Louis-Léopold Boilly, *La promenade,* study for *The Public at the Louvre Salon Viewing "Le Sacre,"* ca. 1808–10. Oil on canvas, 12⅝ × 10¼ in. (32 × 26 cm). Musée des Beaux-Arts, Quimper (873.1.779)

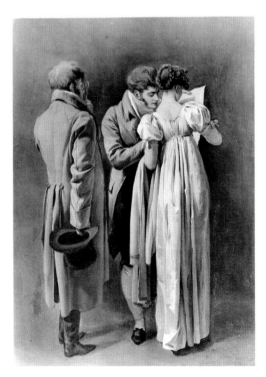

Fig. 3. Louis-Léopold Boilly, *Les amateurs d'estampes,* study for *The Public at the Louvre Salon Viewing "Le Sacre,"* ca. 1808–10. Oil on canvas, 12¾ × 9⅝ in. (32.5 × 24.5 cm). Musée du Louvre, Paris (RF 1721)

could well be that he did not consider the painting appropriate for exhibition after Napoleon had divorced Josephine, given that her coronation occupies nearly a quarter of the composition. Thus the last Salons of the empire, 1812 and 1814, during the reign of Napoleon's second empress, Marie-Louise, were ruled out as well. Moreover, the painting would not have been welcome in the Salons of the Bourbon Restoration, that is, after 1814, when all recidivist—Napoleonic and Revolutionary—imagery was sytematically refused.

Instead, Boilly sent this painting to the now famous "Exposition au profit des Grecs," held at the Galerie Le Brun in Paris in 1826. Seized upon by young painters who worked in the nascent style of Romanticism, among them Delacroix and Vernet (see pp. 334, 326), as a venue for their art, the exhibition also featured a number of paintings, such as Gros's *Napoleon at the Pest House at Jaffa,* that had not been seen since the fall of Napoleon in 1814. Jean-Baptiste Le Brun (1748–1813), a canny dealer and connoisseur as well as husband of the painter Élisabeth Vigée Le Brun (see p. 248), had opened one of the first commercial art galleries in Paris, where Boilly had exhibited as early as 1791.[7] The 1826 exhibition was conceived as a means of raising funds for the Greek War of Independence, a cause eagerly supported by the left but one that the reactionary government of Louis XVIII, which supported the Ottoman sultan, wished to sit out. Although many of the works were not germane to contemporary events, some were drawn from ancient Greece and others had evocative subjects, such as the Massacre of the Innocents. Yet the exhibition is best remembered for a late entry, Delacroix's *Greece on the Ruins of Missolonghi* (Musée des Beaux-Arts, Bordeaux), begun within a few weeks of the opening in May and completed between the middle of June and the middle of August.[8] The relevance of Boilly's painting to the "Exposition au profit des Grecs" is obscure until one recognizes that Jacques-Louis David had died on December 29, 1825, just four months before the opening of the show. Many of the exhibitors had been students, colleagues, or competitors of David, and Boilly's painting could only have been interpreted as an homage to the most famous and powerful artist of the day. Indeed, Le Brun turned part of the exhibition into a retrospective for David, borrowing, among others, the *Portrait of Pope Pius VII and Cardinal Caprara* (Philadelphia Museum of Art) that David executed in connection with the *Sacre*; the *Death of Socrates* (Metropolitan Museum); and *The Oath of the Horatii* (Louvre).[9]

The right-wing press, supporting the Bourbon government, decried the attention given to the regicide David and resented the inclusion of paintings that glorified Napoleon's defunct regime. Although the exhibition was extensively reviewed, Boilly's canvases were not discussed at all.[10] Nevertheless, the Wrightsman painting was remarked upon by the German architect Karl Friedrich Schinkel in his travel diary.[11] Meanwhile, David's autograph replica of the *Sacre* (now at Versailles), begun in 1808 and taken with him in exile to Brussels, where it was completed in 1822, was on tour in the United States, probably on view in Philadelphia at the time of the Le Brun exhibition.[12]

Identification of the Figures

The catalogue of the sale organized by Boilly himself in 1829 (see Provenance, above) was the first to identify figures by name—four of them—among the crowd depicted in the painting: "5. Le tableau du Sacre, exposé aux regards du public dans le grand salon du Louvre.—Dans le nombre considérable de spectateurs, on remarque les portraits forts ressemblants du docteur Gal, de Hoffman, homme de lettres, de M. Baptiste de la Comédie française, et de Robert, peintre." Harrisse (1898) expanded the number to six, and Marmottan (1913), to eleven; to these figures might be added members of the artist's family, at the right. The list of identifiable people has waxed and waned ever since, for both the preparatory grisaille (fig. 4) and the Wrightsman painting, with the occasional addition of an entirely new name (see fig. 5).

In recent years, however, two scholars have adopted opposing views. Sarah Wells Robertson attempted to identify all the figures in unpublished research undertaken for Guy Stair Sainty in 1983.[13] Susan Siegfried, on the other hand, takes a more conservative approach by arguing that even if some of the figures can be identified, this is essentially irrelevant, as Boilly's goal was only to impart a realistic effect in a modern genre scene.[14]

Clearly, Boilly was creating a fabricated scene, populated with many of the great artistic personalities of the day, and was not scrupulously recording a specific moment of a particular event. Part of the problem of identification has been the mistaken insistence on determining whether the individuals portrayed were actually in Paris during one of the public exhibitions of the *Sacre*. The famously low brow and wide nose of Ingres, for example, are visible just to the right of the head of the man wearing a "spencer" jacket (and to the left of Vivant Denon), even though

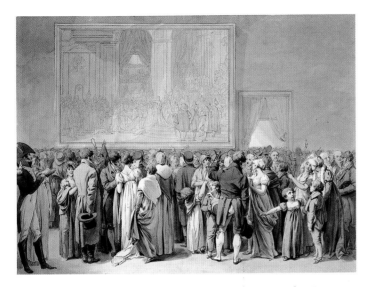

Fig. 4. Louis-Léopold Boilly, study for *The Public at the Louvre Salon Viewing "Le Sacre,"* ca. 1808–10. Pen and black ink, gray wash, and watercolor over traces of graphite on laid paper, 23 3/8 × 31 5/8 in. (59.5 × 80.3 cm). National Gallery of Art, Washington, D.C., Woodner Collection (1991.182.8)

Ingres was in Rome in 1808. (Perhaps Boilly added Ingres at the last minute, in 1826, after his rise in prominence following the 1824 Salon and his conspicuous representation in the Galerie Le Brun exhibition.) As Sylvain Laveissière has remarked (in conversation), Boilly has also taken liberties with the setting, since the doorway leading from the Salon Carré to the Grande Galerie, which is depicted far to the right of its actual location, would not allow a painting as large as the *Sacre* to be hung where he shows it. Furthermore, the *Sacre* alone is depicted, whereas other pictures were in fact hung nearby.[15]

It is worth noting that all of the figures in the foreground of the preparatory grisaille (fig. 4) were transposed to the painting, save one: the second female from the left is, in the drawing, a mature woman resembling Mme Vigée Le Brun, while in the painting she is much younger. In the finished picture, Boilly broke the relentless horizon of heads by inserting two children sitting on shoulders and also some large bicornes; in addition, he added several new faces in the back rows, including Ingres, and moved others. For example, the man commonly identified as Houdon, directly beneath the figure of the emperor, was not present in the drawing; instead, Baptiste of the Comédie Française appears in that spot. In the painting, however, Baptiste was moved further to the right. Susan Siegfried has written that "had Boilly wanted to recreate a pantheon of living artists in the crowd viewing David's *Coronation of the Emperor and Empress,* he easily could

have."[16] In fact, Boilly did both, incorporating a number of famous figures and providing a persuasive sense of occasion.

GT / AEM

NOTES

The authors gratefully acknowledge the assistance of Sylvain Laveissière, whose research on the present painting began over twenty years ago.

1. Oil on canvas, 20 ft. 7 3/4 in. × 32 ft 1 1/2 in. (6.29 × 9.79 m), Musée du Louvre, Paris (3699).
2. Paris, Versailles 1989–90, p. 419 under no. 169.
3. Napoleon requested that the *Intervention of the Sabine Women* (1799; Louvre, 3691) and the *Sacre* be shown at the 1810 Concours. David submitted the former in the category of "peinture d'histoire," the latter as a "peinture nationale." Louis Gonse and Jules-Joseph Guiffrey, eds., "Louis David: Lettres et documents divers (1748–1825)," *Nouvelles archives de l'art français*, 1874–75, pp. 420–21 under no. 13; see also Daniel Wildenstein and Guy Wildenstein, eds., *Documents complémentaires au catalogue de l'oeuvre de Louis David* (Paris, 1973), p. 184 no. 1581, and Paris, Versailles 1989–90, p. 616 under "13 et 15 août 1810."
4. "[L]'illusion singulière produite par ce rapprochement a frappé tous les yeux, ravi tous les suffrages. On la retrouve au Salon; elle se reproduira, plus séduisante que jamais, quand le tableau occupera dans les appartemens d'un palais la place qui lui est destinée." [Jean-Baptiste Boutard], "Beaux-Arts: Tableau du Couronnement; par M. David," *Journal de l'empire*, February 23, 1808, pp. 3–4, quoted in Paris, Versailles 1989–90, p. 416, and Sylvain Laveissière et al., *Le Sacre de Napoléon peint par David*, exh. cat., Musée du Louvre, Paris (Paris and Milan, 2004), pp. 123 under no. 40, 187 n. 54. Also see "Erratum," *Journal de l'empire*, January 26, 1808, p. 3.
5. "David est venue rendre verbalement sa réponse à M. Boilly: elle lui sera favorable comme il avait tout lieu de l'attendre d'une personne qui a toujours fait cas de son talent, surtout voulant traiter un sujet qui ne peut que flatter infiniment. Il lui observe que pour le moment le tableau est encore roulé depuis qu'il est de retour du Salon; mais aussitôt que M. Boilly en aura besoin, c'est-à-dire d'ici à quelques jours, il sera maître de venir à son atelier, place de Sorbone, et là il fera tout ce qu'il pourra lui être nécessaire pour son tableau, dont l'idée est charmante et qui ne pourra que gagner traiter par lui.
 Déjà je l'avais observé, et nous verrons si nous l'avons senti tous deux également.
 David.
 P.-S. Cela n'empêche pas que d'ici à ce temps nous ne puissions causer ensemble soit à mon logement, rue de Seine no. 10, ou à mon atelier. Si c'est à mon logement, il ne faut pas passer onze heures." (English translation based on that of Carol S. Eliel, in *1789: French Art during the Revolution*, ed. Alan Wintermute, exh. cat., Colnaghi, New York [New York, 1989], pp. 94–95.)
 Scholarly opinion on the date of David's letter to Boilly, now preserved in the Fondation Custodia, Paris (autog. 7830), has been divided since it first appeared on the market at the dispersal of his son Julien Boilly's papers (*Catalogue de la vente d'autographes de Julien Boilly*, Charavay, Paris, December 7–10, 1874, lot 539). Daniel Wildenstein and Guy Wildenstein, for example, assigned it to November—Frimaire in the Revolutionary calendar—1808 (*Documents*, p. 180 no. 1545), a date accepted by Élisabeth Agius-d'Yvoire (in Paris, Versailles 1989–90, p. 613), while Louis Gonse and Jules-Joseph Guiffrey dated the letter to late 1809 or early 1810 (in "Louis David," p. 418 no. 4, n. 1). Given that David refers indirectly to the close of the Salon, which occurred in January 1809, the letter cannot be dated any earlier.

Identification of figures in Boilly's *Viewing the Sacre*	vente Boilly 1829	Harrisse 1898	Marmottan 1913	vente Hulot 1892	[Drawing] Paris 1930	[Drawing] M. de Vasselot 1946	Aulanier 1947–71	Robertson 1983	Paris 1984	[Drawing] London 1987	Colnaghi 1989	Paris 2004–5
Antoine-Vincent Arnault, 1766–1834, Secretary of French Academy, and family				x				x				
Baptiste, Comédie française	x		x							x	x	x
Boilly and family, incl. Julien Boilly		x	x	x	x	x	x	x	x	x	x	x
Michel Brézin, 1758–1828, philanthropist								x				
Dubois, obstetrician (*accoucheur*)			x									x
P. F. L. Fontaine, 1762–1853, architect								x				
Gal, doctor	x		x							x		
François Gérard, 1770–1837, painter		x	x	x	x	x		x	x	x	x	
Antoine Gros, 1771–1835, painter		x		x	x	x	x	x		x	x	
F. B. Hoffmann, 1760–1828, writer	x	x	x			x			x	x	x	x
J. A. Houdon, 1741–1828, sculptor		x	x	x	x	x	x	x	x	x	x	
J.-A.-D. Ingres, 1780–1867, painter								x				
J. B. Isabey, 1767–1855, painter								x				
G. G. Lethière, 1716–1832, painter								x				
Charles Percier, 1764–1838, architect								x				
Mme Récamier, 1777–1849					x							
Hubert Robert, 1733–1808, painter	x		x				x			x	x	x
Nicolas Antoine Taunay, 1755–1830, painter			x					x	x		x	
E. Vigée Le Brun, 1755–1842, painter		x	x	x		x	x		x	x	x	
Dominique Vivant Denon, 1747–1825, Director of Musée Napoléon								x				

Fig. 5. Identification of figures in Boilly's *Viewing "Le Sacre"*

6. See Harrisse 1898, p. 25; André Mabille de Poncheville, *Boilly* (Paris, 1931), p. 117; and Marmottan 1913, p. 123.

7. Marmottan 1913, pp. 38–40.

8. The painting was not included in either of two editions of the catalogue of the Le Brun exhibition. See Lee Johnson, *The Paintings of Eugène Delacroix: A Critical Catalogue,* 6 vols. (Oxford, 1981–89), vol. 1 (1981), p. 70 no. 98.

9. On the Le Brun exhibition, see Nina Athanassoglou-Kallmyer, *French Images from the Greek War of Independence, 1821–1830: Art and Politics under the Restoration* (New Haven and London, 1989), pp. 156–65, and passim.

10. His other exhibit, no. 13, *Distribution of Wine and Food in the Champs-Élysées* (1822), is now in the Musée Carnavalet, Paris.

11. Karl Friedrich Schinkel, *"The English Journey": Journal of a Visit to France and Britain in 1826,* ed. David Bindman and Gottfried Riemann and trans. F. Gayna Walls (New Haven and London, 1993), p. 59 nn. 199, 202.

12. Musée Nationale du Château, Versailles (MV 7156). The replica traveled to the Academy of Fine Arts, New York Institution (Chambers Street), New York, January–April 1826; Westminster Hall, Philadelphia, fall 1826; Boston, April–September 1827; and New York again, September–December 1827, after having been shown in England in the early 1820s (Paris, Versailles 1989–90, p. 534 under no. 233).

13. The Metropolitan Museum of Art, Department of European Paintings archives.

14. Siegfried positively identifies only three figures: Hoffmann, Boilly, and Dubois or Gal (letter to Everett Fahy dated November 16, 1993, Department of European Paintings archives).

15. Sylvain Laveissière, in Laveissière, *Le Sacre de Napoléon peint par David,* p. 124 under no. 40.

16. Susan L. Siegfried, *The Art of Louis-Léopold Boilly: Modern Life in Napoleonic France* (New Haven and London, 1995), p. xiii.

NICOLAS-ANTOINE TAUNAY

(1755–1830)

The son of an enamel painter, Nicolas-Antoine Taunay was born in Paris in 1755. He proved to be a versatile and gracious artist; although historical landscape was his primary métier, he was also a talented portraitist and a painter of genre and battle subjects. Taunay exhibited publicly from 1777 until 1827. His work reflects the study of seventeenth-century Dutch painting as well as the efforts of classical French artists, especially Nicolas Poussin (1594–1665). "Taunay," according to Jean-Pierre Cuzin, "is more than a charming entertainer; he deserves to be reconsidered as one of the great painters of his time."[1] Yet knowledge of Taunay's life and oeuvre was incomplete until the first comprehensive monograph devoted to him appeared in 2003.[2]

At the age of fifteen Taunay was enrolled as a student of Nicolas-Bernard Lepicié (1735–1784) at the École des Beaux-Arts, and later he worked in the studio of Nicolas-Guy Brenet (1728–1792), where he first met his lifelong friends Jean-Louis Demarne (1752–1829), Pierre Jean Boquet (1751–1817), and Jean Frédéric Schall (1752–1825). Still later he studied with Francesco Giuseppe Casanova (ca. 1732–1803), whose studio he left by 1783. In the 1770s Taunay is reported to have made plein-air sketching trips in the countryside surrounding Paris with Demarne, Jean Joseph-Xavier Bidauld (1758–1846), Lazare Bruandet (1755–1804), and probably others; in 1779 he undertook a journey to Switzerland with Demarne, Boquet, and J. Voisin, a little-known still-life painter. The first painting that he sold may have been bought by Jean-Honoré Fragonard (1732–1806);[3] although the subject is unrecorded, this possibility suggests Taunay's place in the generation of landscape painters (of whom Pierre-Henri Valenciennes [1750–1819] is the most famous) who linked the plein-air tradition of the eighteenth century with that of Achille Michallon (1796–1822) and Camille Corot (1796–1875) in the nineteenth century.

His popularity among private collectors already established, Taunay was made an agréé of the French Academy in 1784, with the support of Jean Baptiste Marie Pierre (1714–1789) and Joseph Marie Vien (1716–1809). However, he never joined the academy, nor does he seem to have competed for the Prix de Rome; instead, with official encouragement, he left for Italy that year as a "simple pensionnaire" supported by private rather than state funds, returning to Paris in 1787.[4] Soon thereafter he married Joséphine Rondel (1768–1844); they had six children, the first of whom died in infancy. Taunay moved with his family to Montmorency to escape the Terror, but he painted a number of scenes of the Revolution, such as the Fête de la Liberté (Jorge Yunes Collection, São Paulo; LJ P.290) and the Bivouac de sansculottes (Musée des Beaux-Arts, Orléans, 76 21; LJ P.307). In 1795 Taunay was elected a charter member of the Institut de France. For his deluxe edition of the complete works of Racine (1801), Pierre Didot l'aîné (1761–1853) commissioned Taunay to illustrate Les plaideurs (1801). In 1806 Taunay began to do work for the Manufacture de Sèvres; under the empire he was patronized by Josephine and received numerous commissions for battle paintings, many of them now at Versailles. In 1816, in the uncertain months following the definitive defeat of Napoleon, Taunay was invited to participate in the newly constituted Academy of Fine Arts in Rio de Janeiro. He was accompanied on this mission by his younger brother, the sculptor Auguste Taunay (1768–1824), the painter Jean-Baptiste Debret (1768–1848), the engraver Charles-Simon Pradier (1786–1848), and others. Taunay returned to France in 1821.

GT/AEM

NOTES

1. Jean-Pierre Cuzin, in *French Painting, 1774–1830: The Age of Revolution*, exh. cat., Galeries Nationales du Grand Palais, Paris; Detroit Institute of Arts; and The Metropolitan Museum of Art, New York (Detroit, 1975), p. 626.
2. Claudine Lebrun Jouve, *Nicolas-Antoine Taunay (1755–1830)*, preface by Pedro Corrêa do Lago (Paris, 2003).
3. The source for this otherwise undocumented transaction is Edmond and Jules de Goncourt, "Fragonard," *Gazette des beaux-arts* 18 (February 1, 1865), p. 151; see also Lebrun Jouve, *Taunay*, p. 25 n. 50.
4. On the circumstances of Taunay's *pensionnat*, see Henry Lapauze, *Histoire de l'Académie de France à Rome* (Paris, 1924), vol. 1, pp. 396–97; see also Lebrun Jouve, *Taunay*, pp. 37ff.

77. Brazilian Slave

Oil on canvas, 9½ × 7⅜ in. (24.1 × 18.7 cm)
Inscribed and dated on wood box: L[eonard?] 1821: (or possibly 1824?).

PROVENANCE
?The artist's atelier at his death, 1830 (estate sale, Paris, February 28–March 1, 1831, part of lot 67, the lot unsold possibly due to a reported outbreak of street violence that may have interrupted the sale); ?the artist's widow, Madame Nicolas-Antoine Taunay, *née* Marie Joséphine Rondel, Paris (her sale, Galerie Georges Petit, Paris, June 3, 1835, part of lot 44, as "Une jeune nègre et une jeune négresse, peints par Taunay, d'après nature, au Brésil," bought in; given to Rondel); ?her nephew, B. Victor Rondel (1835–69; his sale, Déodor-Roguet, Paris, December 27–29, 1869, lot 20); uncatalogued sale, Hôtel Drouot, Paris, by 1983, to Guy Stair Sainty; [Stair Sainty Fine Art, Inc., by 1983–84; sold to Wrightsman]; Mr. and Mrs. Charles Wrightsman, New York (1984–his d. 1986); Mrs. Wrightsman (from 1986).

LITERATURE
Manuscript inventory of the artist's atelier dated March 30, 1830, Archives Nationales de France, Paris, no. M.C., CXVI, 704 (probably one of two items listed under no. 55 as "Un portrait de nègre et un portrait de négresse prisés ensemble à la somme de seize francs"), repr. in Lebrun Jouve, *Taunay* (see below); Afonso d'Escragnolle Taunay, *A missão artistica de 1816,* expanded ed. (1912; Rio de Janeiro, 1956), p. 109; Stair Sainty Matthiesen, *Old Master and Nineteenth Century Paintings, Drawings and Sculpture* (New York and London, n.d. [ca. 1983]), p. 19, color ill. (as signed and dated indistinctly *"Taunay 1824"*); Claudine Lebrun Jouve, *Nicolas-Antoine Taunay (1755–1830),* preface by Pedro Corrêa do Lago (Paris, 2003), pp. 296 (probably no. P.666 and under P.700, as "Portrait d'enfant noir, non localisé"), 405 no. 55, 422.

PENDANT
See Literature, 1830 atelier inventory, and Provenance, 1830–35, above.

The present painting can now be identified as one of a pair of portraits of Brazilian slaves, male and female, that remained in the artist's studio upon his death on March 20, 1830. Lebrun Jouve lists fifty-eight paintings executed in Brazil (nos. P.671–P.723), with most known examples now in Portuguese and Brazilian collections. While these fall into the two general categories of topographical landscapes and portraits of aristocrats, there is also one major history painting, the *Sermon of Saint John the Baptist* (Préfecture des Alpes-Maritimes, Nîce, 8116, L. 3744; LJ P.701), that Taunay executed in 1818 and shipped back to Paris for the Salon of 1819 (no. 1062).

The Wrightsman *Brazilian Slave,* painted about 1821–24, is thus a rare product of Taunay's Brazilian sojourn, and more precious still for its subject, whose ingratiating smile and casual pose recall the innumerable blackamoors that artists provided for European patrons since the fifteenth century. It was originally one of a pair; the location of the female pendant remains unknown. His name—Léonard?—now nearly impossible to decipher, may have been inscribed on the box on which he sits. Although this young figure resembles some of the staffage in picturesque vignettes found in some of the artist's landscapes, such as *The Largo do Machado in Laranjeiras* (Catholic University of America, Oliveira Lima Library, Washington, D.C.; LJ P.685) and *Vue de Ponta do Calabouço* (Museu de Arte de São Paulo Assis Chateaubriand, São Paulo; LJ P.685 bis), he appears significantly more idealized than his counterparts in paintings by other contemporaries, especially when they are shown laboring. Slavery had been outlawed in France since 1794 (it remained legal in French colonies until 1848), but Taunay's image harks back to the sweetness of eighteenth-century picturesque genre painting. By comparison, a candid rendering of the situation of blacks in Brazil may be found in the book by Taunay's colleague J.-B. Debret, *Voyage pittoresque et historique au Brésil, ou Séjour d'un artiste français au Brésil, depuis 1816 jusqu'en 1831 inclusivement, époques de l'avènement et l'abdication de S.N.D. Pedro 1ᵉʳ, fondateur de l'Empire brésilien.*[1] This monumental work contains many plates with slaves, some frighteningly vivid in their depictions of the violence they suffered.

GT/AEM

NOTE

The authors wish to thank Charlotte Hale for her assistance in examining this work.

1. Paris, 1834–39.

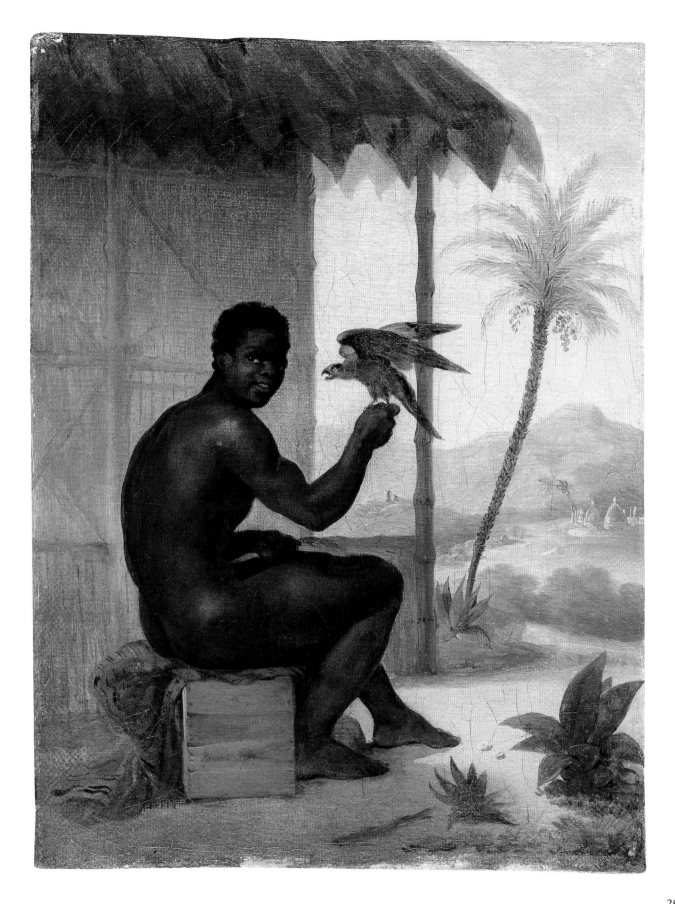

JEAN-AUGUSTE-DOMINIQUE INGRES

(1780–1867)

Although his reputation as the greatest French Neoclassical artist (after Jacques-Louis David; see p. 255) is now secure, Ingres endured a checkered career. He aspired to be the leading history painter of his day, yet his efforts to achieve the ideal perfection he admired in classical sculpture and in the paintings of Raphael were sometimes misguided and misunderstood. In the course of his seventy-year career, Ingres moved between Paris and Rome, fulfilling important public and private commissions for easel paintings and mural decorations, narrative pictures, allegories, and—evidently somewhat grudgingly—portraits of the rich and famous.

A student of David, Ingres won the Prix de Rome in 1801 and, after submitting to the Salon of 1806 five portraits that met with unfavorable notice, departed for Italy, where he was to remain for the next eighteen years. The three paintings produced during his tenure at the French Academy in Rome that he sent back to Paris (the Valpinçon Bather, Oedipus and the Sphinx, and Jupiter and Thetis), with their bizarrely exaggerated features, were not appreciated. Nonetheless, Ingres received a steady stream of commissions from French officials in Rome and Naples, and his monumental decorative paintings for government residences completed in 1813 established his reputation as a history painter. After Napoleon's forces withdrew from Italy and regular commissions declined, the artist was obliged to draw portraits of tourists, who now flooded post-empire Rome. Quickly establishing contact with French Restoration officials, however, Ingres found new assignments in Rome and in Florence, where he took up residence from 1820 to 1824.

While his paintings Roger Freeing Angelica and the Grande Odalisque had been snubbed by the Salon of 1819, his large-scale religious painting for Montauban Cathedral, the Vow of Louis XIII, was received warmly at the Salon of 1824. The long-sought acclaim brought Ingres back to Paris for a decade of honors and commissions, resulting in monumental paintings, such as the Apotheosis of Homer (1827–33; Musée du Louvre), and important portraits, among them that of Louis-François Bertin (1832; Musée du Louvre). However, the derision that greeted his Martyrdom of Saint Symphorian at the Salon of 1834 drove him back to Rome, where he stayed for six years as director of the Académie de France.

It was only after the painting commissioned by the duc d'Orléans, Antiochus and Stratonice, had been exhibited in Paris in 1841 and widely praised that Ingres returned once again to France, there to live out his final twenty-six years. His income was secure, with the largest (but never completed) commission of his career from the duc de Luynes for the Golden Age and the Iron Age. There were also assignments to design stained-glass windows and requests for society portraits, leading to a group of grand costume tableaux, among them the Comtesse d'Haussonville (1845; Frick Collection, New York). A special exhibition of Ingres's most important works was displayed at the Exposition of 1855; unfortunately, the fact that his rival Eugène Delacroix (see p. 334), as well as he, had been awarded a gold medal at that time occasioned his hurt declaration of retirement from public life.

CI

ABBREVIATIONS

London, Washington, New York 1999–2000. Gary Tinterow and Philip Conisbee, eds. *Portraits by Ingres: Image of an Epoch*. Exh. cat., National Gallery, London; National Gallery of Art, Washington, D.C.; and The Metropolitan Museum of Art, New York; 1999–2000. New York, 1999.
Naef 1977–80. Hans Naef. *Die Bildniszeichnungen von J.-A.-D. Ingres*. 5 vols. Bern, 1977–80.

78. Odalisque

Oil on linen on cardboard, 2½ × 4½ in. (6.4 × 11.4 cm)
Signed at lower left: Ingres pinx. Signed in brown ink on the reverse: Ingres Pinxit. Inscribed in a second hand, in brown ink: Suzanne Montet / Noganets / 44 rue de la Comière / Montauban / Tarne et Garonne. In another hand: Mad^me S. Montet / Montauban; this inscription partly over a paper label (octagonal, white with blue border) itself inscribed: 239. Inscribed in brown ink on the back of the frame: M^r Combes l[?] agrafe dans les couins. Remains of French newspaper stuck to the frame, type visible in reverse through paper, possibly dated 1891 (this date visible)[1] (fig. 1).

PROVENANCE
Gift of the artist to Jean-Pierre-François Gilibert, Montauban (1842–d. 1850); his daughter, Mme Emilien Montet-Noganets, *née* Catherine-Pauline Gilibert, Montauban (1850–d. 1908); her daughter, Mlle Suzanne Montet-Noganets, Montauban (1908–d. 1935); her sister, Mme Léopold Fournier, *née* Juliette Montet-Noganets (1935–d. 1938); her niece, Mlle Fournier, Montauban; her descendant (consigned to Sotheby's, London, June 6, 2001, lot 111, color ill. of front and back, to Wrightsman); Mrs. Charles Wrightsman, New York (from 2002).

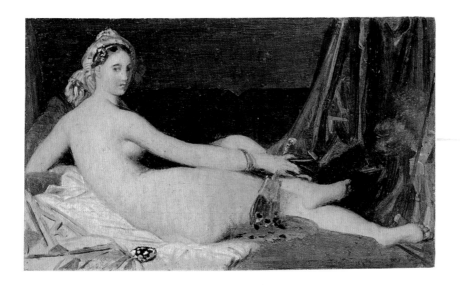

EXHIBITED

Hôtel de Ville, Montauban, May 4–31, 1862, "Exposition des beaux-arts," no. 551 (lent by Mme Montet, née Gilibert); École Impériale des Beaux-Arts, Paris, 1867, "Tableaux, études peintes, dessins et croquis de J.-A.-D. Ingres, peintre d'histoire, sénateur, membre de l'Institut," no. 30 (lent by Mme Montett-Gilibert [sic], Montauban); Montauban, ?May 1877, "Exposition des beaux-arts à Montauban."

LITERATURE

Ingres, Cahier X, Musée Ingres, Montauban, fol. 23, under "Mes ouvrages" as "plusieurs petites répétitions" of "l'odalisque—la grande—perdue"; P[rosper Debia], "Feuilleton de Courrier: Exposition des beaux-arts à Montauban," Le courrier de Tarn-et-Garonne, May 17, 1862; Henri Delaborde, Ingres: Sa vie, ses travaux, sa doctrine, d'après les notes manuscrites et les lettres du maître (Paris, 1870), p. 236 no. 76 (as collection Mme Montett-Gilibert [sic], Montauban); [J.-A.-B.] Boyer d'Agen, ed., Ingres d'après une correspondance inédite (1909; repr. Paris, 1926), pp. 209, 349–50; Georges Wildenstein, Ingres (London, 1954), pp. 179 no. 95, 180, fig. 54, and under nos. 54–58, 93–94, 226, 237, 312, 317, 318; Marie-Jeanne Ternois, "Les oeuvres d'Ingres dans la collection Gilibert," La revue des arts 9 (1959), pp. 121, 127–28; Lise Duclaux et al., Ingres, exh. cat., Petit Palais, Paris (Paris, 1967), p. 104 under no. 70; Emilio Radius and Ettore Camesasca, L'opera completa di Ingres (Milan, 1968), p. 97 no. 82b, ill.; Daniel Ternois and Ettore Camesasca, Tout l'oeuvre peint d'Ingres (Paris, 1971), p. 97 no. 83b, ill.; John L. Connolly Jr., "Ingres Studies—Antiochus and Stratonice: The Bather and Odalisque Themes," Ph.D. dissertation, Graduate School of Arts and Sciences, University of Pennsylvania, Philadelphia, 1974, app. III, "Cahier X: Folio 22 through Folio 27," under "m"; Naef 1977–80, vol. 3, p. 56; Daniel Ternois, Ingres (Paris, 1980), p. 177 no. 107, ill. (as private collection, France); Patricia Condon, with Marjorie B. Cohn and Agnes Mongan, In Pursuit of Perfection: The Art of J.-A.-D. Ingres, exh. cat., J. B. Speed Art Museum, Louisville, Kentucky, and Kimbell Art Museum, Fort Worth, Texas (Louisville, 1983), pp. 20, 33 n. 59, 126, 241; Annalisa Zanni, Ingres: Catalogo completo dei dipinti (Florence, 1990), p. 70 under no. 50 (as private collection, France); Daniel Ternois, "Lettres d'Ingres à Marcotte d'Argenteuil: Dictionnaire," Archives de l'art français, n.s., 36 (2001), pp. 109, 112, 113 n. 18; Véronique Burnod et al., Fantasme d'Ingres: Variations autour de la Grande Odalisque, exh. cat., Musée de Cambrai, Cambrai (Cambrai and Ghent, 2004), n.p., under no. 3. Daniel Ternois and Marie-Jeanne Ternois, eds., Lettres d'Ingres à Gilibert (Paris, 2005), pp. 49 n. 2, 85, 86, 91, 92, 101–3, 104, 228, 272 n. 3, 279 n. 1, 320 n. 7, 501, 503, pl. 9 (erroneously, as Metropolitan Museum).

VERSIONS

ANGERS, Musée des Beaux-Arts (MTC 18). Oil on canvas, 8 × 11 in. (20.3 × 28 cm) 1824, made as a gift for the painter comte Lancelot-Théodore Turpin de Crissé (1781–1859; bequeathed to city of Angers). Wildenstein 94 (fig. 4).
CAIRO, Musée Mahmoud Khalil (no. 72). Oil on canvas, 17 3/8 × 24 1/8 in. (44.2 × 61.3 cm). With a gray painted border, the word "FATIMA" in a cartouche. Executed ca. 1825–26, probably for Marie-Jean-Baptiste-Joseph Marcotte, called Marcotte Genlis (1781–1867), its first owner. According to Geneviève Lacambre, the dimensions of the composition within the cartouche are identical to those of the squared drawing at the Musée Ingres, Montauban (867.1197), which served as the model for Sudre's lithograph. See Geneviève Lacambre et al., Les oubliés du Caire: Ingres, Courbet, Monet, Rodin, Gauguin . . . Chefs-d'oeuvre des musées du Caire, exh. cat., Musée d'Orsay, Paris (Paris, 1994), pp. 38–39 no. 2, color ill.
NEW YORK, Metropolitan Museum (38.65). Oil on canvas, 32 3/4 × 43 in. (83.2 × 109 cm), 1824–34. Grisaille. Wildenstein 226.
PARIS, Musée du Louvre (RF 1158). Oil on canvas, 41 1/4 × 32 1/4 in. (105.4 × 81.9 cm), 1814. La grande odalisque, the source for the present picture and subsequent versions. Commissioned by Caroline Murat, Queen of Naples. Salon of 1819 (no. 619). Wildenstein 93 (fig. 2).
PRIVATE COLLECTION. Owned by the sculptor Baron Henri de Triqueti (1804–1874); his estate sale, Hôtel Drouot, Paris, May 4, 1886 (lot 37, as "signé et daté 1817, toile, 13 × 24 cm"); sale, Hôtel Drouot (Ader, Picard, Tajan), Paris, June 12, 1986, canvas, 5 3/4 × 9 5/8 in. (14.5 × 24.5 cm), for Fr 1,900,000 ("achat britannique"), per La gazette de l'Hôtel Drouot, June 20, 1986 p. 9, ill. (fig. 3).

REPRODUCTIONS

Reference numbers refer to Eric Bertin, "Les peintures d'Ingres: Estampes et photographies de reproductions parues du vivant de l'artiste," Bulletin du Musée Ingres, no. 69 (1996), pp. 39–62.
Alexandre Colin, lithograph, 2 3/8 × 4 1/4 in. (6.2 × 10.7 cm), published by Imprimerie Villain in the series Essais lithographiques, 1819. Bertin 4 (ill.). Proof impression at Bibliothèque Nationale de France, Paris. There is a possibly related drawing in the album Collection de 43 dessins des principaux tableaux de l'exposition au Musée Royal de France, année 1819 (Frick Art Reference Library, New York).

Charles Normand, engraving, 3⅛ × 5½ in. (7.9 × 13.9 cm), published in C. P. Landon, *Annales du Musée et de l'école moderne des beaux-arts: Salon de 1819* (Paris, 1819), vol. 1, pl. 15 opp. p. 28. Bertin 5.

J.-A.-D. Ingres, lithograph (1825–26), 5¼ × 8¼ in. (13.2 × 21 cm), published by Imprimerie Delpech, 1826. This image constituted the eighth, second-to-last number in the series *Album lithographique, année 1826*. Salon of 1831 (no. 2664). In reverse sense of the painting. Bertin 11.

Jean-Pierre Sudre, lithograph (1826), 11¼ × 18⅝ in. (28.6 × 47.3 cm). Published by Imprimerie Bove, directed by Noël *aîné, chez* Noël *aîné*, 1826. Salon of 1827 (no. 1393). In reverse sense of the painting. Bertin 13.

Achille Réveil, etching (1828), published by Duchesne *aîné* as no. 30 in *Musée de peinture et de sculpture, 1828–34*. Bertin 15. Réveil later made a steel engraving of this image, included in [Albert] Magimel, ed., *Oeuvres de J. A. Ingres, membre de l'Institut, gravées au trait sur acier par A^le Réveil, 1800–1851* (Paris, 1851), pl. 31, image border, 2⅝ × 4⅜ in. (6.7 × 11 cm).

Fig. 1. Photograph of the back of the Wrightsman painting and frame, showing inscriptions

At least as early as 1829 Ingres promised his friend Jean-Pierre-François Gilibert (1783–1850) a copy of the *Grande Odalisque* (fig. 2). In a letter of April 7 posted with one of the same date from her husband, Mme Ingres wrote to Gilibert that "I won't have the frame for the *Odalisque* until the end of this week. I hope to have everything next week. Time is necessary to ensure that the clock is well regulated. Don't worry about the shipping; all will go well."[2]

The *Grande Odalisque,* painted in Rome in 1814, was commissioned by Napoleon's sister Caroline Murat as a pendant to the *Dormeuse de Naples* (1808), which her husband Joachim Murat, king of Naples, purchased in 1809. The *Dormeuse,* lost in the aftermath of the fall of Napoleon's empire in 1815, showed a similar reclining figure seen from the front (Ingres later repeated the pose in the *Odalisque with the Slave,* now in the Fogg Art Museum, Harvard University, Cambridge, Massachusetts, painted in the 1830s for another friend, Marcotte d'Argenteuil). The *Grande Odalisque* had not been delivered when the Murats lost their throne in May 1815. The comte de Pourtalès acquired it instead and lent it to the Salon of 1819. After Ingres's triumphal return to Paris in 1824 and the establishment of his teaching studio, he began to receive commissions for copies of some of his celebrated early compositions.

Aside from the grisaille in the Metropolitan Museum and the example in Cairo, two further reductions, both larger than the present work, are known to exist. One, dated 1817, was owned by the sculptor Baron Henri de Triqueti (1804–1874; now in a private collection; fig. 3). The other, from 1824, was made as a gift for the painter Comte Lancelot-Théodore Turpin de Crissé (1781–1859; now in the Musée des Beaux-Arts, Angers; fig. 4).[3]

Jean-François Gilibert and his daughter Pauline visited Ingres in Paris from March through May 1842. Madame Gilibert (née

Virginie Lacaze-Rauly) died in 1832, only three years after her marriage and two years after giving birth to Pauline. Ingres was close to both father and daughter, and after Gilibert himself died in 1850, Ingres—childless himself—treated Pauline like an adopted daughter. One result of that 1842 visit was a double portrait drawing (collection of Mme Pierre Viguié, Montauban) made by Ingres's occasional assistant Armand Cambon (1819–1885), which included copies of Ingres's 1829 portrait drawing of Gilibert *père* and the just-completed portrait drawing of Gilibert *fille* (Musée Ingres, Montauban, 867.253 and 867.254, respectively) on a single sheet, retouched by Ingres and given to his old friend as a memento. Yet a specific event during the Giliberts' visit calls into question the terminus ad quem that Mme Ingres's letter, cited above, would otherwise establish securely: in April 1842, having borrowed the Marcotte *Odalisque* while its owner was away in Pau, in order to copy it for the king of Würtemburg (now in the Walters Art Museum, Baltimore), Ingres exhibited the painting to visitors to his studio. (The *Odalisque with the Slave* was back in Marcotte's home in time for his return.)

On June 26, 1842, Ingres wrote to Gilibert, "I've had a familiar attack of laziness but here I am. I am also able to tell you, almost without lying, that I have finally finished the copy of the *Odalisque,* which I signed yesterday," adding a few paragraphs later, "My noble barber will send you the tracing of my *Odalisque* and, from my wife, a plate of her own."[4] Daniel and Marie-Jeanne Ternois

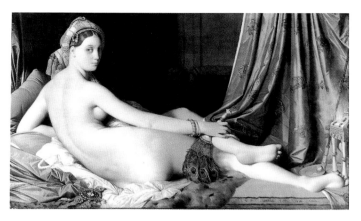

Fig. 2. Jean-Auguste-Dominique Ingres, *La Grande Odalisque,* 1814. Oil on canvas, 41¼ × 32¼ in. (104.8 × 81.9 cm). Musée du Louvre, Paris (RF 1158)

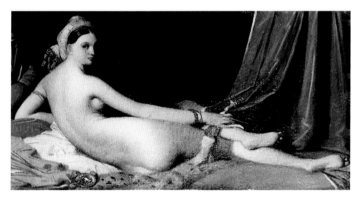

Fig. 3. Jean-Auguste-Dominique Ingres, *Odalisque,* 1817. Oil on canvas, 5¾ × 9⅝ in. (14.5 × 24.5 cm). Private collection

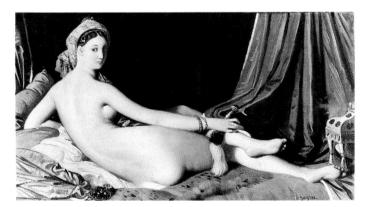

Fig. 4. Jean-Auguste-Dominique Ingres, *Odalisque,* 1824. Oil on canvas, 8 × 11 in. (20.3 × 28 cm). Musée des Beaux-Arts, Angers (MTC 18)

have suggested that this may refer to a now lost tracing of the recently copied *Odalisque with the Slave,* but it is possible that the work in question is the Wrightsman painting.[5] Beyond the delay in execution typical of Ingres—of which the *Odalisque with the Slave* made for Marcotte is a flagrant example—a prolonged delay by the artist in competing the present work may have been an expression of tact following the death of Mme Gilibert in 1832; Ingres was sensible to the sensuality of his female nudes.

It is more likely, however, that the Wrightsman copy was completed in 1829, as Mme Ingres's letter of that year indicated. Although the present work is painted on very fine linen laid down on cardboard, the size of the image corresponds to the 1828 engraving by Ingres's friend Réveil. Ingres used tracing throughout his career to transfer images, and it is likely that in order to make the Wrightsman work he used a sheet of tracing paper to copy the etching and then used a stylus to trace the contours of the figure onto the piece of linen on which the present work is painted. (Alternatively, the linen is so fine that Ingres may have been able simply to lay it over the etching and trace directly.) Infrared reflectography shows that the composition was drawn in pencil in all its details by Ingres, then colored with paint. The execution is precise and seemingly flawless, pointing again to the date of 1829, rather than 1842, and guaranteeing the autograph work of the master. GT/AEM

NOTES

1. The inscription on the back of the frame refers to Léon Combes *père* (1786–1875), a Montalbanais painter who was an old friend of Ingres and Gilibert both. Ingres frequently sent him his regards in letters to the Giliberts.
2. "Je n'aurai le cadre de l'*Odalisque* qu'à la fin de cette semaine. J'espère avoir le tout pour la semaine prochaine. Le temps est nécessaire, pour se rendre bien sûr que le mouvement de la pendule est bon. Soyez sans inquiétude pour l'emballage; tout cela fera bien." Daniel Ternois and Marie-Jeanne Ternois, eds., *Lettres d'Ingres à Gilibert* (Paris, 2005), p. 272 under no. 30.
3. Ingres's portrait drawings of the comte and comtesse Turpin de Crissé are now in the Metropolitan Museum (1972.118.218 and 1972.118.221).
4. "J'ai bien éprouvé une ancienne atteinte de paresse, mais me voilà. Je tiens aussi à pouvoir te dire, sans presque mentir, que j'ai enfin fini la copie de l'*Odalisque*, signée d'hier" . . . "Mon noble barbier te remettra le calque de mon *Odalisque* et, de la part de ma femme, un plat de son façon." Daniel Ternois and Marie-Jeanne Ternois, *Lettres d'Ingres à Gilibert,* p. 320 under no. 45. Note that Daniel Ternois previously revised the date of this letter to July 26, 1842 ("La correspondance d'Ingres: État des travaux et problèmes de méthode," *Archives de l'art français,* n.s., 28 [1986], p. 194 under no. 42).
5. Daniel Ternois and Marie-Jean Ternois, *Lettres d'Ingres à Gilibert,* p. 102.

79. *Madame Jean-Auguste-Dominique Ingres, née Madeleine Chapelle*

Graphite on wove paper, 7 3/16 × 5 5/8 in. (18.3 × 14.3 cm)
Signed and dated in graphite at lower right: Ingres / 1814.
Like the related drawing in the Musée du Louvre (fig. 1; Naef 128), the sheet is foxed. There are repairs along the margin and at the top-right corner; the lower edge shows light staining from the overmat. The signature probably postdates the drawing's execution.
The Metropolitan Museum of Art, New York, Gift of Mrs. Charles Wrightsman, in honor of Philippe de Montebello, 2004 (2004.475.2)

PROVENANCE
Auguste Maillard (friend of Ingres), and by descent; private collection, France; [Hazlitt, Gooden & Fox, London, 1991]; [David Carritt Limited (Artemis Group), London, 1998]; sold to Wrightsman; Mrs. Charles Wrightsman, New York (from 1998); her gift in 2004 to the Metropolitan Museum in honor of Philippe de Montebello.

EXHIBITED
Hazlitt, Gooden & Fox, London, October–December, 1991, "Nineteenth Century French Drawings," no. 4.

LITERATURE
Aileen Ribeiro, *Ingres in Fashion: Representations of Dress and Appearance in Ingres's Images of Women* (New Haven and London, 1999), pp. 54, 56, pl. 29.

RELATED DRAWING
PARIS, Musée du Louvre (RF 3420). J.-A.-D. Ingres, *Madame Jean-Auguste-Dominique Ingres* (fig. 1). Graphite on paper, 6 7/8 × 5 1/8 in. (17.5 × 13.1 cm).

With cherubic, Pre-Raphaelite looks that, by most reports, mirrored her disposition, Madeleine Chapelle (1782–1849) provided inspiration and companionship as Ingres's wife for thirty-six years. Echoes of her face and figure appear in many of the artist's compositions, and her portrait is the subject of at least ten drawings dating from about 1813 to 1841, plus a fine, early painting.[1]

It was after two failed relationships that Ingres finally found his bride, through the intercession of a friend, Adèle Nicaise-Lacroix, wife of an official at the imperial court in Rome where the painter was studying.[2] The confessed object of Ingres's admiration, Mme Lacroix suggested the young man pay suit to the cousin who closely resembled her back home in the town of Guéret. In response to Ingres's initiation of a brief correspondence—including the posting of his own drawn self-portrait—Madeleine Chapelle arrived in Rome (September 1813), and the two were married (December 1814).

Within not much more than a year of their meeting, Ingres produced four portrait drawings of his wife, evidently for himself and for members of their family. The first (ca. 1813; Naef 97) introduces the young woman of thirty or thirty-one dressed with hat and handbag, as if she had just alighted from the carriage that brought her to Rome. The Wrightsman portrait, on the other hand, presents a more casual and intimate picture of Madeleine, who seems to gaze steadily and lovingly at the artist (her husband) drawing her. Indeed, her fuller figure and generally more matronly appearance here suggests she may have been pregnant, for the couple's only offspring was stillborn in the year of the portrait's date, 1814.

A drawing closely related to this work, in the Louvre (fig. 1), would appear to be a study of the same date. However, in it the

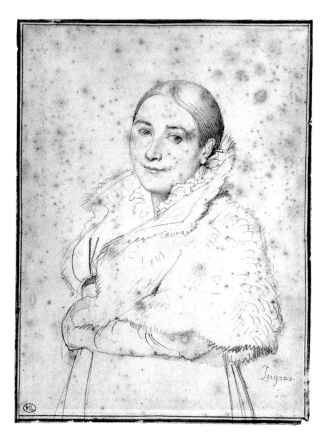

Fig. 1. Jean-Auguste-Dominique Ingres, *Madame Jean-Auguste-Dominique Ingres*. Graphite on paper, 6 7/8 × 5 1/8 in. (17.5 × 13.1 cm). Musée du Louvre, Paris (RF 3420)

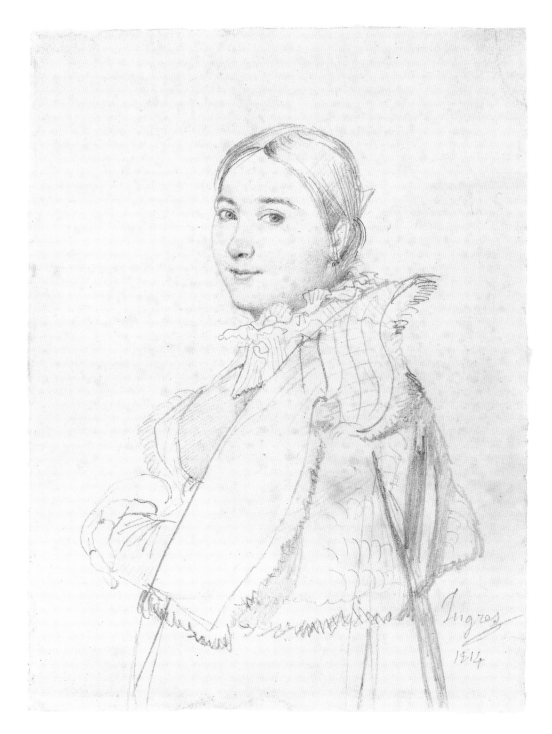

figure and face are turned outward, and the sitter's short fur cape has been drawn more tightly around her shoulders. Having been owned by Madeleine's cousin Adèle, that portrait may have been presented in thanks for her role as matchmaker. It is not known to whom the endearing Wrightsman drawing may have been directed, but it almost certainly would have been a loved one.

CI

NOTES

1. In addition to the work described here, the other portrait drawings of Madeleine Chapelle are Naef 1977–80, nos. 97, 127, 128, 283, 324, 327, 328, 363, 378; see also Naef 1977–80, vol. 1, chap. 40, pp. 358–78. The painting is W. 107, in the E. G. Bürhle Collection, Zurich; see London, Washington, New York 1999–2000, pp. 152–55 no. 36.
2. One may judge the resemblance between Madeleine and Adèle, whose portraits by Ingres are Naef 1977–80, nos. 99, 102–5, 107, 109.

80. *Jean-Joseph Fournier*

Graphite on wove paper, $9\frac{1}{2} \times 6\frac{3}{8}$ in. (24.2 × 16.2 cm)
Signed in graphite at upper left: Ingres Del.; dated in graphite at upper right: rome 1815; inscribed calligraphically in pen and ink at upper center: À L'amitié.

The rough edges of the sheet suggest that it was cut from a prepared drawing tablet, the format in which many of Ingres's early portrait drawings were executed. More recently, the paper has been treated for discoloration, and repairs have been made to tears and losses along the outer margins.

PROVENANCE
?By descent (together with Ingres's portrait of Joseph-Antoine de Nogent) to the sitter's son Fiorillo del Florido-Henri-Edmond Fournier, Paris (until his d. 1895); baron Joseph Vitta, Paris (?bequeathed to him by the former); César M. de Hauke, Paris; John S. Thacher, Washington, D.C. (ca. 1952); private collection, Paris; [E.V. Thaw & Co., Inc., New York, until 1998; sold to Wrightsman]; Mrs. Charles Wrightsman, New York (from 1998).

EXHIBITED
Palais des Arts, Nice, March 1–28, 1931, "Ingres," no. 15; Yale University Art Gallery, New Haven, May 8–June 18, 1956, "Pictures Collected by Yale Alumni," no. 207; Fogg Art Museum, Harvard University, Cambridge, Massachusetts, April 24–May 20, 1961, "Ingres and Degas: Two Classical Draughtsmen," no. 2; Fogg Art Museum, Harvard University, Cambridge, Massachusetts, February 12–April 19, 1967, "Ingres Centennial Exhibition, 1867–1967: Drawings, Watercolors, and Oil Sketches from American Collections," no. 29; Petit Palais, Paris, October 27, 1967–January 29, 1968, "Ingres," no. 80.

LITERATURE
Hans Naef, "Notes on Ingres Drawings," *Art Quarterly* 20 (summer 1957), pp. 183–87, fig. 2; Joanne Eagle, "Museum People as Collectors," *Art in America* 56 (September–October 1968), pp. 44–51, ill. p. 47; Emilio Radius and Ettore Camesasca, *L'opera completa di Ingres* (Milan, 1968), p. 124; Daniel Ternois and Ettore Camesasca, *Tout l'oeuvre peint d'Ingres* (Paris, 1971), p. 124; Hans Naef, "Vier unbekannte Ingres-Modelle," in *Gotthard Jedlicka: Eine Gedenkschrift* (Zurich, 1974), pp. 61–66, 69–70; Naef 1977–80, vol. 4, pp. 272–73 no. 148, and vol. 1, chap. 53, pp. 486–90; London, Washington, New York 1999–2000, p. 270; Marjorie B. Cohn, in *A Private Passion: Nineteenth-Century Paintings and Drawings from the Grenville L. Winthrop Collection, Harvard University,* ed. Stephan Wolohojian, exh. cat., Musée des Beaux-Arts, Lyon, National Gallery, London, and The Metropolitan Museum of Art, New York (New York and New Haven, 2003), pp. 159–62 under no. 54.

Ingres's appreciative appraisal of the handsome Fournier is unique in its presentation of the subject beneath a banner dedication. The heading, "To Friendship," penned in fancy gothic script, contradicts the spare, classical drawing and certainly was not written in Ingres's hand. Naef must be correct in thinking that the artist put to use a sheet of paper already inscribed, and, after drawing the portrait, inserted his signature and date on either side of the block of calligraphy.

Not much is known of Fournier. A long-lost note from Ingres tells of his travel in the spring of 1814 from Rome to Naples in the company of this young man and a mutual friend, Joseph-Antoine de Nogent—both merchants from Lyon.[1] Of the latter, Ingres produced a small, full-length portrait in oil on wood, now in the Fogg Art Museum, Cambridge, Massachusetts. The painting of Nogent and the drawing of Fournier, both dated 1815, bring us face to face with two almost impossibly elegant gentlemen, dressed to the hilt, hands on hips. Marjorie Cohn, however, rightly contrasts the "mask" presented by Nogent to the "frank sensuality of Ingres's drawn portrait of Fournier."[2] Such difference is likely the result of the dissimilarity in medium between the two images and highlights the singular power of Ingres's portrait drawings, with their emphasis on the subject's face rather than on costume or the furnishings of a place. Ingres's summary, devil-may-care strokes that casually allude to Fournier's finely tailored suit simply lend additional swagger to the sitter's dreamy-eyed presence.

At the time of his portrait, Fournier (already married) was settled in Rome, not far from Ingres, in the Via della Croce; he eventually made his home in Naples, where he lived out his final days in apparent prosperity, well connected to influential men of the times, including François Guizot, minister for foreign affairs (1840–48), and the duc de Montebello (Napoléon-Auguste), French ambassador to the court of the Two Sicilies (from 1840). Joseph-Antoine de Nogent bequeathed his Ingres painting to Fournier, and the two friends' portraits stayed together, by descent, until 1935.[3]

CI

NOTES

1. A paraphrased text of the note is given by Guiffrey in the Baron Vitta sale catalogue of 1935 (p. 6) and reproduced in Naef 1977–80, vol. 1, pp. 486–87.
2. Marjorie B. Cohn, in *A Private Passion: Nineteenth-Century Paintings and Drawings from the Grenville L. Winthrop Collection, Harvard University,* ed. Stephan Wolohojian, exh. cat., Musée des Beaux-Arts, Lyon, National Gallery, London, and The Metropolitan Museum of Art, New York (New York and New Haven, 2003), p. 160.
3. Naef, characteristically, ferreted out this and other biographical details; see Naef 1977–80, vol. 1, chap. 53, pp. 486–90.

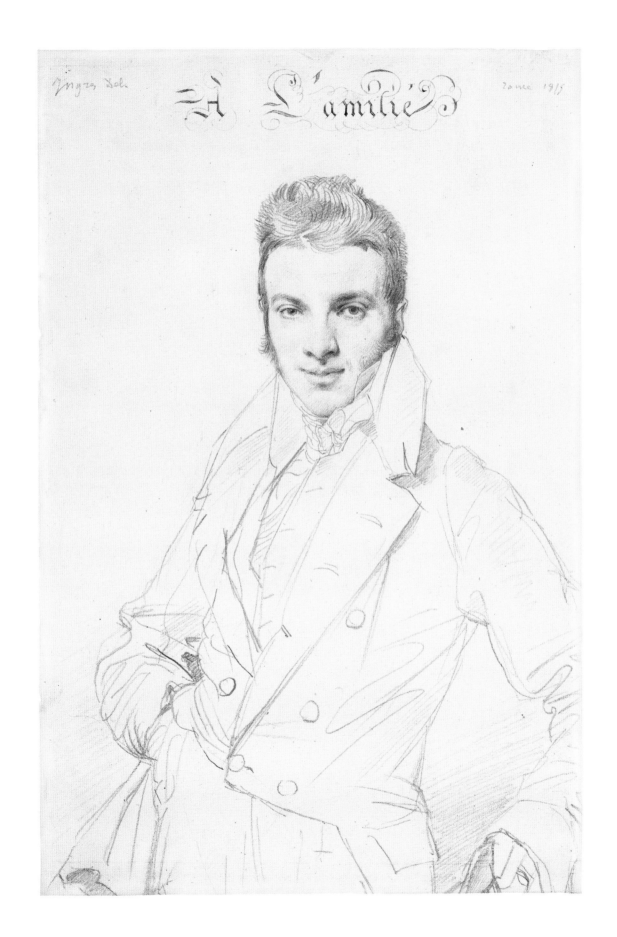

81. *Madame Alexandre Lethière, née Rosa Meli, and Her Daughter, Letizia*

Graphite on tracing paper glued down on support sheet, 9 1/8 × 7 7/8 in. (23.1 × 20.2 cm)
Signed and dated at lower right: Ingres / Rome 1815.

PROVENANCE
Kate Ganz, New York (by 2003, until 2004; sold to Wrightsman); Mrs. Charles Wrightsman, New York (from 2004).

This exquisite drawing belongs to the most remarkable group of portraits—those of the Lethière family—that Ingres produced during his fourteen-year stay in Rome (1806–20). Hitherto undocumented, it is a welcome addition to the series masterfully catalogued by Hans Naef in 1977–80 and revisited on the occasion of the Ingres portraits retrospective held in London, Washington, D.C., and New York in 1999–2000.[1] Guillaume Guillon Lethière (1760–1832), an ambitious painter with only modest talent, arrived in Rome one year after Ingres, in the train of his patron Lucien Bonaparte (1775–1840), who had been exiled to the Eternal City by his brother Napoleon in 1804 because he had chosen his own wife.[2] As Naef has suggested, Lucien Bonaparte probably organized the appointment of Lethière as director of the French Academy in Rome, recently installed in the Villa Medici, because he would not have merited the post on his own accord. Lethière quickly arranged for the young Ingres, unquestionably the most gifted portraitist at the French Academy, to execute the pencil portrait of Lucien sitting among the ruins of the Roman Forum, now in a private collection.[3]

As Naef has surmised, Ingres must have become close to Lethière, because he subsequently made, over the course of many years, extraordinary portrait drawings of every member of Lethière's extended family, often in multiple versions and copies. In 1808 Ingres portrayed Lethière's wife, older than her husband, with their son Lucien, standing near Ingres's studio, with the Villa Medici and Santissima Trinità dei Monti behind them (fig. 1).[4] In 1811 Ingres executed a profile drawing of Lethière alone, now at the Fogg Art Museum, Cambridge, Massachusetts (fig. 2), of which he made an autograph copy on tracing paper now at the Musée Bonnat, Bayonne.[5] In 1815 Ingres, then living just down the street from the French Academy, once again portrayed Lethière in a fulsome, frontal portrait, wearing the overcoat with attached cape known as a carrick and carrying a top hat. That portrait exists in three versions: an undisputed sheet now at The Pierpont Morgan Library (fig. 3); a lithographic copy by Frédéric Legrip in reverse; and a pencil copy by Alexander von Steuben.[6]

That same year, 1815, Ingres made portraits of Lethière's son Alexandre and his family. Alexandre, born in Paris in 1787 to a woman about whom Naef reports that nothing is known save her name, served in the French army and arrived to stay with his father and stepmother in Rome about 1810. He promptly impregnated a housemaid at the Villa Medici, Louise Lafont (ca. 1784–by 1832), whom Ingres also portrayed in two drawings whose present locations are unknown.[7] In November 1813 Alexandre married Rosa Meli, the fifteen-year-old daughter of a local apothecary.

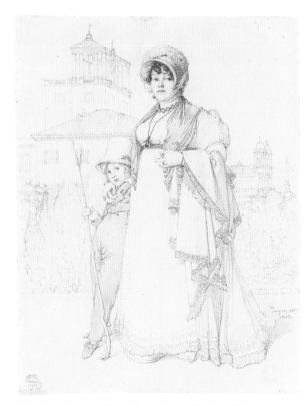

Fig. 1. Jean-Auguste-Dominique Ingres, *Madame Guillaume Guillon Lethière, née Marie-Joseph-Honorée Vanzenne, and Her Son Lucien Lethière*, 1808. Graphite on paper, 9 1/2 × 7 3/8 in. (24.1 × 18.7 cm). The Metropolitan Museum of Art, New York, H. O. Havemeyer Collection, Bequest of Mrs. H. O. Havemeyer, 1929 (29.100.91)

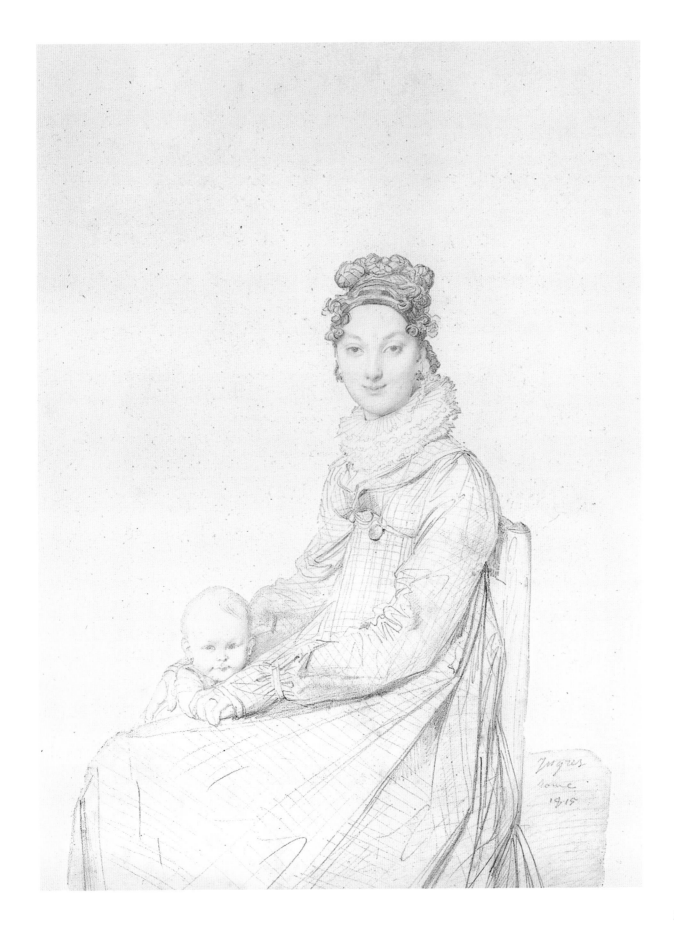

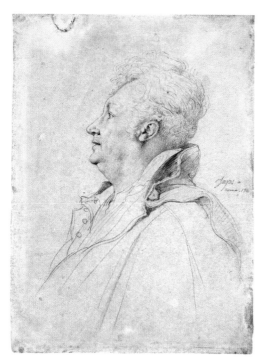

Fig. 2. Jean-Auguste-Dominique Ingres, *Profile Portrait of Guillaume Guillon Lethière*, 1811. Graphite on white wove paper, 8⅞ × 6½ in. (22.4 × 16.5 cm). Fogg Art Museum, Cambridge, Massachusetts, Bequest of Grenville L. Winthrop, 1943 (1943.846)

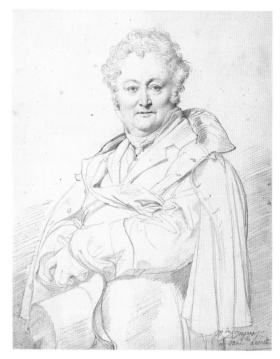

Fig. 3. Jean-Auguste-Dominique Ingres, *Guillaume Guillon Lethière*, 1815. Graphite on paper, 10⅝ × 8⅜ in. (27.1 × 21.1 cm). The Pierpont Morgan Library, New York, Bequest of Therese Kuhn Straus in memory of her husband, Herbert N. Straus (1977.56)

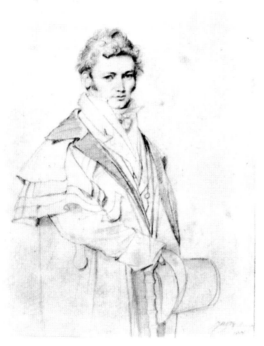

Fig. 4. Jean-Auguste-Dominique Ingres, *Alexandre Lethière*, 1815. Graphite on paper, 10⅝ × 8¼ in. (27.1 × 20.9 cm). Musée Bonnat, Bayonne (NI 932)

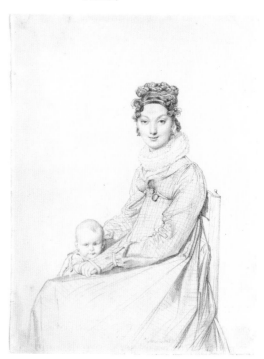

Fig. 5. Jean-Auguste-Dominique Ingres, *Madame Alexandre Lethière, née Rosa Meli, and Her Daughter, Letizia*, 1815. Graphite on paper, 11⅞ × 8¼ in. (30 × 22 cm). The Metropolitan Museum of Art, New York, Bequest of Grace Rainey Rogers, 1943 (43.85.7)

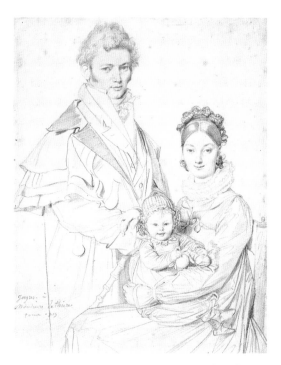

Fig. 6. Jean-Auguste-Dominique Ingres, *The Alexandre Lethière Family,* 1815. Graphite on paper, 10 ⅝ × 8 ⅜ in. (27.1 × 21.4 cm). Museum of Fine Arts, Boston, Maria Antoinette Evans Fund (26.45)

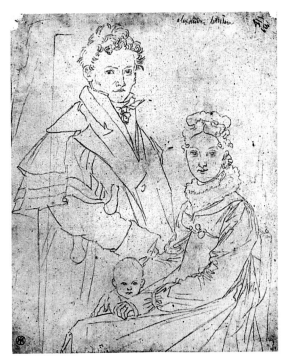

Fig. 7. Jean-Auguste-Dominique Ingres, *Study for the Alexandre Lethière Family.* Graphite on tracing paper, 11 × 8 ⅞ in. (28 × 22.6 cm). Musée Ingres, Montauban (867.312)

Their first child, Letizia, was born in August 1814. Ingres appears to have made the independent portrait of Alexandre now at the Musée Bonnat, Bayonne (fig. 4), and the one of Rosa and Letizia (fig. 5) in the Metropolitan Museum, in about 1815.[8] To make a group portrait of the young Lethière family, he superimposed the two previously executed portraits on a new sheet, now at the Boston Museum of Fine Arts (fig. 6).[9] As an intermediate step, to determine how best to fit the two images together, Ingres made the tracing of both now at the Musée Ingres, Montauban (fig. 7).[10] It is thought that Alexandre was not in Rome in 1815 and thus unavailable to sit for a new portrait. In one of his most charming portraits, a work of 1818 now in the Musée des Arts Décoratifs, Paris, Ingres depicted the Lethière's second child, Charles, born in 1816, sitting in his grandfather's armchair.[11]

The existence of multiple copies and tracings of the Lethière portraits is relevant to the present portrait, since this work is a nearly identical tracing of the Metropolitan Museum's portrait of Mme Lethière and Letizia discussed above. To make it, Ingres—and every mark of graphite bears the mark of Ingres—laid a very thin sheet of white tracing paper over the existing portrait and traced it, not only the contours but the drapery and modeling as well. Only in a few instances did Ingres deviate from the model with extemporized strokes. Ingres then silhouetted the figural group with a blade and glued the tracing onto a sheet of heavy white paper. He signed his copy on the heavy paper, at right. This unnecessarily elaborate procedure, though unique, perhaps, in Ingres's oeuvre, also points to the hand of the artist, since for a copyist or forger the cut-out tracing paper would have exposed the drawing for what it is—a tracing of an existing work. But for Ingres, this work would handsomely fulfill the request from a family member for a copy.

As Hans Naef recounts, the Alexandre Lethière family was unlucky in life. Mme Lethière died in Rome in 1817, at nineteen. Alexandre died in Paris in 1824 of maltreated war wounds, and Letizia died in 1828, at thirteen. Only Charles lived to enjoy his maturity, dying in Paris in 1889.

It has been impossible to determine anything about the previous history of the present sheet before it appeared on the New York art market in 2003. GT/AEM

303

NOTES

1. The present entry is heavily indebted to Naef 1977–80, vol. 1, chap. 43, pp. 403–20, and the abridged translation in London, Washington, New York 1999–2000, nos. 52–55, 81, esp. pp. 182–84.
2. The former Mme Jean-François-Hippolyte Jouberthon, *née* Marie-Laurence-Charlotte-Louise-Alexandrine de Bleschamp (1778–1855).
3. Naef 1977–80, vol. 4, no. 45; London, Washington, New York 1999–2000, no. 38.
4. Naef 1977–80, vol. 4, no. 51; London, Washington, New York 1999–2000, no. 53.
5. Naef 1977–80, vol. 4, nos. 69, 70. The tracing at Bayonne (NI 932) measures 8½ × 6⅜ in. (21.5 × 16.3 cm).
6. Ibid., no. 135; London, Washington, New York 1999–2000, no. 52. The Von Steuben copy, with the Paris dealer Paul Prouté before 1967, was sold to Jean Furstenberg, Paris.
7. Naef 1977–80, vol. 4, nos. 61, 243; see also vol. 1, chap. 44, pp. 421–27.
8. Ibid., vol. 4, nos. 138, 139; London, Washington, New York 1999–2000, no. 54.
9. Naef 1977–80, vol. 4, no. 140; London, Washington, New York 1999–2000, no. 55.
10. Naef 1977–80, vol. 1, p. 412, fig. 12.
11. Ibid., vol. 4, no. 232; London, Washington, New York 1999–2000, no. 81.

82. *Portrait of a Lady*

Graphite on wove paper, 10¾ × 7¾ in. (27.6 × 19.9 cm)

PROVENANCE
Estate of R. E. Summerfield, Cheltenham (sale, Bruton Knowles chartered surveyors, The Avon Hall, Malvern, Worcestershire, March 6, 1990, lot 718); private collection; [Sayn-Wittgenstein Fine Art, Inc., New York, 1998; sold to Wrightsman]; Mrs. Charles Wrightsman, New York (from 1998).

Although previously absent from the literature on Ingres, this portrait was securely attributed to the artist by the principal cataloguer of his drawings, Hans Naef. In a certificate dated May 17, 1990, in Zurich, where he examined the work at Sotheby's, Naef reported it "rich in all the characteristics by which Ingres's portrait drawings are distinguished from those of his contemporaries and imitators: the miraculous sensitivity of the face . . . ; the presence of a living body beneath the clothing . . . ; and finally the supremely nonchalant marks that describe accessories."[1]

Noting the lack of a signature on the sheet, Naef suggested that the portrait might have been one of a pair representing a husband and a wife, where only the gentleman's likeness was signed, as seen in the portraits of Mr. and Mrs. Charles Thomas Thruston.[2] Unfortunately, one searches in vain through Naef's catalogue for an appropriate mate to this demure young woman.

As a date for the drawing, Naef proposed the years 1815–17 on the basis of the lady's costume and the fact that during that time Ingres regularly provided for himself and his family by drawing portraits of the travelers in Rome who resumed their grand tours after Napoleon's downfall. There is some logic in identifying the sitter as English, inasmuch as this drawing emerged in Worcestershire, where it was sold in 1990 from the estate of the antiquarian R. E. Summerfield.

This graphic portrayal characteristically displays Ingres's fine disregard for his sitter's dress in contrast to his keen attentiveness to her face, although the features (wide-set almond eyes, aquiline nose, and tiny mouth) are hardly distinctive, typifying as they do so many of the artist's female subjects. Perhaps most striking is the combination of drawing techniques that converge with the head of this model: a dreamy *sfumato* modeling of the woman's complexion and a bluntly shaded rendering of her coiffure, joined with a playfully sketchy description of her ruffled neckerchief.

CI

NOTES

1. The hand-signed document is written in French and bears Naef's personal letterhead with his Zurich address. The above-quoted passage reads, in its entirety: "Ce dessin non signé est riche de tous les caractéristiques par lesquels l'art d'Ingres dessinateur de portraits se distingue de celui de ses contemporains et imitateurs: La miraculeuse finesse du visage du point de vue de l'exécution autant que de la présence humaine du modèle qui est vu dans sa vérité profonde et sans psychologismes; la presence du corps respirant sous les vêtements qui à son tour ajoute à la 'physionomie' du personage représenté; enfin les graphismes souverainement nonchalants qui rendent les accessoires."
2. Naef 1977–80, vol. 4, pp. 328–31 nos. 178–79.

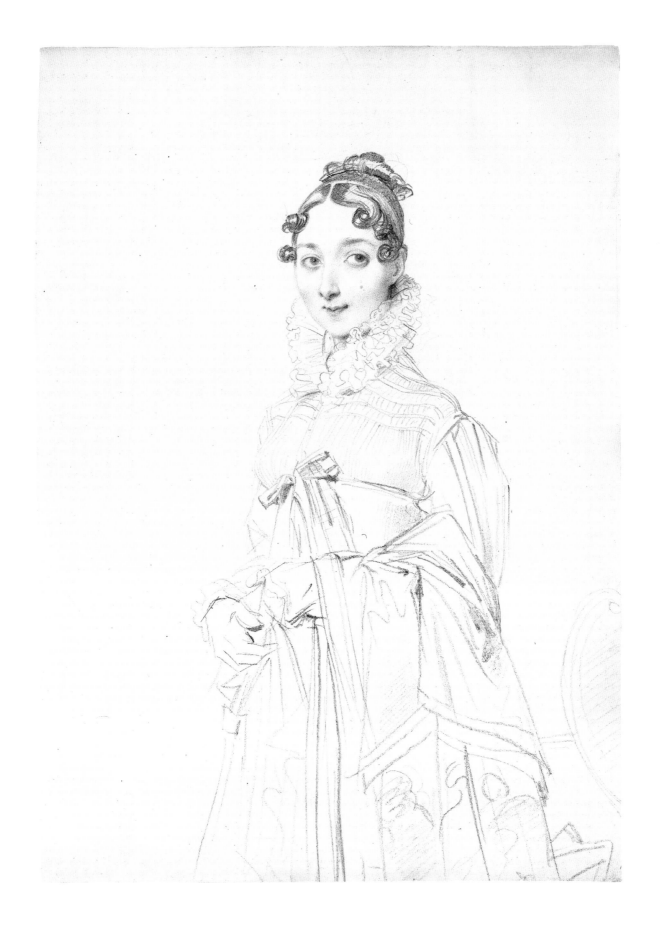

83. Admiral Sir Fleetwood Broughton Reynolds Pellew

Graphite on wove paper, 11¾ × 8¾ in. (30 × 22 cm)
Signed and dated in graphite at lower right: Ingres. Del à / rome 1817.
The Metropolitan Museum of Art, New York, Gift of Mrs. Charles Wrightsman, in honor of Philippe de Montebello, 2004 (2004.475.1)

PROVENANCE
The sitter, Sir Fleetwood Broughton Reynolds Pellew (until his d. 1861); ?by descent to the daughter of the sitter, Harriet Bettina Frances Pellew, Lady Orford, Florence (until her d. 1886); ?by descent to her daughters Dorothy Elizabeth Mary Walpole, later Duchess del Balzo (d. 1921), and Maude Mary Walpole, later Countess Griefeo e Gravana (d. 1874); [Galerie André Weil, Paris; sold to Renand]; Georges Renand, Paris (1935); [Galerie Wertheimer, Paris, 1948]; [Galerie Feilchenfeldt, Zurich, 1949]; [Galerie Paul Rosenberg, New York; sold to Steinberg, 1954]; Mrs. Mark C. Steinberg, St. Louis (until her d. 1974); by descent to Etta E. Steinberg and Florence C. Weil; Mr. and Mrs. Richard Weil, St. Louis; [Thos. Angew & Sons, New York; sold to Wrightsman]; Mrs. Charles Wrightsman, New York (from 1989); her gift in 2004 to the Metropolitan Museum in honor of Philippe de Montebello.

EXHIBITED
Galerie André Seligmann, Paris, June 9–July 1, 1936, "Portraits français de 1400 à 1900," no. 129 (as "Portrait d'un lord"); Galerie Marcel Guiot, Paris, June 8–22, 1937, "Le portrait dessiné au XIXᵉ siècle," no. 13; Fogg Art Museum, Harvard University, Cambridge, Massachusetts, February 12– April 9, 1967, "Ingres Centennial Exhibition, 1867–1967: Drawings, Watercolors, and Oil Sketches from American Collections," no. 39; Thos. Agnew & Sons, Ltd., London, June 3–July 25, 1986, "From Claude to Géricault: The Arts in France, 1630–1830," no. 30.

LITERATURE
Hans Naef, "Ingres' Portrait Drawings of English Sitters in Rome," *Burlington Magazine* 98 (December 1956), p. 428, fig. 6; Else Kai Sass, *Thorvaldsens Portraebuster* (Copenhagen, 1963–65), vol. 1, p. 352, and vol. 3, p. 166; William N. Eisendrath Jr., "Paintings and Sculpture in the Collection of Mrs. Mark C. Steinberg," *Connoisseur* 154 (December 1963), pp. 264, 267; Emilio Radius and Ettore Camesasca, *L'opera completa di Ingres* (Milan, 1968), p. 124; Agnes Mongan, "Ingres as a Great Portrait Draughtsman," *Colloque Ingres* (Montauban, 1969), p. 146; Daniel Ternois and Ettore Camesasca, *Tout l'oeuvre peint d'Ingres* (Paris, 1971), p. 124; Naef 1977–80, vol. 4, pp. 380–81 no. 205, and vol. 2, chap. 79, pp. 139–46.

RELATED DRAWING
PARIS, private collection. Jean-Auguste-Dominique Ingres, *Mrs. Fleetwood Broughton Reynolds Pellew (née Harriet Webster)*, 1817 (fig. 1). Graphite on paper, 11⅝ × 8¾ in. (29.6 × 22 cm). Naef 206.

Fleetwood Pellew (1789–1861) was one of the fortunate Englishmen to have found himself in Rome and in the path of Ingres's steady gaze during a singularly productive chapter in the artist's career. After Napoleon's defeat British tourists returned to Italy in droves, and more than twenty of them paused for Ingres to draw their portraits.

Lady William Henry Cavendish Bentinck, one of the most prominent of Ingres's British subjects, seems to have introduced the artist to Fleetwood and Harriet Pellew. The two had been wed in 1816 and quite possibly were taking their honeymoon in Rome in 1817, when Ingres drew individual portraits of them: the groom, proudly standing; the bride, placidly seated (fig. 1).

Fleetwood's arrogant expression, the affected casualness of his stance, and the studied contradiction between his decorations and the exposed interior of his hat coalesce in an unforgettable characterization. It is an image befitting the favorite son of Admiral Edward Pellew (Viscount Exmouth), supreme commander of the British fleet first in the South Seas and then the Mediterranean.

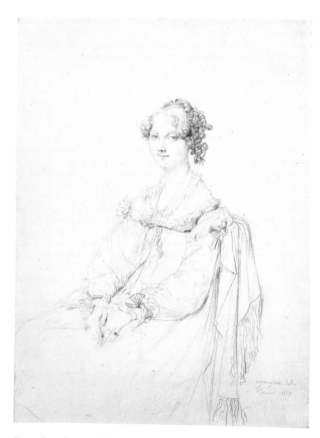

Fig. 1. Jean-Auguste-Dominique Ingres, *Mrs. Fleetwood Broughton Reynolds Pellew (née Harriet Webster)*, 1817. Graphite on paper, 11⅝ × 8¾ in. (29.6 × 22 cm). Private colleciton (Naef 206)

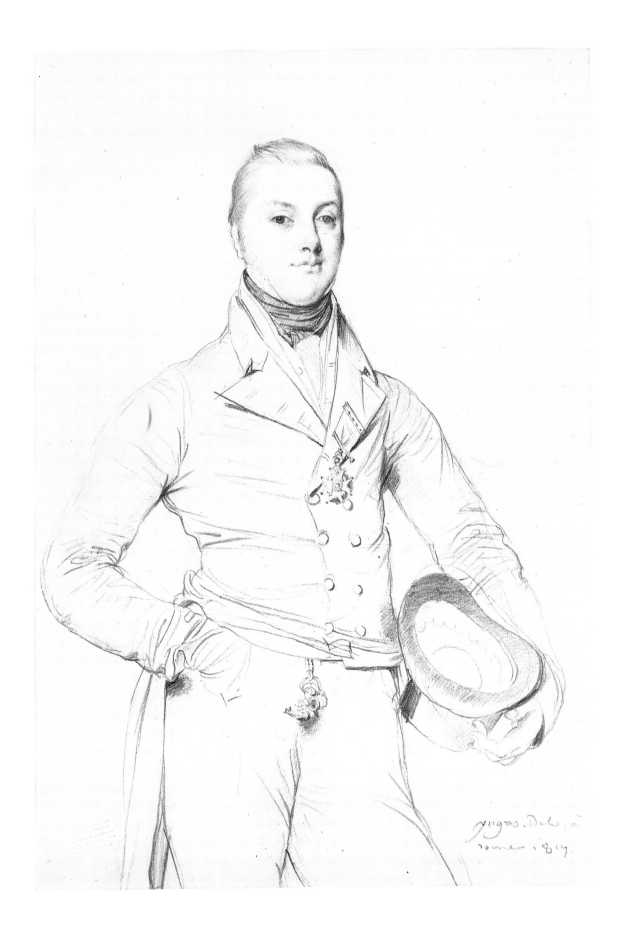

307

Young Fleetwood joined his father in service of the Royal Navy at the tender age of nine and by eighteen was captain of his own ship. The elder Pellew, who had used his influence to obtain the post for his son, was uncommonly pleased with his offspring's performance. "It is a great comfort," he assured the boy's godfather, "to see that one has not reared a bevy of Pigeons." Of the "firm, Manly, decided young man of the mildest manners and civilest deportment," one learns further from his father that "the management of his ship is excellent, his officers and men love him—so just and so temperate . . . he is."[1] In 1814, however, during his command of the forty-six-gun warship *Resistance,* Fleetwood was ordered back to England. His crew had staged a mutiny.

Remarkably, Fleetwood's career was far from ruined. Although he remained without a command until 1818, he was awarded the Order of the Knights of Bath in 1815, an honor that may have helped to secure him a wife. His temporary suspension from active duty allowed him time to marry, to travel, and to sit for his portrait. But the man was a dedicated officer, and—after a thirty-year retirement—he staged his second return to the navy in 1852, assuming command of the base for England's East Indian and Chinese fleet. In 1858 he was promoted to admiral, an astonishing honor given the fact that, in Hong Kong in 1853, a mutiny had again erupted on his ship.[2] CI

NOTES

1. Letter from Edward Pellew to his son's godfather, Alexander Broughton, January 10, 1807, quoted in Naef 1977–80, vol. 2, pp. 139–40.
2. All biographical information regarding Pellew in this entry derives from ibid., pp. 139–46.

84. *The Kaunitz Sisters (Leopoldine, Caroline, and Ferdinandine)*

Graphite on laid paper, 11 7/8 × 8 3/4 in. (30.1 × 22.2 cm)
Signed in graphite at lower left: Ingres Del. Dated in graphite at lower right: rome 1818. Instructions to a framer are inscribed in graphite by Ingres beneath a space left blank for the sitters' names: Partie dans le cadre [this portion (of the sheet) to be hidden by the picture frame] The laid paper is no longer wrapped about a thin wood panel and glued at the back, in the form of a drawing tablet, as it was when Eva Steiner published the work in 1931.[1] The back of the panel bore an inked inscription identifying the sitters. Probably at the time of sheet's removal from the board, the tears in the lower-left and right corners that Steiner observed and attributed to "the warping of the wood" were repaired. The mark of the collector Anton Schmid (Lugt 2330b), said by Naef to be at lower right, is now all but invisible.[2]
The Metropolitan Museum of Art, New York, Gift of Mrs. Charles Wrightsman, in honor of Philippe de Montebello, 1998 (1998.21)

PROVENANCE
?Fürst and Fürstin van Kaunitz-Rietberg; Fürstin von Kaunitz-Rietberg (until 1859); by descent, their daughters, ultimately Fürstin Anton Karl Pálffy (until 1888); Nicolaus Pálffy, Schloss Marchegg, Austria (by 1931); his heirs; the Viennese collector Anton Schmid (shortly after World War II–early 1960s); [H. M. Calmann Gallery, London (between 1961 and 1966)]; Alfred Strölin, Paris (1966–74); [Bruno de Bayser, Paris; sold to Wrightsman]; Mrs. Charles Wrightsman, New York (1995–98); her gift in 1998 to the Metropolitan Museum in honor of Philippe de Montebello.

EXHIBITED
Kunsthalle, Tübingen, September 12–October 28, 1986, and Palais des Beaux-Arts, Brussels, November 7–December 21, 1986, "Ingres und Delacroix: Aquarelle und Zeichnungen," no. 22; National Gallery, London, January 27–April 25, 1999, National Gallery of Art, Washington, D.C., May 23–August 22, 1999, and Metropolitan Museum, New York, October 5, 1999–January 2, 2000, "Portraits by Ingres: Image of an Epoch," no. 77 (shown in New York only).

LITERATURE
Eva Steiner, "An Unknown Drawing by J. A. D. Ingres," *Old Master Drawings 6* (June 1931), pp. 4–5; Brinsley Ford, "Ingres' Portrait Drawings of English People at Rome, 1806–1820," *Burlington Magazine* 75 (July 1939), p. 7; Hans Naef, in *Ingres,* exh. cat., Petit Palais, Paris (Paris, 1967), p. 162 under no. 112; Naef 1977–80, vol. 4, pp. 420–21 no. 224, and vol. 2, chap. 99, pp. 300–306.

Among the most appealing of Ingres's rare group portraits is this presentation of the daughters of Austria's ambassador to Rome, Prince Wenzel von Kaunitz-Rietberg (d. 1848), grandson of Maria Theresa's famous chancellor, Wenzel Anton von Kaunitz. The three young women, pictured here in 1818 aged thirteen to seventeen, are depicted in the discreet luxury of Empire fashion in a

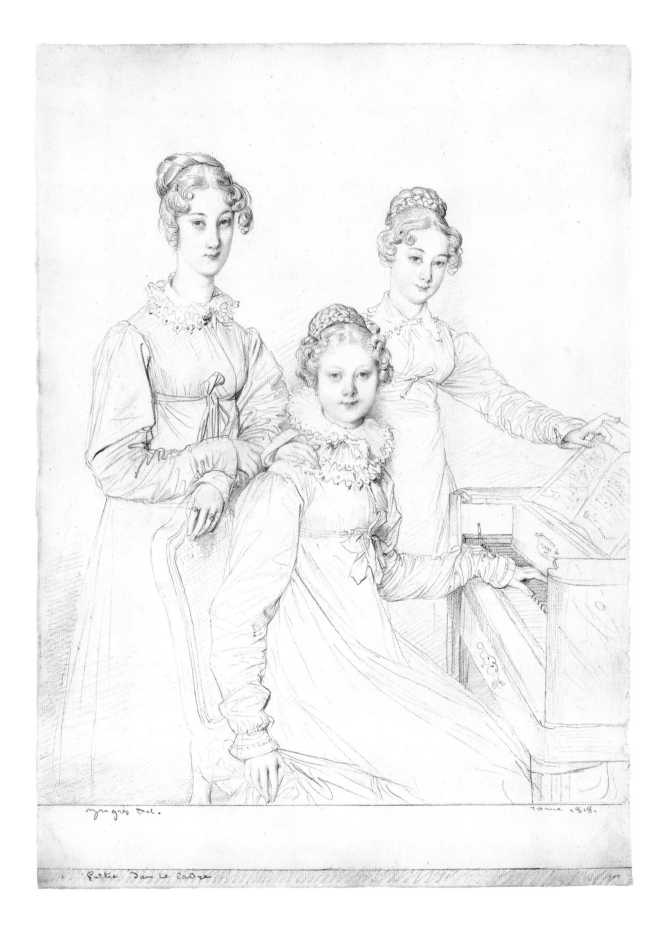

setting that suggests their privileged, cultured world. They cluster about a piano, presumably in the family music room, where virtuoso violinist Niccolò Paganini (1782–1840) was to perform the following year. Ingres's passion for music and his mastery of the violin would easily have attracted him to the Kaunitz residence; it was probably there, as Naef suggests, that Ingres met the great Paganini, whose portrait he drew in 1819.

At the time of this work Ingres was unquestionably at the height of his powers as a graphic portraitist. The precision of his draftsmanship, his rhythmic distribution of accents, and his delicate descriptions of the charmingly bashful faces framed in curls and lacy collars are exquisite. Such a portrait might have helped to secure titled husbands for all three daughters, despite their father's philandering, which brought him to judicial review in Vienna in 1822 and, ultimately, exile.

The eldest girl, Caroline (1801–1875), whom Ingres seated at the center of his portrait, her left hand poised to play upon the keyboard, married Count Anton Gundakar von Starhemberg and then, after his death, Pierre d'Alcantara, duc d'Arenberg. Leopoldine (1803–1888), standing at left, a prototypically dreamy-eyed Ingres subject, became the wife of Graf, later Fürst, Anton Karl Pálffy, ambassador to the court of Saxony. She became a lady-in-waiting to the empress, as did her younger sister, Ferdinandine (1805–1862), who took as her husband Graf Ladislaus Károly.

CI

NOTES

1. Eva Steiner, "An Unknown Drawing by J. A. D. Ingres," *Old Master Drawings* 6 (June 1931), pp. 4–5.
2. Naef 1977–80, vol. 4, pp. 420–21 no. 224, and vol. 2, chap. 99, pp. 300–306.

85. *General Louis-Étienne Dulong de Rosnay*

Graphite (hard and soft pencils) on wove paper, 17¾ × 13½ in. (45.1 × 34.3 cm)
Signed and dated at lower left: Ingres Deli. rom. 1818.
Edges of the paper sheet are slightly browned.

PROVENANCE
The sitter, Louis-Étienne Dulong de Rosnay, Paris (until his d. 1828); his son, Hermand Dulong de Rosnay (until his d. 1894); his grandson Hermand Dulong de Rosnay (until his d. 1939); his son Gilles Dulong de Rosnay, Paris (until 1959; [Galerie Feilchenfeldt, Zurich, 1959; sold to Heinemann]; Dr. Rudolf J. Heinemann, New York (until his d. 1975); his wife, Mrs. Rudolf J.

Heinemann, New York (sale, Christie's, New York, May 22, 1997, lot 17, to Wrightsman); Mrs. Charles Wrightsman, New York (from 1997).

EXHIBITED
Salon des Arts-Unis, Paris, 1861, "Dessins [d'Ingres] tirés de collections d'amateurs"; École des Beaux-Arts, Paris, 1867, "Ingres," no. 555; Galerie Georges Petit, Paris, April 26–May 14, 1911, "Ingres," no. 110; Hôtel de la Chambre Syndicale de la Curiosité et des Beaux-Arts, Paris, May 8–June 5, 1921, "Ingres," no. 88; Galerie André Weil, Paris, June 2–25, 1949, "Ingres," no. 73; Pierpont Morgan Library, New York, May 11–July 31 1973, "Drawings from the Collection of Lore and Rudolf Heinemann," no. 18.

LITERATURE
Émile Galichon, "Dessins de M. Ingres," *Gazette des beaux-arts* 11 (July 1, 1861), p. 46; Charles Blanc, *Ingres: Sa vie et ouvrages* (Paris, 1870), p. 236; Henri Delaborde, *Ingres: Sa vie, ses travaux, sa doctrine, d'après les notes manuscrites et les lettres du maître* (Paris, 1870), p. 295 no. 298; B. de Tauzia, *Musée National de Louvre: Dessins, cartons, pastels et miniatures des diverses écoles, exposés, depuis 1879, dans les salles du 1ᵉʳ étage, deuxième notice supplémentaire* (Paris, 1888), p. 141; E. Titeux, "Le general Dulong de Rosnay," *Carnet de la Sabretache* (Paris), January 31, 1901, p. 2; Henry Lapauze, *Les dessins de J.-A.-D. Ingres au Musée de Montauban* (Paris, 1901), p. 265; Henry Lapauze, *Les portraits dessinés de J.-A.-D. Ingres* (Paris, 1903), p. 47 no. 17; Arsène Alexandre, *Jean-Dominique Ingres, Master of Pure Draughtsmanship* (London, 1905), pl. 12; Henry Lapauze, *Ingres: Sa vie & son oeuvre (1780–1867), d'après des documents inédits* (Paris, 1911), p. 182; Henry Lapauze, *Jean Briant, paysagiste (1760–1799): Maître de Ingres, et le paysage dans l'oeuvre de Ingres* (Paris, 1911), p. 48; Jean Alazard, *Ingres et l'ingrisme* (Paris, 1950), p. 36; Hans Naef, *Rome vue par Ingres* (Lausanne, 1960), p. 29 n. 52, and p. 132 under no. 72; Hans Naef, "Two Unknown Ingres Portraits: M. and Mme Sebastiani," *Master Drawings* 3 (1965), p. 279; Hans Naef, "Ingres und die Familie Stamaty," *Schweizer Monatshefte,* December 1967, p. 26; Felice Stampfle and Cara D. Denison, *Drawings from the Collection of Lore and Rudolf Heinemann,* exh. cat., Pierpont Morgan Library, New York (New York, 1973), p. 26 no. 18; Naef 1977–80, vol. 4, pp. 434–35 no. 231, and vol. 2, chap. 93, pp. 265–69.

LITHOGRAPH
Atala Varcollier, *General Dulong de Rosnay,* ca. 1827. Lithograph. Bibliothèque Nationale de France, Paris.

In 1818, the very year in which Ingres portrayed the stalwart figure of General Dulong de Rosnay (1780–1828), the war hero's name was chiseled into the stone pillars of the Arc de Triomphe in Paris. According to Hans Naef, Dulong was only twenty when his courageous defense of Pesaro brought him to the attention of Napoleon, who greeted him with the words, "Dulong, j'aime les braves, et vous en êtes un."[1] Thirteen years later, this orphaned son of a country doctor was named, for his unwavering valor, Baron de l'Empire.[2]

The extraordinary military career that Naef outlines in detail (incorporating, for example, the text of a medical certificate recommending a six-month leave of duty for Dulong in 1812) included multiple instances in which the soldier was wounded in

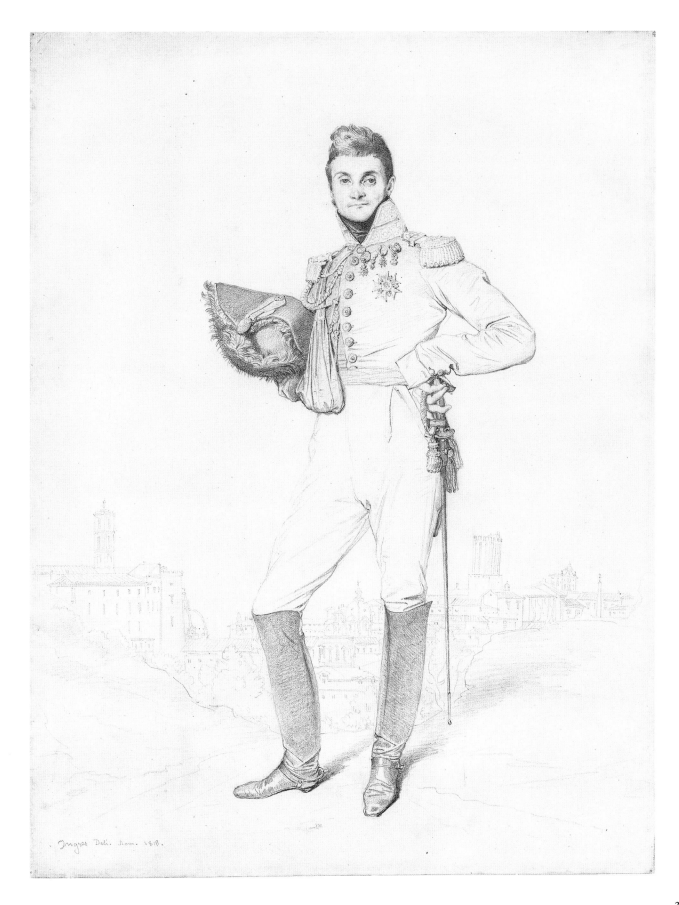

battle either by gunshot or by fierce blows of bayonet and saber. In consequence, he lost of the use of his right arm and suffered incessant pain. In his portrait, Ingres makes no attempt to obscure the general's physical disability but rather gives weight to his sacrificed arm, held in a sling; it supports a large, beribboned cocked hat next to the general's decorated chest. Raised to hip level is Dulong's fully functioning left arm, his hand conspicuously fingering the hilt of his sword, as if to assure us of an enduring resolve.

Indeed, in all aspects this portrait conveys a figure of stature and serious purpose, right down to the shiny, dark-booted feet that stand ready to spring into action. Ingres pictured Dulong on top of Rome's Aventine Hill, with a grand panorama behind him, including the Palazzo del Senatore on the left and the Torre delle Milizie on the right. This view is evidently one of the stock landscapes Ingres copied as backdrops for his portraits from a sketchbook he owned. Long thought to be the work of Ingres himself, this group of some forty graphite landscapes (Musée Ingres, Montauban) has yet to be securely attributed.[3]

Naef presumes that General Dulong's arrival in Rome in 1818 had been occasioned by the death of a relative, Constantin Stamaty (d. 1817), whose family Ingres had only recently drawn in a group portrait.[4] The Stamatys' daughter Atala (1803–1885) had become a pupil of Ingres, and, about a decade later, as Mme Michel-Augustin Varcollier, she produced a lithograph copy of Ingres's drawing of Dulong.[5] In it he wears the ribbon of the Order of Saint Louis that he was awarded in 1827.[6]

CI

NOTES

1. "Dulong, I love brave men, and you are one of them." *Précis de la vie militaire de M. Louis-Étienne Dulong, comte de Rosnay* (Bastia, n.d.), p. 7, quoted in Naef 1977–80, vol. 2, p. 267.
2. Naef 1977–80, vol. 2, chap. 93, pp. 265–69, and vol. 4, pp. 434–35 no. 231.
3. Georges Vigne, "Ingres and Co.: A Master and His Collaborators," in London, Washington, New York 1999–2000, pp. 526–27.
4. Naef 1977–80, vol. 4, pp. 404–7 no. 217.
5. Further information regarding the artist Atala Stamaty Varcollier and her copies after Ingres is provided in Hans Naef, "Two Unknown Ingres Portraits: M. and Mme Sebastiani," *Master Drawings* 3 (1965), pp. 276–80.
6. Naef 1977–80, vol. 2, p. 269, fig. 2.

86. *The Lawyer Paul Grand*

Graphite on wove paper with the watermark J. Whatman / Turkey Mill, 13½ × 10¼ in. (34.2 × 26 cm)
Signed, dedicated, and dated in graphite at lower right: Ingres à Son ami / Paul Grant [*sic*] / 1834.
All four margins of the sheet are darkened by stains where the edges had been folded and glued to the back of the artist's drawing tablet. There are scattered stains on the paper's surface and a filled area in the gentleman's coat at lower center. The patched hole was said to have been the result of shrapnel from a grenade exploded during the Franco-Prussian War of 1870.[1] The label of Ingres's framer Haro is pasted on the back of the frame.

PROVENANCE

The sitter, Paul Grand (until his d. 1889); his daughter Anna Grand de Dedem (until her d. 1920); her estate sale, Hôtel Drouot, Paris, May 27–28, 1921, lot 4, ill., to "un héritier de la succession," for Fr 10,000;[2] M. and Mme Jean-Baptiste Mantelin (Joséphine Grand, niece of the sitter, b. 1870); their son Joseph Mantelin (b. 1928); his daughter Marie Mantelin (Mme Jean Bigeon); sale, Sotheby's, London, June 17, 1992, lot 435; [Walter Feilchenfeldt, Zurich, until 1993; sold to Wrightsman]; Mrs. Charles Wrightsman, New York (from 1993).

LITERATURE

Henry Lapauze, *Les portraits dessinés de J.-A.-D. Ingres* (Paris, 1903), no. 29; Henry Lapauze, *Ingres: Sa vie & son oeuvre (1780–1867), d'après des documents inédits* (Paris, 1911), pp. 286, 317; *Le bulletin de l'art ancien et moderne,* June 25, 1921, p. 95; Frank Elgar, *Ingres* (Paris, 1951), p. 5, fig. 9; Hans Naef, "À propos de deux portraits d'Ingres au Cabinet des Dessins du Louvre," *La revue du Louvre et des musées de France,* 1966, p. 212, ill. p. 214; Naef 1977–80, vol. 5, pp. 194–95 no. 352, and vol. 2, chap. 132, pp. 573–81.

Although Ingres dedicated not only this portrait but also an engraved copy of his self-portrait to his "ami Paul Grant," the "friend" he portrayed here has been identified (despite the spelling) as Paul Grand (1801–1889), a French barrister. One of Grand's relatives purchased the drawing when it was sold at auction in 1921 from the estate of his daughter, Anna Maria Theodora Grand de Dedem, who died childless in 1920, and it remained in the Grand family for many more years.

The son of a cavalry captain, Grand was the godson of Paul Barras (1755–1829), a leader of the French Revolution. Naef speculates that, through his friendship with the Italian patriot and engraver Luigi Calamatta, Grand became acquainted with Ingres.[3] As a lawyer working in Paris in the 1830s, Grand, like the entire bloated population of "legal minds," was subject to the ridicule of the caricaturist Honoré Daumier (1808–1879). Here, however, he cuts a proud figure—one who, four years after this portrait was

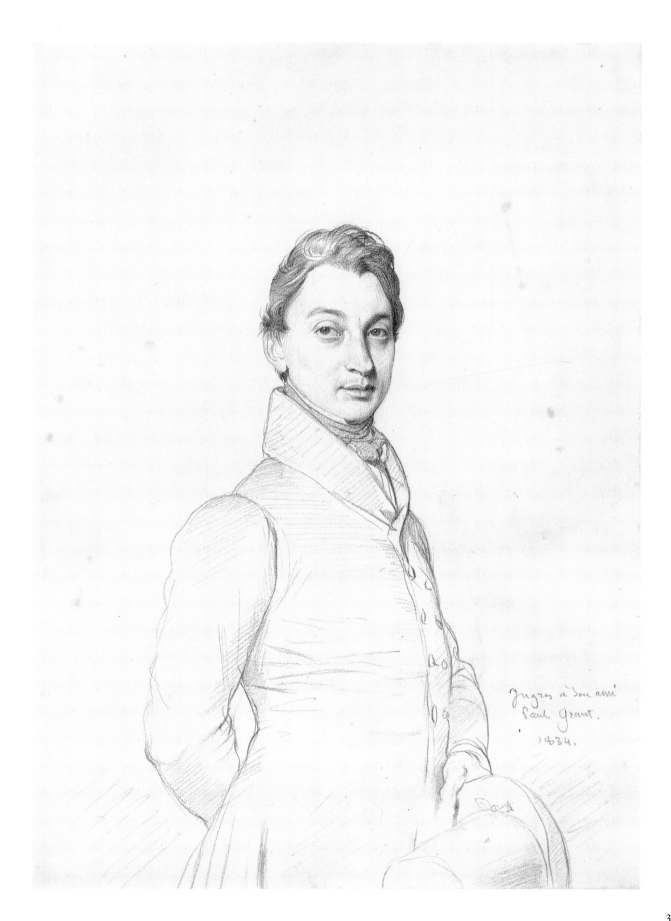

Ingres à son ami
Paul Grant.
1834.

drawn, married into the Dutch royal house through his union with Theodora Friederika van Dedem (d. 1869).

Ingres also drew a touching likeness of Paul Grand's first wife, Cornélie Bonnard (1800–1830), before their marriage, apparently commissioned by her guardian, Charles-Arnould Delorme (1765–1853).[4] Sadly, M. and Mme Grand were wed for fewer than six months before the young woman's untimely death in 1830. The following year Calamatta engraved a copy of Cornélie's portrait.

Yet another portrait by Ingres linked to that of Grand is a drawing of the wealthy speculator Delorme, dedicated to his ward, Mme Cornélie Grand, and dated June 20, 1830.[5] Naef quite plausibly suggests that it may have been produced as a wedding present. CI

NOTES

1. Information credited to Lapauze by Naef 1977–80, vol. 5, p. 194 no. 352.
2. *Le bulletin de l'art ancien et moderne*, June 25, 1921, p. 95.
3. Naef 1977–80, vol. 2, p. 574.
4. Ibid., pp. 114–15 no. 310.
5. Ibid., pp. 152–53 no. 329; see also ibid., vol. 2, chap. 132, especially pp. 578–79.

87. *The Architect Charles-Victor Famin*

Graphite on wove paper, 8¾ × 7 in. (22.3 × 17.7 cm).
Signed, inscribed, and dated in graphite at lower right: Ingres Del. / Roma 1836. On the back of the mount, etiquette outlined in blue: Nicole / M. Savary.

PROVENANCE
The subject, Charles-Victor Famin, Chartres (until his d. 1910); his son, Pierre-Paul Famin, Paris (until his d. 1922); his wife, Mme Famin; her daughter, Mlle Nicole Famin; private collection; [Wildenstein, New York, 1989; sold to Wrightsman]; Mrs. Charles Wrightsman, New York (from 1989).

EXHIBITED
Wildenstein, New York, March–August 1984, "Masterworks on Paper" (no catalogue).

LITERATURE
Henri Delaborde, *Ingres: Sa vie, ses travaux, sa doctrine, d'après les notes manuscrites et les lettres du maître* (Paris, 1870), p. 295 no. 292; Henry Jouin, *Musée de portraits d'artistes . . . nés en France ou y ayant vécu* (Paris, 1888), p. 67; Hans Naef, "Eighteen Portrait Drawings by Ingres," *Master Drawings* 4 (1966), pp. 268–69, 279 n. 48, 282 no. 11, pl. 10; Hans Naef, "The Sculptor Dupaty and the Painter Dejuinne: Two Unpublished Portraits by Ingres," *Master Drawings* 13 (autumn 1975), p. 269 and p. 268, fig. 3; Naef 1977–80, vol. 5, pp. 224–25 no. 367, and vol. 3, chap. 154, pp. 235–39 (also see vol. 2, p. 357 n. 1; vol. 3, pp. 179, 181; vol. 5, p. 200 under no. 355).

A year or so after he returned to Rome to assume the directorship of the French Academy at the Villa Medici, Ingres found occasion to draw the portrait of a newly arrived pensioner, Charles-Victor Famin (1809–1910). The sitter was the son of Auguste-Pierre-Sainte-Marie Famin, winner of the Grand Prix de Rome for architecture in 1801, the same year that Ingres won the prize for painting. It was probably out of friendship for his former colleague that Ingres drew a portrait of the son who followed in his father's footsteps, not long after the young man arrived in Italy.[1]

Ingres remembered having drawn about twenty portraits during the six years he was the academy's director in Rome, between 1835 and 1841.[2] The drawings were largely portraits of friends and colleagues at the academy, people who were close to him, rather than officials or passing tourists like those on whom his living had depended in earlier days. This time, he declared, he "came to Rome in search of an artist's peace and quiet."[3] Thus, freed from the strains of commercial portraiture, he now drew likenesses unembellished by artifice.

His drawing of Famin is a fairly casual, caught-in-the-moment study that shows us a restless lad seated uncomfortably, clasping a drafting pencil, ready to bolt. Perhaps in the fellow's necktie, rakishly askew, Ingres saw the future. A year later, in 1837, and again in 1840, Ingres sent to the Académie des Beaux-Arts in Paris disparaging reports of the young man he sized up as "definitely an idler . . . who failed to fulfill his obligations."[4] Ingres was probably relieved when this student soon departed on an extended tour of Egypt and then returned to Paris.

Naef tells us that, as an architect, Charles-Victor Famin enjoyed far fewer successes than did his father. His career is distinguished only by his Prix de Rome project for a medical school and the designs for a few private houses in Paris. After inheriting his father's wealth, he retired at the age of fifty-two and lived to celebrate his one hundredth birthday.

CI

NOTES

1. In 1834 Ingres drew a portrait of the sitter's uncle, his friend the painter François-Louis Dejuinne (1784–1844), with whom he had spent time in Italy. See Hans Naef, "The Sculptor Dupaty and the Painter Dejuinne: Two Unpublished Portraits by Ingres," *Master Drawings* 13 (autumn 1975), pp. 261–74. The drawing under discussion here is reproduced on p. 268, fig. 3.
2. Ingres's Cahier X, fol. 25, where he noted "portraits dessinés, une vingtaine," is quoted in Hans Naef, "Eighteen Portrait Drawings by Ingres," in *Master Drawings* 4 (1966), p. 268.

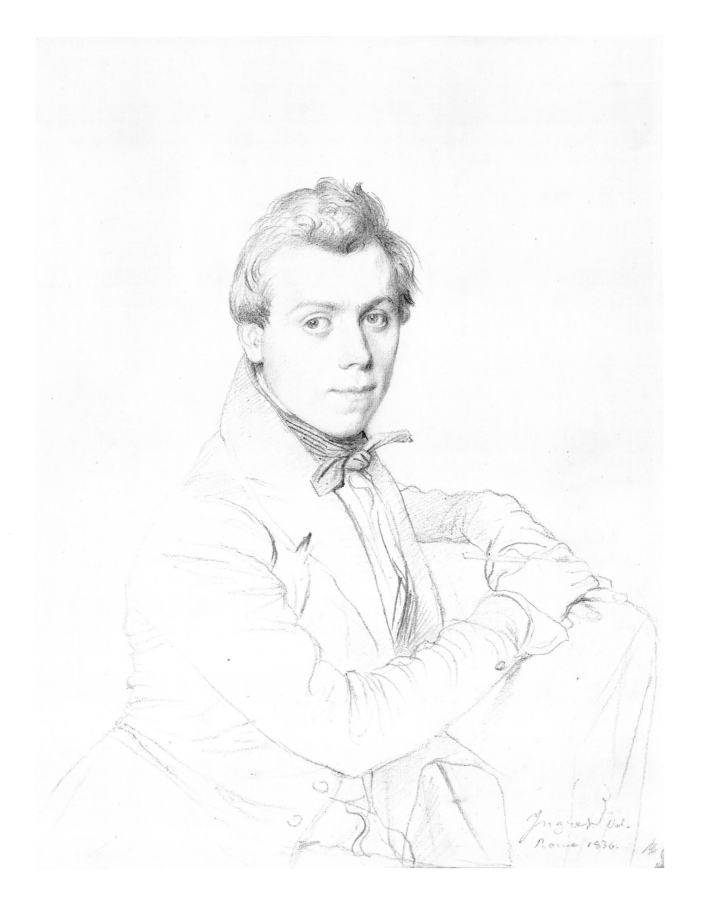

3. "Me violà donc, moi qui suis venu à Rome pour chercher un repos d'artiste." Ingres to Gatteaux, November 24, 1835, quoted in Henri Delaborde, *Ingres: Sa vie, ses travaux, sa doctrine, d'après les notes manuscrites et les lettres du maître* (Paris, 1870), pp. 336–37.

4. Comments recorded in the annals of the academy, quoted in Henry Lapauze, *Histoire de l'Académie de France à Rome* (Paris, 1924), vol. 2, p. 253: "décidément trop flâneur . . . qui [n'a] pas rempli [ses] obligations."

88. *Armand Bertin*

Graphite on wove paper, 12⅜ × 9 in. (31.2 × 22.8 cm)
Signed and dedicated in graphite at lower right: Ingres Del. /
à Madame / Armand Bertin. / 1842.

PROVENANCE
Mme Armand Bertin (*née* Marie-Anne-Cécile Dollfus), the sitter's wife, Paris (until her d. 1853); her widower, Armand Bertin, Paris (until his d. 1854); his daughter, Mme Jules Bapst (*née* Sophie Bertin), Paris (until her d. 1893); her daughter, Mme Georges Patinot (*née* Cécile Bapst), Paris (until her d. 1917); her daughter, Mlle Suzanne Patinot, Paris (until her d. 1969); M. and Mme Jean-Claude Delafon, Paris; [Marc Blondeau, Paris, until 1988; sold to Wrightsman]; Mrs. Charles Wrightsman, New York (from 1988).

EXHIBITED
Galerie André Weil, Paris, June 2–25, 1949, "Ingres," no. 69.

LITERATURE
Max Dollfus, *Histoire et généalogie de la famille Dollfus de Mulhouse, 1450–1908* (Mulhouse, 1909), ill. between pp. 352–53; Alfred Pereire, ed., *Le journal des débats politiques et littéraires, 1814–1914* (Paris, 1914), p. XVIII, ill. opposite p. 104; Daniel Ternois, *Les dessins d'Ingres au Musée de Montauban: Les portraits,* Inventaire général des dessins des musées de province, vol. 3 (Paris, 1959), p. [10]; Hans Naef, "Eighteen Portrait Drawings by Ingres," *Master Drawings* 4 (1966), pp. 269, 282 no. 13, pl. 12; Naef 1977–80, vol. 5, pp. 270–71 no. 391, and vol. 3, chap. 143, pp. 129–33; London, Washington, New York 1999–2000, p. 320, fig. 184.

RELATED DRAWING
Mme Armand Bertin (cat. 89).

Armand Bertin's resemblance to his father, Louis-François Bertin (1766–1841), the powerful newspaper publisher and Ingres's most famous sitter, is unmistakable. The monumental 1832 painting of the elder Bertin, which hangs in the Louvre to symbolize the post-Revolution enthronement of the bourgeoisie, presents a similarly portly figure with a round face draped in jowls.

Ingres drew an equally imposing portrait of Mme Bertin (Naef 342), his frequent hostess at the family estate Les Roches in Bièvres, two years after completing portraits of her husband in

graphite and oil. At the same time, he seems also to have drawn the Bertins' daughter Louise, an aspiring poet and opera composer.[1] But not until he returned to Paris after his six-year term as the academy director in Rome did he direct his attention to other members of the family, drawing their son Armand (1801–1854) and his wife Cécile (cat. 89). Unfortunately, to date no portrait has come to light of an older son, Édouard-François (1797–1871), a landscape painter who studied with Ingres in the late 1820s and may have been responsible for the teacher's introduction to the Bertin family.

The portrait drawings of M. and Mme Armand Bertin did not enter the Ingres literature until 1966, with their discovery by Hans Naef in a published history of the Dollfus family.[2] Surely they are the most attractive and sympathetically rendered couple portrayed by Ingres in the years of his maturity and stand as testimony to the enduring warmth of his relationship with the Bertin clan, to whose personal life he was often a witness. Delaborde maintained that it was during a political discussion between Bertin *père* and his two sons that Ingres observed the master of the house strike the resolute hands-on-thighs posture that later became a driving force in his intimidating portrait.[3]

Bertin *fils,* in a drawing dedicated to his wife and executed a decade after that of his father, offers a more agreeable presence. His face is pleasantly arranged to speak, while one hand clasps his walking stick, the other the brim of his hat. With his father's powerful legs and the broad Bertin stance, he appears ready to take the top chair at the *Journal des débats,* as indeed he did before the older man's death.

Armand Bertin deserves note also as a patron of the arts, capable of straddling the divide between Classicism and Romanticism. He commissioned works from Ingres's pupils and, from an early age, remained close to Eugène Delacroix (see p. 334).

CI

NOTES

1. The portrait of Louise Bertin (1805–1877), dated about 1834 by Naef, is known only from an engraved reproduction by A. Delvaux. See Hans Naef, "Eighteen Portrait Drawings by Ingres," *Master Drawings* 4 (1966), pp. 269–70, fig. 5.

2. Max Dollfus, *Histoire et généalogie de la famille Dollfus de Mulhouse, 1450–1908* (Mulhouse, 1909), pp. 352–53; see Hans Naef, "Eighteen Portrait Drawings," p. 269.

3. Henri Delaborde, *Ingres: Sa vie, ses travaux, sa doctrine, d'après les notes manuscrites et les lettres du maître* (Paris, 1870), pp. 245–46 no. 108, quoted in translation in London, Washington, New York 1999–2000, pp. 302–3.

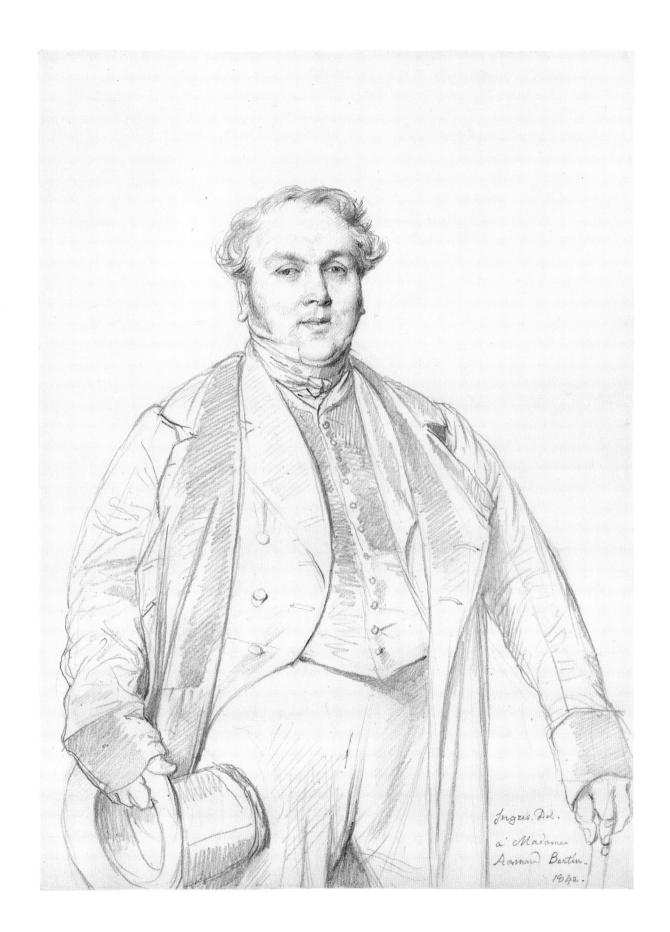

Ingres. del.
à Madame
Armand Bertin.
1842.

89. Madame Armand Bertin, née Marie-Anne-Cécile Dollfus

Graphite on wove paper, 13⅝ × 10¼ in. (34.5 × 26 cm)
Signed and dedicated at lower left: Ingres Del. / à Monsieur /
Armand Bertin. / 1843.

PROVENANCE
Armand Bertin, the sitter's husband, Paris (until his d. 1854); his daughter,
Mme Jules Bapst (*née* Sophie Bertin), Paris (until her d. 1893); her daughter,
Mme Georges Patinot (*née* Cécile Bapst), Paris (until her d. 1917); her daugh-
ter, Mlle Suzanne Patinot, Paris (until her d. 1969); M. and Mme Jean-Claude
Delafon, Paris; [Marc Blondeau, Paris, until 1988; sold to Wrightsman]; Mrs.
Charles Wrightsman, New York (from 1988).

EXHIBITED
Galerie André Weil, Paris, June 2–25, 1949, "Ingres," no. 68.

LITERATURE
André Gide, "Promenade au Salon d'Automne," *Gazette des beaux-arts,* 3rd
ser., 34 (December 1, 1905), ill. opposite p. 476; Max Dollfus, *Histoire et généalo-
gie de la famille Dollfus de Mulhouse, 1450–1908* (Mulhouse, 1909), ill. between
pp. 352–53; Daniel Ternois, *Les dessins d'Ingres au Musée de Montauban: Les por-
traits,* Inventaire général des dessins des musées de province, vol. 3 (Paris,
1959), p. [10]; Hans Naef, "Eighteen Portrait Drawings by Ingres," *Master
Drawings* 4 (1966), pp. 269, 282 no. 14, pl. 13; Naef 1977–80, vol. 5, pp. 272–73
no. 392, and vol. 3, chap. 143, pp. 133–35; London, Washington, New York
1999–2000, p. 320, fig. 183.

RELATED DRAWING
Monsieur Armand Bertin (cat. 88).

Cécile Bertin (1806–1853) appears to have been on very pleasant
terms with the artist who earlier had executed portraits of her
husband and his family (see cat. 88). Ingres had also drawn a like-
ness of her mother, Madame Jean-Jacques Dollfus, probably com-
missioned by her father, an Alsatian manufacturer, to whom it
was dedicated.[1]

M. and Mme Armand Bertin met and, in 1826, married in
Bièvres, where Cécile's father was a municipal consul and where
the Bertin family maintained an estate. Ingres began to visit there
regularly in 1832, when he was commissioned to paint Cécile's
father-in-law, Louis-François Bertin, publisher of the influential
Journal des débats. A decade later, returned from his post at the

Villa Medici in Italy, Ingres drew portraits first of Armand, in 1842,
and then of his wife, in 1843. Each portrait bears a dedication to
the sitter's spouse.

Although the later drawing was done on a slightly larger sheet
of paper, the two likenesses can be paired together gracefully, for
they are drawn with equal sensitivity and charming candor, no
doubt borne of the sitters' long acquaintance with the artist.
Cécile's gentle smile and steady gaze are flanked by tubular curls
the artist seems to have pulled forward deliberately to frame the
woman's face. Her relaxed posture, hands softly crossed, is par-
ticularly convincing.

Mme Armand Bertin was the mother of two daughters, born
in 1836 and 1839, whom she failed to see reach maturity, for she
died in 1853 at the age of forty-seven. At her death, Victor Hugo
sent soothing, appreciative words to the widowed husband, who
survived his wife by only a year.[2]

CI

NOTES

1. Mme Jean-Jacques Dollfus (née Sophie-Cécile Gontard; 1773–1861); Naef
 1977–80, vol. 5, pp. 266–67 no. 389. The drawing is now in the Musée
 Bonnat, Bayonne.
2. "Nous aimions tant votre jeune et charmante femme! Elle va manquer à
 la fois à toutes nos familles. C'est encore une douce figure de notre passé
 qui s'en va." Quoted in Naef 1977–80, vol. 3, p. 135.

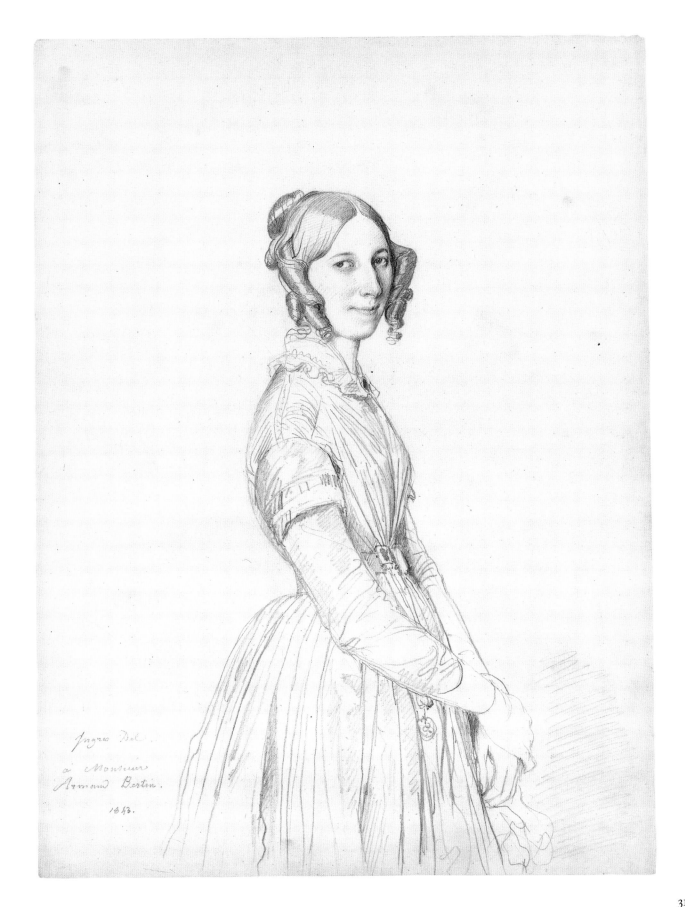

Ingres Del.
à Monsieur
Armand Bertin.
1843.

319

90. *Henri Lehmann*

Graphite on wove paper, 12½ × 9⅜ in. (31.7 × 23.8 cm)
Signed, dedicated, and dated in graphite at lower left: Ingres Del.—/
à son ami et / Eleve Henry / Lehmann. / 6 mai / 1850.
The edges of the wove paper sheet, trimmed diagonally at each
corner, have been released from the prepared tablet about which
they had been folded and glued at the time of the drawing's making.

PROVENANCE
The sitter, Henri Lehman (until his d. 1882); his widow, Mme Henri
Lehmann, *née* Louise-Alexandrine Casadavant (until her d. 1893); her
daughter Mme Antoine-Edmond-Jean Joubert, *née* Marie-Jeanne-Michel
Oppenheimer, Paris (until her d. 1910); her daughter [Gräfin] François de
Hautecloque, *née* Françoise Joubert (sale, Galerie Charpentier, Paris, April 6,
1954, lot 12, to Jacques Dubourg, for Fr 460,000); private collection, 1976;
[Walter Feilchenfeldt, Zurich, 1990; sold to Wrightsman]; Mrs. Charles
Wrightsman, New York (from 1990).

EXHIBITED
École des Beaux-Arts, Paris, 1867, "Ingres," no. 369.

LITERATURE
Charles Blanc, *Ingres: Sa vie et ses ouvrages* (Paris, 1870), p. 238; Henri
Delaborde, *Ingres: Sa vie, ses travaux, sa doctrine, d'après les notes manuscrites
et les lettres du maître* (Paris, 1870), p. 304 no. 350; Henry Jouin, *Musée de por-
traits d'artistes . . . nés en France ou y ayant vécu* (Paris, 1888), p. 113; Henry
Lapauze, *Les dessins de J.-A.-D. Ingres du Musée de Montauban* (Paris, 1901), pp. 249,
267; Solange Joubert, ed., *Une correspondance romantique: Madame d'Agoult, Liszt,
Henri Lehmann* (Paris, 1947), ill. opposite p. 110; John Lehmann, *Ancestors and
Friends* (London, 1962), pl. 1 facing p. 48; Hans Naef, "Ingres und der Maler
Henri Lehmann," *Neue Zürcher Zeitung,* October 29, 1967, suppl., pp. 6–7, ill.;
Schleswig-Holsteinisches biographisches Lexikon, vol. 1 (Neumünster, 1970), p. 182;
Naef 1977–80, vol. 5, pp. 316–17 no. 416, and vol. 3, chap. 175, pp. 431–45.

COPY
Etched copy by Marie-François Dien (1787–1865), ca. 1850.

This casual but knowing study of one of his favorite pupils, the
German-born Henri Lehmann (1814–1882), admirably demonstrates
the extent to which Ingres, even at the age of seventy, retained his
remarkable facility as a portrait draftsman. And, although he
claimed his heart was not much in it, preferring as he did pictur-
ing history and allegory, the artist remained in great demand as a
portrait painter; in the final decades of his life he produced some
of his most lavish and stirring likenesses, including those of the
comtesse d'Haussonville (1845; Frick Collection, New York),
Madame Moitessier (1851; National Gallery of Art, Washington,
D.C.), and the princesse de Broglie (1853; Metropolitan Museum,
Robert Lehman Collection, New York).

In the singular instance of the portrait of Luigi Cherubini (1760–
1842), which was presented to the composer in 1841, Ingres evi-
dently collaborated with young Lehmann as his assistant. The pic-
ture had been begun in Paris in 1834 and then was sent along to
Rome after Ingres assumed directorship of the French Academy.
Like the Flandrins, Desgoffe, Chassériau, and other pupils of
Ingres, Lehmann too found his way to the master's side at the
Villa Medici. In a letter (October 24, 1840) to his confidant Marie
d'Agoult, he boasted of his commission to aid in the overdue por-
trait's completion: "I am also working for M. Ingres, which you
must not repeat, since he intends to pass off what I am doing for
him as his own work, after touching it up, of course."[1]

Lehmann was himself a portraitist of merit and, having made
his way into the best circles of Parisian society, could count
Stendhal, Chopin, and Franz Liszt among his subjects. His great-
est strengths, however, lay in the delineation of energetically
posed figures. At the time of his portrayal by Ingres in 1850,
Lehmann was gaining the recognition that brought him commis-
sions in Paris for large-scale mural compositions for the Hôtel de
Ville (1852), the church of Sainte-Clotilde (1854), and the Palais de
Luxembourg (1854–56). Now, more a close friend than a pupil,
Lehmann could count on Ingres's professional support as well as
the personal affection that shapes so striking and sympathetic a
portrait. Indeed, in 1846 the master demonstrated his extraordi-
nary regard for his student by challenging to a duel an unfeeling
critic of the young painter's work. He asked Lehmann to serve as
his second, but fortunately for both artists the matter was other-
wise settled.

After Ingres's death in 1867, a great posthumous exhibition was
organized by the artist's followers, Édouard Gatteaux (1788–1881),
Jacques-Ignace Hittorf (1792–1867), and Lehmann at the École des
Beaux-Arts, where the last had just become a professor. It was the
first exhibition to feature Ingres's drawings as prominently as his
paintings. This work was among those shown.

CI

NOTE

1. Quoted in the catalogue entry on the Cherubini portrait by Gary
 Tinterow, in London, Washington, New York 1999–2000, pp. 380, 384 n. 13.

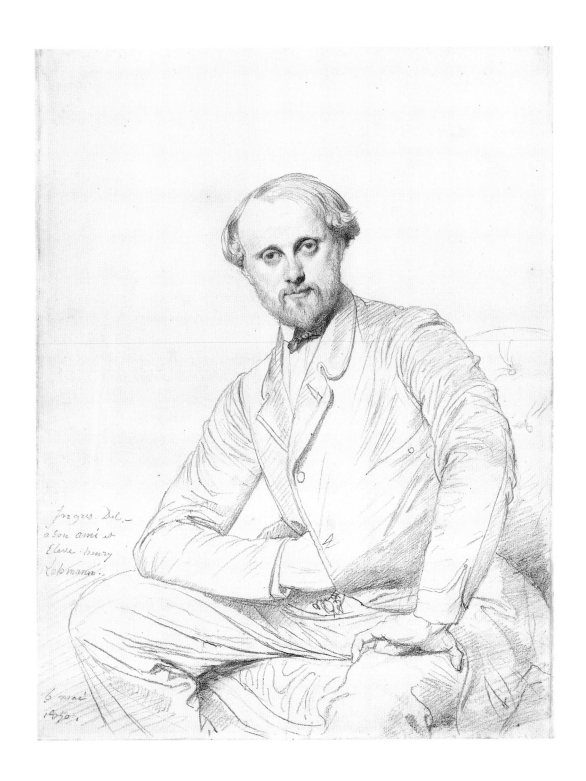

Ingres. Del.
a son ami et
Elève henry
Lehmann.

6 mai
1850.

JEAN ALAUX

(1785–1864)

A native of Bordeaux, where he received his initial training, Jean Alaux entered the studio of François-André Vincent (1746–1816) in Paris in 1807; later he studied with Pierre-Narcisse Guérin (1774–1833). He won the Prix de Rome in 1815, which enabled him to spend the years 1816–20 as a pensionnaire *of the Académie de France at the Villa Medici (where he befriended Ingres, who made two portraits of him); he remained in Italy for the most part until 1824. Although he was attracted to the genre of landscape, producing portfolios of lithographs and contributing to Baron Taylor's* Voyages pittoresques *(a survey of old French monuments, customs, and folklore published in twenty-four volumes between 1820 and 1878), Alaux became better known for his historical and allegorical scenes. Achieving official success at the Salon of 1824, he subsequently executed numerous commissions for the Louvre, Versailles, and Fontainebleau. Louis-Philippe (r. 1830–48) named him court painter, and he served as director of the academy in Rome from 1847 to 1852.* GT/AEM

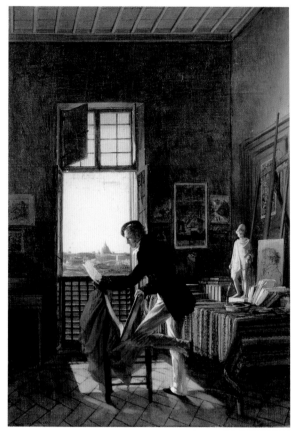

Fig. 1. Jean Alaux, *Picot in His Studio at the Villa Medici*, 1817. Oil on canvas, 19⅞ × 14 in. (50.5 × 35.5 cm). Private collection, France

91. *Louis-Vincent-Léon Pallière in His Room at the Villa Medici, Rome*

Oil on paper, laid on canvas, 22¾ × 17¾ in. (57.8 × 45.1 cm)
Signed and dated at lower left: J. alaux / Roma / 1817.

PROVENANCE
Presumably Léon Pallière, Rome (until d. 1820); his widow, *née* Françoise-Virginie Liégois, later Mme Jean Alaux, from 1827 (1820– her d. 1880); sale, Sotheby's, New York, January 24, 2002, lot 91, for $511,750, to Hazlitt; [Hazlitt, Gooden & Fox, London, 2002; sold to Wrightsman]; Mrs. Charles Wrightsman, New York (from 2002).

LITERATURE
Sotheby's, Paris, sale cat., June 27, 2002, under lot 119; Olivier Bonfait, ed., *Maestà di Roma, da Napoleone all'unità d'Italia, d'Ingres à Degas: Les artistes français à Rome*, exh. cat., Académie de France, Rome (Rome and Milan, 2003), pp. 219, fig. 50a, 372 under no. 51, 415–16 n. 2 under no. 50, 523 under no. 134; Chiara Stefani, in André Cariou et al., *"La nature l'avait créé peintre": Pierre-Henri de Valenciennes, 1750–1819*, exh. cat., Musée Paul-Dupuy, Toulouse (Paris, 2003), pp. 211–13, fig. 4 (color), 217 n. 43; Thomas Le Claire Kunsthandel, *Master Drawings, Recent Acquisitions: A Review of the Years 1982–2002* (Hamburg, 2003), caption to fig. 5 under no. 27 (another painting erroneously ill.).

Like his friend and fellow Prix de Rome–winner Ingres, Jean Alaux made numerous portraits of his colleagues during his stint as a *pensionnaire* at the Villa Medici in the years 1815 to 1820. Three of Alaux's portraits are especially distinctive in that they show the young artists in their quarters, with all the appurtenances of their evocatively bohemian lives; this format would quickly be followed by his friend Cogniet (see below) and by later residents of the Villa Medici, such as Horace Vernet (see p. 326). The Wrightsman painting shows Louis-Vincent-Léon Pallière (1787–1820; Prix de Rome, 1812) playing a guitar in his bedroom. A slightly smaller portrait in a French private collection shows

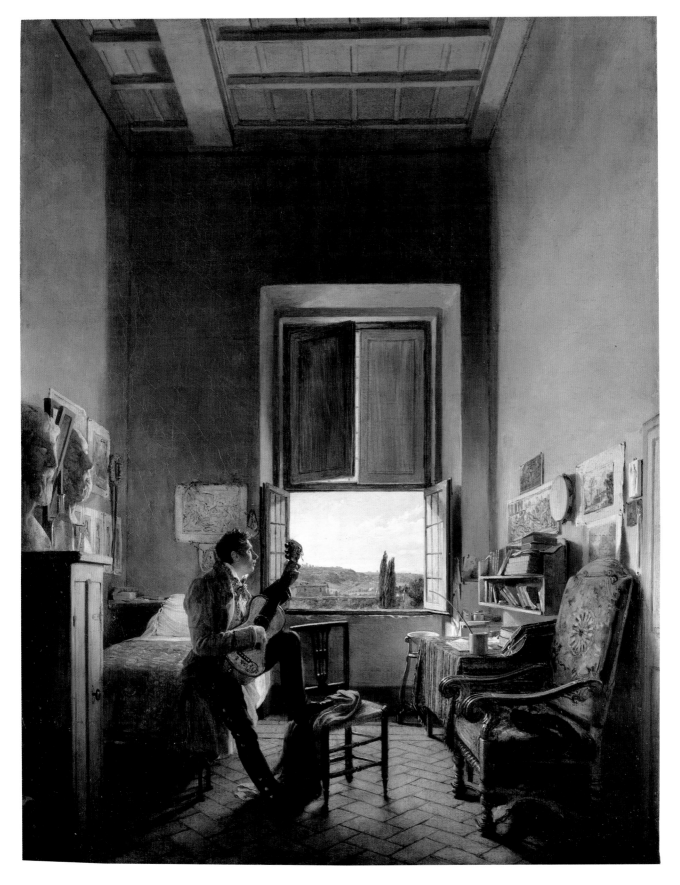

Fig. 2. Jean Alaux, *The Ingres Studio in Rome,* 1818. Oil on canvas, 21 ⅞ × 18 ⅛ in. (55.5 × 46 cm). Musée Ingres, Montauban (50.545)

Fig. 3. Léon Cogniet, *Self-Portrait in the Artist's Studio at the Villa Medici,* 1818. Oil on canvas, 17 ½ × 14 ⅝ in. (44.5 × 37 cm). Cleveland Museum of Art, Mr. and Mrs. William H. Marlatt Fund (1978.51)

François-Édouard Picot (1786–1868; Prix de Rome, 1813) in his studio (fig. 1). Both pictures are dated 1817. The third likeness in this group depicts Ingres, a former *pensionnaire,* with his new wife in his apartment in the via Margutta, not far from the Villa Medici: it exists in two versions, one, dated 1818, in the Musée Ingres, Montauban (fig. 2), the other, presumably made about the same date, currently with the dealer Hazlitt, Gooden & Fox, London (2004). The version now in Montauban was probably given to Ingres by the artist in exchange for Ingres's portrait drawing of Alaux (private collection).[1]

It seems likely that the Picot and Pallière portraits were also gifts from Alaux to the respective sitters and that they descended through their families (the former was first published in 1980, and the present painting resurfaced at Sotheby's, New York, in 2002). If this presumption is correct, then the Wrightsman painting may have returned to Alaux in 1827, when he married Pallière's widow; the two painters had known each other since their youth in Bordeaux.[2]

In his illuminating study of the Picot portrait, Paul Lang was able to identify a number of the artist's works hanging in the room. In addition, he suggests that the sheet of paper the artist is shown examining may be a drawing of the view seen through the open window.[3] Although none of the works in the Pallière portrait have been identified, we can discern some academies on the left wall and a Madonna and child to the left of the window. Indeed, the multifigured compositions visible on the walls are evocative of some of Pallière's history paintings, such as his 1812 winner of the Prix de Rome, *Ulysses and Telemachus Slaying Penelope's Suitors* (École Nationale Supérieure des Beaux-Arts, Paris), or his submission to the Salon of 1819, *Tobias Restoring Sight to His Father* (Musée des Beaux-Arts, Bordeaux).

Pallière—like Alaux, Picot, Henri-Joseph de Forestier (1790–1868), and Jean-Baptiste-Antoine Thomas (1791–1834), who also competed for the Rome prize in 1812—had been a student in Vincent's popular atelier; he and his compatriots all found them-

selves at the Villa Medici by 1816. To this group of friends may be added Jean-Victor Schnetz (1787–1870), Jean-Baptiste Vinchon (1787–1855), and Léon Cogniet (1794–1886; Prix de Rome, 1817), all *pensionnaires* during the period marked by the collapse of Napoleon's empire. Géricault (see p. 330) frequented this group during his stay in Rome in 1816–17, although his trip to Italy was privately financed. Pallière's *pensionnat* should have lasted from 1812 to 1816, but he was granted an additional year by the new director of the French Academy in Rome, Jean-Charles Thévenin (1764–1838),[4] so that he could continue to work on the *Flagellation of Christ,* part of the redecoration, sponsored by the duc du Blacas, of Santa Trinità dei Monti, the French church at the top of the Spanish Steps, adjacent to the Villa Medici.

Perhaps the most immediate impact of Alaux's portraits can be seen in Cogniet's self-portrait in his room at the Villa Medici, now in the Cleveland Museum of Art (fig. 3). Until recently this work was thought to have been executed in 1817, based on an inscription on the stretcher: "ma chambre à la réception de ma première lettre de ma famille 1817." But as Mehdi Korchane recently observed, while Cogniet may have had a letter waiting for him when he arrived at the Villa Medici on December 24, 1817, it is unlikely that the picture itself was completed in the following week.[5] Hence the Cogniet portrait probably dates to 1818, that is, after the Wrightsman painting, which Cogniet undoubtedly saw in Pallière's studio.

The emergence of these paintings as a group contributes to our appreciation of the physical circumstances of the lives of French artists working in Italy in the early nineteenth century. The expressive potential of a portrait in an interior with a view through a window to a landscape beyond was first examined in a 1955 article by the Géricault scholar Lorenz Eitner, who believed that "these pictures belong to the vanguard of the anticlassical movement, yet they are not pointedly romantic." Eitner further observes that one "distinctive innovation" is the artists' "attention on the view *through* [emphasis in the original] the window into a distance far beyond," concluding that "a fragment of reality becomes the expression of a romantic attitude" where "nature appears as a lure" in "the vague poetry of longing and frustrated desire" which the open window expresses.[6]

The neat harmony that exists between the three main elements of the Wrightsman picture—portrait, interior, and view through the window—underscores the painting's connection to the increasingly popular *plein-airisme,* the practice of landscape sketching out-of-doors. In 1819 Alaux and Cogniet joined Achille Etna Michallon (1796–1822; Prix de Rome, 1817), future teacher of Corot, for a sketching trip to Naples and surrounding locales including Vesuvius, Paestum, Castellammare, Pompeii, Ischia, and Capri.

GT/AEM

NOTES

1. Hans Naef, *Die Bildniszeichnungen von J.-A.-D. Ingres,* 5 vols. (Bern, 1977–80), vol. 4, pp. 424–25 no. 226, ill.
2. Ibid., vol. 2, p. 283.
3. Paul Lang, in *Regards sur Amour et Psyché à l'âge néo-classique,* exh. cat., Musée de Carouge and Kunsthaus Zurich (Zurich, 1994), pp. 48–50 no. 7. See also Vincent Pomarède, in *Paysages d'Italie: Les peintres du plein air, 1780–1830,* exh. cat., Galeries Nationales du Grand Palais, Paris, and Centro Internazionale d'Arte e di Cultura di Palazzo Te, Mantua (Paris and Mantua, 2001), p. 17 no. 7.
4. See Henry Lapauze, *Histoire de l'Académie de France à Rome* (Paris, 1924), vol. 2, p. 130.
5. Mehdi Korchane, in Olivier Bonfait, ed., *Maestà di Roma, da Napoleone all'unità d'Italia, d'Ingres à Degas: Les artistes français à Rome,* exh. cat., Académie de France, Rome (Rome and Milan, 2003), pp. 415–16 under no. 50.
6. Lorenz Eitner, "The Open Window and the Storm-Tossed Boat: An Essay in the Iconography of Romanticism," *Art Bulletin* 37 (December 1955), pp. 284–85, 289.

ÉMILE-JEAN-HORACE VERNET

(1789–1863)

Horace Vernet was one of the preeminent painters of his time, equally adept at historical subjects (especially military scenes), Orientalist themes, and portraits. The scion of a distinguished family of French artists, he was literally born in the Louvre (in his father's lodgings there). His grandfathers were the landscape and marine painter Claude-Joseph Vernet (1714–1789) and the engraver Jean-Michel Moreau (1741–1814). His father, who gave him his first lessons, was Carle Antoine-Charles-Joseph Vernet (1758–1836), painter and lithographer of battles and horses, as well as the author of the print series Incroyables et merveilleuses (1797). Horace received formal training in the studio of François-André Vincent (1746–1816), until he competed unsuccessfully for the Prix de Rome in 1810. In 1811 he married Louise de Pujol (the Vernets's daughter Louise would marry the painter Paul Delaroche). Acclaim for La Prise d'un camp retranché de Glatz, en Silésie, one of his entries in his first Salon, in 1812, was rewarded by a commission from Jérôme Bonaparte for an equestrian portrait.

In 1814 Vernet was awarded the Legion of Honor for his role in the defense of Paris, an event commemorated in his 1820 painting Clichy Gate: The Defense of Paris, 30 March 1814 (Musée du Louvre, RF 126). The refusal of this picture and of the 1821 Battle of Jemmapes, 1792 (National Gallery, London, NG2963) by the Royalist jury for the 1822 Salon led Vernet to withdraw all his entries that year and to hold a private exhibition (an exception was made for a royal commission depicting his grandfather, Joseph Vernet Attached to the Mast Painting a Storm [Musée Calvet, Avignon]). The private exhibition was a success, commercially and critically; it provided a model used by later painters, among them Courbet and Manet. Despite his reputation as a liberal, nostalgic for Napoleonic empire, Vernet thrived under each successive regime for the remainder of his life. He was made an officer of the Legion of Honor in 1824 and elected to the Institut de France in 1826. A favorite of the duc d'Orléans, the future King Louis-Philippe, he was named director of the Académie de France in Rome from 1828 to 1834 (following Guérin and preceding Ingres), and he was appointed to a lifelong position as professor at the École des Beaux-Arts in 1835. At the Exposition Universelle of 1855 in Paris Vernet was one of the four French artists honored with a retrospective, along with Ingres (see p. 292), Delacroix (see p. 334), and (inexplicably) Alexandre-Gabriel Decamps (1803–1860). He was

promoted to Grand Officier of the Legion of Honor by Napoleon III in 1858.

It is likely that Horace Vernet met Géricault (see p. 330), two years his junior, when the latter was a student of Carle Vernet in 1808–10. The art historian Lorenz Eitner credits Carle with introducing Géricault to a "vernacular tradition that had its sources in the Netherlands and England, rather than in Hellas or the Academy,"[1] which applies equally to the young Horace. Yet a major source of at least one strand of this tradition, especially in England, actually emanated from Horace's grandfather Claude-Joseph Vernet (whose wife, née Virginia Parker, happened to be English): he counseled numerous English painters schooled in topographical landscape to draw and to paint directly from nature, especially during his extended Roman sojourn (1734–53), and English amateurs aggressively collected his views. Such innovative practitioners as Alexander Cozens (1717–1786), Richard Wilson (1713/14–1782), and Joshua Reynolds (1723–1792) received his encouragement, and Thomas Jones (1742–1803) also admired his pictures, albeit in England.[2]

Vernet and Géricault, together with Jean-Marie-Emmanuel Pujol, called Jamville (b. 1791), finally struck out together for a brief excursion to England in March 1819 to make the acquaintance of artists there.[3] Thus, when Géricault wrote the following to Horace from London during his third trip to England, on May 6, 1821, he was not only alluding to the mania for all things British that resulted from renewed contact following the downfall of Napoleon's empire, but to a privately shared concept of longer standing: "The only thing your talent lacks is to be steeped in the English School . . . color and effect are understood and felt only here. Each school has its own character. If we were to succeed in uniting all their qualities, would we not attain perfection?"[4]

Horace Vernet was the first French artist to illustrate the poems of the British poet Lord Byron. His lithographs The Drowning of Don Juan and The Corsair appeared in 1819;[5] the latter subject was reprised in his 1824 painting Conrad the Corsair (Wallace Collection, London, P368). Another Vernet painting in the Wallace Collection, Allan M'Aulay (1823; P606), which depicts a figure taken from Walter Scott's Legend of Montrose (1819), was exhibited at "the British Salon" of 1824 (no. 1715). Vernet's English subjects are often thinly veiled commentaries on French themes, as in the 1827 Edith Discovering the

Body of Harold after the Battle of Hastings *(Musée Thomas Henry, Cherbourg)*. However, the artist did not actually make an extended visit to London until after his private exhibition of 1822 had provided him with the necessary funds.[6]

GT / AEM

NOTES

1. Lorenz Eitner, *Géricault: His Life and Work* (London, 1983), pp. 14–16.

2. Philip Conisbee, *Claude-Joseph Vernet, 1714–1789,* exh. cat., Kenwood, London, and Musée de la Marine, Paris (London, 1976), introduction and under no. 14 (n.p.).

3. Pujol was Mme Vernet's brother; this trip has long been known by means of a brief account published in *Annals of the Fine Arts* [for the year 1819], vol. 4, no. 12 (1820), p. 157, and is elaborated by Christopher Sells, "New Light on Géricault: His Travels and His Friends, 1816–23," *Apollo* 123 (June 1986), pp. 391–92, 395 nn. 12, 15, 19.

4. Germain Bazin, *Théodore Géricault: Étude critique, documents et catalogue raisonné,* vol. 1 (Paris, 1987), pp. 63–64. Excerpt translated in Patrick Noon et al., *Crossing the Channel: British and French Painting in the Age of Romanticism,* Tate Britain, London, The Minneapolis Institute of Arts, and The Metropolitan Museum of Art, New York (London, 2003), p. 12.

5. Patrick Noon, in *Crossing the Channel,* p. 86 under no. 29.

6. Horace was accompanied by his father; see Sells, "New Light on Géricault," pp. 392–93, 395 n. 25.

92. *Portrait of the Widow Comtesse Jean-Henri Louis Greffulhe, née Marie-Françoise-Célestine de Vintimille du Luc, later Comtesse Philippe-Paul de Ségur (1787–1862), in a Landscape*

Oil on canvas, 18 × 15 ¼ in. (45.7 × 38.7 cm)
Signed and dated 1825.

PROVENANCE
Général comte Philippe-Paul de Ségur (perhaps commissioned by him, in 1825); by descent through the family of the sitter to Princess Antoine Radziwill (sold to Brame et Lorenceau); [Brame et Lorenceau, Paris, by 1990; sold to Hazlitt]; [Hazlitt, Gooden & Fox, London, November 1990–93; sold to Wrightsman]; Mrs. Charles Wrightsman, New York (from 1993).

This strange and evocative painting is emblematic of early Romantic portraiture, in which the landscape, rather than the figure, carries the emotional content of the picture. This particular landscape, furthermore, bears aspects of the eighteenth-century British concept of the Sublime, to which Horace Vernet's grandfather Claude-Joseph Vernet gave pictorial form, influencing a generation of English landscape painters. Horace Vernet was of course intimately familiar with his grandfather's art; however, he did not paint any portraits of this kind until after his second known trip to England in 1822.

Born into an ancient aristocratic family from Provence, Celéstine de Vintimille married Jean-Louis Greffulhe (1774–1820), the second son of a family of successful bankers, in 1811. Greffulhe's loyalty to the Royalist cause during the Hundred Days resulted in his being made a count and a peer of France by Louis XVIII in 1818. A close friend of the king's nephew, the duc du Berry, and his influential wife, Celéstine was one of the leading figures of Paris society in the early years of the Restoration. In February 1820 the Berrys attended a masqued ball at the Greffulhes's; the duke was assassinated the following week. Ten days later comte Greffulhe died, leaving his widow with three children, Charles, Henri, and Amélie. Perhaps through the auspices of her late husband's half-sister Cordelia, comtesse Esprit-Victor-

Élisabeth-Boniface de Castellane (1788–1882), on March 2, 1826, Celéstine remarried. Her new husband was général comte Philippe-Paul de Ségur (1780–1873), who, like herself, also came from old Provençal nobility.

It is possible that Vernet's portrait of Celéstine, the only known image of her, was commissioned by the comte de Ségur in 1825 to mark their forthcoming marriage. This could explain the white dress and Celéstine's calm demeanor as she awaits her fiancé's arrival on this forlorn, windswept shore of widowhood. Ségur was an ultra-Bonapartist who had served as an aide-de-camp to the emperor and who had just published his account of the military campaign of 1812:[1] in this respect he was ideally suited as a client of Vernet. Yet Vernet's appeal across a broad political spectrum cannot rule out another possibility for the commission: it may be that the Wrightsman painting was ordered by Celéstine's sister-in-law from her first marriage, the comtesse de Castellane. Although Celéstine's portrait is not listed in the artist's account book, there is an entry for a payment made by Castellane on April 21, 1824, for her own portrait (whereabouts unknown).[2]

GT/AEM

NOTES

1. *Histoire de Napoléon et de la grande armée pendant l'année 1812*, 2 vols. (Paris, 1825).

2. Vernet's 1824 portrait of the comtesse de Castellane, of which no reproduction is known, was exhibited in the retrospective held at the École Nationale Supérieure des Beaux-Arts, Paris, in 1916 (no. 280); the catalogue describes the sitter as "assise . . . de grandeur naturelle." See *Les Vernet: Exposition organisée au profit du monument à élever à Joseph, Carle, Horace Vernet dans les Jardins de l'Infante et au bénéfice de la Ligue des Enfants de France,* exh. cat., École Nationale Supérieure des Beaux-Arts, Paris (Paris, [1916]). Vernet evidently regarded the painting a considerable work, since he charged 5,000 francs, whereas for other portraits of this period he charged on average 1,500 francs, with the notable exception of 9,950 francs for the 1825 portrait of King Charles X. Vernet also painted portraits of three of the comtesse de Castellane's children, although only one of these is mentioned in the account book ("Août 1 à 16 [1824]. Portrait du jeune de Castellane . . . 1,000"); see Armand Dayot, *Les Vernet: Joseph—Carle—Horace* (Paris, 1898), pp. 169 (ill. of one of the children's portraits), 204–5. Incidentally, Cordelia de Castellane is also known through an 1834 drawing by Ingres (Hans Naef, *Die Bildniszeichnungen von J.-A.-D. Ingres*, 5 vols. [Bern, 1977–80], vol. 5, pp. 207–8 no. 358, and vol. 3, chap. 146, formerly in the collection of Gustav Stein, Bonn, d. 1979) and from an unsigned painting reproduced as the frontispiece to *Lettres de Chateaubriand à la comtesse de Castellane* (Paris, 1927).

JEAN-LOUIS-ANDRÉ-THÉODORE GÉRICAULT

(1791–1824)

Théodore Géricault enrolled in the studio of Pierre Guérin (1774–1833) for two years, 1810–11, encouraged by his first teacher, Carle Vernet (1758–1836). He quickly became dissatisfied with the strictures of Davidian Neoclassicism, however, and spent the next four years copying Renaissance and Baroque masterpieces, many the spoils of Napoleon's campaigns, at the Louvre. Although he exhibited at the Salon only three times, the paintings he submitted were remarkable enough to make a lasting impression on the entire nineteenth century: the Charging Chasseur *(1812, re-exhibited 1814), the* Wounded Cuirassier *(1814), and the* Raft of the Medusa *(1819, re-exhibited in 1824; all now in the Louvre). After the Hundred Days, an ill-fated affair with his uncle's second wife, and failure to attain the Prix de Rome, Géricault visited Italy on his own in 1816–17, studying both antique and Renaissance models and contemporary Roman life, investing the latter with the grand style and timelessness of the former, exemplified in his never-completed project,* Race of the Barberi Horses *(study, 1817; Walters Art Museum, Baltimore).*

At the 1819 Salon Géricault's enormous Raft of the Medusa *was perceived as an attack on Neoclassical conventions as well as a critical commentary of the fragile, newly installed Bourbon regime, and it was criticized on both counts. But in 1820–21 Géricault accompanied the painting to London, where it was displayed to enthusiastic, paying audiences who responded to the sensational scent of cannibalism, to the embarrassment of the French government, and to the evocation of the Sublime, essentially a British idea. While in England the artist returned to painting genre scenes, as he had in Italy, and to making lithographs of equestrian subjects. Having lived comfortably off an annuity from his mother's estate since 1808, Géricault in 1822 suffered a financial setback; rather than return to the Salon with another major picture, he made small-scale works for private collectors, hoping to cater to the tastes of the marketplace. During the final days of the disease that took his life at age thirty-three, Géricault rallied with studies for major projects, including the* Opening of the Doors of the Spanish Inquisition *and the* African Slave Trade, *but he died without completing them. Although Géricault sold few works during his lifetime, his reputation grew posthumously through the dispersal of his studio contents at auction and through the work of his disciple Delacroix (see p. 334). By mid-century he was considered one of the founders of French Romanticism.* GT

93. Horsewoman (Amazone montée sur un cheval pie bai)

Oil on canvas, 17 ½ × 13 ¾ in. (44.5 × 34.9 cm)

PROVENANCE

Achille Boucher (by 1850; his sale, "vente M. A. B.," Hôtel des Ventes Mobilières, Paris, April 19–20, 1850, lot 27); Paul van Cuyck (after 1850–by 1866; his estate sale, Hôtel Drouot, Paris, February 7–10, 1866, lot 19, for Fr 3,300); (Antoine?) Marmontel (after 1866–by 1868; his estate sale, Hôtel Drouot, Paris, May 11–14, 1868, lot 40, for Fr 4,050); Laurent-Richard (after 1868–by 1873; his sale, Hôtel Drouot, Paris, April 7, 1873, lot 34, ill. opp. with either reproductive engraving by Ch. Courtry or photograph, sold for Fr 11,800); [Durand-Ruel, Paris, 1873]; Salomon Goldschmidt (after 1873–by 1888; his estate sale, Galerie Georges Petit, Paris, May 17, 1888, lot 41, ill. opp. with engraving by R. Paul Huet, for Fr 8,500, to Fournier); Fournier (from 1888); M. and Mme Jean Stern (by 1924–at least 1953); Countess Sanjust di Teulada, Paris (in 1979); [Eugene V. Thaw, New York, 1982; sold to Wrightsman]; Mr. and Mrs. Charles Wrightsman, New York (1983–his d. 1986); Mrs. Wrightsman (from 1986).

EXHIBITED

Palais de la Présidence du Corps Législatif, Paris, 1874, "Exposition au profit des Alsaciens-Lorrains," no. 817; École des Beaux-Arts, Paris, 1885, "Portraits du siècle," no. 100; Hôtel Jean Charpentier, Paris, April 24–May 16, 1924, "Exposition d'oeuvres de Géricault, au profit de la Société 'La Sauvegarde de l'Art Français,'" no. 173 (as collection Jean Stern); Galerie de la Renaissance, Paris, June 1–30, 1928, "Portraits et figures de femmes: Ingres à Picasso . . . Exposition au bénéfice de la Société des Amis du Musée du Luxembourg"; Galerie Bernheim-Jeune, Paris, May 10–29, 1937, "Exposition Géricault, peintre et dessinateur (1791–1824), . . . organisée au bénéfice de la 'Sauvegarde de l'Art Français,'" no. 61 (as collection Jean Stern); Galerie Bernheim-Jeune, Paris, April–June 1948, "Exposition de La Femme, 1800–1930, organisée au profit de la Sociéte des Amis du Louvre," no. 41; Musée Carnavalet, Paris, December 1952–February 1953, "Chefs-d'oeuvre des collections parisiennes: Peintures et dessins de l'école française du XIXᵉ siècle," no. 51; Kunstmuseum Wintherthur, August 30–November 8, 1953, "Théodore Géricault, 1791–1824," no. 96 (as collection Jean Stern); Galerie Claude Aubry, Paris, November 6–December 7, 1964, "Géricault dans les collections privées françaises: Exposition organisée au bénéfice de la Société des Amis du Louvre," no. 33 (as private collection); Académie de France, Rome, November 1979–January 1980, "Géricault," no. 32 (as collection Countess Sanjust di Teulada, Paris); Metropolitan Museum, New York, June 29–September 8, 1983, June 1–September 5, 1989, June 28–September 19, 1990, and June 14–September 12, 1991.

LITERATURE

Charles Clément, "Catalogue de l'oeuvre de Géricault—Peinture," *Gazette des beaux-arts* 23 (September, 1, 1867), p. 291 no. 133 under "1820 à 1824"; Charles Clément, *Géricault: Étude biographique et critique avec le catalogue*

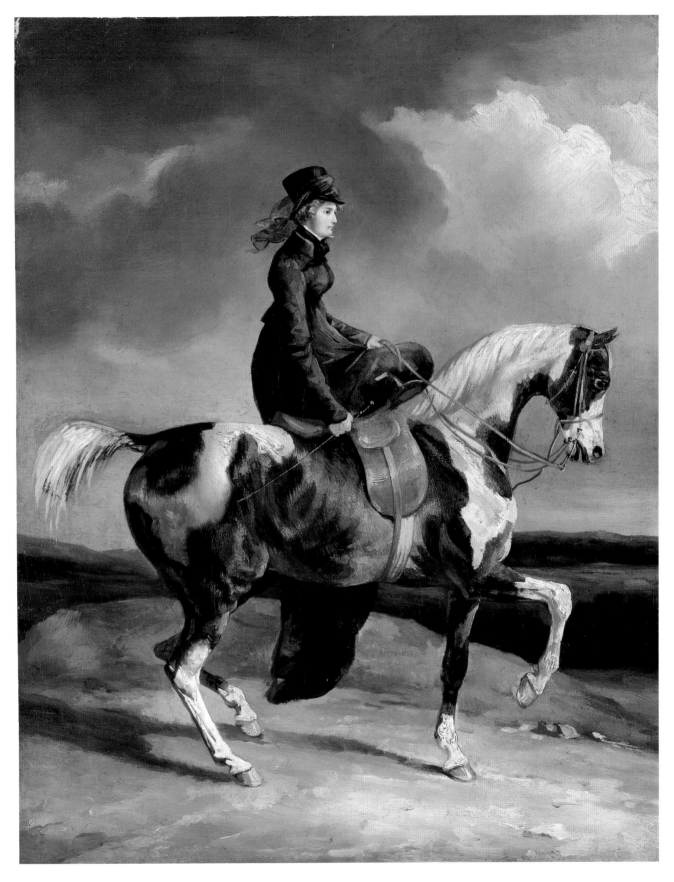

raisonné de l'oeuvre du maître (Paris, 1868), p. 311 no. 139 under "Peintures (1820 à 1824)"; Charles Clément, *Géricault: Étude biographique et critique avec le catalogue raisonné de l'oeuvre de maître,* 3rd ed. (Paris, 1879), p. 311 no. 139 under "Peintures (1820 à 1824)," p. 428 no. 139 under "Supplément au catalogue"; Anonymous, "Revue des ventes," *Le journal des arts,* May 18, 1888, p. 3; Alfred de Lostalot, "La collection de tableaux et d'objets d'art de feu M. S. Goldschmidt," *Gazette des beaux-arts,* 2nd ser., 37 (May 1888), p. 423; Anonymous, "Revue rétrospective des ventes," *Le journal des arts,* February 13, 1897, p. 3; Léon Rosenthal, "L'esthétique de Géricault," *Revue de l'art* 18 (October 1905), ill. opp. p. 292; P. Adry, "L'exposition de Géricault," *Le gaulois,* May 17, 1924, p. 4; Duc de Trévise, "Théodore Géricault," *Arts* 12 (October 1927), p. 194, ill. (as collection Jean Stern); Arsène Alexandre, "Portraits et figures de femmes: Ingres à Picasso," *La renaissance de l'art français* 11, no. 7 (July 1928), pp. 262 no. 81, 296, ill. (as collection Jean Stern); Jacques de Laprade, "Une magnifique exposition d'oeuvres de Géricault . . . ," *Beaux-arts* 75 (May 14, 1937), p. 8; Ernst Goldschmidt, *Frankrigs malerkunst: Dens farve, dens historie,* vol. 6 (Copenhagen, 1938), pp. 88–89, 277 n. (as Stern collection); Maximilien Gauthier, *Géricault,* 2nd ed. (Paris 1939), pl. 48; Klaus Berger, *Géricault: Drawings and Watercolors* (New York, 1946), p. 30 under no. 36, and see also pl. 36; Klaus Berger, *Géricault und sein Werk,* published simultaneously in French, trans. Maurice Beerblock (Vienna, 1952), p. 74 under no. 66, and p. 22, pl. 66; Lorenz Eitner, review of *Géricault und sein Werk,* by Klaus Berger, *Zeitschrift für Kunstgeschichte* 16 (1953), p. 81; Lorenz Eitner, Letter to the Editor, *Art Bulletin* 36 (June 1954), p. 167; Denise Aimé-Azam, *Mazeppa: Géricault et son temps* (Paris, 1956), pp. 262, 321; B. Taslitzky, "Géricault: Héros de roman," *La nouvelle critique,* January 1959, p. 96; R. Rey, "Géricault; ou, L'archange aboli," *Les nouvelles littéraires,* November 12, 1964, p. 8; J. Fischer, "Géricault in French Private Collections," *Connoisseur* 158 (January 1965), p. 52; Denise Aimé-Azam, *La passion de Géricault* (Paris, 1970), pp. 281, 347; Lorenz Eitner, *Géricault,* exh. cat., Los Angeles County Museum of Art, The Detroit Institute of Arts, and Philadelphia Museum of Art (Los Angeles, 1971), p. 143 under no. 99; Lorenz Eitner, in Charles Clément, *Géricault: A Biographical and Critical Study with a Catalogue Raisonné of the Master's Work* (1879; repr. New York, 1974), p. 456 no. 139 under "Supplément par Lorenz Eitner"; Klaus Berger, *Géricault and His Work,* trans. Winslow Ames (1955; repr. New York, 1978), p. 83 under no. 66; Philippe Grunchec, *Tout l'oeuvre peint de Géricault,* introduction by Jacques Thuillier (Paris, 1978), pl. L (color), pp. 119–20 no. 208, ill.; Lorenz Eitner, *Géricault: His Life and Work* (London, 1983), pp. 237, fig. 202, 354 n. 116, and see also pp. 225ff., 351 n. 66; Philippe Grunchec, *Géricault's Horses: Drawings and Watercolors* (New York, 1984), p. 154, fig. A; Philippe Grunchec, *Master Drawings by Géricault,* exh. cat., The Pierpont Morgan Library, New York, San Diego Museum of Art, and Museum of Fine Arts, Houston (Washington, D.C., 1985), p. 157 under no. 82, fig. 82a; Yveline Cantarel-Besson et al., *Géricault,* exh. cat., Galeries Nationales du Grand Palais, Paris (Paris, 1991), pp. 227, fig. 358 (color), 395 under no. 256; Germain Bazin, *Théodore Géricault: Étude critique, documents et catalogue raisonné,* vol. 7, *Regard social et politique: Le séjour anglais et les heures de souffrance,* documentation by Élisabeth Raffy (Paris, 1997), pp. 23–24 (see fig. 15), 114–115 no. 2254, ill.

Drawings

BAYONNE, Musée Bonnat. Four drawings, each known as *La Promenade,* inv. nos. 773 (Bazin 2250), 774 (Bazin 2252), 775r (Bazin 2251), 776 (Bazin 2249). Each depicts a male and female on horseback. Given that they originate in the Elmore collection, these have been regarded as portraits of the Elmores (Germain Bazin, *Théodore Géricault: Étude critique, documents et catalogue raisonné,* vol. 7, *Regard social et politique: Le séjour anglais et les heures de souffrance,* documentation by Élisabeth Raffy [Paris, 1997], p. 22 and respective entries).
PRIVATE COLLECTION. *Amazone en promenade,* watercolor. Ex-collection Elmore; thought to be a portrait of Mrs. Elmore (Bazin 2253).

PROVIDENCE, Rhode Island. Mrs. Murray Danforth Collection (by 1946–at least 1978). Pen-and-ink study of an *amazone* attributed to Géricault by Klaus Berger and thought by him to be a study for the present painting (1946, 1952, 1978), with provenance listed as E. Delacroix, Jenny Le Guillon, Constant Dutilleux, A. A. Préault, and Robert Lebel. The horse and rider are freer, and in the opposite sense. Attribution disputed by Lorenz Eitner (1953, 1954) and subsequent scholars.

Versions

PRIVATE COLLECTION, France. A "weak" version of the Rotterdam watercolor (Philippe Grunchec, *Tout l'oeuvre peint de Géricault* [Paris, 1978]; Philippe Grunchec, *Géricault,* exh. cat., Académie de France, Rome [Rome, 1979]).
ROTTERDAM, Museum Boijmans Van Beuningen (F.II 184) (fig. 1). Watercolor on paper, $11\frac{1}{8} \times 9\frac{7}{8}$ in. (28.2 × 25.1 cm). Sold at Géricault's posthumous studio sale, Hôtel de Bullion, Paris, November 2–3, 1824, one of six watercolors included in lot 28 (Bazin 2255). Lacking whip; reins slack; horse is dappled gray; wooden fence in background at left. Scholarship has not determined whether this is a study for the finished painting or a version of it. A tracing of the Rotterdam watercolor by Léon Cogniet is in the Musée des Beaux-Arts, Orléans, inv. no. 575 (368), C4 (see Germain Bazin, *Théodore Géricault: Étude critique, documents et catalogue raisonné,* vol. 7, *Regard social et politique: Le séjour anglais et les heures de souffrance,* documentation by Élisabeth Raffy [Paris, 1997], p. 24, fig. 15).

Reproductions

Engraving by Ch. Coutry published in catalogue of the Laurent-Richard sale, 1873; an alternate edition of the catalogue featured a photographic reproduction.
Etching by [R.] Paul Huet published in catalogue of the Goldschmidt sale, 1888.

This small, exquisite picture seems to be a genre painting created by Géricault to entice a private collector with its handsome subject and fine execution. It is unquestionably a result of Géricault's three trips to England (March 1819, April–June 1820, and January?–December 1821), although it may have been painted upon his return to France.[1] Conditioned by state patronage in France, Géricault was impressed by the lively private art market in London and sought to capitalize on it for himself, as well as to tap into the Anglophilia that burgeoned in France following the occupation of Paris by the British and their allies in 1815. Many writers have speculated on the identity of the rider, without conclusion, seeing the picture as a portrait rather than a genre scene. The catalogue for the 1885 exhibition in Paris proposed a Mlle Clarke; in 1970 Denise Aimé-Azam proposed a baronne Athalin. It is interesting to note that the woman's costume could be either British or French, since fashionable French men and women wore English-style clothing when riding and hunting. A strong argument against reading the painting as a portrait rests in the watercolor

Fig. 1. Théodore Géricault, *Horsewoman*. Watercolor on paper, 11⅛ × 9⅞ in. (28.2 × 25.1 cm). Museum Boijmans Van Beuningen, Rotterdam (F.II 184)

copy in Rotterdam (fig. 1): whether the watercolor preceded the painting or vice versa, the existence of two nearly identical versions of the composition suggests that Géricault was pleased with it and, by keeping the watercolor, perhaps intended to make further copies, which would not likely be the case with a portrait of a private person. GT / AEM

NOTE

1. Long the subject of confusion, the most comprehensive accounting of the dates of Géricault's trips to England is given by Bruno Chenique, in *Géricault,* exh. cat., Galeries Nationales du Grand Palais, Paris (Paris, 1991), pp. 283ff.; see also Donald A. Rosenthal, *"Géricault's Expenses for the Raft of the Medusa,"* Art Bulletin 62 (December 1980), pp. 638–40, and Christopher Sells, "New Light on Géricault, His Travels and His Friends, 1816–23," *Apollo* 123 (June 1986), pp. 390–95.

EUGÈNE DELACROIX
(1798–1863)

Eugène Delacroix's father was a high government functionary; his mother, née Oeben, came from a family of distinguished cabinet-makers. Their early deaths seem to have made Delacroix especially conscious of his unusual upbringing and appreciative of his extended family, while financial setbacks forced him to rely on his creative resources. In 1815 Delacroix entered the studio of Pierre Guérin (1774–1833), where he met Géricault (see p. 330), perhaps his most formative early influence (he modeled for the Raft of the Medusa), *and in 1816 he enrolled at the École des Beaux-Arts. As a result of the war booty hauled into Paris by Napoleon, Delacroix was one of the first of his generation to admire the Spanish Baroque paintings in the collection of General Soult, as well as the works by Raphael, Veronese, Titian, and particularly Rubens (see p. 113) that were displayed at the Louvre.*

Making his Salon debut with Dante and Virgil *in 1822, in 1824 Delacroix exhibited a scene from the Greek War of Independence,* Massacres at Chios (both Louvre); *these highly expressive paintings established his reputation as the leading exponent of Romanticism. In time his work came to be regarded as the antithesis of Ingres's late Neoclassicism, and Ingres considered him to be his personal nemesis, the "apostle of ugliness." Delacroix was among the first French painters to explore the writings of Shakespeare, Byron, and Walter Scott, and to mine Middle Eastern subjects, following the lead of British painters, notably his friend Richard Parkes Bonington (1802–1828). His portraits usually depict family members and friends. Despite disfavor in academic circles, Delacroix received many official commissions, most notably for the decoration of the Salon du Roi and the library of the Chambre des Députés in the Palais Bourbon (now the Assemblée Nationale), the library of the Senate in the Palais de Luxembourg, and two chapels in the church of Saint Sulpice. After many attempts, Delacroix was finally elected to the Académie des Beaux-Arts in 1857.* GT/AEM

ABBREVIATIONS

Correspondance. Eugène Delacroix. *Correspondance générale d'Eugène Delacroix.* Ed. André Joubin, 5 vols. Paris, 1935–38.

Fahy 1973. Everett Fahy, in *The Wrightsman Collection*, vol. 5, Everett Fahy and Francis Watson, *Paintings, Drawings, Sculpture*. New York, 1973.

Gavoty 1963. André Gavoty. "La 'Bonne Tante' de Delacroix." *La revue des deux mondes*, May 15, 1963, pp. 248–59.

Johnson 1981–89. Lee Johnson. *The Paintings of Eugène Delacroix: A Critical Catalogue.* 6 vols. Oxford, 1981–89.

Journal. Eugène Delacroix. *Journal de Eugène Delacroix.* Ed. André Joubin, 3 vols. Paris, 1932.

Moreau 1873. Adolphe Moreau. *E. Delacroix et son oeuvre.* Paris, 1873.

94. *Rebecca and the Wounded Ivanhoe*

Oil on canvas, 25 3/8 × 21 1/8 in. (64.5 × 53.7 cm)
Signed at upper right: Eug. Delacroix.

PROVENANCE

The artist (sold by December 30, 1823, to Coutan); Louis-Joseph-Auguste Coutan, Paris (1823–29; his sale, Galerie Georges Petit, Paris, March 9–10, 1829, lot 49, as "Eugène Lacroix [*sic*], Sujet tiré d'Ivanhoë, roman de Walter Scott," for Fr 150); Galerie Susse, place de la Bourse, Paris (by December 1835); Oldekop, Château de Saint Jean de la Castelle, Landes, thence by descent (sold with contents of château to Gaulin); Gaulin (about 1982); [E. V. Thaw & Co., Inc., New York, about 1982–83; sold to Wrightsman]; Mr. and Mrs. Charles Wrightsman, New York (1983–his d. 1986); Mrs. Wrightsman (from 1986).

EXHIBITED

Galerie Susse, Paris, December 1835; Metropolitan Museum, New York, June 1, 1989–September 5, 1989, June 28, 1990–September 19, 1990, and August 20, 1991–September 12, 1991.

LITERATURE

Charles Forget, "Les beaux-arts," *Le critique*, vol. 1, no. 1 (December 27, 1835), p. 10; Loudolphe de Virmond, "Ouvrages de M. Delacroix," in Théophile Silvestre, *Histoire des artistes vivants, français et étrangers: Études d'après nature* (Paris, 1856), p. 80; Maurice Tourneux, *Eugène Delacroix devant ses contemporains: Ses écrits, ses biographes, ses critiques* (Paris, 1886), p. 140; *Journal* (1932 ed.), vol. 1, p. 40 nn. 3, 4 under December 30, 1823; Lee Johnson, *Delacroix*, exh. cat., Royal Scottish Academy, Edinburgh, and Royal Academy of Arts, London (London, 1964), p. 39 under no. 68; Martin Kemp, "Scott and Delacroix, with Some Assistance from Hugo and Bonington," in *Scott Bicentenary Essays: Selected Papers Read at the Sir Walter Scott Bicentenary Conference [Edinburgh, 1971]*, ed. Alan Bell (Edinburgh and London, 1973), pp. 214 n. 7, 215; Johnson 1981–89, vol. 1 (1981), p. 203 no. L94, vol. 3 (1986), pp. 311 under no. 9, 316 under Supplement to Volume I, and vol. 4 (1986), pl. 335; Lee Johnson, "A New Delacroix: 'Rebecca and the Wounded Ivanhoe,'" *Burlington Magazine* 126 (May 1984), pp. 280–81, color ill., and see p. 282; Beth Segal Wright, *Painting and History during the French Restoration: Abandoned by the Past* (Cambridge, 1997), pp. x, 135–37 fig. 50, 228–29 n. 33; Barthélémy Jobert, *Delacroix*, trans. Terry Grabar and Alexandra Bonfante-Warren (Princeton, 1998), pp. 114, fig. 82 (color), 115–16, 276, 319 n. 57; Arlette Sérullaz et al., *Delacroix en Touraine*, exh. cat., Musée des Beaux-Arts, Tours (Bordeaux, 1998), p. 153 no. S.9, fig. 16; Paul Joannides, "Delacroix and Modern Literature," in *The Cambridge Companion to Delacroix*, ed. Beth Segal Wright (Cambridge and New York, 2001), pp. 134, 217 n. 25.

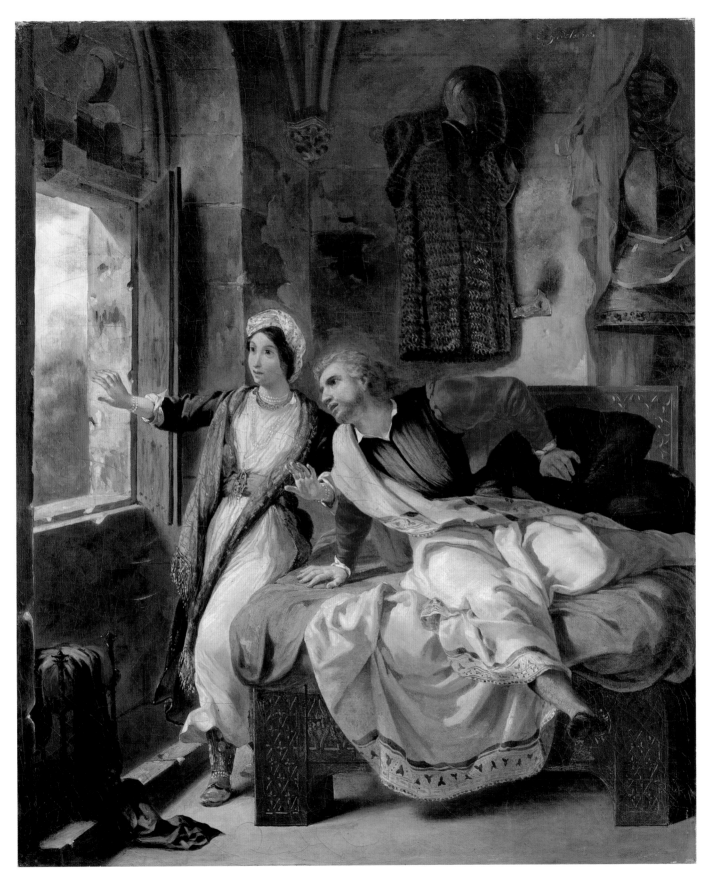

This remarkable early painting of 1823 was not known to the first compilers of Delacroix's work: neither Adolphe Moreau (1873) nor Alfred Robaut (1885) catalogued it, although it did appear, without comment, in the 1856 list compiled by Loudolphe de Virmond. Lee Johnson cited it as a lost work in his 1981 catalogue raisonné, only to publish it as a "new" Delacroix in 1984. Delacroix himself seems to have disdained this work of his youth, since he wrote in his journal: "I've sold to M. Coutan, the collector of [Ary] Scheffer, my execrable painting of Ivanhoe . . . poor man! And he said that he would take a few more from me; I'll be all the more tempted to believe that he's not filled with wonder by it."[1] As Johnson noted, it is "the only painting of a literary or historical subject that [Delacroix] is known to have completed between the *Barque of Dante* in 1822 and the beginning of work on the *Massacres de Scio* in January 1824."[2] Given that it is worked in a style that is as close as Delacroix ever came to the Troubadour manner of Ingres or the artists of the so-called École de Lyon, it is not difficult to understand his rejection of this work after he had begun to create his own very different and much more personal mature style. Nevertheless, this painting may be admired on its own terms, as did its first owner, the distinguished collector Coutan (1779–1830), who assembled the most important holdings of late Empire and early Restoration genre and landscape painting in France. It is significant that the writer Forget noticed the painting when it was shown in an exhibition in Paris in 1835, although Delacroix himself seems to have forgotten it by the end of his life: he did not include it in his list of subjects drawn from *Ivanhoe* included in his journal entry for December 29, 1860.

The subject derives from Walter Scott's historical novel *Ivanhoe* (first published 1791, published in French in 1820), chapter 29. It is, as modern art historians have noted, the first painting by Delacroix to be based on a reading of Scott, and it may be the first visualization of Scott by any French painter.[3] Wilfrid of Ivanhoe and the Jewess Rebecca are imprisoned in the fortress of Torquilstone, which is under siege by forces including the disguised Richard the Lionheart. Because Ivanhoe is wounded and cannot get out of bed, Rebecca describes the combat taking place outside the window. Rebecca, who is secretly in love with Ivanhoe, describes the combat in terms alien to Ivanhoe's chivalric values: as a Jew, she is appalled by the scene, while Ivanhoe is only frustrated that he can neither see it nor, indeed, participate in the bloodletting. His reply to her is now famous: "Thou art no

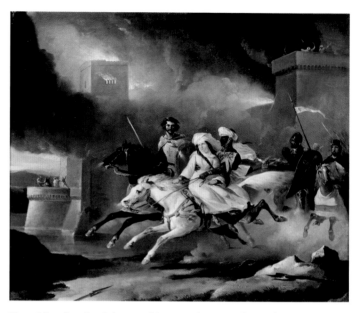

Fig. 1. Léon Cogniet, *Rebecca and Sir Brian de Bois Guilbert*. Oil on canvas, 12⅞ × 15⅝ in. (32.7 × 39.7 cm). The Metropolitan Museum of Art, New York, The Whitney Collection, Promised Gift of Wheelock Whitney III, and Purchase, Gift of Mr. and Mrs. Charles S. McVeigh, by exchange, 2003 (2003.42.11)

Christian, Rebecca." As Beth Wright observes, "The chapter presents a cultural debate as an unspoken subtext and an unseen battle," adding, "This verbal description of temperament and culture, this *epitome of the antivisual* [our emphasis], attracted several Romantic artists,"[4] as can be seen in numerous examples by Léon Cogniet (1794–1880; fig. 1), Tony Johannot (1792–1870), Camille Roqueplan (1800–1855), and Horace Vernet (see p. 326).[5]

Sir Walter Scott, as Wright sees it, "had created a new literary genre: the historical novel. A blend of fictional literature and historical documentation, it was simultaneously didactic (but not pedantic) and entertaining (but not frivolous). Because of its style and format, it reached a wide audience. Precisely the same combination was being sought in the pictorial arts," resulting in *"peinture de genre historique* or *peinture anecdotique."*[6] As practiced by Ingres and other Troubadour artists, this genre adopted a historicist approach, in which detailed renderings of costumes and settings assumed prominence over narrative expression. In Delacroix's hands the dramatic event was always emphasized, even when, in this instance, he took pains to provide a (false) sense of historical accuracy. He relied on what Baudelaire called "the magical art by whose grace he was able to translate the *word* into more lively and accurate plastic images than those of anyone else working in the

same profession."[7] Delacroix would go on to make a number of realizations of scenes from *Ivanhoe,* among which is the magisterial painting of 1846 now at the Metropolitan Museum (fig. 2). For his part, Scott became the most widely read English author in France; his immense popularity there created a demand for almost immediate translations of his novels.

Prompted perhaps by his mentor Géricault, Delacroix looked to Michelangelo for the pose of Ivanhoe. The adoption of aspects of Michelangelo's art by the artists in Géricault's circle was a defining feature of their anti-classical style, which soon became known as Romanticism. GT/AEM

NOTES

1. "J'ai vendu ces jours-ci à M. Coutan, l'amateur de Scheffer, mon tableau exécrable d'*Ivanhoë*. . . . Le pauvre homme! et il dit qu'il m'en prendra quelques-uns encore; je serais d'autant plus tenté de croire qu'il n'est pas émerveillé de celui-ci." *Journal* (1932 ed.), vol. 1, p. 40 under December 30, 1823.

2. Lee Johnson, "A New Delacroix: 'Rebecca and the Wounded Ivanhoe,'" *Burlington Magazine* 126 (May 1984), p. 280. See also Johnson 1981–89, vol. 3 (1986), p. 316 no. L94.

3. As Martin Kemp noted, Delacroix had to imagine his own rendering of the scene, as no stage production of *Ivanhoe* was mounted in France until 1826. See "Scott and Delacroix, with Some Assistance from Hugo and Bonington," in *Scott Bicentenary Essays: Selected Papers Read at the Sir Walter Scott Bicentenary Conference [Edinburgh, 1971],* ed. Alan Bell (Edinburgh and London, 1973), p. 215.

4. Beth Segal Wright, *Painting and History during the French Restoration: Abandoned by the Past* (Cambridge, 1997), pp. 135–36.

5. The Metropolitan Museum's version of Cogniet's *Rebecca and Sir Brian de Bois Guilbert*, illustrated here as fig. 1, is a reduced version of the 1828 canvas in the Wallace Collection, London, which measures $34\,^7/_8 \times 45\,^5/_8$ in. (88.5 × 116 cm).

6. Beth Segal Wright, "Scott's Historical Novels and French Historical Painting, 1815–1855," *Art Bulletin* 63 (June 1981), pp. 268–69.

7. "l'art magique grâce auquel il a pu traduire la *parole* par des images plastiques plus vives et plus approximantes que celles d'aucun créateur de même profession.""L'oeuvre et la vie d'Eugène Delacroix," in Charles Baudelaire, *Oeuvres complètes,* 2 vols. (Paris, 1975–76), vol. 2, p. 743; originally published *en feuilleton* in the first of three installments in *L'opinion nationale,* September 2, 1863, and republished in the collection *L'art romantique* (Paris, 1868).

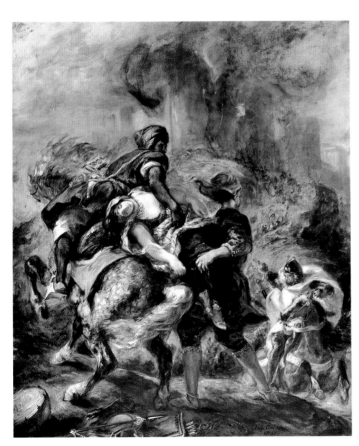

Fig. 2. Eugène Delacroix, *The Abduction of Rebecca,* 1846. Oil on canvas, $39\,^1/_2 \times 32\,^1/_4$ in. (100.3 × 81.9 cm). The Metropolitan Museum of Art, New York, Catharine Lorillard Wolfe Collection, Wolfe Fund, 1903 (03.30)

95. *Madame Henri François Riesener, née Félicité Longrois (1786–1847)*

Oil on canvas, 29 ¼ × 23 ¾ in. (74.3 × 60.3 cm)

The painting, which has never been relined, is on its original stretcher; the paint surface is exceptionally well preserved.

The Metropolitan Museum of Art, New York, Gift of Mrs. Charles Wrightsman, 1994 (1994.430)

PROVENANCE

Probably the sitter, Frépillon, near Montmorency, and Paris (d. 1847); her son, Léon Riesener, Paris (1847–d. 1878); his widow, Mme Léon Riesener (1878–at least 1885); their daughter, Louise Riesener, later Mme Claude Léouzon-le-Duc, ?Paris (1916–at least 1936); Léon Salavin, Paris (by 1952–at least 1969); [Paul Rosenberg, New York, 1971; to Wrightsman]; Mr. and Mrs. Charles Wrightsman, New York (1971–his d. 1986; cat., 1973, no. 8); Mrs. Wrightsman (1986–94); her gift in 1994 to the Metropolitan Museum.

EXHIBITED

École Nationale des Beaux-Arts, Paris, March 6–April 15, 1885, "Exposition Eugène Delacroix au profit de la souscription destinée à élever à Paris un monument à sa mémoire," no. 167; École des Beaux-Arts, Paris, 1885, "Portraits du siècle," no. 49;[1] Paul Rosenberg, Paris, January 16–February 18, 1928, "Expositions [sic] d'oeuvres d'Eugène Delacroix (1798–1863) au profit de le Société des Amis du Louvre," no. 10; Musée du Louvre, Paris, June–September 1930, "Exposition Eugène Delacroix: Peinture, aquarelles, pastels, dessins, gravures, documents," no. 73; Musée du Petit Palais, Paris, May–July 1936, "Gros: Ses amis, ses élèves," no. 241; Wildenstein & Co., London, June–July 1952, "Eugène Delacroix, 1798–1863," no. 18; Musée Carnavalet, Paris, December 1952–February 1953, "Chefs-d'oeuvre des collections parisienne: Peintures et dessins de l'école française du XIX siècle," no. 32; Giardini Pubblici, Venice, XXVIII Biennale internazionale d'arte, June–September 1956, "Eugène Delacroix," no. 18; Ny Carlsberg Glyptotek, Copenhagen, October 15–November 15, 1960, "Exposition des portraits français de Largillierre à Manet," no. 13; Palazzo Venezia, Rome, April 1962, and Palazzo Reale, Milan, June–July 1962, "Il ritratto francese da Clouet a Degas," no. 75; Musée du Louvre, Paris, May–September 1963, "Centenaire d'Eugène Delacroix, 1798–1863," no. 222; Kunstmuseum Bern, November 16, 1963–January 19, 1964, "Eugène Delacroix," no. 41; Kunsthalle Bremen, February 23–April 26, 1964, "Eugène Delacroix, 1798–1863," no. 36; Royal Scottish Academy, Edinburgh, August 15–September 13, 1964, and Royal Academy of Arts, London, October 1–November 8, 1964, "Delacroix," no. 36; Kyoto Municipal Museum, May 10–June 8, 1969, and Tokyo National Museum, June 14–August 3, 1969, "Exposition Delacroix," no. H-14; Metropolitan Museum, New York, June 1–September 5, 1989, June 28–September 19, 1990, and August 20–September 12, 1991.

LITERATURE

Loudolphe de Virmond, "Ouvrages de M. Delacroix," in Théophile Silvestre, *Histoire des artistes vivants, français et étrangers: Études d'après nature* (Paris, 1856), p. 82; Moreau 1873, p. 236; Alfred Robaut et al., *L'oeuvre complet de Eugène Delacroix: Peintures, dessins, gravures, lithographies* (Paris, 1885), p. 161 no. 606; Étienne Moreau-Nélaton, *Delacroix: Raconté par lui-même* (Paris, 1916), vol. 1, pp. 155–56; *Journal* (1932 ed.), vol. 1, p. 104 n. 2 under May 15, 1824, and vol. 3, p. 526 under note to vol. 1, p. 104; Gavoty 1963, p. 258; René Huyghe, *Delacroix* (New York, 1963), pp. 19, 32, 482, 527 n. 41, 535, pl. 26; René Huyghe et al.,

Delacroix, Collection geniés et réalités (Paris, 1963), pp. 55, 282–83 under the year 1854; Maurice Sérullaz, *Mémorial de l'exposition Eugène Delacroix* (Paris, 1963), p. 165 no. 219, ill.; Raymond Escholier, in *Léon Riesener, 1808–1878,* exh. cat., Le Pavillon des Arts, Paris (Paris, 1966), n.p.; Luigina Rossi Bortolatto, *L'opera pittorica completa di Delacroix* (Milan, 1972), pp. 102–3, fig. 275; Fahy 1973, pp. 63–71 no. 8; Johnson 1981–89, vol. 3 (1986), pp. 44–45 no. 226, and vol. 4 (1986), pl. 47.

Unlike Ingres (see p. 292), who is remembered today for numerous portraits executed throughout his career, Delacroix painted comparatively few likenesses, and almost all of them are of intimate friends or members of his family. The present portrait is no exception. It depicts Mme Henri Riesener (1786–1847), Delacroix's aunt by marriage. His letters and journal reveal that she occupied a special place in his heart. Years after she died he wrote, "Upon waking my thoughts turn to such pleasant and sweet moments held in my memory and in my heart, of times spent close to my aunt in the country."[2] His portrait of her conveys this affectionate feeling. It is a remarkably tender and human record of someone Delacroix loved dearly. Despite the busy frills of her lace bonnet or the coruscating color of her foulard, the portrait is serene and unspectacular in a way that few of the artist's works are.

Delacroix was related to Mme Riesener through his mother, one of the daughters of Jean François Oeben (1721–1763), the master cabinetmaker. When Oeben died, he left his widow (Delacroix's grandmother) with an unfinished piece of furniture, the celebrated desk of Louis XV now in the Louvre, which was eventually completed by Oeben's assistant Jean Henri Riesener (1734–1806), who signed it in 1769 with his name alone. Before he completed the desk, Riesener married Oeben's widow, with whom he had a son, Henri François (1767–1828). It is the latter's wife who is portrayed here.

Madame Riesener led a remarkable early life. Born Félicité Longrois, she was the granddaughter of Pierre Longrois, who was in charge of the furniture at the Château de la Muette. Through one of her uncles she was introduced to the imperial

338

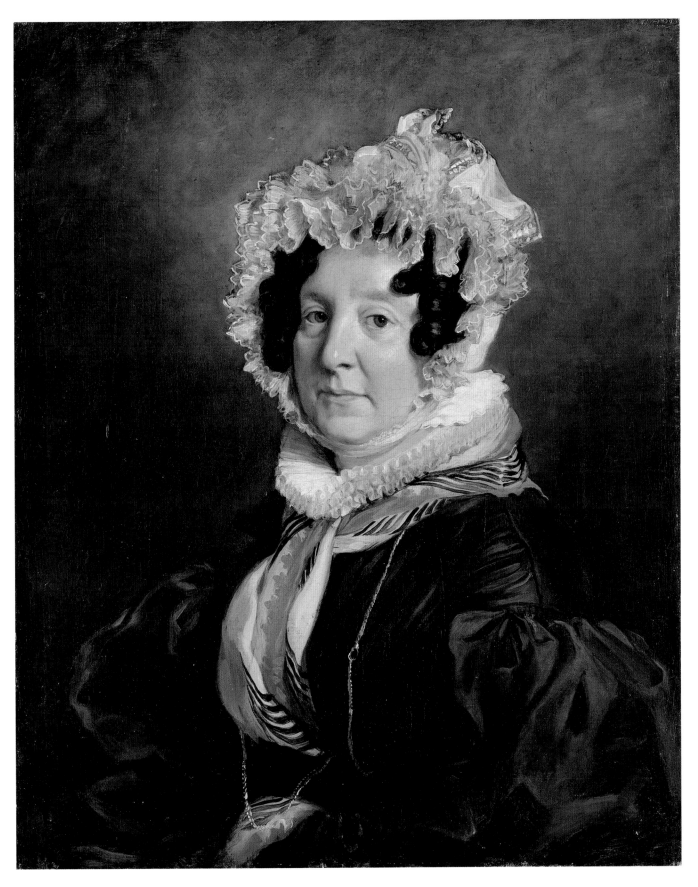

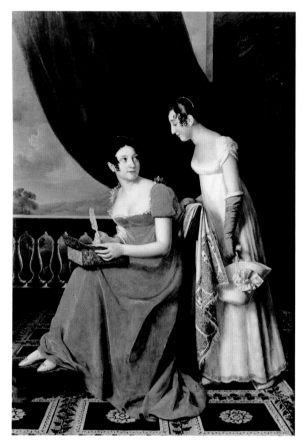

Fig. 1. Henri François Riesener, *Mme Henri François Riesener and Her Sister, Mlle Longrois*. Oil on canvas, 85 × 70⅞ in. (216 × 180 cm). Musée des Beaux-Arts, Orléans

as a mature man frequently stayed with her. In a letter written on August 7, 1832, immediately after he had returned from his trip to North Africa, he expressed how much she meant to him. Proposing to see her within the week, he wrote, "Suffice it to say, dear aunt, that I have thought of you and of the small number of people whose lives are dear to me."[5]

It was probably through Mme Riesener's husband that Delacroix took an interest in painting. A student of Antoine Vestier (see p. 244), Henri Riesener was a tolerably successful painter who specialized in Neoclassical portraits. He spent seven years in Russia, from 1813 to 1820, painting an equestrian portrait of Czar Alexander I and many pictures for the Russian aristocracy. When he came back, he urged Delacroix to study with David (see p. 255). Delacroix reported this advice in a letter of July 8, 1820, to his sister, Henriette de Verninac: "M. Riesener has come back from Russia. Apparently he has made a great deal of money, as well as bringing back diamonds, cashmere shawls, and fine furs for his wife. He had earned about 110,000 rubles. He thinks it would be to my advantage to go and study with M. David in Brussels; I have often considered this, but I must think it over still

service, where she became a *dame d'annonce* (lady-in-waiting). Napoleon took a fancy to her, and she became his mistress for a brief period during the winter of 1805–6. During the following summer she was married off to Henri Riesener, the empress Josephine signing the prenuptial contract. Riesener was then almost forty years old, his attractive wife not yet twenty.[3] Her appearance at this time is recorded in the large double portrait Riesener painted of his fiancée and her sister (fig. 1). The future Madame Riesener, wearing the official red gown of the *dames d'annonce,* is seated with a portable writing table on her lap, while her sister looks over her shoulder.[4]

After the deaths of Delacroix's father in 1805 and his mother in 1814, the Rieseners were his closest relatives, aside from his sister and a surviving brother, and he often spent his holidays with them in the country at Frépillon near Montmorency, about nine miles north of Paris. He grew devoted particularly to his aunt, and even

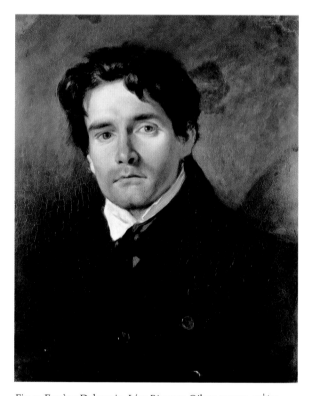

Fig. 2. Eugène Delacroix, *Léon Riesener*. Oil on canvas, 21¼ × 17⅜ in. (54 × 44 cm). Musée du Louvre, Paris

further."[6] It is hard to imagine what course Delacroix's career would have taken had he followed his uncle's advice.

The Rieseners' son Léon (1808–1878) also became a painter and a close friend of Delacroix. They were often together at Frépillon, and, from Delacroix's correspondence, it transpires that he did much to further his younger cousin's career. Léon Riesener sat for Delacroix in 1834: the result is a strikingly vivid and handsome portrait (fig. 2). It is not so large or so elaborate as the painting Delacroix did of Léon's mother, but it has the same immediacy and direct rapport between the artist and his subject.

Madame Riesener sat for her portrait shortly after Delacroix painted her son. According to Moreau, it was executed at Frépillon in the summer of 1835.[7] Although this is the only evidence for the date, there seems to be no reason to question it. Moreau knew Delacroix personally, and he interviewed the Riesener family when he gathered the material for his monograph, the first book on Delacroix. Moreover, the style of the portrait, as much as one can deduce from comparisons with documented works of 1835, seems plausible for that year, and the apparent age of the sitter also corresponds with this period (Mme Riesener was then a widow, about fifty years old). Some writers claim that the portrait was done in February 1835, since that is the only time during the year when it is certain that Delacroix was at Frépillon.[8] One need not be so precise, however, since Delacroix was a regular guest at Frépillon, and the fact that there is no documentary evidence proving he was there during the summer does not eliminate the possibility.

Twelve years later Delacroix wrote to the novelist George Sand, "I have had a sad bereavement. I have lost my good aunt whom I loved like a mother. She was a woman of noble character and one in whom spiritual qualities took precedence over everything, which is rare; one must needs have admired her, even if one had not loved her; you can imagine then what a gap this leaves in my already lonely life. Live, then, dear friend, cherish that precious spark which makes you not only live but love and be loved. I know now by experience that we really live through other people; when one of the beings who are necessary to our existence disappears he takes away with him a whole world of feelings which no other relationship can revive: what are old men, then, and what have they to regret when they leave this world?"[9]

EF

NOTES

1. According to Johnson 1981–89, vol. 3 (1986), p. 44.

2. "Ma pensée se porte à mon réveil sur les moments si agréables et si doux à ma mémoire et à mon coeur que j'ai passés près de ma bonne tante à la campagne"; *Journal* (1932 ed.), vol. 2, p. 173 under April 28, 1854.

3. Gavoty 1963, pp. 252–54.

4. The double portrait was given a prominent position at the Salon of 1808, and it was shown again at the Salon of 1814. Throughout Delacroix's life it remained in the possession of the Riesener family, and it is certain that he saw it many times. Only in 1886 was it presented to the museum at Orléans by Mme Riesener's daughter-in-law (Paul Vitry, *Le Musée d'Orléans* [Paris, 1922], pp. 12, 45; mistakenly said to have been exhibited at the Salon of 1810).

5. "C'est assez vous dire, bonne tante, que j'ai bien souvent pensé à vous et au petit nombre de personnes dont la vie m'est chère"; *Correspondance* (1935–38 ed.), vol. 5, pp. 159–60 (translation courtesy of Asher E. Miller).

6. *Eugène Delacroix: Selected Letters, 1813–1863*, ed. and trans. Jean Stewart (London, 1971), p. 73. "M. Riesener est arrivé de Russie. Il paraît qu'il gagné beaucoup, outre des diamants, des cachemires et de belles fourrures qu'il rapporte à sa femme. Il se trouve avoir gagné à peu près cent dix mille roubles. Il voudrait pour mon intérêt que j'allasse étudier près de M. David à Bruxelles, j'y pensé bien souvent: mais il faut encore y réfléchir"; *Correspondance* (1935–38 ed.), vol. 5, p. 61.

7. Moreau 1873, p. 236.

8. The portrait is dated February 1835 by Raymond Escholier, in *Léon Riesener, 1808–1878*, exh. cat., Le Pavillon des Arts, Paris (Paris, 1966), n.p.; Maurice Sérullaz, *Mémorial de l'Exposition Eugène Delacroix* (Paris, 1963), p. 165 no. 219; and Luigina Rossi Bortolatto, *L'opera pittorica completa di Delacroix* (Milan, 1972), pp. 102–3. René Huyghe et al., *Delacroix,* Collection geniés et réalités (Paris, 1963), p. 283 under the year 1854, states that the portrait was painted in 1834, the year Delacroix executed the portrait of the sitter's son Léon Riesener. Delacroix's presence at Frépillon in February is established by a letter postmarked February 27, 1835; see *Correspondance* (1935–38 ed.), vol. 1, p. 391.

9. "J'ai éprouvé un grand chagrin. J'ai perdu ma bonne tante que j'aimais comme une mère. C'était une femme d'un gran caractère et chez qui (chose rare) les qualités de l'âme avaient le pas sur tout: il aurait fallu l'admirer quand on ne l'eût pas aimée; vous jugez donc du vide que cela fera dans ma vie déjà bien seule. Vivez donc, chère amie, soignez cette étincelle précieuse qui vous fait non seulement vivre, mais aimer et être aimée. J'éprouve déjà bien qu'on vit véritablement dans les autres; chacun des êtres nécessaires à notre existence qui disparaît à son tour emporte avec lui un monde de sentiments qui ne peuvent revivre avec aucun autre: qu'est-ce que c'est donc qu'un vieillard et que regrettent-ils en quittant ce monde?" Letter of November 20, 1847; *Correspondance* (1935–38 ed.), vol. 2, pp. 330–31; translated in *Selected Letters,* p. 278.

Fahy 1973, p. 70, mistakenly connected the Wrightsman painting with a description of Delacroix's portrait "of my old aunt" in the entry in the Journal for October 9, 1849; this passage almost certainly refers to Delacroix's portrait of his great-aunt Mme Louis Cyr Bornot, *née* Anne Françoise Delacroix (1742–1833), now in a private collection, Paris (see Johnson 1981–89, vol. 1 [1981], pp. 42–43, no. 65).

CASPAR DAVID FRIEDRICH

(1774–1840)

Caspar David Friedrich was born in Greifswald, a small town on the Baltic. After studying at the Copenhagen Art Academy, in 1798 he settled in Dresden, then a center of the German Romantic movement. From the beginning of his career, Friedrich favored the subject of landscape, drawing his motifs mainly from two regions in Germany: the mountains of the Riesengebirge and of Bohemia as well as his northern Baltic coasts and the island of Rügen.[1] His early landscape drawings, worked mostly in watercolor and pen-and-ink washes, caught the admiring eye of Goethe.

Friedrich began to paint in oils on canvas in 1807. His first important painting, The Cross in the Mountains (Tetschen Altarpiece) of 1808, was an unprecedented case of a landscape posing as a devotional image and came under fierce attack, catapulting the reclusive artist into a controversy over the meaning of landscape painting. In 1810 Friedrich successfully exhibited The Monk by the Sea and Abbey in the Oak Forest at the Berlin Academy, where they were seen and purchased by the Prussian crown prince. Completed in 1811, Morning in the Riesengebirge was acquired by King Frederick William III of Prussia while it was on display in Weimar. Friedrich was elected a member of the Dresden Academy in 1816. In early 1818 he married Caroline Bommer (they would have two daughters and a son). Later that year, the Norwegian painter Johan Christian Clausen Dahl (1788–1857) arrived in Dresden and sought Friedrich's acquaintance; they became close friends (five years later he would move into Friedrich's house). In 1820 Friedrich received a visit from Grand Duke Nikolai Pavlovich of Russia (later Czar Nicholas I), who would acquire numerous paintings from the artist through the poet Vasily Andreyevich Zhukovsky; the grand duke's first purchases were On the Sailboat (1818–19) and Sisters on the Harbor-View Terrace (Harbor by Night) (ca. 1820).

Although Friedrich was appointed an associate professor of landscape painting at the Dresden Academy in January 1824, his meditative, often barren landscapes, perplexing to all but his fellow Romantics, cost him the full professorship when the position became available. Indeed, during the 1820s his landscapes began to lose favor with a public who preferred the faithfully rendered scenes of the younger generation of artists of the Düsseldorf School. Following an extended illness, Friedrich traveled to the island of Rügen during May and June

of 1826 to regain his health. Nine years later, on June 26, 1835, he suffered a stroke, which forced him to give up painting in oil; from then on he used sepia and watercolor almost exclusively. The melancholic artist's themes became ever more somber. While his emotional and financial hardships were somewhat mitigated by the continuing support of his Russian patron, Czar Nicholas, Friedrich died in poverty and near obscurity in Dresden. SR

ABBREVIATION

Börsch-Supan and Jähnig 1973. Helmut Börsch-Supan and Karl Wilhelm Jähnig. Caspar David Friedrich: Gemälde, Druckgraphik und bildmässige Zeichnungen. Munich, 1973.

NOTE

1. Chronology based on those given in Börsch-Supan and Jähnig 1973, pp. 11–12, and Werner Hofmann, ed., Caspar David Friedrich, 1774–1840: Kunst um 1800, exh. cat., Kunsthalle, Hamburg (Munich, 1974), pp. 83–88.

96. Two Men Contemplating the Moon (Zwei Männer in Betrachtung des Mondes)

Oil on canvas, 13¾ × 17¼ in. (34.9 × 43.8 cm)
The Metropolitan Museum of Art, New York, Wrightsman Fund, 2000 (2000.51)

PROVENANCE

The artist; Dr. Otto Friedrich Rosenberg (1770–1850), Dresden, in exchange for medical attention;[1] by descent through the Rosenberg family to Gottfried Spiegler, Glinde, Germany; sale, Christie's, London, October 7, 1999, lot 10, for £771,500, to Eugene V. Thaw and Artemis Fine Arts, Inc., New York; [Artemis Fine Arts, Inc., New York; sold to the Metropolitan Museum]; purchased by the Metropolitan Museum in 2000 with a gift from the Wrightsman Fund.

EXHIBITED

Museum für Kunst und Kulturgeschichte, Dortmund, June–July 1990, "Caspar David Friedrich: Winterlandschaften," no. 37; Metropolitan Museum, New York, September 11–November 11, 2001, "Caspar David Friedrich: Moonwatchers," no. 3.

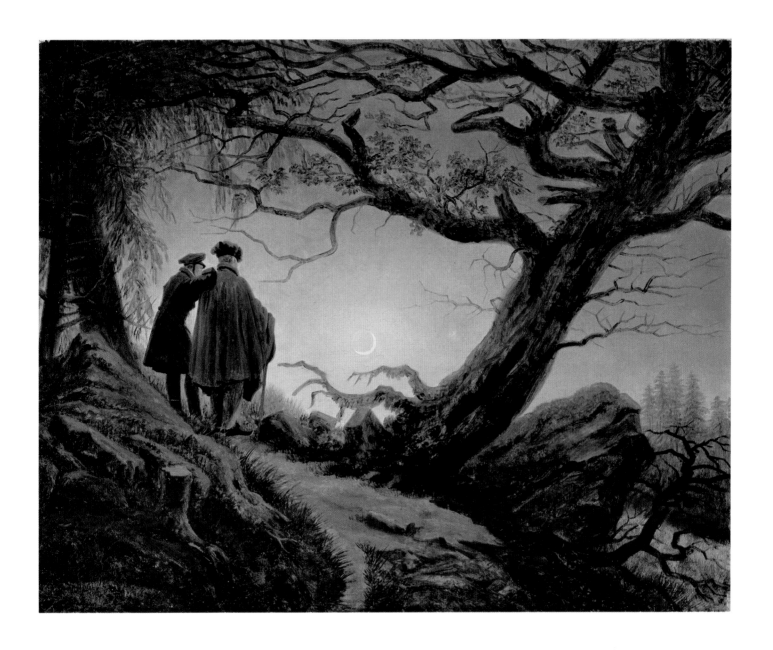

LITERATURE

Werner Sumowski, *Caspar David Friedrich-Studien* (Wiesbaden, 1970), p. 179 n. 116, fig. 395; Helmut Börsch-Supan, *L'opera completa di Friedrich* (Milan, 1976), p. 105 (ill.) no. 182; Gary Tinterow and Sabine Rewald, in "Recent Acquisitions: A Selection, 1999–2000," *The Metropolitan Museum of Art Bulletin* 58, no. 2 (fall 2000), p. 36, color ill.; *Artemis, 1999–2000,* Consolidated Audited Annual Report and Annual General Meeting, January 26, 2001 (2001), color detail on cover, p. 20, color ill.

VERSIONS

BERLIN, Nationalgalerie, Staatliche Museen. Caspar David Friedrich, *Man and Woman Contemplating the Moon,* ca. 1824 (fig. 2). Oil on canvas, 13⅜ × 17⅜ in. (34 × 44 cm). A second version, previously dated 1830–35 by Börsch-Supan; whereabouts before 1935 unknown.

DRESDEN, Gemäldegalerie Neue Meister, Staatliche Kunstsammlungen. Caspar David Friedrich, *Two Men Contemplating the Moon,* 1819 (fig. 1). Oil on canvas, 13¾ × 17½ in. (35 × 44.5 cm). Friedrich gave this version (the first) to his friend and upstairs neighbor, Johan Christian Dahl, in exchange for one of Dahl's works. Dahl kept the picture, of which Friedrich made two more versions, until Friedrich's death, when he sold it to the Dresden Gemäldegalerie. HAMBURG, Galerie Hans (in 2001). Caspar David Friedrich, *Two Men Contemplating the Moon,* of unknown date. Oil on canvas, 13⅜ × 17 in. (34 × 43 cm). A fourth version or copy.

DRAWINGS

DRESDEN, Kupferstichkabinett. Caspar David Friedrich, *Studies of Two Trees,* April 25, 1809 (fig. 3). Pencil, 12½ × 10⅛ in. (31.7 × 25.7 cm).
OSLO, Nasjonalgalleriet. Caspar David Friedrich, *Bare Oak Tree,* May 3, 1809 (fig. 4). Pencil, 14⅛ × 10⅜ in. (36 × 25.9 cm).

The Wrightsman picture is the third variant of one of the artist's most cited and reproduced paintings,[2] of which the first version (1819, fig. 1) is in Dresden[3] and the second one (ca. 1824, fig. 2) in Berlin.[4]

Two men pause on their evening walk through a late autumnal forest to contemplate the sinking moon and Venus, or evening star. Friedrich's landscapes are usually relatively empty and adhere to a severe underlying symmetry. This picture is unusual in that the composition is asymmetrical, and the landscape relatively crowded. Symbol-laden elements line the winding forest path: the evergreen fir tree, a dead oak, a rock, and a large broken-off branch. The widely diverging interpretations accorded to this small picture—pagan, nature-mystical, political, or exclusively Christian—tend to obliterate its simple yet deeply contemplative mood.[5] Contemporary sources have identified the two men as the forty-five-year-old Friedrich and his talented colleague, the twenty-five-year-old August Heinrich (1794–1822). The mood of piously shared contemplation relates to the fascination with the moon experienced in the poetry, literature, philosophy, and music

Fig. 1. Caspar David Friedrich, *Two Men Contemplating the Moon,* 1819. Oil on canvas, 13¾ × 17½ in. (35 × 44.5 cm). Gemäldegalerie Neue Meister, Staatliche Kunstsammlungen, Dresden

Fig. 2. Caspar David Friedrich, *Man and Woman Contemplating the Moon,* ca. 1824. Oil on canvas, 13⅜ × 17⅜ in. (34 × 44 cm). Nationalgalerie, Staatliche Museen, Berlin

at the time. Both figures are seen from the back so that the viewer can identify with their communication with nature, in which the Romantics saw a manifestation of the sublime. They follow in the tradition of the Romantics' wanderers who, as personifications of their restless yearning, roam through their novels, poems, and music (for example, Schubert's *Wanderer* Fantasy [1816] and his song cycle *Die Winterreise* [1827]; Beethoven's *Moonlight* Sonata [1801]; or Chopin's twenty-one Nocturnes [1827–46]).

Fig. 3. Caspar David Friedrich, *Studies of Two Trees, April 25, 1809.*
Pencil, 12½ × 10⅛ in. (31.7 × 25.7 cm). Kupferstichkabinett, Dresden

Fig. 4. Caspar David Friedrich, *Bare Oak Tree, May 3, 1809.*
Pencil, 14⅛ × 10⅜ in. (36 × 25.9 cm). Nasjonalgalleriet, Oslo

Both men's attire—the beret and cape of the figure on the right and the cap and coat of the one on the left—conform to the Old German dress code that had been adopted in 1815 by radical German students. These students opposed the ultraconservative policies that were being enforced in the wake of the Napoleonic Wars. The staunchly patriotic Friedrich deliberately ignored the 1819 royal degree that forbade this dress, seen as a type of "demagogues' uniform," and continued to show his figures in Old German costume until his death.

The landscape is imaginary, as is the juxtaposition of the emblematic oak, fir, rock, and branch; they are, however, based on precise studies after nature that Friedrich had made in various regions at different times and combined here in a single composition. In the 1819 Dresden first version (see Versions, above), a rust-brown haze envelops sky and landscape, dipping the landscape into a nocturnal mood. In the circa 1824 Berlin second version, the two protagonists are a man and a woman, and the sky is changed to a rose-mauve dusk. Here, in the Wrightsman third version of about 1830, Friedrich retained the luminosity of the Berlin picture yet reintroduced the two complicit male figures of the

Dresden picture. Infrared photographs have established that Friedrich made no underdrawings, and his painting is so fluid that the forms appear less detailed than in the other two versions. Suffused with rose-mauve light, the Wrightsman picture conveys the greatest sense of serenity.

SR

NOTES

1. Information on Rosenberg was supplied with help from Dr. Gerd Spitzer, Gemäldegalerie Neue Meister, Staatliche Kunstsammlungen, Dresden. For more detailed information on the picture, see Sabine Rewald, *Caspar David Friedrich: Moonwatchers,* exh. cat., The Metropolitan Museum of Art, New York (New York, 2001), pp. 19, 34.
2. Börsch-Supan and Jähnig 1973, pp. 415–16 no. 366.
3. Ibid., pp. 356–57 no. 261.
4. Ibid., p. 433 no. 404.
5. Werner Busch, "Zu Verständnis und Interpretation romantischer Kunst," in Werner Busch et al., *Romantik,* Arte Fakten (Annweiler, 1987), pp. 19–29; expanded in Werner Busch, *Caspar David Friedrich: Ästhetik und Religion* (Munich, 2003), pp. 172–85.

WILHELM VON KOBELL

(1766–1853)

Born in Mannheim into a family of painters, Wilhelm von Kobell was first taught by his father, the court painter Ferdinand Kobell (1749–1799), then attended Mannheim's drawing academy, at the time under the influence of Dutch seventeenth-century painting. Early inspirations for Kobell included the animal pictures of Paulus Potter (1625–1654), Nicolaes Berchem (1620–1683), and Philips Wouwermans (1619–1683) and English "sporting prints," especially those depicting subjects of jockeys or hunters on horses. In 1792 Kobell became court painter to Elector Palatine Karl Theodor of Bavaria. In 1805 Maximilian I Joseph, king of Bavaria, commissioned Kobell to paint a cycle of seven paintings commemorating the Napoleonic Wars, which he completed in 1807; from 1807 to 1815 Kobell worked on another large cycle of battle pictures for Crown Prince Ludwig I. Kobell's friendship with Johann Georg von Dillis (1759–1841) helped him to discover the Bavarian landscape, and he moved away from the Dutch influence, becoming receptive to the effects of natural light and brighter colors. As Dillis's successor, he taught landscape painting at the Munich Academy from 1814 to 1826, but without much impact. Kobell's reputation rests on his small Begegnungsbilder *(encounter pictures) of 1815–25, in which landscape, figure, and animal staffage are closely linked.[1] His oeuvre extends, both in time and style, from the late Baroque to the end of Biedermeier, to whose development he contributed decisively from 1800 on, being, in fact, the main representative of this style in Munich.*

SR

NOTE

1. Siegfried Wichmann, *Wilhelm von Kobell: Monographie und kritisches Verzeichnis der Werke* (Munich, 1970), p. 72.

97. *A Huntsman and a Peasant Woman on the Isar with a View of Munich (Jäger und Bäuerin an der Isar mit Blick auf München)*

Oil on wood, 9⅞ × 8 in. (25.1 × 20.3 cm)
Signed and dated at lower right: W.Kobell 1823 [W and K in monogram].

PROVENANCE[1]
Major Corbett Winder, Vaynor Park, Berriew, Montgomeryshire; sale, Christie's, London, June 17, 1905, lot 25 (as "W. Kobell, 1823, Sportsmen on Horseback, and Other Figures—a pair, panel, 9½ × 7½ in., £ 14-3-6," to Kenderick, with pendant); sale, Sotheby's Parke-Bernet, New York, June 14, 1973, lot 353 (as "Two Riders in a Landscape and The Afternoon Ride: a Pair of Paintings," $75,000, to Spanierman, with pendant); [Ira Spanierman, New York and Germany]; Rudolf Heinemann, Lugano; [E. V. Thaw & Co., Inc., New York, with Artemis, Fine Arts Ltd., London, 1980]; E. V. Thaw sold the pendant, *Hunter and Lord at the River Isar with View of Munich*, to the Cleveland Museum of Art in 1981, and *A Huntsman and a Peasant Woman on the River Isar with View of Munich* to Mr. and Mrs. Charles Wrightsman, New York (1982–his d. 1986); Mrs. Wrightsman (from 1986).

LITERATURE
Siegfried Wichmann, "Zwei unbekannte Münchenansichten von Wilhelm von Kobell," *Weltkunst* 43 (August 1, 1973), p. 1209, ill.; Siegfried Wichmann, *Wilhelm von Kobell, 1766 bis 1853: Erster Nachtrag zum Verzeichnis der Werke* [first of two supplements to Wichmann, *Wilhelm von Kobell: Monographie und kritisches Verzeichnis der Werke* (Munich, 1970)] (Munich, 1973), no. 41, color ill.

PENDANT
CLEVELAND, Cleveland Museum of Art. Wilhelm von Kobell, *Hunter and Lord at the River Isar with View of Munich*, 1823 (fig. 1). Oil on wood panel, 9¾ × 8 in. (25 × 20.6 cm). Mr. and Mrs. William H. Marlatt Fund (1981.11).

RELATED DRAWING
MUNICH, Staatliche Graphische Sammlung (1697:261). Wilhelm von Kobell, *Study of a Horse*, ca. 1805 (fig. 2). Pencil on white paper, 5¾ × 5⅜ in. (14.7 × 13. 7 cm).

The Wrightsman picture and its pendant in the Cleveland Museum (fig. 1) are typical examples of the artist's small, jewel-like *Begegnungsbilder* (encounter pictures) that were coveted by the landed gentry and bourgeoisie. This painting presents the encounter between a huntsman, mounted on a black thoroughbred and accompanied by a white hunting dog (German Riesenbracke), and a young peasant woman, who wears the costume of the

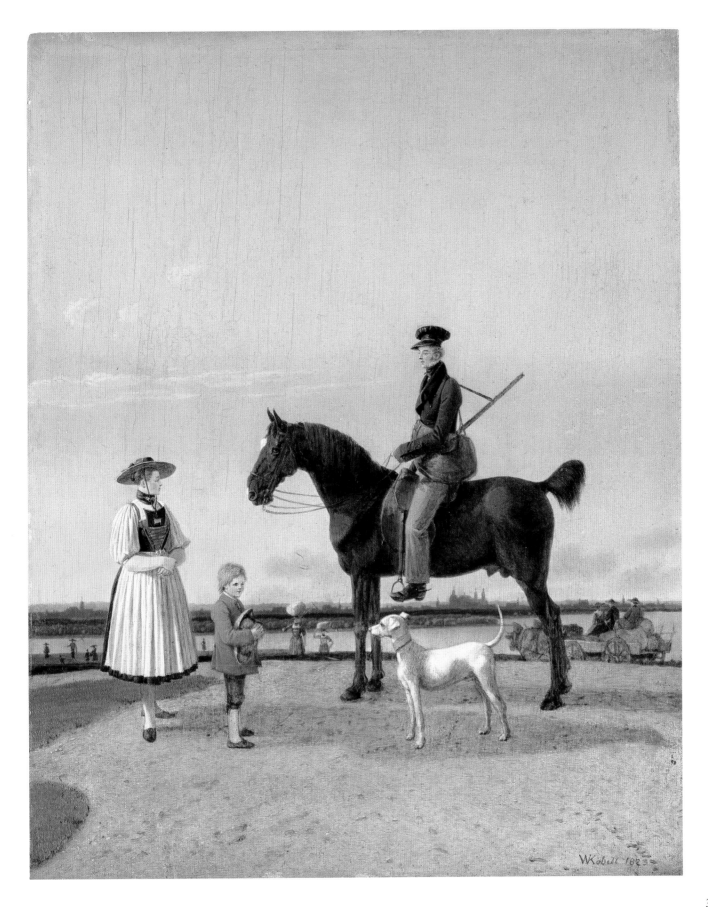

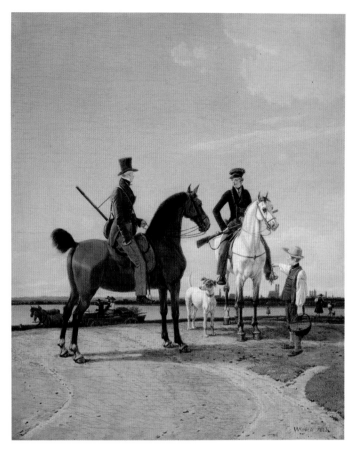

Fig. 1. Wilhelm von Kobell, *Hunter and Lord at the River Isar with a View of Munich*, 1823. Oil on wood, 9¾ × 8 in. (25 × 20.6 cm). Cleveland Museum of Art, Mr. and Mrs. William H. Marlatt Fund (1981.11)

Fig. 2. Wilhelm von Kobell, *Study of a Horse*, ca. 1805. Pencil on white paper, 5¾ × 5⅜ in. (14.7 × 13.7 cm). Staatliche Graphische Sammlung, Munich (1697:261)

Munich environs and is accompanied by a small boy. Figures and animals are motionless. Seen from slightly below, their large silhouettes rise against a blue sky that is traced by a few pink clouds. Their location on the elevated bank across the Isar offers a sweeping view toward the flat planes around Munich in the northwest and the city's skyline beyond. The towers of the Theatiner-Kirche rise just below the black horse's belly,[2] while the north tip of the Prater Island in the Isar is framed by the dog's tail. In the mid- and far distance peasants toil on the fields, carry ballasts on their heads, or sit in an oxen-drawn wagon with bundles of hay.

The Cleveland pendant, *Hunter and Lord at the River Isar with a View of Munich,* depicts the same elevated Isar bank, but its view captures Munich from slightly farther south.[3] In both pictures the sun casts long shadows on a still and translucent late summer afternoon in a serene and magical world.

The artist used his limited repertoire of figures, animals (fig. 2), and landscapes ingeniously. In only slight variations on the same theme, mounted horsemen, local peasants, or gentry usually meet in Kobell's favorite settings on the shore on the Tegernsee, with its view onto the foothills of the Barvarian Alps, or on the Isar bank, as here. Aptly described as "figural still lifes," these works hold a "fascination [that] results not so much from the charm of naïve simplicity as from the magic of the static."[4]

SR

NOTES

1. The provenance listing is taken from Roger Diederen, "Wilhelm (Alexander Wolfgang) von Kobell," in Louise d'Argencourt, with Roger Diederen, *European Paintings of the Nineteenth Century*, vol. 2, part 4, of *Catalogue of Paintings: Cleveland Museum of Art* (Cleveland, 1999), pp. 380–82.
2. Today this southern bank of the Isar is part of the Maximiliananlagen, a parklike setting right in the center of Munich, through which the river runs from south to north.
3. Diederen, "Wilhelm (Alexander Wolfgang) von Kobell," pp. 380–82.
4. Hinrich Sieveking, *Fuseli to Menzel: Drawings and Watercolors in the Age of Goethe from a German Private Collection,* exh. cat., Busch-Reisinger Museum, Cambridge, Massachusetts, The Frick Collection, New York, and J. Paul Getty Museum, Los Angeles (New York, Munich, and Cambridge, Massachusetts, 1998), p. 170.

PIERRE DUVAL LE CAMUS

(1790–1854)

Little is known about the minor painter Pierre Duval le Camus, even though he exhibited prolifically at the Salon from 1819 to 1853. A pupil of Jacques-Louis David (see p. 255),[1] he won a second-class medal for his two exhibits of 1819, A Baptism (whereabouts unknown)[2] and Two Veterans Playing Piquet, Scene Taken at the Invalides (Detroit Institute of Arts). In 1827 he garnered a first-class medal, and in 1837 he was made a chevalier of the Legion of Honor. Since he did not practice history painting, there is little critical record of his work. Nonetheless, he enjoyed a considerable reputation for genre painting, which became fashionable under the Restoration, and he was patronized by the prominent collector in this category, Marie-Caroline de Bourbon-Sicile, duchesse de Berry (1798–1870). When David's Death of Socrates was exhibited at Le Musée Classique de Bazar Bonne-Nouvelle in 1846, Baudelaire paid Duval le Camus a backhanded compliment: "The Death of Socrates is an admirable composition that everyone recognizes, but the appearance has something common about it that reminds one of M. Duval-Lecamus (père). Let the ghost of David pardon us!"[3]

Duval le Camus has been included among the exponents of genre painting in France who "reflected the rise of a painterly realism, tinged with romantic sentiment," exemplified by Martin Drölling's 1815 Kitchen Interior (Musée du Louvre), exhibited at the Salon of 1817.[4] Perhaps Louis-Léopold Boilly (see p. 282) is better considered the primary artist in this field, and Duval le Camus may be thought to follow in Boilly's footsteps. Although the interest of French painters in Dutch and Flemish prototypes was no doubt stimulated by pictures exhibited in Paris under the Directoire and Empire, much of it war booty, throughout the eighteenth century there had always been an undercurrent of Dutch and Flemish influence in French genre painting.

For some years Duval le Camus was mayor of Saint-Cloud. Later he played a leading role in conceiving and enriching the Musée d'Art et d'Histoire in his hometown of Lisieux (Calvados), which owns some of his paintings.[5] Duval le Camus's son Jules-Alexandre (1814–1878) also became a painter; he studied with Delaroche and Drölling and placed second for the Prix de Rome in 1838.

GT/AEM

NOTES

1. Étienne-Jean Delécluze, *Louis David: Son école et son temps* (1855; repr. Paris, 1983), p. 415.
2. A drawing after the painting, attributed to Duval le Camus, is in the album titled *Collection de 43 dessins des principaux tableaux de l'exposition au Musée Royal de France, année 1819* (Frick Art Reference Library, New York).
3. "*La Mort de Socrate* est une admirable composition que tout le monde connaît, mais dont l'aspect a quelque chose de commun qui fait songer à M. Duval-Lecamus (père). Que l'ombre de David nous pardonne!" Charles Baudelaire, *Oeuvres complètes*, ed. Claude Pichois, 2 vols. (Paris, 1975–76), vol. 2, p. 410. Elsewhere, in his *Salon of 1845*, Baudelaire, quoting the poet Nicolas Boileau (1636–1711), wrote two relatively complimentary lines of verse about him: "[Il] Sait d'une voix légère / Passer du grave aux doux, du plaisant au sévère" ([He] has a light voice / to pass from serious to sweet, from pleasant to severe); ibid., p. 384.
4. Lorenz Eitner, "The Open Window and the Storm-Tossed Boat: An Essay in the Iconography of Romanticisim," *Art Bulletin* 37 (December 1955), p. 283 n. 5.
5. See Fernand de Mély and Anatole de Montaiglon, "Musée de Lisieux (Calvados)," in *Inventaire général des richesses d'art de la France, Province, Monuments civils*, vol. 6 (Paris, 1892), pp. 235–38ff.

98. André Jolivard Seated in a Landscape

Oil on canvas, 12⅞ × 9⅝ in. (32.7 × 24.4 cm)
Inscription reportedly on back of original frame, but presumably on back of original canvas: "Andre Jolivard, le peintre / mon gd oncle maternel." Remains of red wax seal.

PROVENANCE
Reportedly descended through the family of the sitter (sold to Spink); [Spink and Son, London, by 1978; sold in April to Hazlitt]; [Hazlitt, Gooden & Fox, London, 1978; sold to Wrightsman]; Mr. and Mrs. Charles Wrightsman, New York (1978–his d. 1986); Mrs. Wrightsman (from 1986).

André Jolivard (1787–1851) was a landscape painter and printmaker from Le Mans. Prior to choosing a career in painting, he had moved to Paris to study law but joined Napoleon's Leipzig campaign of 1813 and completed his art studies upon his return, with Jean-Victor Bertin (1767–1842). He began to exhibit at the Salon in 1816 and won a first-class medal in 1827. In 1835 he was made a chevalier of the Legion of Honor, and Louis-Philippe purchased his *Cour de ferme* (Musée du Louvre 5458) at the Salon that year. A posthumous sale of his atelier was held at Ridel, Paris, January 26–28, 1852. In their brief description of his work, Le Feuvre and Alexandre wrote that Jolivard was "comparable to some extent to Bidault and to the naturalist painters who, at the beginning of the nineteenth century, reacted against [the genre of] historical landscapes."[1]

As seen here, Jolivard's costume indicates a date in the late 1820s or the early 1830s. A personal connection between painter and sitter must lay behind Jolivard's gift of his painting *Paysage, Vue des collines de Saint-Cloud* (1834), on the occasion of its inaugural exhibition, to the museum Duval le Camus founded in Lisieux.[2]

GT / AEM

NOTES

1. "comparable dans une certaine mesure à Bidault et aux peintres naturalistes qui, au commencement du XIXᵉ siècle, réagirent contre le paysage historique." Arsène Le Feuvre and Arsène Alexandre, *Catalogue du Musée des Arts: Peinture, sculpture, dessins, gravures, objets d'art,* Musée de Tessé (Le Mans, 1932), p. 36.
2. *Explication des ouvrages de peinture, aquarelle, gravure et sculpture des artistes vivants, exposés au Musée de Lisieux, le 10 juin 1838,* exh. cat., Musée de Lisieux (Lisieux, 1838), no. 170, as cited in Fernand de Mély and Anatole de Montaiglon, "Musée de Lisieux (Calvados)," in *Inventaire général des richesses d'art de la France, Province, Monuments civils,* vol. 6 (Paris, 1892), p. 244.

ÉDOUARD-HENRI-THÉOPHILE PINGRET

(1788–1875)

Édouard-Henri-Théophile Pingret, a student of Jean-Baptiste Regnault (1754–1829) and of David (though not mentioned by Delécluze in his history of David's studio; see p. 255), was a painter of portraits, history, genre scenes, and landscape. He exhibited at the Salon regularly from 1810 to 1867 and received the Legion of Honor in 1839. Although he is included in the standard biographical dictionaries of artists, there is no monograph devoted to him, nor is he mentioned more than in passing in surveys devoted to his time.[1] He worked in London in 1819, and, from 1850 to 1855, in Mexico City, where his late Neoclassical finish inspired several Mexican painters, among them Agustin Arrieta (1802–1874), who sought to emulate European standards of portraiture.[2] Pingret's self-portrait of 1854 (fig. 1) shows him working outdoors before Mexico City, with Popocatépetl, one of the volcanoes that rings the city, beyond.[3] While not well known for his plein-air paintings, he belonged to the generation of Romantic painters that popularized painting directly from nature and contributed lithographs to several of the voyage pittoresque projects that proliferated in France from the 1820s through the 1860s.[4] Pingret's brief autobiographical remarks, dated 1827, were published in 1862.[5]

GT / AEM

NOTES

1. For example, Léon Rosenthal, *Du Romantisme au Réalisme: Essai sur l'évolution de la peinture en France de 1830 à 1848*, new ed., ed. Michael Marrinan (1914; Paris, 1987).
2. Xavier Moysssén, in *The Dictionary of Art*, ed. Jane Turner (New York, 1996), vol. 24, p. 823; see also Luis Ortìz Macedo, *Edouard Pingret: Un pintor romántico francés que retrató el México del mediar del siglo XIX* (Mexico City, 1989).
3. The view is identifiable by comparison with Henry George Ward's *Mexico: From the Azotea of the House of H.M.'s Mission, San Cosme*, the frontispiece of his book *Mexico* (London, 1829). Thanks to Ross Day for bringing this source to the authors' attention.
4. See Jean Adhémar, "Les lithographies de paysages en France à l'époque romantique," *Archives de l'art français*, n.s., 19 (1935–37; pub. 1938), nos. 41, 87, 170, 371, 488, 592.
5. "Pingret, peintre: Notes par lui-même," in "Autobiographies d'artistes contemporaines," ed. Paul Lacroix, *Revue universelle des arts* 15 (1862), pp. 33–40.

99. *Portrait of Two Young Men*

Oil on canvas, 16 × 13 in. (40.6 × 33 cm)
Signed and dated at lower left: Ed. Pingret. 1830. Stamped on the back of the canvas, in black: ALPH / GIROUX / A PARIS (in a circle). Sticker on the back of the frame, printed in red and inscribed in black: CHENUE / Emballeur / M. Emile Delgarde / 105 [] St. Honoré / 5, Rue de la Terrasse PARIS (oval).

PROVENANCE

?Emile Delgarde, Paris; private collection (until 1976; to Hazlitt); [The Hazlitt Gallery, London, 1976–77; sold to Wrightsman]; Mr. and Mrs. Charles Wrightsman, New York (1977–his d. 1986); Mrs. Wrightsman (from 1986).

EXHIBITED

Musée Royal, Paris, Salon of 1831, no. 1688.

LITERATURE

Ambroise Tardieu, "Salon de 1831," in C. P. Landon, *Annales du musée et de l'école moderne des beaux-arts; ou, Receuil des principaux tableaux . . .* (Paris, 1831), p. 149; *Explication des ouvrages de peinture, lithographie et architecture des artistes vivans [sic], exposés au Musée Royal, le 1ᵉʳ mai 1831* (Paris, 1831), no. 1688 (as "Portraits de deux frères"), reprinted in *Catalogues of the Paris Salon, 1673 to 1881*, comp. H.W. Janson (New York and London, 1978), vol. [18], p. 131, no. 1688.

In London from March to September 1819, Pingret painted, in his own words, "between eighty and one hundred portraits in oil, many full-length and of quite well-known sitters."[1] Travel to Britain became possible for a Frenchman of Pingret's generation only after the definitive defeat of Napoleon in 1815 by the British and their allies. Ironically, all things British became fashionable in France, and French artists were lionized in London. Pingret, like Géricault, Delacroix, and Horace Vernet (see pp. 330, 334, 326), quickly took advantage of all that London had to offer, including new models for informal portraiture. The present picture has all the British qualities taken up by French painters—such as the placement of figures in landscape, informal poses, and fluent brushwork—epitomized, in Britain, by Thomas Lawrence (1769–1830), and in France, by Eugène Delacroix. Pingret's campaign in London indicates that by the age of thirty he had acquired the skill to seize likenesses quickly and finish pictures expeditiously.

Fig. 1. Édouard-Henri-Théophile Pingret, *Self-Portrait*, 1854. Oil on canvas, 39¼ × 31¾ in. (99.7 × 80.6 cm). Private collection

Fig. 2. Édouard-Henri-Théophile Pingret, *Portrait of a Man at the Coast, Normandy*, 1831. Private collection

Pingret showed at least seven paintings at the Salon of 1831, where he won a second-class medal for *Un Baptême, Costumes alsaciennes* (nos. 1683–1689; the last item included various portraits listed under the same number). This picture was exhibited as a portrait of "two brothers"; they remain unidentified. Indeed, the only portrait exhibited by Pingret at the 1831 Salon in which the sitter was named was that of Paganini (no. 1687; whereabouts unknown), who had performed in Paris in early 1831; no doubt the artist sought to capitalize on the violinist's renown.[2] *Un Baptême, Costumes alsaciennes* (no. 1683) was engraved by Charles Normand *fils* and included as plate 60 in C. P. Landon's *Salon de 1831,* where the description by Ambroise Tardieu contains a postscript that reads "M. Pingret has exhibited some very nice full-length portraits, a genre in which he rivals MM. Duval-le-Camus, Roqueplan and Lepaulle."[3]

Pingret was in his prime, and very close to the Romantic current, in the years around 1830; although much smaller, the present portrait is similar in effect to Delacroix's *Portrait of Louis-Auguste Schwiter* (ca. 1826; National Gallery, London), which had been rejected at the Salon of 1827, the last held before 1831. Henri

Decaisne's *Portrait of La Malibran as Desdemona* (1830; Musée Carnavalet, Paris), also shown at the 1831 Salon, was, like Pingret's portraits, heavily indebted to British prototypes.

It is possible that the brothers are wearing school uniforms, although similarly contrived costumes can be found in fashion plates of the day. The mountains and river visible in the background have not been identified. Another portrait by Pingret, also dated 1831, shows a sitter standing before a Normandy coastline (fig. 2).

GT / AEM

NOTES

1. "Pingret, peintre: Notes par lui-même," in "Autobiographies d'artistes contemporaines," ed. Paul Lacroix, *Revue universelle des arts* 15 (1862), p. 34.
2. In his entry on Delacroix's portrait of Paganini, Lee Johnson mentions other contemporary depictions of the violinist; see *The Paintings of Eugène Delacroix: A Critical Catalogue,* 6 vols. (Oxford, 1981–90), vol. 1, pp. 65–67 no. 93, and vol. 2, pl. 79.
3. "M. Pingret a exposé de très-jolis portraits en pied, genre dans lequel il rivalise avec MM. Duval-le-Camus, Roqueplan et Lepaulle." Ambroise Tardieu, "Salon de 1831," in C. P. Landon, *Annales du musée et de l'école moderne des beaux-arts; ou, Receuil des principaux tableaux . . .* (Paris, 1831), p. 149.

THÉODORE CHASSÉRIAU

(1819–1856)

Painter and printmaker Théodore Chassériau was born on the island of Santo Domingo; at the age of three he moved with his family to Paris. A precocious draftsman—his portrait drawings are very close in style to those of Ingres (see p. 292)—he entered the master's studio at the age of eleven and remained there until Ingres left to take up the directorship of the Académie de France in Rome in 1834. Chassériau made his Salon debut in 1836, and in 1840–41, by which time he had begun to feel the sway of Delacroix (see p. 334), he joined Ingres in Rome. His greatest graphic achievement was the portfolio of etchings illustrating Othello (1844). A trip to Algeria in 1846 gave him firsthand experience of Orientalist subjects that he had already begun to explore in his art. Chassériau's premature death, followed by the destruction by fire in 1871 of his most ambitious program, the murals allegorizing War and Peace made for the grand staircase of the Cour des Comptes in the Palais d'Orsay (1844–48), cut short the immediate influence his talent promised.

GT/AEM

Abbreviations

Paris, Strasbourg, New York 2002–2003. Stéphane Guégan, Vincent Pomarède, Louis-Antoine Prat, Gary Tinterow et al. *Théodore Chassériau (1819–1856): The Unknown Romantic.* Exh. cat., Galeries Nationales du Grand Palais, Paris, Musées des Beaux-Arts, Strasbourg, and The Metropolitan Museum of Art, New York; 2002–2003. New York and New Haven, 2002.

Prat 1988a. Louis-Antoine Prat. *Dessins de Théodore Chassériau, 1819–1856.* 2 vols. Musée du Louvre, Cabinet des Dessins. Inventaire général des dessins, École francaise. Paris, 1988.

Prat 1988b. Louis-Antoine Prat. *Théodore Chassériau, 1819–1856: Dessins conservés en dehors du Louvre.* Cahiers du dessin français 5. Paris, 1988.

Sandoz 1974. Marc Sandoz. *Théodore Chassériau, 1819–1856: Catalogue raisonné des peintures et estampes.* Paris, 1974.

100. *Portrait of Comtesse de La Tour-Maubourg, née Marie-Louise-Charlotte-Gabrielle-Thomas de Pange (1816–1850)*

Oil on canvas, 52 × 37 ¼ in. (132.1 × 94.6 cm)
Signed and dated at lower left: T. Chassériau / Rome 1841.
The Metropolitan Museum of Art, New York, Wrightsman Fund, 2002 (2002.29)

Provenance
Presumed gift of the comte de La Tour-Maubourg to his mother-in-law, the comtesse de Pange (1841); subsequently descended in the family of the sitter; her daughter, Gabrielle-Marie-Charlotte de La Tour-Maubourg, who married baron Gustave de Mandell d'Écosse; their son, Fernand-Guillaume de Mandell d'Écosse, called the marquis de La Tour-Maubourg (after 1892); the marquise de La Tour-Maubourg, Château de Locguénolé, Kervignac, Morbihan, Brittany; her daughter, Marguerite, later Mme de la Sablière; sale, Sotheby's, Paris, June 27, 2002 (lot 165, to the Metropolitan Museum); purchased in 2002 with a gift from the Wrightsman Fund by the Metropolitan Museum.

Exhibited
Salon of 1841, Paris, no. 328; Musée de l'Orangerie, Paris, 1933, "Chassériau, 1819–1856," no. 16.

Literature
Proceedings of the seventh and eighth sessions of the jury of the Salon of 1841, Archives des Musées Nationaux, Paris, document no. *KK.58 (no. 1913); Anonymous, "Salon de 1841," *Le siècle,* 1841; Cantagrel, "Salon de 1841," *La phalange,* May 30, 1841; Étienne-Jean Delécluze, "Salon de 1841," *Journal des débats,* May 29, 1841; Théophile Gautier, "Le Salon de 1841," *Revue de Paris* 28 (April 28, 1841), pp. 164–65; Prosper Haussard, "Salon de 1841," *Le temps,* May 21, 1841; U. Ladet, "Salon de 1841," *L'artiste,* 2nd ser., 7 (1841), p. 332; Louis Peisse, "Le Salon de 1841," *La revue des deux mondes,* 4th ser., 26 (April 1, 1841), p. 43; Eugène Pelletan, "Salon de 1841," *La presse,* April 4 and June 3, 1841; Fabien Pillet, "Salon de 1841," *Le moniteur universel,* March 22, 1841; Anonymous, "Salon de 1842," *L'artiste,* 3rd ser., 1 (1842), p. 194; Anonymous, "De la peinture religieuse monumentale," *Journal des artistes* 2 (1845), pp. 17–19; Armand Baschet, "Les ateliers de Paris en 1854—M. Chassériau," *L'artiste,* 5th ser., 12 (June 1, 1854), p. 135; Paul Mantz, "Théodore Chassériau," *L'artiste,* 6th ser., 2 (October 19, 1856), p. 222; Émile Bellier de la Chavignerie and Louis Auvray, *Dictionnaire général des artistes de l'école française depuis l'origine des arts du dessin jusqu'à nos jours* (1882–87; repr. New York and London, 1979), vol. 1, p. 237; Aglaüs Bouvenne, "Théodore Chasseriau," *L'artiste,* September 1887, p. 175; Valbert Chevillard, *Un peintre romantique: Théodore Chassériau* (Paris, 1893), pp. 46–49, 51–52, 276 no. 60; Auguste Dalligny, "Peintres français: Théodore Chassériau," *Journal des arts,* no. 2 (January 10 and 13, 1894), pp. 1–2; Valbert Chevillard, "Théodore Chassériau," *Revue de l'art ancien et moderne* 3 (March 10, 1898), pp. 251–52; Henry Marcel and Jean Laran, *Chassériau,* L'art

de notre temps (Paris, 1911), pp. 55–56; Jean Laran, "Un portrait inédit par Chassériau," *Archives de l'art français*, n.s., 8 (1914; pub. 1916), pp. 320–28, ill.; Paul Jamot, "Le don Chassériau au Musée du Louvre," *La revue de l'art ancien et moderne* 37 (February 1920), pp. 68–69; Lloyd Goodrich, "Théodore Chassériau," *Arts* 14 (August 1928), pp. 68–71, ill.; Léonce Bénédite, *Théodore Chassériau: Sa vie, son oeuvre*, 2 vols. (Paris, [1931]), vol. 1, pp. 139–40, 142, 150, 154, 157, ill., 158–60; Jean-Louis Vaudoyer, "Chassériau's portraits," *Formes*, no. 25 (May 1932), ill. opp. p. 272; Jean Alazard, "Théodore Chassériau," *Gazette des beaux-arts*, 6th ser., 9 (January 1933), pp. 49–51, fig. 3; Paul Jamot, "Théodore Chassériau," in *Les beaux-arts: Études et documents* (Paris, 1933), p. 21; Solange Joubert, ed., *Une correspondance romantique: Madame d'Agoult, Liszt, Henri Lehmann* (Paris, 1947), pp. 138, 144–45, 156, 164, 168–69; Marc Sandoz, "En l'honneur de Théodore Chassériau," *Les cahiers de l'ouest*, no. 13 (September 1956), pp. 19–20; Marc Sandoz, "Théodore Chassériau (1819–1856) et la peinture des Pays-Bas," *Bulletin des Musées Royaux des Beaux-Arts de Belgique* 17 (1968), p. 182; Sandoz 1974, pp. 186–87 no. 87, pl. 70; Jean-François Méjanès, in *Ingres et sa postérité jusqu'à Matisse et à Picasso*, exh. cat., Musée Ingres, Montauban (Montauban, 1980), p. 96 under no. 144; Marie-Madeleine Aubrun, *Henri Lehmann, 1814–1882: Catalogue raisonné de l'oeuvre* (Paris, 1984), vol. 1, p. 20; François-Xavier Amprimoz, "Lettres de Dominique Papety à ses parents et ses amis, Rome, 1837–1842," *Archives de l'art français*, n.s., 28 (1986), see pp. 263, 264 n. 1, letter 58; Marc Sandoz, *Portraits et visages dessinés par Théodore Chassériau*, vol. 2 of *Cahiers Théodore Chassériau* (Paris, 1986), pp. 24, ill., 25 under no. 13; Prat 1988a, vol. 1, pp. 89–91 under nos. 87–92, ill., and vol. 2, pp. 864–65 under no. 2240, fols. 19v–20v; Christine Peltre, *Théodore Chassériau* (Paris, 2001), pp. 87–89, fig. 98, 190, 246; Paris, Strasbourg, New York 2002–2003, pp. 20, 38, 39, 63, 104 under no. 31, 116 and 118 under no. 47, 118–19 under no. 48, 122 under no. 52, 122 and 124 under no. 53, 179–81 in the Chronology, 402–5; Carol Vogel, "Inside Art: A Retrospective That's a First," *New York Times*, October 18, 2002, p. E32, ill.

DRAWINGS

PARIS, Musée du Louvre. Eight studies that were in the artist's studio at the time of his death:

RF 26083 [sketchbook] fol. 19v. *Standing Woman in a Landscape, Three-Quarter View from the Left, Partially Repeated* (fig. 1). Pen and brown ink on buff paper, 5⅝ × 8⅜ in. (14.2 × 21.2 cm). Prat 1988a, no. 2240 fol. 19v.

RF 26083 [sketchbook] fol. 20r. *Standing Woman, Seen Almost Directly, Arms Crossed*. Pen and brown ink and graphite on buff paper, 5⅝ × 8⅜ in. (14.2 × 21.2 cm). Prat 1988a, no. 2240 fol. 20r.

RF 26083 [sketchbook] fol. 20v. *Standing Woman in a Landscape*. Graphite with touches of white heightening on buff paper, 5⅝ × 8⅜ in. (14.2 × 21.2 cm). Prat 1988a, no. 2240 fol. 20v.

RF 26.107. *Study of Leaves and Compositional Sketch for the Portrait*. Graphite on blue paper, 12¾ × 9⅜ in. (32.3 × 23.7 cm), mounted to fol. 6v of *Album Factice* 1. Prat 1988a, no. 90.

RF 26.108. *Study of Trees and Plants*. Graphite on blue paper, 12⅝ × 9½ in. (32 × 24.1 cm), mounted to fol. 7v of *Album Factice* 1. Prat 1988a, no. 91.

RF 26.114. *Dress Study* (fig. 3). Graphite and white heightening on cream paper, 11⅜ × 8⅞ in. (28.8 × 22.4 cm), mounted to fol. 11r of *Album Factice* 1. Prat 1988a, no. 88.

RF 26.488. *Standing Figure, Almost Three-Quarter View, with Two Head Studies* (fig. 2). Graphite on buff paper, 11⅞ × 6⅜ in. (30.3 × 16.2 cm), mounted to fol. 42r of *Album Factice* 3. Prat 1988a, no. 87.

RF 26.511. *Study of Hands and Arms, Neck, and Dress* (fig. 4). Graphite and touches of oil on blue paper, 12⅜ × 9⅜ in. (31.6 × 23.7 cm), mounted to a fragment of fol. 49v of *Album Factice* 3. Prat 1988a, no. 89.

Chassériau arrived in Rome in August 1840 with the painter Henri Lehmann (1814–1882), a fellow student of Ingres who was vying with him to be the master's favorite pupil. On the trip south, Lehmann confided that he hoped to portray Dominique Lacordaire (1802–1861), the charismatic French priest who had revived the Dominican order. To Lehmann's everlasting chagrin, Chassériau won permission to paint the priest instead. Luckily for Chassériau, the wife of the French ambassador in Rome, the comtesse La Tour-Maubourg, visited his studio on November 21 to see the portrait of Father Lacordaire, and she admired it greatly.[1]

Chassériau described this encounter and subsequent developments in a letter written to his brother Frédéric (1807–1881) two days later. Of the negotiations that took place the prior day, he stated that the ambassador was ill and confined to his bed but still managed to bargain the price down from 2,500 francs; he wrote, "[W]ith that the husband, who wants to give a present without ruining himself, painfully turned in his bed and said that I was too expensive, that I had enough talent to be [expensive], that he was sorry, but that he did not want to pay more than 1,000 francs." Terms notwithstanding, Chassériau exulted in the commission, bragging that the countess was "a woman beautiful like an angel," adding that she was "very sweet and perfectly elegant. M. Ingres was jealous when I told him that I was painting her." Indeed, work proceeded without delay: "Since yesterday I have been installed at the Palazzo Colonna, where the ambassador lives. We met yesterday and get along very well."[2]

Once again, Lehmann vainly aspired to win the commission. He wrote to his confidant Marie d'Agoult (1805–1876) of his hope to take a stab at a portrait of the ambassador's wife, "but as Chassériau is doing her portrait it would have been most inappropriate."[3] When the painting was completed, Ingres, out of professed solidarity with Lehmann, refused to see it. Lehmann reported to d'Agoult on January 16, 1841, "M. Ingres had a marvelous intuition [against Chassériau] that, as a good friend, I fought with all my power, but which [now] I have to acknowledge. He did not even go to see the portrait of the ambassador's wife, although M. de Latour Maubourg had expressly asked him to, and although I had told him that I found this utterly harsh and unfair, and that he owed this to Chassériau as his student. In short, he really mistreated him." The jealous Lehmann could not resist taking a swipe and continued, "[T]he one of the ambassador's wife is weak beyond words, she is like a little sheep who dreams of the taste of the flowers of the surrounding countryside—and she

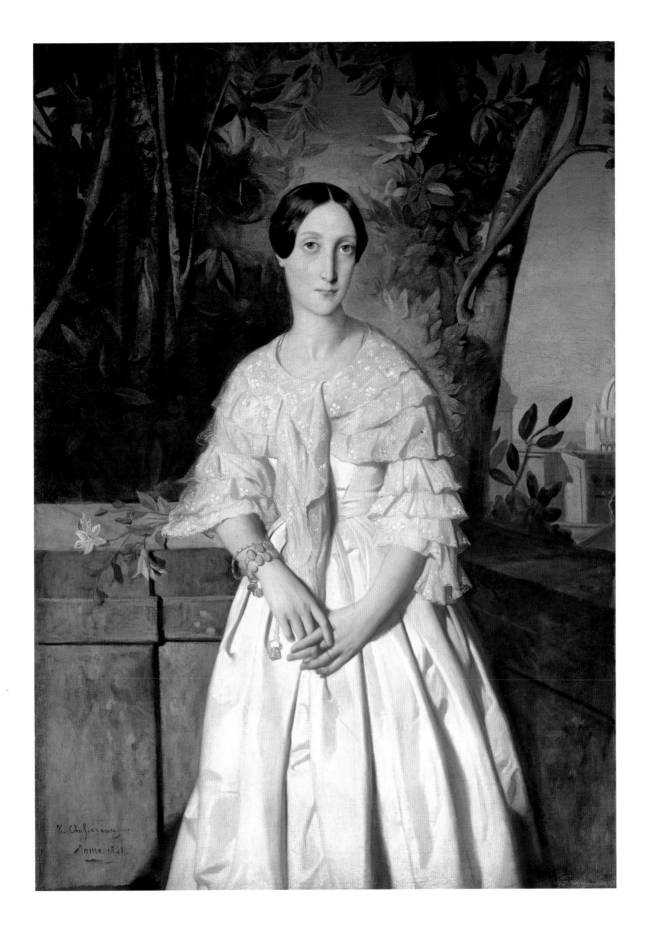

Fig. 1. Théodore Chassériau, *Standing Woman in a Landscape, Three-Quarter View from the Left, Partially Repeated*. Pen and brown ink on buff paper, 8 ³⁄₈ × 5 ⁵⁄₈ in. (21.2 × 14.2 cm). Musée du Louvre, Paris (RF 26083 fol. 19v)

Fig. 2. Théodore Chassériau, *Standing Figure, Almost Three-Quarter View, with Two Head Studies*. Graphite on buff paper, 11 ⁷⁄₈ × 6 ³⁄₈ in. (30.3 × 16.2 cm). Musée du Louvre, Paris (RF 26.488)

Fig. 3. Théodore Chassériau, *Dress Study*. Graphite and white heightening on cream paper, 11 ³⁄₈ × 8 ⁷⁄₈ in. (28.8 × 22.4 cm). Musée du Louvre, Paris (RF 26.114)

looks as if she has already been grazing. It is badly drawn, badly painted (except for some very subtle color relationships—of the hands with the dress, the sky with with earth, etc. . . .), not a very good likeness, in short, the mistake of a man of talent."[4]

The extant preparatory drawings (figs. 1–4) are now in the Louvre. They show that from the beginning Chassériau conceived the countess standing with a parasol in her garden at the Palazzo Colonna. In some sheets the countess is posed at an angle to the picture plane, with her head turned sharply toward her left shoulder, her right shoulder fading from view. In one (fig. 1), the corners of the composition are rounded, conforming to the fashion for lozenge-shaped frames, and the initial composition as a whole smacks strongly of the theatrically staged portraits of the Romantic era. The long-sleeved day dress found in the first drawings was changed to a more formal, short-sleeved costume, without parasol, in a subsequent effort (fig. 2), in which the countess turns her head to her right.

Having made only a few preparatory drawings, Chassériau continued to improvise the composition directly on the canvas, bringing it closer to the classicizing conventions of Ingres's por-

traits while avoiding the master's approach of transferring an already finished design to the canvas. Examination of the painting under infrared light shows that he made further adjustments after he had lightly sketched the figure in pencil onto the ocher-buff ground. Although the figure initially faced the spectator directly, pentimenti reveal that Chassériau modified the position of the head and hands, the necklace, the contours of the dress, and the height of the parapet at right. Figure 3 is a fine study of the dress, while figure 4 details the exquisite hands with interlaced fingers. The confident elaboration of the portrait directly on the canvas would be remarkable in the work of any artist, but it becomes astonishing when one considers that the painter was only twenty-two years old.

With its ivory satin and lace flounces at the half sleeves, the countess's dress represented up-to-the-minute Paris fashion at its most elegant and refined. The absence of strong color and contrast shows sophistication and restraint, as does the choice of modest jewelry. The short sleeves indicate that the costume was worn in the late afternoon, perhaps to receive visitors (long sleeves were the custom for morning and noon); the absence of hat,

Fig. 4. Théodore Chassériau, *Study of Hands and Arms, Neck, and Dress*. Graphite and touches of oil on blue paper, 12⅜ × 9⅜ in. (31.6 × 23.7 cm). Musée du Louvre, Paris (RF 26.511)

purse, and gloves indicates that the countess is at home. Out of modesty, she wears a matching lace fichu to cover her décolletage and to protect her from Rome's cool autumn breezes. The realization of the dress is a tour de force of subtly nuanced tonal variation that even detractors like Lehmann were forced to acknowledge.

The view[5] Chassériau depicted was taken from the back corner of the garden at the Palazzo Colonna, two blocks from the bottom of the Corso (near the Piazza Venezia), facing southeast. Beyond the countess we see the domes of two churchs in Trajan's Forum, Santa Maria di Loreto (1508) and Santissima Nome di Maria (1738); Trajan's column, though not visible, is nearby. The top of the Coliseum, dark ocher in the light of sunset, is at the horizon.

When the portrait was shown at the 1841 Salon, its reception was generally unfavorable. Ingres's partisans seem to have been fully aware of the rift between master and student, and what they objected to were precisely the Romantic qualities of the picture—the expressive elongation of the head, the gazelle-like eyes, the pallor of the skin, the delicacy of the hands—all of which seem so remarkable today. Delécluze wrote of the lack of strength and

life in Chassériau's work; an anonymous reviewer in *L'artiste* wrote of the "pale image of a woman, silhouetted against pale foliage, the shadow of a shadow";[6] still others used words like "spectral" and "sepulchral" to describe the mood.

A few critics, however, understood the picture in more sympathetic terms. As Eugène Pelletan wrote, "we have heard the criticism of the portrait of M. Lacordaire and of Mme de La Tour-Maubourg. We are not laughing at the faults of these two portraits[;] we are fortunate to find them in an artist: they represent the excess of talent."[7] At Chassériau's death fifteen years later, Paul Mantz summed up the reaction to the picture: "The austerity of execution and the dryness of the rigid silhouette of the portrait of the comtesse de La Tour-Maubourg frightened Parisians. Strange in effect—a sort of phantom of sepulchral whites that seemed to be enveloped in lace as if in a shroud—the fiery comehither eyes and transparent pallor nevertheless allowed one to guess the radiance of the countess's inner lamp."[8]

Needless to say, the countess, in Rome and with child during the showing of the Salon in spring 1841, heard of the torrent of opinion heaped upon her portrait. Ingres's disciple Dominique Papety (1815–1849) communicated gleefully to the sculptor Auguste Ottin (1811–1890), "Mme de Maubourg (who is pregnant) is furious with Chassériau; he has lost all favor and it is us who will replace him."[9]

GT

NOTES

This entry has been adapted from my text in Paris, Strasbourg, New York 2002–2003.

1. Marie-Louise-Charlotte-Gabrielle-Thomas de Pange was born to a noble family in 1816. In 1837 she became the second wife of Armand-Charles-Septime de Fay, comte de La Tour-Maubourg (1801–1845), who came from a distinguished family of generals and ministers of war. A lifelong diplomat, he was posted as an attaché in Constantinople in 1823, Lisbon in 1826, and Hanover in 1827. Resigning after the 1830 revolution, he was reinstated by the government of Louis-Philippe and sent to Vienna. He served in Brussels in 1832 and Madrid in 1836, before being named ambassador to Rome in 1837 to succeed his older brother, the marquis, who had just died in office. Together, the La Tour-Maubourgs had two daughters. Until recently the identity of one of them was confused with that of her mother, whose maiden name was first published by Jean Laran in 1916 as Charlotte de Pange, and which has recently been given as Marie-Louise-Gabrielle; one daughter was called Gabrielle-Marie-Charlotte, and the confusion may stem from that (*Dictionnaire de biographie française* [Paris, 2000], pt. 113, p. 57). The count died in Marseilles in 1845, and his widow died in Pau five years later; they are both buried in Marseilles. Jean Laran, "Un portrait inédit par Chassériau," *Archives de l'art français*, n.s., 8 (1914; pub. 1916), p. 323.

2. "Là-dessus, le mari, qui veut faire un cadeau sans se ruiner, s'est agité douloureusement sur son lit et a dit que j'étais trop cher, que j'avais assez de talent pour l'être, qu'il était désolé, mais qu'il ne voulait pas donner plus de mille francs. [. . .] [U]ne femme belle comme un ange [. . .] très douce et parfaitement élégante. M. Ingres m'a envié quand je lui ai dit que je la peignais [. . .] Je suis donc fort bien installé pour peindre, depuis hier, au palais Colonna où demeure l'ambassadeur. Nous avons fait connaissance hier et nous sommes très bien." Letter from Théodore Chassériau to his brother Frédéric dated November 23, 1840; Valbert Chevillard, *Un peintre romantique: Théodore Chassériau* (Paris, 1893), pp. 46–50.

3. "[J]e désirais surtout aller chez eux [the La Tour-Maubourgs] dans l'espoir de faire deux portraits de l'ambassadrice que je trouve très jolie; mais comme Chassériau fait son portrait c'eût été mal à propos." Letter from Henri Lehmann to Marie d'Agoult dated December 16, 1840; Solange Joubert, ed., *Une correspondance romantique: Madame d'Agoult, Liszt, Henri Lehmann* (Paris, 1947), p. 138.

4. "M. Ingres a eu une intuition merveilleuse que j'ai combattue de tout mon pouvoir, en bon camarade, mais à laquelle je suis obligé de rendre justice. Il n'est même pas allé voir le portrait de l'ambassadrice, quoique M. de La Tour Maubourg l'en ait prié expressément et quoique je lui eusse dit que je trouvais cela parfaitement dur et injuste et qu'il ôtait par là toute obligation d'élève à Chassériau. En somme, il l'a fort maltraité. Sur le portrait de l'abbé Lacordaire, je conserve mon avis [. . .] [C]elui de l'ambassadrice [*sic*] est faible au-delà de toute expression, c'est un petit mouton qui rêve du goût des fleurs de la campagne qui l'entourent et qu'il paraît avoir brouté [*sic*]. Il est mal dessiné, mal peint (excepté quelques rapports très fins de couleurs des mains à la robe, du ciel à la terre, etc. . . .), peu ressemblant, enfin l'erreur d'un homme de talent." Letter from Henri Lehmann to Marie d'Agoult dated January 16, 1841; Joubert, *Une correspondance romantique*, pp. 143–45, cited in Marie-Madeleine Aubrun, *Henri Lehmann, 1814–1882: Catalogue raisonné de l'oeuvre* (Paris, 1984), vol. 1, p. 20.

5. Studied in two drawings at the Louvre, RF 26.107 (Prat 90) and RF 26.108 (Prat 91).

6. "Une pâle image de femme, découpée sur un feuillage pâle, l'ombre d'une ombre"; Anonymous, "Salon de 1842," *L'artiste*, 3rd ser., 1 (1842), p. 194.

7. "Nous avons entendu faire la critique du portrait de M. Lacordaire et de Mme de Latour-Maubourg par M. Chassériaux [*sic*]. Nous ne rions pas les défauts de ces deux portraits, et nous sommes très aises de les trouver dans un artiste; ils sont l'excès d'un mérite"; Eugène Pelletan, "Salon de 1841," *La presse*, April 4 and June 3, 1841.

8. "Celui de la comtesse de la Tour-Maubourg, qu'il exposait à la même époque, effraya les Parisiennes par l'austérité de l'exécution et la sécheresse de sa silhouette rigide. Étrange image en effet, sorte de fantôme aux blancheurs sépulcrales, qui paraissait enveloppé de ses dentelles comme d'un suaire, et qui, par l'ardeur de sa prunelle, par sa pâleur transparente, laissait cependant deviner le rayonnement de la lampe intérieure"; Paul Mantz, "Théodore Chassériau," *L'artiste*, 6th ser., 2 (October 19, 1856), p. 222.

9. "Mme de Maubourg (qui est enceinte) est furieuse contre Chassériau, il a perdu toute faveur et c'est nous qui le remplaçons." Letter from Dominique Papety to Auguste Ottin dated May 15, 1841; François-Xavier Amprimoz, "Lettres de Dominique Papety à ses parents et à ses amis, Rome, 1837–1842," *Archives de l'art français*, n.s., 28 (1986), p. 263, letter 58.

101. *Jeune homme arabe debout*

Oil on canvas, 12¾ × 9⅝ in. (32.4 × 24.4 cm)
Back of original canvas stencilled: J. [BOV under stretcher bar]ARD / TOILES [et, under stretcher bar] COULEURS / RUE [de B, under stretcher bar]USSY 15.[1]

PROVENANCE
Adolphe Moreau (by 1849–51); French private collection; [E. V. Thaw & Co., Inc., New York, 1981; sold to Wrightsman]; Mr. and Mrs. Charles Wrightsman, New York (1981–his d. 1986); Mrs. Wrightsman (from 1986).

EXHIBITED
Metropolitan Museum, New York, June 1–September 5, 1989, and June 28–September 19, 1990.

LITERATURE
[Adolphe Moreau], *Collection de tableaux modernes tirés du cabinet de M. Adolphe Moreau*, 3 vols. (Paris, 1849–53), vol. 2, pl. 84 (as "Poëte indien"; blindstamp dated 1851; Aglaüs Bouvenne, *Théodore Chassériau: Souvenirs et indescrétions* (Paris, [1884]), p. 23 no. 32; Aglaüs Bouvenne, "Théodore Chasseriau," *L'artiste*, September 1887, p. 177 no. 21; Léonce Bénédite, *Théodore Chassériau: Sa vie et son oeuvre* (Paris, [1931]), vol. 2, p. 285, ill. (lithograph from 1849–53 Moreau collection catalogue); Sandoz 1974, p. 222 no. 111, pl. XCI (lithograph from 1849–53 Moreau collection catalogue).

LITHOGRAPH
[Adolphe Moreau], *Collection de tableaux modernes tirés du cabinet de M. Adolphe Moreau*, 3 vols. (Paris, 1849–53), vol. 2, pl. 84, image, 9⅞ × 6⅞ in. (25 × 17.2 cm), Moreau blindstamp dated 1851, edition of 50 privately published and distributed to the collector's friends.

Thanks to a recent discovery by Jay Fisher,[2] this painting has been identified as the work reproduced by lithograph in the luxurious three-volume collection of the preeminent collector of French Romantic painting, Adolphe Moreau *père* (1800–1859), grandfather of Étienne Moreau-Nélaton (1859–1927). It is fitting that this small, exquisitely executed cabinet picture would find a home in a distinguished collection almost immediately after it was created, as Chassériau doubtless painted it specifically to satisfy the taste of this kind of clientele.[3] The picture, with an imaginary landscape evocative of North Africa, was probably prompted by the memory of an individual Chassériau saw during his trip to Algeria in May–June 1846, but no drawing of the figure has yet been identified.

In 1884 Aglaüs Bouvenne called the reproductive lithograph *Arabe à l'oeillet,* though the flower in the hand of the young man looks more like an oleander than a pink or carnation. Marc Sandoz, who knew the work solely by means of the reproductions

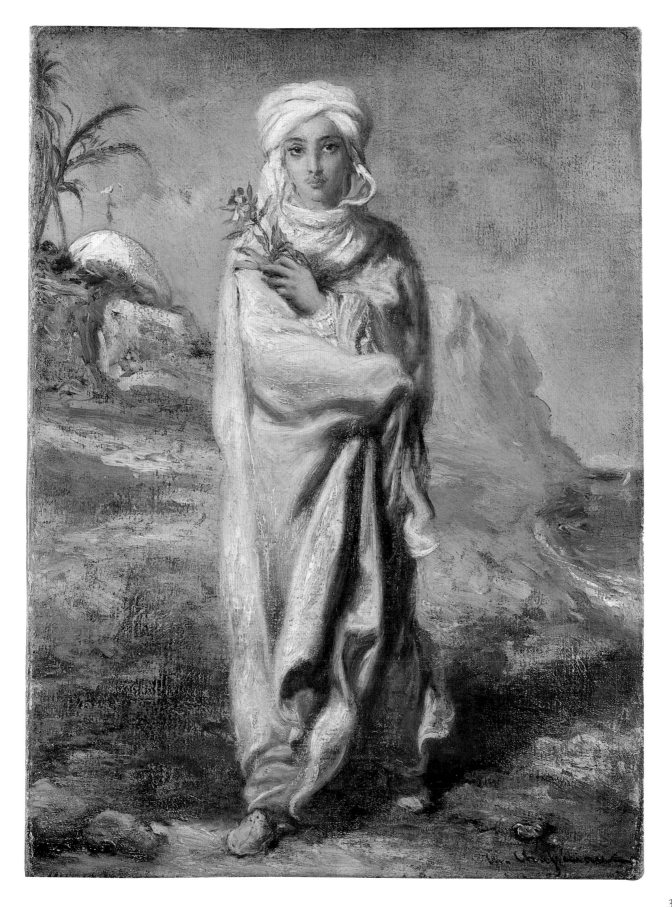

he cites, suggests a date of ca. 1847–48, following the artist's return from Algeria. Jay Fisher, who identified the Moreau publication as the source of the lithograph, suggests a date closer to 1850.

GT/AEM

NOTES

1. This is the cachet of "Bovard, fab. de toiles à tableaux, Bussy, 15," as listed in the *Annuaire Didot-Bottin* of 1851–53. Bovard was established on the third story at this address (in the present rue de Buci) by about 1850 and remained there until 1855, when the space was taken over by Chabot, another supplier of artist's materials. The authors wish to thank Pascal Labreuche for supplying this information, graciously forwarded by Bruno Chenique.
2. Letter of May 5, 2004.
3. Moreau owned at least one other work by Chassériau, *Christ at the House of Mary and Martha* (Sandoz 215), which was exhibited at the Paris Salon of 1852 (no. 228) and illustrated in [Adolphe Moreau], *Collection de tableaux modernes tirés du cabinet de M. Adolphe Moreau*, 3 vols. (Paris, 1849–53), as pl. 108. In 1859 Moreau's widow gave the painting to the town church of Marcoussis près Monthléry (Essonne). It was recently stolen (see Louis-Antoine Prat, in Paris, Strasbourg, New York 2002–2003, p. 371 under no. 241).

102. *Desdemona (The Song of the Willow)*

Oil on wood, 13¾ × 10⅝ in. (34.9 × 27 cm)
Signed and dated at lower left: *Th. Chasseriau 1849.* On the reverse, in an oval panel-maker's stamp: MULLER FILS / A PARIS; various summer loan labels: McIlhenny to Philadelphia Museum of Art, mid-1970s (1975, 1976, other labels obscured by these).

PROVENANCE
C. Mareilhac; Madame Gras (estate sale, "la Succession de Madame X . . . ," Hôtel Drouot, Paris, May 22, 1917, lot 3, possibly for Fr 2,600); the artist's nephew, Baron Arthur Nedjma Chassériau (by 1931; gift to Nouvion); Henri Nouvion (by 1931–at least 1933); Jakob Goldschmidt (until 1960; sale, Galerie Charpentier, Paris, June 16, 1960, lot 38, color ill. on cover, to Tourettes); [Galerie de la Tourettes, Basel (branch of Otto Wertheimer, Paris), 1960, sold on December 7 for $31,000, to McIlhenny]; Henry P. McIlhenny, Philadelphia (1960–by March 1982; sold through Sotheby Parke-Bernet to Wrightsman); Mr. and Mrs. Charles Wrightsman, New York (by March 1982–his d. 1986); Mrs. Wrightsman (from 1986).

EXHIBITED
Musée de l'Orangerie, Paris, 1933, "Chassériau, 1819–1856," no. 50 (as "A M. Henri Nouvion, Paris"); California Palace of the Legion of Honor, San Francisco, June 15–July 31, 1962, "The Henry P. McIlhenny Collection: Paintings, Drawings, and Sculpture," no. 5; Allentown Art Museum, Allentown, Pennsylvania, May 1–September 18, 1977, and Museum of Art, Carnegie Institute, Pittsburgh, May 10–July 1, 1979, "French Masterpieces of the Nineteenth Century from the Henry P. McIlhenny Collection"; Metropolitan Museum, New York, and June 1–September 5, 1989, and June 28–September 19, 1990.

LITERATURE
Armand Baschet, "Les ateliers de Paris en 1854—M. Chassériau," *L'artiste,* 5th ser., 12 (June 1, 1854), p. 135 (possibly), as "Desdemone se déshabillant"; Valbert Chevillard, *Un peintre romantique: Théodore Chassériau* (Paris, 1893), pp. 285 no. 122 (as collection Mme Gras), 290 no. 171 (as collection M. de Mareilhac) [evidently the same work listed twice]; Léonce Bénédite, *Théodore Chassériau: Sa vie, son oeuvre* (Paris, [1931]), vol. 2, p. 247, ill. (as collection Henri Nouvion); Sandoz 1974, pp. 254 under no. 121, 256 no. 122, pl. CXII; *Chassériau, 1819–1856: Exposition au profit de la Société des Amis du Louvre,* exh. cat., Galerie Daber, Paris (Paris, 1976), under no. 13; Jay M. Fisher, *Théodore Chassériau: Illustrations for Othello,* exh. cat., Baltimore Museum of Art, Baltimore, Maryland (Baltimore, 1979), pp. 90, 101 n. 1; Donald A. Rosenthal, *Orientalism: The Near East in French Painting, 1800–1880,* exh. cat., Memorial Art Gallery of the University of Rochester, Rochester, New York, and Neuberger Museum, State University of New York College, Purchase, New York (Rochester, 1982), pp. 116, 158 n. 14 under chap. VI; Prat 1988a, vol. 1, p. 272 under no. 585 (possibly no. 8, "La romance du saule X"; as Sandoz 1974, no. 122), and vol. 2, pp. 923–24 ("Revers du plat inférieur de la couverture," no. 8, "La romance du Saule—X"; as Sandoz 1974, no. 122) under no. 2250; Paris, Strasbourg, New York 2002–2003, p. 328 n. 6, under no. 196 (as "Song of the Willow").

ETCHING
Plate 9 from the suite *Othello,* published by Eugène Piot, Paris, 1844 (Sandoz 1974, no. 279), image, 11⅝ × 9 in. (29.3 × 22.9 cm). There are no fewer than sixteen studies for the etching, most in the Louvre, but no known preparatory drawings for the painting.

VERSIONS
LONDON, art market. More loosely brushed. Oil on wood, 7⅛ × 4¾ in. (18 × 12 cm). Signed and dated 1849. Ex-collection baron Arthur Chassériau. Sandoz 1974, no. 123. Sold at Christie's, London; November 18, 2004, lot 22.
PARIS, Musée Louvre (RF 3876). Grisaille study, 1849. Oil on canvas, 13¾ × 10⅝ in. (35 × 27 cm). Sandoz 1974, no. 121.
PRIVATE COLLECTION, France (in 1976); ex-collection Baron Vignal, Bordeaux. Oil on wood, 13 × 10 in. (33 × 25.5 cm). Signed and dated 1850 (exhibited for the first time in Paris, 1976).

Chassériau's comprehensive statement on Shakespeare, a suite of fifteen etchings illustrating *Othello,* was produced in 1844 for the publisher Eugène Piot (1812–1890).[1] The artist approached the project in drawing campaigns in sketchbooks datable to 1836–40.[2] Based on plate 9 (fig. 1), *La romance du saule (The Song of the Willow),* the Wrightsman painting illustrates act 4, scene 3, of the play, a final moment of calm preceding Desdemona's murder by her husband, Othello.

The source of the violent denouement is to be found earlier in the story, when Othello promotes the young Cassio to the rank of lieutenant. Angered, Iago—who felt his claim to the position to be the stronger one—seeks revenge by arousing unfounded suspicion on the part of Othello about his wife's faithfulness. In the Wrightsman picture, Emilia—Iago's wife and Desdemona's maid—

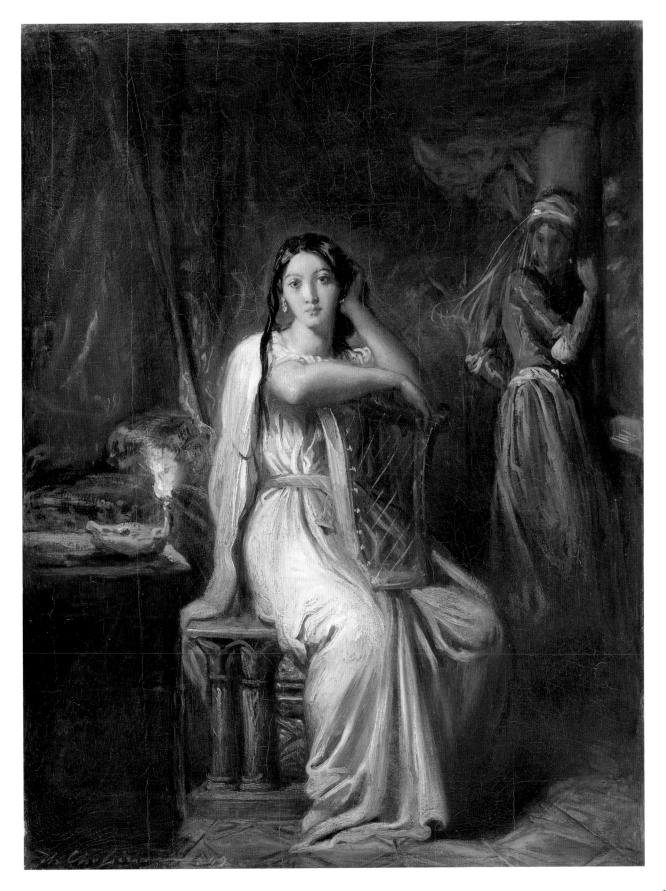

Fig. 1. Théodore Chassériau, *The Song of the Willow*, plate 9 from the suite *Othello*, 1844. Etching, image, 11⅝ × 9 in. (29.3 × 22.9 cm). Bibliothèque Nationale de France, Paris

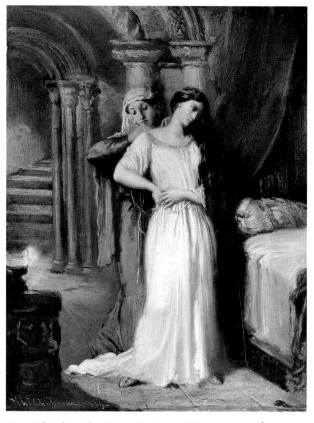

Fig. 2. Théodore Chassériau, *Desdemona*. Oil on canvas, 16⅝ × 12¾ in. (42.1 × 32.5 cm). Musée du Louvre, Paris (RF 3880; Sandoz 119)

departs on Othello's orders; Desdemona has been singing the "Romance of the Willow," a lament her mother's maid, Barbara, had sung when she realized that her own lover was mad and had forsaken her:

> The poor soul sat sighing by a sycamore tree,
>> Sing all a green willow;
> Her hand on her bosom, her head on her knee,
>> Sing willow, willow, willow.
> The fresh streams ran by her and murmured her moans
>> Sing willow, willow, willow;
> Her salt tears fell from her, and soft'ned her stones . . .

As she sings, Desdemona interrupts herself, nervous but not expecting what is to follow.

The lyre Desdemona holds here was not described by Shakespeare; Chassériau observed it in an 1836 Paris production of Rossini's *Otello,* in which the part of Desdemona was performed by the celebrated singer Maria Malibran Garcia (1808–1836), called La Malibran: she was the model for the figure of Desdemona in the etching. Indeed, Henri Decaisne (1779–1852) had painted a portrait of *La Malibran as Desdemona,* with a lyre, in 1830 (Musée Carnavalet, Paris). A final impetus for Chassériau's *Othello* series was the publication in 1843 of Delacroix's *Hamlet* lithographs,[3] and it was probably the appearance of Delacroix's painting *Othello and Desdemona*[4] at the 1849 Salon that spurred Chassériau to make ten reprises of the 1844 etchings in oil.[5] Chassériau may also have seen the canvases by Delacroix, now lost, that depicted Desdemona and Emilia.[6]

There are at least sixteen studies for the etching, yet there are no known preparatory drawings created specifically for this paint-

ing. Chassériau made numerous changes from the etching, among them the elimination of most of the architectural detail in the background in favor of a prominent display of furniture; the right-hand orientation of Desdemona, who now directly confronts the viewer; and the retreating position of Emilia.

Although at one time there was some confusion on the matter, it is unlikely that the present painting, a small cabinet picture, was exhibited at the Salon. Instead, the much larger *Desdemona* (fig. 2) was shown at the 1850–51 Salon. That *Desdemona* and five other paintings by Chassériau were displayed at the first annual exhibition of the Société des Amis des Arts in Bordeaux (opened November 15, 1851; no. 103). The Wrightsman picture may well have been among them. Mareilhac, the name of the first owner of this picture, is attached to the Château de La Louvière in Léognan, near Bordeaux: the Mareilhacs were Bordelais merchants already in the eighteenth century (there is a portrait of *J. B. Mareilhac and His Wife*, 1798, by François-Louis Lonsing, in the Musée des Beaux-Arts, Bordeaux, Bx E 1728).[7]

The four painted versions of this subject (see note 7, below) bear witness to the appeal of the composition and its significance to the artist. GT / AEM

NOTES

1. See Paris, Strasbourg, New York 2002–2003, pp. 196–201; a sixteenth plate, the frontispiece, was published posthumously in the *Gazette des beaux-arts* in 1900.
2. Sandoz 1974 proposed two sketching campaigns, in 1836–37 and in 1839–40 (p. 420 under no. 270). More recently, Prat 1988a offered dates for Chassériau's use of four individual sketchbooks—also used for other projects—now in the Musée du Louvre; these are RF 26.054 (no. 2229, as ca. 1836–38), RF 26.089 (no. 2230, as 1836–38), RF 26.055 (no. 2232, as ca. 1837–40), and RF 26.056 (2235, as ca. 1838–41 and 1842–46).
3. As Louis-Antoine Prat suggested in Paris, Strasbourg, New York 2002–2003, p. 201 under nos. 84–99.
4. National Gallery of Canada, Ottawa, inv. no. 15700; Lee Johnson, *The Paintings of Eugène Delacroix: A Critical Catalogue,* 6 vols. (Oxford, 1981–90), vol. 3, no. 291.
5. The ten paintings Chassériau made based on his etchings are listed as follows (nos. 1–10), with selected exhibitions and references:

Plate 2, *She Thank'd Me, and Bade Me, If I Had a Friend That Lov'd Her, I Should But Teach Him How to Tell My Story, and That Would Woo Her / Elle me remercia . . .* : (1) Louvre RF 3897 (1850), exhibited Paris, Strasbourg, New York 2002–2003, no. 195, Sandoz 125.
Plate 8, *If I Do Die before Thee, Prithee, Shroud Me in One of These Same Sheets / Si je meurs avant lui . . .* : (2) Louvre RF 3880 (1849), exhibited Paris Salon 1850–51, no. 536, Bordeaux Salon 1855, no. 103, Paris, Strasbourg, New York 2002–2003, no. 196, Sandoz 119; (3) Musée des Beaux-Arts, Strasbourg, inv. no. 1430 / Louvre RF 3875 (grisaille study, 1849), Sandoz 120; (4) private collection as of 1974 (1852), exhibited Paris Salon 1852, no. 240, Sandoz 124.
Plate 9, *The Song of the Willow / La romance du saule*: (5) Wrightsman collection (1849), Sandoz 122; (6) sold at Christie's, London, November 18, 2004, lot 22 (study for or replica of Wrightsman, 1849), Sandoz 123; (7) Louvre RF 3876 (grisaille study, 1849), Sandoz 121, as a "première pensée" for Sandoz 119; (8) French private collection in 1976 (1850).
Plate 12, *Have You Pray'd To-night, Desdemona? / Avez-vous fait votre prière ce soir, Desdémone?*: (9) Musée des Beaux-Arts, Strasbourg, inv. no. 1431 / Louvre RF 3877 (grisaille study, 1849), exhibited Paris, Strasbourg, New York 2002–2003, no. 197, Sandoz 117.
Plate 13, *He Smothers Her / Il l'étouffe*: (10) Musée Municipal, Metz, inv. no. 869 / Louvre RF 3883 (1849), exhibited Paris, Strasbourg, New York 2002–2003, no. 198, Sandoz 118.
6. Delacroix executed two versions of the same subject, *Desdemona and Emilia,* both now lost but known through reproductions: Johnson L98 (1825) and Johnson 304 (1849–53).
7. A slight mystery surrounds a *Desdemona* shown at the 1851 Bordeaux exhibition (no. 103, as not for sale); which version this was has not been determined. It has been suggested that it is the one given by the artist to Alice Ozy—in the Louvre since 1934—which was shown at the Paris Salon of 1850–51 and at Bordeaux in 1855. Indeed, the Louvre oil was identified as identical with Bordeaux 1851, no. 103, in the Chronology of the Paris, Strasbourg, New York 2002–2003 exhibition catalogue (p. 392), although not in the entry for that painting (no. 196) or anywhere else in the prior literature. It is, of course, possible that Ozy's picture was shown in Bordeaux in 1851, and that Monsieur Mareilhac admired it and requested the version now in the Wrightsman collection, which is dated 1849. Yet an alternate possibility exists, namely, that Mareilhac saw Ozy's *Desdemona* exhibited at the Paris Salon and thereupon acquired the present version, which was then exhibited at Bordeaux in November 1851. It is interesting to note that the fourth oil version of this subject (Marc Sandoz, in *Chassériau, 1819–1856: Exposition au profit de la Société des Amis du Louvre,* exh. cat., Galerie Daber [Paris, 1976], under no. 13) was in another Bordeaux collection, that of a baron Vignal. Further research may reveal the identity of yet another Bordelais family that owned three presentation drawings by Chassériau, including *Desdémone venant de chanter la romance du saule,* whose descendants sold it at auction (Gersaint Group, Strasbourg, June 20, 1989, no. 15, ill.; subsequently sold at Sotheby's Monaco, December 8, 1990, lot 309, ill.), and which is reproduced by Louis-Antoine Prat in "The Drawings of Chassériau: Some Particulars," *Drawing* 13 (November–December 1991), p. 77, fig. 1.

FRANZ XAVER WINTERHALTER

(1805–1873)

Born amid humble circumstances in the village of Menzenschwand (Baden-Württemberg) in 1805, Franz Xaver Winterhalter went on to become the most sought-after court portraitist of the mid-nineteenth century: his clients constituted an Almanach de Gotha from royal houses of his time, in addition to many of the noble families of Austria, Belgium, England, France, Germany, the Netherlands, Portugal, Russia, and Spain. He and his brother Fidel, known as Hermann (1808–1891), his lifelong collaborator, studied art with a local priest, who brought the young men to the attention of an influential nobleman, Daniel Seligmann, second Baron Eichtal. In 1818 Eichtal arranged for Franz to study in Freiburg im Breisgau with Karl Ludwig Schüler (1785–1852), with whom he traveled to Munich in 1823. In 1825 Franz joined Munich's Academy of Fine Arts, secured an annual stipend from Ludwig I, grand duke of Baden, and entered the studio of Josef Stieler (1781–1858). Trained in Paris, Stieler's French-inflected portrait style ran counter to the Nazarene aesthetic then dominant in German-speaking Europe, which was to have a decisive effect on the student.

Winterhalter made his obligatory trip to Rome in 1833–34; there he gravitated toward the French community of artists housed at the Villa Medici, and especially to Horace Vernet (see p. 326), who was then the director. Returning to Baden, he was named court painter to Grand Duke Leopold, successor to Ludwig I, only to leave in 1835 for Paris, which would remain the base of his operations until 1870, when the Franco-Prussian War obliged him to leave. Exhibiting portraits as well as slick, arcadian confections in the manner of Adolphe-William Bouguereau (1825–1905) and Alexandre Cabanel (1823–1889), Winterhalter made his reputation in Paris. The painter's talent as a portraitist coincided with the Rococo revival, and his "suave, cosmopolitan and above all plausible"[1] pictures were certain to flatter the noble and rich women he depicted. His enormous Empress Eugénie and Her Ladies-in-Waiting (Compiègne) was ridiculed at the Paris World's Fair of 1855—even the empress's confidant Prosper Merimée found it absurd: "detestable in my opinion, but nothing must be said about it to the court. It is a troop of tarts in a garden, all dolled up, with little affected looks. It could be used as a dance hall signboard for the Bal Mabille."[2] Nevertheless, his career flourished at the court of Napoleon III.

While on vacation in Switzerland in 1870, news reached Winterhalter of the hostilities between Germany and France, and finally, of the French emperor's surrender at Sedan. Unwelcome as aliens in France, Franz and his brother retired to Karlsruhe, where he had retained his title of court painter since 1835. He died during an outbreak of typhus in Frankfurt in 1873.

GT / AEM

ABBREVIATION

London, Paris 1987–88. Richard Ormond and Carol Blackett-Ord, with contributions by Susan Foister et al. *Franz Xaver Winterhalter and the Courts of Europe, 1830–70.* Exh. cat., National Portrait Gallery, London, and Petit Palais, Paris; 1987–88. London, 1987.

NOTES

1. See Richard Ormond's biography of the painter in London, Paris 1987–88, pp. 18–71, esp. 31–33, 51.
2. Cited by Odile Sebastiani in *The Second Empire, 1852–1870: Art in France under Napoleon III*, exh. cat., Philadelphia Museum of Art, Detroit Institute of Arts, and Grand Palais, Paris (Philadelphia, 1978), p. 359 under no. VI-110.

106. *Countess Orlov-Denisov, née Elena Ivanovna Tchertkov, later Countess Peter Andreievitch Shuvalov (1830–1922)*

Oil on canvas, 39⅜ × 31⅞ in. (100 × 81 cm)
Signed and dated: F. Winterhalter / Paris 1853.

PROVENANCE

?The sitter (1853–d. 1922); [Thomas Gibson Fine Arts, London; sold to Colnaghi and Guy Stair Sainty, in shares, by 1985]; [Stair Sainty Fine Art, Inc.; sold to Wrightsman]; Mr. and Mrs. Charles Wrightsman, New York (1985–his d. 1986); Mrs. Wrightsman, New York (from 1986).

LITERATURE

London, Paris 1987–88, possibly p. 236 no. 423, "La Comtesse Orloff (Lilly)," size and present whereabouts unknown, in "The Portraits of Franz Xaver Winterhalter: An Annotated Edition of Franz Wild's List of 1894."

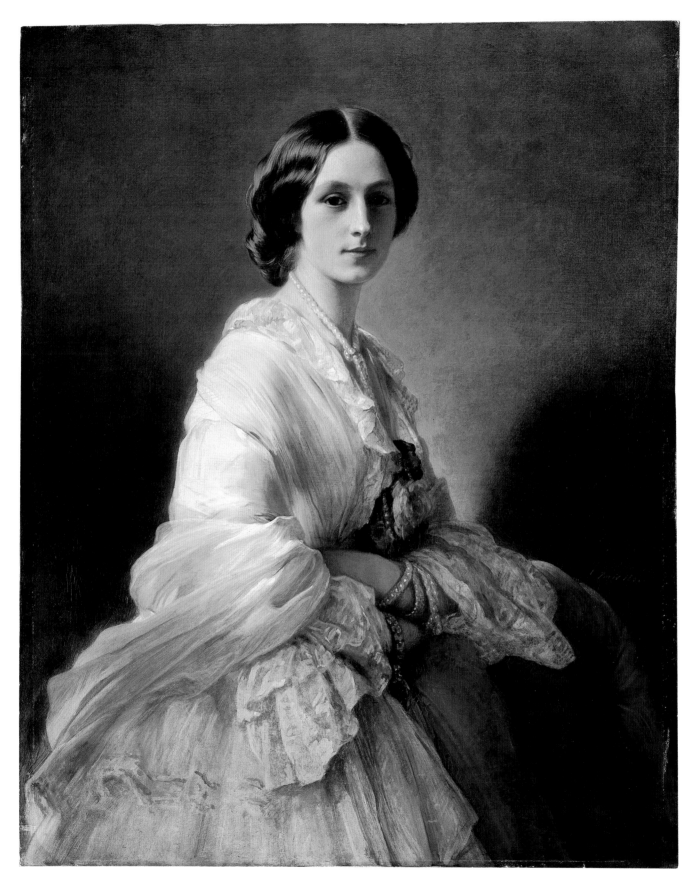

The sitter was born Elena Ivanovna Tchertkov (1830–1922), daughter of Ivan Dmitrievich Tchertkov (1796–1865), stallmeister (head groom) of the imperial court, and Baroness Elena Grigorievna Stroganova (1800–1832). Baroness Stroganova was the daughter of Baron Grigorii Stroganov (1770–1857), who had served as grand chamberlain of the imperial court and ambassador to Sweden, Spain, and Turkey (made Count of the Russian Empire in 1826), and Princess Anna Sergeievna Trubetskaya (1765–1824).

Elena first married a Count Orlov-Denisov, presumably Mikhail Vasilieivitch (1823–1863), a civil servant who attained the rank of Polkovnik, or collegial counselor (equivalent to that of army colonel).[1] Following his early death, on May 5, 1864, the young widow married Count Peter Andreievitch Shuvalov (1827–1889), who rose to the highest ranks of Russia's civil service and ambassadorial corps. He served Russia as a general of the imperial cavalry; as the governor of Livland, Courland, and Estland (modern Latvia and Estonia), from 1864 until 1866; as the head of the imperial police corps, from 1866 to 1874; and as ambassador to the Court of Saint James's, from 1874 to 1879. They had five children.[2]

On May 4, 1853, the *Badische Landeszeitung* announced that Winterhalter had been invited to Paris "in his official capacity" to paint Empress Eugénie (his passport, Baden to Paris, is dated July 22). He traveled to the Château de Compiègne to paint the imperial couple prior to one of their weeklong *séries élégantes*. The portraits were finished in December, and the artist received the grand sum of 24,000 francs. (A standard government commission for an important work at this time was 10,000 francs.) Although the originals are now lost, they were copied not only in oil but as engravings, porcelains, tapestries, and miniatures.[3] Winterhalter went on to paint the empress dressed as Marie Antoinette (1854, Metropolitan Museum) and the large group portrait of the empress surrounded by her ladies-in-waiting (Compiègne).

Countess Orlova-Denisova was twenty-three when she sat in Paris for Winterhalter in 1853. A striking beauty and extremely rich from her own family money as well as her husband's, she conformed precisely to the clientele that Winterhalter sought. It is not known why she was in Paris, but given the status of her family as well as that of her husband, she would have had access to the highest social circles, including the imperial French court.

Another version of this portrait hangs in the Château de Montrésor, in the Loire valley near Tours. In 1849 the medieval castle, dating back to 1005, was bought by a Polish nobleman, Count Xavier Branicki. He restored the ruins and endowed it with an impressive collection of works of art, still visible today among the nineteenth-century furnishings of the Branickis. One room is hung with Winterhalter portraits of the Branickis and their friends, including Countess Orlova-Denisova (members of the two families had been friendly since the time of Catherine the Great). While they appear to be nearly identical, the precise relationship of the Wrightsman painting to the painting in Montrésor—replica or variant—cannot be determined at this time.

In 1894 Winterhalter's nephew Franz Wild listed all the portraits known to him to have been executed by his two uncles. The present portrait may be his number 423, "La Comtesse Orloff (Lilly)." Based on the evidence of the list, it seems that Winterhalter made a later painting of our sitter as "La Comtesse Pierre Schouvaloff" as well as a portrait of her five children (nos. 325, 326) and numerous other members of the Shuvalov family.[4]

As Nicholas Nicholson[5] observed, Winterhalter repeated the pose of Countess Orlova-Denisova for the 1857 portrait of Empress Maria Alexandrovna (State Hermitage Museum; a nineteenth-century copy is currently in a New Jersey private collection).

GT/AEM

NOTES

1. If Mikhail Vasilieivitch Orlov-Denisov was not Elena's first husband, then there are two other candidates among his six brothers: Nikolai Vasilieivitch (1815–1856) or Petr Vasilieivitch (d. 1859). Little is known about their lives. They were the sons of the great Cossack general Vasily Vasilieivitch Orlov-Denisov (1775–1843), defender of Russia against the Napoleonic armies, notably at the Battle of Leipzig (1813), whose exploits later figured in *War and Peace*. See Valerii Fedorchenko, *Dvorianskie rody, proslavivshie Otechestvo: Entsiklopediia dvorianskikh rodov* (Krasnoiarsk and Moscow, 2001), p. 318. The authors wish to thank Margaret Samu for translating from the Russian and for pointing out the Russian Table of Ranks, reproduced in *Imperial Russia: A Source Book, 1700–1917*, 3rd ed., trans. and ed. Basil Dmytryshyn (Fort Worth, 1990), pp. 19–21.
2. The authors thank Nicholas Nicholson for providing information on the Orlov-Denisov and Shuvalov families.
3. London, Paris 1987–88, pp. 15, 47.
4. An annotated edition of the Wild list is included in ibid., pp. 226–37.
5. Correspondence with the authors.

JOHN FREDERICK LEWIS
(1805–1876)

Born in London, John Frederick Lewis received his earliest artistic training from his father, the landscape painter and engraver Frederick Christian Lewis (1779–1856). John Frederick began his career as a sporting artist, entering the studio of Thomas Lawrence (1769–1830), president of the Royal Academy, in 1820 as a draftsman of animals. This youthful period culminated in Lewis's Buck-Shooting in Windsor Great Park of 1825 (Tate Britain, London) and two sets of etchings depicting animals published in 1825–26.

Shortly thereafter, however, Lewis's interests—and his métier—would change. By 1827 he had abandoned animals for human figures and landscapes, and he turned from etching and oil painting to watercolor, the medium in which he would make his name. Inspired by the example of Richard Parkes Bonington (1802–1828), and motivated by a desire to distinguish his works within an increasingly crowded marketplace for art, Lewis developed a distinctive style of watercolor, notable for its high-keyed palette, meticulously worked surfaces, intricate designs, and effective use of gouache. For John Ruskin (1819–1900), Lewis's "severe" attention to detail was unsurpassed; the great Victorian critic (and fellow artist) ranked Lewis "the painter of greatest power, next to Turner, in the English school."[1]

In 1827, the year in which he became an associate member of the Society of Painters in Water-Colours (he received full membership in 1829), Lewis made his first foreign tour, visiting Switzerland and Italy. Five years later, inspired by the example of his friend the painter David Wilkie (1785–1841), Lewis traveled to Spain, Morocco, and Tangier. His experiences there inspired brighter hues and new, exotic subjects, some of which he published upon his return in Lewis's Sketches and Drawings of the Alhambra (1835) and Lewis's Sketches of Spain and Spanish Character (1836).[2]

His appetite for exotic lands whetted, Lewis departed on a prolonged tour through Italy and Greece to the Near East in 1837. He visited Constantinople, where he encountered Wilkie, before settling in Cairo, where he remained for a decade (1841–51).[3] In 1844 the writer William Makepeace Thackeray (1811–1863) described the (former British dandy) Lewis living there "in the most complete Oriental fashion . . . like a languid Lotus-eater," dressed and housed according to the local custom, generally enjoying his "dreamy, hazy, lazy, tobaccofied life."[4]

The studies Lewis made during his extended Egyptian sojourn would provide the raw material for virtually all of his future creations: vividly imagined fantasies set in painstakingly rendered harems, mosques, bazaars, and desert encampments. Encouraged by the wildly enthusiastic critical reception of The Hareem (Nippon Life Insurance Company, Japan, 1849, exhibited with the Old Water-Colour Society in 1850), Lewis returned to England in 1851, accompanied by his wife, Marian Harper, whom he had married in Alexandria, Egypt, in 1847. Elected president of the Old Water-Colour Society in 1855, Lewis resigned the position in 1858 to return to the more lucrative medium of oil painting (he became an associate of the Royal Academy in 1859, and a full member the following year). His work in oils continued the style and subject matter popularized in his watercolors.

EEB

ABBREVIATION

Lewis 1978. Michael Lewis. John Frederick Lewis, R.A., 1850–1876. Leigh-on-Sea, 1978.

NOTES

1. The Works of John Ruskin, ed. E. T. Cook and Alexander Wedderburn, 39 vols. (London and New York, 1903–12), vol. 35, p. 403.
2. Lewis's Sketches of Spain and Spanish Character, Made during His Tour in That Country in the Years 1833–4 (London, 1836), and Lewis's Sketches and Drawings of the Alhambra, Made during a Residence in Granada in the Years 1833–4 (London, 1835).
3. For Lewis's motivations in undertaking this journey—including the growing travel literature on the Near East, the legacy of Lord Byron (George Gordon, sixth Baron Byron, 1788–1824), and the example of David Roberts (1796–1864)—see Briony Llewellyn, "David Wilkie and John Frederick Lewis in Constantinople, 1840: An Artistic Dialogue," Burlington Magazine 145 (September 2003), pp. 628–29.
4. William Makepeace Thackeray, Notes of a Journey from Cornhill to Grand Cairo, new ed., with an introduction by Sarah Searight and illustrations compiled by Briony Llewellyn (1846; Heathfield, 1991), pp. 142–46.

107. *Iskander Bey and His Servant*

Watercolor and gouache over graphite on buff paper, 20 × 14½ in.
(50.8 × 36.8 cm)
Signed at lower right: J. F. Lewis/Cairo.

PROVENANCE
Mrs. M. Fitzpatrick, Cairo (until 1969; sale, Sotheby's, London, June 19, 1969,
lot 77, as "Prince Hassan," to Agnew's, London, for £900); private collection,
United States (January 1970); [Agnew's, London]; private collection, United
States (December 1970); [Spink, London]; [Fine Art Society Ltd., London, 1978,
as "Iskander Bey and His Servant"; sold to Wrightsman] Mr. and Mrs. Charles
Wrightsman, New York (1978–his d. 1986); Mrs. Wrightsman (from 1986).

EXHIBITED
Agnew's, London, January 19–February 20, 1970, "Ninety-seventh Exhibition
of Water-Colours and Drawings," no. 115 (as "Prince Hassan and His Servant");
Spink, London, 1978, "English Watercolours and Drawings," no. 112 (as
"Prince Hassan and His Servant"); Fine Art Society, London, June 26–July 28,
1978, "Eastern Encounters: Orientalist Painters of the Nineteenth Century,"
no. 44 (as "Iskander Bey and His Servant").

LITERATURE
Lewis 1978, p. 86 no. 455, fig. 42 (as "Prince Hassan & His Servant").

VERSIONS
Two other versions of this portrait are known.¹ A slightly larger version
(watercolor and gouache over graphite with gum arabic on buff paper, 21 ×
15 in. [53 × 38 cm]), is inscribed in graphite at lower left, "à son Excellence/Le
Genèral," erased, and reinscribed below, "J. F. Lewis/à son Excellènce le
Genèral/Sulieman Pacha./1848." Private collection, Cairo (in 1978); sale,
Sotheby's, London, June 9, 1998, lot 24, for £58,000 (£65,300 with premium; as
"Prince Iskander and His Nubian Servant"); sale, Christie's, London, June 21,
2001, lot 9, for £111,550 (with premium; as "Prince Hassan and His Nubian
Servant") (fig. 1). A slightly smaller version (watercolor and gouache, 19⅛ ×
13¾ in. [48.6 × 34.9 cm]), signed "J. F. Lewis," offered at Sotheby's, New York,
November 2, 2001, lot 28 (as "Prince Hassan and His Nubian Servant"), was
bought in (fig. 2).

Fig. 1. John Frederick Lewis, *Prince Iskander and His Nubian
Servant*, 1848. Watercolor and gouache over graphite with gum
arabic on buff paper, 21 × 15 in. (53 × 38 cm). Private collection

The sitter, formerly thought to be Prince Hassan, has been
identified as Iskander Bey (b. 1840).² Iskander (the Islamic
form of the name Alexander; the respectful title "Bey" signifies
high rank) was the son of a French-born Egyptian major gen-
eral described by Gustave Flaubert (1821–1880), who met him
in Alexandria in 1849, as "the most powerful man in Egypt, the
terror of Constantinople."³

Octave-Joseph-Anthelme Sève (1788–1860), son of a Lyon
draper, began his military career in the French navy before enlist-
ing in the army, where—after being cashiered for insubordination
and then pardoned—he reportedly rose to the rank of captain and

served as aide-de-camp to Marechal Emmanuel, marquis de
Grouchy (1766–1847), in 1814 during the Hundred Days.⁴ Following
a failed plot to liberate the imprisoned Marechal Michel Ney
(1769–1815), Sève fled France to Egypt, where the Ottoman gov-
ernor-general Muhammad ʿAlī Pasha (r. 1805–48) hired him to
instruct the Egyptian infantry in European-style warfare.
Muhammad ʿAlī, who began his dramatic ascent to the top of the
Ottoman power structure with the brutal elimination of his
Mamlūk adversaries, while consolidating his regional power with
British backing, initiated the modernization and industrialization
of Egypt; he enlisted Sève's assistance as he entered the imperial,
expansionist phase of his rule. As chief of staff to Muhammad
ʿAlī's son (and designated heir), Ibrāhīm Pasha (1789–1848), Sève—
who adopted the name Sulāyman upon his conversion to Islam—

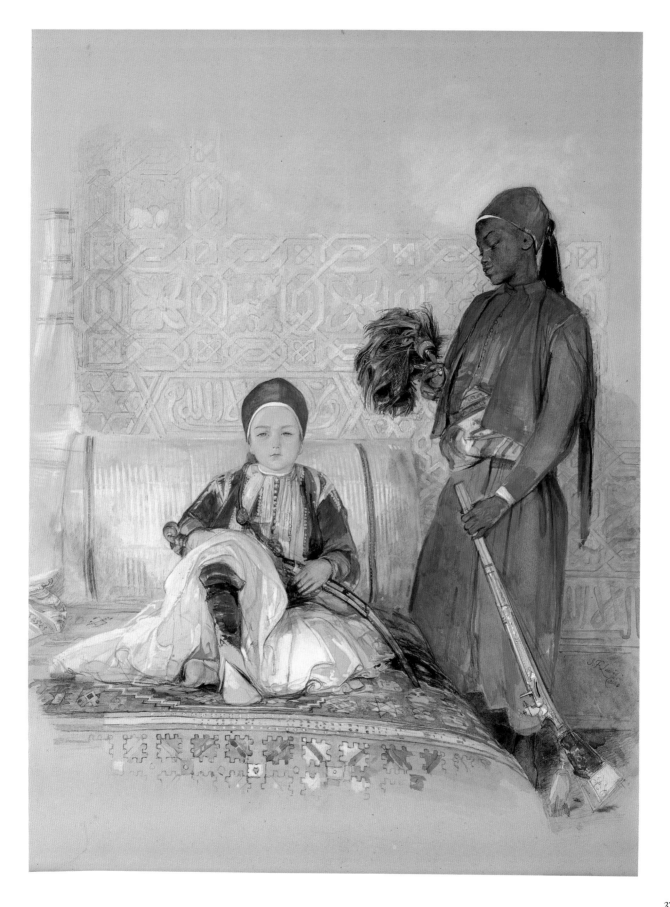

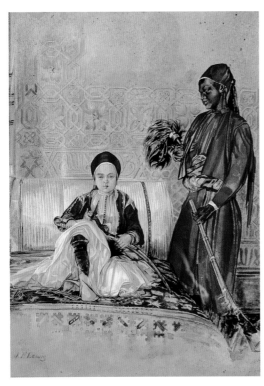

Fig. 2. John Frederick Lewis, *Prince Hassan and His Nubian Servant*. Watercolor and gouache, 19⅛ × 13¾ in. (48.6 × 34.9 cm). Private collection

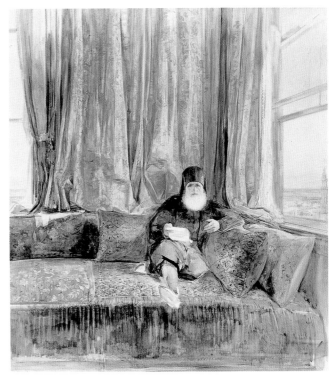

Fig. 3. John Frederick Lewis, *Portrait of Mehemet Ali Pasha, painted in the Citadel, Cairo, with a View of the Pyramids and the City of Cairo*, 1844. Watercolor, 41 × 36 in. (104.2 × 91.5 cm). Victoria and Albert Museum, London

played a vital role in Egypt's military affairs. For his service in the Morea he was made a major general (1831), and for his distinction in the battle of Konya (1832) he received the title of Pasha. Henceforth known as Sulāymān Pasha al-Faransawī (the Frenchman), Sulāymān's loyal service was lavishly rewarded. A succession of distinguished European visitors—including the painter Horace Vernet (see p. 326); Marechal Auguste-Frédéric-Louis Viesse de Marmont, duc de Raguse (1774–1852); and the writer Maxime du Camp (1822–1894)—recorded the grandeur of his Cairo palace and noted its harem.[5] Sulāymān's principal consort, Sittī Maria, a beautiful Hellenic woman whom he reportedly rescued from captivity during the Morea campaign, bore Iskander Bey.[6]

The circumstances surrounding the commission for the boy's portrait are not recorded; perhaps Sulāymān learned of Lewis from Muhammad ʿAlī, whom the artist had depicted in watercolor in 1844 (fig. 3).[7] Sulāymān seems to have been interested in art generally, and he might well have been drawn to the British expatriate for personal reasons.[8] Both men, after all, had traveled far and acclimated to a foreign culture to test the limits of their skills and find success. Lewis, like Sève, had unquestionably "gone

native."[9] Thackeray characterized as thoroughly exotic his visit to Lewis's "long, queer, many-windowed, many-galleried house" in the Arab quarter—which, the writer mused, may once have belonged to "some Mamaluke Aga, or Bey, whom Mehemet Ali invited to breakfast and massacred." Ushered by a succession of servants through a broad court filled with hens, pigeons, a gazelle, and a camel into a great hall decorated with a "large Saracen oriel window," Thackeray was offered a seat and a long pipe. When Lewis entered the room, the writer almost failed to recognize his old friend, who stood "in a long yellow gown, with a long beard, somewhat tinged with grey, with his head shaved, and wearing on it first a white wadded cotton night-cap, second, a red tarboosh."[10]

Although Lewis's intimate familiarity with local costume would certainly have aided his depiction of Iskander Bey, the Wrightsman watercolor offers far more than a mere anthropological record of the sitter. In 1848, the probable date of its commission, paternal affection would not have been the only topic on Sulāymān Pasha's mind.[11] Rather, he must have been preoccupied with concerns about power and succession: earlier that year, Muhammad ʿAlī, no longer in possession of his faculties, had abdi-

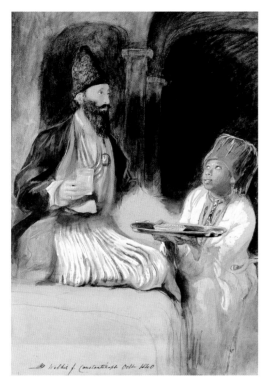

Fig. 4. Sir David Wilkie, *Slave Bringing Sherbert to a Persian Prince,* 1840. Watercolor, gouache, and chalk, 18 ⅛ × 12 ½ in. (46 × 31.6 cm). Aberdeen Art Gallery and Museums

cated in favor of his son Ibrāhīm, who ruled for only four months before his untimely death from tuberculosis thrust power upon his cruel nephew, ᶜAbbās Hilmī I. Considered in the context of this highly charged political atmosphere, Lewis's watercolor portrait takes on new meaning. The astute characterization and luxurious setting seem not only to describe an individual's personality and his domestic circumstances but also to address broader issues of military prowess and the security of a family dynasty. As Lewis shows him, the eight-year-old child is indeed formidable. Fixing the viewer with his piercing blue gaze, he grips the scimitar as if to draw it from the scabbard. The deferential presence of the other child (presumably a Nubian slave), who brings him a modern weapon, underscores Iskander's authoritative role.[12] If Muhammad ᶜAlī's line was beginning to appear weak, Sulāymān's own family—or so this likeness seems to proclaim—remained strong.[13]

The portrait is further distinguished by its compelling style, which contrasts highly finished figures with comparatively lightly sketched surroundings, allowing large portions of the initial graphite design to remain visible in the final work. Other portraits

by Lewis present a similarly expressive, selectively detailed appearance (fig. 3), suggesting that the artist employed this distinctive manner specifically for portraits, much as he favored a vivid palette and meticulous hand for his large exhibition watercolors and a loose, sketchy stroke in his character sketches and costume studies. Lewis's portrait style as shown here is well suited to its task, providing a recognizable likeness imbued with a sense of freshness and immediacy. It may also serve as an homage to the bravura portrait drawings of David Wilkie, an artist and fellow traveler whom Lewis greatly admired (fig. 4).[14]

EEB

Notes

1. Michael Lewis notes Lewis's penchant for producing duplicates of his own work in the last period of his life, citing replicas of at least fourteen of his major works; Lewis 1978, pp. 40, 42 n. 21.
2. Lewis 1978, p. 86 no. 455, fig. 42, identified the subject as "Prince Hassan & His Servant." Rodney Searight's reattribution—presumably based on the inscription found on another version of this subject (see Versions, above)—is recorded on an old label, dating to the picture's exhibition at the Fine Art Society, London, in 1978. Searight developed his expertise while amassing a substantial collection of Orientalist art, which was acquired by the Victoria and Albert Museum in 1985; see Briony Llewellyn, "The Searight Collection," in *The Burlington House Fair . . . 9–20 September 1987* (London, 1987), pp. 17–20, and Briony Llewellyn, *The Orient Observed: Images of the Middle East from the Searight Collection,* Victoria and Albert Museum, London (London, 1989).
3. Letter dated November 17, 1849, from Gustave Flaubert in Alexandria, Egypt, to his mother, Anne-Justine-Caroline (née Fleuriot) Flaubert; Francis Steegmuller, trans. and ed., *Flaubert in Egypt: A Sensibility on Tour—a Narrative Drawn from Gustave Flaubert's Travel Notes and Letters* (Chicago, 1979), p. 30.
4. Arabic names listed in this entry follow the spellings given in *The Encyclopaedia of Islam: New Edition,* ed. C. E. Bosworth et al., 11 vols. (Leiden, 1954–2002). For more on Sève, see Édouard Gouin, *L'Égypte au XIXᵉ siècle: Histoire militaire et politique, anecdotique et pittoresque de Méhémet-Ali, Ibrahim-pacha, Soliman-pacha (colonel Sèves)* (Paris, 1847); Richard Monckton Milnes, first Baron Houghton, "Suleiman Pasha," written in 1846 and published in his *Monographs: Personal and Social* (New York, 1873), pp. 1–17; Aimé Vingtrinier, *Soliman-pacha, colonel Sève, généralissime des armées égyptiennes; ou, Histoire des guerres de l'Égypte de 1820 à 1860* (Paris, 1886); Pierre Larousse, *Grand dictionnaire universel du XIXᵉ siècle: Français, historique, géographique, mythologique, bibliographique, littéraire, artistique, scientifique, etc.,* 17 vols. (Paris, 1866–90), vol. 14, p. 641; and *Encyclopaedia of Islam,* vol. 9 (1997), pp. 828–29, with further references to the modern literature.
5. Lord Houghton reported, "To strangers generally, and especially to the French and English, the house of Suleiman Pasha is opened with a cordial hospitality"; Milnes, "Suleiman Pasha," pp. 11–12. The entrance to the palace is illustrated in Jakob August Lorent, *Egypten, Alhambra, Tlemsen, Algier: Reisebilder aus den Anfängen der Photographie* (1861; reprint Mainz am Rhein, 1985), pl. 13. The palace, which no longer exists, was situated directly opposite Ibrāhīm Pasha's palace and the Nilometer (ancient river gauge).

6. Little is known of Iskander Bey's later life. A letter written by Sulāymān Pasha near the end of his life (on February 18, 1859) indicates that the son followed the father into military service: "Mons fils, Skander Bey, est dans l'artillerie. Dans peu, il doit passer capitaine." The letter is transcribed in Aimé Vingtrinier, *Soliman-pacha, colonel Sève, généralissime des armées égyptiennes,* p. 581.

7. Lewis 1978, p. 83 no. 406, fig. 40; Lionel Lambourne and Jean Hamilton, *British Watercolours in the Victoria and Albert Museum: An Illustrated Summary Catalogue of the National Collection* (London, 1980), p. 228.

8. In addition to his documented meeting with Vernet and his patronage of Lewis, Sulāyman invited Flaubert to dine with him in Cairo on February 5, 1850, in the company of "M. Macherot, ex-professor of drawing at the school in Gizeh (abolished)"; Steegmuller, *Flaubert in Egypt,* p. 96.

9. For more on Lewis's assimilation, see Briony Llewellyn, "The Islamic Inspiration: John Frederick Lewis, Painter of Islamic Egypt," in *Influences in Victorian Art and Architecture,* ed. Sarah Macready and F. H. Thompson, Occasional Paper (Society of Antiquaries), n.s., 7 (London, 1985), pp. 121–38; Briony Llewellyn, "A 'Masquerade' Unmasked: An Aspect of John Frederick Lewis's Encounter with Egypt," in *Egyptian Encounters,* Cairo Papers in Social Science, vol. 23, no. 3 (New York and Cairo, 2000), pp. 133–51; Briony Llewellyn and Charles Newton, "John Frederick Lewis: 'In Knowledge of the Orientals Quite One of Themselves,'" in *Interpreting the Orient: Travellers in Egypt and the Near East,* ed. Paul Starkey and Janet Starkey (Reading, Berkshire, 2001), pp. 35–50; Caroline Williams, "John Frederick Lewis: 'Reflections of Reality,'" *Muqarnas* 18 (2001), pp. 227–43; Emily M. Weeks, "John Frederick Lewis (1805–1876): Mythology as Biography, or Dis-Orienting the 'Languid Lotus-eater,'" in *Travellers in the Levant: Voyagers and Visionaries,* ed. Sarah Searight and Malcolm Wagstaff (Durham, 2001), pp. 177–95.

10. Thackeray, *Journey from Cornhill to Grand Cairo,* pp. 142–44.

11. Lewis inscribed the date on another version of this portrait, and there is no reason to assume a long gap between repetitions.

12. A black youth with closely similar features, possibly modeled on the same figure, appears in *The Pipe Bearer* (oil on panel, 17 × 12 in. [43.2 × 30.5 cm], 1856, Birmingham City Art Gallery); Lewis 1978, p. 93 no. 566, fig. 50.

13. In fact, history would validate both lines: King Farouk I of Egypt (r. 1936–52) claimed Muhammad ʿAlī and Sulāyman as ancestors.

14. Wilkie's *Slave Bringing Sherbert to a Persian Prince* (fig. 4) was reproduced in lithograph by Joseph Nash and published in Wilkie's posthumous *Sir David Wilkie's Sketches in Turkey, Syria and Egypt, 1840 and 1841* (London, 1841); Nicholas Tromans, *David Wilkie: Painter of Everyday Life,* exh. cat., Dulwich Picture Gallery, London (London, 2002), p. 149 no. 67.

WILLIAM POWELL FRITH

(1819–1909)

William Powell Frith spent his childhood in North Yorkshire, first at Studley Royal (at Aldfield, near Ripon), where his parents served as butler and cook on the estate, and later (after 1826) in Harrogate, where they ran the Dragon Hotel. Juvenile copies after Dutch genre prints inspired his artistic education, begun at Knaresborough and Saint Margaret's, near Dover. Frith continued his studies in London (1835–37) at the drawing academy of Henry Sass (1788–1844); at the Royal Academy schools; and, less formally, in the convivial company of fellow students Richard Dadd (1817–1886), Augustus Egg (1816–1863), Henry Nelson O'Neil (1817–1880), and John Phillip (1817–1867), who constituted a sketching club called "The Clique." Frith remained in London for the rest of his life, living with his mother and siblings when they moved to the city in 1837 following his father's death, and then with his wife, Isabelle Baker (d. 1880) of York, whom he married in 1845.

Although Frith's first public exhibition was a portrait of one of the Sass children (shown at the British Institution, London, in 1838), he soon turned his attention to narrative subjects. Significantly, Frith's 1840 debut at the Royal Academy featured a subject from Shakespeare, Malvolio, Cross-Gartered before the Countess Olivia (whereabouts unknown). Further literary and historical scenes, precisely crafted with an eye to detail, among them the Village Pastor from Goldsmith (1845, private collection), English Merrymaking a Hundred Years Ago (1847, Proby Collection, Elton Hall), and Coming of Age in the Olden Time (1849, private collection), secured his reputation. Frith was elected an associate member of the Royal Academy in 1845, becoming a full Royal Academician in 1852.

At mid-career, Frith pioneered a new genre of large-scale, carefully observed panoramic views of modern social life. Queen Victoria's purchase of the first of these—the innovative Life at the Seaside, or Ramsgate Sands (1854, Royal Collection, Buckingham Palace)—lent validity to the enterprise and prompted Frith to embark on the equally ambitious Derby Day of 1858 (Tate Britain, London) and the Railway Station (1862, Royal Holloway College, Surrey), considered—then as now—to be his masterpieces. In these works, Frith fluently arranged vast numbers of closely observed figures in compelling scenes bursting

with anecdotal detail, creating visual counterparts to the richly textured descriptions of contemporary life found in the novels of his friend Charles Dickens (1812–1870). If Frith's distinctive subjects—beach resorts, horse races, and railway stations—anticipate the Impressionists, his compositions—brilliantly stage-managed casts of thousands—predict the cinema.[1]

Following Derby Day's successful tour across Britain and to Vienna, America, and Australia (prompting the moniker "The Circumnavigator"), the art dealer and publisher Ernest Gambart commissioned a series of paintings depicting London at various times of day. Regrettably, Frith abandoned these promising works in 1862 at the sketch stage (private collection). He did complete two later series, the 1878 Road to Ruin (private collection) and the 1880 Race for Wealth (Vadodara Museum and Picture Gallery, India), which, in their intimate focus on a few central characters, recall the work of William Hogarth (1697–1764). The sentimentality of their moralizing messages, however, seems distinctly Victorian.

Frith continued to exhibit until 1902. In his final years he also established a reputation as a writer; his efforts include the charming Autobiography and Reminiscences (1887) and Further Reminiscences (1888); articles criticizing the Pre-Raphaelites; and a memoir of his friend the Punch caricaturist John Leech (1891).

EEB

ABBREVIATION

Frith 1887–88. William Powell Frith. My Autobiography and Reminiscences. 3 vols. 3rd ed. London, 1887–88.

NOTE

1. For the notion that Manet may have taken inspiration from "le pinceau spirituel de William Frith" in Derby Day in designing his own scene of a racecourse, Races at Longchamps (1867), see Robin Spencer, "Manet, Rossetti, London and Derby Day," Burlington Magazine 133 (April 1991), pp. 228–36. The quotation is taken from Manet's friend Paul Mantz, "Salon de 1865," Gazette des beaux-arts 18 (June 1865), p. 512, and cited by Spencer, "Manet, Rossetti, London and Derby Day," p. 233 n. 46.

108. *Study for the Two Central Figures of "Derby Day"*

Oil on canvas, 18 × 12½ in. (45.5 × 32 cm)
Signed and dated at lower right: W.P. Frith 1860.

PROVENANCE
Sale, Sotheby Parke Bernet, London, June 15, 1982, lot 24, for £20,900, to Wrightsman; Mr. and Mrs. Charles Wrightsman, New York (1982–his d. 1986); Mrs. Wrightsman (from 1986).

RELATED WORKS
LONDON, Bethnal Green Museum. Small-scale preparatory oil sketch of the entire composition, *Sketch for "Derby Day"* (fig. 3), signed and dated at lower left, "W.P. Frith 1858." Oil on canvas, 11⅛ × 17⅛ in. (28.3 × 43.5 cm). Dixon Bequest.
LONDON, Tate Britain. *Derby Day,* ca. 1856–58 (fig. 1). Oil on canvas, 39⅜ × 86⅝ in. (100 × 220 cm). Bequest of J. Bell.
MANCHESTER, Manchester Art Gallery. Full-size replica of the completed *Derby Day* canvas, 1893–94 (fig. 2). Oil on canvas, 40¼ × 92¼ in. (102.3 × 234.4 cm).
WHEREABOUTS UNKNOWN. Most of the artist's preparatory drawings for *Derby Day,* his original *modello* in oil, and a second, larger oil sketch of the entire composition (all recorded in Frith's autobiography).

ENGRAVINGS
At the time Jacob Bell commissioned *Derby Day,* Frith astutely retained the copyright for the engraving; he sold it for an additional fifteen hundred pounds (the same price as the painting) to the leading mid-Victorian publisher and dealer, (Jean Joseph) Ernest (Théodore) Gambart (French, active in Britain, 1814–1902). The investment was well founded; the edition of 5,025 prints (preceded by an undated promotional pamphlet, "Mr. W. P. Frith's Celebrated Picture of the Derby Day") must have grossed 45,000 guineas. Gambart and Co., Paris, published the engraving of Frith's *Derby Day* (19⅝ × 43½ in. [49.8 × 110.5 cm]) by Auguste (Thomas Marie) Blanchard III (French, 1819–1898), in September 1863 (fig. 4).[1] In 1862 the Parisian reproductive engraver Alphonse François (1814–1888) announced his intention to prepare an etching after Frith's *Derby Day,* but no examples of this print are known.[2]

As the young woman inclines her head to write in the small volume that she holds in her left hand, the brim of her hat conceals her eyes, as if modestly guarding her thoughts.[3] Light reflected from the open pages—or perhaps a word from her companion—lends her face a rosy blush. Her suitor (for so he appears) presses his gloved left hand to his waist in a gesture that conveys both polite regard and intensity of feeling.

The same couple appears, in virtually identical poses and costumes, near the center of Frith's celebrated *Derby Day* (figs. 1, 2).[4] Indeed, the only notable difference is the exchange of the woman's metal-framed leather purse in the larger painting for the book and writing instrument shown here. Frith is known to have made extensive life studies—of friends and professional models as well as real acrobats and jockeys—during his "fifteen months' incessant labour" on the complex racecourse scene.[5] The present canvas may have originated as one such study, which the artist later transformed into a discrete work by altering the woman's gesture and adding the landscape setting.[6] (The stylistic contrast between the precisely articulated figures and their loosely rendered surroundings suggests that they might have been painted during different campaigns.)

Frith's preparations for his epic canvas of 1858 are well documented. His first visit to Epsom Downs in May 1856 convinced him that the "kaleidoscopic aspect of the crowd" offered a worthy

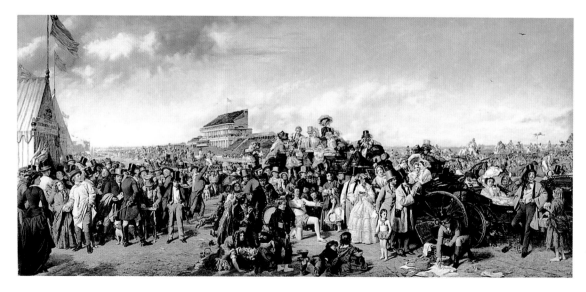

Fig. 1. William Powell Frith (1819–1909), *Derby Day,* ca. 1856–58. Oil on canvas, 39⅜ × 86⅝ in. (100 × 220 cm). Tate Britain, London, Bequest of J. Bell

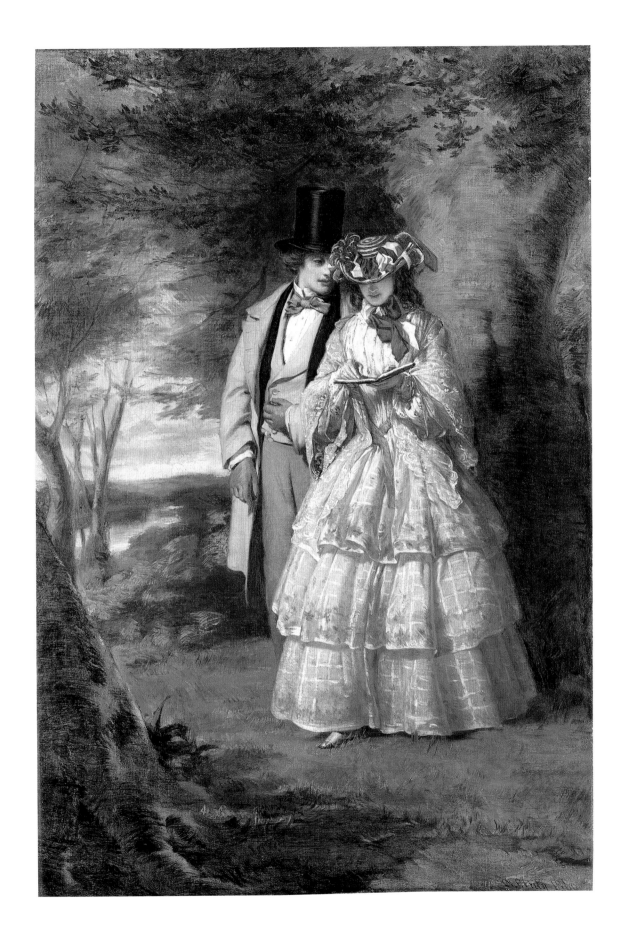

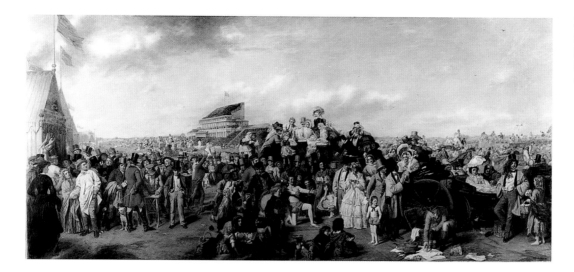

Fig. 2. William Powell Frith (1819–1909), replica of *Derby Day*, 1893–94. Oil on canvas, 40 ¼ × 92 ¼ in. (102.3 × 234.4 cm). Manchester Art Gallery

subject for a painting.[7] Within three days of returning home he had prepared a "rough charcoal drawing" of the entire composition. After making "studies from models for all the prominent figures," he painted "a small careful oil-sketch" that included all of the main groups (fig. 3).[8] On the basis of this preliminary work, the enterprising chemist and amateur artist Jacob Bell (1810–1859) immediately commissioned a large painting ("five or six" feet long) for the price of fifteen hundred pounds. To speed its production, Bell provided Frith with a succession of "remarkably pretty" women to serve as models, producing on demand "fair or dark, long nose or short nose, Roman or aquiline, tall figure or small."[9]

According to Frith, Bell took a particular interest in the female figure studied in the Wrightsman sketch:

> "What kind of person do you want for that young woman with the purse in her hand, listening to that spooney fellow—lover, I suppose?"
>
> "I should like a tall, fair woman. Handsome, of course," I replied.
>
> "All right. I know the very thing. Been to the Olympic lately?"
>
> "No."
>
> "Well, go and see Miss H—. . . ."[10]

"Miss H—" has been identified as Louisa Ruth Herbert (1831–1921), the Victorian actress admired by the Pre-Raphaelites who modeled for Dante Gabriel Rossetti (1828–1882), Val Prinsep (1838–1904), Frederick Sandys (1829–1904), Roddam Spencer Stanhope (1829–

1908), and George Frederic Watts (1817–1904).[11] Frith took Bell's advice and arranged for Miss Herbert to pose, although with disappointing results: "She was undeniably handsome; but I failed miserably, indeed unaccountably, in my attempts—again and again renewed—to reproduce the charm that was before me. At last I felt that I must either rub out what I had done and seek another model, or let my work go with a very serious blot in the centre of it. I did not hesitate long, for after a last and futile attempt, I erased the figure; and repainted it from one of my own daughters."[12] The episode concluded with the woman's suitably theatrical dismay, expressed "in a style that would have 'brought down the house,'" upon finding herself replaced in the final work and with Frith's own ineffectual apologies.[13] His reference to the "very serious blot" that this problematic figure made "in the centre" of his work suggests that he was painting directly from "Miss H—" onto the final canvas rather than on an intermediary sketch. If Frith did work exclusively on the canvas itself during its final stages of preparation, then the Wrightsman study must predate Herbert's (and Frith's daughter's) involvement with the project. And Frith seems most likely to have begun the Wrightsman canvas in the summer of 1856, either in preparation for the *modello* shown to Bell or possibly for one of the two oil sketches that followed it (of which only the smaller example is known, fig. 3). He then presumably set it aside while engaged in preparing the larger canvas for exhibition and only returned to it in 1860 (the year inscribed beneath his signature), possibly completing it in the autumn, given the warm-hued trees at the left of the scene.

Fig. 3. William Powell Frith (1819–1909), *Sketch for "Derby Day,"* 1858. Oil on canvas, 11 ⅛ × 17 ⅛ in. (28.3 × 43.5 cm). Bethnal Green Museum, London, Dixon Bequest

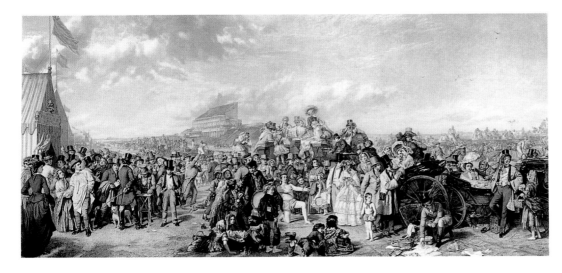

Fig. 4. Auguste (Thomas Marie) Blanchard III (French, 1819–1898), after William Powell Frith (1819–1909), *Derby Day*. Engraving, 19 ⅝ × 43 ½ in. (49.8 × 110.5 cm). Published by Gambart and Co., Paris, September 1863. Victoria and Albert Museum, London

If neither Louisa Herbert nor the artist's daughter posed for the woman in the Wrightsman sketch, might a photograph have provided the model? Intriguingly, Frith is known to have commissioned photographs of the Epsom Down crowds to assist in the preparation of his view of the racecourse—a detail tellingly omitted from his own account of the picture's genesis but eagerly related by one of his contemporaries: "[for] 'A Derby Day,' Mr. Frith employed his kind friend Mr. [Robert] Howlett to photograph for him from the roof of a cab as many queer groups of figures as he could; and in this way the painter of that celebrated picture, the 'Derby Day,' got many useful studies, not to introduce literally into his picture as Robinson or Rejlander would have done, but to work up in his own mind and then reproduce with the true stamp of genius upon them."[14]

Only one photograph by Howlett related to the project is known.[15] It provides the general contour of the distant crowds but shows little of interest in the largely unpopulated foreground. Assuming this image to be typical of Howlett's studies, it would appear that Frith used such photographs to establish the broad outlines of distant masses rather than to study individual figures, which he plausibly records composing himself, in drawings from his imagination and in sketches from living models.[16] Frith would not have needed a photograph of the two figures depicted in the present work in order to paint them; given Howlett's unwieldy camera apparatus, moreover, and the distance of the figures that it captured, it seems unlikely that one ever existed.

EEB

NOTES

1. *L'artiste,* 7th ser., 7 (June 12, 1859).
2. *Art-Journal,* April 1862, p. 111; *Art-Journal,* June 1862, p. 147.

3. For a detailed description of the figure's clothing, see *A Visual History of Costume,* vol. 5, *The Nineteenth Century,* by Vanda Foster (New York, 1984), pp. 78–79.

4. Tate Gallery, *An Illustrated Companion* (London, 1898), p. 85.

5. Frith 1887–88, vol. 1, p. 284.

6. In addition to the present work, only two such studies are now known: an oil study of *A Girl Holding a Parasol* (collection Roy Milnes) and a graphite sketch for the (father) acrobat (British Museum). Both are reproduced in Mary Cowling, *The Artist as Anthropologist: The Representation of Type and Character in Victorian Art* (Cambridge and New York, 1989), pp. 207 and 273, figs. 184 and 258, respectively.

7. Frith 1887–88, vol. 1, p. 272. Frith was not particularly concerned with the horse race itself—indeed, his friend J. F. Herring prepared the studies of the two horses seen in the background. Herring's preparatory sketch and his related letter to Frith are now in the British Museum; A. M. Hind, "A Sheet of Studies for Frith's Derby Day," *British Museum Quarterly* 10 (August 1935), pp. 18–19, pl. V; A. M. Hind, "Frith's 'Derby Day' and J. F. Herring," *British Museum Quarterly* 10 (March 1936), pp. 91–92.

8. Frith 1887–88, vol. 1, p. 273.

9. Ibid., p. 280. The quotation "remarkably pretty" is rephrased from the following passage: "Mr. Bell was also very useful to me in procuring models. Few people have a more extensive acquaintance, especially amongst the female sex, than that possessed by Joseph Bell; and what seemed singular, was the remarkable prettiness that distinguished nearly all these pleasant friends. I had but to name the points required, and an example was produced." Ibid., pp. 279–80.

10. Ibid., p. 280.

11. Patricia Connor and Lionel Lambourne, *Derby Day 200: An Exhibition Sponsored by Coutts & Co., Financial Times, Moët & Chandon and Sotheby's,* exh. cat., Royal Academy of Arts, London (London, 1979), p. 75. For more on Herbert, see Virginia Surtees, *The Actress and the Brewer's Wife: Two Victorian Vignettes* (Wilby, Norwich, 1997).

12. Frith 1887–88, vol. 1, pp. 280–81. Herbert's family recalled a different version of events, remembering that when Frith exhibited the painting in his studio on the Sunday before the Royal Academy opening, "someone exclaimed that the image on the canvas was a libel on Louisa's beauty. Annoyed, Frith took his brush and painted a round hat to conceal the greater part of the face, but everyone knew that it was Miss Herbert"; Surtees, *Actress and the Brewer's Wife,* pp. 46–47.

 The daughter in question has not been identified. It might possibly have been "Cissy," or Jane Ellen Frith, later Mrs. James Panton, who became a novelist and recorded posing for her father as a child. But there would have been no shortage of candidates in Frith's large family: in addition to his twelve legitimate children, Frith had two more with his mistress, Mary Alford, whom he later married following the death of his first wife. Aubrey Noakes, *William Frith, Extraordinary Victorian Painter: A Biographical and Critical Essay* (London, 1978), p. 134.

13. Frith 1887–88, vol. 1, p. 282.

14. Thomas Sutton, Esq., "On Some of the Uses and Abuses of Photography," a paper read before the Photographic Society of Scotland, published in *Photographic Journal* (Photographic Society, London) 8 (January 15, 1863), p. 204.

15. Robert Howlett's *The Grandstand, Epsom* (1857) is reproduced in Cowling, *Artist as Anthropologist,* p. 268, fig. 253.

16. Neve argues that Frith's use of photographic studies lent a disjointed quality to the final composition, a quality the present writer fails entirely to detect. Christopher Neve, "A Guilty Secret? Photography and Victorian Painting," *Country Life* 147 (June 18, 1970), p. 1152.

JEAN-LÉON GÉRÔME

(1824–1904)

A native of Vesoul (Haute-Saône), Jean-Léon Gérôme first moved to Paris in 1840 to study with Paul Delaroche (1797–1856) at the École des Beaux-Arts. When Delaroche closed his atelier in 1843, Gérôme followed him to Rome, returning to Paris the following year and studying briefly with Charles Gleyre (1806–1874), Delaroche's successor. Gérôme first exhibited at the Salon of 1847 and soon gained renown as the leader of the neo-grec *school of painting, which included his friends Jean-Louis Hamon (1821–1874), Henry Pierre Picou (1824–1895), and Gustave Boulanger (1824–1888). He specialized in a brand of photographic realism that distinguished him from the increasingly stale Neoclassical style promulgated by such students of Ingres (see p. 292) as the Fandrin brothers and Amaury-Duval. In 1859 Gérôme began a long and prosperous relationship with the dealer and art publisher Adolphe Goupil; he married the impresario's daughter Marie in 1863. Although he received few official commissions during the Second Empire, Gérôme was appointed a professor at the École des Beaux-Arts in 1863 and elected to the Institut de France the following year. Gérôme's success in the newly established private marketplace liberated him from state commissions and submission to the Salon, although he continued to exhibit there, in the 1870s showing sculpture in addition to painting. Emulated by the majority of his students, Gérôme's production has been confused with that of his numerous imitators. His famous antipathy toward Impressionism and other innovative styles has eclipsed the extraordinary quality of his own work.*

GT/AEM

109. Portrait of a Lady, perhaps the Artist's Wife, Marie Gérôme, née Goupil (1842–1912)

Oil on canvas, 21 ½ × 14 ½ in. (54.6 × 36.8 cm)

PROVENANCE
Reportedly by descent through the family of the artist or of his wife; Allart-Charcot, Neuilly; sale, Sotheby's, London, June 15, 1982, lot 65, color ill., to Wrightsman; Mr. and Mrs. Charles Wrightsman, New York (1982–his d. 1986); Mrs. Wrightsman (from 1986).

LITERATURE
Robert Rosenblum, in Gary Tinterow and Philip Conisbee, eds., *Portraits by Ingres: Images of an Epoch*, exh. cat., National Gallery, London, National Gallery of Art, Washington, D.C., and The Metropolitan Museum of Art, New York (New York, 1999), pp. 15, 17, fig. 22 (as location unknown, ca. 1866–70), 23 n. 40; Gerald M. Ackerman, *Jean-Léon Gérôme: Monographie révisée, catalogue raisonné mis à jour*, 3rd ed. (Courbevoie, 2000), pp. 81, ill. (color), 262–63 no. 167, ill.

This painting first reappeared when it was offered at auction in 1982, with the sitter identified as the artist's wife, and with a provenance suggesting that it had descended through their family. Marie Goupil (1842–1912) was the daughter of the Paris art dealer and art publisher Adolphe Goupil (1806–1893). She married Gérôme, one of the rising stars of her father's stable of artists since they began working together in 1859, in January 1863. The couple moved into a private house in the rue de Bruxelles, near the place Clichy, and had five children. Around the time of their marriage Gérôme made an unfinished portrait in oval format of Marie, which emerged from a private collection in 1995 (Musée Goupil, Bordeaux, 97.VI.1.1). The only other known painted portrait of Marie Gérôme is the one by Charles-François Jalabert (1819–1901), who produced a few other portraits of women in the Goupil-Gérôme family.[1] Yet the identity of the sitter in the Wrightsman picture has been repeatedly questioned, and she does not resemble the Bordeaux painting closely. Régine Bigorne's recent discussion of Goupil-Gérôme family portraits ignores it entirely.[2]

Gerald Ackermann has proposed that this painting might be the portrait of baronne Nathaniel de Rothschild that was lost sometime around 1866.[3] Nevertheless, the features of this woman seem closer to those of the oval unfinished portrait of Madame

387

Gérôme from about 1863 (see above) than to those in the likeness of the woman thought to be baronne Nathaniel that surfaced on the Paris art market in 2003.[4]

Regardless of the identity of the woman, it is clear that Gérôme aspires in the Wrightsman painting to inscribe himself in the tradition of portraiture established by Ingres (see p. 292) in his works of the 1840s and 1850s. The models for this painting are Ingres's *Vicomtesse d'Haussonville* (1845, Frick Collection), *Baronne James de Rothschild* (1848, private collection), the portraits of Madame Moitessier (1851, National Gallery of Art, Washington, D.C.; 1856, National Gallery, London), and *Princesse Albert de Broglie* (1853, Metropolitan Museum, Lehman Collection).[5] All of these portraits by Ingres were exhibited to the public in the artist's studio prior to the posthumous Ingres retrospective held at the École Impériale des Beaux-Arts in 1867, and some were engraved or photographed. Gérôme knew them well and applied what he had learned from them in both the portrait of baronne Nathaniel de Rothschild and the one of his wife, which may have been executed any time between his wedding in January 1863 and 1870. It is characteristic of Ingres's followers, however, to give too much attention to fashion and furnishings: their portraits lack the grand style that Ingres's portraits embody.[6]

Decourcy McIntosh has recently identified the figure whose oval portrait is reflected in the mirror in the Wrightsman painting as Paul Goupil (of whom there is a portrait in a private collection, Chevy Chase, Maryland), a distant cousin of Adolphe. It is possible that *his* wife's name was Marie. As McIntosh indicates, not only did Gérôme paint very few portraits but most are bust-length depictions of his immediate family. Therefore it is likely that this work, which is not a bust, was a commissioned work. The dog the sitter holds (a griffon), a traditional symbol of fidelity, would be appropriate for a portrait of a married woman that had been commissioned by her husband.

GT/AEM

NOTES

The authors wish to thank DeCourcy McIntosh for his assistance in cataloguing the present work.

1. Jalabert's *Souvenir d'un bal costumé (Madame Gérome)* was exhibited at the Salon of 1870. This painting, presumably in a private collection, was reproduced in Émile Reinaud's *Charles Jalabert: L'homme, l'artiste, d'après sa correspondance* (Paris, 1903), pp. 198–99, pl. 15, to which Gérôme contributed the preface. It was last reproduced in Aleth Jourdan, *Charles-François Jalabert, 1819–1901*, exh. cat., Musée des Beaux-Arts, Nîmes (Nîmes, 1981), p. 68 no. 137 (as "localisation inconnue"), and in Pierre Chantelat, Albert Benamou, and Gilles Cugnier, with an introduction by Gerald Ackerman, *Jean-Léon Gérôme, 1824–1904, peintre, sculpteur et graveur: Ses oeuvres conservées dans les collections françaises publiques et privées,* exh. cat., Musée Municipal, Vesoul (Vesoul, 1981), p. 184, ill. (no location given).
2. See Hélène Lafont-Couturier et al., *Gérôme & Goupil: Art et entreprise,* exh. cat., Musée Goupil, Bordeaux, Dahesh Museum of Art, New York, and The Frick Art and Historical Center, Pittsburgh (Paris, 2000), pp. 71–73, and see also no. 4.
3. Emma Louise de Rothschild (1844–1935) married her first cousin Nathaniel Mayer de Rothschild (1840–1915) in 1867.
4. Hôtel Drouot, Paris, April 30, 2003, lot 15, color ill., 19½ × 14⅛ in. (49.6 × 35.8 cm).
5. See Gary Tinterow and Philip Conisbee, eds., *Portraits by Ingres: Images of an Epoch,* exh. cat., National Gallery, London, National Gallery of Art, Washington, D.C., and The Metropolitan Museum of Art, New York (New York, 1999), nos. 125, 132, 133, 134, 145, respectively.
6. See, for example, Ary Scheffer's *Charlotte, baronne de Rothschild* (1842, private collection), reproduced in Tinterow and Conisbee, *Portraits by Ingres,* p. 417, fig. 248.

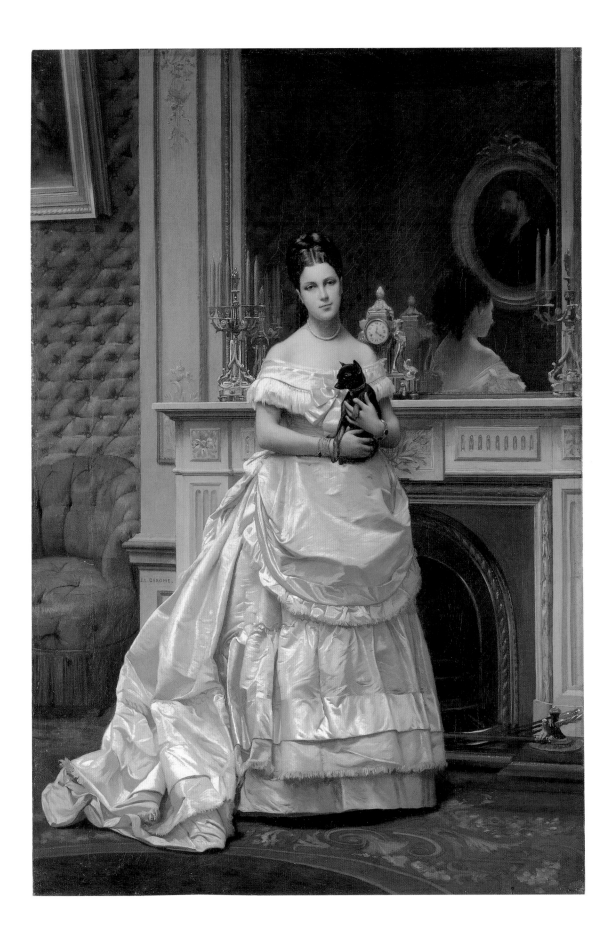

110. *Bashi-Bazouk*

Oil on canvas, $31\frac{3}{4} \times 26$ in. (81×66 cm)

PROVENANCE
The artist (sold in March 1869 for Fr 4,000, to Goupil); [Goupil, 1869–about 1871, sold for Fr 7,500 (£500), to Wallis]; [Henry Wallis of The French Gallery, London, about 1871–73, sold on July 21 for £550, to Avery]; Samuel Putnam Avery (from 1873); Henry T. Cox, New York (by 1883); sale, Sotheby's, London, June 23, 1981, lot 29, color ill., to Koch; William I. Koch, Boston (1981–94; sold to Acquavella); [Acquavella Galleries, New York, 1994; sold to Wrightsman]; Mrs. Charles Wrightsman, New York (from 1994).

EXHIBITED
Possibly Cercle de l'Union Artistique, Paris, 1869 (the present picture or Gerald M. Ackerman, *Jean-Léon Gérôme: Monographie revisée, catalogue raisonné mis à jour* [Courbevoie, 2000], no. 192); London, The French Gallery, November 1870, "Eighteenth Annual Winter Exhibition," no. 25; Brooklyn, New York, January 10–February 2, 1884, "Brooklyn Art Association Exhibition in Aid of the Bartholdi Statue Pedestal Fund," no. 71 (lent by H. T. Cox); Royal Academy of Arts, London, March 24–May 27, 1984, and National Gallery of Art, Washington, D.C., July 1–October 28, 1994, "The Orientalists: Delacroix to Matisse," no. 34.

LITERATURE
Anonymous, "Winter Exhibition at the French Gallery," *Athenaeum* (London), no. 2246 (November 12, 1870), p. 631; Anonymous, "Opened: The Loan Exhibition for the Bartholdi Pedestal," *Brooklyn Daily Eagle,* January 10, 1884, p. 2; Anonymous, "Propitious: The First Day of the Bartholdi Loan Exhibition," *Brooklyn Daily Eagle,* January 11, 1884, p. 2; Anonymous, "The Bartholdi Statue: Brooklyn's Loan Exhibition of Paintings in Aid of the Pedestal Fund," *New York Times,* January 13, 1884, p. 6; *A Catalogue of Oil Paintings Loaned for Exhibition in Aid of the Bartholdi Statue Pedestal Fund,* exh. cat., Brooklyn Art Association Exhibition, Brooklyn, New York (Brooklyn, 1884), pp. 23 no. 71, 94; Fanny Field Hering, *Gérôme: The Life and Works of Jean Léon Gérôme,* introduction by Augustus St. Gaudens and preface by Jean-Léon Gérôme (New York, 1892), p. 211; Samuel Putnam Avery, *The Diaries, 1871–1882, of Samuel P. Avery, Art Dealer,* ed. Madeleine Fidell Beaufort, Herbert L. Kleinfield, and Jeanne K. Welcher (New York, 1979), p. 187; Gerald M. Ackerman, *Jean-Léon Gérôme: Monographie révisée, catalogue raisonné mis à jour,* 3rd ed. (Courbevoie, 2000), pp. 84, ill. (color), 272–73 no. 193, ill.; Hélène Lafont-Couturier et al., *Gérôme & Goupil: Art et entreprise,* exh. cat., Musée Goupil, Bordeaux, Dahesh Museum of Art, New York, and The Frick Art and Historical Center, Pittsburgh (Paris, 2000), pp. 126 under no. 79 (see also ill. p. 125), 157.

REPRODUCTIONS
Bibiothèque Nationale de France, Cabinet des Estampes, Paris (DC293a). Jean-Léon Gérôme, *Receuil: Les oeuvres de Jean-Léon Gérôme,* 29 vols., vol. 9, 7. Photograph.
Goupil & Cie., Paris, Galerie Photographique no. 753, 1869–70, available until at least April 1904. Albumen print mounted to card, $8\frac{3}{8} \times 6\frac{3}{4}$ in. (21.2×17.2 cm) (fig. 1). Musée Goupil, Bordeaux (99.II.4.9 [1]).

Fig. 1. Goupil & Cie. after Jean-Léon Gérôme, *Bachi-bouzouk* (Galerie Photographique no. 753). Albumen print mounted to card, $8\frac{3}{8} \times 6\frac{3}{4}$ in. (21.2×17.2 cm). Musée Goupil, Bordeaux (99.II.4.9 [1])

As a category of his oeuvre, Gérôme's Orientalist works belong to a larger group of essentially Mediterranean subjects drawn from various periods, from the antique to his own. These include not only scenes of Arabs and other Ottomans but also subjects from ancient and modern Greece, the death of Caesar as well as contemporary *pifferari*. Yet with Gérôme, the romanticism of earlier artists such as Delacroix (see p. 334) and Ingres gives way to the very contemporary objective of photographic realism, which re-creates the scene depicted rather than evoking it. Gerald Ackerman has observed that Gérôme's Orientalist pictures were not necessarily painted or even conceived abroad and that many of them were executed in his studio using props acquired on his travels: Gérôme led a safari through Egypt and Asia Minor from January 1 to April 13, 1868. Other participants on this trip included the writer Edmond About, who composed a novel about the trip (*Le Fellah,* 1869, dedicated to Gérôme), the journalist Frédéric

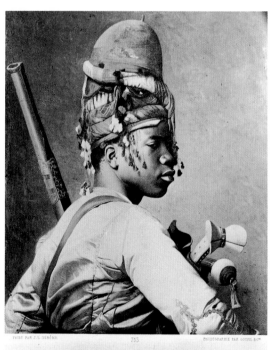

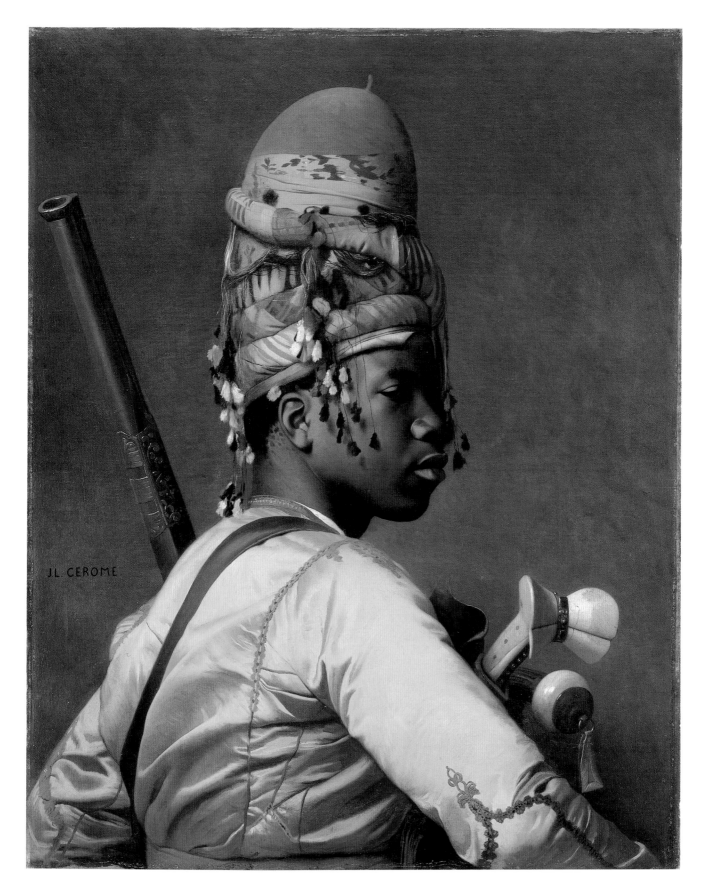

Masson, the painter Léon Bonnat, and Gérôme's brother-in-law Albert Goupil, an amateur photographer.[1] Gérôme showed no Orientalist pictures at the Salon of 1868, which opened soon after his return, and, although there are no known studies for the Wrightsman painting, it is probable that he began work on the canvas by the middle of 1868; it was completed by March 1869.

Bashi-bazouk is the transliteration of a Turkish term whose literal definition is "headless." "Bashi-Bazouks were irregular Turkish troops of the Ottoman Empire. They were not paid for their services, but lived from plunder, and were especially feared for their ferocity."[2] The subject held obvious appeal throughout the nineteenth century.[3] Similar figures were included in many of Gérôme's paintings, alone and in groups, but none is as arresting an image as this.[4] The expanse of pink silk across the figure's back, shoulders, and arms, combined with the shadow that hides his eyes, disperses and softens the visual impact of the many details of his costume. The figure's aloofness is a byproduct of the illusion that he has not yielded himself entirely to the painter, which endows him with a proud dignity. Photographic reproductions of the Wrightsman painting were circulated by Goupil, Gérôme's dealer, as early as 1869–70 (fig. 1).[5]

Although the distinguished collector Samuel Putnam Avery bought this painting in 1873, it drew considerable attention when a subsequent owner, Henry T. Cox, lent it to the 1884 exhibition organized to raise money for the pedestal for Bartholdi's Statue of Liberty in New York Harbor. As noted by a critic for the *Brooklyn Daily Eagle,* "A strong contrast to the handling of Munkacsy is the finished but powerful handling of Gerome [*sic*], seen in the Loan exhibition through a good sized canvas hung on the wall opposite the Assembly Room, and showing a half-length portrait of 'A Bashi-Bazouk.' The swarthy features of the fellow are shown partially in profile, and the dark color of the skin is brought out against the still darker background. He wears a loose, light silk tunic and a tall, elaborately decorated turban, while above one arm protrude the handles of two or three weapons. There is a great deal of character and dramatic power in the picture, and although not large it is an admirable example of the famous artist."[6]

<div align="right">GT / AEM</div>

NOTES

1. Much of Gérôme's travel diary is reprinted in Charles Moreau-Vauthier, *Gérôme: Peintre et sculpteur* (Paris, 1906), pp. 223–53. The journey was also recounted by Paul Lenoir, in *Le Fayoum, Le Sinaï, et Pétra: Expédition dans la moyenne Égypte et l'Arabie sous la diréction de J. L. Gérome* (Paris, 1872), translated, with some omissions, as *Le Fayoum; or, Artists in Egypt* (London, 1873); most of the English translation is reprinted in Fanny Field Hering, *Gérôme: The Life and Works of Jean Léon Gérôme,* introduction by Augustus St. Gaudens and preface by Jean-Léon Gérôme (New York, 1892), pp. 90–215, passim. See also Gerald M. Ackerman, *Jean-Léon Gérôme: Monographie révisée, catalogue raisonné mis à jour,* 3rd ed. (Courbevoie, 2000), pp. 78–80, 338 nn. 221, 226.

2. Gerald M. Ackerman, *The Life and Work of Jean-Léon Gérôme, with a Catalogue Raisonné,* 2nd ed.(London and New York, 1986), p. 83.

3. For example, Horace Vernet's *Bashi-bazouk* (unlocated), formerly in the Paul Demidoff collection (sale, Paris, Galerie Georges Petit, February 26, 1863, sold for Fr 12,400, cited in Hippolyte Mireur, *Dictionnaire des ventes d'art faites en France et à l'étranger pendant les XVIIIᵐᵉ et XIXᵐᵉ siècles* [Paris, 1912], vol. 7, p. 339). An example by Charles Bargue, dated 1875, is in the Metropolitan Museum (87.15.102).

4. A similar, contemporaneous, *Bashi-bazouk* by Gérôme is in a private collection (Ackerman, *Jean-Léon Gérôme: Monographie révisée,* no. 192, ill.). In that work, the subject's upper torso faces the picture plane at a forty-five-degree angle.

5. These reproductions were available until April 1904. In 1894 the price was "6 francs depuis 5 francs"; see Hélène Lafont-Couturier et al., *Gérôme & Goupil: Art et entreprise,* exh. cat., Musée Goupil, Bordeaux, Dahesh Museum of Art, New York, and The Frick Art and Historical Center, Pittsburgh (Paris, 2000), pp. 124–25 no. 79, ill., 157.

6. Anonymous, "Opened: The Loan Exhibition for the Bartholdi Pedestal," *Brooklyn Daily Eagle,* January 11, 1884, p. 2. The Brooklyn pedestal fund exhibition followed one held at the National Academy of Design in Manhattan, which opened December 3, 1883. Charles Bargue's *Bashi-bazouk* (see n. 3, above) was included in that exhibition (no. 17). According to one critic, one of the faults of the earlier exhibition was the dearth of works by contemporary masters favored by rich collectors, such as Gérôme (Anonymous, "The Pedestal Art Loan," *New York Times,* December 16, 1883, p. 5, cited by Maureen C. O'Brien in her introduction to *In Support of Liberty: European Paintings at the 1883 Pedestal Fund Art Loan Exhibition,* exh. cat., Parrish Art Museum, Southampton, New York, and National Academy of Design, New York [Southampton, N.Y., 1986], p. 20 n. 13).

ALFRED ÉMILE-LÉOPOLD STEVENS
(1823–1906)

Like his younger contemporary Tissot (see p. 400), Alfred Stevens's paintings of women in elaborate dress belie his status as an advanced painter in his own time. Born in Brussels, Stevens first studied with Jacques-Louis David's disciple François-Joseph Navez (1787–1869) from 1840 to 1844. The Romantic painter Camille Roqueplan (1803–1855), a family friend, then took him to Paris, where he is thought to have received instruction from Ingres (see p. 292) at the École des Beaux-Arts. Aside from an extended trip to Brussels in 1849–51, where he exhibited for the first time at the Salon of 1851, Stevens lived in Paris for the rest of his life.

Stevens's Young Man Sketching before the Anatomy Model *of 1849 (private collection, Brussels) shows that while in Paris he had already come under the sway of Gustave Courbet (1819–1877), who would paint his portrait in 1861 (Musée Royaux des Beaux-Arts de Belgique, Brussels). Through his brother Joseph (1816–1892), a popular* animalier, *Stevens came to know Camille Corot (1796–1875), Thomas Couture (1815–1879), Narcisse Diaz (1807–1876), Eugène Isabey (1803–1886), Jean-François Millet (1814–1875), and Théodore Rousseau (1812–1867), artists who gathered at the Restaurant du Havre.[1] It was probably through Joseph as well that Alfred befriended Delacroix (see p. 334), who served as a witness at his marriage to Marie Blanc in 1858. Joseph and Alfred's younger brother Arthur (1825–1890) was a successful critic and art adviser to the king of the Belgians.*

Making his Paris debut at the Salon of 1853, Stevens was a success: three pictures were accepted, one of which, Ash-Wednesday Morning, *won a third-class medal and was acquired by the state (Musée des Beaux-Arts, Marseilles). In 1855 Stevens showed his best-known early painting,* What is Called Vagrancy *or* The Soldiers of Vincennes *(Musée National du Palais de Compiègne), along with five others, at the Exposition Universelle. The 1850s witnessed the launching of Stevens's career and also his adoption of a single genre, women in interiors, which, with the exception of his landscapes after 1880, would remain closely identified with him. Baudelaire, a friend of all three Stevens brothers, wrote critically of Stevens's single subject:*

> *The strongest, one says, of the Belgian painters, he whom these faro [beer] drinkers and potato eaters compare with ease to Michelangelo, Mr. Alfred Stevens, will ordinarily paint a little woman (his version of a tulip), always the same, writing a letter, receiving a letter, hiding a letter,*

receiving a bouquet, hiding a bouquet, in short, all the pretty nonsenses which Devéria sells for 200 sols, with no greater pretension.—The great misfortune of this meticulous painter is that the letter, the bouquet, the chair, the ring, the lace, etc. . . . becomes, each in turn, the important thing, the thing which catches the eye.—In sum, he's an utterly *Flemish painter, inasmuch as there is perfection in* emptiness, *or in the* imitation of nature, *which is the same thing.[2]*

In the 1860s Stevens became friendly with Manet, Degas, and their younger contemporaries while achieving one success after another both in France and in Belgium, and soon in the United States as well. He received a first-class medal at the 1867 Exposition Universelle and was promoted to officer of the Legion of Honor. Although Stevens never exhibited with the Impressionists, he supported their efforts. He helped the temporarily impoverished Manet, for example, by introducing him to the dealer Durand-Ruel in 1871; his garden in Paris, a popular gathering spot, served as the setting for Manet's La partie de croquet *(1871; Städelsche Kunstinstitut, Frankfurt).*

Stevens took on Sarah Bernhardt as a pupil in 1874; in the 1880s he would open his atelier to students, primarily women; female artists became a favorite subject for his paintings. Among his few male students was Henri Gervex (1852–1929), with whom he executed the Panorama du Siècle *exhibited at the 1889 Exposition Universelle (divided and dispersed; repetitions solely by Stevens now in the Musée Royaux des Beaux-Arts de Belgique, Brussels).*

GT/AEM

NOTES

1. See Edmond and Jules de Goncourt, *Journal: Mémoires de la vie littéraire,* ed. Robert Ricatte (1956; repr. Paris, 1989), vol. 3, p. 742 (entry for August 11, 1892); Stevens was the subject of a number of pithy passages: for example, vol. 2, pp. 635–36 (March 13, 1875), 969 (November 28, 1882), 991 (February 22, 1883), 997–98 (April 2, 1883). On the circle of the Restaurant du Havre, see also William A. Coles, *Alfred Stevens,* exh. cat., University of Michigan Museum of Art, Ann Arbor, Walters Art Museum, Baltimore, and Musée des Beaux-Arts, Montreal (Ann Arbor, 1977), p. xiv; Coles is the main source for the present biography.

2. "Les plus fort, dit-on, des peintres belges, celui que ses buveurs de faro et ces mangeurs de pommes de terre comparent volontiers à Michel-Ange, M. Alfred Stevens, peint d'ordinaire une petite femme (c'est sa tulipe, à lui) toujours la même, écrivant une lettre, recevant une lettre, cachant une lettre, recevant un bouquet, cachant un bouquet, bref, toutes les

jolies balivernes que Devéria vendait 200 sols, sans plus grande préten-
tion.—Le grand malheur de ce peintre minutieux, c'est que la lettre, le
bouquet, la chaise, la bague, la guipure, etc. . . . deviennent, tour à tour,
l'objet important, l'objet qui crève les yeux.—En somme, c'est un peintre
parfaitement flamand, en tant qu'il y ait de la perfection dans le *néant,* ou
dans l'*imitation de la nature,* ce qui est la même chose." Excerpt from
unpublished notes titled *Pauvre Belgique!,* in Charles Baudelaire, *Oeuvres
complètes,* ed. Claude Pichois, 2 vols. (Paris, 1975–76), vol. 2, p. 932, and see
also pp. 1473–75, 1503 n. 1. On Baudelaire and the Stevens brothers, see Jean
Adhémar, "Baudelaire, les frères Stevens, la modernité," *Gazette des beaux-
arts,* 6th ser., 51 (February 1958), pp. 123–26.

111. *Femme au chale des Indes dans un atelier*

Oil on wood, 22 ½ × 15 ½ in. (57.2 × 39.4 cm)

PROVENANCE
Ernest Le Roy, Brussels; ?Ochsé (to Petit); [Galerie Georges Petit, Paris (Petit
sale?)]; possibly acquired at that sale by Jeanne Lanvin, or Melet-Lanvin, Paris
(by 1924–her d. 1946); her daughter, Marie-Blanche, comtesse de Polignac, *née*
Marguérite di Pietro (1946–her d. 1958); presumably by descent through her
or her husband's family [?sold to Brame & Lorenceau]; [Galerie Brame &
Lorenceau, Paris, 1980–81; sold to Shickman]; [H. Shickman Gallery, New
York, 1981; sold to Wrightsman]; Mr. and Mrs. Charles Wrightsman, New
York (1981–his d. 1986); Mrs. Wrightsman (from 1986).

EXHIBITED
La Renaissance, Paris, June 1–30, 1928, "Portraits et figures de femmes: Ingres
à Picasso, no. 166 (collection Mme J. Melet-Lanvin); Galerie Charpentier,
Paris, 1943, "Scènes et figures parisiennes," no. 206.

LITERATURE
Jean-Louis Vaudoyer, "Ricard et Stevens à propos d'un double centenaire,"
La renaissance de l'art français et des industries de luxes 7 (January 1924), p. 93, ill.
(as "La toilette de bal," collection Melet-Lanvin); François Boucher, *Alfred
Stevens* (Paris, 1930), p. 64, pl. 59 (as "La toilette de bal," collection Mme Melet-
Lanvin); Gustave Vanzype, *Les frères Stevens* (Brussels, 1936), p. 106 no. 166 (as
"La toilette de bal," collection Mme Lanvin, Paris); Eveline Schlumberger, "Au
16 rue Barbet-de-Jouy avec Jeanne Lanvin," *Connaissance des arts,* no. 138 (August
1963), pp. 64, 65, fig. 5 (ill. in situ); Peter Mitchell, *Alfred Émile Léopold Stevens,
1823–1906,* exh. cat., John Mitchell and Sons, London (London, 1973), p. 29 under
no. 11 (as "La toilette de bal"); Robert Rousseau and Annie Grenez, *Rétrospective
Alfred Stevens,* exh. cat., Palais des Beaux-Arts, Charleroi (Charleroi, 1975), under
no. 18 (as "La toilette de bal"); Barbara Scott, "Letter from Paris: The *Biennale
des Antiquaires,*" *Apollo* 112 (September 1980), p. 202, fig. 7; Peter Mitchell, *Alfred
Stevens, 1823–1906,* exh. cat., organized by John Mitchell Fine Paintings at Adam
Williams Fine Art, New York (London, 2004), p. 55, fig. 37, under no. 19.

RELATED PAINTING
NEW YORK, private collection. *La petite bohémienne.* Oil on wood, 13 × 10 in.
(33 × 25 cm).

Fig. 1. Alfred Stevens, *La petite bohémienne.* Oil on wood, 13 × 10 in. (33 × 25 cm).
Private collection, United States, courtesy John Mitchell Fine Paintings,
London

The title of this painting refers to the paisley shawls that first
became popular after Napoleon's Egyptian campaign of 1798. The
hand-embroidered wraps were highly prized and expensive, and
they remained popular until the very end of the nineteenth cen-
tury, long after less costly versions were manufactured on
European jacquard looms.

In the background, Stevens included a remarkable, freely
painted sketch of *La petite bohémienne* (fig. 1), one of the rare pic-
tures in his studio views that can be identified. It has been specu-
lated that the sitter for the sketch may have belonged to the troupe
of Spanish dancers from Madrid, including Lola de Valence, that
performed at the Hippodrome in Paris from August 12 to
November 2, 1862, and that Manet painted in Stevens's studio
rather than his own because it was larger.[1] Interestingly, the pic-
ture resembles the contemporary work of James McNeill
Whistler (1834–1903), who was friendly with Courbet, Manet, and
other artists in Stevens's circle.

This painting once belonged to the celebrated couturier and
collector Jeanne Lanvin, whose Paris apartment was the apogee of
Art Deco style. GT

NOTE

1. Peter Mitchell, *Alfred Émile Léopold Stevens, 1823–1906,* exh. cat., John
Mitchell and Sons, London (London, 1973), p. 29 under no. 11.

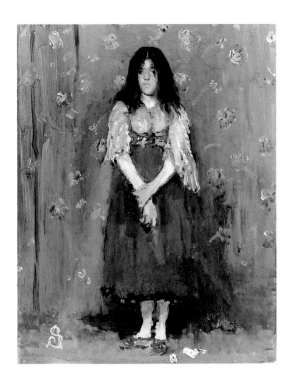

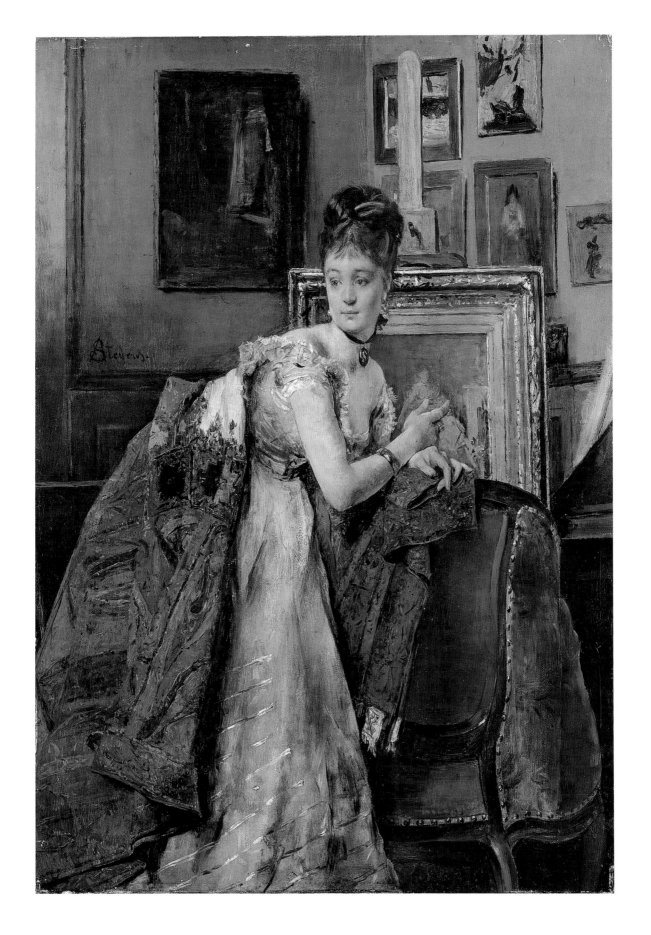

112. *In the Studio*

Oil on canvas, 42 × 53 ½ in. (106.7 × 135.9 cm)
Signed and dated at lower left: AStevens [initials in monogram] .88.
The Metropolitan Museum of Art, New York, Gift of Mrs. Charles
Wrightsman, 1986 (1986.339.2)

PROVENANCE
Louis Sarlin, Paris (by 1900–1918; his estate sale, Galerie Georges Petit, Paris,
March 2, 1918, lot 68, ill., sold together with entire contents of that sale for
Fr 3,000,000, to Heilbuth); Herman Heilbuth, Copenhagen (in 1918); sale,
Galerie Fievez, Brussels, June 14–15, 1927, lot 262 (ill.); ?G. L. Lechien, Brussels
(in 1936); [Galerie Bruno Meissner, Zurich, in 1978]; Dr. and Mrs. Edwin J. De
Costa, Chicago (until 1980; their sale, Sotheby's, New York, January 25, 1980,
lot 148, color ill., for $77,500, to Hirschl & Adler Galleries, Inc., New York,
for Wrightsman); Mr. and Mrs. Charles Wrightsman, New York (1980–his
d. 1986); Mrs. Wrightsman (1986); her gift in 1986 to the Metropolitan
Museum.

EXHIBITED
Société Nationale des Beaux-Arts, Paris, May 7–?, 1892, no. 966; École des
Beaux-Arts, Paris, February 6–27, 1900, "Exposition de l'oeuvre d'Alfred
Stevens," no. 148 (lent by Louis Sarlin, Paris).

LITERATURE
Charles Yriarte, *Figaro-Salon,* 1892, p. 120, ill. (photogravure); Camille
Lemonnier, *Alfred Stevens et son oeuvre, suivi des impressions sur la peinture par
Alfred Stevens* (Brussels, 1906), p. 32, pl. XXXV (as Sarlin collection, Paris);
Gustave Vanzype, *Les frères Stevens* (Brussels, 1936), p. 102 no. 53 (as M. G. L.
Lechien collection, Brussels); Lucy Oakley, in The Metropolitan Museum
of Art, *Recent Acquisitions: A Selection, 1986–1987,* (New York, 1987), pp. 38–39,
color ill.; John Russell, "Art: Met Favorites, Outdoors and In," *New York Times,*
July 31, 1987, p. C28; Peter Mitchell, *Alfred Stevens, 1823–1906,* exh. cat., organ-
ized by John Mitchell Fine Paintings at Adam Williams Fine Art, New York
(London, 2004), p. 40, fig. 31, under no. 5.

RELATED PAINTING
BRUSSELS, Musées Royaux des Beaux-Arts de Belgique. *Salomé,* 1888. Oil on
canvas, 46 ⅞ × 38 ⅝ in. (119 × 98 cm).

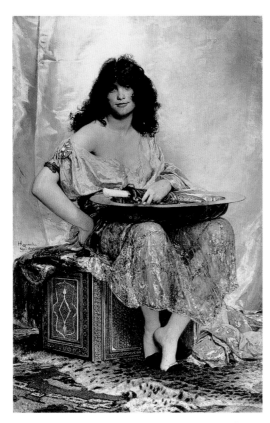

Fig. 1. Henri Regnault, *Salomé.* Oil on canvas, 63 × 40 ½ in.
(160 × 102.9 cm). The Metropolitan Museum of Art,
New York, Gift of George F. Baker, 1916 (16.15)

An artist and her model take a break from a painting session to
welcome a visitor to the studio—another woman, dressed in
street clothes. On the easel is Stevens's *Salomé* (Musées Royaux
des Beaux-Arts de Belgique, Brussels), a freely interpreted version
of the painting by Henri Regnault (1843–1871) that was the sensa-
tion of the 1870 Salon (fig. 1).

Although the painter in the picture is a woman, the setting is
thought to be Stevens's own studio, which was admired for its styl-
ish arrangement of his collections of exotic and luxurious objects.
With the open portfolio, pictures-within-the-picture, and mirror
(reflecting a mundane coal stove), this work of 1888 presents an
elaborate play on the paradoxical relationship between art and
reality. The studio, its contents, and its inhabitants are cast in the
role of the artist's mental laboratory.

Stevens welcomed female students at his studio in the avenue
Frochot during the 1880s, among them Camille Prévost (daughter
of his teacher Roqueplan), Clémence Roth, Louise Desbordes,
Pauline Cuno, Marie Beck, Alix d'Anethan, Berthe Art, and
Georgette Meunier. Other students included Henri Gervex and
several other males.[1]

A number of other canvases by Stevens depict his studio, such
as *L'atelier* (Musées Royaux des Beaux-Arts de Belgique, Brussels)
and *The Painter and His Model* (Walters Art Museum, Baltimore),
where the artist is present. *Interior of a Studio* (Carnegie Institute,

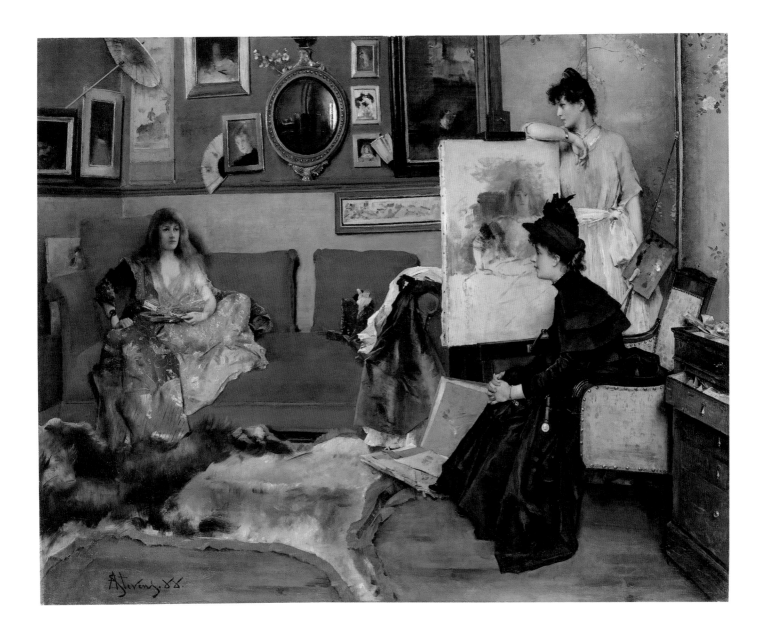

Pittsburgh) and *Visite à l'atelier* (private collection, Indianapolis) depict women looking at a canvas. The model on the sofa in this painting may be the same woman who posed for Stevens's *Ophelia* of 1887 (location unknown).

GT/AEM

NOTE

1. William A. Coles, *Alfred Stevens,* exh. cat., University of Michigan Museum of Art, Ann Arbor, Walters Art Museum, Baltimore, and Musée des Beaux-Arts, Montreal (Ann Arbor, 1997), p. xxxiv.

FRANÇOIS VERNAY

(Francis Miel, 1821–1896)

The illegitimate son of Anne Miel and Antoine Vernay, the artist generally used his mother's maiden name on official documents and his father's name professionally. Although he seems to have had good relations with his father, Vernay remained unrecognized by him, even after his parents were finally married in 1839. Primarily a landscape painter, Vernay worked increasingly in still life after 1865 (two genres for which painters of his native Lyon were well known); he also made a few portraits. He remained almost completely unknown outside his region; he may have met Camille Corot (1796–1875) around 1857. Better known were his contemporaries Auguste Ravier (1814–1895) and Adolphe Appian (1818–1898). Nevertheless, Vernay developed an original approach to drawing and painting landscape, with simplified, geometric forms somewhat in the style of the paintings of Théodore Caruelle d'Aligny (1798–1871) and Corot in the 1830s. At the end of the nineteenth century, this naïveté had affinities with the emerging synthetist style.

Vernay entered Lyon's École des Beaux-Arts at the end of 1840, remaining for less than a year despite some modest success. He exhibited at the Salon de la Société des Amis des Arts de Lyon from 1850 until the 1890s and at the Paris Salon in 1868, 1876, and 1880. In 1881, after twenty years together, he married Catherine Budin (d. 1920), thereby legitimizing their six children. Although he had collectors who purchased his work, Vernay was poor. In the late 1880s he took on a student, Marguerite Cornillac. She married the painter and writer Albert André (1869–1954), whose association with La Revue Blanche resulted in Vernay's first solo exhibition there, albeit posthumously, in 1902.[1] The Musée des Beaux-Arts in Lyon, which holds a number of his works, published the most comprehensive source on the artist on the occasion of a retrospective held in 1999.[2]

GT/AEM

NOTES

1. La Revue Blanche, Paris, January 20–February 5, 1902; see *François Vernay, 1822–1895* [sic]: *Exposition de cent un tableaux et dessins*, exh. cat., with an introduction by Claude Anet (Paris, 1902).
2. Musée des Beaux-Arts, Lyon, September 23–December 19, 1999; see Dominique Brachlianoff and Patrice Steffan, *François Vernay, 1821–1896*, exh. cat. (Lyon and Paris, 1999).

113. *Still Life with Fruit*

Oil on canvas, 10½ × 15 in. (26.7 × 38.1 cm)

PROVENANCE
[Claude Aubry, Paris, 1978; sold to Wrightsman]; Mr. and Mrs. Charles Wrightsman, New York (1978–his d. 1986); Mrs. Wrightsman (from 1986).

The timeless, painterly quality of this charming still life has stumped any number of art historians and curators visiting the Wrightsman collection, who rarely recognize the author. Evoking the natural geometry and soft touch of Chardin's still lifes, Vernay ignored the precise realism characteristic of still-life painters of his own time, such as Henri Fantin-Latour (1836–1904) or Blaise Desgoffe (1830–1901).

GT/AEM

JAMES JACQUES-JOSEPH TISSOT
(1836–1902)

Born in the port of Nantes, James Tissot was the second of four sons of a wholesale linen dealer and a milliner. He moved to Paris about 1856 and studied with Louis Lamothe (1822–1869) and Hippolyte Flandrin (1809–1864), both former students of Ingres (see p. 292). His first pictures, such as the Meeting of Faust and Marguerite of 1860 (Musée d'Orsay, 1983–93), were painted in the romantic Troubadour style, emulating Henri Leys (1815–1869) of Antwerp as well as the English Pre-Raphaelites. This early manner gave way to paintings of modern life after he met Gustave Courbet (1819–1877) and, eventually, Stevens (see p. 393). Edgar Degas (1834–1917), who made a nearly life-size portrait of him (ca. 1868, Metropolitan Museum, 39.161), and James McNeill Whistler (1834–1903) both had an impact on his art in the 1860s, as all three accommodated aspects of Japanese art and lessons learned from photography into their work. Like them, Tissot was a prolific etcher. Yet the refined, illusionist technique learned from Lamothe and Flandrin lent Tissot's paintings an imitative aesthetic that was enhanced by his involvement with photography (he used photographs both as studies for his paintings and to record them once finished). Tissot's works reflect a panoply of innovations usually associated with the avant-garde of his day, though his narrative subjects and naturalist style were considered retrograde throughout most of the twentieth century.

Tissot first exhibited at the Paris Salon in 1859 and continued to do so regularly through 1870, but only occasionally thereafter. Although he participated in the defense of Paris during the Franco-Prussian War, he left for London in 1871, perhaps fearing reprisals after the fall of the Commune. He had reliable connections there, having contributed caricatures to Thomas Gibson Bowles's magazine Vanity Fair as well as having exhibited at the Royal Academy from 1864 (he exhibited regularly there until 1881). In France in the late 1860s, Tissot had begun a series of costume pieces set in the Directoire period; following his arrival in England, he simply adopted Georgian settings and continued to work in the same vein. These British scenes enabled Tissot to introduce ships and port settings into his compositions, which became ever more elaborate contemporary costume pieces that were prized in London for their exquisite craftsmanship as well as for their mirror-like reflection of contemporary mores.

In 1873 Tissot purchased a house and studio in fashionable Saint John's Wood. Around 1875 he met Kathleen Newton, eighteen years his junior, who became his mistress and muse. The most significant showings of Tissot's English sojourn were the three exhibitions held at the Grosvenor Gallery, London, annually from 1877 to 1879. Upon Newton's death in 1882, Tissot returned to France. In 1885 Tissot showed the fruit of three years' work, the series of fifteen oils entitled La Femme à Paris, at the Galerie Sedelmeyer, modified slightly for exhibition at Arthur Tooth in London in 1886 (the best known of these is Les Femmes de sport, Museum of Fine Arts, Boston). Following the death of his father in 1888, Tissot divided his time between Paris and the family château at Buillon (Normandy).

While working on La Femme à Paris, Tissot experienced a mystical vision and set out to illustrate the life of Christ. He visited Palestine in 1886–87 and again in 1889 to make studies. An initial 270 gouaches were exhibited in Paris in 1894; the full complement of 365 was published in 1896–97 and exhibited in Paris, London, and North America from 1896 to 1899, before the Brooklyn Museum bought them in 1900. Tissot followed up his life of Christ with an equally ambitious project to illustrate the Old Testament, returning to Palestine in 1896. The first group of 95 gouaches (Jewish Museum, New York) were exhibited at the Salon du Champ de Mars in Paris in 1901; studio assistants completed the 396 illustrations published posthumously in 1904. Upon Tissot's death in 1902, it was thought that these religious subjects would be his greatest legacy.

GT/AEM

ABBREVIATIONS

London, Manchester, Paris 1984–85. Krystyna Matyjaszkiewicz, ed. James Tissot. Exh. cat., Barbican Art Gallery, London, Whitworth Art Gallery, University of Manchester, and Petit Palais, Paris; 1984–85. Oxford and London, 1984.

Lochnan 1999. Katherine Jordan Lochnan, ed. Seductive Surfaces: The Art of Tissot. New Haven and London, 1999.

Minneapolis, Williamstown 1978. Michael Wentworth. James Tissot: Catalogue Raisonné of His Prints. Exh. cat., Minneapolis Institute of Arts and Sterling and Francine Clark Art Institute, Williamstown, Massachusetts. Minneapolis, 1978.

Wentworth 1984. Michael Wentworth. James Tissot. Oxford, 1984.

114. *Tea*

Oil on wood, 26 × 18⅞ in. (66 × 47.9 cm)
Signed and dated at lower right: J.J. Tissot / L. '72.
The Metropolitan Museum of Art, New York, Gift of Mrs. Charles
Wrightsman, 1998 (1998.170)

PROVENANCE
Private collection, Rome (in 1971); [Somerville & Simpson, Ltd., London,
1979; sold to Wrightsman]; Mr. and Mrs. Charles Wrightsman, New York
(1981–his d. 1986); Mrs. Wrightsman (1986–98); her gift in 1998 to the
Metropolitan Museum.

LITERATURE
Willard E. Misfeldt, "James Jacques Joseph Tissot: A Bio-Critical Study"
(Ph.D. dissertation, Washington University, Saint Louis, Missouri, 1971),
pp. ix no. 72, 138–39, 382, fig. 72 (as private collection, Rome); Wentworth
1984, pp. xvii no. 79, 103, pl. 79; London, Manchester, Paris 1984–85, pp. 20,
107 under nos. 44, 45, and see also p. 68; Christopher Wood, *Tissot: The Life
and Work of Jacques Joseph Tissot, 1836–1902* (London, 1986), p. 60, fig. 56;
Russell Ash, *James Tissot* (London, 1992), colorpl. 12 (and text, opp.); Gary
Tinterow, in "Recent Acquisitions: A Selection, 1998–1999," *The Metropolitan
Museum of Art Bulletin* 57, no. 2 (fall 1999), pp. 46–47, color ill.

VERSION
CARDIFF, National Museum of Wales (NMW A 184). James Tissot, *Bad News*,
1872. Oil on canvas, 27 × 36 in. (68.6 × 91.4 cm). The Wrightsman painting is a
replica of the left-hand side, differing in minor details.

STUDY
OPIO DE ROURET (Alpes Maritimes), Thomas S. Parr collection. James Tissot,
Young Lady Pouring Coffee. Pencil on buff paper, 12¾ × 8½ in. (32.4 × 21.6 cm).
Study used for either or both the Wrightsman and Cardiff paintings; gift of
Tissot to Edgar Degas.

Although it is not known whether Tissot visited London in the
1860s, the French painter had already oriented his subjects and
style to suit British taste by the time he moved there in 1871. Like
many fellow artists—for example, Monet, Pissarro, and Degas—
he sought to escape the tumult and aftermath of the civil war in
Paris that followed the Prussian defeat of France. He immediately
immersed himself in the London scene, with work for *Vanity Fair*
and genre paintings with the Thames as a backdrop. Hoping to
bank on the success he had in France with historical genre pic-
tures peopled with fancifully costumed *Incroyables* and *Merveilleuses*
(young Parisians of the Directoire period who paraded in extraor-
dinary and exaggerated dress), he painted several anecdotal scenes
set in late-eighteenth-century London.

Bad News (fig. 1), shown at the 1872 London International
Exhibition to great acclaim, was one of the first and most suc-
cessful of Tissot's British genre scenes. It shows a young ship's
captain and his girlfriend absorbing the news of his imminent
departure while a companion prepares tea. Evidently encouraged
by the positive reception, Tissot made two further pictures: *An
Interesting Story* (fig. 2), perhaps conceived as a pendant to *Bad
News* and exhibited at the Royal Academy the same year, 1872 (the
figures are different but they are located in the same interior, with
a new view through the window); and *Tea*, the Wrightsman paint-
ing, the third in this group of related works.

Tea is essentially a replica of the left-hand side of *Bad News*.
Nevertheless, there are numerous differences between the two pic-
tures, some notable. Indeed Michael Wentworth characterizes such
works of the early 1870s as "variations" rather than "replicas."[1] The
table leaf, dropped in *Bad News,* is here extended to reveal more of
the young lady's dress, with the entire table moved to the right. In
addition, the view beyond the windows is more decidedly urban and
recognizably London.[2] The silver tea service (but not the porcelain,
which shows coffee cans rather than tea-cups) and the play of
light, especially on the face, are different as well. There are other,
less obvious small discrepancies in the hat ribbons and the ruff of
the apron along the back, and the young woman has lost her earring.

While *Bad News* and *An Interesting Story* could conceivably be
hung as pendants, *Tea* is too similar to both to be exhibited
together with them. Hence it must have been an independent
work designed to entice a collector through its association with
the first two well-regarded exhibition pictures. For this variant,
Tissot brought his astounding technique to new heights. He
reveled in the variety of surfaces—brilliant silver, polished
mahogany, matte silk, and flawless skin—and in the complex play
of patterns—venetian blinds, slotted shutters, striped silk, and the
masts and rigging of the ships at port. Nevertheless, it seems that
all three works were made within a short span. A drawing, for-
merly in the collection of Edgar Degas, has a study for *An
Interesting Story* on one side (fig. 3), and another study, perhaps
made after rather than for *Bad News,* on the reverse. This drawing
may well have been used in the creation of *Tea*, dated 1872.

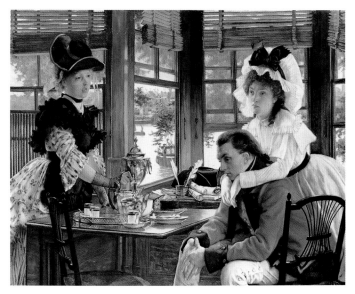

Fig. 2. James Tissot, *An Interesting Story*. Oil on panel, 22¾ × 29½ in. (57.8 × 74.9 cm). National Gallery of Victoria, Melbourne, Felton Bequest, 1938 (536-4)

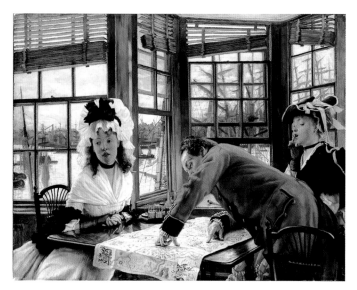

Fig. 1. James Tissot, *Bad News*. Oil on canvas, 27 × 36 in. (68.6 × 91.4 cm). National Museum of Wales, Cardiff (NMW A 184)

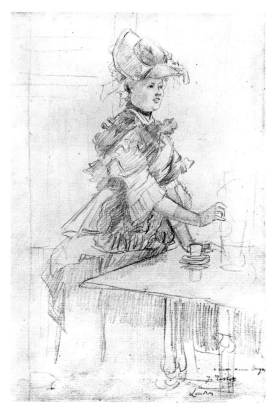

Fig. 3. James Tissot, *Young Lady Pouring Coffee*. Pencil on buff paper, irregular, 12¾ × 8⅜ in. (32.4 × 21.3 cm). Thomas S. Parr collection, Opio de Rouret (Alpes Maritimes)

It is worth noting that this working method is identical to that used by Edgar Degas at approximately the same time. For example, Degas's two pictures of *The Rehearsal of the Ballet on the Stage* (both now part of the H. O. Havemeyer Collection in the Metropolitan Museum) are close variants of the same composition, for which the same drawings were used, but they have important differences—perhaps improvements—nonetheless.[3] Not only were Degas and Tissot good friends before and after the Franco-Prussian War, but

Degas often sought advice from Tissot and hoped to emulate his success with commercial illustration and genre pictures. Degas hoped that Tissot could help him sell *The Rehearsal of the Ballet on the Stage* as a commercial illustration, and his *Portraits in an Office (New Orleans)* of 1873 was specifically conceived to lure a client akin to Tissot's British clientele, as suggested by Degas's letter to him from New Orleans: "And you, what news is there since the 700 pounds? You with your terrible activity would be capable of drawing money out of this crowd of cotton brokers and cotton dealers, etc."[4] GT/AEM

NOTES

1. In London, Manchester, Paris 1984–85, p. 20.
2. *An Interesting Story* and *Tea* seem to share the same view of the Thames; the bay window seen here and in other paintings may be the same one shown from the exterior in *The Captain's Daughter,* 1873 (Southampton Art Gallery, 580) and *The Three Crows Inn, Gravesend,* ca. 1873 (National Gallery of Ireland, Dublin, 1105).

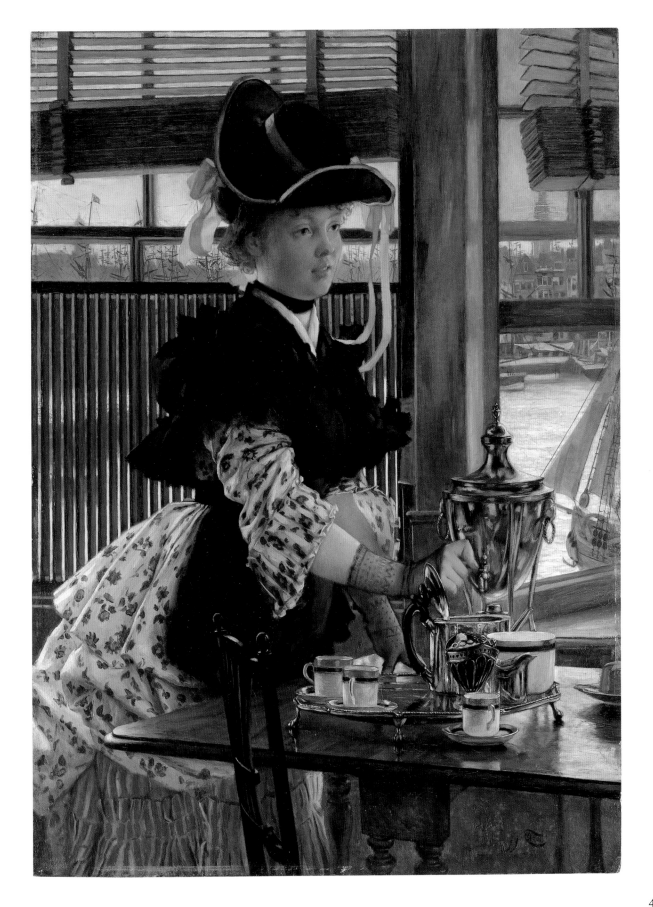

3. The two versions of *The Rehearsal of the Ballet on the Stage* by Degas are both dated 1874?; one of these, inv. no. 29.160.26, measures 21 3/8 × 28 3/4 in. (54.3 × 73 cm), while the other, inv. no. 29.100.39, is 21 × 28 1/2 in. (53.3 × 72.3 cm). See Michael Pantazzi, in *Degas*, exh. cat., Galeries Nationales du Grand Palais, Paris, National Gallery of Canada, Ottawa, and The Metropolitan Museum of Art, New York (New York, 1988), pp. 225–30 nos. 124–25.

4. In 1878 this would become the first work by Degas to enter a public collection, the Musée des Beaux-Arts, Pau (878.1.2), which acquired it for 2,000 francs. Degas's letter to Tissot is dated November 19, 1872 (*Edgar Germain Hilaire Degas: Letters*, ed. Marcel Guerin [Oxford, 1947], p. 18).

115. *Spring Morning (Matinée de printemps)*

Oil on canvas, 22 × 16 3/4 in. (55.9 × 42.5 cm)

Labels on reverse (remounted): (1) THOMAS MᶜLEAN / PRINTSELLER AND PUBLISHER / DEALER IN WORKS OF ART / NO. 7 HAYMARKET, LONDON, W / NEXT DOOR TO THE HAYMARKET THEATRE; (2) GOUPIL & COMP (of Paris) / Publishers and Dealers in / Foreign Pictures, Engravings, / and Other Works of Art / London; (3) inscribed, UX C.[S or 8]. L; (4) inscribed, W.D. / 638 B / 13/2²/20; (5) inscribed 10S over Board n° 11 [le enter?] James Tissot.

PROVENANCE
[?Thomas McLean, London]; [Goupil, London]; sale, Sotheby's Belgravia, London, March 23, 1981, lot 67 (color ill.), for £40,000; Mr. and Mrs. Charles Wrightsman, New York (1981–his d. 1986); Mrs. Wrightsman (from 1986).

LITERATURE
Jane Abdy, *J. J. Tissot: Etchings, Drypoints and Mezzotints,* exh. cat., Frederick Mulder, London (London, 1981), under no. 1; London, Manchester, Paris 1984–85, pp. 56, 57, fig. 23, 60, 73, 116 under no. 90 (as private collection), and see also nos. 91, 93.

DRYPOINT
James Tissot, *Spring Morning (Matinée de printemps).* 19 7/8 × 11 in. (50.6 × 27.9 cm). Signed and dated at lower right: JJ Tissot / 1875. In the reverse sense of the painting (Minneapolis, Williamstown 1978, pp. 76–79 no. 13).

Like *En plein soleil* (cat. 117), the composition of *Spring Morning* was known for a century only through the related etching (fig. 1) before the painting reappeared at auction in 1981. It was common practice for Tissot not only to repeat his paintings as etchings but to also reuse and recombine figures, motifs, costumes, and compositions. Indeed, elements of this painting served as the sources for a number of works. The dress reappears in the etching *Woman at the Window* (ca. 1875) and again with the hat in the painting *Holyday* (ca. 1876); the rhubarb plant and reeds in the foreground

are featured in the painted and etched versions of *The Widower* (1876); and the reeds appear again in the similar composition *Orphan* (1879).[1]

Wentworth has remarked that the principal motif here, the figure silhouetted against the light, is reminiscent of certain Japanese color woodblock prints, such as Buncho Ippitsusai's *The Actor Segawa Kikunojo in a Female Role* (ca. 1796), and the clump of vegetation in the foreground is similar to a motif in Hokusai's *Manga,* sources that were available to Tissot throughout the 1860s.[2] Tissot, along with his friends Baudelaire, Bracquemond, Degas, Fantin-Latour, Manet, Monet, and Whistler, was an early and avid aficionado of the Japanese color prints that began to arrive in France in the late 1850s and early 1860s. In addition, Tissot may have been inspired by the sight of related motifs in the works of his contemporaries, where a similar contre-jour effect may be seen.[3] Most of the Impressionist artists employed this effect at one point or another in the 1870s and 1880s.

When the etching derived from this painting was exhibited in London in 1876, it was inexplicably singled out for criticism: "intensely vulgar, but clever enough for the public it appeals to."[4] The vulgarity that offended the critic was perhaps the direct, unmitigated stare of the model, addressing the viewer from across

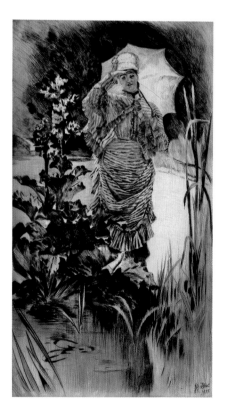

Fig. 1. James Tissot, *Spring Morning (Matinée de printemps).* Drypoint on laid paper, sheet, 20 5/8 × 11 5/8 in. (52.4 × 29.6 cm), plate, 19 7/8 × 11 in. (50.6 × 27.8 cm). Art Gallery of Ontario, Toronto, Gift of Allan and Sondra Gotlieb, 1994 (94/20)

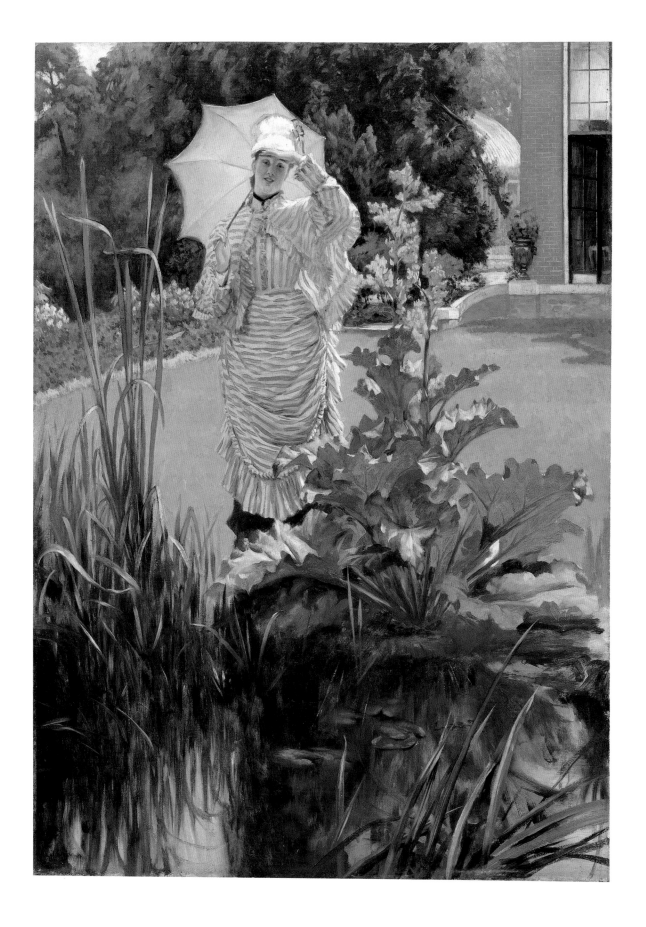

a small pond. But there is nothing vulgar about her gesture, her dress, or the garden. While it is not known whether Tissot portrayed a specific garden (perhaps his own in Saint John's Wood) or invented an imaginary one, the remarkable specificity of the blooming plants—acanthus and iris in the foreground, red pelargoniums, white azaleas, and rhododendrons in the background—suggests a setting in spring, perhaps April or May.

It is possible that this is the earliest representation of Tissot's companion, Kathleen Newton. According to Newton's niece Lilian Hervey, "One day [Tissot] called to ask if he might paint her portrait. Over sittings they fell deeply in love, and soon Mrs. Newton went to live with Tissot."[5] The details of Newton's life in the years that immediately preceded her moving in with Tissot sometime in 1876 are unknown. Given that in March of that year she gave birth to a son, Cecil George, who could have been fathered by Tissot (there is no evidence either way), the Wrightsman painting, ca. 1875, may document an early phase of their relationship.[6]

<div style="text-align: right">GT/AEM</div>

NOTES

1. *Femme à la fenêtre (Woman at the Window)* is known only as an etching, while *Holyday* was executed only in oil (Tate Gallery, London). *Le Veuf (The Widower)* exists as both an oil painting (Art Gallery of New South Wales) and as an etching in the same sense, as does *L'orpheline (Orphan)*, the painted version of which is in a private collection. The relationship between Tissot's prints and paintings is explored in depth in Minneapolis, Williamstown 1978 and in Willard E. Misfeldt, *J. J. Tissot: Prints from the Gotlieb Collection,* exh. cat., Dixon Gallery and Gardens, Memphis, Detroit Institute of Arts, Naples (Florida) Performing Arts Center Galleries, Fort Wayne Museum of Art, Museum of Fine Arts, Montreal, and Christopher Wood Gallery, London (Alexandria, Virginia, 1991); Misfeldt does not mention the painted version of *Spring Morning.*
2. Reproduced in Minneapolis, Williamstown 1978, p. 78, figs. 13a and 13b, respectively; see also Gabriel Weisberg et al., *Japonisme: Japanese Influence on French Art, 1854–1910,* exh. cat., Cleveland Museum of Art, Rutgers University Art Gallery, New Brunswick, New Jersey, and Walters Art Gallery, Baltimore (Cleveland, 1975), p. 3.
3. See, for example, Monet's *Gladioli* of 1876 (Detroit Institute of Arts, 21.71; Wildenstein 414), p. 79, fig. 13C.
4. Anonymous, "Exhibition of Works in Black and White—Dudley Gallery," *Athenaeum,* June 17, 1876, p. 837, quoted in Minneapolis, Williamstown 1978, p. 76 n. 3 under no. 13.
5. Lilian Hervey, quoted by Marita Ross, in "The Truth about Tissot," *Everybody's Weekly,* June 15, 1946, p. 6.
6. See Wentworth 1984, pp. 126–27, esp. n. 4.

116. *In the Conservatory*

Oil on canvas, 15 × 20 in. (38.1 × 50.8 cm)
Signed at lower left, with ornamental signature.

PROVENANCE
Robert Knowles; Kaye Knowles (estate sale, Christie's, London, May 14, 1887, lot 149, as "Afternoon Tea," for 50 guineas, to Agnew); [Agnew, London, 1887]; Mrs. Mary Grant (by 1937–at least 1955); J. E. Grant, Esq. and Mrs. P. M. Mackay Scobie (after 1955–1981; sale, Christie's, London, October 16, 1981, lot 84, color ill.); [Richard Green Gallery, London, 1981, stock no. RH250, as "Rivals"; sold to Wrightsman]; Mr. and Mrs. Charles Wrightsman, New York (1981–his d. 1986); Mrs. Wrightsman (from 1986).

EXHIBITED
The Leicester Galleries (Ernest Brown & Phillips, Ltd.), London, January 1937, "The Second James Tissot Exhibition," no. 18 (lent by Mrs. Grant); organized by the Arts Council of Great Britain: Graves Art Gallery, Sheffield, May 28–June 26, 1955, possibly as no. 33; Bolton Art Gallery, July 16–August 13, 1955; Bristol City Art Gallery, August 20–September 17, 1955; Birmingham City Art Gallery, September 24–October 15, 1955; Bradford, Cartwright Memorial Hall, October 22–November 12, 1955; "Paintings, Drawings and Etchings by James Tissot, 1836–1902."

LITERATURE
James Laver, *"Vulgar Society": The Romantic Career of James Tissot, 1836–1902* (London, 1936), ill. on front jacket (as collection Mrs. Grant); Graham Reynolds, *Painters of the Victorian Scene* (London, 1953), pp. 36, 99, fig. 101 (as collection Mrs. Grant); Willard E. Misfeldt, "James Jacques Joseph Tissot: A Bio-Critical Study" (Ph.D. dissertation, Washington University, Saint Louis, Missouri, 1971), pp. 162 n. 53, 391, fig. 88 (erroneously, as "Rivals, 1879, unlocated"); Wentworth 1984, pp. xix no. 137, 6, 141–42, 145 n. 56, pl. 137; London, Manchester, Paris 1984–85, pp. 21, 76, and see also p. 70, fig. 25 (as whereabouts unknown); Christopher Wood, *Tissot: The Life and Work of Jacques Joseph Tissot, 1836–1902* (London, 1986), pp. 106, 107, fig. 107 (color), 157 no. 107; Russell Ash, *James Tissot* (London, 1992), mentioned in text opp. pl. 23, colorpl. 31 (and text, opp.); Margaret Flanders Darby, "The Conservatory in St. John's Wood," in Lochnan 1999, pp. 163, 177, 179, 181, pl. VII; Katharine Lochnan, "The Medium is the Message: Popular Prints and the Work of James Tissot," in Lochnan 1999, pp. 11, pl. VII; Carole G. Silver, "Tissot's Victorian Narratives: Allusion and Invention," in Lochnan 1999, pp. 128–29, pl. VII.

This work of about 1875–78 is another example of a highly finished exhibition picture that dropped from view soon after completion, only to emerge at the saleroom in 1887 and in exhibitions in 1937 and 1955 (perhaps Tissot sold the painting to Mr. Knowles before he had the opportunity to exhibit it; see Provenance, above). As Michael Wentworth has pointed out, this painting was sometimes wrongly called *Rivals,* a now lost painting set in the same conservatory that was exhibited at the Grosvenor Gallery, London, in 1879; it is known through the photograph Tissot made of it for

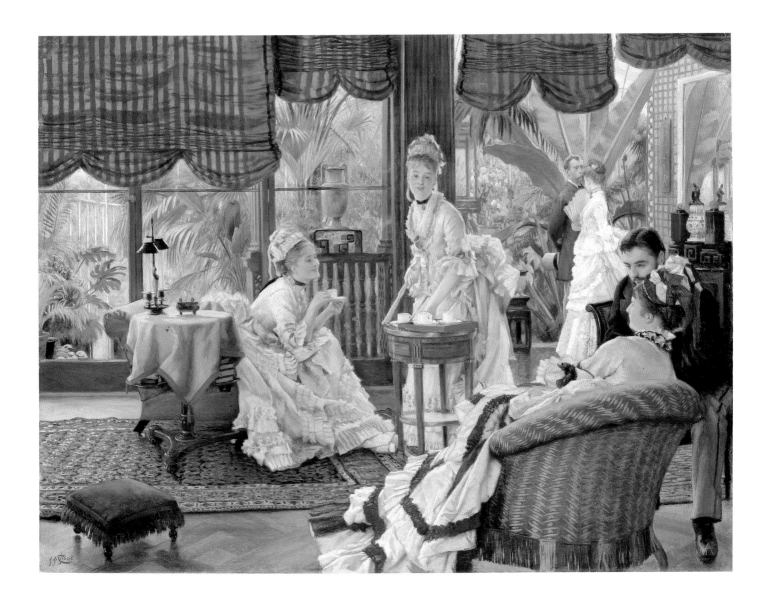

his albums. However, *In the Conservatory* is probably not Tissot's title for the Wrightsman painting, and since no etching was made, we are not likely to find it. Wentworth argues that while the pair of twins are obviously the "narrative hinge" of the picture, discovery of the work's actual title would almost certainly lead to a better understanding of it.[1] On the other hand, the scene that Tissot lays out seems clear enough.

The two girls in the center of the composition are twin sisters; their mother sits in the foreground with a gentleman who may be a prospective suitor. Or, perhaps he has no interest and has

been unjustly targeted by the women; put off by the girls' gregariousness, he feigns interest in their mother's conversation. The man and woman in the background seem to be commenting disapprovingly on the comedy in the foreground. As Wentworth observed, *In the Conservatory* "looks to the opulent world of the social conversation pieces, but combines their neutral display of millinery with a triangular comedy of manners—surely Tissot's favourite English narrative subject—as twins in juvenile blue preen before a gentleman who takes refuge in conversation, or at least embarrassed silence, with a lady presumably their doting

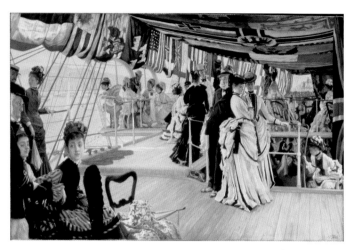

Fig. 1. James Tissot, *Ball on Shipboard,* ca. 1874. Oil on canvas, 33⅛ × 51 in. (84.1 × 129.5 cm). Tate Britain, London

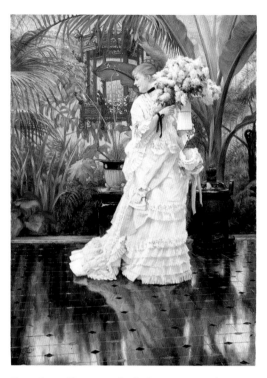

Fig. 2. James Tissot, *Bunch of Lilacs,* ca. 1875. Oil on canvas, 20 × 14 in. (50.8 × 35.6 cm). Private collection

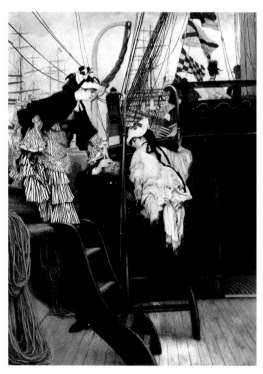

Fig. 3. James Tissot, *Boarding the Yacht,* 1873. Oil on canvas, 30 × 21¾ in. (76.2 × 55.2 cm). The Hon. P. M. Samuel, London (as of 1984)

mother." Wentworth sees a relationship to Tissot's *Ball on Shipboard* of ca. 1874 (fig. 1), although he considers *In the Conservatory* "less technically perfect and glacially incisive." It is also close in date and spirit to *The Bunch of Lilacs* of about 1875 (fig. 2). "If its narrative pushes satire dangerously close to caricature, a drift clear in comparison with the deliciously subtle comedy of early works like *Boarding the Yacht* [fig. 3], its loquacious vulgarity at least has a life which marks it out from the often less than incisive narratives set in St. John's Wood."[2]

Carole Silver has ventured a compelling if speculative elaboration of Wentworth's interpretation. She believes that Tissot often alludes in one work to scenarios in another, as well as to published literary works (sometimes obscure), but that he is equally capable of what she calls "invention"—"visual pseudo-narratives" that she characterizes as "visual invitations to narrative" in which there may be no fixed meaning—and that there is a constant tension between these two possibilities in his work. (The same is true of Edgar Degas's genre pictures of the 1860s and 1870s.) She observed, as have others, that the twin sisters in *In the Conservatory* are repeated from Tissot's *Ball on Shipboard* (which she dates to 1873) and believes that both pictures allude to the twin sisters found in George John Whyte-Melville's *M. or N.,* a popular 1869 novel. Tissot had caricatured the author for *Vanity Fair.* "Whether or not Tissot specifically refers here to Whyte-Melville, the recurrence of these figures points to an internal narrative, a structure of self-allusion that makes his works unusually rich in implications."[3]

The setting is based on Tissot's studio and conservatory in Saint John's Wood, London. Many of the furnishings and accessories may be seen in other works of this period.

GT

NOTES

1. See Wentworth 1984, pp. xix no. 137, 6, 141–42, 145 n. 56, pl. 137, and Wentworth, in London, Manchester, Paris 1984–85, p. 21.
2. Wentworth 1984, pp. 141–42.
3. Carole G. Silver, "Tissot's Victorian Narrative: Allusion and Invention," in Lochnan 1999, pp. 128–29.

117. *En plein soleil*

Oil on panel, 9¾ × 13⅞ in. (25 × 34 cm)
Signed at lower left: J.J. Tissot. Label on panel: Boulevart Montmartre, 8. / [CARPE]NTIER-DEFORGE, / MARCHAND DE COULEURS / Dorure et Encadrements / EN TOUS GENRES. / Atelier de Rentoilage et de Restauration de Tableaux. / NETTOYAGE DE GRAVURES. Label partially obscures panel-maker's impressed mark: [G.] ROWNEY / PREPARED / MA[HOGANY PANEL] / [LONDON / ?RATHBONE PLACE].

PROVENANCE
[Thomas Lenz, Milwaukee, by 1976; sold on March 31 to Williams]; [Williams and Son, London, 1976; sold to Stair Sainty]; [Guy Stair Sainty, 1976; sold to Bristol]; the marquess of Bristol, London (1976–83; sold to Stair Sainty); [Guy Stair Sainty, 1983; sold to Wrightsman]; Mr. and Mrs. Charles Wrightsman, New York (1983–his d. 1986); Mrs. Wrightsman (from 1986).

LITERATURE
Willard E. Misfeldt, *The Albums of James Tissot* (Bowling Green, Ohio, 1982), pp. 10, 66 no. III-31, ill.; Stair Sainty Matthiesen, *Old Master and Nineteenth Century Paintings, Drawings and Sculpture* (New York and London, n.d. [ca. 1983]), p. 22, color ill.; Wentworth 1984, p. xiii no. IV, color pl. IV, opp. p. 139, pp. 151, 152 (see. n. 85 [etching after the painting]), 153 (see also pl. 165); London, Manchester, Paris 1984–85, pp. 95 n. 4, 126 under no. 132, 131, fig. 145c under no. 145; Christopher Wood, *Tissot: The Life and Work of Jacques Joseph Tissot, 1836–1902* (London, 1986), pp. 89, 91, fig. 86 (color), 157 no. 86; Willard E. Misfeldt, *J. J. Tissot: Prints from the Gotlieb Collection*, exh. cat., Dixon Gallery and Gardens, Memphis, Detroit Institute of Arts, Naples (Florida) Performing Arts Center Galleries, Fort Wayne Museum of Art, Museum of Fine Arts, Montreal, and Christopher Wood Gallery, London (Alexandria, Virginia, 1991), p. 122, fig. 32 under no. 47; Nancy Rose Marshall and Malcolm Warner, *James Tissot: Victorian Life, Modern Love*, exh. cat., Yale Center for British Art, New Haven, Musée du Québec, and Albright-Knox Art Gallery, Buffalo (New Haven and London, 1999), pp. 136 under no. 58, 199 n. 9.

STUDY
WHEREABOUTS UNKNOWN. Photograph of Kathleen Newton, on which the woman seated on grass at left and other details in the painting are based

(Marita Ross, London, in Minneapolis, Williamstown 1978, p. 234 under no. 54). The artist may have made other photographs for use as studies for the painting.

ETCHING
James Tissot, *En plein soleil*, 1881. Etching with drypoint, in reverse sense of the painting, 7½ × 11¾ in. (19 × 29.7 cm). Minneapolis, Williamstown 1978, no. 54. Tissot also photographed the finished painting (Willard E. Misfeldt, *The Albums of James Tissot* [Bowling Green, Ohio, 1982], no. III-31, ill.).

RELATED WORKS
James Tissot, *"Garden-party" d'enfants (A Children's Garden Party)*, ca. 1880–81. Drypoint, 10 × 6¼ in. (25.4 × 15.9 cm). Minneapolis, Williamstown 1978, no. 49. James Tissot, *Sur l'herbe (On the Grass)*, ca. 1880–81. Etching with drypoint, 7¾ × 10⅝ in. (19.7 × 27 cm). Minneapolis, Williamstown 1978, no. 50. These two etchings, the latter based on a lost painting, contain figural groupings that the artist may have asked the sitters to restage, to be photographed for use in developing the composition of the present work.

"Certainly among the most beautiful of [the paintings of Kathleen Newton with children] in its composition, fresh colour, and sentiment," *En plein soleil* was known for a century through the etching that the artist made after the painting, and so a body of literature relating to the subject and the composition developed before this, the original painting, dating to about 1881, resurfaced about 1976.[1] Tissot's own photograph of the painting, which he had inserted into albums that he kept as a record of his production, was published by Willard Misfeldt in 1982.[2]

The Wrightsman painting is also remarkable for the fact that it is based in part on a photograph that Tissot had made (others, now lost, may also have been used). The sitter, Kathleen Newton (May or June 1854–November 9, 1882), Tissot's companion from at least 1876 until her death from tuberculosis, is seated with her parasol on a lawn just as she would appear in the painting (fig. 1), although it is not known exactly when this photograph or others like it were made. As Lilian Hervey, Kathleen Newton's niece, described Tissot's practice (for another picture), "Tissot got his studio assistant—a good amateur photographer—to record the scene with his camera. Later he transferred it to canvas."[3]

As Michael Wentworth observed:

The chief aesthetic effect of Tissot's new reliance on the photograph was a dilution of the careful design of the pictures of the middle seventies which had been based on his Ingriste training and the study of Degas, Whistler, and the Japanese print. The increas-

409

ing capacity of the camera to capture instantaneous effects translates itself into a random quality in the paintings which, no matter how carefully contrived in actuality, gives an effect of discursiveness which was clearly intended to keep his work 'modern'. Japanese art and the photograph had tended to validate one another in the seventies when the actual 'truthfulness' of many seemingly abstract effects in Japanese prints was corroborated by the evidence of the photograph, and this double influence had often struck a balance in works like *En plein soleil*.[4]

In addition to this fusion of photographic spontaneity and Japonisme, Tissot here displays some of his trademark painterly effects, with neat brushstrokes but dense pigments, that thrilled his admirers, such as the illusion of light passing through the translucent Japanese paper parasol, and his incomparable rendering of textiles and patterns. Painted on wood panel, the picture is exceptionally well preserved.

The children in the picture have been identified as Kathleen's son Cecil George Newton (March 21, 1876–May 4, 1941) and her daughter Muriel Mary Violet Newton, known as Violet (December 20, 1871–December 28, 1933).[5] The remaining figures have not yet been identified with certainty. Misfeldt saw the woman seated on the garden wall, sewing, as a second representation of Kathleen Newton, but she could also be Kathleen's elder sister Mary Hervey (1851 or 1852–March 4, 1896); this would help account for the second, slightly younger girl, who might be one of Mary's two daughters, Isabelle (June 30, 1873–June 3, 1929) or Lilian (March 5, 1875–March 1, 1952). Like Tissot, whose address was 17 Grove End Road, the Herveys lived in Saint John's Wood in north London; Kathleen Newton was living with her sister when she met the artist.

Far removed from the witty scenes of seduction and social intercourse for which Tissot is best known, the *hortus inclusus* depicted in *En plein soleil* seems to reflect the cozy private life that Tissot hoped for or perhaps even attained. In this respect he is much like his colleague Claude Monet, who, in the mid-1870s, painted his companion Camille in dresses finer than those she owned resting in the garden of their small, rented house, whose flower beds Monet improved in paint. Tissot, however, was always affluent; although he and Monet both came from solid bourgeois stock, Tissot never knew the hard times that Monet endured until

Fig. 1. Photograph of Kathleen Newton used for *En plein soleil* (whereabouts unkown)

after Camille died and he took up with his wealthy companion, Alice Hoschédé, in 1879.

The tender domesticity that unfolds on this patch of lawn, presumably at Grove End Road, was short-lived. Kathleen Newton's funeral was held on November 14, 1882; Tissot apparently abandoned this property and its contents and on that day left for Paris, where he stayed for five years. The early history of this painting is not known; Michael Wentworth could not find a record of early exhibition. GT/AEM

NOTES

1. Wentworth 1984, p. 152.
2. Willard E. Misfeldt, *The Albums of James Tissot* (Bowling Green, Ohio, 1982), p. 66, as no. III-31. The catalogue of the Tissot exhibition held at the Dudley Gallery, London, in May 1882 states, "The Complete Collection of the Artist's Works are reproduced in a Series of Photographs, which are contained in three albums, also on view: Vol. I.—1859–1870; Vol. II.—1870–1876; Vol. III.—1876–1882" (Misfeldt, *Albums of James Tissot*, p. 1). Now seemingly lost, it is not possible to know whether those albums are identical with the ones whose contents (lacking the years 1871–78) Misfeldt reproduces, although they came from the artist's former country home, the Château de Buillon near Besançon. The albums were extensive but not exhaustive: the earliest works reproduced with photographs are Tissot's entries for the Salon of 1859, the first Salon in which he participated.
3. Lilian Hervey, quoted by Marita Ross, in "The Truth about Tissot," *Everybody's Weekly*, June 15, 1946, p. 7. As the result of another article in the same periodical about the mysterious woman who appeared in many of Tissot's paintings, the author received a letter from Hervey, who subsequently came forward to be interviewed. Thus did Kathleen Newton enter the Tissot literature. For more extensive treatments of Newton's biography, see David S. Brooke, "James Tissot and the 'Ravissante

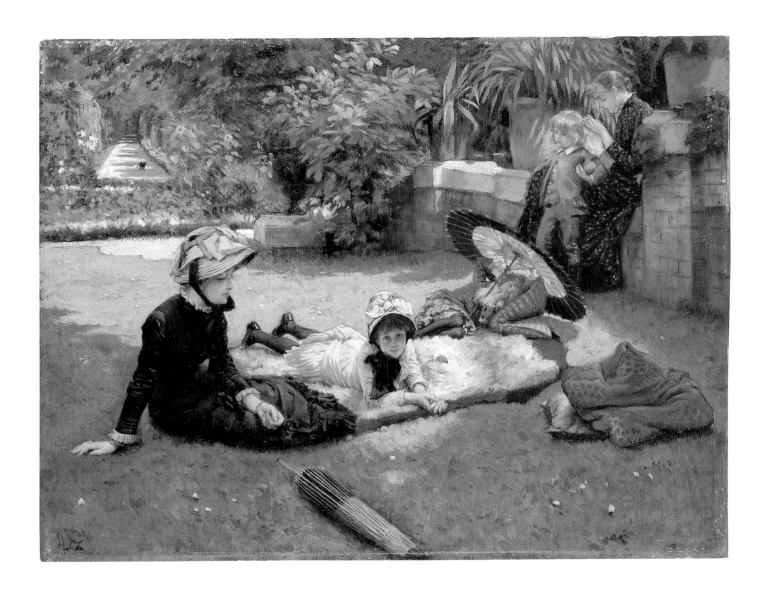

Irlandaise,'" *Connoisseur* 168 (May 1968), pp. 55–59; David S. Brooke, "Author's Note," in Henri Zerner, David S. Brooke, and Michael Wentworth, *James Jacques Joseph Tissot, 1836–1902: A Retrospective Exhibition*, exh. cat., Museum of Art, Rhode Island School of Design, Providence, and Art Gallery of Ontario, Toronto (Providence, 1968), n.p.; Wentworth 1984, pp. 126–29; Willard E. Misfeldt, *J. J. Tissot: Prints from the Gotlieb Collection,* exh. cat., Dixon Gallery and Gardens, Memphis, Detroit Institute of Arts, Naples (Florida) Performing Arts Center Galleries, Fort Wayne Museum of Art, Museum of Fine Arts, Montreal, and Christopher Wood Gallery, London (Alexandria, Virginia, 1991), pp. 15–17.

4. Wentworth 1984, p. 153.

5. For Cecil George Newton's dates, see London, Manchester, Paris 1984–85, p. 126 under no. 132; for Violet Newton's dates, see Misfeldt, *Tissot: Prints from the Gotlieb Collection,* p. 122 under no. 47.

ÉVA GONZALÈS

(1849–1883)

Today Éva Gonzalès is remembered principally as a pupil of Édouard Manet (1832–1883) and as one of the quartet of serious and talented women—including Marie Bracquemond (1840–1916), Mary Cassatt (1844–1926), and Berthe Morisot (1841–1895)—who painted alongside the Impressionists. Daughter of a Spanish writer and a Belgian musician, Gonzalès was born into the Parisian art world. She began taking lessons from society portraitist Charles Chaplin (1825–1891) at the age of sixteen and continued as his student until she was twenty-one.

It was in 1869, in the studio of the Belgian painter Alfred Stevens (see p. 393), that Gonzalès met Manet, whom she seems to have impressed immediately with her robust beauty, becoming first his model and later his pupil. Manet's portrait of Gonzalès, which presents her charmingly dressed and seated, working at her easel, was displayed at the Salon of 1870, at which she too (for the first time) showed a painting, The Little Soldier (Musée Gaston Rapin, Villeneuve-sur-Lot).

Like other women artists of the period with whom she is most closely associated, Gonzalès usually pictured the kinds of quiet domestic scenes with which she was intimately acquainted, often employing her sister Jeanne, also an artist, as sitter. Her paintings are reminiscent of Manet's Spanish-influenced compositions, for they appear somewhat heavy and somber. Yet the pastels she produced in the late 1870s are, again, rather like Manet's of the same period, lighter and more delicate, seemingly reviving the confectionery of François Boucher (see p. 170) and Jean-Honoré Fragonard (1732–1806).

In 1879 Gonzalès married the engraver Henri Guérard (1846–1897). She died from complications in childbirth four years later, only six days after the death of Manet, her friend and teacher. CI

118. *The Bouquet of Violets*

Pastel on wove paper, 9⅞ × 7½ in. (25 × 19 cm)
Signed in black chalk at upper right: Eva Gonzalès.

Provenance
Raymond Deslandes (by 1885); Henri Guérard, widower of the artist, Paris (until his death in 1897); Jeanne Guérard-Gonzalès, sister of the artist; Jean-Raymond Guérard, Paris (1924); [David Carritt Limited, London]; [Paul Rosenberg & Co., New York]; [Noortman & Brod, London, 1983; sold to Wrightsman]; Mr. and Mrs. Charles Wrightsman, New York (1983–his d. 1986); Mrs. Wrightsman (from 1986).

Exhibited
Salon de la "Vie Moderne," Paris, January 15–31, 1885, "Peintures et pastels de Éva Gonzalès," no. 38 (lent by Raymond Deslands); Grand Palais de Champs-Élysées, Paris, October 1–22, 1907, Salon d'Automne, no. 14; Galerie Bernheim-Jeune, Paris, March 30–April 18, 1914, "Éva Gonzalès," no. 30; Galerie Marcel Bernheim, Paris, June 20–July 9, 1932, "Exposition rétrospective Éva Gonzalès (1850–1883)," no. 32; Galerie Alfred Daber, Paris, 1950, "Éva Gonzalès," no. 15; Musée National des Beaux-Arts, Monte Carlo, March 3–23, 1952, "Exposition Éva Gonzalès," no. 29, ill.; Galerie Daber, Paris, May 28–June 13, 1959, "Éva Gonzalès, 1849–1883," no. 33; Noortman & Brod, London, November 17–December 17, 1982, "Seventh Annual Exhibition of Nineteenth and Twentieth Century French Watercolours and Drawings," no. 13; Noortman & Brod, Maastricht, April 23–May 28, 1983, and London, June 14–July 29, 1983, "Impressionists: An Exhibition of French Impressionist Painting," no 11.

Literature
Roger Marx, "L'exposition Éva Gonzalès," Le journal des arts, January 20, 1885, p. 2; Edmond Jacques, "Beaux-Arts," L'intransigeant, January 21, 1885, p. 3; Robert Henard, "Les expositions," La renaissance, April 4, 1914, p. 25; François Monod, "L'Impressionnisme féminin, deux élèves de Manet: Berthe Morisot (1841–1895), Éva Gonzalès (1849–1883)," Art et décoration, May 1914, suppl., p. 3; Paule Bayle, "Éva Gonzalès," La renaissance, June 1932, ill. p. 113; Claude Roger-Marx, "Éva Gonzalès," Arts, July 14, 1950, p. 8; Claude Roger-Marx, Eva Gonzalès (Saint-Germain-en-Laye, 1950), p. xi; "London Calendar," Burlington Magazine 124 (December 1982), p. 794, fig. 59; Marie-Caroline Sainsaulieu and Jacques de Mons, Eva Gonzalès, 1849–1883: Étude critique et catalogue raisonné (Paris, 1990), p. 204 no. 92; Carol Jane Grant, "Eva Gonzalès (1849–1883): An Examination of the Artist's Style and Subject Matter" (Ph.D. dissertation, Ohio State University, 1994), pp. 298, 498, pl. 169.

Manet's influence pervades this pastel (dated circa 1877–78) by his student Eva Gonzalès although it is, overall, a softer, sweeter picture than anyone might expect from the master. The pearly gray and pink palette, the brisk handling of the pigments, and an ensemble of pictorial elements that awaken our senses, including the silky, rustling gown and the fragrant violets, all bring to mind Manet's singular powers. It was in the 1870s that he, too, produced tender portraits of women and flowers—perhaps finding himself not altogether immune to the tastes of his pupils Gonzalès and Berthe Morisot.

Gonzalès often employed her sister Jeanne (also a talented artist) as a model for her pictures of women engaged in polite daily life, and most likely it is she who is portrayed (in "lost" profile) arranging a bunch of violets to be placed in a small blue porcelain vase. Earlier, in 1872, Manet depicted Berthe Morisot wearing a corsage of violets and then painted a nosegay for her in a still life.

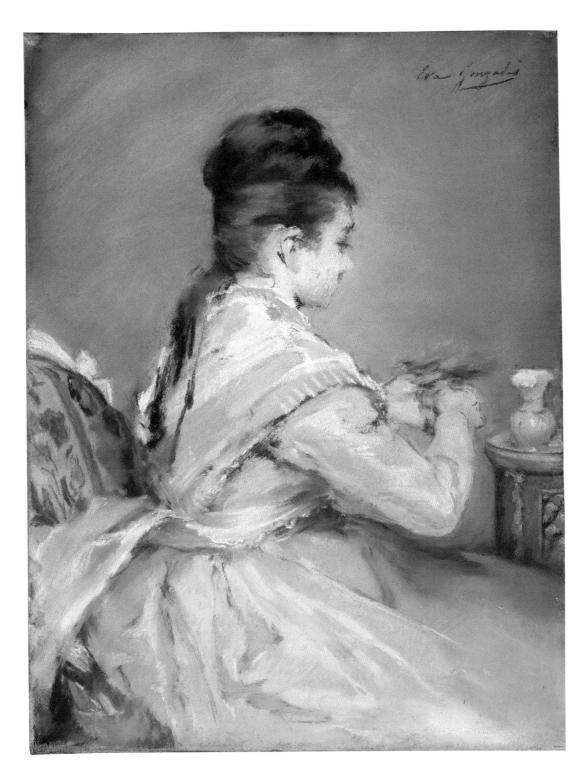

Associated with friendship, admiration, and constancy, the violet has a long history in art, establishing itself in the West as a praiseworthy subject during the early Renaissance in tapestries and in a well-known watercolor by Albrecht Dürer (1471–1528). In the nineteenth century the flower gained popularity, as strains of the Parma violet were adapted for growth in more northern climes and a perfume was developed by Italian monks for Napoleon's second wife, Maria Luigia, duchess of Parma. About 1870 the jealously guarded secret formula was obtained so that the fragrance might be produced for a wider audience. CI

PAUL-DÉSIRÉ TROUILLEBERT

(1829–1900)

Parisian-born Paul-Désiré Trouillebert studied with Antoine-Auguste-Ernest Hébert (1817–1908) and Charles-François Jalabert (1819–1901). A portraitist, genre painter, and landscapist, Trouillebert exhibited at the Salon from 1865 until at least 1882.[1] He is best known, if not notorious, for landscapes that imitate the style of Camille Corot (1796–1875). Trouillebert held regular sales of his own works as of 1883, a tradition continued after his death, presumably by his widow, who may have been the painter Mme Trouillebert, née Clémentine Saint Edme (n.d.; debuted at Salon of 1868).

In 1883 Alexandre Dumas fils purchased at the well-regarded Paris gallery of Georges Petit a painting by Trouillebert falsely signed "Corot." A law suit instigated by Trouillebert ensued, casting suspicion on many works by Corot as well as drawing attention to his several imitators.[2]

GT/AEM

NOTES

1. Émile Bellier de la Chavignerie and Louis Auvray, *Dictionnaire général des artistes de l'école française depuis l'origine des arts du dessin jusqu'à nos jours* (1882–87; repr. New York and London, 1979), vol. 4, p. 595.
2. Alfred Robaut, *L'oeuvre de Corot* (Paris, 1905), vol. 1, pp. 334–35; see also Vincent Pomarède, "Corot Forgeries: Is the Artist Responsible?" in Gary Tinterow, Michael Pantazzi, and Vincent Pomarède, *Corot*, exh. cat., Galeries Nationales du Grand Palais, Paris, National Gallery of Canada, Ottawa, The Metropolitan Museum of Art, New York (New York, 1996), pp. 392–93.

119. *Nature morte aux violettes*

Oil on wood, $7\frac{1}{2} \times 9\frac{1}{2}$ in. (19.1 × 24.1 cm)
Signed, on the card: Trouillebert. Inscribed on the reverse:
A Madame Alfred Barbou, hommage affectionaux de Trouillebert,
1 Janvier 1898.

PROVENANCE
Mme Alfred Barbou, Paris (from 1898); [Browse and Darby, London, by 1985; sold to Wrightsman]; Mr. and Mrs. Charles Wrightsman, London (1985–his d. 1986); Mrs. Wrightsman (from 1986).

If Trouillebert is best known for his landscapes in the style of Corot, this morsel is unquestionably based on Manet's *Bunch of Violets* of 1872 (fig. 1), which Manet painted for his friend, student, and sister-in-law Berthe Morisot (1841–1895). Like Manet, Trouillebert signed his name, trompe-l'oeil fashion, on the calling card. It is difficult to determine how and when Trouillebert saw the Manet, which remained in Morisot's family throughout the twentieth century, but it is not impossible that he saw it at her apartment in Paris. A version of the picture, also dated 1898, dedicated to a Madame Paris, was sold at Sotheby's, London, February 14, 1990 (lot 119, illustrated in color).

GT/AEM

Fig. 1. Édouard Manet, *Bunch of Violets*, 1872. Oil on canvas, $8\frac{3}{4} \times 10\frac{3}{4}$ in. (22 × 27 cm). Private collection, Paris

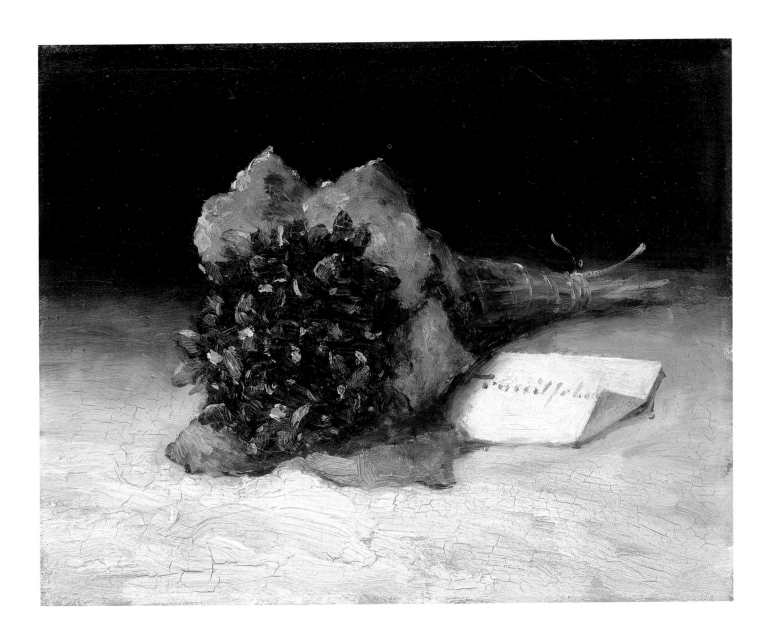

ERNEST-ANGE DUEZ

(1843–1896)

A fashionable painter of portraits, modern genre scenes, and religious subjects, Ernest-Ange Duez studied with Isidore Pils (1813–1875) and made his debut at the Salon of 1868. His Honeymoon *(whereabouts unknown), which depicted a couple holding hands in moonlit woods, gained notoriety at the Salon of 1873. At the Salon of 1874 he garnered a third-class medal for his paintings* Splendeur *(Musée des Arts Décoratifs, Paris) and* Misère *(whereabouts unknown), and successfully exhibited thereafter. The large triptych* Saint Cuthbert, *considered to be the artist's masterpiece, was acquired by the state for the Musée de Luxembourg from the Salon of 1879 (now Musée d'Orsay, Paris, RF 245). Duez's technique, similar to that of Alfred Stevens (see p. 393) and James Tissot (see p. 400), took the palette of more advanced painters such as Manet and Degas and applied it to the carefully descriptive depiction of modern affluent society. His dealers may have included Goupil, who dealt in Barbizon painters as well as Gérôme (see p. 387), and Paul Durand-Ruel, who handled the Impressionists.[1]*

In 1883 Duez moved his studio to 39, boulevard Berthier; John Singer Sargent (1856–1925) was working nearby at number 41. Sargent painted portraits of Duez and his wife in 1884–86 (see cat. 121, figs. 1, 2). At Sargent's request in 1888, Duez contributed 100 francs to the fund to acquire Manet's Olympia *for the French state. In addition to the American expatriate, Duez's circle at this time included the composer Gabriel Fauré (1845–1924) and the painters Jacques-Émile Blanche (1861–1942), Albert Besnard (1849–1934), Joseph Roger-Jourdain (1845–1919), and Winaretta Singer (princesse de Scey-Montbéliard from 1887 until 1892, princesse Edmond de Polignac after 1893).*

An active collector, Duez owned works by the Old Masters as well as pieces by Delacroix, Ingres, Adolph Menzel, Eugène Boudin, Degas, Stevens, and Rodin; in 1879 he lent Monet's L'Entrée du port du Trouville *of 1870 to the fourth Impressionist exhibition (as no. 147,* Estacade de Trouville, marée basse; *now Szépmüvészeti Múzeum, Budapest, 4970).[2] Among Duez's public commissions were two contributions to a cycle personifying the months (November and December) in the Paris Opéra,* Virgil Seeking Inspiration in the Woods *(1888) at the Sorbonne, and a pair of allegorical figures,* Botany *and* Physics *(1892), for the Hôtel de Ville, Paris.*

GT/AEM

NOTES

1. See Durand-Ruel's letter in the issue of *L'événement* dated November 5, 1885, reprinted in Anne Distel, *Impressionism: The First Collectors*, trans. Barbara Perroud-Benson (New York, 1990), p. 23, where Duez is included in a list of young artists he has supported.
2. The Monet excepted, these works were included in Duez's posthumous sale, Galerie Georges Petit, Paris, June 11–12, 1896.

120. *Au restaurant Le Doyen, Paris*

Oil on canvas, 34½ × 45 in. (87.6 × 114.3 cm)
Signed at lower right: E. Duez.

PROVENANCE
Edmond Javet, Limoges (by 1879); sale, Sotheby's, London, November 25, 1981, lot 39 (color ills., incl. cover), to Wrightsman; Mr. and Mrs. Charles Wrightsman, London (1981–his d. 1986); Mrs. Wrightsman (from 1986).

EXHIBITED
Galerie Goupil, Paris; Cercle de la Place Vendôme, Paris; Goupil Gallery, London (by 1879).

LITERATURE
Manuscript letter from Duez to Edmond Javet, dated July 1, 1879, Wrightsman collection; Jean-Marie Bruson and Christophe Leribault, *Au temps de Marcel Proust: La collection François-Gérard Seligmann au Musée Carnavalet*, exh. cat., Musée Carnavalet, Paris (Paris, 2001), p. 78.

Le Doyen was a popular meeting place during the Second Empire and the Third Republic, thanks to its location in the verdant strip of the Champs-Élysées behind the gardens of the Elysées Palace and its proximity to the Palais des Beaux-Arts (later replaced by the Grand Palais), where the annual and semiannual Salons were held. While the view chosen by Duez shows a trellised terrace, a different outdoor seating area provided the setting for a slightly later painting by Tissot (see p. 400) called *The Artists' Ladies* (fig. 1).[1] On the varnishing day of the Salon, as artists gave final touches to their works at the Palais des Beaux-Arts, their companions would lunch at Le Doyen. Alphonse Daudet's 1876 novel *Les femmes d'artistes* recounted this tradition as well as the myriad difficulties

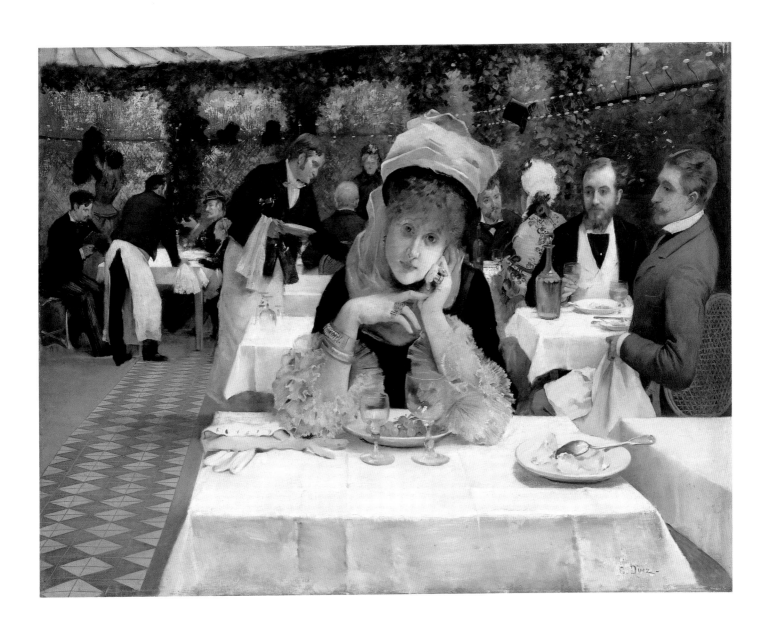

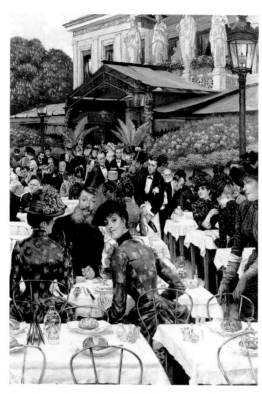

Fig. 1. James Tissot, *The Artists' Ladies,* 1885. Oil on canvas,
57 1/2 × 40 in. (146.1 × 101.6 cm). Chrysler Museum, Norfolk,
Virginia (81.153)

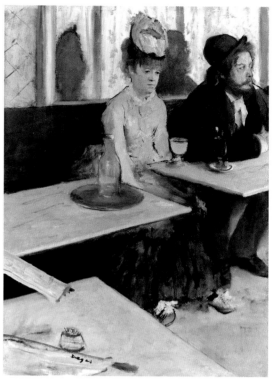

Fig. 2. Edgar Degas, *In a Café (The Absinthe Drinker),* 1885.
Oil on canvas, 36 1/4 × 26 3/4 in. (92 × 68 cm). Musée d'Orsay,
Paris (RF 1984)

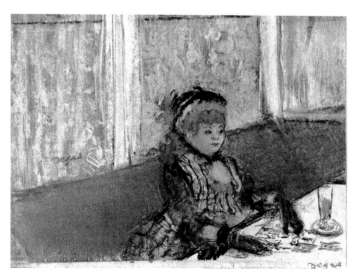

Fig. 3. Edgar Degas, *Woman in a Café,* ca. 1877. Pastel over monotype in black
ink, plate, 5 1/8 × 6 3/4 in. (13.1 × 17.2 cm). Ex-collection Donald and Jean Stralem,
New York

Fig. 4. Édouard Manet, *The Plum,* 1878? Oil on canvas, 29 × 19 3/4 in.
(73.6 × 50.2 cm). National Gallery of Art, Washington, D.C., collec-
tion of Mr. and Mrs. Paul Mellon (25.85)

of marriage that pitted the career ambitions and unstable fortunes of the artist against the social ambitions of his wife.

The fashionable, overdressed sitter in the present work may represent a mistress, or a potential mistress, of a painter. Too many and too large for a wife, the four rings on her fingers are all the more suggestive for the gloves placed on the table. The social status of this woman remains ambiguous, since she is emphatically alone: the table is set for one, and she is not waiting for a companion. Married women, or any woman with pretensions of propriety, would not dine alone in public; this must be the reason the gentlemen seated at the table behind her have taken note of her presence. Thanks to a letter sent by Duez to the painting's first owner, Edmond Javet, five of them can be identified: Édouard Detaille (1848–1912), on the far right, turns toward the woman; Roger Jourdain (1845–1918) sits across from him; Étienne Berne-Bellecour (1838–1910) faces the lady in the pink hat; Louis Leloir (1843–1884), at the table in the far-left corner, wears the uniform of an artillery officer; and, facing Leloir, *carte de vin* in hand, is Alphonse de Neuville (1834–1885).

At the time the Wrightsman picture was painted, about 1878, the theme of a solitary woman in a public place had recently been explored by both Degas and Manet. In a series of works from 1875 to 1877, among them *In a Café (The Absinthe Drinker)* (fig. 2) and *Woman in a Café* (fig. 3), Degas depicts working-class women, while Manet's *The Plum* (fig. 4) shows a woman whose place in society is questionable, as in this scene by Duez.

In his letter to Javet, Duez remarked: "This painting is and will be for me one of the most curious in my oeuvre and among those I prefer. I asked a very high price for it at first, but its very originality frightened away those collectors who don't always follow where we lead! I sell the least little female figure that I make in just a few days for four times the price, while by contrast the *Restaurant*, which took me months of work, brings me nothing."[2]

GT/AEM

NOTES

1. On the identification of the setting in the Tissot, see Tamar Garb, "Painting the 'Parisienne': James Tissot and the Making of the Modern Woman," in *Seductive Surfaces: The Art of Tissot,* ed. Katharine Lochnan (New Haven and London, 1999), pp. 102, fig. 38, 112–13.
2. "Ce tableau est et sera pour moi un des plus curieux de mon oeuvre et c'est un de ceux que je préfère. J'en ai demandé, dans le principe, un très gros prix, mais son originalité même a effrayé les amateurs qui ne suivent pas toujours quand nous allons de l'avant! Je vends quatre fois plus cher la moindre petite figure de femme que je fais en quelques jours, tandis que

le Restaurant qui m'a demandé des mois de travail, ne me rapporte rien, au contraire." Manuscript letter from Duez to Edmond Javet, dated July 1, 1879, Wrightsman collection.

121. *Portrait of a Woman, possibly the Artist's Wife*

Oil on canvas, 24¼ × 19¾ in. (61.5 × 50.2 cm)
Signed at upper left: E. Duez.

PROVENANCE
Possibly the artist's wife; [J. P. Hagnauer, Paris, by 1979; sold to Wrightsman]; Mr. and Mrs. Charles Wrightsman, New York (1979–his d. 1986); Mrs. Wrightsman (from 1986).

The woman depicted in this portrait is traditionally thought to have been the artist's wife. Amélie Duez was an amateur singer of some renown; Fauré dedicated his *Aubade* to her. Duez exhibited at least three portraits of a "Madame D . . . ," presumably his wife, at the Paris Salon, in 1877 (no. 760), 1886 (no. 826), and 1889 (no. 905). None can be located today.[1]

Although the sitter in the Wrightsman portrait does not resemble John Singer Sargent's portrait of Amélie Duez, painted in 1884–86 along with a portrait of Duez himself (figs. 1, 2), the identification cannot be ruled out definitively.[2] Sargent painted Amélie with very dark brown or black hair, while the woman here has lighter chestnut hair. Nevertheless, in Sargent's depiction one of Mme Duez's most prominent features is the fullness of her cheeks, which may be why her husband—in his only firmly identified portrait of his wife—concealed her cheeks with the high collar of her coat (fig. 3); the present subject is shown in a three-quarter view seen from behind, with a scarf or boa obscuring her jaw as well.

GT/AEM

NOTES

1. One of the three is almost certainly the *Portrait de Mme Duez* illustrated in Eugène Montrosier, "Ernest Duez," *Gazette des beaux-arts,* 3rd ser., 15 (May 1, 1896), p. 429 (whereabouts unknown), reproduced here as fig. 3. The painting was also illustrated in *L'illustration,* May 13, 1893, as *La Parisienne.*
2. On the Sargent portraits, see *The American Painting Collection of the Montclair Art Museum: Research Supplement I* (Montclair, New Jersey, 1979), pp. 11–16, entry by Maureen C. O'Brien on the male portrait. On both portraits, see Richard Ormond and Elaine Kilmurray, *John Singer Sargent: Complete Paintings,* vol. 1 (New Haven and London, 1998), pp. 152–53 nos. 149–50 and passim. These entries contain the best modern biographies of the Duezes.

Fig. 1. John Singer Sargent, *Portrait of Ernest Ange Duez,* ca. 1884–86. Oil on canvas, 29 × 23¾ in. (73.7 × 60.3 cm). Montclair Art Museum, Montclair, New Jersey, Gift of Dr. Arthur Hunter in memory of Ethel Parsons Hunter (1962.32)

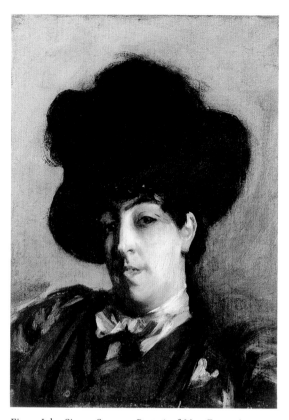

Fig. 2. John Singer Sargent, *Portrait of Mme Ernest Ange (Amélie) Duez,* ca. 1884–86. Oil on wood, 14 × 10 in. (35.6 × 25.4 cm). Private collection

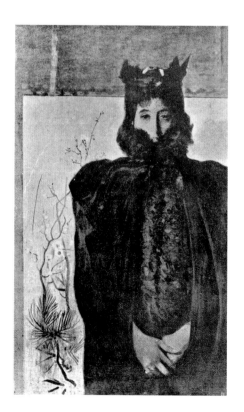

Fig. 3. Ernest Ange Duez, *Portrait of Madame Duez.* Whereabouts unknown. Reproduction from the *Gazette des beaux-arts,* 3rd ser., 15 (May 1, 1896), p. 429

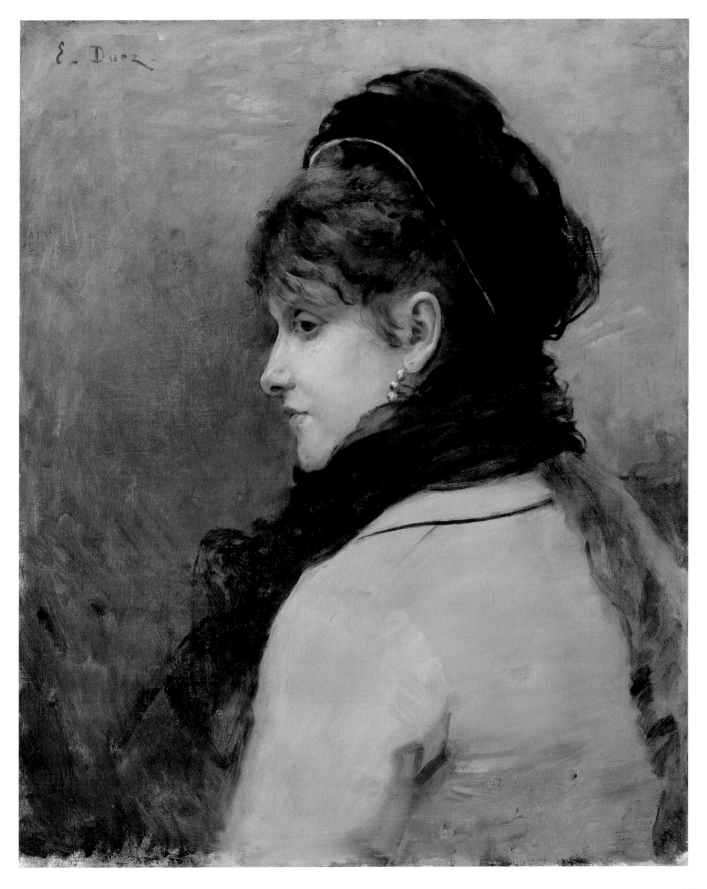

421

GEORGES-PIERRE SEURAT

(1859–1891)

Born in Paris, Georges Seurat first demonstrated an interest in draw-ing during his last year of school, 1874–75; the following year he attended drawing classes taught by the sculptor Justin Lequin fils (1826–1882) at the École Municipale de Sculpture et de Dessin. In March 1878 he enrolled in the studio of Henri Lehmann (1814–1882), a prominent disciple of Ingres (see p. 292), at the École des Beaux-Arts. Seurat placed poorly in ranked classes and not at all in the 1879 end-of-year competition; that fall he fulfilled his military obligation by serving one year. In the summer of 1881 Seurat began to work in the studio of his friend from Lequin's classes, Amand-Edmond Jean, or Aman-Jean (1858–1935/36), while studying the works of Delacroix (see p. 334), Puvis de Chavannes (1824–1898), and the Impressionists, whose exhibi-tions he may have visited as early as 1879. He rented his own studio in 1882, in the rue de Chabrol. For his initial attempt at exhibition at the 1883 Salon, Seurat submitted two drawings: Broderie, a portrait of the artist's mother, was refused, while his portrait of Aman-Jean was accepted, although it erroneously appeared with the former work's title (Metropolitan Museum, 55.21.1 and 61.101.16, respectively).

In the following year, 1884, Une baignade, Asnières (National Gallery, London) was refused by the official Salon but included in the unjuried first Salon of the Société des Artistes Indépendants. From May 1884 to October 1885, Seurat worked on his second major composi-tion in oil, an enormous canvas titled Un dimanche à la Grande Jatte, 1884 (Art Institute of Chicago). During this period, Seurat befriended Paul Signac and Armand Guillaumin, and, through them, Camille Pissarro (see p. 426), whose role as an organizer of the Impressionist group led to their inclusion in the exhibition organized by Durand-Ruel in New York in April 1886 and in the group's final exhibition in Paris in May–June; La Grande Jatte was included in both (and again in the Indépendants' second exhibition in August and at Les Vingts in Brussels in February 1887). This painting, whose dis-tinctive technique had already won the emulation of Signac and Pissarro, among others, is Seurat's signal achievement, the touchstone for what has variously been termed neo-Impresionism, post-Impressionism, divisionism, and pointillism. Yet despite claims made by others close to him, notably the critic Félix Fénéon, that Seurat's pointillist technique and compositional relationships were based in sci-ence, we now know that he developed it over a period of years by studying the works of the Impressionists and then painting numerous small oil studies on boards the size of cigar-box lids, called croque-tons, testing intuited color juxtapositions against the color theory then current in art schools.

Seurat habitually worked on large figure paintings showing scenes of urban leisure in the winter and eerily silent and motionless landscapes and marines in the summer, exhibiting them with the Indépendants and Les Vingts until his early death at the age of thirty-one, leaving his companion and a young son, Pierre.

GT / AEM

ABBREVIATIONS

Fahy 1973. Everett Fahy, in The Wrightsman Collection, vol. 5, Everett Fahy and Francis Watson, Paintings, Drawings, Sculpture. New York, 1973.

Paris, New York 1991–92. Robert Herbert et al. Georges Seurat, 1859–1891. Exh. cat., Galeries Nationales du Grand Palais, and The Metropolitan Museum of Art, New York; 1991–92. New York, 1991.

122. A Man Leaning on a Parapet

Oil on wood, 6½ × 4⅞ in. (16.5 × 12.4 cm)

PROVENANCE
The artist's estate (panneau no. 1 in the posthumous inventory of his studio); the artist's brother-in-law, Léon Appert, presumably a gift from the artist's mother, Ernestine Faivre (by 1898–about 1908; to Natanson); Alexandre Natanson (by 1908–14; sold on January 13, to Bernheim-Jeune); [Bernheim Jeune & Cie., Paris, 1914 (stock no. 20.162); sold on January 24, to Kann]; Alphonse Kann, Paris (from 1914; sold to Rodrigues-Henriqués); Jacques Rodrigues-Henriqués (after 1914–by 1924); Albert Roothbert, New York (by 1924); his widow, Toni A. Roothbert, Topstone Farm, Ridgefield, Conn. (d. 1970); Topstone Fund (1970–71; sold to Wrightsman); Mr. and Mrs. Charles Wrightsman, New York (1971–his d. 1986); Mrs. Wrightsman (from 1986).

EXHIBITED
La Revue Blanche, Paris, March 19–April 5, 1900, "Georges Seurat (1860–1891): Oeuvres peintes et dessinées," no. 2; Galerie Bernheim-Jeune, Paris, December 14, 1908–January 9, 1909, "Exposition Georges Seurat (1859–1891)," no. 3 (lent by "M.A.N."); Joseph Brummer Galleries, New York, December 4–27, 1924, "Paintings and Drawings by Georges Seurat," no. 20 (lent by Albert Roothbert); The Museum of Modern Art, New York, November 20, 1934–January 20, 1935, "Modern Works of Art," no. 25 (lent by Albert Roothbert); The Renaissance Society of the University of Chicago, February 5–25, 1935,

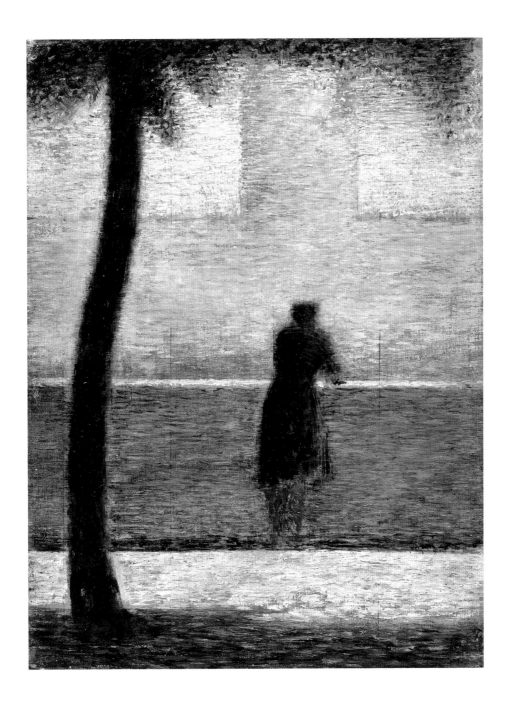

"Studies for 'La Grande Jatte' and Other Pictures," no. 19; The Museum of Modern Art, New York, March 4–April 12, 1936, "Cubism and Abstract Art," no. 258 (lent by Albert Roothbert).

LITERATURE
Lucie Cousturier, "Georges Seurat (1859–1891)," *L'art décoratif* 27 (June 20, 1912), p. 364, ill. (as "L'invalide," drawing); André Fontainas and Louis Vauxcelles, *Histoire générale de l'art français de la Révolution à nos jours* (Paris, 1922), vol. 1, *La peinture, la gravure, le dessin*, p. 240, ill. (erroneously as a drawing); Gustave Coquiot, *Seurat* (Paris, 1924), p. 245 (under "Peinture, 1881," as "Petit homme au parapet"); Elie Faure, *History of Art*, trans. Walter Pach, vol. 4, *Modern Art* (New York and London, 1924), p. 460, ill.; Jacques de Laprade, *Georges Seurat* (Monaco, 1945), fig. 1, p. 95 (erroneously described as oil on canvas); Germain Seligman, *The Drawings of Georges Seurat* (New York, 1947), p. 38; Henri Dorra and John Rewald, *Seurat: L'œuvre peint, biographie et catalogue critique* (Paris, 1959), p. 9 no. 9, ill. (as whereabouts unknown); César Mange de Hauke, *Seurat et son œuvre* (Paris, 1961), vol. 1, pp. 8–9 no. 12, ill. (dimensions incorrect); Anthony Blunt, *Seurat* (London, 1965), p. 77 no. 1, colorpl. 1; Pierre Courthion, *Georges Seurat* (New York, 1968), p. 44, ill.; Fahy 1973, pp. 206–12, colorpl. (2 details); Fiorella Minervino and André Chastel, in *Tout l'œuvre peint de Seurat*, trans. from the Italian by Simone Darses (Italian ed., 1971; Paris, 1973), p. 91 no. 8, ill.; Richard Thomson, *Seurat* (Oxford, 1985), pp. 34, fig. 29 (color), 39, 228 nn. 43, 44; Herbert Wotte, *Georges Seurat: Wesen, Werk, Wirkung* (Dresden, 1988), p. 214, fig. 8 (erroneously as Roothbert collection); Catherine Grenier, *Seurat. Catalogo completo dei dipinti* (Florence, 1990), p. 21 no. 8, ill. (erroneously as Roothbert collection); Richard Tilston, *Seurat* (London, 1991), pp. 34, color ill., 35; Michael F. Zimmermann, *Seurat and the Art Theory of His Time* (Antwerp, 1991), pp. 68, 71, color ill., 453 n. 24; Paris, New York 1991–92, pp. 27–28 under no. 14.

RELATED WORKS
Locations as of César Mange de Hauke, *Seurat et son œuvre* (Paris, 1961), abbreviated throughout this entry as H followed by the respective catalogue number.

STUDIES
PRIVATE COLLECTION. *Man Leaning on a Parapet, Seen from Behind,* ca. 1881 (fig. 2). Pastel, squared, 9½ × 6⅛ in. (24 × 15.5 cm). H459.
RODRIGUES-HENRIQUÉS, Jacques. *Man Leaning on a Parapet, Seen from Behind,* ca. 1881 (fig. 1). Conté crayon, squared, 9¼ × 5⅞ in. (23.5 × 15 cm). H460.

RELATED DRAWINGS
ANGRAND, Pierre. *Woman Leaning on a Parapet, Right Hind View,* ca. 1881. Conté crayon, 9⅜ × 6¼ in. (23.7 × 15.7 cm). H462.
ARAGON, Louis. *Man Leaning on Parapet, Left Hind View,* ca. 1881. Graphite and chalk on gray paper, 3¾ × 2¾ in. (9.5 × 6 cm). H416.
MARSEILLE, Robert. *Butcher Leaning on a Parapet, Seen from Behind,* ca. 1880–81. Graphite, 6½ × 3⅞ in. (16.5 × 10 cm). H407.
NEW YORK, Mr. and Mrs. Arthur Sachs. *The Hotel des Invalides, Seen over a Parapet by the Seine,* ca. 1881. Conté crayon, 12¼ × 9¼ in. (31.2 × 23.3 cm). H461 (where it is claimed that the dome is closer to that of the Institut of France).
PARIS, Jacques Dubourg. *Man Leaning on a Parapet, Seen from Behind,* ca. 1880–81. Graphite, 6½ × 3⅝ in. (16.5 × 9.2 cm). H400.

At the time of Seurat's death on March 29, 1891, this small painting was left in the artist's studio at 39, passage de l'Élysée-des-Beaux-Arts, in the 18th *arrondissement* of Paris. On May 3 of that year, Mlle Madeleine Knobloch, Émile Seurat (the artist's brother), Paul Signac, Maximilien Luce, and Félix Fénéon gathered there to inventory the studio's contents, and the works themselves were divided up among the artist's family and friends. The Wrightsman picture was listed as "panneau no. 1," an appellation that should be understood as much more than haphazard: the inventory was prepared very carefully, and its organization often encoded a hierarchy that probably reflected the relative importance that Seurat gave to his various works.

Although the artist made some one hundred sixty small paintings on wood, primarily cigar-box lids, referred to in the literature as *croquetons,* these are predominantly studies. The present work projects an air of self-sufficiency uncharacteristic of the croquetons. Opinion is unanimous that this is among the artist's earliest works, and it is usually dated to about 1881, although Robert Herbert has suggested that it may be as early as about 1878–79.[1] (However, this is contradicted by Herbert's later contention that Seurat only used colored chalks between 1879 and 1881.)[2]

The motif of a man seen from behind leaning against a low wall or parapet is found in three small early sketches seemingly drawn from life, in graphite, which have been dated to about 1880–81 (H400, H407, H416). Numerous studies from this period focus on single figures absorbed in thought or in their work (an example in oil is *The Mower* in the Robert Lehman Collection of the Metropolitan Museum, 1975.1.206). In their focus on ordinary people engaged in everyday life, they resemble the work of Honoré Daumier (1808–1879).

The present painting was developed through two studies, one in conté crayon (fig. 1), the other in pastel (fig. 2), both of which are squared. In these latter two works all the elements of the painting's composition are present, although both are actually larger than the oil.[3] Two other drawings that most likely predate the small panel are worthy of consideration in terms of its development. One is a view past some shade trees, over a parapet, toward a dome that is certainly the same dome as the one that appears in the painting, but lacking a figure (H461). The second is a conté crayon drawing of a woman leaning against a parapet, although seen more from the side than from behind (H462).

424

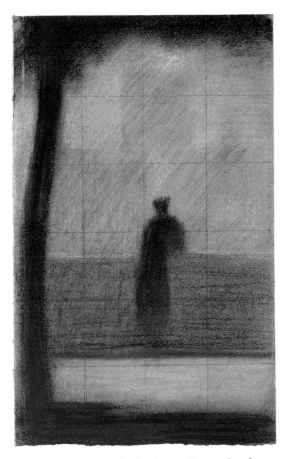

Fig. 1. Georges Seurat, *Man Leaning on a Parapet, Seen from Behind,* ca. 1881. Conté crayon, squared, 9¼ × 5⅞ in. (23.5 × 15 cm.). Collection of Jacques Rodrigues-Henriqués

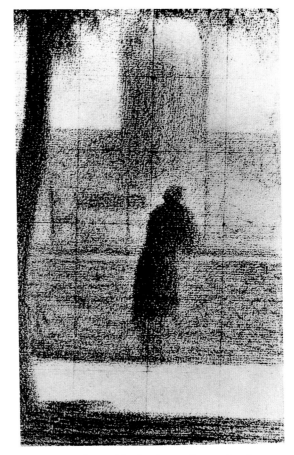

Fig. 2. Georges Seurat, *Man Leaning on a Parapet, Seen from Behind,* ca. 1881. Pastel, squared, 9½ × 6⅛ in. (24 × 15.5 cm). Private collection

Two later drawings reflect the composition of the Wrightsman picture. The first, known as *Le tronc d'arbre,* depicting a house seen past a tree, has been signaled as a correlative work given the compositional function of the tree (H546); although dated by de Hauke to about 1883, Robert Herbert dated it 1879–81 in the catalogue of the 1991–92 retrospective exhibition. Another pertinent work is the study of about 1884 for *Sunday on La Grande Jatte* known as *Man and Tree* (H616; Stadtische Museum Wuppertal), for which the Wrightsman painting and its studies might be considered a precursor.

The Wrightsman picture has traditionally been called *A Man Leaning on a Parapet (The Invalid).* "The Invalid" has been understood as a reference to the dome of Les Invalides, and the man was first called an invalid when the panel was exhibited in 1908. As many writers have remarked, however, the dome is more likely that of the Institut de France, across the Seine from the Louvre.

GT/AEM

NOTES

1. Unpublished letters from Herbert cited in Fahy 1973.
2. See Herbert in Paris, New York 1991–92, p. 27 under no. 14, where he admits that H459—see below—may date to as late as 1881.
3. The development of the picture is discussed in Anthony Blunt, *Seurat* (London, 1965), p. 77 no. 1; Fahy 1973, pp. 206–12; Richard Thomson, *Seurat* (Oxford, 1985), pp. 34, 39, 228 nn. 43, 44; and, most succinctly, by Robert Herbert, in Paris, New York 1991–92, pp. 27–28 under no. 14. Michael F. Zimmermann published a related drawing in a private collection that has not been accepted by all scholars (*Seurat and the Art Theory of His Time* [Antwerp, 1991], p. 70, fig. 98).

JACOB CAMILLE PISSARRO
(1830–1903)

Born into a Jewish family of French—originally Portuguese—descent on the island of Saint Thomas in the Danish West Indies, Camille Pissarro was raised in Paris. Essentially self-taught, his calling as an artist with a love of landscape solidified as a result of his early friendship with the Danish painter Fritz Melbye (1826–1896), with whom he traveled to Caracas in 1852–54. He returned to Paris in time to visit the Exposition Universelle in 1855, which exposed him to works by Corot, Millet, and Courbet. In 1859 he enrolled at the Académie Suisse, where he first met Paul Cézanne (1839–1906), Claude Monet (1840–1926), and Armand Guillaumin (1841–1927). He exhibited at the Salon from this time until 1870; he also befriended Auguste Renoir (1841–1919) and Alfred Sisley (1839–1899) during this period. About 1860 Pissarro entered into a relationship with Julie Vellay (1838–1926), with whom he was to have eight children; they were married in London in 1871, having fled Louveciennes the previous year to avoid the Franco-Prussian War. In London, Pissarro worked alongside Monet, a fellow exile. Returning to France that year, the Pissarros set up house in Pontoise, whose surrounding landscape is among the most familiar in the artist's oeuvre.

Thus began three decades of incredible productivity, which brought the artist into close collaborative relationships with, by turns, Cézanne, Edgar Degas (1834–1917; under whose influence figures acquired a greater role in his compositions), and Paul Gauguin (1848–1903). Pissarro was the leading advocate of the Impressionists as an exhibiting group, being the only one among them to participate in all eight of their shows between 1874 and 1886. Yet he was also the most open to experimenting with new approaches, notably the divisionism, or pointillism, of Georges Seurat (1859–1891) and Paul Signac (1863–1935), after meeting them in 1885. Consonant with his searching approach to technique, especially manifest in peasant subjects, Pissarro was politically active in leftist causes, including anarchism. Because of eye trouble that plagued him from 1889 onward, Pissarro stopped painting out-of-doors, but his late cityscapes painted from windows reveal a confident and free painterliness. GT / AEM

ABBREVIATIONS

Bailly-Herzberg 1980–91. Camille Pissarro. Correspondance de Camille Pissarro. Ed. Janine Bailly-Herzberg. Preface by Bernard Dorival. 5 vols. Paris, 1980–91.

Clark 1999. Timothy J. Clark. Farewell to an Idea: Episodes from a History of Modernism. New Haven, 1999.

Fahy 1973. Everett Fahy, in The Wrightsman Collection, vol. 5, Everett Fahy and Francis Watson, Paintings, Drawings, Sculpture. New York, 1973.

Pissarro and Venturi 1939. Ludovic Rodo Pissarro and Lionello Venturi. Camille Pissarro: Son art—son oeuvre. 2 vols. Paris, 1939. [Repr. San Francisco, 1989].

Venturi 1939. Lionello Venturi. Les archives de l'Impressionnisme. 2 vols. Paris, 1939.

123. Two Young Peasant Women

Oil on canvas, 35¼ × 45⅞ in. (89.5 × 116.5 cm)
Signed and dated at lower right: C.Pissarro.1892. Selected marks on the reverse: stretcher bears the oval stamp of maker, P. Aprin, rue du Douai, Paris; labels on the stretcher: printed exhibition label (Amsterdam 1938) inscribed in ink, Pissarro / La Causette / [illeg.] M de Rothschild Paris; printed shipper's label (J. Chenue) inscribed in ink, WW Gemeente; printed exhibition label (Paris 1930); label inscribed in ink, La Causette N⁰ 25 (the number struck out); printed shipper's label (James Bourlet & Sons, London) bearing the number B61266; inscription on the stretcher, in ink, La causette; French export stamps on stretcher and canvas.
The Metropolitan Museum of Art, New York, Gift of Mr. and Mrs. Charles Wrightsman, 1973 (1973.311.5)

PROVENANCE
Gift of the artist to his wife, Mme Camille Pissarro, née Julie Vellay, Eragny and Paris (1892–d. 1926; her sale, Galerie Georges Petit, Paris, December 3, 1928, lot 25, as "La causette," for Fr 173,000, to Rosenberg); [Paul Rosenberg, Paris, 1928]; private collection, ?Paris (in 1930); baron Maurice de Rothschild, Paris (by December 1933–52); [Rosenberg & Stiebel, New York, 1952; sold to Wrightsman]; Mr. and Mrs. Charles Wrightsman, New York (1952–1973); their gift in 1973 to the Metropolitan Museum.

EXHIBITED
Galeries Durand-Ruel, Paris, [January 23]–February 20, 1892, "Exposition Camille Pissarro," no. 50 (as "Deux Jeunes Paysannes"); Galeries Durand-Ruel, Paris, April 7–30, 1904, "Exposition de l'oeuvre de Camille Pissarro,"

no. 84 (as "La Causette, à Mme V^{ve} Pissarro"); Galerie Manzi et Joyant, Paris, January–February 1914, "Rétrospective C. Pissarro," no. 4; Galerie Nunês & Fiquet, Paris, May 20–June 20, 1921, "La collection de Madame Veuve C. Pissarro," no. 29 (as "La Causette"); Musée de l'Orangerie, Paris, February–March 1930, "Centenaire de la naissance de Camille Pissarro," no. 81 (lent by M. X . . .); Galerie Beaux-Arts, Paris, December 1933–January 1934, "Seurat et ses amis: La suite de l'Impressionnisme," no. 49 (lent by baron Maurice de Rothschild); Wildenstein & Co., London, May 9–June 15, 1935, "Nineteenth Century Masterpieces," no. 29 (as "The Chatterer," lent by baron Maurice de Rothschild); Wildenstein & Co., London, January 20–February 27, 1937, "Seurat and His Contemporaries," no. 26 (as "La Causette"); Stedelijk Museum, Amsterdam, July 2–September 25, 1938, "Honderd jaar Fransche kunst," no. 195 (lent by baron Maurice de Rothschild, Paris); National Gallery of Art, Washington, D.C., February 1956–October 1957, and April 1959; Metropolitan Museum, New York, July 1–August 20, 1961, "Paintings from Private Collections: Summer Loan Exhibition" (not in catalogue); Metropolitan Museum, New York, December 12, 1974–February 10, 1975, "The Impressionist Epoch," no. C-22; Metropolitan Museum, New York, October 1–December 31, 2001, "Neo-Impressionism: The Circle of Paul Signac."

LITERATURE
Pissarro, manuscript letter dated Eragny, January 13, 1892, to Joseph Durand-Ruel, Durand-Ruel Archives, Paris, reprinted in Venturi 1939, vol. 2, p. 32 no. 44, and Bailly-Herzberg 1980–91, vol. 3, p. 189 no. 745; Pissarro, manuscript letter dated Eragny, January 19, 1892, to Joseph Durand-Ruel, Durand-Ruel Archives, Paris, reprinted in Venturi 1939, vol. 2, pp. 33–34 no. 46, and Bailly-Herzberg 1980–91, vol. 3, p. 193 no. 750; Félix Fénéon, "Exposition Camille Pissarro," L'art moderne de Bruxelles, February 14, 1892, reprinted in Félix Fénéon, Oeuvres plus que complètes, ed. Joan U. Halperin (Geneva, 1970), vol. 1, p. 209; Pissarro, manuscript letter dated Paris, February 26, 1892, to Octave Mirbeau, Cabinet des Dessins, Musée du Louvre, Paris, reprinted in Bailly-Herzberg 1980–91, vol. 3, p. 201 no. 760; Théodore Duret, Histoire des peintres impressionistes: Pissarro, Claude Monet, Sisley, Renoir, Berthe Morisot, Cézanne, Guillaumin (Paris, 1906), pp. 64–65; Théodore Duret, Manet and the French Impressionists: Pissarro, Claude Monet, Sisley, Renoir, Berthe Morisot, Cézanne, Guillaumin, trans. John Ernest Crawford Flitch (London, 1910), p. 132; Georges Lecomte, Camille Pissarro (Paris, 1922), ill. opp. p. 46, and see also p. 31; Théodore Duret, Die Impressionisten (Berlin, 1923), p. 86; Emil Waldmann, Die Kunst des Realismus und des Impressionismus im 19. Jahrhundert (Berlin, 1927), pp. 88, 468, ill.; Charles Kunstler, "La collection Camille Pissarro," Le figaro: Supplément artistique, November 29, 1928, p. 103, ill.; Anonymous, "Les grandes ventes prochaines: La collection Camille Pissarro," Le bulletin de l'art ancien et moderne, December 1928, pp. 410, ill., 412; Charles Kunstler, "Camille Pissarro (1830–1903)," La renaissance de l'art, December 1928, p. 505; Léo Larguier, "Le cabinet de l'amateur . . . les ventes Pissarro," L'art vivant, January 1, 1929, pp. 33, ill., 35; Anonymous, La revue française, March 1930, ill.; André Fage, Le collectionneur de peintures modernes: Comment acheter—comment vendre (Paris, 1930), p. 63, pl. XI; Charles Kunstler, "Des lettres inédites de Camille Pissarro à Octave Mirbeau (1891–1892) et à Lucien Pissarro (1898–1899)," La revue de l'art ancien et moderne 57 (March, April 1930), pp. 189, ill., 224, 226; Hemmets Konversationslexikon, vol. 6 (Stockholm, 1934), ill.; Anonymous, "Nineteenth-Century Masterpieces," Burlington Magazine 66 (June 1935), p. 297, ill. opp. p. 293; Pissarro and Venturi 1939, vol. 1, p. 61 no. 792, vol. 2, pl. 163, and see also no. 1593; Venturi 1939, vol. 2, pp. 32 under no. 44 (letter of January 13, 1892), 34 under no. 46 (letter of January 19, 1892); John Rewald, Pissarro (Paris, n.d. [1945?]), fig. 10; Fahy 1973, pp. 151–57 no. 17 (detail, color ill.); R. A. Cecil, review of The Wrightsman Collection, vols. 3–5, by Francis Watson, Carol C. Dauterman, and Everett Fahy, Burlington Magazine 107 (July 1976), p. 518; Christopher Lloyd, Pissarro (New York, 1979), pp. 8, 9, 15, colorpl. 32; Bailly-

Herzberg 1980–91, vol. 3, pp. 189 under no. 745 (letter of January 13, 1892), 193 under no. 750 (letter of January 19, 1892), misidentified as P.V.616; Richard Brettell and Christopher Lloyd, A Catalogue of the Drawings by Camille Pissarro in the Ashmolean Museum, Oxford (Oxford, 1980), p. 141 under no. 137; Anne Schirrmeister, Camille Pissarro (New York, 1982), colorpl. 12 opp. p. 11, pp. 14, 15, cover (color ill.); Charles S. Moffett, Impressionist and Post-Impressionist Paintings in The Metropolitan Museum of Art (New York, 1985), pp. 92–93, color ill.; John House, "Camille Pissarro's Idea of Unity," in Studies on Camille Pissarro, ed. Christopher Lloyd (London and New York, 1986), pp. 23, fig. 18, 30–31, 34 n. 37 (as "La Causette"); John House, "Camille Pissarro's Seated Peasant Woman: The Rhetoric of Inexpressiveness," in In Honor of Paul Mellon, Collector and Benefactor: Essays, ed. John Wilmerding (Washington, D.C., 1986), pp. 162, fig. 4, 163, 167, 170 n. 21; Richard Shiff, "The Work of Painting: Camille Pissarro and Symbolism," Apollo 136 (November 1992), pp. 309, fig. 2, 310 (as "La Causette"); Joachim Pissarro, Camille Pissarro (New York, 1993), pp. 30, 35, fig. 26 (color); Albert Schug, "De l'importance de la théorie néo-impressionniste de Seurat," in Pointillisme: Sur les traces de Seurat, ed. Rainer Budde, exh. cat., Wallraf-Richartz-Museum, Cologne, and Fondation de l'Hermitage, Lausanne (Lausanne, 1998), p. 20 (color ill., as "La Causette"); Clark 1999, pp. 54–137, 414–22 passim; Timothy J. Clark, "Time and Work-discipline in Pissarro," in Work and the Image, vol. 1, Work, Craft, and Labour: Visual Representations in Changing Histories, ed. Valerie Mainz and Griselda Pollock (Aldershot and Burlington, Vermont, 2000), pp. 109–32 passim, fig. 6.1; David S. Stern et al., Camille Pissarro and His Descendants: Impressionism to the Present, exh. cat., Museum of Art, Fort Lauderdale (Fort Lauderdale, 2000), pp. 14, 54; Karsten Harries, review of Clark 1999, Art Bulletin 83 (June 2001), p. 359; Richard Shone, The Janice H. Levin Collection of French Art, exh. cat., The Metropolitan Museum of Art, New York (New York, 2002), pp. 31–32, fig. 14, under nos. 6–7; Christie's, London, sale cat., June 26, 2003, p. 96 under lot 361.

DRAWINGS
OXFORD, Ashmolean Museum. Study of a Field with a Receding Row of Trees on the Left (fig. 2). Black chalk on light brown paper, inscribed in pencil, plus haut, terre laboure, vert, 9 1/2 × 12 1/4 in. (24.1 × 31.2 cm). Richard Brettell and Christopher Lloyd, A Catalogue of the Drawings by Camille Pissarro in the Ashmolean Museum, Oxford (Oxford, 1980), p. 141 no. 137, ill. This view, which probably served as the basis for the landscape, can be dated to ca. 1882–83, since it was used for three paintings from those years (see Related Works, below).
PRIVATE COLLECTION, France. Study for the woman at left in Two Peasant Women (fig. 1). Pastel, 18 1/4 × 11 7/8 in. (46.5 × 30 cm). Pissarro, Venturi 1939, no. 1593.

RELATED WORKS
MELLON COLLECTION. Camille Pissarro, Female Peasants Tending Cows, 1882. Oil on canvas, 25 5/8 × 31 7/8 in. (65 × 81 cm). Pissarro and Venturi 1939, no. 567.
PRIVATE COLLECTION. Camille Pissarro, Appletrees, ca. 1883. Oil on canvas, 21 1/4 × 25 5/8 in. (54 × 65 cm). Pissarro and Venturi 1939, no. 590.
WHEREABOUTS UNKNOWN. Camille Pissarro, Weeding the Vines, Pontoise, 1883. Gouache, 9 1/2 × 11 7/8 in. (24 × 30 cm). Pissarro and Venturi 1939, no. 1377.

Pissarro began this picture in the summer of 1891 and completed it in mid-January 1892, a month before the opening of a large exhibition of his work organized by Joseph Durand-Ruel. The artist's Neo-Impressionist paintings of the preceding five years or so had

failed to interest his small circle of admirers; therefore the artist held great hopes for the exhibition to rescue him financially and critically. Many of the fifty paintings were sold from the show, but not this one. Afterward, Pissarro presented this canvas, one of the largest of the group, to his wife, Julie Vellay.[1] T. J. Clark has recently speculated that this gift may be linked to the subject, since Julie Vellay was the child of peasants, and Richard Nathanson has identified the figure on the left as Eugenie Estruc, called Nini (1863–1931), Julie Vellay Pissarro's niece and a maid to Pissarro's mother.[2] While there is no known study for the right-hand figure, there is a pastel portrait of Nini that served as a study for the woman on the left (fig. 1).[3] In working out the trees that retreat on a sharp diagonal at left, Pissarro returned to a device he had used on at least three occasions almost a decade before, based on a single black chalk drawing executed *en plein air* (fig. 2).[4]

By 1891 Pissarro was already moving away from pointillist technique, and this canvas shows the variety of marks and intuited approaches to color division that he had developed as an alternative to Seurat's much more controlled method. In his letters Pissarro explained that he sought "sensation," perhaps best expressed as an optical vibrancy. But the large scale of the figures, their prominent position, and their carefully choreographed rela-tionship suggest the impact of Seurat's figure paintings, such as the *Parade de Cirque* of 1889 (Metropolitan Museum), as well as recent works by Degas. Like Seurat, Pissarro found inspiration in the quiet dignity of the rural world depicted by Jean-François Millet (1814–1875), and this painting, as Everett Fahy first observed, appears to have been built on poses borrowed from Millet: *Seated Shepherdess* (fig. 3) and *Man with a Spade* (fig. 4), which Pissarro knew from woodcuts.[5] But the stylistic resemblance to Millet stops there. As Théodore Duret explained in 1906, "His peasants, in particular, have none of that superimposed grandeur with which Millet, still in part under the influence of his time, never failed to endow them. Pissarro aptly defined the quality which separated his art from that of Millet's. Writing to me in March 1881, he said: 'They are all throwing Millet at my head. But Millet was biblical! It is curious, but for a Hebrew, I don't seem to have much of that quality in me.'"[6]

By virtue of their size, placement, and quiet dignity, the two women dominate the landscape setting: an open field near the artist's house at Eragny.[7] A confirmed anarchist, opposed to the intrusion of a controlling government in the everyday life of man, Pissarro wanted to preserve the ancient values of France's agrarian society, threatened by rapid industrialization. In this respect

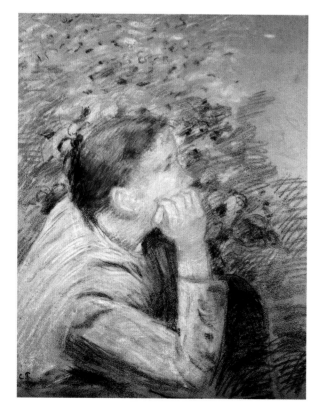

Fig. 1. Camille Pissarro, *Peasant Woman*. Pastel, 18 1/4 × 11 7/8 in. (46.5 × 30 cm). Private collection, France

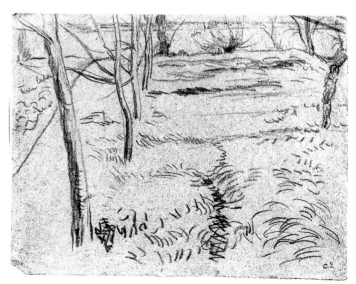

Fig. 2. Camille Pissarro, *Study of a Field with a Receding Row of Trees on the Left*. Black chalk on light brown paper, 9 1/2 × 12 1/4 in. (24.1 × 31.2 cm). Ashmolean Museum, Oxford

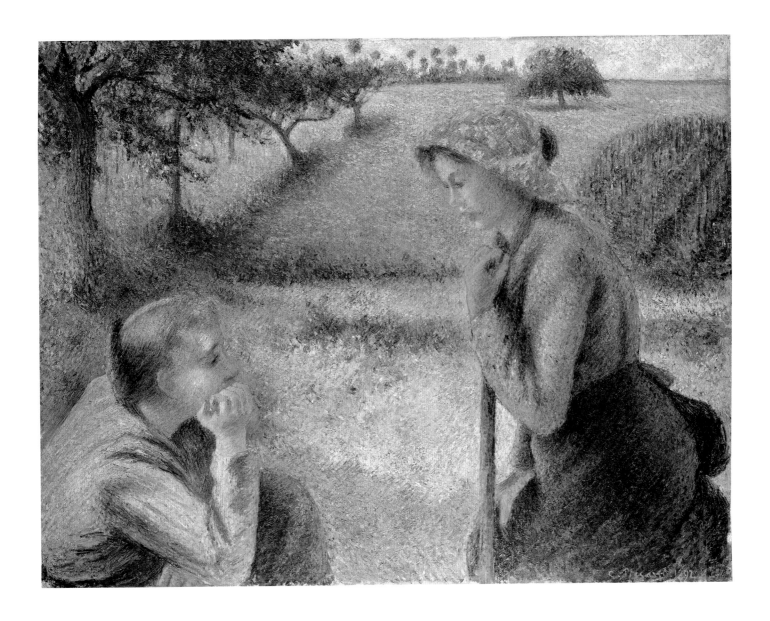

the goal of the art of both Millet and Pissarro at this time was the same—namely, to romanticize peasant life for urban sophisticates, since the reality was inevitably harsher and much more unattractive than their depictions. However, Millet and Pissarro rendered their depictions in very different styles, the first looking back to Raphael and Michelangelo, the second looking to his contemporaries like Degas and to younger painters such as Seurat and Signac.

An entire chapter of T. J. Clark's recent book *Farewell to an Idea* (1999) is devoted to this picture. Clark hoped to marry what he learned about Pissarro's anarchism with his own romantic yearning for an art that could express his notion of a socialist society uniting "human beings in a community without requiring them to surrender their freedom." But the author had to admit that it is difficult if not impossible to find evidence of anarchist belief in this painting, certainly not the brand of anarchism with its

Fig. 3. Jean-François Millet, *Seated Shepherdess*. Woodcut on paper, 10⅝ × 8⅝ in. (27.1 × 21.9 cm). The Metropolitan Museum of Art, New York, Rogers Fund, 19.34.1

Fig. 4. Jean-François Millet, *Man with a Spade*. Woodcut on paper, 7⅜ × 5¼ in. (18.8 × 13.2 cm). The Metropolitan Museum of Art, New York, gift of Van Horne Norrie, 17.34.15

Fig. 5. Camille Pissarro, *Peasant Women Planting Pea-Sticks*. Oil on canvas, 21⅝ × 18⅛ in. (55 × 46 cm). Private collection

"rhetoric of horror"[8] expressed by the bomb that François-Claudius Ravachol exploded just prior to the completion of Pissarro's work. Clark concluded that the true subject of the painting is "a form of sociability, and specifically of mental life, imagined as belonging to women."[9] This reading resembles the previously published analysis of Richard Shiff, who, unburdened by Clark's ideology, found that the painting suggests a "harmonious social circuit of (ungendered) labour and leisure . . . a harmony between the human functions of physical work and mental imagination." Shiff proposes that "through the *pictorial* [emphasis in original] device of the women's 'chat' or exchange, Pissarro suggests the possibility of bridging their difference, that between rural labour and a labourer's imaginative, mental life." Shiff notes that the themes of the picture are found in both contemporary literature—namely, Octave Mirbeau's novel *Dans le ciel* (1891)—and in the anarchist Peter Kropotkin's *La conquête du pain* (1890), both of which Pissarro knew.[10]

Although *Two Young Peasant Women* was noteworthy at its first exhibition because of its large scale, it did not receive much press. It was singled out by Félix Fénéon, the influential critic, anarchist,

Fig. 6. Camille Pissarro, *Seated Peasant Woman, Sunset.* Oil on canvas, 31⅞ × 25⅝ in. (81 × 65 cm). Private collection

and close friend of Seurat, but he did not lavish the attention that he attached to other works by Seurat at the show, such as the 1891 *Peasant Women Planting Pea-Sticks* (fig. 5): "en guirlande de gestes et de couleurs pour de vernales fêtes botticeliennes" (in a garland of gestures and colors for vernal Botticellian celebrations).[11] Indeed, the Wrightsman painting, *Peasant Women Planting Pea-Sticks,* and *Seated Peasant Woman, Sunset* (fig. 6) together formed a trio at the exhibition,[12] but that was not remarked upon either. From Georges Lecomte, writing in Durand-Ruel's catalogue introduction, and from the words of the artist himself, which appeared in an article by Joleaud-Barral in *La justice,* we learn that the decorative or abstract qualities of these large paintings, arrived at in the studio through the harmonious fusion of monumentality, open brushwork, and color, were considered the strongest statements of Pissarro's latest enterprise.[13]

GT/AEM

NOTES

1. Based on the dimensions cited by Pissarro and Venturi 1939, Anne Poulet determined in 1971 that this painting was among the seven largest produced by Pissarro, and that all subsequent works were of more modest size (Metropolitan Museum Archives).

2. Letter from Richard Nathanson to Christopher Lloyd dated June 22, 1999, Metropolitan Museum, Department of European Paintings archives.

3. Pissarro and Venturi 1939, no. 1593 (private collection).

4. *Study of a Field with a Receding Row of Trees on the Left* (fig. 2) is executed in black chalk on light brown paper and is inscribed in pencil, *plus haut, terre laboure, vert* (Richard Brettell and Christopher Lloyd, *A Catalogue of the Drawings by Camille Pissarro in the Ashmolean Museum, Oxford* [Oxford, 1980], p. 141 no. 137, ill.). The three pictures based on the drawing are: *Female Peasants Tending Cows* (Pissarro and Venturi 1939, no. 567), 1882, oil on canvas, 25⅝ × 31⅞ in. (65 × 81 cm), Mellon Collection, Upperville, Virginia; *Appletrees* (Pissarro and Venturi 1939, no. 590), ca. 1883, oil on canvas, 21¼ × 25⅝ in. (54 × 65 cm), private collection (see discussion in Clark 1999, pp. 63, 65, fig. 29, 415 n. 20); and *Weeding the Vines, Pontoise* (Pissarro and Venturi 1939, no. 1377), 1883, gouache, 9½ × 11⅞ in. (24 × 30 cm), whereabouts unknown (Clark 1999, pp. 63, 65, fig. 30, 415 n. 20).

5. Pissarro owned impressions of both these prints, which were given to him by Millet's son-in-law in 1884 (Pissarro to his son Lucien, early March 1884; Bailly-Herzberg 1980–91, vol. 1, p. 293), and which were sold in his widow's second posthumous sale, Hôtel Drouot, Paris, April 12–13, 1929, lot 258 and part of lot 259, respectively.

6. Théodore Duret, *Histoire des peintres impressionistes: Pissarro, Claude Monet, Sisley, Renoir, Berthe Morisot, Cézanne, Guillaumin* (Paris, 1906), p. 68, translated in Théodore Duret, *Manet and the French Impressionists: Pissarro, Claude Monet, Sisley, Renoir, Berthe Morisot, Cézanne, Guillaumin* (London, 1910), pp. 133–34.

7. Fahy writes that "The [Wrightsman] picture's setting is a field near the Pissarro house at Eragny," and he mentions that it appears in Pissarro and Venturi 1939, nos. 590 and 1377 (see also note 4, above; Fahy 1973, p. 152), citing a letter from the summer of 1891 in which the painter writes to his son Lucien saying that he is painting in *his* field. Clark, however, disputes that the site recorded in the Ashmolean drawing, and therefore in the Wrightsman painting, is in Eragny, as Pissarro spent much of 1882 and 1883 at Osny, near Pontoise.

8. Clark 1999, p. 102.

9. Ibid., p. 121.

10. Richard Shiff, "The Work of Painting: Camille Pissarro and Symbolism," *Apollo* 136 (November 1992), p. 310.

11. See Félix Fénéon, "Exposition Camille Pissarro," *L'art moderne de Bruxelles,* February 14, 1892, reprinted in Félix Fénéon, *Oeuvres plus que complètes,* ed. Joan U. Halperin (Geneva, 1970), vol. 1, p. 209.

12. Numbers 41 (Pissarro and Venturi 1939, no. 772; private collection) and 48 (Pissarro and Venturi 1939, no. 824; private collection) in the 1892 Durand-Ruel exhibition (see Exhibited, above), respectively.

13. Lecomte, who returns to the phrase "décor naturel" with respect to Pissarro's recent works, wrote of *Peasant Women Planting Pea-Sticks* and *Seated Peasant Woman, Sunset:* "Two canvases of great ideal and plastic importance reveal especially the grand style and decorative amplitude obtained by these artistic interpretations of the gifts of nature (Deux toiles, de très haute signification idéale et plastique, révèlent particulièrement le grand style et l'ampleur décorative obtenus par ces artistiques interprétations des données de la nature)"; see Georges Lecomte, *Exposition Camille Pissarro,* exh. cat., Galeries Durand-Ruel, Paris (Paris, 1892), p. 15. Excerpts from Pissarro's interview with Joleaud-Barral are quoted by Clark 1999, pp. 133, 421 n. 165.

GUSTAVE MOREAU

(1826–1898)

Gustave Moreau is one of only a few nineteenth-century artists whose reputation has survived a straddling of the academy and the avant-garde. His art is a heady mix of imagination and myth, at once studied in content and principle yet frequently wildly personal and innovative.

Raised in an affluent Parisian household, the son of an architect, Moreau enjoyed the freedom to pursue any literary or artistic attractions that came his way. He held himself apart from the main movements of his day, finding academic art inert and the schools of Realism and Impressionism unimaginative. For inspiration he looked to the art of antiquity, the Middle Ages, the Italian Renaissance, the French Baroque, and a variety of non-Western cultures.

Moreau first studied under the Neoclassical painter François-Édouard Picot (1786–1868) but seems to have been swayed more by the artist who worked next door, Théodore Chassériau (see p. 355). He spent three years (1857–59) in Italy copying pictures in museums and churches, sometimes alongside his friend Edgar Degas (1834–1917). The first of his three Salon prizes was awarded in 1864 to his painting Oedipus and the Sphinx (Metropolitan Museum), which established his reputation and set the stage for further passionate works steeped in classical erudition and technically brilliant. His final Salon appearance was in 1880, nearly two decades before he died, a recluse, of stomach cancer.

More than fourteen thousand paintings, drawings, and sketches were left behind by Moreau and bequeathed to the French state along with his Paris house, a public museum since 1903. Its first curator was Georges Rouault (1871–1958), one of Moreau's students at the École des Beaux-Arts, who, like Henri Matisse (1869–1954), profited from the master's instruction and encouragement.

CI

124. Saint Cecilia

Gouache and watercolor over graphite on wove paper mounted to wood panel, 13⁵⁄₁₆ × 6³⁄₈ in. (33.8 × 16.2 cm)
Signed in pen and red ink at lower left: Gustave Moreau.
The Metropolitan Museum of Art, New York, Gift of Mrs. Charles Wrightsman, 2004 (2004.475.3)

PROVENANCE
Charles Viguier; his sale, Galerie Georges Petit, Paris, May 4, 1906, lot 92, repr. Fr. 2,050; Francis Neilson (1867–1961); [Hazlitt, Gooden & Fox, London, 1989; sold to Wrightsman]; Mrs. Charles Wrightsman, New York (1989–2004); her gift in 2004 to the Metropolitan Museum.

LITERATURE
Pierre-Louis Mathieu, Gustave Moreau, with a Catalogue of the Finished Paintings, Watercolors and Drawings (Boston, 1976), p. 370 no. 418.

To express his fervent belief in the spiritual value of art, Moreau put the sacred heroes and heroines of legend and myth at the center of all he did. He painted luxuriously imagined tributes to Hercules and Samson, Venus and Bathsheba, Oedipus and Saint George. The classically educated son of agnostics, Moreau was not a practicing Christian but his personal iconography included martyrs of the Catholic Church, like Saint Cecilia, whom he painted in no fewer than two oils and two watercolors between about 1877 and 1897.[1]

Like Orpheus, Hesiod, and Sappho, whom Moreau also painted, Cecilia was an honored figure among fabled poets and musicians. A patrician Roman who dedicated her life to Christ with a vow of chastity, she protested her pagan marriage around the year 115 with songs dedicated to God. She was declared the patron saint of church music at the end of the fifteenth century and came to be considered one of the muses of poetic art.

The Saint Cecilia that Moreau envisioned in this sumptuous watercolor of about 1890–95, near the final years of his life, is an ethereal beauty. Placed on a pedestal of mounded earth, she holds an elaborate lyre and raises her haloed profile heavenward in the promise of song. At her side a tall flower blooms, a symbol of the Catholic Church for which she, a founder, was martyred.[2]

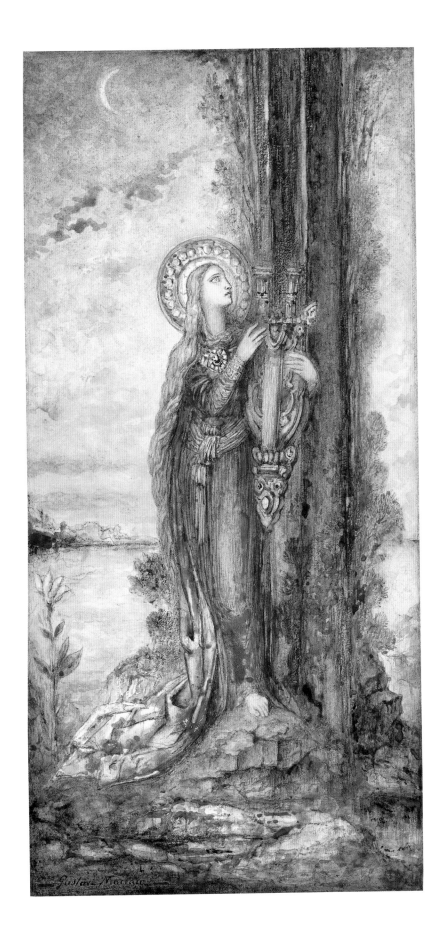

433

Having refined over the course of some thirty years the presentation of statuesque figures in intricately conceived, fantastic settings, Moreau here displays his mastery of icon-making in every rich, Byzantine detail. Indeed, the dreamscape, radiant at dawn, imagined as the atmospheric backdrop for this femme fatale/saint, was designed, as was she, to enchant fin-de-siècle sensibilities.

CI

NOTES

1. Pierre-Louis Mathieu, *Gustave Moreau, with a Catalogue of the Finished Paintings, Watercolors and Drawings* (Boston, 1976), pp. 364 no. 384, 370 nos. 418–19, 372 no. 428.

2. This symbol appears in Moreau's watercolor *The Ideal Flower—The Catholic Church*, ca. 1890–98, Musée Gustave Moreau, Paris (ibid., p. 309 no. 84).

INDEX

Note: Page numbers in *italics* refer to illustrations; **boldface** page numbers refer to catalogue discussions.